THE FILMS THAT
MADE ME

THE FILMS THAT MADE ME

Essays and Reviews
from *The Guardian*

Peter Bradshaw

BLOOMSBURY CARAVEL
LONDON · OXFORD · NEW YORK · NEW DELHI · SYDNEY

BLOOMSBURY CARAVEL
Bloomsbury Publishing Plc
50 Bedford Square, London, WC1B 3DP, UK

BLOOMSBURY, BLOOMSBURY CARAVEL and the Diana logo are trademarks
of Bloomsbury Publishing Plc

First published in Great Britain 2019

A catalogue record for this book is available from the British Library

Library of Congress Cataloguing-in-Publication data has been applied for

ISBN: TPB: 978-1-4482-1755-7; eBook: 978-1-4482-1756-4

2 4 6 8 10 9 7 5 3 1

Typeset by Deanta Global Publishing Services, Chennai, India
Printed and bound in Great Britain by CPI Group (UK) Ltd, Croydon CR0 4YY

To find out more about our authors and books visit www.bloomsbury.com
and sign up for our newsletters

For Caroline

Contents

Introduction I

The films that made me feel good 8
The films that made me feel bad 64
The films that made me laugh 177
The films that made me cry 223
The films that made me worry: 9/11, the War on
 Terror, Obama and the awful aftermath 239
The films that made me scared 270
The films that made me swoon: love stories and sexiness 295
The films that made me freak: shocking movies 328
The films that made me think about the real world:
 documentaries 363
The films that made me reflect on childhood, mine
 and other people's 401
The films that made ponder my suitability for Lycra 419
The films that made me take my protein pills and
 put my helmet on 442
The films that made me consider Tilda Swinton's
 maxim: "There is no such thing as an old film." 470

Index 537

Introduction

Like a pizza delivery driver who travels everywhere by moped, or a volcanologist who keeps turning the central heating up, I'm a film critic who loves going to the cinema.

Since I have been doing this job at *The Guardian*, solicitous questions about whether I can possibly still enjoy it (answer: yes, increasingly so) have morphed into a general need to discuss the crisis in the activity of film criticism itself. And, yes, there is a crisis. We need to return to the lost age of critical heroism when giants like Pauline Kael or André Bazin intervened spectacularly in the culture of cinema and when the careers of film-makers like Truffaut and Godard could evolve naturally from their former existences as critics, cinephiles and evangelists for humanity's newest artform.

The status of cinema criticism changed: it became professionalised and normalised. And then, shortly after the time I started, it was declared to be on the verge of extinction. The web changed everything, and the old saying "everyone's a critic" was now pretty much literally true. In terms of cultural discourse, the democratic explosion of comment applied most obviously to film criticism. Not everybody read new fiction. Not everybody went to art exhibitions. Not everybody went to the theatre or the opera and in age of web-surfing not even everybody watched TV quite the way they used to. But everybody went to the movies. Everybody had an opinion. Everybody could let rip.

Literary critics, music critics, architecture critics, were not considered to be in trouble in quite the same way. But professional movie critics were thought to be like brontosauruses up to their armpits in warm lakes, complacently cropping their leaves from

low-hanging branches as per usual, dimly sensing a faint whooshing and fizzing overhead, and after briefly looking up, getting hit in the face by a gigantic meteor.

Reviewers were getting laid off left and right – we didn't realise it, but this was actually a symptom and forerunner of a greater crisis within newspaper publishing – and throughout the noughties I was forever being invited onto panels at film festivals, in a spirit of *schadenfreude*-concern, to discuss the decline and fall of film criticism.

But something strange happened. It didn't decline and it didn't fall. The web invigorated criticism, not merely with the new voices that it allowed to be heard, but with the new opportunities and a whole new grammar of interaction with the reader. Social media and YouTube offered new ways of performing as a critic. And then, a few years ago, something else happened, in the wake of the #OscarsSoWhite and #MeToo campaigns: once dismissed for being absurdly powerless, critics were attacked for being too powerful – a white male cartel that was rigging the cinema system against women and people of colour. There is something in it, of course. Criticism has to be opened up. I myself am white and male, but I also understand the duty and responsibility of all critics, all writers, to reach beyond their provincial backgrounds, to identify, to sympathise, to understand the movies as an international artform, unimprisoned by gender.

It has all made critics realise that they themselves are eligible for criticism. I used to hear film-makers complain that critics were dubiously qualified to judge their work and then hear critics respond, with the thin-skinned resentment we traditionally show on the occasions we are criticised, that on the contrary we are highly qualified, thank you very much. Now I hear critics erupt with vexation when they read disobliging below-the-line comments on their work, and snarl that these people, whoever they are, are not qualified to judge their writing.

One of the great and still under-discussed issues of what we used to call Web 2.0 is the fact that it has put an end to the one-party state of media and publishing: a one-party state that came into power in 1475, with Gutenberg's printing press, and which began to lose its grip in 1989, with Tim Berners-Lee's world wide web. Before the web, if you wanted to publish an opinion you had to apply for a job

in journalism and work your way up, and even then you couldn't publish an opinion about journalism because that wasn't the way it worked.

The internet changed all this, and film criticism was one of its biggest victim-beneficiaries: shaken up, shaken loose. The unspoken contract between reader and critic used to be that one would read a review, and then see the film. Or not. Now people see the film, and then read the review – often on their phones or tablets on the way out of the theatre, and then start vehemently commenting. And they can go directly to the critic: their interest in that critic is not a subsidiary part of some brand loyalty to the larger paper or publication in the way it used to be. On the web, the critic's identity floats free. But like everyone else in the troubled world, he or she depends on the business model of the paper that is underwriting everything.

Film critics are giving it away for free. Film-makers, on the other hand, charge for their wares and vigorously crack down on people stealing movies – while of course resenting the way new media has conferred quasi-legitimacy on pirating.

And what about cinema itself? Some fads have come and gone. 3D enjoyed a revival ten years ago with the release of James Cameron's sci-fi fantasy *Avatar*, but has now vanished again. I was never reconciled to 3D, finding it uncomfortable and believing that we, the viewers, are the true third dimension. Also, in 2012, Peter Jackson experimented with High Frame Rate in his movie *The Hobbit*, shooting at forty-eight frames per second, rather than the traditional twenty-four. It made the images sharper and smoother, but just like video. The infinitesimal "motion blur" of twenty-four fps is what makes images richer, denser and cinematic. The forty-eight fps innovation was quietly dropped. Yet despite those disappearing innovations, all movie critics must realise how very young their chosen artform is. It is still in its infancy, still rooted in literature and theatre, still rooted in the idea that cinema is very largely created by adapting novels or short stories or plays (but not poems or paintings, for reasons never discussed). There may be some radical, unguessed–at generic change in cinema far ahead of us, arriving like the novel long after Shakespeare's day. Peter Greenaway says that we are still living in a pre-cinematic age.

Crisis is the dominant mode of discussion when it comes to talking about movie criticism, and perhaps assuming the existence of crisis is the only way of justifying the subject in the first place. And yet there is something in that crisis which is exciting and liberating. Critics have written about the way "cinema" and new cinema releases in the traditional sense have been abolished. It's not a question of a film getting shown in cinemas and getting reviewed in print, and finally becoming widely available. Films can be released in the Video-On-Demand format, or through Netflix, they can be consumed online, legally or not, through Vimeo or YouTube. The existence of old and inaccessible movies – so recently hardly more than a rumour – has now been reaffirmed by the retail explosion in DVD editions. This is the opportunity for a new and diversified cinephilia. Some pundits find something offensive in the existence of cinema which is getting experienced – or not – on tablets or smartphones. And yes, it isn't the same as the pure sensual thrill of the full-sized cinema. But wait. Where did you first see the great movies, where did you first see cinema itself? On TV, of course, probably with many vulgar and crassly timed commercial breaks. And TV is where people continue to find movies. And that small screen didn't poison your appreciation of cinema.

The selection of reviews and essays in this book represents work which in some senses has changed little over the past two decades. The films come out, and they have to be reviewed, every Friday. I produce a "lead" review, of about eight hundred words or so, and then a series of shorter, capsule-sized notices, of two to three hundred words. I am very lucky in that I get to choose which is the lead review, a relative rarity in newspaper criticism, and lucky also in having such superb colleagues and editors. What has happened, almost invisibly, is that the pace of everything, from distribution to critical reception, has accelerated. More and more films are released – from about five or six a week twenty years ago, it is closer to fifteen now – and many play perhaps one or two screens before being smartly withdrawn. It is increasingly the case that a movie's theatrical run is effectively an advertisement for its DVD-download release. Reviews have to be available more quickly, too, put up online almost hyper-instantaneously, together, of course, with links from Twitter and Facebook.

This brings me to the subject of whether critics regard themselves as consumer guides, and whether they should put star-ratings on their work. For many pundits, and those of a certain age who feel that the golden age has passed, star-ratings are the sign of everything that is wrong with criticism and with our allegedly dumbed-down society. It is certainly true that star-ratings have become the Esperanto of arts journalism throughout the world, and it is also true that the five-star system has encouraged the exasperatingly dumb practice of aggregating reviews from individuals with very different views and approaches, coleslawing them together on sites like Rotten Tomatoes, to arrive at some entirely meaningless and valueless statistic to the effect that such-and-such a film is sixty-five percent worthwhile.

As it happens, I like the star-rating system, and the existence of stars over the top of a review needn't detract from that piece of writing. It is the critic's responsibility to write in such a way that the reader wants to carry on past the stars. Far too often, I have read intriguing reviews which have been absolutely bursting at the seams with nuance. But after I have finished reading, I wanted to call the author on the phone and ask, just as a matter of idle passing interest ... is the film any good? Because an awful lot of critics find it convenient to retreat into wit and whimsy, especially with a big popular studio movie. They are droll; they appear to mock ... and if the film is a big hit, well, these remarks were clearly an affectionate acknowledgement of the film's potency as entertainment, and if the film is a flop, well, the same remarks are evidence of the film's egregious silliness. So the star-rating forces the critic to be clear, to shoulder the burden of making a value judgment. This is why I have retained my star-ratings in this collection. I haven't sneakily revised them upwards or downwards: for good or ill, this is what I thought at the time and I haven't tried to cheat with the benefit of hindsight, although in some cases I have been able to use the original, longer reviews that I wrote at the time, for which there was no space. The critic's version of The Director's Cut. And I have grouped these selected reviews into approximate (and miscellaneous and overlapping) categories: good films, bad films, superhero films, scary films, sexy films etc.

Very occasionally, I have come into conflict with directors on account of bad reviews, and I guess this this is inevitable, especially if

you are not just expressing your opinions but declining to take films and film-makers at their own estimations of themselves. Actually, needle between critics and film-makers is far less widespread than people assume, although in my experience it tends to be the film-makers who owe most to the critics who are the most prickly about their existence. Very recently, the British film-maker Ben Wheatley made an entirely understandable comment about criticism: "It's a job that I wouldn't want or seek out. As a creative person, I think you should be making stuff. That's the challenge. Talking about other people's stuff is weird. Why aren't you making stuff?" Perfectly fair. Critics will only really flourish if they know their place, which is below that of the creative artist. But writing (and broadcasting, tweeting, vlogging etc) is just close enough to the work of the film-maker to seem presumptuous or even parasitic. The film-maker can resent the critic in a way that the athlete doesn't resent the sportswriter.

I myself have never had a problem acknowledging the superiority of what the film-maker does, and I don't believe that the critic envies the film-maker in this pernicious sense. But there is only one tiny footnote I would add: the critic is responsible to the same constituency as the film-maker, and that's the public. The critic addresses the same audience, but from a different, smaller stage and from a different angle.

Harold Wilson said that the Labour Party is a moral crusade or it is nothing; film criticism is an act of love or it is nothing, or an act of fan-worship, or an act of celebration. Conversely, it's an act of extravagant rejection or derision of anything that threatens to endanger your adoration for cinema as a whole. Critics have to be in a state of vigilance against mediocrity and dullness – their own.

To be a film critic is to participate in a globally accessible and portable artform. Maybe only music is comparable. A film, wherever in the world it is created, can, with the relatively minor and unobtrusive addition of subtitles, be viewed and appreciated anywhere else in the world. This was always possible, and digital technology is making it a reality.

Cinema critics for newspaper are often condemned for having no rigorous methodology or clearly established criteria for their analysis, and it's true: they haven't, or I haven't anyway. It's more a Thelonious

Monk style improvised subjectivity-effusion of thoughts, comments, jokes, insights. If I have anything approaching a philosophy of criticism, it would be to borrow the title of Roland Barthes's *The Pleasure of the Text*. Movie criticism should be about the pleasure of the screen. Churnalism, PR-driven reviewing, hype-collaboration, mean-spirited obtuseness and cultural snobbery all militate against pleasure. Critics notice and amplify what they have felt to be pleasurable in the movies.

I acknowledge the following people: my lovely editor Jayne Parsons at Bloomsbury for her help and advice and the wonderful Philippa Brewster for having initiated the project. My thanks go to my tremendous agent Sam Copeland at Rogers, Coleridge and White and I also pay tribute to my friend, the late David Miller, a lovely man who left us far too early. My work would not be possible without *The Guardian*'s film editor Catherine Shoard, for whom no superlative is sufficiently extravagant, and my heartfelt thanks also go to friends and colleagues whose work inspires me: Andrew Pulver, Xan Brooks, Henry Barnes, Alex Needham, Benjamin Lee, Andrew Gilchrist, Liese Spencer, John Patterson, Hadley Freeman, Marina Hyde, Simon Hattenstone, Jordan Hoffman, Caspar Llewellyn Smith, Melissa Denes, Malik Meer and of course *The Guardian*'s editor Kath Viner and her predecessor Alan Rusbridger, who made me film critic in the first place. I salute my own predecessor in this job, the great Derek Malcolm, whose friendship and guidance have been invaluable.

And of course there is someone with whom I have been going to the movies for over thirty years, my wife Caroline – and my son Dominic, who shares my intense liking for superhero films.

The films that made me feel good

The James-Brown-ish title for this heading is "The films that make me feel good" – and a good film will always create in me in a kind of inchoate pleasure. I remember after seeing Paul Thomas Anderson's *Phantom Thread*, I felt like I was gliding along the pavement afterwards, as if partaking, miraculously, of the elegance and *soigné* style of its leading man: I moved like a hover mower, or a surfboard on a light current, or like someone doing a forwards-version of the Michael Jackson moonwalk. Pleasure is an under-investigated, under-acknowledged part of cinema: the simple sensory caress which criticism sometimes forgets about in its hasty rush to contain with writing.

But critics who presume to offer opinions about what is and isn't good at the cinema this week can expect to be challenged about their unargued, undiscussed criteria for what has or hasn't got value. If I say that a film is good, then what on earth does that mean? Sadly, I've got no theoretical manifesto to offer. Perhaps I should. What a critic does is accumulate a kind of common law over time, a gathering body of opinions or prejudices that the reader comes to understand, or tolerate, or be enraged by. It is a recurring complaint that criticism creates a vaudeville display of opinionating and subjective emoting, and spends too little time analysing, deconstructing; too little energy challenging the assumptions on which a film's effects are based. And this is true. But it is still a responsibility of the critic to make a value judgment, and risk being in a minority. It isn't enough to measure and analyse the limb. You have to go out on it.

THE MAN WHO WASN'T THERE

26/10/01

★★★★★

"Didja ever think about hair?" asks the Barber, played by Billy Bob Thornton, snipping away at a chipmunk-favoured, comic-book-reading little boy, the crown of whose head he has turned into a hypnotic blond whorl. "How it's a part of us? How it keeps on coming, and we just cut it off and throw it away?" His colleague tells him to cut it out: his weird intense talk is going to scare the kid. But the Barber persists. "I'm gonna throw this hair away now and mingle it with common house dirt," he says wonderingly, quietly, apparently on the verge of some kind of breakdown. But then, with an infinitesimally dismissive wince, the Barber waves the thought away and replaces his ever-present cigarette: "Skip it."

All of the power, the understatement and the profound enigma of Billy Bob Thornton's magnificent performance is contained in that brilliantly controlled and modulated scene, difficult though it is to single that out or anything else. This movie is quite simply the Coen brothers' masterpiece, and Thornton's brooding presence as the Barber, Ed Crane, is a stunning achievement. He is reticent, watchful, neither ingenuous nor jaded, but toughly stoic; he's quietly cynical and even desperate yet with a strong strain of decency, even quaintness: his strongest oath is "Heavens to Betsy!"

Ed Crane's Americanness runs through him like a stick of rock. He has hardly any dialogue, but dominates the movie through his rumbling, tenor voiceover: he is indeed there but not there. This is a classic performance from Thornton, displaying the kind of maturity and technical mastery that we hardly dared hope for from this actor. His Ed Crane forms a kind of triangle with Henry Fonda in *The Wrong Man* and Gary Cooper in *High Noon*: a paradigm of virile, yet faintly baffled American ordinariness.

The work is a thriller in the style of James M. Cain, set in suburban California in 1949 and obviously influenced by the movies of the period, yet somehow transmitting the atmospheric crackle of a strange tale from *The Twilight Zone*. It is the story of how self-effacing Ed

9

Crane, in yearning for a better station in life than that of the humble barber, with his smock and scissors, succeeds only in getting mixed up in the adulterous affair being conducted by his wife Doris, played by Frances McDormand, and her boss Big Dave (James Gandolfini), leading to blackmail, bloodshed, and the shadow of the electric chair.

The Man Who Wasn't There is shot in black and white by the Coens' long-standing cinematographer Roger Deakins, with superbly observed locations and sets: exquisitely lit, designed and furnished. As in so many of the Coens' films, an entire universe is summoned up, partly recognisable as our own, and yet different, a quirky variant on real life with its very own fixtures, fittings and brand names. Doris and Big Dave work in a department store with the jocose name of Nirdlinger's, whose creepy manikins and hulking display cabinets are shown in the empty store at night. Ed Crane reads pulp magazines with names like *Stalwart, Muscle Power* and *Salute*. Yet in one shot he's also frowning over *Life* magazine, whose cover advertises an arresting article: "Evelyn Waugh: Catholics in the US". In a previous scene we've seen Ed and Doris attending church on a Tuesday night for the charity bingo session: a secular High Mass for the semi-believers.

Frances McDormand is the second compelling reason to see this film, the querulous wife who married our dourly taciturn Ed after a courtship of just two weeks, and on being asked if they should get to know each other more, simply replied: "Does it get better?"

Ed is to reveal, glumly, that he and Doris "have not performed the sex act for many years", yet somehow their relationship is saturated with a gamey erotic perfume, like the ones she gets from Nirdlinger's with her staff discount. She lounges in the bath, asking languidly for a drag of his cigarette and getting him to shave her legs, which he does humbly, unhesitatingly: an uxorious moment of displaced sexuality which is recalled in the movie's final, devastating scene.

With extraordinary clarity and economy, Joel and Ethan Coen present scenes from a marriage as fascinatingly fraught as anything in the cinema. All the time, Thornton's face looms over everything, a one-man Mount Rushmore of disquiet. Later on, Ed's pushy lawyer is to describe him as a piece of modern art, and that indeed is what he is, a piece of art, one moreover that the camera loves: his face is a composite of planes and lines, crags and wrinkles, defined by the

crows' feet that fan out as he squints into the sun, or to filter out the cigarette smoke.

What a stunning, mesmeric movie this is. I can only hope that on Oscar night the Academy are not so cauterised with dumbness and cliché that they cannot recognise its originality and playful brilliance. *Noir* is the catch all term given to movies like this – yet the Coens achieve their greatest, most disturbing moments in fierce sunlight, in the outdoors and in the dazzling white light of the final sequence. So I propose a new genre for this film – *noir-blanc*, a seriocomic masterpiece which transforms the quotidian ordinariness of waking lives. It is the best American film of the year.

VERA DRAKE

7/1/05

★ ★ ★ ★ ★

Vera Drake: Portrait of a Serial Killer. It wouldn't be an entirely inapposite subtitle for this masterly movie. Mike Leigh captures his heroine's secret life, her *modus operandi* and her final calamity with the icy skill belonging to a master of suspense. It is as gripping and fascinating as the best thriller, as well as being a stunningly acted and heart wrenchingly moving drama of the postwar London working class. Imelda Staunton has already picked up an armful of awards for her performance as Vera Drake, the middle-aged cleaning lady with a hidden existence. She will certainly collect a whole lot more.

It is 1950, and Vera is cheerfully getting on with things. She pops in to help neighbours, nurses her elderly mother and looks after the family. But this life co-exists with, to paraphrase another Leigh title, a secret and a lie: something she's kept quiet from everyone, including her loved ones. With her trusty kit-bag of syringe and other assorted implements, Vera has for decades been "helping out" wretched girls who have "got themselves into trouble". Not just girls, either, but exhausted and despairing married women who can't possibly feed another mouth. With a chirpy smile, Vera arrives in their flats, puts the kettle on (for all the world as if she was making a nice cup of tea), and tells them briskly to pop themselves on the bed and take their underwear off. For this service, Vera does not accept a penny piece. She does it out of the Christian goodness of her heart, although it is to become horribly clear that Vera is being exploited by the grasping black-marketeer who fixes these appointments.

Vera's vocation as an abortionist exists entirely within the concentric circles of criminal concealment and euphemistic taboo. It is not merely that it is a secret from the authorities: it is a secret from Vera herself. She has no language to describe what she does or reflect on it in any way. The closest she comes to telling the miserable women what will happen to them after their appallingly dangerous treatment is to say that they will soon get a pain "down below", at which point they should go to the lavatory and "it will come

away". So when one of these women is taken to hospital almost dying in agony, and poor respectable Vera is confronted by the police, she is as hapless and hopeless as her victim-patients, with no way of defending or explaining herself. Her only response is mutely to absorb unimaginable quantities of shame.

Vera has withheld this awful business from everyone as naturally and unworriedly as a midwife of the period would conceal the moment of childbirth from the expectant father. It is just a job, and Leigh gives us his trademark scenes showing the customer class: in *Secrets & Lies*, it was Timothy Spall's photographic subjects; in *All or Nothing*, it was his minicab fares. Now it is women about to undergo illegal abortions.

Vera Drake's overwhelming mood of danger and transgression reminded me of the moment in Michael Powell's *Peeping Tom* when the seedy newsagent and his furtive customer quickly hide the pornography as an innocent girl comes in to buy sweets. Leigh pitilessly captures a similar kind of unmentionable fear and disgrace to which working women were subject – but which the middle classes with money and contacts could avoid. And, with a tragedian's ruthlessness, he etches that same fear and disgrace on Drake's face, too, when she is caught. It is the face of someone forced to acknowledge the elephant in the living room. Imelda Staunton's Vera simultaneously ages thirty years and becomes a terrified little girl. It is one of the most moving, haunting performances I have ever seen in the cinema.

The triumph of the film is in unselfconsciously juxtaposing Vera's crime with her ordinary public life as wife and mother, and with making us care about this other story just as much or even more. With compassion and gentleness, Leigh tells us about her husband Stan (Phil Davis) and his life in the motor trade with a brother who, despite having done better for himself materially, envies Stan's simple happiness. Vera welcomes into hearth and home a lonely neighbour, Reg (Eddie Marsan) who, movingly, becomes part of the family. Leigh has, in particular, two superbly managed scenes: Stan and Reg's good-natured, mutually respectful discussion of what sort of war they'd had, and Vera's son Sid (Daniel Mays), a tailor, selling a suit to a young Irishman preparing to go home for a wedding. These are moments worthy of the lyrical 1940s film-maker Humphrey

Jennings, whose documentary-collage *Listen to Britain* must have been an inspiration for much of Leigh's film.

Now, it might prove tempting for the movie's distributors to market Vera Drake as a provocatively "neutral" talking point on abortion for the benefit of American moviegoers and, indeed, Oscar voters. But there is actually no fence-sitting on the issue. Leigh's coup is to transfer the sympathy and dramatic emphasis away from the pregnant woman to the abortionist herself – a brilliant upending of the traditional stereotypes and pieties. This is not, however, the same thing as neutrality, and the film plainly shows the squalid hypocrisy of Britain before the Abortion Act. Vera Drake looks to me like a fully formed modern tragedy with a towering central performance from Imelda Staunton as poor, muddled Vera – and Staunton couldn't be so good if she was not given such superb support. This could be Mike Leigh's masterpiece: that is, his masterpiece so far, because at sixty-one years old, he shows every sign of entering a glorious late period of artistry and power.

THE SUN

2/9/05

★ ★ ★ ★ ★

Just in time for the sixtieth anniversary of VJ Day comes Aleksandr Sokurov's new film: a mesmerisingly mad, brilliantly intuitive study of Emperor Hirohito and his *Götterdämmerung* in the days after Hiroshima and Nagasaki, as he is summoned to make an unthinkably humiliating account of himself by General Douglas MacArthur. It is the last panel in Sokurov's triptych of twentieth-century despots – the first two being *Moloch* (1999), about Hitler, and *Taurus* (2001), about Lenin – but this, it seems to me, is the tragicomic masterpiece of the three, and certainly superior to his recent, unrewarding movie *Father and Son*.

The Sun shows the living god who emerges blinking into the scorched, radioactive daylight of the modern world and decides he must commit the act of *hara-kiri* appropriate on Mount Olympus: renounce his divinity and become a man. Oliver Hirschbiegel's *Downfall* was accused of leniency to the Führer in his bunker; Sokurov's Hirohito is never sympathetic exactly – he is just too alienated, too mysterious, the godhead who will never lower himself to the ordinary human emotions consistent with defeat, but must, through some superhuman effort of stoicism and politesse, accommodate himself to the reality of placing his head under America's yoke.

The emperor is the sun-god to his people, but over him defeat has cast a mushroom cloud. Appropriately the movie is shot throughout in crepuscular twilight, a sepia gloom for interior shots and a truly strange bleached-out blankness on the rare occasions when the emperor goes out of doors – as if the shock of defeat and nuclear catastrophe had leached all the natural light out of the world. It really is a quite extraordinary visual effect, and for a long time you watch it blinking, as if your eyes might eventually become accustomed to this subdued light.

Sokurov is both cinematographer and director, and the well-documented fact of his own failing eyesight must of course make his admirers wonder if this effect is entirely intentional. Maybe; maybe

not. Common sense suggests that this problem would make his films too bright. In any case, the question itself for me lends its own aesthetic and human poignancy to the work, a sense that the director has found his own very personal, serendipitous access to the idea of failure and the withdrawal of light.

The sound design is also a thing of wonder. Almost continually under the dialogue, the score murmurs and crackles like bad radio reception, and the effect is to make the film look like a remembered nightmare or like images from another planet. It murmurs like an unquiet spirit or like the plumbing of a haunted house. With masterly control, Sokurov orchestrates passages of Bach and, inevitably, Wagner, rising and falling in the white noise of Japan's nuclear winter.

The emperor and the American general are profoundly alien to each other. Hirohito is played by Issei Ogata as part gawkish boy, part sclerotic old man, his mouth continually working in a palsied, neurotic tic, as if over ill-fitting dentures. Clothed in a Western-style morning suit with tailcoat, top hat and owlish spectacles, he is forced to dine with MacArthur (Robert Dawson), who is angry, contemptuous, profoundly uncomprehending. They are like two separate species, or even separate planetary forms.

The emperor is protected from the real world in his fortified royal apartments, poring over his photo collection. He gazes glumly at one shot of Hitler and Hindenburg, perhaps realising that he personally embodies both Hitler's defeat and Hindenburg's Ruritanian obsolescence and irrelevance. Throughout Japan's disaster, he has been chiefly interested in his hobby of marine biology research (a little like George V's stamp collection) and he has vivid dreams of Japanese cities being firebombed by malign airborne fishes. His Darwinian convictions have been accelerated by defeat, leading him to "evolutionary" views about Japan's future modernity. The amateur geneticist in him senses that the history of homo sapiens will be advanced by disaster, by the comets and meteorites which will extinguish one era and usher in another. Viewing this film sixty years after its historical period, it is remarkable to think that the Japanese are still alone in experiencing nuclear attack and the evolutionary consequences it brings in its train.

A Tom Stoppard or a Ronald Harwood might well tell this story differently on the stage, perhaps clarifying its shape and putting

brilliant speeches into the mouths of Hirohito and MacArthur. Sokurov prefers a cloud of unknowing and fear. Some might find the perpetual semi-darkness a difficulty and some of the dialogue uneasy. But for my money, even this is utterly appropriate. *The Sun* is a film about a world that has lost its bearings, an existential feeling of being unmoored from everything that had been taken for granted, cut adrift in an outer space of strangeness. Even its flaws – if they are flaws – are absorbing, and there is something exhilarating in the traumatised irrationality that Sokurov has somehow ingested into his creative procedure as a film-maker. Everything is managed with incomparable seriousness and grandeur.

INLAND EMPIRE

9/3/07

★ ★ ★ ★ ☆

The great eroto-surrealist David Lynch has gone truffling for another imaginary orifice of pleasure, with results that are fascinating, sometimes very unwholesome, and always enjoyable. His new film can best be described as a supernatural mystery thriller – with the word "mystery" in seventy-two-point bold. A Hollywood star called Nikki Grace, played with indestructible poise and intelligence by Laura Dern, accepts the heroine's role in an intense southern drama about adultery and murder, working with a roguishly handsome leading man (Justin Theroux) and an elegant British director (Jeremy Irons). But to her bafflement and then terrified dismay, Nikki discovers that the script is a remake of a lost, uncompleted Polish film, and that the project is cursed. The original lead actors died, as did the poor devils in the folk tale of fear on which it was based.

Acting out the role, in its new Americanised setting, is a seance of evil and horror. One of the rooms on the set turns out to be a portal into an infinite warren of altered states: Nikki finds herself in the first Polish film, or maybe it is that Polish characters and producers from that film are turning up in the second film, or in her real life, which sometimes turns out to be a scene from the film and sometimes something else entirely. There is a disquieting chorus of LA hookers, and often we come out into an imaginary sitcom featuring a braying laugh-track and characters dressed as rabbits. Curiouser and curiousest.

The nightmare goes on and on – for three hours, in fact. But believe me when I say that, though this is familiar Lynch stuff, it is never dull, and I was often buttock-clenchingly afraid of what was going to happen next and squeaking with anxiety. The opening scene, in which Nikki is visited by a creepy neighbour (Grace Zabriskie) is so disturbing, I found myself gnawing at a hangnail like a deranged terrier.

The epic length of *Inland Empire* is perhaps explained by the freedom afforded by the cheaper digital medium, with which the

director is working for the first time, handling the camera himself. Unlike the plasma TV screens in Dixon's, David Lynch is evidently not HD-ready; this is ordinary digital video we're talking about, with all its occasional gloominess and muddiness, and for which the director is compensating by using many big, almost convex close-ups. Vast fleshy features loom out of the grainy fog.

Chief among these is Laura Dern's wonderful face: equine and gaunt, sometimes, but always lovely and compelling in a way that goes quite beyond the cliché of *jolie laide*. It is either radiant or haunted, and in one terrible sequence transformed into a horror mask that is superimposed on to the male face of her tormentor. These searing images made me think that Lynch is still inadequately celebrated as a director of women, with a sensitivity somewhere between Almodóvar's empathy and Hitchcock's beady-eyed obsession.

Inland Empire is, as with so many of Lynch's movies, a meditation on the unacknowledged and unnoticed strangeness of Hollywood and movie-making in general, though I am bound to say that it does not have anything like Naomi Watts's marvellous "audition" scenes in *Mulholland Drive*. The director's connoisseurship of Hollywood, his anthropologist eye for its alien rites, are however as keen as ever.

Lynch is entranced by the straight movie-making world: he loves the stars on the Hollywood Walk of Fame – something awful happens here on Dorothy Lamour's star – the rehearsals, the shooting, the cutting and printing and checking the gate, and he loves the spectacle of actors walking contemplatively beside enormous sound-stages, for all the world as if they are in *Singin' in the Rain*. Yet he finds something exotic and bizarre in it; these qualities are not superimposed on normality, however; he finds the exoticism and bizarreness that were there all along.

Because watching movies is a bizarre business, and a movie creates its own world, in some ways more persuasively cogent and real than the reality surrounding it, Lynch positions himself in the no man's land between these two realities and furnishes it with a landscape and topography all his own. Nobody else brings out so effectively the hum of weirdness in hotel furniture, in Dralon carpeting and in smouldering cigarette butts in abandoned ashtrays. His music and sound design, with echoes and groans, are insidiously creepy, though

only once does he give us the signature Lynch motif: the slow vibrato on an electric guitar chord.

He establishes a bizarre series of worm-holes between the worlds of myth, movies and reality, with many "hole" images and references, which culminate horribly, and unforgettably, in a speech from a homeless Japanese woman over Nikki's prostrate body about a prostitute who dies on account of a "hole in her vagina wall leading to the intestine". It is a gruesome but gripping image of how the vast, dysfunctional anatomy of David Lynch's imaginary universe is breaking down and contaminating itself. This gigantic collapse is perhaps the point, and the film-versus-reality trope is simply the peg on which to hang a gigantic spectacle of anarchy with no purpose other than to disorientate. It is mad and chaotic and exasperating and often makes no sense: but it is actually not quite as confusing as has been reported. Even the most garbled of moments fit approximately into the vague scheme of things, and those that don't – those worrying rabbits – are, I guess, just part of the collateral damage occasioned by Lynch's assault on the ordinary world. How boring the cinema would be without David Lynch, and for a long, long moment, how dull reality always seems after a Lynch movie has finished.

JUNO

8/2/08

★ ★ ★ ★ ★

A naked Nicole Kidman was once famously described as "pure theatrical Viagra"; in this thoroughly delightful teen comedy, the fully clothed Ellen Page is pure cinematic Prozac. With its smart dialogue by newcomer Diablo Cody and a miraculously effective and evocative lo-fi soundtrack, the film has the ephemeral charm of a great pop song.

Page plays Juno MacGuff, a hyper-articulate sixteen-year-old who has cultivated sarky irony to insulate her against the pain and awfulness of being a teenager. In a spirit of experiment she has had sex for the first time with Paulie (Michael Cera), with whom she was once in a band. Paulie was also surrendering his virginity, or as Juno puts it, "going live". As ill fortune would have it, Juno gets pregnant the first time out, and is catapulted in a world of genuine grown-up experience to match and exceed her super-cool mannerisms. Unable to express his deeply hurt and confused feelings, Paulie shrugs and lets Juno do what she wants, and she decides to keep the baby and find a couple for adoption. This turns out to be the uptight yuppies Mark (Jason Bateman) and Vanessa (Jennifer Garner). Mark is a cool composer with a guitar collection, secretly unreconciled to fatherhood; inevitably he begins a dangerous flirtation with Juno, whose baby threatens to destroy the marriage it was intended to complete, and to undermine Juno's own future in ways she had not begun to imagine.

It may be that like Judd Apatow's comedy *Knocked Up*, Juno will be criticised for neglecting to endorse abortion, or to reflect that this is the option that is the most tenable in real life. In this paper, Hadley Freeman recently wrote an insightful article, noting that *Juno* is not the product of an anti-abortion culture, but one which has taken abortion for granted. Absolutely right. But this needn't mean abortion rights are being slighted; it would be a relief to see a culture in which, say, evolution was taken for granted.

Juno is a fiction with irresistible charm and wit and Page carries everything before her, creating a character with a powerful sense of right and wrong, an overwhelming belief in monogamy, and a nascent talent for leadership.

The film owes its power to Ellen Page's lovely performance and to Cody's funny script, which treats the subject of status with shrewdness and compassion. If women all too often find status only in the dangerous and expendable commodity of sexual attractiveness, then in getting pregnant, Juno would seem to have catastrophically abandoned this one tiny prerogative, and looked stupid into the bargain. Yet she finds that, as a pregnant woman, she is the centre of attention, and in offering her child for adoption, she has dizzying power over rich adults. It is a power that gives her insight and clarity, and humbles her elders. Like I said: this film is a happy pill.

SYNECDOCHE, NEW YORK

15/5/09

★ ★ ★ ★

For his directorial debut, the screenwriter Charlie Kaufman has outdone himself, for good or ill, with the strangest, saddest movie imaginable, a work suffused with almost evangelical zeal in the service of disillusion. It's a film of mad Beckettian grandeur about the terrible twin truths of existence: life is disappointing and death inescapable. And it supplies a third insight: art is part of life and so doomed to failure in the same way.

The film is either a masterpiece or a massively dysfunctional act of self-indulgence and self-laceration. It has brilliance, either way: surreal, utterly distinctive, witty, gloomy in the manner that his fans will recognise and adore, but with a new epic confidence, absorbing the influences of Fellini and Lynch. As with his previous films, *Adaptation* and *The Eternal Sunshine of the Spotless Mind*, I had the uneasy feeling that one single idea was being extruded to an excessive length, but this movie's crazy emotional intensity and ambition really punched my lights out on a second viewing. And that protracted final sequence is quite extraordinary, in which the dying hero is instructed what to think and do, via a voice through an earpiece, while he stumbles through the wrecked stage-set of his self-created existence.

The early comedies and short stories of Woody Allen are a perennial source of inspiration for Kaufman, and he may well have found particular impetus from a scene at the end of *Annie Hall* in which Allen anxiously watches two actors playing out an autobiographical scene he's written: he's anxious, dissatisfied. The scene is a disappointment: it doesn't nail his experience, but as life itself is disappointing, perhaps this failure has an ironic integrity.

Kaufman proposes a *theatrum mundi* of his own. Philip Seymour Hoffman plays Caden Cotard, a miserable and hypochondriac theatre director living in Schenectady, New York, a place-name that whimsically mutates in the title, though nowhere in the script, to that obscure literary-critical term "synecdoche", meaning an image

23

in which the part stands for the whole – for example, "head of cattle" meaning cow, or "crown" meaning king. The significance of this emerges later.

Caden is unhappily married to Adele, played by Catherine Keener, an artist who clearly wants out of the relationship, and Caden is deeply dissatisfied with the middlebrow sameness of the work he's doing: an unadventurous revival of Arthur Miller's *Death of a Salesman*. He is also terrified by the possibility of sexual adventures with women who are very available: Hazel, who works in the box office, played by Samantha Morton, and his callow, sexy leading lady Claire, played by Michelle Williams.

Yet just when things are at their darkest, Caden improbably receives a letter to say he has won a "genius" grant to create a challenging, powerful, and above all truthful artwork. Thrilled by this opportunity to transcend the mendacity and mediocrity of the culture industry, Caden has a wild new plan. He will purchase a rundown city-block, construct apartment buildings and fill them with actors who will improvise entire created "lives" of unflinching reality and pain on a 24/7 basis. Years and decades pass while his company rehearse and improvise with no audience. Caden hires actors to play himself and his lovers. Head-spinningly, the gulf between theatrical make-believe and reality collapses.

Of course, the action of the film can't be taken literally: no "genius grant foundation" would have enough money to sustain such a crazy scheme. Yet neither is it supposed to be a fantasy: this is not merely what Caden is imagining he might do. It is Kaufman-reality, unreality, irreality, and the film won't have the same impact if you are not prepared to grant it some kind of "reality" status. It adjoins reality – and this, I think, is where "synecdoche" comes in, the part for the whole. Caden's huge, mad, pasteboard world stands for the real world, is part of it, is superimposed on to it, and finally melts into it.

The movie double-takes and hallucinates about itself, in ways that are captivating, exasperating. Its procedure is, in a way, recessive: disappearing down, down, down into an Alice-rabbit hole of a modified future reality. The narrative leapfrogs ahead in sudden fast-forward leaps. Caden's kid is four – no, wait, she's eleven, living in Berlin with her mother and dissolute lover – no, hang on, she's in her

thirties, tattooed, messed up, working in some pornbooth. Before you know it, she's on her deathbed, angrily accusing a decrepit Caden of abuse.

The insane theatrical fabrication of all this does not lessen its impact. On the contrary, it gives it a hyperreal intensity. Time itself jump-cuts and makes Caden suddenly older in spurts, until, through a bizarre twist, his own identity as the "director" of his life is taken over by someone more competent, and his individuality is annulled.

At the end of it all, you will feel as if you have lived through some crazy tragedy, swum a chlorinated Hellespont of tears. It is not for everyone, but is utterly extraordinary in its way. If Charlie Kaufman never does anything again, this will stand as his cracked monument.

BRIGHT STAR

5/11/09

★ ★ ★ ★ ★

"The beginning of your poem has something very perfect," says Keats's lover, Fanny Brawne, of his *Endymion* – before complaining that the rest of it isn't nearly as good. Tactfully, Jane Campion allows us to understand that this is not so much a criticism of Keats's poetry but his life, in fact of all our lives. They are finest at the beginning and careless youth is an *Endymion* moment, a blaze of perfection and rightness, destined to decay with adulthood's compromises and responsibilities.

With this account of John Keats's love affair with Fanny Brawne, played by Ben Whishaw and Abbie Cornish, Campion has made a fine and even ennobling film: defiantly, unfashionably about the vocation of romantic love. She has Whishaw and Cornish actually recite poetry – which, for most actors, is as difficult as walking on your hands or juggling with knives – and even proposes a kind of secular martyrdom for them in the movie's final act. Their love is murdered by the false choice between love and art, and sacrificed to a petty tangle of money worries, social scruples and irrelevant male loyalties.

The movie is vulnerable to mockery or irony from pundits who might feel that Campion has neglected to acknowledge the primal force of sex, or from those who feel their appreciation of the poet exceeds that of the director. Nonetheless, I think it is a deeply felt and intelligent film, one of those that has grown in my mind on a second viewing; it is almost certainly the best of Campion's career, exposing *The Piano* as overrated and overegged.

Very few films allow you to listen to the sounds of silence, or near-silence, between the lines of dialogue: the sounds of birdsong, or the rustle of clothing, or footfalls in a country lane – but that is what Campion's does. Her film proceeds at a quiet, measured tempo and with a lucid calm. Another type of film would have supercharged its narrative moments with surging music and the engine-roar of dramatic acceleration, but Campion simply lets each scene unspool

evenly. There is something coolly unobtrusive about her cinematic staging. Silently reading a letter in a picture-window is allowed no more ostensible weight than the flirtatious conversation at a ball, or even the final announcement of Keats's death. And the action of the film proceeds largely within the summery pastures of nineteenth-century Hampstead, occasionally switching to the crowded squalor of Kentish Town. When Campion suddenly takes us to Keats's silent funeral procession in Rome's deserted Piazza di Spagna, it is the nearest thing to a flourish that she allows herself. But what a brilliant coup.

Cornish gives a wonderful performance as Fanny Brawne: the sensitive young woman who is intrigued and amused by the reputation of her neighbour, John Keats, but insistent on her own rival skills as a dressmaker and seamstress. Keats, as portrayed by Whishaw, has the self-possession of a middle-aged adult, the affected detachment of an artist and the eerie self-absorption of a child. Fanny's "meet-cute" – to use the classic Hollywood term – is however not just with him; she also encounters Keats's possessive and boorish best friend Charles Brown, played by the American actor Paul Schneider with a Scottish accent that British audiences may need to indulge a little. The same goes for his tartan waistcoat and trews.

Brown's appearance in the story alerts us to the fact that this is a love triangle. Grumpy, cigar-smoking Brown is quite as in love with Keats as Fanny is. Desperate to maintain their fusty bachelor idyll together, idling, musing and writing, he is (justifiably) afraid that marriage will condemn his friend to poverty and exterminate his poetic gift. Brown even sends Fanny a valentine card for reasons that he can scarcely understand himself: a shabby attempt at both seducing and lowering her in Keats's esteem? Is it an imitation of his revered friend – an attempt to get closer to Keats by behaving as he does? Or merely an admission of his own loneliness?

For a while, Fanny penetrates the mystery of Keats's world and their affair proceeds: their single kiss is ecstatic in that lost metaphysical sense. It is also very physical. But how can things proceed when Keats cannot afford to marry and is already married to his work? He is moreover very ill, and his protective chorus of jealous critical admirers is never far away, fearing another English winter for their hero. They club together to buy a ticket for him to travel to the

healthier climes of Italy, and the simple, abysmal fact of having spent all that money for him to go away crushes all hope for their love. Both his lover and his best friend see no choice but to concede the fiction that he may recover and that this arrangement is more seemly: an act of dishonesty that unites Brown and Fanny in shame. There's no avoiding the dreadful sadness that descends on the film like a shroud, but even in the sadness there is a kind of euphoria, an ecstasy of loss.

THE WHITE RIBBON

12/11/09

★ ★ ★ ★ ★

The White Ribbon is a ghost story without a ghost, a whodunnit without a dénouement, a historical parable without a lesson, and for two and a half hours, this unforgettably disturbing and mysterious film leads its viewers alongside an abyss of anxiety.

It has chilling brilliance and icy exactitude, filmed in black and white with the lustre of liquid nitrogen, and its director, Michael Haneke, achieves a new refinement of mastery and audacity. He has created a film whose superb technical finish and closure seems to me in contrast to its status as an "open" text, a work which resists clear interpretation. It reminded me of the group-guilt dramas of Friedrich Dürrenmatt and Max Frisch, and also the 1980 novel *Wie Deutsch ist es?* by Walter Abish, in which the son of a 1944 anti-Hitler plotter, who has just testified against a gang of fellow terrorists, returns to West Germany from France in the 1970s and asks himself how much of his homeland is in his soul. How German is it? Applied to *The White Ribbon*, the answer to this question can only be: very, very German indeed.

The setting is a remote village in northern Germany, in 1913, an outwardly placid but actually dysfunctional and repressive society, plagued with anonymous, retaliatory acts of malice and spite. The local doctor (Rainer Bock), out riding one day, is painfully thrown from his horse because a trip-wire was strung between two trees, and stealthily removed by unseen hands after the incident. The infant son of the local Baron (Ulrich Tukur) is abducted and later found in a local woodland, badly beaten with a cane. A boy with Down's syndrome is similarly assaulted and almost blinded. In addition to these unsolved crimes, there are, enigmatically, others with perpetrators whose guilt is plain, such as the destruction of a cabbage crop by an embittered farmhand.

The movie is narrated in voiceover by the local teacher (Christian Friedel), now an old man, who explicitly announces that these painful events "could perhaps clarify some things that happened

in this country". Could they? And what is the narrator's motive in remembering or misremembering these events? Could it be that, having presumably lived through both world wars, and very possibly achieved an important social standing in Germany, his own hindsight is questionable?

At the heart of everything is the pastor – an outstanding performance from Burghart Klaussner. He is a severe disciplinarian who rules his household with a rod of iron and insists on his family tradition of the "white ribbon" for wrongdoers, symbolising purity. His errant children have to wear the humiliating white ribbon tied around their arm until their father is convinced they are cleansed. The white ribbon could be the ancestor of the Jewish yellow star, or the Nazi armband. Or both. Or neither.

Haneke establishes a web of motive, and moreover suggests the ways in which the victims of some punishment could be displacing revenge on to people easier to attack than their actual tormentors. A group of local children, who appear to go around together in unwholesome intimacy like the blond devils in *The Village of the Damned*, could be the culprits. Yet there are others with grievances. The midwife and mother of the child with Down's syndrome, played by Susanne Lothar, is having an unhappy affair with the doctor, who treats her cruelly, and she further has evidence that he is abusing his fourteen-year-old daughter Anna. The scene in which Anna's tiny brother, wandering the house wakefully in the middle of the night, stumbles upon his father and sister together, is a masterpiece of ambiguous horror.

This is a place in which secrets can be kept for ever, revealing themselves only indirectly, in sociopathic symptoms. When war arrives in 1914, it is almost a relief: a sweeping away of all these festering resentments – like smashing the window in a stifling sick-room. Haneke is however also suggesting that Germany's twentieth-century wars are merely a continuation of this sickness on a bigger scale, though the link can never be clearly, definitively made. His villagers are convulsed by an enemy within, and although the Baron employs a number of Polish estate workers, there is no quasi-Jewish outsider upon whom the community focuses its fear.

Within this puzzle, Haneke constructs scenes and sequences that are instant classics. The schoolmaster is conducting a delicate

courtship of a local young woman, and despite Haneke's reputation for darkness, this plot-strand is gentle, touching and humorous – difficult though that may be to believe. Anna's little brother has the existence of death explained to him, and the result is funny and shocking at once, and the same goes for the sub-plot that follows from the pastor's little son asking if he can keep a caged bird, like the one his father has, and the consequence is both unsettling and poignant.

In the end, there is no solution to the mystery; it could be that history and human agency are unknowable, untreatable, or it could be that the Nazi generation grew up with unexpired resentment and the frustration of not getting a solution – and the director wishes us to hear the malign echoes of that word. This is a profoundly disquieting movie, superbly acted and directed. Its sinister riddle glitters more fiercely each time I watch it.

THE HEADLESS WOMAN

18/2/10

★ ★ ★ ★ ★

In the past decade, there have been three great films about guilt, denial and the return of the repressed: Mike Leigh's *Vera Drake* in 2004, Michael Haneke's *Hidden* in 2005 – and this is the third, *La Mujer Sin Cabeza*, or *The Headless Woman*, directed by Lucrecia Martel and co-produced by Pedro and Agustín Almodóvar. It is a masterly, disturbing and deeply mysterious film about someone who strenuously conceals from herself the knowledge of her own guilt.

Each time I have seen it, this film has swirled residually in my subconscious for days, and each time I have witnessed exactly the same spectacle outside the cinema afterwards: knots of people excitably, grumpily arguing about it. Some denounce it for being boring, wilfully obscure arthouse stuff – and, yes, be warned, it is a difficult, challenging film – while others, like onlookers trying to piece together events leading up to a robbery, frantically ask each other what happened and where and how and why. Then there's a smaller group, including me, dazed and wondering if what we have seen is not a portrait of a guilty person, but rather the autobiographical and minutely realistic dream this person is having.

The Headless Woman is set among an extended wealthy family in Argentina. Maria Onetto plays Verónica, an elegant, middle-aged woman who works as a dentist. Driving back from a family get-together, Verónica hits something in her car – bang! – her forehead lunges forward and appears to smash either into the steering wheel or the windshield, and whiplashes back. Verónica brakes and for a long, long moment, Martel's camera holds the shot of her profile: as she sits immobile and silent in the car. Is she in shock? Is she gazing at what she has hit in the rear-view mirror? For the first time, we see a child's handprint on the driver's-side window, a handprint which, in some kind of nightmarish continuity error appears to change position in the next shot.

But couldn't that just be from the kids who were larking around her car at the party earlier? We turn with Verónica, and all we can see

at this stage is a dead dog in the distance, which in an earlier scene had been with some boys playing by the roadside.

Verónica returns home: clearly traumatised. She cannot answer simple questions; she is confused. But it is not merely the physical impact. Verónica is dealing with the awful suspicion that she killed not merely the dog, but its owner. She has killed a child. Verónica confesses as much, in a quiet, wondering voice, to her husband, perhaps conveying an unspoken instruction that he and the menfolk of the family – doctors and medical types well connected with the cops – should handle this situation.

Martel's movie intuits and imitates her concussed state, a state which embraces evasive semi-consciousness. Shots are asymmetrically composed in such a way that we can't be sure what we are supposed to be looking at: Verónica, with her faint, not-all-there smile, will be in one part of the screen, while someone else, in another part, will be quietly getting something sorted. Like Verónica, the film glimpses the truth out of the corner of its eye. The sound design is such that voices that we think are emanating from just behind the camera, near Verónica, are coming from people talking in the middle distance: belatedly, we match the sound to their moving lips.

Often, people talking to Verónica will be seen only from the neck down – they are headless, like the famous photo of the "headless man" in the 1963 Duchess of Argyll divorce case. Her disorientation becomes most disturbing when she goes with a family party to visit an ancient aunt, who is suffering from dementia, and who complains that her apartment with its ancient furniture is filled with squeaks, like the sounds of the dead. In the same state of suppressed panic that she perceives everything else, Verónica sees that this old woman is a kindred spirit; she too must now live with ghosts.

But even here the complications and agonies are not complete. This is not the first time Verónica has had to swallow a secret and live a lie. There is another elephant in the living room she has to feed. A long, mysterious trip to a hotel just after the accident, and sexualised encounters with two different family members, indicate that avoidance, secrecy and denial are lifelong habits.

This is not an easy film to watch, or to understand, but the potency with which it resonates in the imagination is remarkable. Lucrecia Martel's other films, *The Swamp* (2001) and *The Holy Girl* (2004) have

both had something of this spacey, floating style, but never before has it been applied to something so painful, so relevant, and never before has she delivered such a psychologically real portrait: demonstrating in both style and content what happens when we go into denial. I'm as certain as I can be of the towering talent of Lucrecia Martel, but I can't quite be certain of exactly what *The Headless Woman* is about. For example: the child's handprint changing position … did I just imagine that? You tell me.

LOURDES

25/3/10

★ ★ ★ ★ ☆

"Leaving the miraculous out of life is like leaving out the lavatory or dreams or breakfast," wrote Graham Greene, but the miraculous certainly does tend to get left out of films, unless they are specifically about the life of Christ. So a contemporary movie set in Lourdes, among the believers and wheelchair-users who have come to that famous shrine in the hope of a cure, must inevitably trigger a series of expectations in the viewer: expectations of irony and disillusion, of some grotesque reversal, or maybe, in place of a cure, some violently satirical *Dr Strangelove* moment, a nauseous anti-miracle, like the ex-Nazi's euphoric scream of "I can walk!" in Kubrick's film at the instant when the earth's nuclear destruction is guaranteed.

Furthermore, this movie is by Jessica Hausner, the Austrian director whose name is habitually mentioned in the same breath as Ulrich Seidl and Michael Haneke: film-makers who are capable of exposing the refrigerated cruelty beneath the surface of *gemütlich* European middle-class life. But Hausner manages and controls our expectations in this superbly subtle, mysterious and brilliantly composed film. It concerns what seems to be a genuine miraculous event, after which Hausner adroitly, and repeatedly, allows us to suspect that something counter-balancingly awful is about to happen, bringing us close to the brink of apparent catastrophe, and then allowing the danger to recede, while at the same time letting us suspect that disaster has in fact in some way happened – or perhaps something entirely the opposite of disastrous. Either way, as the action of this outstanding movie proceeds, you get the eerie feeling that everything on screen has been invisibly deluged with something very important.

Sylvie Testud gives a tremendous performance as Christine, a young Frenchwoman who has multiple sclerosis and has come to Lourdes as part of a religious tour group organised by the Order of Malta. Her arms and legs are immobile and her hands are clenched fists. At Lourdes, she takes an alert and intelligent interest in the proceedings, though without seeming fervent or desperate,

and relates easily to her fellow pilgrims, including a woman with a disabled child, and an older woman Madame Hartl (Gilette Barbier), who takes it upon herself to be Christine's companion and roommate. Elina Löwensohn plays the senior nurse and tour group leader, something of a martinet who disapproves of any impious or egotistical behaviour. There is also Kuno, played by Bruno Todeschini, a handsome male volunteer who in the most refined, discreet and gentlemanly way, admires Christine's quiet beauty and courage.

Like everyone else, Christine absorbs the ruling ethos at Lourdes that spiritual healing is the important thing – a credo that allows everyone to leave without thinking that they have had a wasted or disappointing journey. Also, everyone is quite aware of the routine phenomenon of the "phantom" miracle. Some, in the heat of the moment, do indeed rise from their wheelchairs, only to sink back, hours or days later, when the euphoria has worn off. Everywhere, there is a patiently rational and metaphorical approach to the miraculous. And yet ...

As events unfold, it seems possible that some sort of strange quantum of health and sickness is in force. If physical strength should suddenly desert one of the party, it might migrate to someone else – but if divine grace should be visited on someone via these mysterious means, then this might cause ripples of dissatisfaction and resentment among the rest of the group, and the *status quo ante* could yet be reasserted. A cool, elegant and almost imperceptibly black-comic detachment is created with Hausner's group compositions, in which the viewer must always stay attentive for something vital happening in the middle distance.

The last film featuring a scene in Lourdes was Julian Schnabel's *The Diving Bell and the Butterfly*, in which Mathieu Amalric's disabled magazine editor Jean-Dominique Bauby remembers a dirty weekend spent in that bizarrely chosen location. Jean-Pierre Cassel was cast in the significant dual role of priest and vendor of cheap commercial trinkets. All the worldly, knowing irony of that scene – all the i-dotting and t-crossing – is utterly absent from Jessica Hausner's grippingly enigmatic work, shot on location in Lourdes itself: the mass scene appears to have been filmed with the actors "embedded" among genuine pilgrims. The audience is entitled to wonder if some of the ambiguity and restraint of Hausner's film was contrived to get

official permission for these sequences, but even that possibility has its own subversive fascination.

Towards its end, I found myself thinking of Dreyer's *Day of Wrath*, in which Anna's vocation for evil appears to pass from the metaphorical to the real: a sense that witchcraft is not merely a parable for disempowerment, but something that she is literally capable of doing. It is a moment of astonishment that punctures the rational fabric of the film – there is no clearly comparable sense here, but certainly a batsqueak of anxiety that the miraculous might be real, and that it is therefore just as alarming, unsettling and threatening – and perhaps, also, just as absurd and banal – as everything else in the real world. Some viewers may find themselves disconcerted or even exasperated by the film's final moments, but I found in them a final flourish of Hausner's sheer, exhilarating technique and intelligence, like that of a superb musician. It is her best film yet.

DOGTOOTH

22/4/10

★ ★ ★ ★ ☆

A black-comic poem of dysfunction, a veritable operetta of self-harm, this brilliant and bizarre film from the Greek director Giorgos Lanthimos is superbly acted and icily controlled – it grips from the very first scenes. Development does not get more arrested than this. *Dogtooth* could be read as a superlative example of absurdist cinema, or possibly something entirely the reverse – a clinically, unsparingly intimate piece of psychological realism. Watching this, and alternately gaping at the unselfconsciously shocking scenes of violence, thwarted sexuality and unexpressed sibling grief, I was reminded of Alan Bennett's maxim that all families have a secret: they are not like other families. But I can't imagine any family being quite as unlike others as this.

Somewhere in the Greek countryside, a wealthy middle-aged businessman and *paterfamilias* (played by Christos Stergioglou) has a handsome house with beautiful grounds and a gorgeous swimming pool – the upkeep of which this family appears to manage without external help. He has a quietly submissive wife (Michelle Valley), and three handsome children in their twenties: two daughters and one son, played by Aggeliki Papoulia, Mary Tsoni and Hristos Passalis. So far, so wholesome.

But something is very wrong with this picture. The children, as becomes chillingly clear, are infantilised: they have never been permitted to leave the family compound, and, like Baron von Trapp's children responding to a naval whistle, they have been trained in obedience like dogs, woofing and leaping about on all fours to order, but also capable of walking and talking like convincing human beings, although their conversation has a stilted quality, as if in a light, hypnosis-induced trance.

Their education has been a parody of home-schooling in which mum and dad have deliberately taught them the wrong meaning of words, perhaps to shield them from outside reality, to render this reality meaningless and unreadable, and therefore to blur and

jumble its very existence. This grotesque anti-teaching is a symptom of their parents' own shock and trauma, an alienation they have fanatically passed on to their offspring. The father pays his factory's security guard, Christina (Anna Kalaitzidou), to come to the house (blindfolded) and service the son sexually, an arrangement he furiously terminates on learning that Christina is a bad influence on his daughters, before deciding that the arrangement can be carried on, as it were, in-house.

The key to the mystery may reside in a missing family member and a Doberman that the master of the house has evidently, paradoxically, decided to have trained by a professional outside the family group.

It is a movie of southern Europe, which bears the influence of something more northern European. With its pristine clarity, refrigerated light and deadpan stabs of violence, it looks unmistakably like something by Michael Haneke or his Austrian contemporaries, Ulrich Seidl and Jessica Hausner. It also brought to my Anglo-Saxon mind William Golding and the early fiction of Ian McEwan. The scalp-prickling strangeness of a family that is outwardly normal yet privately horrific inevitably invites memories of Josef Fritzl and his cellar, and also for me, at one remove, Hancke's *The Seventh Continent*. Perhaps the two sinister boys in *Funny Games* were brought up in a household like the one in *Dogtooth*.

Yet for all this, Lanthimos's movie has a sense of pitch-black humour and even playfulness. He has a brilliant opening sequence in which the children are solemnly taught incorrect meanings to the words "sea", "motorway" and "excursion", complete with incorrect contexts. A "zombie" is a yellow flower, leading to the son's gentle, childlike delight in finding a couple in the garden. It's as if these people are trying to live their lives according to Borges's Celestial Emporium Of Benevolent Knowledge, or Monty Python's Hackenthorpe Book Of Lies. Yet even here reality will intrude. Pressed for the meaning of "pussy", which the children have found written on one of their parents' private stash of videocassettes, the mother blurts out that it means "a big light", and incautiously rushes to demonstrate its use: "The pussy is switched off and the house is plunged into darkness." A psychoanalyst would have a field day with that, but sadly there are no psychoanalysts available.

The humour is not entirely cruel, or alienated. At one stage, the son tells the family over one of their meals that they have run out of black tint for his eyebrows, and that he can't use blue tint – because that would be unnatural. The line delivers something unavailable in Haneke: a big laugh.

The film is superbly shot, with some deadpan, elegant compositions, and intentionally skewwhiff framings of the "headless" variety that Lucrecia Martel used in her film *The Headless Woman*, imbibing both the sociopathy of the characters and, at one remove, the reality-TV surveillance aesthetic of the Big Brother house. Lanthimos holds your attention with wonderfully inscrutable images, such as trees dappled with Hockneyesque sunlight from the swimming pool. It is a film about the essential strangeness of something society insists is the benchmark of normality: the family, a walled city state with its own autocratic rule and untellable secrets.

THE CLOCK

7/4/11

★ ★ ★ ★ ★

This week, very late to the party, I visited Christian Marclay's staggering moving-image installation *The Clock*, a twenty-four-hour montage of thousands of film and TV clips with glimpses of clocks, watches, and snatches of people saying what time it is. This incredible installation is set up so that whatever time is shown is, in fact, the correct time as of that instant. So as well as providing food for thought about the nature of time in the cinema, and indeed in life itself, the whole thing itself functions as a gigantic and gloriously impractical clock. By the time you read this, it may be possible to get *The Clock* as a streaming-video app to download to your iPhone, automatically putting itself in sync with your time setting.

The Clock is now showing at the Hayward Gallery in London as part of the British Art Show 7 and is soon moving on to Glasgow and then Plymouth. The London showings finish this weekend, when *The Clock* has a special late-night opening until 1 a.m. Generally, gallery opening times permit visitors only to experience the "daylight" part of *The Clock*. The night-time stretch promises a special intensity.

Some time ago, I blogged about a montage compilation which I hailed as the greatest YouTube clip of all time, simply showing a hundred tiny film clips, quoting numbers in countdown-sequence from a hundred to one. It is now clear that this piece was simply John the Baptist to the Jesus of Christian Marclay's *The Clock*. Many commenters on that blog did in fact presciently refer to the work of Christian Marclay. Another critic recommended Godard's *Histoire(s) du Cinéma*.

I should confess, when I first sat down to *The Clock*, that I had a sneaking, off-message feeling that the humble YouTube "number" compilation might actually be delivering the same idea with less fuss. But that's not true. You have to settle into *The Clock*, and go into the extraordinary trance-like state that it induces. When I first arrived, I found myself giving a little amused laugh at each appearance of the time. Then the novelty wore off and I became silent. Some other

people, arriving after me, went through the same process. I arrived just after eleven in the morning and left before 1 p.m., so I went through the midday climax of emotions: I expected, and got, Gary Cooper in *High Noon*. Then there were a lot of shots of clocks and watches and lunchtime and people wondering if it was time for lunch. There were, generally, a large number of shots of Big Ben and large institutional clocks, lots of scenes of people hurrying for trains, late for trains, early for trains, hanging around on platforms. *The Clock* might turn out to be one of the great train movies.

Sometimes the time is just glimpsed in the background of a shot, irrelevant to the action and sometimes the time gives a sharp stab or poke to the dialogue: particularly with scenes in which time is running out. *The Clock* is, unexpectedly, quite a sensual, sexy film, in that the late morning stretch features plenty of shots of people in bed, waking up, embracing and then realising that these are forbidden pleasures – forbidden by the clock. ("What's the time? Is that the time?" etc.) The time is an alarm clock, a constant silently pinging alarm clock.

There are droll shots of sundials in period movies. There is an ambiguous moment from *Easy Rider* in which Peter Fonda looks at his watch (showing 11:40 a.m.) and throws it away. It appears to have stopped. (Wait. So is that the time in the film? Has it just stopped that moment?) Marclay even shows the "Alas poor Yorick" scene from Olivier's *Hamlet*. Where was the time going to be mentioned? Just before the end of the clip, a distant bell tolls the quarter-hour. Later clips show 12:13 p.m., 12:14 p.m. So is Shakespeare's clock fast? And is there textual evidence that this is the time?

For me, the weirdest effect of *The Clock* is that the time references became fictional – I stopped noticing that they were telling me exactly what the time actually was. They became a series of numbers which ordered the mosaic of moods and moments. And then, slowly but surely, I stopped noticing the time entirely. I just drank it in, just accepted the juxtapositions.

The Czech writer Petr Král, in the essay entitled "Time Flies" (collected in Gilbert Adair's excellent 1999 anthology *Movies*) describes watching with a companion the 1916 silent movie serial *Judex* by Louis Feuillade. He recalls: "Suddenly on the screen there appears a clock set in the centre of the kind of sumptuous salon that

epoch, and Feuillade, alone had a taste for; it shows 4:40 p.m. One of us automatically consults his watch: 4:40 to the second. For an instant our present, across the ruins of several decades, has rejoined that of an afternoon in the 1910s."The pleasure of making this connection, infinitely repeated, is at first a conscious, then a subconscious or unconscious pleasure in *The Clock*. (I wonder if Marclay actually uses the 4:40 p.m. moment from Judex – can anyone tell me?)

I walked out of *The Clock*, on to the bleached-white concrete walkway on the South Bank, and saw the clock on the Shell Building on the other side of the Thames. 12:55 p.m. "Ha!" I found myself thinking. "Five to one! It's five to one. You can see the time on that clock in this shot." A fraction of a second later, I realised that – ahem – I had been returned to real life, and that the clocks you see around the place will, of course, give you the actual time. Or will they? They are not guaranteed accurate like the ones in Christian Marclay's installation. What a fascinating and pleasurable event it is. It will run and run – without needing to be wound.

MARGARET

1/12/11

★ ★ ★ ★ ★

Since 2000, when he made his mark with a tremendous debut, *You Can Count on Me*, Kenneth Lonergan has been absent from the radar as a director. The reason turns out to have been years of acrimonious studio argument over the length of his follow-up project, a post-9/11 New York drama in a world of trauma, rage, blame, overtalking and interrupting. Originally conceived as a three-hour movie, it has been allowed into cinemas in a two-and-a-half hour cut.

Perhaps Lonergan is content with this and perhaps not, but the resulting movie is stunning: provocative and brilliant, a sprawling neurotic nightmare of urban catastrophe, with something of John Cassavetes and Tom Wolfe, and rocket-fuelled by a superbly thin-skinned performance by Anna Paquin. Its sheer energy and dramatic vehemence, alongside that raw lead performance, puts it way ahead of more tastefully formed dramas.

Paquin plays Lisa, the daughter of divorced parents: a mouthy, smart-but-not-that-smart teen at private school, sexy but emotionally naive, self-absorbed and scarily hyper-articulate in the language of entitlement and grievance. She may have inherited drama-queen tendencies from her mother Joan (J Smith-Cameron), a Broadway stage star, with whom she lives in New York. One day, after an encounter of pouting defiance with her exasperated mathematics teacher (Matt Damon), Lisa takes it into her head to buy a cowboy hat. She sees a bus driver wearing one she likes: he is played by Mark Ruffalo. With a teenager's heedless disregard for the consequences, she flirtatiously runs alongside his bus, waving wildly, asking where he got it. He smiles back at her, taking his eyes off the road – with terrible results.

Lisa is overwhelmed with ambiguous emotion at having contributed to a disaster and then participated in a coverup, and, compulsively driven to do something, draws everyone into a

whirlpool of painful and destructive confrontations. But is that emotion guilt or righteousness? Or a sociopathic convulsion, a need to create a huge redemptive drama with herself at the centre, to lash out against her mother and the entire adult world; or to enact vengeance against a man who, without trying, has placed her in a position of weakness – at the very point at which she considers she should be attaining her adult, queen-bee status? Paquin creates that rarest of things: a profoundly unsympathetic character who is mysteriously, mesmerically, operatically compelling to watch.

ONCE UPON A TIME IN ANATOLIA

15/3/12

★ ★ ★ ★ ★

Few films are about simply waiting and talking, but this is one; a film in which, for most of the time, nothing appears to be happening – but, in fact, everything is. Nuri Bilge Ceylan's new film is long and difficult, and perhaps not for everyone, but I can only say it is a kind of masterpiece: audacious, uncompromising and possessed of a mysterious grandeur in its wintry pessimism. Nothing in it reminds me of Sergio Leone, incidentally – unless it is that long, long wait at the beginning of *Once Upon a Time in the West*, with the keening wind-wheel and sighing desert. Actually, this has something of Antonioni, or Chekhov or even the later stories of Tolstoy.

The action extends over a single, rainy, sleepless night and into a grim morning at the workplace. A convoy of official vehicles, containing police officers, the state prosecutor, a medical examiner and guys with shovels are accompanying two prisoners out into the eerie expanse of the Anatolian steppe: the plain where Asia reaches west into Iran, Armenia and Turkey. The men are murder suspects, but are evidently about to plead guilty and, perhaps in a sentencing deal, have promised to lead officers to a body. One, Kenan (Firat Tanis), is all-important to the police, and this haunted wraith of a man is the centre of the film.

Their excursion started at the end of the working day, with everyone anticipating a quick discovery, but to the cops' fury, the prisoners become muddled; they can't remember exactly where the corpse is in the darkness. The quest continues into the deepest night, stopping periodically at likely-seeming spots, and at one stage, for a meal from a local mayor.

There is mostly nothing to do but talk, but the occasion inspires something other than ribaldry. When they see how heart-stoppingly beautiful the mayor's daughter is, they become thoughtful, solemn. Kenan is reduced to inexplicable tears. Mortality has become very real, as it always will, to any of us, in the middle of the night. And always the presence of that victim – out there somewhere in the rainy

blackness – nags at their minds, exhuming dark thoughts. Ceylan shows that it has a sobering, clarifying, perhaps even ennobling effect.

The reason for the crime is never spelled out, although there is a discovery that casts a new light on Kenan's relationship with the victim. What is important is the ancillary, internal drama, the interactions between the careworn officials made possible by this deeply disagreeable task. Without the narcosis of sleep or work, they are forced to think about their lives, or perhaps about the fact that, in T.S. Eliot's words, they have nothing to think about. The handsome, distinguished state prosecutor Nusret (Taner Birsel) – a man who prides himself on his resemblance to Clark Gable — recounts an anecdote to the young doctor, Cemal (Muhammet Uzuner) intended to demonstrate that death can just come along and there's nothing we can do. But the doctor, a scientist and rationalist, questions his story in such a way as to open up a terrifying insight into the prosecutor's life.

Ceylan displays pure, exhilarating mastery in this film: it is made with such confidence and flair. In one shot, he shows us a tableau of five men in a car, two cops in the front, and between the two officials in the back, there is Kenan, his gaunt figure in darkness. The four law-men's faces are illuminated in the faint flame-light, but Kenan's is just an outline: and Ceylan holds the shot, moving the camera forward just slightly, until it dawns on us how disturbing his silent presence is.

Perhaps his most quietly spectacular flourish comes near the end: a virtuoso moment. The doctor, exhausted after this punishing night, comes into his office and switches on his computer: he notices – as he must surely do every time – personal photos of himself. Ceyland enigmatically suspends the film's action just to show us these images. A series of stills fill the screen: the doctor as a young man, in love. There is something heartbreaking in it.

We are heading towards a terrible anti-miracle, as a discovery comes about the victim and a decision must be made about how much to reveal. We are witness to the jettisoning of Cemal's innocence, and the final loss of that refined, boyish quality that had intrigued and amused the cops during their long night: it has been his own rite of passage into the disillusioned manhood that everyone else joined a long time ago – police and murderers both. With his two early features, *Distant* (2002) and *Climates* (2006), Ceylan has showed himself a superb film-maker. This is his greatest so far.

THE MASTER

1/11/12

★ ★ ★ ★ ★

Paul Thomas Anderson's new movie *The Master* is brilliant, mysterious and unbearably sad, in approximately that narrative order. It is just that brilliance and formal distinction, together with a touch of hubris in the title, that could divide commentators. Anderson has within living memory knocked us for the biggest loop with his *There Will be Blood* in 2007, and nothing makes critics more nervous than a director who makes two exceptional films in a row. Reviewers get a bit self-conscious about dishing out the top prize again, scared of looking like fanboys and pushovers. They feel the need to change the mood, to validate the uniqueness of their former praise. And I admit that after seeing *The Master* for the first time at the Venice film festival (the second was in London this week), I experienced a dark and timid microsecond of the soul on this score, before I swallowed my pride and just responded to what was in front of me: a superb film.

Like a lot of Anderson's previous work, it is about pioneers, leaders and dysfunctional families, and like *There Will be Blood* it is about the origins of American modernity, the pre-history of a certain kind of self-help and self-belief, entrepreneurial and evangelical. In this case, it is the Year Zero of a belief system that does not yet have extreme age to put its irrationality above reproach. *The Master* is about homemade spirituality and gimcrack philosophy, a snake-oil salesman of religion offering self-medication of the mind and body, attracting desperately lonely and vulnerable people to his new cult. It all happens in a meticulously realised postwar America, like something from the pages of Steinbeck or DeLillo, but with bizarre set pieces and an extra-terrestrial strangeness all of its own. Jonny Greenwood's unsettling score makes a strong contribution.

Joaquin Phoenix gives a laceratingly powerful performance as Freddie Quell, invalided out of the US Navy in 1945 with a nervous

breakdown, exacerbated by addiction to his own moonshine. His face is incised and gaunt like that of a medieval saint, he mumbles and giggles almost unintelligibly; walking around with his fists in the small of his back, elbows akimbo, like someone recovering from a terrible injury – which of course is what he is. (To me, Phoenix's Quell looks a little like Neal Cassady, the model for Dean Moriarty in Kerouac's *On the Road*.) Living semi-rough and on the lam, Freddie finds himself stowing away on a grand and somewhat preposterous steamboat.

In charge is the charismatic Lancaster Dodd, played by Philip Seymour Hoffman, a puce-faced public speaker who styles himself "The Master", hammy and plummy and steely. Dodd is a mix of L. Ron Hubbard, Ayn Rand and Dale Carnegie. He believes in curing physical and psychological ills by rooting out previous selves and interplanetary interlopers from millions of years ago, through confrontational interrogations and therapies that are like hypnosis or recovered memory or even electro-convulsive shock treatment. The Master is amused by Quell, gets a taste for his hooch, and decides to make of him a special case for his treatment. Freddie is the Fool to his Lear, or Peter (or maybe Judas) to his Jesus. The Master resolves to break Freddie down and build him up anew, and Quell's chaos and Dodd's charlatanism become locked together in a dance of death – erotic and homoerotic.

When I first saw *The Master*, I saw it as an eloquent drama of ideas, a Foucauldian account of unreason, all about crazy and marginal worldviews excluded from mainstream histories of the Western enlightenment. On a second viewing, I responded far more to the personal story of Quell and Dodd, and their absurd, sinister and poignantly doomed love story. Freddie's gift for brewing up moonshine out of anything to hand (paint-stripper, developing fluid, fruit, bread) and making himself the life and soul of the party is no incidental detail. His booze-genius is of course analogous to Dodd's gift for intoxicating rhetoric and ideas, cobbled together from bits and pieces of science and established religion. They are a match made in sociopath heaven. Both have a long-term addiction to their own supply, and maybe Quell and Dodd are the ancestors of showbiz faith; they fully understand the masses' opiate, having

tested it extensively on themselves. But more than this, Anderson suggests that Quell is ultimately wiser than Dodd, and has finally understood that his association with him is happening on the rebound, the effect of personal heartbreak, missed chances and a lifetime of regret. *The Master* is a supremely confident work from a unique film-maker, just so different from the standard Hollywood output: audacious and unmissable.

IN THE FOG

25/4/13

★ ★ ★ ★ ☆

The fog of the title is the fog of war, the fog of fear and the abysmal fog of European history: it is a kind of residual pall of smoke across the field of battle – maybe it also means the obliteration brought by death itself. This is the chilling and mysterious historical parable from film-maker Sergei Loznitsa, based on the 1989 novel by the Belarusian author Vasili Bykov, resembling Elem Klimov's *Come and See*. (Bykov also wrote the 1970 novel *The Ordeal*, filmed by Larisa Shepitko as *The Ascent*.)

Its subject is the Nazis' invasion of the Soviet Union, and in particular the poisonous shame of collaboration that they disseminated in every part of the Reich. An important part of this film's meaning is to show that collaboration was not simply an administrative necessity, but a secret and exquisitely cruel perquisite of victory: sadistically imposing self-hate on the defeated ones, renewing the triumph by perpetuating the conquered people's division and dismay.

It begins in 1942 with a laceratingly grim spectacle in which the Nazis parade three guerrilla-saboteurs through their village in Belarus on the way to be hanged: they are railway workers who have loosened a length of track to disrupt the Germans' supply lines. The officer superintending this theatre of cruelty is Grossmeier, played by Vlad Ivanov (who memorably portrayed the abortionist in Cristian Mungiu's *4 Months, 3 Weeks & 2 Days*); with a toadlike expression of contempt, he is the only character that smiles. But four workers were understood to be involved in the sabotage attempt. One is still free, and therefore instantly suspected of having cut a deal with the Nazis; this is Sushenya, played by Vladimir Svirskiy. One night, two partisans with rifles over their shoulders arrive at his cottage to take him away: they are Burov (Vladislav Abashin) and Voitik (Sergei Kolesov) – the former, it appears, knows Sushenya from his boyhood. Sushenya is made to bring a shovel with him, and there can be no doubt what the penalty for collaboration is going to be: he calmly proclaims his innocence, but offers no resistance, accompanying them into the

ancient, trackless forest where a mysterious answer to the question, "Who is betraying whom?" awaits all three.

Sushenya looks to me like a cross between Anatoly Solonitsyn in *Andrei Rublev* and Dennis Hopper in *Apocalypse Now*: stricken and stoic. Extended flashback sequences show what has brought both Burov and Sushenya to this point, and though none of it undermines the latter's protestations of innocence, it shows how he alone understood the terrible choices involved in being a partisan, how whole villages will of course be murdered by the Nazis in reprisal and how, in resisting, one runs the arguable risk of amplifying the original evil. Sushenya makes no secret of his envy for the men who were hanged: the shame of (supposed) collaboration begins to look like a symptom of the larger shame of defeat, the unthinkable desecration of the motherland that may yet be part of some larger divine plan. (Like many other critics, I found Sushenya's ordeal comparable to the scenes in the last volume of *War and Peace*, in which partisans, based in the forest, fought against Napoleon's invading armies and struggled to protect a core of the Russian soul.)

It may be that Loznitsa intended a subliminal suggestion of Christ and the two thieves, but the resonances are more secular. "Why do we trust the Germans, but no longer our neighbours?" asks one partisan, and the fear and paranoia being dramatised here carries an echo of the great betrayals and purges of the previous decade, and the "I sold you and you sold me" refrain of Orwell's *Nineteen Eighty-Four*.

Sushenya behaves as he does because of any number of reasons: fatalism, perhaps, or world-weariness, or a subtle intention to dissuade his captors from killing him, or a Soviet patriotism and loyalty that exceeds any sense of personal choice or guilt. Perhaps, like T.S. Eliot's Becket, he has already resigned himself to his fate in the weeks that preceded the partisans' arrival at his cottage, and now faces his quasi-martyrdom with equanimity; or perhaps he has decided that dying at the hands of a countryman is preferable to being killed by the enemy, and Sushenya has devised a new kind of Belarusian *hara-kiri*. (Another comparison that came to mind watching this was Alexandr Sokurov's *The Sun*, and Hirohito's renunciation of divine status after Hiroshima and Nagasaki: the ritual suicide of a god.) *In The Fog* is a haunting depiction of the hidden tragedies of war.

THE BLING RING

4/7/13

★ ★ ★ ★ ☆

Sofia Coppola's *The Bling Ring*, first shown in Cannes earlier this year, is the cool, blank, interestingly unironised movie account of a strange true story. In 2009, a bunch of spoilt and negligently parented teens with a celebrity obsession figured out a way to burgle the LA homes of rich and famous people like Paris Hilton, almost as a kind of aspirational fan tribute. Stealing here looks like a symptom of the same dysfunction and compulsive disorder that creates the need for fame, or the quasi-fame of social media. There is something in Coppola's weightless, affectless portrayal of their crime spree that is very effective, and this is a film whose interest definitely grows on a second viewing. It gives you an uncanny, sisterly access to the characters and their eerily dream-like career in larceny.

The film puts you right inside the opium den of celeb-worship; for the burglary scenes Coppola actually uses Paris Hilton's home, the Tutankhamun tomb of kitsch. Now, maybe that makes this movie complicit with the celebs, but there's a real frisson. It is well acted; the cast includes Emma Watson as burglar Nicki. Her mother, Laurie (Leslie Mann), homeschools her with chuckleheaded new-age theories and show'n'tell teaching sessions on why Angelina Jolie is a role model. Since this movie was made, the positive invocation of Jolie doesn't look so ironic – yet the revelation of her courage facing surgery was arguably a product of the same old PR/image factory, sharpening the appetite for more vacuous stuff. An intriguingly intuitive and atmospheric film.

12 YEARS A SLAVE

9/1/14

★ ★ ★ ★ ★

The dirty open secret in the history of Western prosperity is Steve McQueen's subject: unabolished and unchallenged slavery. Specifically, it is the slavery that thrived in an American era habitually known by an opaque Latinism: *antebellum*, although this is a story from the cold civil war that preceded the hot one. *12 Years a Slave* is adapted by screenwriter and novelist John Ridley from the 1853 memoir by Solomon Northup, a black man born free in New York state, tricked, drugged and kidnapped in Washington DC and then sold in chains into slavery in the south. Chiwetel Ejiofor gives a performance of incomparable heroism and presence as Northup; Lupita Nyong'o is passionate and defiant in the role of his fellow prisoner Patsey, and Michael Fassbender is the sadistic slavemaster Epps, whose habitual sexual abuse and angry self-hate is revealed to be a pathological and under-reported part of the system; a system, which in the words of one character, enables the abuser's violence to "trample his guilty sensation".

The appearance of this film coincides with an upsurge in the debate about Hollywood's traditional reticence on the subject of slavery's everyday existence; recently, it has taken iconoclasts and pulp provocateurs such as Quentin Tarantino and Lars von Trier to break the tactful, diplomatic hush with refreshingly tasteless pictures such as *Django Unchained* (2012) and *Manderlay* (2005). Victor Fleming's stupendous epic *Gone With the Wind* (1939) always looked culpably naive historically – and McQueen's movie has made that perspective even clearer – but perhaps no more culpable than the placidly apolitical, ahistorical output of modern white Hollywood. For me, the most startling film on the subject of recent times is *The Yes Men* (2003), which showed the anticapitalist pranksters sneaking into corporate conventions to give presentations praising twenty-first-century globalised outsourced workforces because they are cheaper than slavery. The zero-wage-bill model is outdated because

it leaves the employer hopelessly exposed to board, lodging and security costs.

McQueen's previous films were called *Hunger* and *Shame*; there is plenty of both in this almost unwatchably shocking and violent film. The beatings and lynchings are represented with uncompromising brutality and force. As much as anything, each use of the N-word is another turn of the screw. Here is the word reconnected to its past, to all its hateful hinterland. Here is what the word actually means and does.

12 Years a Slave has all of McQueen's effortlessly powerful visual sense, all his determination to look at ugly realities head-on. I sat down to this movie expecting to see one of the long, fixed camera-position takes, in medium- or long-shot, which McQueen has made such a brilliant signature with his cinematographer Sean Bobbitt. But there isn't one. Or not quite. We get a superbly composed, continued shot of Solomon's wondering face after a fateful conversation with a sympathetic carpenter Bass, played by Brad Pitt, and we see hope and fear and loss register with him, along with a new realisation of all that he has endured. It is a bravura performance from Ejiofor and McQueen. But there isn't the same icy, eerie effect; the sense of steely, refrigerated technique isn't as prominent. There is a new passion and moral force in the film; a new tragic grandeur.

McQueen's visual acuity and flair, and the ferocity of those images, might expose him to charges of fetishism. But this is to miss the point of what this film does. It certainly forces you to see, but in a different sense. The structure of the narrative defamiliarises the condition of slavery and the slave trade, gives it a shocking visibility. Northup is conned, captured, chained, bound in a slave ship – just as normal, but all within the borders of the US. History is happening to him and us in microcosm. Northup is an educated, refined man, a man with a wife and children, a free man; his being in slavery is a grotesque mistake, a terrible injustice. We can see it only too clearly. But McQueen is making us see the point is that they are all free – or should be. They are all dignified human beings with families. Northup's sensational situation is only an amplification and distillation of the whole crime.

It is a triumph for everyone involved, and McQueen's career trajectory is thrilling: early work in video art, a famous pastiche of Buster Keaton, a study of hunger strikers, an investigation of sex addiction, and now a pioneering drama about American slaves: the political prisoners of history and race. It takes the blood, sweat, tears and physicality of his former preoccupations and goes beyond: an essay in outrage and injustice, and a visualisation of an end to tyranny. It is a modern classic.

ONLY LOVERS LEFT ALIVE

20/2/14

★ ★ ★ ★ ☆

I have warmed up – or maybe rather cooled down – to Jim Jarmusch's beautifully made and exquisitely designed vampire movie since seeing it at Cannes last year. At first, it looked studenty and self-congratulatory. But if it is an exercise in style ... well, what style. With its retro-chic connoisseurship and analogue era rock, this is a brilliant haute-hippy homage: a movie that could almost have been conceived at the same time as *Performance* or *Zabriskie Point*.

As the undead lovers, Tilda Swinton and Tom Hiddleston hang out together very elegantly, exchanging worldly badinage and wondering what's in the fridge, like Withnail and Withnail, or I and I. Hiddleston is Adam, a reclusive vampire rock star hiding out from his fans in Detroit and savouring the necrophiliac ruin-porn thereabouts. Swinton plays his paramour, Eve, with her habitual queenly hauteur: she is living in Tangiers for the time being, pondering her literary collection (worryingly, this includes *Infinite Jest*) and chatting with Christopher Marlowe (John Hurt), who appears to have been frozen in vampiredom in old age. Adam has a postcard of the Corpus portrait of Marlowe digitally tweaked to look like Hurt, so all that stuff about Marlowe being murdered at twenty-nine must be untrue. (For people who love the dark, incidentally, neither has any interest in the seventh art.)

They get back together in Detroit, but when Eve's lairy rock-chick sister Ava (Mia Wasikowska) shows up too, things go badly wrong. There is inexpressible languor to everything. I have had my crises of faith in the past about exactly how interesting or insightful vampirism is as a metaphor – that was part of my initial scepticism – and I still don't think this is in the same league as Abel Ferrara's *The Addiction*. Yet the sulphurous chemistry between Hiddleston and Swinton makes their twenty-year age-difference irrelevant.

The damned have never looked so beautiful.

UNDER THE SKIN

13/3/14

★ ★ ★ ★ ★

It sure as hell got under mine. Jonathan Glazer's sci-fi horror is loosely adapted, or atmospherically distilled, by Walter Campbell from the 2000 novel by Michel Faber. The result is visually stunning and deeply disturbing: very freaky, very scary and very erotic. It also comes with a dog-whistle of absurdist humour that I suspect has been inaudible for some American reviewers on the international festival circuit so far.

The heroine is an alien predator at large in Scotland. Maybe you have to be a Scot, or anyway a Brit, to appreciate Glazer's masterstroke in casting Scarlett Johansson as the exotic alien in humanoid form, with her soft London accent, tousled black wig and sexy fake fur, driving a knackered white van around the tough streets of Glasgow, picking up men. She winds down the passenger-side window, artlessly engages them in conversation, and takes them back to her place. Between encounters, she roams, gazing at streetscapes, and making them alien with that gaze – like a Craig Raine poem. At one stage, she and her van are surrounded by guys with Celtic scarves. She is the ultimate Rangers supporter.

There is pure situationist genius in the bizarre spectacle of sleek Johansson being placed in this context, with lots of hidden-camera shots of real passers-by in real Glasgow streets and real Glasgow shopping centres, all these people being coolly sized up and assessed for their calorific value. From these genuine crowds, professional actors will seamlessly emerge for dialogue scenes. You can never forget it is Johansson on the screen, and that is surely the point. A Hollywood A-lister is as much of an alien here as any extra-terrestrial from a flying saucer. (The final credits reveal that as well as a personal assistant, Johansson had a "personal security" team. I wonder if they were called upon at any point.) Her alien is voluptuous, superbly insouciant, unaffected by her surroundings – though I think feeling the cold a tiny bit. She greets the stunned menfolk with an unreadably polite half-smile. This is how I imagine Elizabeth Taylor to have looked and behaved when Richard Burton first took her to Port Talbot.

The story of Johansson's alien begins with a mysterious and Kubrickian "birth" scene in a brilliantly rendered dimensionless otherworld. The alien is transferred to Scotland's dark, rainy streets and it – she – appears to have a minder, who rides a motorbike, and secures for her a human body shape from a dead girl retrieved from the roadside. Or perhaps that is another expired alien whose shape is being reused. At any rate, our alien is soon up and running in her Ford Transit, seducing wide-eyed males who can't believe their good luck and are quite right not to.

At the seashore, she witnesses a complex "rescue" scene in which earthling emotions of pity and compassion are on display – feelings she does not share. The most staggering scene is one in which the alien picks up a young man with the facial disfigurement of neurofibromatosis, played by Adam Pearson. The alien does not essentially distinguish between his looks and those of her other victims, but there is a crisis, and the alien becomes vulnerable: a potential victim herself.

Glazer has stylishly absorbed the influences of Nic Roeg and David Lynch, with something of Gaspar Noé in the hardcore moments and maybe an echo of Bertrand Tavernier's Glasgow film *Death Watch*. There are memories of *An American Werewolf in London* and even, in the alien's loneliness, a touch of *E.T.* But Glazer places his film in such a different and unexpected locale: in tough city streets more associated with Andrea Arnold or Ken Loach. The quicksilver shapes of futurist bodyhorror fantasy are scuffed with social-realist grit, but modified, too, with Jonathan Glazer's brilliant flair for visual impact. And I'm someone who still watches this director's horses-in-the-surf Guinness commercial on YouTube and gasps. His previous films *Sexy Beast* (2000) and *Birth* (2004) had more conventional twisty plots. This is a pure intravenous injection of mood.

And what is that alien doing anyway? Just eating? Or is she the advance party of a colonising power that has conquered England and is coming north? Johansson's alien has clearly hit a Hadrian's Wall of trouble in these misty lands and found that the Scots are not so easy to subdue.

At the press screening, the final credits were greeted by a sudden nasal exhalation from us critics: the sound of people realising they have been holding their breath. It's the equivalent of regular audiences jumping to their feet and applauding.

GRAND CENTRAL

17/7/14

★ ★ ★ ★ ☆

Rebecca Zlotowski has made a startling erotic drama set in and around a nuclear power station; its characters are irradiated with the sickness of obsessive love. Some critics have expressed reservations about melodrama and overworked symbolism, but I found it gripping, with an edge of delirium; the locations within the power station are positively Kubrickian; there's a disquieting electronic score and Tahar Rahim gives a very open, generous performance.

It is set in France – a country wholly dependent on nuclear energy for its power – and concerns a crew of itinerant workers who get well paid but dangerous work as decontamination operatives at a power station, where Silkwood-shower-type crises are commonplace. Rahim is a conscientious, likeable worker, but starts falsifying his radiation-exposure records so that he can remain employed and stay close to co-worker's wife Karole (Léa Seydoux) with whom he has fallen passionately in love. Rahim is very plausible as the lovestruck guy and Seydoux is commandingly opaque as the woman who has bewitched him.

The power station itself (played by the Zwentendorf plant in Austria) is a cathedral of strangeness, a vast, pale structure that does not contaminate the beauty of the surrounding countryside but does seem to emanate something which seeps into its workers' very souls.

FORCE MAJEURE

9/4/15

★★★★☆

Ruben Östlund's icily disturbing family drama, set in an upscale ski resort in the French Alps, is a disaster movie without a disaster. Or it could be that the disaster, like the death of Schrödinger's cat, both happens and does not happen. Actually, the non-disaster is more catastrophic, revealing to its participants their true nature and true situation, but withholding from them the drama and catharsis of outright tragedy. All of which makes this film sound rather cerebral and internalised. In fact, it is as nail-biting as *Where Eagles Dare*.

Tomas (Johannes Bah Kuhnke) and Ebba (Lisa Loven Kongsli) are a handsome professional couple on a well-earned break with their two beautiful young children at a ski resort whose crisp design, cool efficiency and pale wood features all seem rather northern European. (So, oddly, does the accordion version of Vivaldi that occasionally thunders on the film's soundtrack.) Charming and relaxed, enjoying the skiing, and maybe drinking more than usual, the couple befriend a middle-aged divorcee who is on holiday with his pretty twentysomething girlfriend, and also a racy married woman who is there on her own and fairly open about seeking sexual adventures.

The catastrophe happens when Tomas and Ebba are at an open-air mountaintop restaurant for lunch, with a magnificent view. There is a loud and alarming bang, which, Tomas airily explains to his frightened wife and children, is merely to provoke controlled avalanches, improving the terrain for skiing. Soon, an exciting tidal wave of snow is whooshing directly towards them, and diners are taking pictures and videos on their phones. But how controlled is it?

Things can never be the same again. Tomas and Ebba cannot unsee what they have seen, or undo what they have done, no matter how much they want to. There are confrontational conversations and one spouse challenges the other to admit something, and there is evasive and self-important waffle about their differing interpretations. Östlund shows how this attitude makes the trauma worse: it is a poison that begins to destroy their whole conception of themselves.

It reminded me of the photo of Jacqueline Kennedy in Dallas in 1963 just after John F. Kennedy was shot, apparently clambering towards a secret service agent at the rear of the car – leading many to express or suppress surprise that she did not instinctively stay with her husband. In fact, there is some Zapruder-style footage on Ebba's phone that is revealed to her new friends in an all-but-unwatchable scene.

Force Majeure has something of Michael Haneke's *Hidden* (2005) and *The Seventh Continent* (1989), although the ending – which discloses what Ebba is prepared to do to repair the situation – is perhaps overextended, and takes away some of the story's delicious chill.

The Alps themselves are sinister in their forbidding, implacable vastness and so, somehow, is the activity of skiing – an ecstatic, solitary pleasure and an escape from the boring cares and responsibilities of family life. Östlund is clearly a sharp-eyed connoisseur of all this. (He began his directing career in the 1990s making skiing films called *Addicted* and *Free Radicals*.) Using mostly fixed camera positions, he will intersperse scenes with establishing shots of the clanking, pitiless machinery of the ski lift, rattling rhythmically as bits of cable and metal thunk into each other. It's the kind of machinery in which you might sever your leg or from which you might fall and kill yourself. Then there are the pipes, like mysterious weapons of war, from which great big bangs are discharged to make the snow shift. We get weird, almost extra-terrestrial, scenes at night that show a rich kid flying his drone about the place; this supplies a *coup de cinéma* that will get the audience jumping out of their seats.

Force majeure is a legal concept that allows you to get out of a contractual obligation: an act of God that means you can't be sued. Even the intimate assumptions of family life constitute a tacit contract liable to be nullified in a crisis. Safety and comfort are concepts civilised societies have invented to protect themselves from self-knowledge, not physical harm, and perhaps even our most basic conventions are no more than a rickety rope-bridge, or clanking ski-lift. If we glance down at the abyss below, we are lost.

SECOND COMING

4/6/15

★ ★ ★ ★ ☆

If this seems a bit televisual, maybe it's because of Russell T. Davies's two-part drama from 2003 with the same name, all about Christopher Eccleston's video-store worker and his struggle with divine destiny. Actually, this movie is more interesting: a mysterious and intimate fable in the guise of gritty social realism, simply and powerfully acted. It never feels burdened or self-conscious about its subject matter, and interestingly there is nothing about religion.

If there is a fault with the story, it lies in the issue of how on earth to end it. Nadine Marshall and Idris Elba play a married couple, Jacqueline and Mark, who have a young son Jerome, or J.J. (Kai Francis Lewis). But their relationship is stagnant: Jacqueline has not had sex with Mark – or anyone else – for some time. Then she discovers she is pregnant. This would be a difficult subject to raise with Mark at the best of times.

Director Debbie Tucker Green plausibly imagines what might happen: intense denial and pressure-cooker levels of fear and anger rising as the bump gets bigger – and maybe even a mute need to believe in the fiction of adultery and risk hurting one's partner, rather than confront the unthinkable supernatural truth. The pure fear that Marshall wordlessly suggests is superb.

The films that made me feel bad

"No one sets out to make a bad film," says a director, stung by negative reviews. And in the same vein I feel like adding: "No one sets out to write a bad review." Hand on heart, I can say that I have never sat down to a film, having decided in advance to give it a hammering. Although on this point I am a bit suspicious when critics begin their pieces with this phrase: "I so wanted to like this ... " Translated, this means: "I decided long ago to give this a superciliously sorrowing review, and I am now nervous that my prejudice will be transparently obvious."

Some of my negative reviews are collected in this following chapter, and there is no doubt that bad reviews are fun to read. People are always attracted by that single star positioned above the text, twinkling with cruelty. But they are not always fun to write. However, the really difficult job is writing the two-star review, the "meh" review, the review that says something's bad but not that bad. Actually, the better a film is, the easier it is to review: something in a film's success induces clarity in the critic.

One of the reasons I am careful about reaching for the one-star vitriol it is that it is precisely the wacky films, the daring films, the challenging films, the out-on-a-limb films which can be too easily mocked, the films which are outside the box of good taste. Sometimes, your very first response to a film can be resistance or dismissal, and it is lazy and unreflective to let that be the tenor of a review, especially if you are seduced by the opportunity to serve up a gag. What if the joke is on you? What if you just failed to get the film, and didn't understand something in its guilelessness or force? The critic has to think again.

But the bad review is still part of the critic's rhetorical lexicon, and it's important to keep it there. I sometimes think that social media is making polemic harder for a critic, especially as almost every film has a fanbase of some sort which can be mobilised on Twitter.

Two notable terms of criticism current in journalism today are the brow-furrowing adjectives "problematic" and "troubling" – as opposed to, say "loathsome" or "deplorable" – because people are more and more reluctant to say something which is overtly judgmental. In part, this is an understandable and in fact welcome move, a much-needed gesture towards civility, so often lacking in our public discourse. But there is also a kind of nervousness about the very idea of vehemence.

In his 1991 book, *Bad, or the Dumbing of America*, Paul Fussell said something I still agree with – that the really insidious bad things are not straightforward shlock or honest hokum, but middlebrow affectation. It's the films which pointedly raise their claim to be truly artistic and good for you, films which are drinking their tea with their pinky raised, almost stupefied with their own supposed cultural superiority. These are the films which are in the running for a single star. Spleen is an important critical organ.

PEARL HARBOR

1/6/01

★ ☆ ☆ ☆ ☆

What can you say about Jerry Bruckheimer and Michael Bay's big, loud, dumb, boring mega-movie — apart from Oof and Ouch and Aaargh and Zzzzzzzzz? What response is there, apart from a yelp of incredulous dismay every five minutes? What historical insights can it offer — apart from the blinding revelation that maybe Steven Spielberg's *1941* wasn't quite that bad after all?

Fundamentally, the movie offers a vision of what *Titanic* might have looked like if the iceberg was a warlike Jap. It's a tremulous love story about a triangle of pretty young people in historical costumes — two best buddies and the cute nurse they both love — set against the mighty backdrop of war, planes, shooting, guns and ammo: a chick flick and a guy flick.

Ben Affleck is Rafe, the square-jawed, cubic-headed US army pilot who is temporarily away in England, winning the Battle of Britain single-handed. If you thought that the war in the Pacific would be one World War II story which didn't need time out to patronise the Brits, you were wrong. The RAF squadron leader, soaking his stiff upper lip in a pint of limey warm brown beer, is overcome with gratitude for Ben: "If there are any more like you, God help anyone who goes to war with America!"

Meanwhile, back in sleepy, peaceful Pearl Harbor, his comrade Danny (Josh Hartnett) is making time with Rafe's girl Evelyn (Kate Beckinsale). And so the emotional balloon goes up just as the sneaky Jap bombers arrive at 7.55 a.m., 7 December 1941.

Affleck, Hartnett and Beckinsale give performances of such somnambulist awfulness that the three of them achieve an almost zen-like state of woodenness. This is bad acting above and beyond the call of duty; this is Purple Heart bad acting. And Cuba Gooding Jr, playing the African-American fighting man forced through prejudice to be a cook, is so camp he could be in Village People.

Never at any time does director Michael Bay give any hint of the real human cost of war. At least *Saving Private Ryan* made an

honourable attempt to show the ugliness of violence: the sweat, the pain – and the fear and hatred of the enemy. But all Bay requires of Ben, Josh and Kate is to look cute or, as it might be, overjoyed, or troubled.

The effects are indeed impressive, no question about it, and for the recreation of the attack itself there are some breath-taking scenes of what a warship looks like from the point of view of the bomb that's about to sink it. But the whole thing is an effect: the drama, the people, the emotions, everything. When Affleck and Hartnett take to the skies in their fighter planes in a feisty but doomed attempt to repulse the enemy, they looked like no one so much as Will Smith seeing off the aliens in *Independence Day*. It had about as much relationship to the reality of wartime combat as a Gap ad for khakis.

As for the Japanese themselves, the film smoothes away both America's "yellow peril" racist invective and the realities of Japanese nationalist aggression: a kind of bogus two-way political correctness, somehow as insidiously offensive as anything else. The Japanese themselves are carefully drawn as a kind of modernised, New Labour Jap enemy, tough on the causes of foreign devils: they are thoughtful, almost regretful about launching the attack. On being congratulated on his brilliant strategy, the Admiral says sadly: "A brilliant man would find a way not to fight the war." There's even a shot of one Japanese pilot desperately signalling to baseball-playing kids to take cover before his duty to the emperor compels him to reduce them all to ashes.

And it is the thought of being reduced to ashes that brings me to the most curious part of this film. After Pearl Harbor, the movie's final act is to show Hartnett and Affleck spearheading the retaliatory raid on Tokyo on 18 April 1942, commanded by Lt Col. Jimmy Doolittle (improbably and plumply played by Alec Baldwin) – a desperately dangerous mission. I won't give away what happens, but suffice it to say that Kate's final voiceover gestures towards the end of the war, informing us that this was the decisive turning point. "America suffered, and grew stronger," she says, "through the trial we overcame."

Uh, yeah…? Is that how America overcame? Through the "trial"? The one moment which really excited me in *Pearl Harbor* was when President Roosevelt (Jon Voight) rises miraculously from

his wheelchair to show what can be achieved if we really try. Aha, I thought, is this a brilliant ironic reference to Peter Sellers' mad Nazi scientist in *Dr Strangelove*, who rises from his wheelchair and shrieks: "I can WALK!" just as the nuclear anti-miracle is unfolding? Is producer Jerry Bruckheimer going to hint at a big historical truth: that Pearl Harbor led to Hiroshima and Nagasaki? Nope – no mention of it. As far as multiplex audiences are concerned, America's key response was that gallant, symbolic little raid on Tokyo, and naturally suffering and growing stronger – not the vaporisation of civilian populations.

What can be done about this film? I would suggest some sort of campaign of civil disobedience. But maybe we should just take cover as best we can as the bombs of stupidity and dullness and silliness detonate above our heads – $75m at the US box office in the first weekend? For you, Tommy, the war is over.

LARA CROFT: TOMB RAIDER

6/7/01

★ ★ ☆ ☆ ☆

Check out that job description. Lara is not a Tomb Studier, or a Tomb Analyser. A Tomb Fancier she ain't. Lara does not share Indiana Jones's occasional donnish bent. Lara has no truck with the wussy business of whisking bits of dust away from inscriptions with brushes, and there's no nonsense about heritage preservation orders. Lara goes in blasting with a couple of sleek automatic handguns; she's only interested in tombs with mythical beasts lying in wait to protect their zillion-year-old treasures, and it's a rare old tomb that isn't reduced to rubble by the time Lara's through with it. Incredibly, much of this film is set in Cambodia's Angkor Wat: that exquisite, magnificent wonder of the world. Lara more or less flattens it!

Anyway, Lara Croft is the super-sexy Bondified heroine, and Angelina Jolie's formidable sexuality has been carefully packaged for the cyber-role made flesh. She is dominant, and in control. Hair tied back. Weaponry strapped to gorgeous legs. Lips big and smouldering like a fire damaged Dali sofa. Huge breasts monolithically immobile, as if encased in some new brand of hi-tech assault sports bra. There's no disempowering cleavage, and in any case, the movie has to make it into the American PG-13 category, and our 12 certificate – which, in view of Lara, chief censor Andreas Whittam Smith has publicly pondered abolishing.

Technically she's supposed to be a "photojournalist": a brilliant job which sadly doesn't exist in real life. But she is actually Lady Lara Croft, the English daughter of the fabulously wealthy English adventurer Lord Richard Croft (have they checked these titles with Debrett's?). Tragically, her papa, played by real-life dad Jon Voight, died when she was eight, leaving her to a lonely life of raiding tombs and kicking mythical, monstrous ass. Lara does not appear to have friends in the conventional sense; in fact she is Lara No-Mates, and in lieu of a social life, Lara whiles away her evenings doing bungee-ballet in her enormous hall. But Lara does have a genuine English country house and a genuine English accent, which was very severely

tested at one stage when Lady Lara, looking up through a telescope at the night sky in her private observatory, has to say: "Neptune is in alignment with Uranus." Angelina coyly made that last word "Yyyeeuh-ness". Edith Evans would have been proud of her.

Much of the film's grasp of our poor nation is more uncertain. Iain Glen, playing the black-haired dastardly villain, is described to Lara, before they meet, as a "lawyer". He introduces himself to her as "Manfred Powell QC". "So," says Lara, after some cool chit-chat, "you're a lawyer?" Perhaps Mr Powell's work is at the Commercial Bar, and so not very well known.

Basically, the trick should be to make it look as if the game is based on the film, rather than the other way round. The film doesn't have the game's weird echoing silences, and Angelina doesn't do cyber-Lara's cry when she dies: that ambiguous semi-orgasmic whimper. Because, of course, Lara does not die. She is undefeatably ranged against the bad guys: the creepy Illuminati cult, led by Glen, who want to steal a mystic amulet which, like, controls time – or something.

The amulet is in two halves, inconveniently enough. The first is to be found in Angkor Wat, where a bunch of orange-clad Cambodian monks are chuffed to meet Lara, despite the punishment she hands out to their national treasures – and she accepts a cup of soothing tea from them. Then we are off to Iceland to pick up the second half. In the freezing cold and swirling snow, everyone is wrapped up toasty and warm. Everyone except Lara, who wears a revealing little top open to the elements without so much as a goosepimple – the hardy little minx! – and her one concession to the weather is a floppy, furry hat which she has perhaps picked up at the airport.

Director Simon West, with his background in commercials, is happier with the zappy image than the actual plot, which gets fuzzy to say the least, especially at those points in the script when Lara has to find some sort of temporary common cause with the Illuminati. And there is a dodgy American called Alex, played by British actor Daniel Craig, who Lara sort of fancies, but successive rewrites have left his romantic status unclear.

In fact, Lara's emotional life is centred more on a frankly unwholesome obsession with her father. She's always droning on about him, periodically making visits to her own bizarre "tomb" for

the old boy in the garden, shaped like a tent. Lara needs a trained therapist to get her to confront the psychological link between this homely tomb-edifice and her tomb-raiding exploits elsewhere.

Frankly, it's all very weak – though not as bad as, say, *The Saint* or *The Avengers* – perhaps because we are not asked to believe in some non-existent sexual chemistry between Angelina and a co-star. But in the end, for all her über-babe sexiness, there is something just a wee bit humourless about Angelina Jolie.

HALF PAST DEAD

2/5/03

★ ☆ ☆ ☆ ☆

Steven Seagal is back! Look upon his fleshy neck, his dodgy hair and his strangely puffy immobile face, ye pantywaist liberals, and tremble!

Steven is back to kick ass, or as much ass as is consistent with his self-declared status as a reincarnated lama. Well, it looks like Seagal has ditched the orange robes for the less flattering black T-shirts and body armour.

He plays a tough guy mixed up in a prison siege situation necessitating sclerotic "action" spectacle and some close-quarter martial-arts blocking moves which look like a jersey-pulling contest between elderly transsexuals.

The title refers to the fact that Steven, unstoppable *hombre* that he is, revives after being clinically dead for nearly half an hour. As someone impertinently puts it: "I heard you took a ride on the flatline for twenty-two minutes!" Steven's career's been riding the flatline longer than that.

IMAGINING ARGENTINA

30/4/04

★ ☆ ☆ ☆ ☆

Some films are so spectacularly misjudged they make you want to put a brown paper bag over your head, and roll off your cinema seat in a foetal ball of embarrassment and shock.

Such a one is Christopher Hampton's new work, which super-imposes a fatuous layer of magic-realist whimsy on the abduction and murder of 30,000 people in Argentina by the fascist junta in the 1970s and 1980s.

Antonio Banderas is a theatre director in Buenos Aires, and Emma Thompson, speaking in Spanish-accented English, plays his dissident journalist wife who is kidnapped by faceless government thugs.

Banderas finds that he has the clairvoyant power to see what is happening to the "disappeared" and convenes regular seances to tell grief-stricken relatives what is happening. The scenes showing Banderas exercising his sensitive magic powers and sometimes strumming mournfully on his guitar – interspersed with Thompson's character getting brutally raped, with close-ups on her quizzical face contorted with agony – are grotesquely crude and clumsy. Thompson has recently won well-deserved plaudits in *Love, Actually*, showing what a class act she is in the right role. But this is one to forget.

THE CAT IN THE HAT

2/4/04

★ ☆ ☆ ☆ ☆

The sun did not shine, it was too wet to play,
So we sat in the house, all that cold, cold, wet day.
Do bored kids, this Easter, want something for kicks?
That *Cat in the Hat* thing is on at the flicks.

It's a book for young kids in the US of A,
But it turns out the film version's subtly risqué.
In the States children love it, but need I say more?
Over here, to be frank, it's a tiresome bore.

We've got JK Rowling with her massive great wad
And old Philip Pullman who's slagging off God.
And Jacqueline Wilson we've read loads of times,
Do we need Dr Seuss with his fatuous rhymes?

Well *The Cat*'s now a movie; Mike Myers the lead,
Alec Baldwin's the villain – he's going to seed,
He's put on some weight now; he's really quite chunky,
How weird to remember he used to be hunky.

Dakota Fanning plays the sweet little dear,
How I long to give Fanning a clip round the ear.
But it's Myers who pains me; he truly looks sad,
Humourless, frazzled, and really quite mad.
In costume and make-up he's destined to fail,
He's just Dr Evil with ears and a tail.
(But I still won't believe that his star's on the wane
For me, Austin Powers was Citizen Kane.)

So if someone says: "Let's see *The Cat in the Hat*" –
Just turn it down flat. I wish I'd done that.

THE STEPFORD WIVES

30/7/04

★ ☆ ☆ ☆ ☆

Another Bad Idea from the Bad Ideas factory – and this one's just about as bad as they come: so unfunny and unintelligent, so clueless and so humourless that it sent me into a state of virtual anaphylactic shock. It's an all-new, low-IQ version of Bryan Forbes's 1975 movie of the Ira Levin bestseller about the couple who move into an upscale suburban neighbourhood, where the creepy menfolk conspire to replace their wives with sexy-submissive robots.

Just like Tim Burton's terrible version of *Planet of the Apes* three years ago, it vandalises a gutsy satirical classic, in this case with a mixture of misjudged condescension, smirking spoofery and culpable failure of nerve. Whatever you think of Bryan Forbes's original picture – and I think it holds up pretty well – it had the courage of its convictions, and succeeded as feminist satire because it played everything straight: a chilling fantasy which was darkly funny because it never went for laughs.

This overegged "comedy thriller" update from Frank Oz can't stop pre-emptively giggling at the idea that it could be guilty of something as *démodé* as feminism, though the f-word is never mentioned. What the new *Stepford Wives* appears to be satirising isn't male chauvinism or suburban small-mindedness, but simply the original film – to which it is hopelessly inferior.

Now it's Nicole Kidman who plays the newcomer Joanna, a high-flying TV executive specialising in reality schlock. She has a top-rated show called *I Can Do Better*, which puts married couples on a desert island and tempts them into adultery with babes and beefcakes. But a humiliated male contestant attempts to murder Joanna on the air; the network takes fright and fires her, so Joanna has a comedy nervous breakdown, with some hilarious references to her electro-shock treatment.

Her supportive spouse (Matthew Broderick) takes her away from the neurotic city for a new life in squeaky-clean Stepford, where they find Glenn Close and Christopher Walken presiding over

the reactionary citizenry. Stepford has some sympathetic pals for Nicole: a Jewish writer (Bette Midler) who bridles at the Wasp-ness of everything, but who eventually submits to the *goyische* status quo. And this being the twenty-first century, there's also a gay couple, including a witty camp guy (Roger Bart) who sort of adores the uptightness of it all, but whose Stepford makeover turns him into a ghastly gay republican.

Nicole Kidman is here being called upon to play comedy. Now, excellent performer though Kidman is, comedy is not and never will be her strong suit. You could as soon ask Danny DeVito to play James Bond. But it's not her fault, and despite a couple of nice lines in the script for Midler and Bart, it's the concept itself which is so awful. The big shocks that finished the first movie – the robot breakdown, Katharine Ross's breasts getting bigger – are here shunted to the beginning, blowing the secret and crassly playing it for guffaws. A haywire fembot goes loco at a square-dance; another gets post-coital mammary enlargement via remote control. To which the only response is a wince of baffled embarrassment. These Stepford Wives are not funny or scary. So what are they?

You've got me. Director Frank Oz and screenwriter Paul Rudnick don't appear to be sure either. Everything appears to rest on the premise that the issue of sexual politics is a period piece. But the evocation of female submission is evasively presented as a kind of cod-1950s pastiche: the ladies dress in the obviously absurd frilly pinched-waist outfits of half a century ago, and when Christopher Walken presents a secret instructional film about how the Stepford Wives are surgically changed, it's explicitly modelled on a kind of grainy, flickering high-school movie from that era. In fact, the whole thing is worryingly like the recent migraine-inducing, period-pastiche sex comedy *Down With Love* – especially the scenes set in the glitzy network office, with Nicole sashaying self-consciously about in her black couture outfit.

Did we even need a remake in the first place? Sydney Pollack's 1993 John Grisham thriller *The Firm* about the small community secretly owned by the Mob was in its way a far better update of *The Stepford Wives*. Sam Mendes's *American Beauty* and Todd Solondz's *Happiness* showed how real film-makers investigate the secrets of American suburbia with wit and flair, and Todd Haynes's *Far From*

Heaven was a superb intersection of modern gay aesthetic and provincial sex-stereotype.

In any case, the 1970s original is not as obsolete as this dire film implies. A look at modern Hollywood might make you think that *The Stepford Wives* was not a satire, but a prophecy. Cosmetic surgery is rampant. The sleek supermodel template rules. Turn to the fashion pages and see how Sophie Dahl has changed, or Kate Beckinsale, or, for that matter, Nicole Kidman. And on the TV news, the stereotype holds true. The men can be silvery-haired and fatherly and the women are identikit babes. Michael Douglas and Catherine Zeta-Jones could be a newsreading duo. Bestsellers like *The Rules* and *The Surrendered Wife* suggest that conforming is the next big thing. Millions of American women are said to want to emulate Martha Stewart, even as she heads for the prison cell.

Rich pickings there, surely, for any satirist – or for anyone with an observant sense of humour? But the pusillanimous new *Stepford Wives* steers well clear of anything resembling real modern life, preferring its postmodern, retro-suburban world, with its bets hedged and its jokes mistimed. The worst moment is that demo film where Christopher Walken shows how women are lobotomised. That's what this film is trying to do to the original. And to the audience.

THE WEDDING DATE

22/4/05

★ ☆ ☆ ☆ ☆

Stop all the clocks, cut off the telephone,
Let Richard Curtis shriek and wail and moan.
They've tried to nick his style for this, and he should sue.
That actor from *My Best Friend's Wedding's* in it too.
Dermot Mulroney. You know. The boring one who wasn't gay.
He here pretends to be the heroine's lay.
Her ex-boyfriend has to be made jealous;
Why we should care at all, the script won't tell us.
Debra Messing stars, with slightly anxious face,
Will this be her career, post-*Will and Grace*?
It's all been managed better in the past,
There's even a sub-Duckface woman in the cast.
Let aeroplanes circle droning overhead
Scribbling on the sky the message: "Romcom's Dead".
I sat through all *The Wedding Date*, but God knows how.
I thought this film would last for ever. Shoot me now.

LASSIE

16/12/05

★ ☆ ☆ ☆ ☆

What? What's that? What is it, girl? ... Oh love, look – it's our preternaturally intelligent collie! I was just having my tea and she keeps barking, pulling at my sleeve, running to the back door, barking in the direction of the old disused mine shaft, running back, pulling at my sleeve, barking, and running to the back door and barking again! She's done it about fifteen times! D'you think she wants us to follow her? ...

All right then, girl ... here we go, out of our picturesque back-to-back coalworker's home, down the street, and ... oh no, it's not the mine, we're ... we're heading for the local Odeon in the high street! What is it girl? It's as if ... as if she's trying to warn us of something! She's barking at ... well, by gum, she's barking frantically at the poster for *Lassie*, the new film version of the sentimental children's classic about the heartbreakingly poor family from oop north who have to sell their preternaturally intelligent collie to some rich but basically good-hearted toffs! She's pointing with her paw at the picture of ageing lead Peter O'Toole and then putting it up to the side of her head and making a circular motion. What's that girl? What are you saying? That Peter O'Toole is more authentically barking than any actual dog in the cast?

Now look ... the dog's pointing with his paw at the name of the director ... what's his name ... Charles Sturridge. Now what's the dog doing? Why, she's got up on her hind legs and she's mincing about with her long pointy collie face on one side, like a fey Oxford undergraduate holding a teddy bear! Gracious, it's almost as if the dog's trying to remind us of Mr Sturridge's past work, directing Granada TV's much-loved version of *Brideshead Revisited*. Now she's got a puzzled expression, pointing back at the title! And now she's gesturing with her paws outspread, shrugging her collie shoulders. What are you trying to say, love?

And now she's pointing a paw at the picture of Edward Fox, who has apparently got a cameo! The dog's miming holding a telephone

receiver – it's as if she's saying that Mr Fox is just phoning in his performance! And how about Samantha Morton who plays the saintly mum? And John Lynch, who plays the dad? What is it, girl? Why are you pointing at their names and then making that frantic downwards motion with both your paws? Hmm, I hadn't noticed collies had thumbs.

Goodness me, what a state that dog's in! She's running in and out of the foyer, barking like crazy, scaring the customers, jumping up at the refreshments counter; there's nachos and Diet Coke and those absurdly large overpriced bags of Toffets all over the floor! She's barking at those people by the ticket window! It's as if she's desperately trying to tell them all something! Tell them before it's too late!

Come here, girl, I'll have none of this nonsense, we're going home. I'm going to grab you by the scruff of your neck, and … oh no! The preternaturally intelligent collie has got away from me again! Determined and lovable creature that she is, she's wriggled out of my grasp and got back outside the Odeon again! Barking fit to beat the band! Oh for goodness sake you daft canine, just say what you think about these films on offer! *Narnia*? *King Kong*? Hmmm … wagging your tail. And what do you think about *Lassie*? … Oh dear. Has anyone got a plastic bag and some rubber gloves?

STAR WARS 3: REVENGE OF THE SITH

13/5/05

★ ☆ ☆ ☆ ☆

"Henceforth you will be known as Darth Vader!" These dire words, addressed to a tormented Anakin Skywalker as he crosses the threshold to the much-mentioned Dark Side, mark the definitive moment of his Luciferian journey, which will end with him in a black, neo-Wehrmacht helmet-mask, with incipient emphysema and a walk that makes him look as if he has had concrete hip replacements.

It supposedly forms the mythic heart of the gigantic Third Episode of George Lucas's colossally inflated *Star Wars* prequel trilogy. Yet when this moment happens – after what seems like seven hours of CGI action as dramatically weightless as the movement of tropical fish in an aquarium – I looked blearily around the cinema and sensed thousands of scalps failing to prickle. We had all been bored into submission long ago.

George Lucas is now not so much a director as chief executive cum potentate in charge of a vastly profitable franchise empire in which striking back is not an option. And within this empire's boundaries, Lucas is so mind-bogglingly powerful that none of his lieutenants dares tell him the truth: that yet another *Something of the Something* title, after *Attack of the Clones* and *Return of the Jedi*, is pretty annoying. (It's actually his fourth, if you count the original script title to the first *Star Wars: Adventures of the Starkiller*.) But here at any rate, finally, is the end of the road, or rather the middle of the road – the moment in 1977 where we came in. Lucas has taken three pointlessly long and artificially complicated movies to get to the point: precisely how did Luke Skywalker's father come to embrace the forces of darkness?

Hayden Christensen is Anakin, the talented but mercurial Jedi pupil of Obi-Wan Kenobi, in which role Ewan McGregor wears a big and bushy beard, to indicate the aged wisdom that we know is his destiny. Their mighty contest is to be at the centre of this movie, during which in quiet moments leading characters will gaze

out over massive futuristic cityscapes resembling the photorealist artwork once used for 1970s sci-fi paperbacks: pointy buildings with swarms of pointy aircraft criss-crossing overhead, often bathed in crimson sunsets.

Once again, McGregor speaks in a simperingly lifeless Rada-English accent, a muddled and misconceived backdating of the Guinness original – the young fogey with the light-sabre. In boringness he is matched by that Jedi master of woodenness: Hayden Christensen, the flatliner to end all flatliners. As an actor Christensen must show the terrible embryo of future wickedness within himself. And how does he do this? By tilting his head down, looking up through lowered brows and giving the unmistakable impression that he is very, very cross. If Princess Diana had gone to the Dark Side, she would have looked a lot like this.

So why does Anakin desert the forces of light? It is his passionate love and concern for his pregnant wife, Princess Amidala, coupled with a sense of his own slighted dignity that are to be the tragic and fateful factors leading to the most unconvincing evil act you can imagine, an event weirdly neutralised by the bloodless unreality that surrounds everything. The vicious Anakin massacres – oh, horror! – a bunch of innocent Jedi children.

But that is not how Lucas's solemnly high-flown script chooses to refer to them. With sub-Shakespearian gravitas, McGregor intones: "Not even the younglings survived." I'm sorry, not even the what? Is that their surname or something? Are Mr and Mrs Youngling going to come home to find a nursery bloodbath?

One of the things about the previous film, *Attack of the Clones*, that made you think things might be looking up was the terrific performance by Christopher Lee as the sinister Count Dooku. Almost the very first thing Lucas does here is kill him off. It is a crippling blow that leaves us with a range of scandalously dull secondary characters. People such as Senator Bail Organa, played by Jimmy Smits, and Samuel L. Jackson as the fiercely uninteresting Mace Windu. They are acting as if on some kind of medication.

As with everyone else – certainly with McGregor and Christensen and the incorrigibly clunky Natalie Portman as Princess Amidala – a heavy blanket of self-consciousness descends, under which they must act out the stilted myth on which depend the hopes and

expectations of millions of fans. There are zero comic moments. C-3PO is allowed on to whinge briefly and unfunnily.

Revenge of the Sith has some almost decent things. Yoda is good value as ever, though his character is never allowed to breathe in the airless galaxy Lucas creates, and there is a good sequence at the end showing the "birth" of Darth Vader while Princess Amidala is delivered of her twins. It has what the rest of the film so conspicuously lacks: a spark of real dramatic life. But it comes far too late and it is over immediately. How depressing to compare any of this with the fun and gusto of Harrison Ford, Carrie Fisher and Mark Hamill in the first movie. As for the elephantine trilogy as a whole, it was all too clearly a product of George Lucas's overweening production giant Industrial Light and Magic. No magic, little light, but an awful lot of heavy industry.

ELIZABETHTOWN

4/11/05

★ ☆ ☆ ☆ ☆

When the lights went up after this sentimental family comedy by Cameron Crowe, my face was frozen in the attitude of someone auditioning for the lead role in an Edward Munch painting. It is an unending nightmare of life-affirming laughter and tears, evidently conceived by someone with a sketchy idea of how carbon-based lifeforms behave. Of the three lead performances, it is difficult to decide which is the most horrifying. The bronze medal, however, goes to Orlando Bloom, playing a whizzkid who bankrupts a trendy shoe manufacturer with his catastrophic new design for sneakers. Just as he is about to kill himself, Orlando gets a call saying his dad is dead and he must return home to organise the funeral, learn life lessons etc. Bloom, with his cute face, is very much the George Lazenby of his generation.

Silver medal of ghastliness goes to Kirsten Dunst, playing the air-stewardess who befriends Bloom on the flight home and actually sits next to him and flirts with him – the way flight attendants all do. With her unvarying, eerily vampiric grin, Kirsten is pretty scary, but not as bad as gold medal winner, Susan Sarandon, playing Orlando's grieving mom. Sarandon treats us to a pop-eyed display of tremulous courage, during which I wondered if I could make legal history by taking out a restraining order against a fictional character. At the memorial service for her late husband, she instantly entrances his extended family – craggy Southern types who have never liked her that much – with a heart-warming speech, claiming that she wants to do wonderful things in his honour, like learn to tap-dance. Which she then does, to much whooping and applause. And if this wasn't bad enough, Crowe then gives Bloom an extraordinary road-trip of self-discovery at the very end which protracts this film by an excruciating quarter of an hour. Ever since *Jerry Maguire*, Cameron Crowe has been becoming more and more sucrose. Can no-one persuade him to take the road less travelled – back to making decent movies?

THE HOLIDAY

8/12/06

★ ★ ☆ ☆ ☆

"I'm a book editor from London – you're a trailer-maker from LA. We're worlds apart!" In this new romantic comedy about Americans and Brits falling in love, Jude Law actually has to say that line. He has to open his mouth and say it. To Cameron Diaz – whose character makes film trailers, by the way, not caravans. Poor Jude Law has to say this line, without wincing or crying or being turned into a column of soot by an angry Old Testament God.

The line is very important, you understand, in showing how adorably different the characters are, and yet how deeply and felicitously they understand each other. In fact, their utter mutual incomprehension is far more serious than the movie ever concedes. Jude Law's character might as well say: "I'm a geologist from one of the moons circling Pluto; you're a chub fuddler from the Forest of Dean. We're worlds apart!" What Jude Law the actor might say is: "You're an attractive Hollywood star whose career could go either way, and so am I! We're from the same world! If we had sex, it wouldn't be legal, because we're already practically conjoined twins!"

Cameron Diaz – her beaming, hyperactive face almost entirely devoid of ordinary human emotion – plays Amanda, a movie executive who has come to England on a cute "house swap" holiday with a stressed English journalist called Iris (Kate Winslet). Iris has had her heart broken and strikes various Bridget Jonesy poses of snuffly, tissuey, jumper-wearing despair around the house, before snapping up the house-swap offer and zipping over to live in Amanda's spiffy Los Angeles home for the Christmas holidays, leaving behind her roguish brother, Graham. This is the pulchritudinous Jude Law, the "book editor" with whom Amanda has raunchy sex with her bra on. Out in the US, Kate Winslet finds herself drawn to quirky, vulnerable musician Miles (Jack Black) – chubby, yet hubby material.

This glutinous film is coated in a kind of buttery stuff, a soft golden glow of ersatz romance. It's as if they have taken the brown gooey contents of a million Mars bars and used it to develop the

film – with the leftovers being poured down our throats. Everything is bizarrely unreal. Iris is allegedly employed as court and social correspondent of *The Daily Telegraph*, whose premises writer-director Nancy Meyers imagines as having an indoor cladding of Tudorbethan panelling, like the ground floor of Liberty department store. Amanda comes to live in Iris's chintzy cottage in "Surrey": a part of Surrey usually accessible only from the back of a wardrobe. Unforgivably, Meyers's script has someone saying that Cary Grant was from Surrey. My suspicion is that Meyers knows perfectly well Grant was from unpicturesque Bristol.

Meanwhile, out in LA, Kate Winslet has befriended an ageing scriptwriter from Hollywood's golden age, played by Eli Wallach, whose elderly, twinkly-eyed, life-affirming wisdom heals poor Winslet's emotional wounds, and prepares her for the big new romance with Jack Black. If you get a chance, take a look at the poster for this film, on which the paired photos of Winslet and Black are smiling blandly, blankly in each other's general direction. It's entirely representative of what's not happening on the screen. They could be two waxworks together. Forget chemistry – were they even on set the same day when their scenes were filmed? It's a kind of bluescreen acting. Black had more of a relationship with King Kong. And he just does not work as a romantic lead: his face is hardwired for wacky comedy. When he smiles in what is clearly supposed to be a winning way, it just looks creepy, or as if he is having some sort of intestinal spasm.

But for real creepiness, for real oh-my-God-I-think-he-might-be-a-serial-killer creepiness, Jude Law's character wins hands down. When he shows up at Cameron's house-swap cottage, tipsy and needing somewhere to go to the loo and stay the night, my blood ran cold. Something about his cuddly overcoat, lovable scarf and Brit specs, made me think I was watching a remake of *10 Rillington Place*. It seemed like Graham was going to wind up keeping Amanda in various sections of the freezer. Nothing quite so deplorable occurs, yet this is how he playfully rebukes Amanda, after some fairly sober talk about relationships and such: "You're seriously the most depressing girl I've ever met!" Diaz, who is thirty-four years old, plays a high-status professional who is surely entitled to consider herself exempt from the indignities of being addressed as a "girl". But she

never betrays, with word or deed, any emotion other than awestruck gratitude for all this.

Cameron and Jude are supposed to be the beautiful ones; Kate and Jack clearly less so. And yet it is Winslet, by persistently looking like a real human being, and maintaining an air of cheerful good humour, who weirdly emerges from this train-wreck of a film with her class intact. Like everyone else, she never gets any decent lines or convincing characterisation, and yet she somehow always looks at ease, unlike the unrelaxed other three. In this Christmas season, it would be lovely to have a romantic comedy that soothed away our workaday cares. But this doesn't feel like a holiday. It feels like two hours and ten minutes of very hard graft.

BABEL

19/1/07

★★☆☆☆

There are some films that arrive here from the international festival circuit almost incandescent with self-importance. They hover into the cinema in a kind of floating trance at how challenging and moving they are. They are films with a profound reluctance to get over themselves. They look up at the sceptical observer with the saucer-eyed saintliness of a baby seal in culling season, or a charity mugger smilingly wishing a nice day on the retreating back of a passer-by.

One such is *Babel*, the exasperatingly conceited new film from Alejandro González Iñárritu. It is well acted and handsomely photographed, but still extraordinarily overpraised and overblown, a middlebrow piece of near-nonsense: the kind of self-conscious arthouse cinema that is custom-tailored and machine-tooled for the dinner-party demographic. The script is contrived, shallow, unconvincing and rendered absurd and almost meaningless by a plot naivety that is impossible to ignore once its full magnitude dawns on you.

Exactly like *Amores Perros* and *21 Grams* – the previous movies of Iñárritu and his screenwriter Guillermo Arriaga – *Babel* is structured around a disparate group of characters yoked together by a quirk of fate. In those films, the quirk was respectively a car crash and a heart transplant, and just as in *21 Grams*, we are here presented with fragments of lives and invited to guess how the jigsaw pieces fit together.

This time it's a gun which joins everything up, an object passed from hand to hand. It is a Winchester hunting rifle which a shepherd in north Africa buys and (rashly) entrusts to his two young sons, telling them to shoot jackals that menace his flock. There are no prizes for guessing if something terrible happens. One tragic shot from this rifle is, as they say, heard around the world. The fate of the shepherd and his boys (Mohamed Akhzam, Boubker Ait El Caid and Said Tarchani) is now welded to that of a desperately unhappy

American couple (Brad Pitt and Cate Blanchett); their terrible situation causes the lives of a brash Mexican guy and his respectable aunt (Gael García Bernal and Adriana Barraza) to go tragically off course and everyone is enigmatically connected to a Japanese widower and his hearing-impaired teenage daughter (Kôji Yakusho and Rinko Kikuchi).

It is arguably bold and ambitious in its way, set in world of globally intuited emotional distress. The opening event is a butterfly's wingbeat that sends a ripple of anguish all over the planet. With one extravagant narrative flourish, Iñárittu and Arriaga seek to create a postmodern We-Are-the-World spectacle, uniting the prosperous nations with the developing ones in a kind of pain-continuum. Notably, however, it is the characters from the poor countries who really bear the brunt by the movie's finish, and it is difficult to see exactly how intentional this irony is.

As the action intercuts between Morocco, Japan, Mexico and the US, the connections become apparent, and as the truth dawns, so will your irritation and incredulity. It is when the Japanese link is explained that the plot hole opens up. Suffice it to say that a key piece simply doesn't fit. Despite self-consciously invoking the tough new post-9/11 world, in which international politics is coloured by fear and loathing of international terrorism, *Babel* is very naive about how easy it is to bring a dangerous firearm into a foreign country and then casually leave it behind as a present. Plenty of classic films have plot glitches, of course, but this one is pretty excessive.

The movie's later sequences in the Californian desert verge on gratuitous miserablist agony, though neatly concluded with a laughably convenient stroke of luck. *Babel*'s final scene is particularly suspect, involving tastefully softcore teen nudity, and the exploitative conflation of vulnerability and disability. In fact its final shot, pulling back from two figures at the balcony of an apartment building to show the whole city with all its twinkling lights – well, it gets very close to Richard Curtis territory, though Mr Curtis would not be so heavy-handed about it all. There are well-turned individual scenes, and it is never dull exactly. Brad Pitt, whose gaunt, careworn appearance about the eyes has perhaps been cosmetically emphasised, gives a good performance, though Cate Blanchett has nothing much to do other than lie on the floor whimpering, and her prone

position is emblematic of the passive agony underlying the movie's body language.

Iñárritu has been such an exciting film-maker until now, but in simply repeating the narrative device, he looks like a one-trick pony and *Babel* has the unfortunate effect of retrospectively diminishing the value of his previous two films. It is less than the sum of its grandiose parts, while remaining bloated with its own euphoric spiritual pain.

WILD HOGS

13/4/07

★ ☆ ☆ ☆ ☆

Looking at the actors on the poster outside the cinema – John Travolta, William H. Macy, Tim Allen and Martin Lawrence – triggers a kind of awestruck anticipation. They are four faces on a Mount Rushmore of rubbishness. Which one of these Hollywood middleweights is going to be the most utterly abysmal? Which is going to phone in the most inept performance? It's like King Kong versus Godzilla versus Alien versus Predator: all four creatures lined up on the starting blocks for the 100m Terrible Acting event.

Well, it's a photo-finish, but by a nose, by the briefest sliver of proboscis, it is John Travolta, whose great smug slab of a face with its bandanna and strange unvarying wince of disgust to denote all forms of disapproval or indeed emotion of any sort, really is exasperating and depressing in equal measure. Travolta is first among equals in this mind-sodomisingly mediocre family comedy from Walt Disney. It's a film that has none the less elicited some deafening ker-ching at the US box office, and its staggering success has even promised to revive the career of Ray Liotta, who has a crudely and unfunnily written supporting role as an evil biker. That can't be bad, of course, but couldn't fate have chosen a worthier film to boost this estimable actor's profile? And it's sad to see Macy on auto-pilot like this.

Travolta and the three other beta-males play a quartet of adorably normal guys who were kind of wild in their twenties but have now settled down to dull, prosperous lives in the 'burbs. Their only way of letting off steam is their silly little bikers' club, the Wild Hogs. Every weekend or so, the guys pull some leather jackets over their paunches, get on their machines and roar around the surrounding countryside for some male bonding. There's a cringeworthy opening sequence showing the non-fearsome foursome cruising along the main street, fraternally touching fists – and then nerdy William H. Macy loses control of his bike and hilariously ploughs up a grassy verge. Does this happen all the time?

Then one of them – for the life of me, I can't quite remember which – gets seriously depressed about his life, and his crisis plunges the gang into a group menopause. The only cure is for them all to take a remedial road trip on their bikes to confront their masculine demons.

There's no reason why this shouldn't make for good entertainment, and I have happy memories of Billy Crystal and the late Bruno Kirby in *City Slickers*, about townies indulging in manly yet therapeutic cow-punching. That had a decent script; this doesn't.

What happens is that the Hogs get picked on by some real, mean bikers – led by Liotta – and they wind up defending a blameless small town against these nasty outlaws in a laboured kind of sub-*Seven Samurai* situation. It really is very Disneyfied, and the fight scenes in this town look worryingly like a staged stunt display in some Disney theme park or Universal Studios tour-type tourist attraction. And there is the very dispiriting spectacle of Ray Liotta and, in cameo, Peter Fonda parodying their bad-guy personas for the benefit of the emasculated heroes in an emasculated film. Not an easy ride.

ELIZABETH: THE GOLDEN AGE

2/11/07

★ ☆ ☆ ☆ ☆

I've heard of revisionism. But this ... There are, to say the least, some startling moments in this Sellar-and-Yeatman retelling of the story of England's Virgin Queen, Elizabeth I, and her golden years, spent flirting, giving thin and enigmatic smiles, watching masques, and opening up a family-share-sized can of Tudor whup-ass on the Spanish and their beastly Catholic Armada. The story begins in 1585, as Elizabeth must contend with plots directed by Spain's Philip II to topple her with a seaborne invasion.

The best bit comes when the Queen, played of course by Cate Blanchett, arrives on horseback on the coast to give her troops an inspirational speech while the Armada's first devilish pixels are digitally visible on the choppy horizon. Gorgeous flame-red tresses caress her shoulders in elaborate plaits: another of her wigs, presumably, because we have already seen her close-cropped head in other private scenes with various ladies of the bedchamber. She is wearing the most strikingly tailored and highly polished armour. It is as if she has thought to herself on the eve of battle: "How can I, by the Grace of God Defender of the Faith, inspire my people to defend these islands and fling the Spaniards' pride back, yea, back in their very teeth? I know! I shall come out dressed as a cross between Pippi Longstocking and Metal Mickey." She does, however, look very good for fifty-five years old.

Elizabeth is riding man-style, incidentally: astride. Those exquisite armoured pins are either side of the horseflesh. This is very much not the case earlier, in more carefree scenes when she is out riding with her main beau and semi-platonic squeeze Sir Walter Raleigh, played by rugged Clive Owen with a West Country burr that comes and goes.

Here, she's allegedly riding side-saddle, and at a pretty good gallop, what's more. But come on. Blanchett is still sneakily riding astride; her right leg is concealed in the folds of her dress and there's a floppy fake right leg bouncing on the saddle next to the real left leg, like one

of the limbs of Rod Hull's Emu. It really is very odd, as if the strain of combating the Papist plots has caused one of the Queen's limbs to dwindle to the mass of a baby leek. Perhaps Blanchett and director Shekhar Kapur will fess up to this contrivance on the DVD, or maybe they will claim that's how the current Queen Elizabeth used to manage it when she still did Trooping the Colour on horseback.

In the first movie from 1998 about Elizabeth's early life, also directed by Kapur, the Queen's main love affair was with Robert Dudley, Earl of Leicester, played by Joseph Fiennes. But Dudley hasn't been brought back for this sequel, unlike the wily spymaster Sir Francis Walsingham, played by Geoffrey Rush, who has returned for more Olympic-standard skulduggery. No, poor Dudley has been written out of the script, perhaps because audiences would see Fiennes and think the Queen is about to get off with William Shakespeare.

It's Raleigh who is the sole love-interest now: he does the traditional business of taking his cloak (worn asymmetrically over one shoulder) and putting it on a puddle for her dainty foot, and then impulsively arrives at court with all his swag from the new world: two genuine Native Americans, and a trunk containing some potatoes and tobacco. Elizabeth is of course charmed and amused by the forthright adventurer, whose robust masculinity is so thrillingly at variance with the milksops and greybeards at court. She instructs her favourite, Bess Throckmorton (Abbie Cornish), to befriend him, a proxy seduction, in fact. But Bess and Walter fall in love.

Raleigh is to distinguish himself in battle in a remarkable way while on board one of Her Majesty's fire-ships. At the very height of the carnage and confusion, Raleigh actually dives overboard, and we see him swimming somewhere underwater, as lithe and purposeful as a dolphin. What the figgy pudding is Sir Walter doing now? Is he going to attach a rudimentary sixteenth-century explosive device to the hull of a Spanish ship? Is he going to deliver a box of chocolates to his Queen? Heaven knows. We see him later, quite dry, and nobody refers to his watery dive, or says anything like: my goodness Walter, that water must have been cold, what were you thinking?

Where Kapur's first *Elizabeth* was cool, cerebral, fascinatingly concerned with complex plotting, the new movie is pitched at the level of a Jean Plaidy romantic novel. Certainly compared to the excellent recent TV version of the same period with Helen

Mirren as Elizabeth I and Jeremy Irons as Dudley, it is pretty silly, and Elizabeth's agony over signing Mary Stuart's death warrant is perfunctory.

No one else could carry the role of Elizabeth I now on the big screen; it is a role that Blanchett has made her own, and it's the role that made her career. She certainly has the royal chops: only by playing Katharine Hepburn playing Elizabeth I could she be more imperious. How can Cate top this part? I can see the opening scene now: night ... outside Conservative Party Headquarters in Westminster ... it is 1979 ...

SLEUTH

23/11/07

★ ☆ ☆ ☆ ☆

In its own way, this film is an awesome, even terrifying demonstration of star power. If really, really big names are involved, they can get anything made. Even this. And this is a Dead Film Walking, a zombie of a film, a shuffling Frankenstein's monster of a film, leaking electricity from its badly-fitting neck bolts, tragically whimpering at the pointless agony of its own brief existence. Whose idea was it to zap this raddled corpse with electrodes and make it jolt and reel and stagger around for eighty-eight impossibly painful minutes? The culpable white-coated scientists are its stars, Michael Caine and Jude Law, whose conceit the idea appears to have tickled; its screenwriter, Nobel laureate Harold Pinter, and its director, Kenneth Branagh. This formidable quartet's very worst aspects have here come together in a perfect storm of rubbishness.

It is an unendurably boring, stagey, boring, arthritic, misconceived – and did I mention boring – new adaptation of *Sleuth*, the 1970 play by Anthony Shaffer, about a middle-aged thriller writer called Andrew Wyke, who invites his errant wife's sexy young lover Milo to his palatial country pad, ostensibly to discuss divorce arrangements like a civilised person. But really he wants to toy with him, play games with him, and generally mess with his head – as revenge for being sexually humiliated. It became a 1972 movie starring Laurence Olivier and a young Caine. Now it is Caine who plays the malign oldster and Law, very self-consciously indeed, inherits the younger man's mantle.

But wait. "New"? A "new" version? Well, it is new in the sense that Pinter has tinkered with the plot and very much recreates Wyke in his own image. Olivier's catty theatricality has gone and Wyke is now full of taciturn, fish-eyed menace. There is much play with the modernity of a hi-tech surveillance system, which Wyke operates with an iPod-ish remote. Branagh begins by tricking out his movie with some wacky camera angles, inspired by the CCTV-motif. After

just a few minutes, however, the gimmick is dispensed with, and normal cinematography is sheepishly restored.

There is, catastrophically, nothing new about this new *Sleuth*: there is no sense of history or perspective, no ingenious transformation or clever recontextualisation. It's about as new as the billionth performance of *The Mousetrap* or *No Sex Please, We're British*. Its assumptions about sex and class are thirty years old; its creaky plot points about divorce don't make sense; it has a Dr Evil-style pre-inflationary belief in the value of a "million pounds" and its attempts to interest us in a potential homoerotic charge between the principals are not daring but just embarrassing. It's the deadest possible mutton dressed as twenty-first-century lamb.

Pinter's dialogue is painfully unconvincing and mannered, neither remotely believable nor entertaining in its artificiality. The script has Wyke offering his young victim endless and laborious "drinks" in a way I thought Mike Leigh had killed off with *Abigail's Party*. The drinks he offers are 1970s drinks, stage-business drinks, unrefrigerated drinks offered from a sideboard, or a clump of bottles on a round silver tray; drinks are the bottomless source of filler-dialogue to keep things moving. (Like a drink? Vodka? Scotch? As it comes? What are you drinking? How's your glass? Christ – who cares?) There isn't a soda-siphon, but there might as well be.

Well, Caine always brings a certain charisma to any film, a basic level of background radioactivity, although his capacity for auto-pilot detachment is on display. Law, however, with his saucer-eyed mugging and terrible accents, is frankly awful, but as the film's co-producer and driving force, he may simply be beyond direction. Branagh, as a talented and accomplished actor himself, may have fatally indulged what he saw as an actors' project or, worse yet, a stars' project. And Pinter's script is just self-parody, and dull self-parody at that.

It has long been a bee in my bonnet that Branagh has unjustly fallen out of favour with London's arts media set, obsessed with boorish luvvie-bating: that he is a high-minded director whose attractive and intelligent *As You Like It* I recently enjoyed and to whose *Magic Flute* I look forward very much. But this does not do him any favours and certainly doesn't do the audience any favours either.

What a waste. Maybe if Branagh had revived *Sleuth* for the stage, and got Law and Caine to face off, in real time, in front of a packed theatre crowd, night after night – that might have worked. Doing it live might have been an antidote to the datedness and deadness and even given a weird necrophiliac frisson to the proceedings. This is just necrophilia.

GOOD LUCK CHUCK

9/11/07

★ ☆ ☆ ☆ ☆

Cross the street to avoid this one. Cross a dual carriageway. Cross the Limpopo. A high-concept fratboy comedy about Chuck (Dane Cook) who's got this magic-power-cum-curse: any woman who has sex with him will find the (entirely different) man of her dreams immediately afterwards. Hot, marriage-hungry women line up to shag Chuck and he gratefully takes advantage. But then he falls in love with adorable Cam (Jessica Alba) who wants to have sex without knowing or caring about his magic. But yikes! Chuck realises that if they do the nasty, she will run out on him for someone else! D'you get it? D'you get the dilemma? Oh dear.

NO RESERVATIONS

31/8/07

★ ☆ ☆ ☆ ☆

Here is a romcom that has been developed on a Petri dish in some unspeakable secret department at the Porton Down biological warfare unit, designed to release a gaseous vapour into cinemas, rendering the civilian population immobile with a mixture of embarrassment, boredom and distaste. Catherine Zeta-Jones plays Kate, a top New York chef – beautiful, fiery high standards, lonely personal life – whose world is rocked by two twists of fate. Her sister dies, leaving her in charge of a ten-year-old niece-moppet played by Abigail Breslin, and a handsome sous-chef called Nick comes into her kitchen, played by Aaron Eckhart, renowned for his coldly brilliant performance as the seducer-destroyer in Neil LaBute's 1997 classic, *In the Company of Men*, but now evidently re-positioning himself in the market as an unthreatening slice of beefcake. Both events humanise her, and open her to life's possibilities. It is remade from a much-admired German film from 2001 called *Mostly Martha*, which starred Martina Gedeck.

God help us, but Zeta-Jones is terrible. For all the conviction she gives it, she might as well be playing a neurosurgeon, or a jockey, or a piece of Jarlsberg cheese. The flash of sly vanity and self-mockery she showed in the Coens' underrated *Intolerable Cruelty* or even the very moderate romp America's *Sweethearts* has entirely gone. Her face is eerily blank as if she has been self-medicating with Prozac-Loganberry Smoothies. When she has to come storming out of the kitchen in her white chef's outfit to kick the ass of some complaining diner, she just sort of whinges at him. And those lovely, and distinctively prosperous features are never disturbed by a single droplet of sweat. Eckhart is just as bad. His character is supposed to be exuberant and life-loving, given to singing opera in the kitchen in a way that in the real world would mark him out as a hyperactive, condescending prat.

When the entire staff gather round, laughing and coo-ing as he sings, it reminded me of John Hannah obsessively doing the Monty

Python parrot sketch in *Sliding Doors*. It's supposed to be absolutely adorable. In real life, behaving like this would get you hit over the head with a length of pipe.

As for the supporting cast, Patricia Clarkson is on cruise-control as the restaurant's proprietor who sort of stabs Kate in the back by planning to over-promote Nick. Then there's a very odd and completely pointless character who is Kate's neighbour Sean (Brian F. O'Byrne): a nice, divorced Irish guy with kids and a crush on Kate. He has been inserted into the script, I suspect, to target the female audience demographic who feel they would never stand a chance with handsome Aaron but might with Brian.

The statuesque and starry Zeta-Jones is in any case wasting her time with material like this. She is born to play one role and one role only: it would be in the film version (forthcoming from someone, somewhere, surely) of Tom Bower's book *Conrad and Lady Black* She would play the sexy journalist Barbara Amiel, married to the doomed Canadian tycoon – who would of course be played by Michael Douglas. Until that script arrives, it's just films like this. Which should be sent back to the kitchen.

ALIEN VERSUS PREDATOR: REQUIEM

18/1/08

★ ☆ ☆ ☆ ☆

If Gabriel Fauré were alive today, idly reading the cinema listings, and he fancied watching an action-horror illogically pitting two dull trademarked monsters against each other, the title of this one might close the deal for him. Something about it would appeal to his sense of grandeur, and cultural resonance. Perhaps he would call Mozart on the phone and say: "Wolfgang, I don't know if you've seen the latest *Aliens Versus Predator* film, or if you're waiting for the DVD or what, but there's something in the title's last word which makes me think it's a film for us. I'm convinced that it doesn't see death in the usual ugly, violent sense, but has imported the richer, more spiritually rewarding sense of being "at rest". The directors, the Brothers Krause, have a background in gaming and SFX, and yet I have an inkling they have been influenced by our work or at the very least by the form of the Catholic Mass." Anyway, the long-standing grudge-match of extra-terrestrial beasties has flared up anew, and the coy Latinism of the title should alert us to the frankly awe-inspiring possibility that this is their final, cataclysmic encounter. Or, gulp, is it? The slobbering, teeth-baring, tummy-bursting Aliens and the snarling Predator from the Arnie-in-the-jungle action package have once again kicked off, this time on Planet Earth where the poor humans are not directly targeted but nonetheless in great danger as innocent bystanders.

There are moments that abjectly seek to recreate the magic of the original: Aliens jump suckingly on to people's faces and snarl up-close-and-personal at women doing some sub-Sigourney sobbing. It's an almost Weimar-style devaluation of dramatic impact. The Aliens and Predator are equally yucky, and confusingly there is a sort of cross-breed this time called the Predalien – not the result of sexual intercourse, though there's no reason not to have a bit of a Romeo-and-Juliet situation between an Alien guy and Predator girl. No, it's just a question of the aliens doing their cheeky parasitic thing actually inside Predator. (I don't remember the Alien from the

first film coming out looking like John Hurt. Or, come to think of it, perhaps it did.)

Predator himself, with his conceited quasi-dreadlock hair extensions, has evidently modelled himself on 1990s football star Ruud Gullit. But perhaps it is time to extend this face-off principle to other kinds of cinema. We could have an action-horror with Keira Knightley from *Atonement* battling Helena Bonham Carter from *A Room with a View*, the delicate porcelain of their English complexions flecked with spittle and blood as their jaws extend into slavering mandibles, from which lesser rows of teeth would extend as they rampaged around the Tuscan countryside fanatically trying to kill each other. Or perhaps Keisha Castle-Hughes from *Whale Rider* could take on Anna Paquin from *The Piano*. Or Thomas Sangster from *Love Actually* versus Haley Joel Osment from *The Sixth Sense*.

Suffice it to say, the elemental contest between Aliens and Predator is so massive that when the US army drops a nuclear bomb on the quarantined area where they are scrapping, this detonation is hardly noticed. And there is no CND-style whingeing from the various hotties and babes in the cast when the truth about this nuclear holocaust is casually revealed to them. Taking on Aliens and Predator, as they take on each other, is an aid to stoicism.

THE ACCIDENTAL HUSBAND

29/2/08

★ ☆ ☆ ☆ ☆

This week we learned that ninety-nine percent of Sun readers want a return to capital punishment. I learned that 100 percent of me wants it for 100 percent of people involved in this romcom. Uma Thurman plays a – actually, wait … Uma Thurman doesn't do anything as dramatically intelligible as "play" anything. She grins, mugs and capers like a whippet on crack in the role of Emma, a radio advice doctor with a wussy British fiancé, Richard (Colin Firth), whom she is all too clearly destined to leave for hunky firefighter Patrick (Jeffrey Dean Morgan). As ever with this kind of romcom, there's an awful hint of the non-chemistry of its actors in the poster. If you get a moment, look at Colin Firth's face, smiling tightly like a waxwork, in Uma's vague direction. It's the face of an actor concentrating on his fee.

LOVE IN THE TIME OF CHOLERA

21/3/08

★ ☆ ☆ ☆ ☆

Javier Bardem's starring role in this horrifically boring festival of middlebrow good taste points up a general fact about his career, which the best supporting actor Oscar in the Coen brothers' film *No Country for Old Men* briefly obscured. He can be a completely terrible actor. With his dreamy, fish-eyed gaze and purring voice, he is unbearably mannered and self-conscious; his mouth is habitually pursed in a little smirk, sometimes archly knowing, sometimes seraphically accepting; it makes you want to slap him.

In *No Country For Old Men*, everyone thought that his coiffure represented an unbeatable low in screen hair. Wrong. Bardem's moustache in this film, with its dandy little twists at either end, is just as repulsive, but it isn't supposed to be. A string of female co-stars actually have to kiss him while this loathsome thing is nestling on his upper lip, without screeching or throwing up.

Directed by Mike Newell and adapted by Ronald Harwood from Gabriel García Márquez's 1985 novel, the film is set in late nineteenth-century Colombia; where cholera becomes a queasy metaphor for the sickness of love. Its hero is moonstruck telegraph operator Florentino, and in Bardem's hands this character becomes one of the most annoying passive-aggressive types imaginable. While still penniless, he falls for Fermina (Giovanna Mezzogiorno), the beautiful daughter of a wealthy but boorish new-money businessman Lorenzo Daza (John Leguizamo). Daza cruelly forbids the match and instead steers her towards cultured, handsome Dr Urbino (Benjamin Bratt). They are married, not very happily, and poor Florentino grows old keeping the flame of love alive in his heart. It is only fifty years later, when Fermina and Florentino are both ancient, that he can put the moves on her.

So far, so adorable. But wait. Florentino hasn't exactly been keeping himself chaste for Fermina, and even given that such a thing wouldn't be reasonable for any normal red-blooded man, this story gives him a startling consolation prize. He becomes an absolute

babe magnet. Something in that spaniel-eyed inner hurt has the señoras flinging themselves at him. Florentino is shown getting it on with women, more than 600 by his own self-congratulatory count, who obligingly reveal their breasts to the camera. Even as a frankly revolting oldster – who is now incidentally rich – he is shagging a besotted student a millionth of his age. Who shows us her breasts.

We are expected to sigh and swoon while Florentino finally has his narrative cake and eats it, eventually climbing into bed with Fermina. She also, with much bittersweet hesitation, reveals her breasts. Mezzogiorno is apparently wearing a latex upper-body-frontal nude old lady suit. Dreamy, romantic Florentino, spiritually monogamous even in mortality's shadow, evidently forgives Fermina for not looking as hot as the hundreds of younger women he's been bedding. But we never see his sagging body.

The stately parade of young actors dressed up to look old in period costume at the beginning of a film is a worrying sign of its forthcoming pomposity and conceit: radiating an entirely unearned sense of awe at setting out to tell someone's important life story. This film is plainly supposed to be life-affirming and life-enhancing, a classy literary date movie for the educated classes. It actually looks smug and tacky and dull: a softcore *Captain Corelli*. A film to be strictly quarantined.

THE INCREDIBLE HULK

13/6/08

★ ☆ ☆ ☆ ☆

"Hulk. Smash!" Yes. Hulk. Smash. Yes. Smash. Big Hulk smash. Smash cars. Buildings. Army tanks. Hulk not just smash. Hulk also go rarrr! Then smash again. Smash important, obviously. Smash Hulk's USP. What Hulk smash most? Hulk smash all hope of interesting time in cinema. Hulk take all effort of cinema, effort getting babysitter, effort finding parking, and Hulk put great green fist right through it. Hulk crush all hopes of entertainment. Hulk in boring film. Film co-written by star. Edward Norton. Norton in it. Norton write it. Norton not need gamma-radiation poisoning to get big head. Thing is: Hulk head weirdly small. Compared with rest of big green body.

Hulk not scary. Hulk look like Shrek. Wait. Critic have ... second thought. Hulk look like Shrek when Shrek turn handsome, in *Shrek 2*. Like Gordon Brown. Hulk rubbish. Hulk not look powerful. Especially when Hulk do jumpy bouncy floaty thing. Over New York buildings. Then Hulk look wussy. Big. Yet wussy. Not good combination.

Stan Lee have big cameo. Stan Lee keen on self. Previously Stan Lee just glimpsed. Now Stan in it for thirty seconds. Or more. Stan clearly on roll. Stan even give Robert Downey Jr cameo. As Iron Man. This very irritating. Audience supposed to be excited. Audience nod off. Long ago.

Idea is. Dr Bruce Banner – on run. Keep anger under control. Banner hope not turn into Hulk. Banner live ... in Brazilian slum. Work in factory. Total babe there fancy Banner. Banner quite fancy babe. But Banner not make move. Babe in film to keep guys interested. Until Banner's girlfriend Liv Tyler come into action later. Tyler not mind Hulk thing. Hulk remind her of dad. Steven Tyler. Possibly. Much location work. Overhead shots. Of slums. *City of God* vibe intended. But this rubbish. Like everything else.

Tim Roth come on. As evil soldier. Fighting Hulk personal for him. Roth typical evil Brit. Roth supposedly working for US army. Yet Roth Brit. Critic annoyed by stereotyping. Roth get injected

with serum. Become Hulky supervillain. Smash cars. Tanks. Only with no trousers. Roth groin area ambiguous. Groin area look lumpy. Bumpy. Perhaps odd penis. Perhaps odd trousers. Critic … not sure.

Same old story. Superhero movie give superhero mirror–image antagonist. Like in *Spider-Man 3*. Idea rubbish in *Spider-Man 3*. Idea rubbish here. Hulk versus humanity important thing. Cancelled out here. Basic problem … critic not believe Hulk angry. Hulk just roar. It not look convincing. Not truly seem angry. Critic think about this. Critic decide why. It because Hulk not swear. Hulk just say: "Hulk. Smash" etc. If Hulk shout C-word … different matter. Then Hulk look angry. Sound angry. Not here. Hulk genteel.

Critic remember Ang Lee version. Ang Lee version slagged off. Yet rubbish new *Hulk* film make that look like *Citizen Kane*. Critic exit cinema miffed. Film take away two hours of critic's life. Critic not get time back. Ever. Rarrrrr.

ROCKNROLLA

5/9/08

★ ☆ ☆ ☆ ☆

That title of Mr Guy Ritchie's new featcha. Means geeza. Or mobsta. Top bruisa. In his London manna. Sad to say, the film's a shocka. A right depressa. Bit of a dispirita. For this directa, it ain't exactly a departcha. And the title means as well as everything else Mr Ritchie's become a dodgy spella. What a dismaying orthographical decline since his last pictcha. Which we must now think of as *Revolva*. This was influenced by the belief system known as Kabbala. Rememba? Espoused by his spouse, whose name may originally have been spelt "Madonner".

Howeva. This one does not have Danny Dya. That really would have been a killa. But it has got Tom Wilkinson (what a troopa), Gerard Butla and many an acta who learned to speak cockney at Rada.

It's got Thandie Newton, playing someone name-a Stella. She's just a stunna in designa clobba. And for the filmgoa who recalls her in *Flirting*, this is a bit of a choka. (I think she deserves betta.) And it's got Toby Kebbell, who once played the managa of that northern pop whingea who just felt sadda and sadda and finally came a fatal and tragically self-inflicted croppa.

All of these thesps pretend to be well harda than anyone else, in scenes that get shorta and shorta, accompanied by a well irritating mockney voiceova. Each playa's got his shoota. Each of them gets a silly monika, like "One Two" or "Mumbles". Sometimes they wear hats or caps – but a titfa is no substitute for a propa characta. There's a violent Russian monsta who appears to be a football club proprieta, which may trigga anga in a certain real life fella from Russia who will holla for his lawya. (I've seen subtla.) Guy Ritchie, who is also the writa, moreova has someone saying that London property prices are going to go up and up for eva and eva, which isn't exactly cleva, given the current financial weatha.

As so often in the *oeuvra* of the film's creata, each cipha sounds like he's a Groucho Club memba, a haunta of that exclusive London booza which contains many a bourgwa meeja wanka who thinks he's a West Ham supporta after a night on the powda. I mean, Mr Ritchie: this genra: it's ova. I mean, doing yet anotha stinka of a drama about the mee-lee-a of the ersatz London gangsta? You're taking the piss – intcha?

AUSTRALIA

22/12/08

★ ☆ ☆ ☆ ☆

Something strange happened to my face shortly after the beginning of Baz Luhrmann's excruciating new wartime romance epic, starring Nicole Kidman as the posh English Lady Sarah who travels out to Australia in 1940, and Hugh "Russell Crowe is not available" Jackman as the bit of local rough with whom she falls swooningly in love. A kind of clinical shock caused the upper part of my body to go into a state of paralysis. The skin on my face became as tense and inert as Kidman's forehead. My whole face was as taut as a snare drum, or the back of a saddleback pig. The roof of my mouth became locked as I tried to give a traumatised whinny of distress: "Nggg … ngggg …" Right back at me came Kidman's English accent: "Fauu maah-eye Gord, th-eauu-se cahh-tle are escayyy-ping acrawss thuh bil-ah-bongggg."

At war's outbreak, Lady Sarah furiously suspects her absent husband is getting some extracurricular jollies on the family's cattle station in Australia, although her emotional state has to be inferred from the dialogue, rather than from Kidman's immobile face, in which the only discernible movement is a faint pursing of the mouth and a quiver of that *retroussé* nose, perhaps induced by two tiny invisible electrodes being jabbed into her lips below the nostrils. She impulsively travels out there — quite a quick journey, evidently — to the impotent dismay of various servants and submissive salaried flunkies. Turns out her husband has been killed as a result of a creepy conspiracy by white monopolists to bankrupt her business, and a preternaturally wise Aborigine called King George, played by David Gulpilil, has been fitted up for the murder.

Imperious and adorable, Lady Sarah announces she wants to drive her cattle billions of miles across the CGI Outback to market anyway, to the exasperation of her hairy stockman, Drover, played of course by Hugh "Russell Crowe's fee was just that bit too high" Jackman. As they encounter all sorts of tempests and setbacks, love inevitably flowers between Nicole Kidman and Hugh "Russell's agent was frankly unreasonable on the phone" Jackman.

They are accompanied by Nullah (Brandon Walters), a young mixed-race boy of the sort the Australian authorities notoriously used to insist on spiriting away to conceal the evidence of sex between the races. The grotesque condescension of making the only important Aborigine character a child would rather seem to underline the racists' repeated declarations that the Aborigines are just children. But Luhrmann is always mustard-keen to accord his Aborigine characters their own narrative of cultural identity. "The only thing you really own is your story," says Drover solemnly – which is quite something, as Luhrmann pinches almost everyone else's story. *Gone With the Wind*, *Out of Africa*, *The African Queen*, *Empire of the Sun* and many others get nicked. The characters also go to see *The Wizard of Oz*, because the last word of that title is slang for a certain antipodean country, geddit? The score, moreover, offers variations on *Waltzing Matilda*, *Sheep May Safely Graze* and – to accompany Nullah's ecstatic embrace of his Aboriginal identity – Elgar's *Nimrod*.

Cattle-related adventures satisfactorily concluded, Kidman embarks on a blissful but tragically short period of quasi-marital happiness with Hugh "Russell's putting on weight anyway" Jackman. But then their relationship is thrown into crisis when the Japanese attack. With an awful inevitability, the hero and heroine are saved by the aged wisdom of King George, who is often seen in long shot: part of, and effectively indistinguishable from, the awesome digital landscape. King George is pretty damn useful with that spear of his, and in the film's final moments, despite having been arrested, he chucks it to great effect – how very fortunate the authorities neglected to take it off him. Perhaps they were culturally sensitive enough to realise it was part of his "story".

The zappy, hyperactive cuts and zooms that are so much a part of Luhrmann's style melt away as the solemnity of the film sets like concrete. We are left with slow-moving insincerity and conceit, summed up in the flatulence of that title: *Australia*, a country reborn in terms of facetious Hollywood clichés. The film seems to mark the moment when the white man's burden of colonial condescension passed from Britain to the US. All this *Australia* offers is a cringe, but not a very cultural one.

THE READER

2/1/09

★ ☆ ☆ ☆ ☆

Much praise has been given to this adaptation by screenwriter David Hare and director Stephen Daldry of Bernhard Schlink's 1995 novel *Der Vorleser*, or *The Reader* – the German title has the sense of "reader-aloud". Everyone involved in this film is of the highest possible calibre, but their combined and formidable talents could not annul my queasiness that the question of Nazi war guilt and the death camps had been reimagined in terms of a middlebrow sentimental-erotic fantasy. This was, I admit, a problem I had with the original novel, and the movie treatment has not alleviated it. Its full, questionable nature emerges as the narrative unfolds; those fearful of spoilerism had better look away now.

Kate Winslet gives a typically intelligent performance as Hanna, a sturdy, unprepossessing woman in a provincial town in 1950s West Germany; she is employed as a tram conductor. One rainy day, she chances upon Michael (David Kross), a teenage boy shivering, throwing up and almost delirious with undiagnosed fever in the courtyard of her apartment building. With brisk and motherly can-do, she mops his brow, sloshes away the sick with a bucket of water and makes sure he gets home all right. Some months later, after a lonely recuperation, he comes back to her flat with a bunch of flowers to say thank you. They end up having a glorious affair, and their passionate lovemaking is accompanied with a ritual hardly less erotic – she loves him to read aloud to her from the classics: Chekhov, Homer, Rilke.

But one day, Hanna mysteriously vanishes and it is only many years later that Michael, now a law student, is astonished to see her again, older and greyer – in the dock. For Hanna was an SS camp guard at Auschwitz, one of half a dozen who committed a particular, atrocious mass murder, described in the bestselling memoir of a Holocaust survivor. Michael is horrified to hear testimony that Hanna liked to pick and choose "favourites" from among the prisoners who were forced to come to her quarters to read to her. It is only now that

Michael realises that Hanna is illiterate. As an older man, played by Ralph Fiennes, Michael must come to terms with his feelings of horror at being violated, at having his own capacity for forming relationships stunted, mingled with pity and even tenderness for this vilified creature.

Hanna's condition is by no means a metaphor for the moral illiteracy of Nazism. She is shown as being the only honest defendant among the guards on trial; she silences the presiding judge with a heartfelt: "What would you have done?" She only takes the blame for having written a mendacious SS report, and therefore having been the guards' ringleader, because disproving it would mean submitting a handwriting specimen – and Hanna is still ashamed of being illiterate.

The dramatic and emotional structure of the film insidiously invites us to see Hanna's secret misery as a species of victimhood that, if not exactly equivalent to that of her prisoners, is certainly something to be weighed thoughtfully in the balance, and to see a guilt-free human vulnerability behind war crimes. The movie boldly flashes backwards and forwards between Michael's youth and middle age, but there are no flashbacks to the Auschwitz era, so we cannot judge the central facts of Hanna's life and behaviour, and her continuing silence on the subject of anti-Semitism is never challenged. One sequence shows the older Michael wandering thoughtfully through the deserted but clean and tidy camp with its grim bunks and shower rooms. Were West German law students really allowed to do this? Unaccompanied?

In a final scene, Ralph Fiennes, as the older Michael, comes to New York to visit Ilana Mather, one of Hanna's surviving victims, bearing Hanna's savings in an old tea-can. (Alexandra Maria Lara plays Ilana as a young woman, with whom young Michael had exchanged a friendly grimace of sympathy in court; she is played in middle age by Lena Olin.) This is because Hanna wanted Ilana to have her money, to do with "as she wishes". Surely any sentient human being, no matter how burdened they might feel by a perverse obligation to carry out Hanna's wishes, would see what a grotesque insult that is? Michael's failure to acknowledge it is one of the most agonising, toe-curling aspects of the film.

He explains Hanna's illiteracy to Ilana and the woman asks sharply: "Is that an explanation? Or an excuse?" This highly pertinent question

never gets a satisfactory answer from Michael or anyone else. Ilana does not take the money, but incredibly, she does accept the battered old tea-can because it resembles one she lost in the camps – thus legitimising this appalling payment in a far deeper, more emotional sense. The sheer fatuity of this exchange left me gasping.

Kate Winslet thus participates in the Hollywood tradition of having the Nazi played by a Brit; she is very good, and in fact no purely technical objections could conceivably be levelled in any direction. But I can't forgive this film for being so shallow and so obtuse on such a subject, and I can't accept it as a parable for war-guilt-by-association suffered by goodish Germans of the next generation. Under the gloss of high production value, under the sheen of hardback good taste, there is something naive and glib and meretricious. It left a very strange taste in my mouth.

THE CURIOUS CASE OF BENJAMIN BUTTON

6/2/09

★ ☆ ☆ ☆ ☆

Remove "curious" from the title and replace it with "twee and pointless", and you're close to it. What an incredible shaggy-puppy of a movie, a cobweb-construction patched together with CGI, prosthetics, gibberish and warm tears. And, at two hours and forty minutes, it really does go on for an incredibly long time.

David Fincher directs this adaptation, by screenwriter Eric Roth, of a minor 1921 story by F. Scott Fitzgerald. The idea is that Benjamin Button – a name that, incidentally, does not get any less annoying as the minutes and hours drag by – is an Everyman-ish sort of fellow who is born in New Orleans just after the end of World War I and lives until his late eighties. The weird thing is that he emerges from the womb a tiny shrivelled old man and gets younger and younger until he becomes super-gorgeous Brad Pitt. Then he dwindles to a boy and a baby again, unlined this time. As a wizened geezer-munchkin at the beginning of his strange existence, Button is to meet Daisy, a clear-eyed, auburn-haired little girl with whom he has an instant connection that is not at all creepy or paedophilic. This girl, a brilliant ballet dancer, grows up to be Cate Blanchett; as their ages converge, Daisy and Benjamin have a brief, passionate love affair, before the contraflow of time takes them away from each other: ships that pass in the night.

Before they finally consummate their love, however, there are a number of false starts. At first, the callow and conceited Daisy wants to jump into bed with wise old Benjamin because she likes the idea of doing it with an older man. He gently demurs, but years later, when the slightly younger Benjamin shyly shows up backstage at her triumphant New York show, she is far too cool and famous to spend time with him. It is only after she has been crippled in a car crash – humbled, in fact, like the blinded Mr Rochester in *Jane Eyre* – that Daisy is spiritually ready for the privilege of a relationship with winsome Benjamin Button.

The idea of Button getting younger and younger is not imbued with any great comic or tragic insight. Or any insight at all. He is not like Dracula or Dorian Gray. He is just bland-faced Benjamin Button, who eventually, in his youthful pomp, riding his motorcycle or sailing his yacht, has all the interest of a model in a Gap advert. Apart from his remarkable physical quirk, which never attracts any medical or media attention, Benjamin really is very boring indeed. You could change the story's concept to, say, gravity working the opposite way around for Benjamin, causing him to bob around up on the ceiling with everyone else milling around on the floor, and that empty, beefcake expression of pure existential zilch wouldn't be any different. He also has a *Zelig*-type habit of showing up at important events: while he's sailing in Florida, you can see Apollo 11 taking off in the distance. "Oh my God, look over there everyone!" I wanted to shout. "Something interesting is happening!"

Benjamin has learned nothing of any great note on his backward journey through life, and remains placidly incurious about his condition; even the imminent tragic departure from Daisy does not elicit so much as a tear. In the intellectual stakes, this guy makes Forrest Gump look like Karl Popper.

The technical trickery used to make characters look older than they are is certainly impressive, particularly for the ancient Daisy on her hospital deathbed. But the way it makes the actors look younger, in their early twenties, is very strange. Both Cate and Brad's skin is digitally tweaked to look eerily smooth all over the face and up to the eyes, like state-of-the-art remedial work on a burns victim. The sheer, undifferentiated flesh has a metallic sheen; it looks as if it would ring if you tapped it. They don't look like youngsters as such, more like robot-replicants from *Westworld*. The only entirely real-looking face is that of Julia Ormond, playing Daisy's grown-up daughter, reading aloud to her dying mother from Benjamin's preposterous autobiographical journal – erm, when is he supposed to have written this? – a supercilious device that triggers the film's flashback structure.

For all the apparent mirror-world strangeness, this is just another syrupy-sentimental nostalgiafest from the south, for which Hollywood has always found a lucrative market among older audiences, like

the novels of Fannie Flagg. In fact, the movie it reminded me of was Nick Cassavetes's *The Notebook*, a treacly tale starring buttery oldsters James Garner and Gena Rowlands. David Fincher, the director of *Se7en*, *Fight Club* and *Zodiac* brings nothing dark to this material, and nothing really distinctive at all, although he couldn't be a safer pair of hands. But this film's combination of soupy love-story and undemanding tricksiness appears to have hit the spot, with thirteen Oscar nominations. Maybe it's a wish-fulfilment fantasy for thousands of Hollywood execs, who dream that as the years go by, ever increasing cash and power is making them more and more youthfully handsome.

FILTH AND WISDOM

14/2/08

★ ☆ ☆ ☆ ☆

Well, it had to happen. Madonna has been a terrible actor in many, many films and now – fiercely aspirational as ever – she has graduated to being a terrible director. She has made a movie so incredibly bad that Berlin festivalgoers were staggering around yesterday in a state of clinical shock, deathly pale and mewing like maltreated kittens. She is also the producer and co-author of the script. If she'd done the location catering as well, they'd have had a Jonestown situation on their hands.

Madonna has made a dumb and tacky comedy-drama about three people sharing a flat in a quaintly conceived "London", and her conception of super-cool streetwise reality is so clueless it's as if Marie Antoinette had made a film about cake-munching peasants. One of her characters is a pill-popping pharmacy assistant; one's a wannabe ballerina forced through poverty to work at a lap-dancing club; and the third is a Ukrainian punk-poet who earns a few bob humiliating masochists while wearing ex-Soviet military garb in his ratty bedroom. This last is played by Eugene Hutz, who does occasionally raise a smile, but everything else is a mess.

Madonna's script is a nightmare of crass and fatuous stereotypes: south Asians, Jews, gays – no-one escapes her lack of insight or common sense. Despite living in Britain for many years, she has only the sketchiest notion of what the place is like. There is a scene in a posh restaurant where we encounter a well-to-do English author and journalist who supposedly lives in a "seven-floor manor house in Chelsea" and has won the "Pulitzer Prize" – which is impressive in many different ways. Her film reaches a Zen state of pure offensive awfulness when the lap-dancer's mentor comes round with a gigantic wad of £20 notes. This was her "tips from last night". Her "tips"? From "last night"?

Perhaps Madonna really does think that this is what lap-dancers make in a night. Or perhaps it's what she thinks they ought to make,

or what they'd make if she was playing a lap-dancer in her acting pomp, the 1980s era of *Desperately Seeking Susan*, whose picturesque vision of Bohemian life this film faintly and tragically recalls. Oh dear. How is it possible that the exhilaratingly talented star from that time has dwindled to such a dullard?

MY SISTER'S KEEPER

26/6/09

★ ☆ ☆ ☆ ☆

Connoisseurs of agony in the cinema routinely torment themselves with the thought that they will never see Jerry Lewis's legendary "lost" film *The Day the Clown Cried*, the controversial World War II drama starring Lewis as a rascally clown who is sent to a Nazi concentration camp, but finds personal redemption there, doing gurning pratfalls to sweeten the poor children's final moments. Lewis withdrew the still incomplete film at the last moment and refuses to show it.

Instead, we will all have to make do with Nick Cassavetes's child-cancer-courage weepie *My Sister's Keeper*, based on the heart-tugging bestseller by Jodi Picoult, a book for which no complimentary bar of Galaxy chocolate will ever be big enough. Cameron Diaz stars as the life-affirmingly brave mom, whose teen daughter Kate has leukaemia, and whose younger daughter Anna, played by super-moppet Abigail Breslin, is now in existential revolt against the realisation that she was brought into the world specifically to be a donor for her sister.

With a fistful of savings, she has feistily engaged a roguish heart-of-gold lawyer, played by Alec Baldwin, to free herself of any more painful and possibly futile operations. Cameron has incidentally given up her own job as a hotshot lawyer to look after her sick child, but their hunky firefighter dad, played by stubbly Jason Patric, is evidently pulling down enough bucks to keep them all in a gorgeously spiffy house.

For those of you keen to undergo a 109-minute soft-focus Calvary of empathy, aspirational lifestyle choices and upscale family values with a tastefully rendered terminal illness, this is a total must. Some films have certificates like U or PG; this one should be OMG with a row of teardrops and frowny-face emoticons.

I say soft focus, incidentally, but this might not be a directorial decision. The camera lens could spontaneously have formed a welling layer of tears. Because miracles do happen. In one scene,

goaded by her chemo-afflicted daughter's miserable avowals that she looks ugly with no hair, Cameron Diaz bounces defiantly into the bathroom and shaves off her own blonde crowning glory, and there's a montage showing the entire family, bald mom and all, showing some joyous solidarity on a day out to the funfair. But in the next scene, Cameron's hair has entirely grown back. There's no nonsense about one scene showing it stubbly, then another showing it short. It just grows back exactly as it was. For heaven's sake, Mr Cassavetes: show us where Cameron's hair-related miracle took place, and we will build a shrine and lay on Ryanair flights.

The film is accessorised with some very lugubrious flashbacks to sketch in the family's backstory in all its complexity. Concerned grown-ups will ask Anna things like: "Did you and your sister ever fight?", and Anna will go into what looks like a stunned trance, evidently beginning to remember one such argument, while the camera does an ultra-slow zoom into her face, so slow you can go out for nachos, return to your seat, and the flashback still won't have started. The girls have a troubled brother, incidentally, called Jesse, and at one stage Kate's syrupy voiceover tells us: "While everyone was worried about my blood count, I didn't even notice that Jesse was dyslexic … "

Maybe she just thought he was stupid. They do have short attention spans in that family; Kate gets a hottie cancer-patient boyfriend whose narrative purpose is to introduce her to some sensitive love-making – falling short of the act itself – after which his departure from this life is briskly forgotten about – no funeral scene, no nothing.

Of course, Anna's sensational legal battle would seem to indicate an extremely painful rift between her and her sister. Surely, no matter how much Kate sympathises with her hurt at being just a spare-organ breeder, this would cause real sibling friction? But no. The two girls seem to maintain a glassy-eyed seraphic adoration of each other. The ultimate reason for this is revealed in a twist which is also an outrageous cop-out, a get-out clause cancelling the high concept that suckered us into the story in the first place, and which was the only risky or interesting thing about it.

In any case, there could be another reason why Abigail Breslin is reluctant to be an organ donor: her bad acting may be intended to tip

us off to the fact that she is a Terminator-style robot, an Emotionator. Dig too deep into the realistic-looking tissue, and you will find diodes and steel, and that wise head on young shoulders will turn into a Chucky-style mask of rage. As it is, this is a film that looks like a feature-length infomercial for some prescription medication which should, in a sane world, be taken off the market.

FAME

24/9/09

★ ☆ ☆ ☆ ☆

The awful truth about no one from the *Fame* movie or TV show going on to become famous may not yet have dawned on the cast of this new and bizarrely pointless remake. Because there they all are, a whole new generation of volatile, yearning unknowns, now with mobile phones instead of leg-warmers, but basically it's the same deal. And they are all eagerly signing on for the curse of *Fame*, like a happy band of cult hippies following Jim Jones into the jungle.

What is going on? The publicity material for this film suggests that *Fame*, a fictional account of wannabes' hopes and dreams throughout a four-year course at New York's High School of Performing Arts, is a back-to-basics call to something higher than our modern infatuation with "celebrity". With its stern demand for training and technique, *Fame* is supposedly about becoming well-known based on real talent and achievement – not just crass reality TV and having your own Facebook page. But fame was always the point. All that dancing in the streets and leotard-wearing was a means to an end, and so going on *Big Brother* and blogging and tweeting was simply the next evolutionary step. And the original 1980 movie by Alan Parker, with its spectacle of vulnerable youngsters being patronised or yelled at by the supercilious meanies and bores on the teaching staff, laid the groundwork for *American Idol* and *Strictly Come Dancing*. The difference is that all these genres have more humour and zip than the ponderous and self-congratulatory *Fame*.

This remake sticks pretty closely to the structure of the first film: four acts corresponding to four academic years – freshman, sophomore, junior, senior. There is the obligatory opening montage of young students all in a whirl of energy with their various callings: ballet, theatre, music – though all those classical types scraping away at their violins are there to add cultural ballast. They are of zero interest once we get stuck into the main action, which is about sexy dancers, actors and pop musicians. The new *Fame* revives the mass bop scene in which students spontaneously start improvising,

dancing and jamming in the middle of the day through sheer life-affirming vitality and, just as before, this supremely embarrassing sequence is as unwatchable as the most explicitly violent horror film.

At some stage, of course, these young idealists must encounter brutal showbiz reality outside school. So the question that must be in all our minds is – how are they going to do the "Irene Cara Taking Her Top Off" scene?

In the 1980 original, Cara, playing Coco, a lovely yet naive young student, is tricked into showing up for what she thinks is a legitimate audition. This turns out to be some slimeball with a video camera in his scuzzy apartment, and Coco is bullied into undressing and starts crying while reading out the porny script she's been given. It was a genuinely nasty, sleazy moment – perhaps nastier than the director ever quite intended – reminding us that *Fame* was a product of the gritty 1970s, and that Alan Parker had just made the gamey prison drama *Midnight Express*, often double-billed in those days with *Taxi Driver*.

This scene is now displaced into two different versions. Jenny (Kay Panabaker) is an innocent, uptight acting student who goes into a star's trailer for a "reading" in front of the video camera: he tries it on, but is rejected without difficulty or loss of clothing. Neil (Paul Iacono) is a would-be film-maker, rooked into handing over his dad's savings to a bogus producer who then skips town. But aside from admitting ruefully that he will be paying his dad off until he is thirty, Neil suffers no real emotional pain. The "Irene Cara Topless" scene has been decaffeinated and cleaned up for the High School Musical generation.

The next question about the new *Fame* is: how gay is it? The Wayans brothers' recent spoof, *Dance Flick*, offered a crudely knowing send-up of the *Fame* ensemble dance scene with the word "Gay!" replacing "Fame!" in the lyrics. All these boys away from the family nest, so tremulous, so uncertain, so thrilled to the very core of their being by showtunes: are they just not 'fessing up to something? Well, this new *Fame* is reticent on the subject. Straight relationships are the only ones permitted; gay sexuality is not mentioned, and – a little insultingly – the one character who really does look properly gay is a quasi-suicidal loser who flunks and has to go back to Iowa.

But is *Fame* "gay" after all? Isn't it, in fact, straight? Tragic straight, thin-skinned straight, a world of straights in every sense, earnestly

and conventionally striving to achieve bohemian euphoria via some classroom qualification? Infuriatingly, the teachers are a condescending bunch who seem always to be giving the wrong advice. A rage-filled young African-American guy is patronisingly told to calm down because there is no anger in the theatre, just actors playing angry roles. Jenny's subdued rendition of "Someone To Watch Over Me" seemed to me more interesting in its melancholy, unassuming simplicity than the show-offy Vegas-lounge-vibrato version her teacher wanted to hear. On this basis, obscurity beckons for one and all.

LOVE HAPPENS

98/10/09

★ ☆ ☆ ☆ ☆

C.S. Lewis famously wrote books called *The Problem of Pain* and *A Grief Observed*, attempting to reconcile the supposed existence of a loving Creator with the reality of human suffering. Having sat through this horrifically mawkish, joyless film I am now going to retreat to my monastic cell and write *The Problem of Jennifer Aniston Romcoms* and *A Jennifer Aniston Romcom Observed*, in which I shall tackle the evident incompatibility of romcoms starring Jennifer Aniston with any notion that life is worth living.

How can we go on like this? How can we, as a species, tolerate Jennifer Aniston with her blurry expression of emotional bravery? Here she plays a florist – but of course – with a quirky confidante-sidekick – naturally – who falls in love with a smugly successful self-help guru played by Aaron Eckhart, and the stubborn flame of her compassionate honesty helps him confront his own issues. Obviously.

The film ends with Eckhart stunning the crowd by making a genuinely brave, tearful speech at one of his silly seminars, and we get the clichéd moment when someone stands up and starts clapping loudly and slowly in the awed silence – then someone else, and someone else, and pretty soon they're all at it.

I am planning to go round the country's cinemas where *Love Happens* is playing with a group of like-minded souls, repeating this scene in the auditorium. Instead of handclaps, however, it will be sharp shrieks of agony, getting louder and more numerous until the whole cinema erupts in existential despair. Who's with me?

THE TWILIGHT SAGA: NEW MOON

19/11/09

★ ★ ☆ ☆ ☆

In the first *Twilight* film, lovely, young Bella Swan couldn't have sex with her vampire beau in case he got carried away and bit her. In this new one, on the other hand, Bella can't get it on with her werewolf suitor in case he gets carried away and claws the bejeepers out of her. In the next in the series, Bella won't have sex with the Mummy in case he gets carried away and strangles her with a bit of manky old bandage, and in the film after that, she mustn't shag Frankenstein's monster in case he gets carried away and rams his electrified neck-bolts into her ears. There will be no end to the parade of neo-horror archetypes who are not getting anywhere near Bella's silver ring of abstinence.

After a terrifically enjoyable start, the *Twilight* series is settling into a somewhat predictable groove, with its tragi-romantic motif of not having sex becoming a bit gimmicky and worn. At the beginning of this film, directed by Chris Weitz, Bella (Kristen Stewart) turns eighteen and starts worrying about becoming the older woman to her eternally youthful undead boyfriend Edward Cullen, played by Robert Pattinson. So, with his heart audibly breaking, Edward finally bites the bullet – as it were – and leaves her for her own good, settling apparently in Rio de Janeiro, that city being glimpsed subliminally just once. Poor, post-breakup Bella mopes and whinges as the months drag past, taking refuge in dangerous not-sex activities such as motorbike riding.

It is at this point that she restarts her relationship with her childhood friend, Jacob Black, played by Taylor Lautner, a buff, shirtless guy who is a member of the Native American Quileute people. They start hanging out, and it's clear that Jacob has feelings for her – but also that he has something to hide: something to do with the crowd of other buff, shirtless guys to be seen in the local forest. It really is incredible how often these boys are to be glimpsed shirtless, and Jacob has stomach muscles so developed he looks like he could pick up a pencil using the crevice between his abs. And

Jacob has a lupine secret, putting him in a very similar emotional dilemma to the absent Edward. Bella is probably thinking to herself: when, oh when, am I going to meet a boy who doesn't have tragic loyalties to a family group of mythical beasts?

For those *Twilight* fans who secretly thought Edward was all very well but a little too wimpy, Jacob is just the job: a real macho gym bunny. But Edward is always Bella's number one guy, and ultimately he must return to claim her heart. Together, Bella and Edward must confront the malign Vampire king Aro, played by Michael Sheen with red eyes and the campest hair extensions this side of the Carpathians.

There are some entertaining things about *New Moon*: Stewart is developing as an actor in a way Pattinson isn't, and there are droll scenes in which some characters go and see films. Bella's friend has a tongue-in-cheek complaint about the metaphorical content of zombie films, and there's an awful action movie called *Face Punch* (tagline: *Let's Do This*). But the franchise is looking a little anaemic.

OLD DOGS

18/3/10

★ ☆ ☆ ☆ ☆

This is a Disney family comedy starring Robin Williams and John Travolta, and … I know what you're thinking. Stop. Stop now. Stop before the quality of all our lives is permanently cheapened. In the name of merciful Christ and all the saints and martyrs, stop writing now about a Disney family comedy starring Williams and Travolta as middle-aged hombre bachelors who run a sports marketing firm and have to look after two adorable little kids. Please, not a keystroke more on this abysmal subject. Stop now – the way you might stop talking about the recent violent murder of a much-loved clergyman, whose tearful widow has just walked into the room. But as Samuel Beckett might have put it: "You must go on. I can't go on. You must go on. I'll go on. Hold it – a Disney family comedy starring Williams and Travolta? I seriously don't think I can go on."

To continue. Robin Williams and John Travolta play a couple of absolutely great guys who have to look after some adorable little kids. Early on in the film, Robin Williams's character goes to a tanning salon and gets too much tan, right? And he comes out with his face completely brown! Then some uproarious ethnic comedy kicks off, including a south Asian-looking person talking to him in their own language, because Robin Williams looks like one of them! Of course! For long, long hours after the film, I wandered the streets of London's West End, numbed by this film and by this LOL moment in particular, pondering the question: was it as well to get the unfunny racial moment out of the way early on, thus cauterising your senses for the regular, common-or-garden unfunny stuff? Or was it like ripping off a Band-Aid all at once, only to have someone start jabbing with a fork at the exposed region?

Anyway, Robin Williams and John Travolta have to look after these two sweet children. They are in fact Robin Williams's children, from an ill-starred marriage for which he is still pining. Travolta's affections, on the other hand, are entirely engaged with his pet dog, a canine character brought into the plot to assure us of John's

essential likeability. Tom Hanks's wife, Rita Wilson, is also in the film, in a baffling small role, doing a wacky cross-eyed funny face for reasons that escaped me at the time and escape me now in retrospect. Williams and Travolta, and we the audience, are finally invited to consider the following question: which is better, a soulless life of work and striving for money, or a joyous embrace of family and kids in all their gorgeous life-affirming messiness? There is actually a third option, which I considered for a good long while after seeing this film: to walk armed into Nando's, and spray the room with bullets before turning the weapon on oneself. It's a dilemma.

THE TWILIGHT SAGA: ECLIPSE

8/7/10

★ ☆ ☆ ☆ ☆

And so the parable of the unpopped cherry goes on … and on. The epic of the unbroken duck continues. As the final whistle blows on the third *Eclipse* movie, after more than two hours, with still nothing on the scoreboard, virginal high-school teen Bella Swan is starting to make Doris Day look like the nympho from hell.

Bella (Kristen Stewart) is still deeply in love with dreamboat vampire Edward Cullen, played by Robert Pattinson, who has unattractive sideburns, beige contact lenses and increasingly quiffy hair, like some sort of diffident, undead Elvis. But she, of course, is also being courted by a werewolf hunk called Jacob, played by Taylor Lautner, a reckless, shirtless individual who has fallen for her. Both Edward and Jacob are gallant enough to realise that pressing their physical attentions on Bella means her having to relinquish human identity and commit. And there is no question of any noisome compromise, such as that by which ex-President Clinton technically avoided "relations" with Monica Lewinsky. So far, Bella has been reluctant to take the momentous step, but she certainly likes Edward more than Jacob.

As the film starts, the idea seems to be that she will make Edward wait only as far as her high-school graduation. But then things change. Edward proposes marriage and so the moment is deferred. Now he will wait until they are actually Mr and Mrs Cullen. Who knows if there won't be many other excuses to put off the evil hour? Perhaps she will make Edward wait until she's left college, until she's finished grad school, until she's had her bar exam, or until he's had his first prostate exam. Or perhaps she will relent and give him a portion at some stage in the fourth and fifth *Twilight* movies: *Breaking Dawn Part One* (expected 2011) and *Breaking Dawn Part Two* (expected 2012). I only hope that these people's expectation of their first experience has not become unrealistically high. In the meantime, Bella's L-plates seem to be pretty much welded to her

moped – and I moreover wonder if there isn't another undercurrent of emotion flowing here.

The latest crisis in Bella's emotional and non-sexual life happens to coincide with a terrible situation in Seattle. A grotesque serial killer is reportedly laying waste to the local population: news that Bella's divorced cop dad monitors by idly reading the headlines in the local paper, while perhaps sipping a frosty one from the fridge. We see one empty can on the coffee table, denoting that he is lonely, but not excessively so.

But we know that the culprit is not homo sapiens, as such. A crew of "newborn" vampires is running wild, under the influence of the red-haired Victoria (now played by Bryce Dallas Howard), who is out for revenge after Edward killed her lover, James, in the previous movie. This awful new bunch of vampires is thirsting to destroy Bella. So the vampires and the werewolves, Team Edward and Team Jacob, have to team up to see off the intruders and protect Bella.

There is an arresting scene in which, having used Bella's scent to lure the newborns to a certain strategically advantageous part of the forest for a showdown, Jacob has to carry her around the woods in his hunky arms to mask her musk – I think – and Bella snuggles coyly in his stern embrace. This looks like yet another excuse for non-sex contact.

It has become a truism to notice that the romance of vampires and other creatures in the *Twilight* books and movies is a metaphor for abstinence and denial. Over and over again, Edward and Jacob square up; over and over again, they find themselves smouldering at each other, at close quarters. Somehow, they find themselves camping out on the remote mountain, all three of them sharing a tent, and while Bella demurely gets some sleep, these two alpha males yet again face off, taunting each other. "I really get under that ice-cold skin of yours, don't I?" breathes Jacob. "If we weren't natural enemies, I might actually like you," murmurs Edward.

Oh my lordy, you could cut the tension with a knife. Later, Jacob discovers that Edward is engaged to be married to Bella, and he is really upset, and the audience is entitled to wonder if his state of mind isn't cloudier than it at first appears. If E. Annie Proulx and

Larry McMurtry were writing this, Jacob might have to go away and get some unsatisfying cowpoke job after he came down off the mountain, while Edward works in Bella's father's farm machinery business. As it is, they struggle on in the roles society has laid down for them. This vampire tale was a refreshing novelty in the first film: with the fourth and fifth now on the way, it could be time to sharpen the wooden stake.

THE REBOUND

22/7/10

★ ☆ ☆ ☆ ☆

The "rebound" is what your lifeless, smashed body may well do, bouncing fifteen inches off the asphalt, having thrown yourself from the top of the nearest tall building in despair at having watched this truly horrendous romcom. Sleek Catherine Zeta-Jones – her eyes as dead as an alligator's – plays Sandy, a super-attractive older mom from the 'burbs who moves to Manhattan with the kids after divorcing her cheating scumbag of a husband. She finds herself drawn to Aram, played by Justin Bartha (from *The Hangover*), a mixed-up young guy who has had his heart broken. Aram agrees to babysit Sandy's kids while she starts her new job, working at a cable sports channel. Needless to say, Aram's gentle charming nature is a breath of fresh air after the horrible conceited middle-aged bores that Sandy keeps getting fixed up with, and she and Aram embark on a May-to-September romance, each of whose plot transitions feels like getting a tooth wrenched out without anaesthetic. On entering the cinema and seeing this movie on offer, my advice is to rebound in the opposite direction.

THE LAST AIRBENDER

12/8/10

★ ☆ ☆ ☆ ☆

The English language can be a treacherous and slippery thing, with some entirely innocuous words changing their character as they cross the Atlantic. This has sadly been the case with the new movie from M. Night Shyamalan, which has just arrived here from Hollywood, a deeply serious and long fantasy epic – the first in a number of parts, in fact – based on an animated TV series. For a British audience, the film's language is inadvertently flavoured by associations and nuances that are vulgar, abusive, and very, very unfortunate indeed.

The story is set in an imaginary era in which the world is divided into four nations based on the four ancient elements: earth, air, fire and water. The Fire nation is warring with the others for total domination. Yet each nation has a certain type of people, a favoured race different from the rest, people with the Jedi-like power to control or "bend" the elements. Firebenders. Earthbenders. Waterbenders. And Airbenders. At the cinema showing I attended, the British crowd reacted derisively at key dialogue moments. One wise old lady says solemnly to a young man: "I could tell at once that you were a bender, and that you would realise your destiny." One character tells another wonderingly: "There are some really powerful benders in the Northern Water Zone." Another whispers tensely: "We want to minimise their bender sources." A key figure is taken away by brutal soldiers, one of whom shouts cruelly: "It's... a bender."

And so on, for almost two hours. Each time, the response from the auditorium was deafeningly immature, and brought many of us to a state of nervous collapse. By the end of the film, I felt like a bit-part player in some feature-length adaptation of a *Viz* comic – *Springtime for Finbarr Saunders*, perhaps. This scene will inevitably be repeated in every cinema in the land showing *The Last Airbender*. For Friday and Saturday night showings, the police may have to be called.

But at least this linguistic lurch provided some interest in a film that is mind-bendingly boring, with an utter lack of narrative drive, an absence of jeopardy or anything at all being at stake, or of interest, in any way whatever. After the first five seconds, it seems as if you have been watching it for around two-and-a-half hours, and that this time has passed in four-and-a-half days. And even the glassy-eyed idealism has already been compromised: the film has been widely condemned for recasting the good characters as white, with south Asians only allowed to play the villains. It features the British star Dev Patel, from *Slumdog Millionaire*, a bright young player who deserves better than this.

It is incredible how awful the once feted director M. Night Shyamalan has become and how he is still allowed to make big-budget films. I didn't think it was possible for him to make something worse than his *Lady in the Water* or *The Happening*. But he has managed it.

EAT PRAY LOVE

23/9/10

★ ☆ ☆ ☆ ☆

Sit, watch, groan. Yawn, fidget, stretch. Eat Snickers, pray for end of dire film about Julia Roberts's emotional growth, love the fact it can't last for ever. Wince, daydream, frown. Resent script, resent acting, resent dinky tripartite structure. Grit teeth, clench fists, focus on plot. Troubled traveller Julia finds fulfilment through exotic foreign cuisine, exotic foreign religion, sex with exotic foreign Javier Bardem. Film patronises Italians, Indians, Indonesians. Julia finds spirituality, rejects rat race, gives Balinese therapist sixteen grand to buy house. Balinese therapist is grateful, thankful, humble. Sigh, blink, sniff. Check watch, groan, slump.

Film continues, persists, drags on. Wonder about Julia Roberts's hair, wonder about Julia Roberts's teeth, wonder about permanence of Julia Roberts's reported conversion to Hinduism. Click light-pen on, click light-pen off, click light-pen on. Eat crisps noisily, pray for more crisps, love crisps. Munch, munch, munch. Munch, munch, suddenly stop munching when fellow critic hisses "Sshhh!" Eat crisps by sucking them, pray that this will be quiet, love the salty tang. This, incidentally, makes me plump, heavy, fat. Yet Julia's life-affirming pasta somehow makes her slim, slender, svelte. She is emoting, sobbing, empathising. She has encounters, meetings, learning-experiences. Meets wise old Texan, sweet Indian girl, dynamic Italian-speaking Swede who thinks "Vaffanculo" means "screw you".

Roberts eats up the oxygen, preys on credulous cinemagoers, loves what she sees in the mirror. Julia shags Billy Crudup, James Franco, Javier Bardem. Ex-husband, rebound lover, true romance. Crudup is shallow'n'callow, Franco is goofy'n'flaky, Bardem is hunky'n'saintly. We hate Crudup, like Franco, love Bardem. Divorced Javier is gorgeous, sexy, emotionally giving. About his ex-wife we are indifferent, incurious, uninterested. She is absent, off the scene, unnamed. That's how Julia likes it, needs it, prefers it.

Movie passes two-hour mark, unfinished, not over yet. Whimper, moan, grimace. Wriggle, writhe, squirm. Seethe, growl, rage. Eat own

fist, pray for death, love the rushing sense of imminent darkness. Scream, topple forward, have to be carried out of cinema. Reach life crisis, form resolution, ask editor for paid year's leave to go travelling. Editor stands up, shakes head, silently mouths the word: "No". Nod, turn, return to work. Personal growth, spiritual journeys, emotional enrichment? Not as easy as one–two–three.

NEW YEAR'S EVE

8/12/11

★ ☆ ☆ ☆ ☆

Like alcoholics, critics can reach rock bottom. Some moment of horror or revulsion or wretchedness, some terrible epiphany of disgust, whose only saving grace is a later glimmer of hope that things can only improve after that. I had that moment last year, staggering out of the sucrose all-star rom-com *Valentine's Day* by Pretty Woman director Garry Marshall, after which my colleagues had to stage a desperate intervention on the pavement outside the cinema, snatching the razor away from my throat. But, sadly, things can always get worse, and now Marshall has put together another of his sinister feelgood-event ensemblers, this time based around New Year's Eve in New York.

Structured weirdly like an old-fashioned disaster movie, this also features an all-star cast phoning in dead-eyed performances as their characters' disparate lives criss-cross round a clunky premise building to an uninteresting climax: a towering inferno of awfulness. Hilary Swank plays an adorably nervous city executive whose job is to make the famous Times Square ball drop at the stroke of midnight on New Year's Eve; Michelle Pfeiffer plays a cranky lady with a bucket list of life-affirming things she wants to do that night; Zac Efron is a feisty young dude who helps her; Ashton Kutcher is the quasi-Scrooge who hates New Year; Katherine Heigl is a super-hot chef with a broken heart; Jon Bon Jovi is a rock star allegedly popular with young people (here Mr Marshall is showing his age) and, most depressingly of all there is Robert de Niro, playing a sick old guy in hospital who wants to see the ball drop one more time. I would like to see it drop on Garry Marshall's head.

In *Valentine's Day*, the plot was sprinkled with cute mini-reveals at the end, showing how the characters connected. There was even a daring gay twist, and audiences could be forgiven for wondering which male characters were going to hook up this time around. It would be entirely plausible for any of them, except perhaps De Niro. In the previous movie, Julia Roberts played a soldier in the

US army, and, with breath-taking cynicism, Marshall actually repeats this military idea just to siphon off a bit more audience support for the troops.

Among the other aspects of this unfunny and heartless Hogmanay Horror is Jessica Biel, who plays a heavily pregnant woman planning to get the hospital's rumoured cash prize for the first mom to pop after midnight. This role exactly confirms the potential for comedy she has showed in her previous work, including *Valentine's Day*. Most embarrassing, though, has to be Heigl, so likeable in *Knocked Up*, now looking like some waxy-faced escapee from Madame Tussauds.

Perhaps Marshall will now develop the franchise and bring it over to the UK. how about an all-star event on the opening night of the 2012 London Olympics, getting stuck down in the Underground, or in Harrods, or in a traffic jam on the M25, while Boris Johnson woodenly waves the Union flag in the stadium? It can't be worse than this.

W.E.

19/1/12

★ ☆ ☆ ☆ ☆

Having already applied her insights to Eva Perón as a performer, Madonna now lavishes the full force of her empathy and historical sense on another strong-yet-vulnerable power behind the throne – in this, her second movie as director and co-writer. Her heroine is Wallis Simpson, the woman who, as storm clouds of war gathered, fell in love with the British king and helped cause his abdication. Edward VIII was supposed to have given up everything for her. But what, Madonna's film asks poignantly, did she give up for him? A feisty divorced American, married to a prominent Brit, vilified, misunderstood … oh dear.

Andrea Riseborough plays Wallis in the cocktail-quaffing 1930s, and, in a parallel world, Abbie Cornish plays Wally, a lonely, beautiful, maritally abused but reassuringly wealthy woman in Manhattan in 1998, who finds herself obsessed with Wallis's story and haunted by the gutsy Mrs Simpson herself. The multi-tier concept is pinched from Michael Cunningham's *The Hours*.

This is one long humourless and necrophiliac swoon at the Windsors' supposed tragi-romantic glamour, in which we get to feel their pain and appreciate their emotional victimhood. The Windsors' meeting with Hitler in Berchtesgaden in 1937 is not dramatised, but modern-day Wally waves away this issue, explaining that Wallis and David were just naive and desperate for peace. That's a respectable point of view. But it's uncomfortable to see in the list of style gurus and fashion mavens thanked in the closing credits, a certain Mr John Galliano. Let's hope he wasn't helping with the script.

The fantastically wooden drama moves in a deafening series of clunks; set pieces are agonisingly orchestrated, and Madonna's historical perspective is eccentric. On the occasion of national grief at the death of a monarch in 1936, a faux newsreel announcer intones over flickering black-and-white images: "King George the Third has died…" Well, he had a good innings.

The next step now is surely for Madonna to make a deeply sympathetic film about a British woman haunted by the ghost of Diana Mitford, whose second marriage and political views were so misunderstood. Or maybe a film about a hip young Kazakh model, haunted by the lonely wife of Attila the Hun, whose political views were irrelevant to compared to her sheer stylishness, her gowns and her mean way with a cocktail shaker, far more elegant than anyone else in the boring Hunnic Empire in the fifth century AD.

EXTREMELY LOUD & INCREDIBLY CLOSE

16/2/12

★ ☆ ☆ ☆ ☆

A meaty whiff of phoney-baloney rises from this extremely contrived and incredibly preposterous movie, a mawkish, precious and bizarre fantasy of emotional pain. It is adapted by Eric Roth from the bestselling novel by Jonathan Safran Foer, about a hyper-intelligent, hyperactive eleven-year-old boy who is on a mission to discover a secret about his beloved dad, killed in the 9/11 terrorist attacks.

Thomas Horn plays Oskar, who speaks throughout in the teeny-tiny quiet little voice pioneered by Haley Joel Osment in *The Sixth Sense*. Tom Hanks is the bespectacled, saintly father who cheerfully encouraged his son's precocious interests in science, nature and exploring; his uncomplicated personality is witnessed in flashback. Sandra Bullock plays the quietly devastated mom, keeping it together.

Oskar is haunted by the desperate phone messages his father left on the answering machine in their New York apartment as he was stuck up there in the World Trade Centre on that terrible day; he converts his anguish into a fanatical obsession with a mysterious key in an envelope with the surname "Black" that he discovers in his late father's closet. He goes on a colossally strenuous quest to track down everyone in the New York phone book with the surname Black, to ask them if they have a lock that this key fits, to write down their responses, and to uncover some final crucial secret that will somehow resolve his pain. Oskar takes along with him a mysterious old mute guy played by Max von Sydow, a tenant of his grandmother's – a man whose backstory, manners and character are as tiresomely unconvincing as everything else in the film. The poor child's task is exhausting and apparently futile as he goes around asking questions, taking photos and writing stuff down but, of course, his journey generates a redemptive vernacular archive of New Yorkers' experiences. ("So many of them had lost somebody or something, mom!")

Oskar's elaborately dysfunctional mannerisms are a way of allowing the drama to tackle, head-on, the day-to-day pain of 9/11

bereavement, with a quasi-adult observational acuity and a child's energy and tactlessness, but avoiding the danger of being capsized by all the emotional and intellectual implications. But the film declines to confirm whether Oskar specifically suffers from autism or Asperger's; it's revealed that "tests" were carried out on him, but that they were not "definitive".

You could well be struck by the resemblances to Martin Scorsese's *Hugo*, also about a key and a father figure. I found myself thinking how much it resembled the humorous and consciously absurd vision of Michel Gondry, only quite without the humour and the conscious absurdity. Gondry often evokes the same elaborate, homemade worlds of lonely boys, but the physical impossibility, or at any rate implausibility, of what they are making is an important comic effect: tiny granules of audience incredulity are part of the recipe. Here, we are not supposed to be sceptically amused by Oskar's handiwork and quixotic determination, but very clearly awestruck and humbled and emotionally exalted. Oskar, on his weekends, and presumably with chores and homework to take care of, has somehow had the time and energy to journey across the five boroughs of New York and talk to all these people, and create all these little maps and models.

The poor child is desperate to make sense of this menacing, bewildering world. At the end of her tether, his mother yells at him: "Not everything makes sense! I don't know why a man flew a plane into a building!" Now, she may well already have sat Oskar down and talked to him seriously about the reasons for 9/11. He is clearly smart enough to understand. Or she may consider the 9/11 attacks meaningless, and there is a respectable argument that they were rooted far more in malign psychological anarchy and pure hate than in activism for any clear cause. But the unhappy effect is further to surround 9/11 with a wilfully obtuse and depoliticised adult-infantilism and self-absorption. The film offers a historical perspective with a reference to the destruction of Dresden – where Oskar's grandparents are supposed to be from – but this history is evoked in just the same shallow and incurious way.

Extremely Loud & Incredibly Close looks on screen not unlike those sugary family-drama bestsellers by Nicholas Sparks, like *Message in a Bottle* and *The Notebook*, stories that turn on glutinously

sentimental messages from a lost beloved who turns out to be not so lost after all.

There is just one moment here that resembles real life: when Oskar angrily turns on his mother and tells her he wishes it was her, and not his dad, who was killed on "the worst day". That moment of pain is hurriedly smoothed away, but it is a flash of something that an actual human being might say to another, and very different from anything else in this intensely self-conscious movie that contrives to make the human cost and human meaning of 9/11 distant and faint.

THE BEST EXOTIC MARIGOLD HOTEL

23/2/12

★ ★ ☆ ☆ ☆

The cast are spry, but this bittersweet comedy about English
retirees in India needs a Stannah chairlift to get it up to any level
of watchability, and it is not exactly concerned to do away with
condescending stereotypes about old people, or Indian people of any
age. It's a film which looks as if it has been conceived to be shown
on a continuous loop in a Post Office queue.

The Best Exotic Marigold Hotel is based on a novel by Deborah
Moggach, directed with a sure hand by John Madden. The premise
is interesting: older people find themselves swept to South Asia by
globalised market forces. A chaotic and dilapidated hotel in Jaipur
run by a fast-talking but hopeless young entrepreneur called Sonny
(Dev Patel) offers itself to UK customers looking to "outsource"
their retirement-care needs. Maggie Smith plays against *Downton*
type as Muriel, a grumpy old cockney bigot; Judi Dench is Evelyn,
a melancholy widow; Bill Nighy and Penelope Wilton are a
quarrelsome couple; Celia Imrie and Ronald Pickup are roguish
older singletons with a twinkle in the eye and some lead in the
pencil, and Tom Wilkinson is Graham, the former High Court judge
nursing a secret.

Some of these people are nice, and some are nasty, and this naturally
affects the speed at which the teeming wonders of India will open
them up to real, life-affirming values. The realities of commerce
are notionally present in the form of a call centre, where Evelyn
gets a very unlikely job, advising the employees, including Sonny's
girlfriend, on the cultural niceties of talking to Brits and phone
manners in general. Her workload appears pretty civilised and gentle
and supervisory, which makes this a very laidback call centre.

There's no doubt that this is a very impressive cast doing their best
with genteel characters, though I would have liked to see Catherine
Tate's famously plain-speaking gran get in there and perk things up.
Nothing in this insipid story does anything like justice to the cast's
combined potential. Theoretically we are in Rajasthan, but really we

are off on a Saga holiday to *Tea-with-Mussolini* country, a world in which picturesque oldsters, out of their comfort zone, demonstrate vulnerability, vitality and pluck.

This is not to say that there isn't a scattering of nice moments. Nighy capering with joy and attempting to do a high five after fixing a tap is an entertaining spectacle, and Wilkinson brings a certain gravitas to the proceedings. But it is oddly like an Agatha Christie thriller with all the pasteboard characters, 2D backstories and foreign locale, but no murder.

JOHN CARTER

8/3/12

★ ☆ ☆ ☆ ☆

John Carter is one of those films that is so stultifying, so oppressive and so mysteriously and interminably long that I felt as if someone had dragged me into the kitchen of my local Greggs, and was baking my head into the centre of a colossal cube of white bread. As the film went on, the loaf around my skull grew to the size of a basketball, and then a coffee table, and then an Audi. The boring and badly acted sci-fi mashup continued inexorably, and the bready blandness pressed into my nostrils, eardrums, eye sockets and mouth. I wanted to cry for help, but in bread no one can hear you scream. Finally, I clawed the doughy, gooey, tasteless mass desperately away from my mouth and screeched: "Jesus, I'm watching a pointless film about an 1860s American civil war action hero on Mars, which the inhabitants apparently call Barsoom. I can't breathe."

It is based on a fantasy-romance serial by Edgar Rice Burroughs from 1912, *A Princess of Mars*, and is adapted and directed by the renowned Pixar–Disney talent Andrew Stanton, notable for having worked on animated gems such as *Wall-E*, *Toy Story*, *Monsters Inc* and *Up*. But this heavy, airless film doesn't have a fraction of the wit, fun and imagination of those films. Something in the wacky fusion of period drama and interplanetary travel multiplies the gravitational force a thousand times, dragging everything down.

Taylor Kitsch plays John Carter, a bone-weary civil war veteran and lone-wolf tough guy who we first see in Arizona, prospecting for gold in territory where there are Apaches. Carter fought for the Confederacy, and he is masculine, reticent and polite with the womenfolk, but a ferocious battler against those who would seek to circumscribe his liberty. And then, of all the crazy things, a golden amulet with runic occult symbols whooshes Carter off to Mars – that is, Barsoom.

Anyway, Carter finds that he can leap tall mountains with a single bound, but becomes captured by creatures called Tharks. They live in the shadow of two warring humanoid tribes, the evil and tyrannous

149

Zodangans who are oppressing the Heliumites, from Helium, with whose beautiful Princess Dejah Thoris (Lynn Collins) Carter is soon to fall in love.

Might it be that Barsoom has parallels with the Earthly strife that Carter has just lived through? "Let red man kill red man until only Tharks remain," says one, and it could be that Tharks are the Native Americans, and the Zodangans and the Heliumites are the civil war belligerents. But which is which? And is there any equivalent of America's slavery? No — unless you count the bondage suffered by proud Carter himself on that fierce red planet.

This film can't go ten minutes without one of this nation's character actors striding on saying something ridiculous in a silly outfit with a straight face. Dominic West, Ciarán Hinds, Mark Strong, James Purefoy – all lend the story some exotic Brit classiness. Strong plays one of the all-powerful Therns, a sinister priestly caste of intergalactic puppet-masters, seeking to control everything that goes on. Hinds is Tardos Mors, leader of the Heliumites and West is Sab Than, of the wicked and opportunist Zodangans. Their clothes look like a mix of Roman and Aztec, sometimes with a quasi-Greek singlet, usually associated with a high priest about to sacrifice a small animal. They are also pretty keen on guyliner.

The fact that some characters are from Helium might lead you to hope that they will release some balloon animals, or at least enliven the story by speaking in a squeaky-high voice. Many of the solemn lines could well have been improved by being delivered in a gaseous nasal falsetto: "If Helium falls, so does Barsoom!"; "Will you stay and fight – for Helium?"

But this struggle is merely the backdrop to the love story between Carter and Dejah Thoris, and Carter's ability to fly means he can impress the princess by catching her in mid-air like Superman with Lois Lane, or David Copperfield with Claudia Schiffer. But Dejah, with her seen-it-all-before smirk, is not a very sympathetic heroine, and Kitsch is stolid and dull. And as for the red planet, the answer to David Bowie's famous question is no. What a sadd'ning bore it is.

TOP CAT – THE MOVIE

31/5/12

★ ☆ ☆ ☆ ☆

Huge big band intro.

Top Cat! Do you remember it?
Top Cat! Well, they've dismembered it.
Cartoon cats who're breaking the law
— we loved it on TV, but the film version's poor.
Top Cat! The indisputable worst film of the year!
The animation's bad, and the script is just sad,
I think we've all been had by – *Top Cat*!

Middle instrumental section: a badly animated TC and the gang zoom unfunnily and jerkily around New York, trick Officer Dibble in various ways, go into a club, throw the doorman a dollar bill attached to a piece of string and pull it back etc, while audience wonder what happened to their much-loved childhood TV memories. Instrumental section ends.

Top Cat! It's ineffectual.
Top Cat! It's just incredible.
A decent film is what you desire,
but oh, my, God, this really is dire.
"Top" Cat? In what sense is the word "top" justified?
It's the bottom of the heap, and it frankly looks cheap,
the disaster of the year is – *Top Cat.*

GAMBIT

★ ☆ ☆ ☆ ☆

I have had paper cuts on the soft flesh between the thumb and forefinger less painful and more rewarding than this: an agonisingly pointless remake of the 1960s heist caper that starred Michael Caine and Shirley Maclaine. Michael Hoffman, the formidable film-maker responsible for *The Last Station*, directs. And Joel and Ethan Coen have written the script, to which the only rational response is to shout the single word: "Why?" Their interest in remaking the Ealing classic *The Ladykillers* in 2004 was a bit baffling but the result did at least have some kind of distinctive writerly flavour. This, however, just looks like the Coens have taken a holiday from trying their hardest and doing their best. Colin Firth plays Harry Deane, an "art curator" who supervises the fabulous collection belonging to a haughty and horrible businessman called Lionel Shahbandar (a mugging, grimacing Alan Rickman). Sick of being bullied by his boss, Harry decides to sting Shahbandar by getting his old buddy and talented pasticheur Wingate (Tom Courtenay) to fake a "lost" Monet believed to be somewhere in the US, stage a phoney discovery and then persuade Shahbandar to buy it. For this, he needs the help of a feisty blond Texas gal, played on *Westworld*-autopilot by Cameron Diaz. Firth reprises his lovably stuffy-uptight routine, although surely he could have told the Coens that no English person uses the word "math". Firth also makes some attempts at big Clouseauesque physical comedy, which are game enough but don't come off. The plotting is a damp squib, with laugh-free scenes and set pieces that don't go anywhere, although I have to acknowledge a good line about the Connaught Hotel and a gag about a room number at the Savoy. An awful lot of talent has been put to waste here.

HANSEL & GRETEL: WITCH HUNTERS

28/2/13

★ ☆ ☆ ☆ ☆

These are dark days. The Oscars are over, and now morale doesn't get any lower, as the very worst films are dumped ignominiously into cinemas like a vanload of cook-chill equine lasagnes delivered to schools and hospitals. This movie is a case in point. It's a film which is so demeaningly bad, so utterly without merit, that there is a kind of purity in its awfulness. There is a Zen mastery in producing a film which nullifies the concept of pleasure.

The idea is that Hansel and Gretel, having evaded a horrible fate as children in the witch's candy cottage in the woods, are now all grown up, and they have become super-cool kick-ass witch hunters – in a weirdly regressive sibling partnership – roaming the vaguely Germanic countryside armed with steampunky shotguns for the purposes of blasting witches with maximum violence. They are played with very little discernible talent by Jeremy Renner and Gemma Arterton. Peter Stormare phones in a bad-guy performance as some sort of a tyrannical mayor, and Famke Janssen plays an evil witch whose face is always turning into that of a hyper-real crone, a digital effect that succeeds in being uninteresting and depressing at the same time.

Watching this film, it is incredible to think that only recently I was raising niggling little objections to some minor things I wasn't sure about in *Argo* or *Beasts of the Southern Wild*. I feel like a billionaire who has become poor overnight, remembering when I was not entirely happy with a certain type of champagne. *Hansel & Gretel: Witch Hunters* is so uncompromisingly rubbish that it is impossible to watch it without your rage and despair doubling with every minute that passes. You'll feel like making all the Hollywood executives responsible stand up, like naughty schoolchildren, while you rage: "Which one of you greenlit this unspeakably bad film? We're not going home until someone owns up."

It manages to be nasty as well as dismal. There is a great deal of brutal violence, and people getting their noses broken and heads

153

squished. Women are punched and kicked all the time. People also have an unpleasant habit of registering their surprise at something by saying things like: "You've gotta be *shitting* me" in a charmless way I haven't experienced since the *Matrix* sequels.

How did *Hansel & Gretel: Witch Hunters* get to be this terrible? I suspect that it may possibly have started life as something rather different. Two of its executive producers are Will Ferrell and Adam McKay, and I wonder if the film was not originally conceived as some sort of high-concept comedy with the grown-up witch hunters perenially squabbling among themselves? Oddly, the movie does begin with a halfway-decent gag: bottles of milk have crude line drawings of missing children on them, like milk cartons in modern-day America. It seems to belong to a rather different film. (And I can't help remembering that Owen Wilson's character in *Zoolander* is called Hansel.) Perhaps the film got changed somewhere along the line, comprehensively rejigged as a humourless fantasy action adventure.

Well, I'm clutching at theoretical straws here. Maybe it was just always like this. Basically, *Hansel & Gretel* is a film that does not neglect any opportunity to be abysmal. Gemma Arterton – who can be very good in the right part – has to play Gretel with a fantastically irritating, phoney, swaggering American accent, to match Jeremy Renner's; baffling since everyone else has a sort of *mittel*-Europa-ish peasant voice, given that they live in somewhere called Augsburg. She is someone else who has this sadistic infatuation with violence, smirking at one of her victims that "it won't be an open casket".

The oddest thing about this movie is how it feels it has to give both leads some kind of romantic interest in order to nullify the creepy, incestuous impression. Hansel gets to go nude-bathing with a comely white witch, but all Gretel gets is a bizarre and platonic "beauty-and-the-beast" relationship with an ugly giant called Edward with a huge, misshapen head. Why? It doesn't develop the plot in any interesting way whatsoever.

Well, there is something salutary about a film as appalling as *Hansel & Gretel: Witch Hunters*: it demonstrates the gravitational pull of terribleness that the good films heroically resist and rise above. The Oscars now seem a very, very long time ago.

OLYMPUS HAS FALLEN

18/4/13

★ ★ ☆ ☆ ☆

For a moment, I misread the title and thought that one of America's best-loved character actors was in desperate trouble: Olympia Dukakis was lying at the bottom of her stairs, pressing frantically at her personal alarm, and the rapid-response operative at the end of the line had wrenched off his headset phone and reduced the call centre to stunned silence by intoning: "Olympia has fallen. And she can't get up."

It's actually worse than that. "Olympus" turns out to be US secret service code for the White House, and this is a no-stereotypes-barred, red-scare disaster movie of the sort Jerry "*Airplane!*" Zucker might write after a head injury. You could well wish that the title held out a crumb of hope by being *Olympus is Fallin'*. But it is in the past tense. The unthinkable worst has already happened.

The film is about an attack on the presidential home by a bunch of loathsome North Korean terrorists who circumvent security with worrying ease. But they prove to be vulnerable to counterattack from one guy, just one guy, armed with nothing but guns, guts, patriotism and a pair of cojones the size of Saturn's moons.

Antoine Fuqua directs, Aaron Eckhart plays the president, and Ashley Judd is his adoring wife. While the first family is being ferried away from Camp David one night in heavy snow, the president's stretch limo blows a tyre and teeters terrifyingly over a bridge with only the VIPs in the back keeping it from toppling over. What they needed was a young Michael Caine to show up and say he's got a great idea. Sadly, what they got was the president's secret service bodyguard and total best bud Mike Banning, played by Gerard Butler, who makes a fateful, split-second decision.

Trusty Mike bears the mental scars of that night, but some time later, and with the air of a man taking the lemon fate has handed him and grinding it into the juicer, he converts his pain into purpose: a determination to redouble his efforts to protect the chief and to redeem himself. And when the appalling North Koreans bust into

the White House – having indulged in a little sub-9/11 vandalism in that plane of theirs – Mike sees his chance.

Part of the weirdness of this film lies in the fact that the tense North Korean situation in the real world gives it no realism or satirical edge, or prophetic authority of any kind. Just as the stopped clock is correct twice a day, so the Hollywood screenwriter trying to find a non-Islamic bad guy might occasionally stumble into the middle of the nightly news. The president in this fiction is white, but Fuqua's film clearly alludes to the ethnicity of the actual president by casting Morgan Freeman as the House speaker and wise old owl who must make executive decisions while the C–in–C and his VP are tied up and held hostage. "You are the acting president of the United States," someone says solemnly to Freeman. "That's fine, because I have already played Nelson Mandela," is what Freeman should have replied in his quavery nasal baritone.

And when he reassuringly addresses America in an emergency TV broadcast, he really does sound like Leslie Nielsen at the controls of his airplane, making a calming announcement to the passengers. But all the time, feisty hero Banning is creeping along the wrecked corridors of the White House, in contact with the good guys via a secure-line mobile phone. He is a one-man rescue squad, occasionally pausing to torture the bejeepers out of some North Korean goons for valuable intel – like a cross between Bruce Willis in *Die Hard* and Kiefer Sutherland in *24*. But he also manages to bestow redemption on a certain acquaintance.

The real laughs, however, are in the Pentagon crisis room, where Robert Forster plays the grizzled, frowning general who strides in and demands of his aghast subordinates: "How bad is it?" Pretty bad, if they've wheeled out Forster to play the general.

As it happens, the film does not dwell on the pettifogging distinctions between North and South Korea, although it suggests that the South Korean state itself is a worrying Trojan horse for evildoers. The terrorists may not, in fact, have the authority of the powers-that-be in Pyongyang – a nice diplomatic touch. But their demands are plain enough: pull out your troops from the demilitarised zone in the Korean peninsula, or the prez gets it, which makes the final plot turn baffling. In a movie such as *Independence Day*, the bad guys came from another planet, and that was fun, but *Olympus Has Fallen* is an unfortunate descent.

THE GREAT GATSBY

14/5/13

★ ★ ☆ ☆ ☆

F. Scott Fitzgerald's classic, complex novella of bad timing and lost love in the Jazz Age has been brought once again to the cinema, now starring Leonardo DiCaprio as the enigmatic young plutocrat Gatsby himself; Carey Mulligan as Daisy, the object of his passion, and Tobey Maguire as Daisy's cousin Nick, the outsider-insider through whose wondering narration the story is filtered. Having watched this fantastically unthinking and heavy-handed adaptation, the opening gala of this year's Cannes festival, I feel the only way to make it less subtle would be to let Michael Bay direct it. As it is, the task has fallen to Baz Luhrmann, the director of *Moulin Rouge!* and *Australia*, a man who can't see a nuance without calling security for it to be thrown off his set.

With literary adaptations, part of the fascination generally lies in seeing how the director has read the source material, perhaps with some new interpretation. But what exactly Luhrmann makes of the legend of Jay Gatsby — the invisible, wounded centre of a thousand extravagant parties — is still a mystery to me, hours after the final credits have rolled. If Luhrmann was to make a new version of *The Wizard of Oz*, his wizard would finally stride out from behind the curtain a magnificent and talented giant, every bit as awesome as his reputation, and the final forty-five minutes of the movie would be a colossal party scene, dominated by the colossus Oz, with crash zooms and 3D swoops.

As for his *Gatsby*, it is bombastic and excessive, like a 144-minute trailer for itself, at once pedantic and yet unreflective, as if Luhrmann and co-writer Craig Pearce had created the film on the basis of a brief, bullet-pointed executive summary of the book prepared by a corporate assistant. They are quite clear in their minds that the final sentence of the book is very famous and very important and they actually spell it out on screen in typewriter-letters as it is being narrated. But the actual ending, those desperately sad, subdued final scenes, and the heart-wrenching encounter with Gatsby's elderly

father — well, Luhrmann hasn't attached much importance to that. It's a glib and shallow film; but there are moments of sweetness in DiCaprio's scenes with Mulligan as their love is rekindled, and those anachronistic musical sequences from Jay-Z, such a bone of contention, are actually bold moments when the film comes crazily alive, and has some of the irreverent energy of Lurhmann's version of *Romeo and Juliet*.

The film is in fact narrated in flashback, with Maguire's Nick attempting therapy for his depression and alcoholism, an interesting twenty-first-century slant on all the frenzied drinking going on. He recalls being a young bond trader in the Prohibition years who somehow rents a tiny cottage up in the Hamptons, just next door to the much-whispered-about Gatsby, who holds staggeringly sumptuous parties in his mansion. Nick renews his acquaintance with his cousin Daisy (Mulligan) who lives in elegant *ennui* and unspoken melancholy just across the bay from Gatsby, with her boorish wealthy husband Tom Buchanan (Joel Edgerton). Gatsby is keen for Nick to engineer a discreet meeting with Daisy, and whatever lucrative racket Gatsby's into, he's prepared to let Nick have a piece of it, with an introduction to his shadowy business acquaintance Wolfsheim: an odd cameo from Bollywood legend Amitabh Bachchan. For his part, Nick is disturbed by evidence that Tom is having an affair with Myrtle Wilson (Isla Fisher), the brassy wife of a roadhouse manager.

Luhrmann creates vivid 1920s backdrops behind all this: faintly preposterous and yet undeniably lively: all-singing, all-dancing, all-greenscreening effects work, and Jay-Z's music is audacious and exhilarating. There is colourised black-and-white footage and depthless digital panoramas of New York, the Hamptons and the ashy, crummy no-man's-land in-between; there are hyper-real street scenes through which Gatsby roars in his sports car. And of course there are plenty of those headache-inducing camera zooms.

The parties are logistically impressive, but Fitzgerald's disturbing sense that we are witnessing something like an American Weimar is not really there, and even the gushing, shaken-champagne-bottle approach doesn't quite approximate the giddy sense that America really is where gigantic fortunes are suddenly and unfairly to be made. When Gatsby finally reveals himself, it is to the accompaniment of fireworks and Gershwin's *Rhapsody in Blue*, a misjudged moment

and an ambient gimmick Luhrmann has clearly taken off the peg from the opening of Woody Allen's *Manhattan*.

DiCaprio carries the role off reasonably well; he is probably the only possible casting, and Mulligan's Daisy has gentleness and vulnerability. Their initial intimate meeting over tea in Nick's cottage, has some charge, and DiCaprio and Mulligan handle it well. But we are soon back to the digital city scenes and crash zooms, and we are incessantly left with the obtuse and tiresome figure of Nick himself, that non-participating narrator played by Maguire with a zonked expression of … well, what exactly? He looks perpetually supercilious and hungover without having drunk half as much as anyone else. This is a movie whose adjective is unearned. It's a flashy *Gatsby*, a sighing *Gatsby*, an angry *Gatsby*, a celeb *Gatsby*. But not a great one.

THE LONE RANGER

8/8/13

★ ☆ ☆ ☆ ☆

Like a defibrillator cranked up to the highest possible voltage, Rossini's *William Tell Overture* is slapped on to this film twice – at first briefly, then for a while. It results in something that isn't exactly a gallop, more like the protracted convulsive thrashings of a dead horse with its hoof jammed in the electric socket. Hearing the theme is always enjoyable (specifically, the *Overture's* fourth "Finale" movement), and maybe it's as well to reassert a wholesome association with the Lone Ranger, his horse, Silver, and his trusty guide, Tonto – and get away from the thought of Malcolm McDowell having sped-up sex with two women in Kubrick's *A Clockwork Orange*. But the energy, brio and brevity of that musical signature is in mighty contrast to this fantastically mediocre and long film, starring Armie Hammer as the masked Ranger himself and Johnny Depp as Tonto, produced by Jerry Bruckheimer and directed by Gore Verbinski, the men who gave us *Pirates of the Caribbean*.

It really is long. I have known movies by Theo Angelopoulos and quadruple albums by Wishbone Ash that seemed shorter. Verbinski has surely modified this film's running time using dastardly new temporal-distortion technology, so that each of its 149 minutes contains 250 seconds. The South American landmass peeled off from the western seaboard of Africa quicker than this.

What sort of a film is it? A family film, but too bloodless and archly self-aware to be a through-and-through Western, and it's something other than an unassuming cinema version of the much-loved radio and TV adventure serials that in fact spawned two films in the 1950s. It's often self-consciously big and mythic, with Monument-Valley-grandeur tendencies that undercut the stabs at humour. Really, it's yet another superhero-origin franchise product, like the recent *Superman* and *Dark Knight* films, giving massively elaborate explanations for the hero's name and that of his horse. "The Lone Ranger" is finally spelt out haltingly, like "The Bat Man" – a legend being born. Pretty soon every film franchise in the world will be rebooted with this origin-myth style: a black-eared rodent called

Michael will be tentatively hailed, at the end of a three-hour film culminating in a helium-inhalation tragedy, as "Mickey ... Mouse".

Armie Hammer is John Reid, a rather mousy, intellectual fellow who arrives in Texas in the 1850s to visit his alpha-male brother, Dan (James Badge Dale), a fearless lawman who is now married to the lovely Rebecca (Ruth Wilson), for whom John still carries a torch. Dan is tracking down loathsome bandit Butch Cavendish (William Fichtner); the resulting melee brings John into contact with crooked railroad chief Latham Cole (Tom Wilkinson) and also charismatic Native American Tonto (Depp), whose people are about to be screwed over by the white man's business interests, and who finds only John is his friend. Everywhere in America, it seems, bad guys are getting away with bad stuff, and the authorities do nothing. Who can come to the rescue?

No new version of *The Lone Ranger* can simply leave Tonto as the lesser sidekick, and casting the A-lister Depp is perhaps intended to redress the balance all by itself. Depp brings a kind of deadpan drollery to the part, but I found his performance unbearably mannered, cute and coy. It is worryingly comparable to his catatonically detached hipster turn in the Venice-set caper *The Tourist*. Tonto has a wacky dead bird perched atop his head-dress, and there's a bit of comedy business here and elsewhere, but these cheeky flourishes sit uncomfortably with the need to be respectful. Depp's Tonto has a weird whiteface mask, which the actor says is based on historical photo research, but none of the other (genuine) Native Americans in the film have this, and it also looks like a way of finessing the racial imposture.

The Lone Ranger winds up looking sort of like something by Sergio Leone – though it's difficult to tell if this isn't simply a by-product of the length – and there are pale allusions to Buster Keaton and *The General*, but unlike Keaton, Depp gets to do his cool, deadpan stunts in the comfort of a greenscreen studio. What this resembles most of all is Jon Favreau's *Cowboys & Aliens* (2011) – without the Aliens – or Barry Sonnenfeld's jokey *Wild Wild West* (1999). Like a single-ingredient mashup, it has a smug, tongue-in-cheek pastichey feel, a passionless lack of actual interest in the imagery of the Old West, and the Lone Ranger is evoked with a fraction of the humour and zing of, say, Sheriff Woody from *Toy Story*. The masked man may well be back for two or three more films, but I can't help hoping that he's trotted over the horizon for the last time.

DIANA

5/9/13

★ ☆ ☆ ☆ ☆

Poor Princess Diana. I hesitate to use the term "car crash cinema". But the awful truth is that, sixteen years after that terrible day in 1997, she has died another awful death. This is due to an excruciatingly well-intentioned, reverential and sentimental biopic about her troubled final years, laced with bizarre cardboard dialogue – a tabloid fantasy of how famous and important people speak in private.

The green space outside the Odeon Leicester Square may well be covered in cellophane-covered bouquets in the days to come, in memory of this new woe. It was here, after the film was over, that I crouched down and like Martyn Lewis of old, my lip trembled. Only by imagining a cathartic waltz with John Travolta was I able to control myself.

Is this film an MI5 plot to blacken Diana's name and make her look plastic and absurd? The movie isn't so much Mills & Boon as a horrendous *Fifty Shades of Grey* with the S&M sex taken out – and replaced with paparazzi intrusion and misunderstood charity work.

It has the highest credentials: the highly talented Naomi Watts plays Diana – an actor who, since her appearance in David Lynch's *Mulholland Drive* in 2001, has been searching for a project worthy of her. That search goes on. And it is directed by the German film-maker Oliver Hirschbiegel, who made the brilliant *Downfall*, about Hitler. However, his touch with a love story – with English dialogue – is less sure.

The drama is about Diana's post-Charles affair with the handsome Pakistani heart-surgeon, Dr Hasnat Khan, a dismally written role with which the actor Naveen Andrews can do little or nothing. Diana is forced to see Hasnat in disguise, wearing a black wig that makes her look weirdly like Liz Hurley. Dr Khan is a proud and passionate man who loves Diana, but his family is unsure about it all and he can't reconcile his feelings with the prospect of his work being disrupted and achieving global celebrity as mere arm-candy.

And Dodi? Dodi was no one. He is presented here as a mere rebound fling – a ruse Diana co-created with long-lens photographers, which was intended to make Hasnat jealous.

Well, maybe. But this seems a highly simplistic view of events. It seems possible, to say the least, that her feelings were much more complicated than this, and that Hasnat meant less and Dodi more than this sucrose and emotionally-authorised version will allow.

Watts's elaborate impression of Diana has the upward look, the doe-eyed gaze of seduction and reproach and she can do the estuary-posh voice. But she looks like she's in a two-hour *Spitting Image* sketch scripted by Jeffrey Archer. And despite some nods to that manipulative reputation, there is nothing to show the grown up wit and charm which entranced many. One scene shows her private secretary reminding Diana of her upcoming lunch with Clive James. I would give a lot to see that scene (Ben Mendelsohn? Bald wig?) but they don't try it. And despite some hints at her moody and irrational side, all is fundamentally bland saintliness.

Those very small parts of the film which are just silent montages of Diana's lonely, alienated life work well. But the moment anyone, anyone at all, opens their mouth we are in TV-movie-land, soap-land.

Ironically, we see Diana and Hasnat settling down on the sofa to watch an episode of *Casualty* and then hanging on for *Match of the Day*. The dialogue echoing out of the TV sounds more relaxed than what is being said by the characters.

"A doctor's triumphs are only temporary; I learned that from Victor Chang," Hasnat says to her wisely as they walk along. "He was the man you studied under in Sydney," replies Diana.

And so it goes on: so many lines are actually stage directions, telling us who people are and what we should be thinking about them.

As her affair with Hasnat unravels, Diana starts to harass him and behaves badly. But things calm down. "Yes, I've been a mad bitch," she says matter-of-factly. Well not exactly. More like a silly and somehow implausible schoolgirl.

A good film could be made about Diana's dark side – that is, her flawed, non-saintly human side.

An entire movie could be made, for example, about her ugly, obsessional spat with her sons' nanny Alexandra "Tiggy"

Legge-Bourke, whom she suspected of having an affair with Charles and whom she publicly insulted. That really was dark. But it doesn't fit the image and so it is airbrushed out of the record here.

Diana's relationship with Hasnat may conceivably have been exactly as this film says it was. People in love can sound gooey and silly, of course. But by excluding everyone else: by excluding Charles (still an important figure in her life) and any real depiction of her relationship with her sons – perhaps through some unspoken deference to these important and very-much-alive royals – the film creates a distorted, sugary and preposterous impression. She is the Heiress Of Sorrows.

GRUDGE MATCH

23/1/14

★ ☆ ☆ ☆ ☆

Never have I wanted to un-see a film more badly than this. Never have I yearned more passionately to climb into my time machine and journey back to before my memory of *Raging Bull* was needlessly trashed by this incredibly depressing and worthless mediocrity. As Shakespeare's *Macbeth* might have put it: had I but died an hour before the opening credits rolled on *Grudge Match*, I had lived a blessed time.

The story is about two ageing retired boxers, Billy "the Kid" McDonnen and Henry "Razor" Sharp, played by Robert De Niro and Sylvester Stallone. These grumpy old rivals have been persuaded to get back together for a preposterous geriatric "grudge match". There are a couple of nice, digitally created scenes showing the boxers in their heyday – sort of like that 1990s TV Reebok ad showing George Best passing the ball to Ryan Giggs. But all too clearly, Razor and the Kid are supposed to be variants on the *Rocky* and *Raging Bull* characters: Stallone gets the blue-collar dignity and the roadwork training scenes; De Niro is the louche guy who misbehaves with younger women.

The implied equivalence between the two films is infuriating. If Stallone wants to do yet another dopey *Rocky* spinoff, fine. But for this film wilfully to recall *Raging Bull*, for it actually to show De Niro's old fighter doing a cheesy nightclub routine *à la* Jake LaMotta – but minus any kind of interest – is just awful. Can't a committee of concerned cinephiles enact some emergency power of attorney and stop De Niro doing this kind of thing?

GRACE OF MONACO

14/5/14

★ ☆ ☆ ☆ ☆

It's traditional for Cannes to start with something spectacular. This is certainly no exception. It is a film so awe-inspiringly wooden that it is basically a fire-risk. The cringe-factor is ionospherically high. A fleet of ambulances may have to be stationed outside the Palais to take tuxed audiences to hospital afterwards to have their toes uncurled under general anaesthetic.

Grace of Monaco is a stately and swooning homage to Princess Grace, formerly Grace Kelly, focusing on her alleged courage in keeping plucky little Monaco safe for tax-avoiding billionaires. This was during its supremely parochial and uninteresting 1962 face-off with Charles De Gaulle, who wanted to absorb the principality and its monies into France's national bosom. So can Grace, by finally sacrificing her movie career on the altar of this cockamamie Ruritanian state, and flaunting her martyred couture loveliness, win the respect of the Monégasque folk and even the grumpy old Général himself?

The resulting film about this fantastically boring crisis is like a 104-minute Chanel ad, only without the subtlety and depth. Princess Grace herself is played by Nicole Kidman, wafting around the Palace with dewy-eyed features and slightly parted lips which make her look like a grown-up Bambi after a couple of cocktails, suddenly remembering his mother's violent death in the forest.

It doesn't seem that long since we endured a horrendous biopic of Princess Diana, that other super-rich blonde *pasionaria* — played by Naomi Watts. As audiences reeled into the foyer after that, they comforted themselves with the thought that surely things couldn't get worse. Surely they wouldn't be forced to endure another badly acted, badly directed film about a wealthy and self-pitying royal?

How very wrong. I can now actually imagine a creepy science-fiction short story about someone going back to prehistoric days in a time machine, killing a tiny trilobite, and then coming to the present to find everything the same, only now it's Naomi Watts playing Grace and Nicole Kidman playing Diana.

The movie begins with a sketch of jowly and adorable old Alfred Hitchcock (Roger Ashton-Griffiths) coming to Monaco hoping to tempt Grace back to the movies, proffering a juicy leading role in his latest film, *Marnie*. Two recent dramas about Hitchcock's troubled life — one for cinema, a better one for TV — have in fact begun in approximately the same way, but then followed the troubled director back to the US. Here, we stay with Kidman's Grace, who is effectively confronted by a dilemma. Should she return to her selfish, shallow life in Hollywood or build a new shallow, selfish life in Monte Carlo?

And so the terrible mental turmoil begins. She pores over the script, late at night, in bed, with stylish reading glasses. During the day, she tries her darnedest to impress the wittering ladies of Monaco by entering into the spirit of charity galas and such. She worries about plotting against her at court. She consults her confidant, one Father Francis Tucker, a sorrowing priest who is evidently permitted the familiarity of calling her "Gracie", played with conviction by Frank Langella.

Then, in order to bone up on the history and culture of Monaco — and perhaps because the situation is not yet sufficiently gay — Grace consults a local nobleman, Count Fernando D'Aillieres, played by Derek Jacobi. He scampers about the hillsides, with Grace in tow, filling her in on all the tiresome details, while also presuming to give her tips on acting and deportment. (Surely as an Oscar-winning star she knows this stuff already?) Jacobi has a little fun with the part, although it needed Ian McKellen to come on, playing the Count's ageing houseboy.

But how about the people for whom it is all supposed to be about? Her, erm, husband and children? Well, the absolute indifference shown by Grace to her kids here is startling. And what of Prince Rainier himself, that fairy-tale prince for whom she gave it all up? He is played by Tim Roth, who gives a very cigarette-smoking, glasses-wearing, moustache-having performance. He is always leaning in his chair, leaning against door frames — looking through his glasses, and smoking. What is this remarkable head of state thinking about? As performed by Tim Roth, it looks like he is thinking about how much he regrets taking this appalling role, and how inadequate he considers his fee, whatever it is.

An interesting, complex film could be made about a talented woman who decides to make the best of being trapped in an imperfect marriage. But such a film would have to stop curtsying, and really think about its subject.

THE MAZE RUNNER

9/10/14

★ ☆ ☆ ☆ ☆

This week's YA dystopian-lite teen adventure features yet more celibate chiselled hotties in some ritualised game-playing future world, who discover that they are in some super-special way different, or divergent, or exceptional. As Nietzsche once said: destiny is cheekbones. Will it never end? Based on an insidiously sequel-spawning bestseller by James Dashner, this film features a teenage amnesiac called Thomas (Dylan O'Brien) who wakes up in a weird grassland called the Glade, enclosed by a mysterious stonewalled maze: this is the only way out, but it's filled with creepy spider-like creatures.

Thomas finds he is part of a community of adolescents led by an autocratic bully called Gally (Will Poulter), who permits a certain number of boys to explore the maze – called Maze Runners. But are they all just lab rats in some mad corporate experiment? Well, only a Freudian pedant would insist on the symbolism of burgeoning young adults in that spider-filled maze. But these are teenage males who supposedly haven't seen a female person in years. So when a young woman finally appears (Kaya Scodelario) – shouldn't that provoke a little more of an, erm, emotional response? As it is, everyone looks at each other with bland intensity, like members of a Christian volleyball team getting a team talk from the coach.

THE BEST OF ME

16/10/14

★ ☆ ☆ ☆ ☆

Here is a film based unmistakably on a novel by the great rom-dram maestro Nicholas Sparks. It has the steroidal-sucrose flavour of a standard-issue Sparks story about lovers wrenched apart by fate and flung together by destiny – usually hinging on some super-secret handwritten letters. It's the sort of film where you're supposed to check your corrosive cynicism at the door. As it happens, there were no cloakroom facilities at the cinema where I saw it, so I brought mine into the auditorium with me, and it was only this that allowed me to appreciate the calculated narrative ploys and manipulations. James Marsden and Michelle Monaghan play two former high-school sweethearts who meet up again. Marsden's character is called Dawson and, in a gender reversal, he actually used to climb in through his girlfriend's bedroom window! Yikes! As teenagers in flashback, they are played by different actors. Marsden's looks so bafflingly unlike him I was certain the plot twist would involve facial reconstructive surgery. His abusive dad, however, looks so much like Will Ferrell I was sure the actual Will Ferrell would turn up later to get a savage retributive beating. The sugar content of this film is so horrendously high, it could be available on the NHS for hypoglycaemia.

SAY WHEN

★ ☆ ☆ ☆ ☆

Say why is more to the point. Why? Why? Why inflict on everyone this incredibly unfunny, un-insightful and annoying nonsense? Why put audiences through another example of that most insidious genre: the quirky-phoney modern-family dramedy? The story could be interesting, were it not for the fact that every part of its potential for satire was overlooked in favour of yuckily supportive sentimentality, with bits and pieces half-remembered from *American Beauty* and even, I suspect, *Clueless*. Keira Knightley plays an unemployed twentysomething who peaked in high school; a marriage proposal from her boyfriend causes a quarterlife crisis and under cover of attending some personal growth seminar out of town she winds up staying with a cool teen she has befriended called Annika (Chloë Grace Moretz) and kind of falling for Annika's hot lawyer dad (Sam Rockwell). Nothing in this story is in any way amusing or plausible: it is a Frankenstein's monster of indie-screenplay clichés, with a teeth-grating performance of intolerable gawkiness from Knightley.

ANNIE

16/12/14

★ ☆ ☆ ☆ ☆

There's been an update to that well-known tune about Annie, the parentless little cutester melting the flinty heart of the scowling plutocrat billionaire looking after her. It's based on – and basically mired in – the 1970s Broadway musical, which has already had two movie adaptations: the 1982 film directed by John Huston with Aileen Quinn as Annie and Albert Finney as Daddy Warbucks, and the 1999 version directed by Rob Marshall with Alicia Morton and Victor Garber.

This new one, on the other hand, is basically like a horrific mix of Lionel Bart's *Oliver*, *My Fair Lady* and *Pretty Woman*. Did we really need another go-around for Annie, that indomitable little curly-haired moppet, who defiantly sings about how she'll "love ya tomorrow", when life is kicking her in the teeth? This movie is slathered in slush, immersed in yuckiness and positively laminated in ickiness. It's supposed to warm your cockles. It might do something entirely different to your gag reflex. If someone near you in a restaurant is choking and you don't know the Heimlich manoeuvre – well, hold your smartphone up and play them some YouTube clips of this film. That'll get the job done. I like the odd spoonful of sugar in the cinema. But this is like a hundredweight of sparkly radioactive waste in a pink carton.

Quvenzhané Wallis (who made a notable debut in *Beasts of the Southern Wild* in 2012) plays ten-year-old Annie. We see her in school in the first scene, giving a souped-up show'n'tell about Franklin D. Roosevelt's New Deal – of all the adorably wised-up, super-cool things to do. She actually takes over from some obviously lame-o ringleted showbizzy kid to present this: ie shoving aside an Annie 1.0 figure. And in being tipped this sly wink, we are evidently given to understand that this hipper new version of Annie is not the same old silly schmaltz.

It's worse. When Annie's all through breaking out her 1970s, *Fame*-style, irrepressible classroom number on the subject of postwar

inequality, she gets back to the foster home to find the same old heartless cruelty in effect (and the film's distinctively political analysis of the situation ends here). There is a horrible foster house mom presiding over Annie and her unhappy pals and this woman is played with eyeball-bulging, kohl-running, head-waggling charmlessness by Cameron Diaz. It is supposed to be a comic role, though her performance is about as funny as the proverbial orphanage fire.

Annie and her fellow foundlings and unfortunates hang out, interact and sing with the kind of mugging stageyness that I haven't seen since the boxing-gym scene in *Bugsy Malone*. But a mishap in the streets ensures that Annie's path crosses with that of Will Stacks, cellphone mogul and all-around blowhard played by Jamie Foxx who is running for New York mayor purely to increase his profile and promote his business interests. He saves little Annie from being run over in the streets by a truck: this act of unwonted charity is captured on video, shared on social media, and it sends Stacks's poll numbers skywards. His icy PR adviser Guy (Bobby Cannavale) tells him to let little Annie stay in his colossal penthouse apartment. ("Is he nice?" Annie's friends ask her. "I think so – he just doesn't know it yet," says Annie.) Meanwhile, Stacks's gorgeous personal assistant Grace, played by Rose Byrne, bonds with Annie over how much they love talk radio because they are so lonely, the announcers are like their friends. For his part, Stacks shows his caring side and there could be a spark between him and the inexpressibly demure Grace. But catastrophe is on the way.

The songs are boringly and flatly presented – certainly compared to the glorious power and punch in, say, *Frozen*. And the queasiest moment comes when Stacks takes Annie and her friends and Grace to a way cool movie premiere: a droll visual gag reveals that the formulaic fantasy romance was written by Phil Lord and Christopher Miller, of *Lego Movie* fame. If only. At the after party, we see the kids stuffing themselves with free candy. And that's how this film feels: enough unwholesome sucrose to cure an entire continent of hypoglycemia. Annie delivers the sugar rush of nausea. Foxx himself just about emerges from this mess intact, largely by keeping his performance fairly restrained. But everyone and everything else is drowning in goo.

TAKEN 3

6/1/15

★ ☆ ☆ ☆ ☆

It's difficult to know what subtitle to give this. *Taken 3: Not Again*, or *Taken 3: Seriously?* or *Taken 3: This is Getting a Bit Much Frankly*. It is another episode in the eventful life of former special forces hombre Bryan Mills: the role which made a bankable action star of Liam Neeson, famously leaving his daughter's kidnappers the most defiantly butch answering-machine message in film history. Now his daughter is in jeopardy yet again. Lordy! We needed Maggie Smith to come on as Lady Bracknell, jab her parasol into Liam's chest and announce: "To allow your nearest and dearest to get into mortal danger twice is all very well, Mr Neeson, but thrice looks like carelessness!" Neeson has himself said of this film: "What makes *Taken 3* a quintessential *Taken* movie is that, at its heart, it's still about Bryan Mills doing everything in his power to save his family". Well you say that, Liam, but maybe *Taken 4* will boil down this quintessence of *Taken*-ness into an even denser conceptual *Takenic* purity. We shall have to see.

Anyway, Liam's girl is in peril, and Liam does his traditional phone riff in that unmistakable mid-Atlantic rumble, though this time speaking to someone directly, not a machine. He's framed by the bad guys for something he didn't do and must go on the run from the cops, whose chief, played by Forest Whitaker, is overwhelmed with admiration in spite of himself for Liam's courage and derring-do. Forest can only gasp with wonder as he and his flatfooted LAPD cops traipse after Liam as our hero tries to clear his name and protect his girl. I've got a sinking feeling it'll be his grandchild in the next movie.

FIFTY SHADES OF GREY

11/2/15

★ ☆ ☆ ☆ ☆

"I don't make love. I fuck. Hard." With these bold but very misleading words we are introduced to what is the most purely tasteful and softcore depiction of sadomasochism in cinema history. It is also surely the most intensely anticipated literary adaptation since *The Da Vinci Code*. Millions of fans have already enjoyed E.L. James's erotic bestseller on their discreet e-readers. Now there is a film version written by Kelly Marcel and directed by Sam Taylor-Johnson and cinemas can perhaps introduce special "Kindle" screenings before which the poster in the foyer is covered with a brown paper bag.

In the murky history of sexual deviancy and perversions in literature and cinema we have had *Venus In Furs* and *The Story of O*; we have had Oshima's *Ai No Korîda* and Shainberg's *Secretary*. James's original book started out as fan-fiction triggered by the sexy vampires of Twilight. But thirty minutes into *Fifty Shades of Grey* I realised what the real inspiration for the film is: Victoria Wood's famously dark and disturbing song about the transgressive ecstasy of turning off *Gardener's Question Time* in expectation of being bent over your hostess trolley, and beaten on the bottom with a *Woman's Weekly*.

Except that in *Fifty Shades of Grey* it is more like being bent over a Jasper Conran pine-effect table and having your bum smacked with a copy of Condé Nast *Traveller* while the Nespresso capsules go all over the floor. This is a movie about submitting to erotic chastisement by a handsome man who plays Chopin on his grand piano and sips Chardonnay from long-stemmed glassware. He is extremely rich. Because there's nothing sexy about spanking if he's skint.

But rest assured – it's not just about spanking. Before the pervery commences, our hero lowers his trousers and undergarments and in a more conventional sense does to the female lead what Ms James did to the book trade and what Taylor-Johnson does to your chances of seeing an actual penis. Seriously – there are no glimpses of a penis in this film, not in any state. It's primly off-camera. Or maybe the

smoulderingly sado-obsessed hero does not have a penis. It could account for his tastes. And his decor.

Dakota Johnson (daughter of Melanie Griffiths and granddaughter of Tippi Hedren) plays Anastasia, the pretty, shy, klutzy student who finds herself interviewing a local billionaire for the college paper. This is the icily well-dressed Christian Grey, played by Jamie Dornan (he was the sexy serial killer in the BBC drama *The Fall* – casting to which the script playfully alludes).

Anastasia's interview does not elicit any information about what Grey's firm does – and this remains a mystery. But he is very taken by Anastasia, who in the time-honoured Mills & Boon style of demure secretaries with tempestuous plutocrats and nurses with hot-tempered brain-surgeons, is strangely unafraid of him. Anastasia tells him she is studying English literature and he asks if she was inspired by Charlotte Brontë, Thomas Hardy or Jane Austen. She earnestly replies Hardy and Christian smirkingly says he would have guessed Austen. (I personally would have guessed Brontë, as Mr Rochester is Christian's generic ancestor.)

At any rate, Christian is soon sending our Anastasia a first edition of *Tess of the D'Urbervilles* – and shows up in the hardware store where she has a part-time job, to buy rope and cable-ties. Soon they are dating, but Christian frowningly tells Anastasia she must submit to regular sessions in his "Red Room of Pleasure", tied up and beaten, sub to his dom. Biting her lip, Anastasia agrees, after a lengthy contractual discussion about what is and is not allowed: anal and vaginal fisting are not on, and neither are genital clamps. Neither, apparently, is having a penis. But ropes are OK. He also takes her up in his helicopter. And then his glider. Going up in his hot air balloon and then the Ford Anglia he bought from Harry Potter is presumably in the next movie.

But the performances are strictly daytime soap. At one stage we see Christian shouting masterfully into his phone: "That is unacceptable! I don't have twenty-four hours!" before turning to fix Anastasia with the kind of burning gaze which in most circumstances is quickly interrupted by a commercial break. Perhaps in the next movie Anastasia will get a job, or an internship in Christian's offices, being one of those sinister, stick-thin grey clad assistants that glide about the place. And we will find out what Christian does for a living.

PAN

15/10/15

★ ☆ ☆ ☆ ☆

The title signifies that deeply special and mythical "Pan" down which all your cinematic hopes must be flushed. With no Frish. Or maybe there's a missing "i" between the second and third letters.

This is a fantastically boring and parasitic origin-myth reboot of the *Peter Pan* story from people who don't care how it got booted in the first place. It looks like a John Lewis Christmas TV ad dreamed up by executives who have found a way to smoke Ambien.

Peter (Levi Miller) is a tiresome golden-child orphan in World War II London with a cockerney accent that comes and goes: he is a special prophesied one whose mother's name is Mary. OMG. Peter is kidnapped from his orphanage and taken to a mysterious land where, in what looks like a deleted scene from *Mad Max: Fury Road*, thousands of grubby slave-worker youths mine for magical fairy-related minerals. It is called Neverland and they sing along to Nirvana's *Smells Like Teen Spirit* … from their album *Nevermind*. Geddit? That single idea is enough to justify a thirty-year prison sentence for all concerned. These poor souls are ruled over by wicked Captain Blackbeard, an ah-harr turn texted in by Hugh Jackman.

Peter revolts, assisted by doe-eyed Rooney Mara playing Tiger Lily. Garrett Hedlund maintains his reputation for undemanding buttery handsomeness playing the young Hook, who at this stage is uninterestingly reimagined as Peter's unreliable chum: a roguish roisterer with an Indiana Jones hat.

Peter is the boy who never grows up. But at the end of this, you'll feel like you've aged about 800 years.

The films that made me laugh

Of all the genres and types of film, comedy is the one most misunderstood by critics, and it's the one that gives me a scorpion-sized bee in my bonnet. It is the one genre which so many critics can't find it in their hearts to appreciate. Horror, romcom, thriller, action, weepie – they all get a reasonably fair shake. But comedy gets frowned on by critics, and the good films have to wait years or decades before they are praised. (I include here, in a spirit of Mao-ist self-criticism and self-mortification, my first rather stingy review of the comedy *Blades of Glory*; to my shame I didn't see the glorious humour which has now been revealed to me over dozen of subsequent viewings.) I have lost count of the number of screenings of mainstream comedies in which I have been the only one giggling in a mass of Puritans. Or, conversely, I have been one of many people giggling away, happily enough – but then I have turned to these people's reviews to see that their enjoyment has somehow, on its way to print, cooled to a supercilious detachment. I have also found myself bemused to see interesting highbrow dramas – excellent films whose element of humour is not their only or chief point of interest – subsequently praised in print as howlingly funny: I have witnessed the alert and respectful silence in which they have been received by critics, who then claim to have screamed with laughter. Funniness in films which are not claiming to be funny is critically permissible, and in those overtly claiming to be dark or tragic it can be eagerly celebrated. But films billed as comedies can expect a cool reception.

The reason, I suspect, is a kind of rivalry, and here is the one issue on which I concede a kind of truth in the perennial complaint that critics are jealous. Comedy is something which modern newspaper

critics fancy they are rather good at; it may be a central part of their professional identity as writers. They think it is *their* job to be funny – at the movies' expense. It used to be a maxim of the Cambridge critic Eric Griffiths that "criticism cannot laugh". Actually, that isn't quite true. Film criticism can do laugh-at, but it has a problem with laugh-with. It sometimes struggles to find an appropriate tonal register or rhetorical mode to salute successful comedies, and I'd include myself in that criticism. Critics disagree often about comedies, disputes often uneasily concluded with all parties submitting to the consensus that comedy is very "subjective". But it's no more subjective than anything else, and in fact the simple, objective fact that some comedies get big laughs from audiences is an argument in favour of the idea that comedy is the one genre which *can* in fact be objectively assessed. (Tragedies don't get bursts of sobbing and indie films don't get flurries of nodding and chin-stroking. Comedies are probably closer to horror, with sudden gasps and screams – followed by ripples of nervous laughter. Laughs are a vehement, emphatic, and undeniable demonstration of success. But it is also true that if you don't find something funny, the spectacle of everyone else laughing can make it unbearably unfunny.)

There are countless great comedy moments in film history, but I can't help remembering one, in a recent film, which I extravagantly praised. It is Adam McKay's cop buddy comedy *The Other Guys* from 2010. Will Ferrell plays Detective Gamble, a nerdy, uptight police officer that nobody likes, and to humiliate him, his colleagues trick Gamble into thinking that it is an accepted rite of passage for new officers to fire their gun into the air just once, while seated at their desk doing paperwork: the so-called "desk pop". Incredibly, Gamble believes it and one busy morning in the office, sitting at his desk, he points his weapon at the ceiling and pulls the trigger. The absolute realism in which this scene is presented – the deafening sound of an indoor gunshot and the astonishment and outrage of the people surrounding Gamble – makes this a great comedy moment and one of the very few moments in film history when the firing of a gun, with all its horror and transgression, is actually honestly presented. Comedy is the cinematic artform most purely dedicated to pleasure.

BEING JOHN MALKOVICH

17/3/00

★ ★ ★ ★ ☆

There are some films with a premise so simple and so unanswerably brilliant they make all aspiring screenwriters slap their foreheads with envy and self-loathing. Six years ago it was: "Of course... a moving bus... with a bomb that explodes if it goes under a certain speed! Why didn't I think of that?"

Now it can only be a case of: "Of course... a failing puppeteer who works on the seventh-and-a-half floor of a Manhattan office-building and accidentally discovers a tiny door that leads directly into John Malkovich's head! Why didn't I think of that? It's been staring me in the face!"

Being John Malkovich is the outrageously funny new movie from director Spike Jonze, with a screenplay by Charlie Kaufman, whose every scene, every line, every narrative refinement, every exquisitely hand-tooled joke and sight-gag is of the purest gold. Jonze and Kaufman take us on a cheeky raid behind the enemy lines of thinkability in the cinema, into the realm of the six impossible things the Red Queen believed before breakfast.

John Cusack plays Craig Schwartz, a sweaty, unshaven puppeteer, miserably resentful that no one appreciates his street theatre art, and forced to ply his trade in New York's uncaring thoroughfares. Finally compelled to find a day job, he becomes a lowly filing clerk on a bizarre, secret quasi-mezzanine floor of a skyscraper, a place where the ceilings are four feet high and everyone goes about their business bent double. Here Craig meets and falls abjectly in lust with the mysterious Maxine, instantly forgetting about his homely wife, Lotte, a pet shop attendant who brings home sick parrots and conflicted chimps.

It is one of this film's sly reversals and pre-emptive strikes that it is Cameron Diaz who is cast as the dowdy wife – with "no-make-up" make-up and unflattering perm – while Catherine Keener is the other woman, her innate sexiness effortlessly surviving having to walk around like Groucho Marx.

Their three lives are changed by the discovery of this magic portal, the door that leads into the consciousness of one of the grooviest, classiest, campest celebrities on the block. For a Warholian fifteen-minute session, they can see what Malkovich sees, feel what Malkovich feels; they experience him sorting through his mail, ordering a new periwinkle-blue shade of bathmat in that fluting, mellifluous voice – before they are ejected ecstatically onto a grass verge by the New Jersey turnpike.

The film effects a terrifying *mise-en-abîme* when John furiously discovers what is going on and demands to go through the door himself into his own mind, with astonishing results. But not before Lotte has discovered she kinkily enjoys being John Malkovich while he is having actual-reality sex with Maxine: "It's as if the portal is vaginal," breathes Lotte wonderingly. "It shows John's feminine side."

This film comes as close as it is possible to get to a sustained nirvana of giggling, a hovering delirium of comedy. It's like breathing in nitrous oxide, making you feel liable at any moment to float away. It has a Woody Allen-ish quality – and Cusack's performance is not that far from his lead in *Bullets Over Broadway* – but not so much Allen's films as the playful short stories. It has something of the F. Anstey of *Vice Versa*, and the Gore Vidal of *Myra Breckinridge* and *Myron*, and also a little of *The Truman Show* and *EDtv*.

Being John Malkovich brings a light touch to the important things it says about the ballooning cult of celebrity, how the aristocracy of the famous bombards us with gilded, gorgeous lives and hyper-real existences from every screen – subtly encouraging us to believe not merely in the inferiority of the non-famous existence, but its relative unreality. And in doing so, it returns us to the childlike reverie, as we look down at our hands, arms, and the tapering perspective of our bodies, of what it is like to be someone else. And further, to wondering what it is to be ourselves.

The choice of John Malkovich himself is inspired: he treats the role with a sporting lack of pomposity and yet absolute seriousness. In doing so, he has magnified his reputation and career a thousandfold. (For ten minutes after the house lights went up, and I gently came down, I tried to think of any British name with the

class to bring off the same tightrope act. Someone with grandeur and style, a premiership celebrity player who is simultaneously able to make a knight's-move away from, and above celebrity. *Being Ian McKellen?*)

Put simply, *Being John Malkovich* just has to be one of funniest, cleverest films of the year, a Fabergé egg of comic delight.

TEAM AMERICA: WORLD POLICE

14/1/05

★ ★ ★ ★ ☆

The United States of America, 2005; an uncongenial time and place for liberal assholes. Mr Bush has won his second term, fair and square, and his electoral opponent, Senator – Kelly, was it? – has crawled into the dustbin of history and pulled the lid closed behind him. Rather than be labelled sore losers, an entire media class has elected not to mind about the grotesque untruth of Iraqi WMD. In political and policy circles progressives are being invited to walk with bowed head into the Versailles railway carriage to sign the instrument of surrender, and many hardly know whether to know to holler their defiant rage at the enemy, or their own team for having been so milksop as to be defeated – or are perhaps tempted to side with the conqueror.

Team America: World Police brilliantly captures this complex contemporary mood, telling you more about America than Fox News, salon.com and *The New York Times* combined. It is a jaw-droppingly bizarre puppet show from Trey Parker and Matt Stone, the creators of *South Park*, and its style is taken (though I am sorry to say without a word of thanks or acknowledgement) from Britain's cult TV show *Thunderbirds*.

Our heroes are an elite A-team of potty-mouthed tough-guy superheroes with strings attached and a jauntily wooden way of walking, who cruise around the globe in their fleet of helicopters and hi-tech pursuit vehicles, kicking terrorist ass. Soon they have to confront a world-threatening conspiracy, masterminded by North Korea's Kim Jong-il, manipulating the useful idiots – the puppets, if you will – on the moderate showbiz left.

Parker and Stone gleefully pull the pin from their comedy grenade, and the result is an explosion of hilarious bad taste and ambiguous political satire. Everyone is sprayed with shrapnel, from gung-ho patriots to mealy-mouthed pantywaist liberals, and a special kicking is given to Hollywood itself and its bleeding-heart aristocracy: Tim Robbins, Susan Sarandon and even, heaven forgive them,

the documentary film-maker Michael Moore. The entire acting profession, in fact, is washed away in a river of bile – and the offence given to them is somehow, well, more offensive considering that the creators have used puppets rather than flesh-and-blood thesps.

You know you shouldn't laugh. You know it's wicked and wrong. You shouldn't laugh when Team America's high-minded opponents reveal themselves to be members of the liberal Film Actors Guild or "FAG". Puppets representing Alec Baldwin and Sean Penn mince around reminding everyone in whingeing voices that they have been to Iraq.

Many will wince and wrinkle their noses at this film's sheer, uncompromising immaturity. Perhaps they prefer their satire more middlebrow, more responsible, like that *Manchurian Candidate* remake. But *Team America: World Police* is criminally, deplorably funny. The giggling starts at the spectacular opening scene when TAWP take down a bevy of terrorists in Paris – though at the unfortunate expense of destroying the Eiffel Tower, the Arc de Triomphe and the Louvre – and things more or less continue from there. The explicit puppet sex scene between Gary and Lady Penelope-lookalike Lisa is incredible, in every sense. And I joined the audience in its snowballing delirium at the scene when one of the guys, consumed with drunken self-loathing for having let down the team, hits rock bottom and vomits outside a bar for what seems like twenty minutes. The hi-tech magic of CGI might have expanded the realms of what is physically possible, but old-fashioned puppetry has done the same with the bounds of taste. You can get away with a heck of a lot more if it's a puppet saying it.

And the Michael Moore stuff – well, I am a huge fan of his excellent film *Fahrenheit 9/11* and I groan at those grumpy and defensive pundits, writing their squirrelly little Hutton reports into it. Yet Moore's ego is entertainingly punctured when he is shown as a smug liberal martyr attempting to destroy Team America's headquarters – by rigging himself up as a suicide bomber. Again, a breath-taking moment of offensiveness: a veritable chain-mail fist through the paper-screen of celebrity correctness. It wasn't that long ago that Michael Moore, in his anti-gun documentary *Bowling for Columbine*, was interviewing Matt Stone, and generally praising him to the skies as a fellow satirist. And this is how he is repaid? Oh dear!

But where are *Team America*'s politics? Despite the incessant swearing and homo-erotic fellatio gags at *Team America*'s expense, a certain type of rock-ribbed Republican could well enjoy the film a great deal: maybe of the P.J. O'Rourke kind, though P.J. O'Rourke was never this funny. The attacks on the Hollywood whingers outweigh the mickey-taking of all-American machismo, and it often looks like a rightwing *Spitting Image*. There are puppets here mocking everyone from Hans Blix to Tony Blair. But where are the puppets of George W. Bush, Donald Rumsfeld, and Condoleezza Rice? There are none, and it appears certain figures are, if not off limits exactly, then irrelevant to the overall satirical thrust.

Silly and infantile it may be – but *Team America* is defiantly funny, tweaking the nose of the polite classes with its mad iconoclasm. Why can't non-puppet films be as good as this?

BORAT: CULTURAL LEARNINGS OF AMERICA FOR MAKE BENEFIT GLORIOUS NATION OF KAZAKHSTAN

27/10/06

★ ★ ★ ★ ★

Talent is luck, they say, and right about now, no comedian has more of either than Sacha Baron Cohen. The taxpayers from the sovereign state of Kazakhstan have been lavishly subsidising the publicity for Baron Cohen's new movie with fury-filled full-page government ads in *The New York Times*, and a personal complaint from the Kazakh president to Mr George W. Bush, followed by a belated and half-hearted official invitation to Baron Cohen to come visit.

Borat is the hero of this extraordinary mocu-reality adventure: a film so funny, so breath-takingly offensive, so suicidally discourteous, that strictly speaking it shouldn't be legal at all. He is the naive provincial TV reporter supposedly from Kazakhstan, though it is clear that this "Kazakhstan" is a joke cardboard country, a post-Soviet neverland picked at random, as cheerfully as Robert De Niro and Dustin Hoffman, the spin doctors in the political satire *Wag the Dog*, once picked "Albania" for their diversionary hoax war. Reportedly, Baron Cohen was actually inspired to create Borat by his youthful travels as a student in the then Soviet republic of Georgia. The character coincidentally resembles Alex, the Ukrainian guide with the bizarre mangled English in Jonathan Safran Foer's novel *Everything is Illuminated*. Borat is however immeasurably funnier.

Our hero leaves his dirt-poor Kazakh village, and travels to New York with a cameraman and his obese and unreliable producer to make a documentary for state TV. He experiences an epiphany there in his budget hotel-room, whose opulence has already reduced him to tears of incredulous joy. Watching a re-rerun of *Baywatch*, he falls in love with Pamela Anderson and journeys across the US to Los Angeles, where he dreams of subjecting her to the Kazakh forcible-marriage ceremony, whose legality he believes will be just as valid in America as at home. Grinning nervously, unable to comprehend anything of what he sees or hears, Borat is an innocent of the guiltiest

sort: he is boorish, he is grotesquely misogynist, he is crass. Above all he is an anti-Semite, and for cinemagoers who have become used to the unwritten convention that anti-Semitism is not represented on screen other than in the period garb of Nazi Germany, it is almost a physical shock to feel the swipe of Borat's contemporary bigotry. The last time I experienced this was listening to Terry Jones's sentimental cleaning-lady in Monty Python's *The Meaning of Life* in 1983: "I feel that life's a game, you sometimes win or lose/And though I may be down right now, at least I don't work for Jews." But this really is something else.

One of the first sequences is Borat introducing a TV clip showing one of his community's oldest folk traditions: the Running of the Jew. It is quite incredible, and conceived on an epic scale to rival the chariot race from *Ben-Hur*. Obviously, Sacha Baron Cohen is himself Jewish and perhaps we should here quickly rehearse the saloon-bar truisms: only Jewish people are allowed to tell Jewish jokes, if these comedians wanted to be dangerous why don't they take on Islam – yes, yes, quite … but is Sacha Baron Cohen really allowed to do this? Is anyone? It is a sensational provocation, a nineteenth-century anti-Semitic cartoon gigantically reborn in the twenty-first century, in which anti-Semitism is alive and well all over the world, in places where they have incidentally never heard of the liberal West's carefully nurtured distinction between anti-Semitism and anti-Zionism. It goes beyond satire into pure anarchy, pure craziness. And it's also very funny.

From the way it is shot, some of Borat's encounters could be staged. I certainly hope that Pamela Anderson's final encounter with Borat happened with her connivance. But the best moments, and that's pretty much all of them, have the unmistakable look of real people really being astonished and horrified by Borat. He hits a comic goldmine simply by going up to male New Yorkers on the streets and trying to kiss them on both cheeks. One screams abuse; another skips away, zig-zagging, hunching his shoulders and flapping his arms at the elbow like a ten-year-old evading a wasp. It is sublime.

Baron Cohen really shows his class when Borat is a guest at a Texan rodeo. He fearlessly strides into the centre of the ring with his mic, loudly praises his hosts' "War of Terror", leads wild cheering when he expresses the hope that Iraq is bombed so that even the

lizards are killed, but then with magnificent effrontery allows his audience to suspect they've been duped by singing a transparently absurd "Kazakh national anthem" about potassium production to the tune of *The Star-Spangled Banner*. The sheer miasma of wrongness and unease that washes over the crowd causes a young cowgirl demonstrating horse-riding techniques to lose her concentration and fall off her horse at the end of Borat's song: a brilliantly surreal moment.

The fascination of Borat's comedy situationism, his theatre of cruelty, is that its hero is deeply unsympathetic. Ali G had a kind of goofy charm, but Borat is just so horrible, with a deplorable quality mitigated only by his ineffectuality. *Borat 2* must surely now be in the works: perhaps a face-off with a rival TV star from the hated neighbouring republic of Uzbekistan? (Will Ferrell? Jonathan Pryce? Stephen Merchant?) Like Freddy Krueger, that living nightmare on bad taste street, Borat will surely be back. Fools don't come unholier than this.

BLADES OF GLORY

6/4/07

★ ★ ★ ☆ ☆

Fratpack comics Jon Heder and Will Ferrell have had some dodgy outings in the past year with, respectively, a terrible *School for Scoundrels* remake and a piece of sub-Kaufman noodling called *Stranger than Fiction*. It's a relief to see them back in this serviceably funny underdog sports movie – the kind of thing that suits them best, or suits Ferrell best, at any rate: big, broad, elaborately detailed comedy characters in the *Saturday Night Live* tradition. They play egomaniac rivals in the narcissistic world of men's figure skating, an arena of sparkly spandex costumes on the ice and foot-stamping tantrums and seething resentments backstage.

Heder is Jimmy MacElroy, an absurdly vain peacock of a skater with a figure-hugging, powder-blue outfit and blow-dried blond hair. He has an appallingly affected routine that involves imitating a peacock on the ice and finally releasing a dove, somehow secreted within his skin-tight getup. His hated enemy is Chazz Michael Michaels, played by the permanently sweaty Ferrell: a skater with a James Brown hairdo and a sensual beer gut, who insists on his own brash brand of bad-boy heterosexuality. He is proud of the fact that he is the only skater to have won Olympic medals and adult movie awards. The two titans of skating fatefully meet when they are forced to share the gold medal position on the podium at the Stockholm championships.

They get involved in a queeny brawl after much pushing and shoving and shrill demands to "scoot over". Because of the disgrace, Jimmy and Chazz get a lifetime ban. Inevitably, there are the scenes showing these fallen hombres of the ice in their degradation: Jimmy sells skates to little girls in a sporting goods store, and Chazz has to play a wizard in a kids' ice show. Constantly drunk, he reaches his nadir when he throws up inside his giant wizard mask and starts shouting abuse, but has to keep wobbling about the rink to the children's bafflement and growing disgust. Finally, a loophole is discovered. The two guys are not banned from partner-skating.

If they can put aside their differences and skate together in an unprecedented boy-boy combo, they have a chance at redemption. But, as one sceptic wearily remarks: "Isn't skating gay enough?"

Ferrell has already worked the comeback-kid storyline in *Anchorman* and *Talladega Nights*, but with enough gags, comedy training montages and funny secondary characters, it always works perfectly well, even if Heder is always in danger of getting eclipsed by Ferrell, that one-man macho-comedy delivery system. They are both faced with a scene-stealing turn from Will Arnett and Amy Poehler as the creepy brother-sister skating team, Stranz and Fairchild Van Waldenberg, a pampered duo forever trying to introduce inappropriate levels of eroticism into their work and whose professional climax comes with a horrifically misjudged ice-dance creation based on the forbidden relationship between John F. Kennedy and Marilyn Monroe.

There is a steady stream of laughs and narrative interest. *Blades* isn't quite as funny as *Zoolander* or *Dodgeball*, but it deserves a solid score from the judges.

2 DAYS IN PARIS

31/8/07

★ ★ ★ ★ ☆

Nothing sets the alarm-bells clanging in the critic's mind like the realisation that the star has a producer credit. Oh great, he or she will groan. A vanity project. A piece of indulgence that the star's pure clout has managed to get off the ground. Some long-nursed project they've dreamed of imposing on the world since high school. Perhaps it's something from the star's own fantastically delusional "production company", which in the corporate interests of kowtowing to the talent, has been given office space on the studio lot. Or maybe the film itself is something which the studio has, with clenched teeth, agreed to release as a condition for securing the star's continued participation in the lucrative action franchise that has made his or her name.

I can never think of the star's producer credit without remembering the passage in Hollywood producer Art Linson's memoir, *What Just Happened?*, where he has to tell an air-head pretty-boy star that his ugly new pseudo-intellectual beard has to be shaved off before filming can commence. The star/producer credit is a little like that beard, and has plenty of journalists grumpily reaching, as it were, for their razors. And I have to confess I was reaching for mine when I settled down to this movie, starring and co-produced by Julie Delpy. It is the story of a French woman and her American boyfriend, played by the saturnine Adam Goldberg, experiencing a fraught and life-changing couple of days together in Paris. There is, of course, an all-too-obvious parallel with Delpy's performance in the great Richard Linklater romances *Before Sunrise* (1995) and *Before Sunset* (2004), in which she played opposite Ethan Hawke, supplying some of the semi-improvised dialogue.

And it really did look at first as if Julie Delpy was just trying to clone that movie's reputation for a project of her own. But wait. As well as starring and producing, Delpy has written and directed the film; she has edited it and composed all the original music, and even contributed a family member: her father, the seasoned actor

Albert Delpy, puts in a hilarious turn more or less playing himself. *2 Days in Paris* turns out to be a very likeable, smart, offbeat film that, though not as emotionally telling as those Linklater films, and burdened initially with some silly affectations, is arguably funnier, and is certainly a technically accomplished, well carpentered piece of film-making.

We join the story as Delpy and Goldberg, playing Marion and Jack, return from a naggingly unsatisfactory romantic break in Venice and are about to spend a couple of days in Marion's family home in Paris before heading home to New York, where they have exemplary media-artistic careers; she is a photographer and he is an interior designer. For Jack, the nightmare is to meet Marion's parents for the first time, as he undergoes the embarrassment-Calvary of staying with her in her childhood bedroom.

Marie Pillet and Albert Delpy, playing Marion's impossible parents Anna and Jeannot, are terrifically funny. Jack witnesses a bizarre row between Marion and her mother, who has been looking after Marion's cat; she has discovered that her mother has been feeding it *foie gras*, thus rendering it morbidly obese. And Jack is very far from being a success with Jeannot, the ageing swinger-radical and bohemian, who scarcely troubles to conceal his contempt for the uncultured Yank.

The nightmare of dealing with his girlfriend's mum and dad is merely a curtain-raiser to a new problem. Jack is chagrined to discover that Marion has cheerfully shown her family an intimate photograph that she took of him on holiday, in a certain posture, and to his horror he finds a photograph of an old boyfriend of Marion's in precisely the same pose. This disclosure, coupled with her suspiciously warm encounter with old boyfriends on the street, ignites his paranoia that Marion is simply a serial monogamist, and that he is merely an exotic American conquest to be imminently discarded.

As well as Richard Linklater, *2 Days in Paris* is indebted to middle-period Woody Allen, and in fact Delpy sports a clunky pair of specs at the beginning of the film, which suggests she might be hinting at the comparison herself. There are family lunches and encounters at parties, in which Jack is called upon to explain and explain away his Jewishness, and there are encounters on the street with former

sexual partners: encounters managed with no little drollery and sophistication. It is derivative, of course, and yet relaxed and stylish and charming. The only aspect of the film that tries the patience are the studied narrative voiceovers that Delpy goes in for at the top of the movie, illustrated with supercilious still-photo images in the *Amélie* style. But these quickly fade out.

What an eye-opener the film is. The time has come to stop patronisingly thinking of Julie Delpy as a blonde actress, and start giving her some respect as an auteur. She is now reportedly working as writer-director-star on *The Countess*, a movie about the notorious Blood Countess Elizabeth Bathory. Vincent Gallo is a co-star. The time was when my heart would sink into my boots at this news: but now I'm looking forward to it.

YOU, THE LIVING

28/3/08

★ ★ ★ ★ ☆

When Ingmar Bergman died in July last year, the soul-searching and breast-beating began on the subject of whether there was anyone who could possibly take his place. There isn't. Why should there be? At the time, though, I made a muted and qualified proposal that one candidate has a sliver of something little noticed in Bergman: his sense of humour. This was the Swedish film-maker Roy Andersson, whose poignant and hilarious movies – like a hypnotic succession of sumptuously mounted Beckettian tableaux – take him an enormously long time to fund and produce. The last was *Songs from the Second Floor* in 2000 and now this, premiered at last year's Cannes film festival.

His films are profoundly different from the work of any other film-maker, and in a different league from most. There are extraordinary visions of lost souls adrift in worlds that I can only describe as resplendent with vivid, hyperreal drabness. The people are loosely interconnected, some of them anyway, and everywhere there is the disquieting sense that we are witnessing the last hours of a doomed world. The final sequence shows a fleet of bombers breaking cloud-cover and apparently intent on destroying everything and everyone we have just seen. Everything is bathed in the distinctive, weird greeny-grey light, as if reflected from an aquarium just behind the camera. It's a light that picks out lines with crispness: the lines being mainly those etched on the characters' careworn faces.

There are miserable men and women of all shapes and sizes, caught in a kind of sleepwalker's pause: their dialogue has a stymied, stricken quality. Andersson's camera rarely moves; it is established as statically as a painter's easel and the resulting pictures look like something by Hopper or Vermeer or maybe Gary Larson. There are long, rectangular perspective lines; we see tatty rooms and seedy bars and gloomy streets, whose endlessly receding angles make them look like chambers of some refrigerated hell.

"Painterly" is an overused adjective for films, but here's one where it makes sense. The static set-ups are composed as intricately as paintings, and I don't know of any film-maker whose work gives the viewer so much incentive and indeed leisure to examine the background of a shot. Andersson's films allow you to appreciate production design and art direction. In any scene, it is a secondary but real pleasure to let yourself gaze out of the window at the back of the room to the distant, exotic imaginary cityscape beyond: this is sometimes a painted backdrop, sometimes apparently not. An open door might lead to a second, mysterious, partly glimpsed room, from which stunted characters will briefly appear – and you find yourself craning your neck to see more.

You, the Living is a very funny film – though in the darkest possible way. It is a silent comedy, but with words. There are some old-fashioned sight gags and silent routines: for example, one sequence shows a hapless man in a railway station trying to decide which ticket window queue to join. The movie's central, outrageous set piece comes when a van driver recounts his nightmare about trying the traditional cloth-pulling stunt. He has somehow found himself at a grand dinner party whose posh guests, for some reason, stand back and allow him to try pulling the cloth off a table fully laden with antique chinaware. He is sentenced to death by electrocution for the predictably calamitous result. We follow the action through in a series of slo-mo deadpan scenes from the dinner party to the electric chair.

The weird, misty locations and huge, elaborately built sets look very similar. Interiors and exteriors are all of a piece, and give the film a giant, intimate-epic quality that is more impressive than any CGI, although some of the most startling effects must surely have been created, or at least assisted, digitally. The most remarkable is another dream sequence. A lovestruck rock-chick, hopelessly swooning over the guitarist and lead singer of a band called the Black Devils, imagines that she has got married to him and they are honeymooning in his apartment – in an apartment block which is travelling through the countryside like a train and pulls into a station where a vast, cheering crowd is celebrating their wedding. It is an extraordinary achievement technically, and inexplicably very moving. It also reminded me of a routine by the comic Steven

Wright about accidentally inserting his car keys into his front door and starting up the whole building.

Andersson takes his title from lines by Goethe: "Be pleased then, you, the living, in your delightfully warmed bed, before Lethe's ice-cold wave will lick your escaping foot." "Lethe" is the destination of a tram glimpsed in a typically enigmatic scene. Those lines have the gloomy compassion and northern European black humour that permeates Andersson's films. Are these people actually the "living"? Or the demi-zombie dead? Tragically, they cling to the scraps of life allowed to them in this wretched world.

Watching this, I was struck by the hints of Woody Allen and Terry Gilliam that surfaced when I saw *Songs from the Second Floor*, but this is the work of a real original – I might almost say a genius. He is radically different from anyone else, with a technical, compositional rigour that puts other movie-makers and visual artists to shame. And he really is funny.

FANFAREN DER LIEBE: THE ORIGINAL *SOME LIKE IT HOT*

2/4/09

★ ★ ★ ★ ★

This year sees the fiftieth anniversary of what some think is the greatest Hollywood comedy in history, or maybe simply the greatest comedy, or just greatest film: Billy Wilder's *Some Like it Hot*, starring Jack Lemmon and Tony Curtis as two hapless 1920s musicians, on the run from murderous mobsters. They disguise themselves as women, join an all-girl band, Sweet Sue and her Society Syncopators, and find themselves sharing intimate sleeping cars on an overnight train to Florida, where the band has a hotel engagement. Both men are to be entranced by the sexy, yet lonely and vulnerable blonde singer, Sugar Kane, played of course by Marilyn Monroe.

Some Like it Hot is a remake. Billy Wilder took his inspiration from the 1951 German film *Fanfaren der Liebe*, or *Fanfares of Love*, directed by Kurt Hoffman – itself a remake, in fact, of the 1935 French comedy, *Fanfare d'Amour*.

Wilder himself was always vague about how much he took from *Fanfaren Der Liebe*, maintaining he kept the basic, farcical element of cross-dressing musicians, and chucked out everything else. But did he?

There is no video or DVD edition of *Fanfaren der Liebe*, so it's never been easy to check Wilder's claims. But in a few weeks' time, the Goethe Institute in London is putting on a rare screening of this cult item. The truth is that *Fanfaren der Liebe*, though not a patch on its famous Wilder remake, is much more similar than the great man ever conceded, and for anyone who loves *Some Like it Hot*, it is an absolute must-see.

Go and see it, and you will find what I found when I saw it this week: it's a fascinating and even electrifying insight into Wilder's creative thought processes, into the hidden European roots of Hollywood Americana, and into what my colleague John Patterson unimprovably called the "give-and-take, steal-and-fake" tradition of the movies.

Interviewed for the foreword to the German publisher Taschen's massive, celebratory facsimile edition of the screenplay in 2001,

Barbara Diamond, the widow of Wilder's co-writer I.A.L. Diamond, said that her husband never saw the German film and even suggested Wilder didn't either. But Wilder himself said: "There was a German picture before the war" – actually 1951 – "about two musicians who are looking for jobs, and they find jobs in various disguises, Bavarian music, mountain music, by doing music in blackface – we could do that in Germany, blackface – but ultimately they have jobs in a girls' orchestra. From then on, it becomes absolutely new."

Not quite, Mr Wilder! The hugely new thing in *Some Like it Hot* is obviously the 1920s-Chicago-gangster angle, which is not in the German film. It undoubtedly creates dramatic tension and gives the two guys more of a reason for their desperate drag act: their mortal peril, and some previous ogling at women, also clears them of any suggestion of effeminacy. The rest of the film is, however, fascinatingly familiar.

The two musicians in *Fanfaren der Liebe* are Hans (Dieter Borsche) and shorter, plumper Peter (Georg Thomalla), who are, respectively, the Curtis and Lemmon characters, but much more conventionally straight-man and funny-man.

Work is scarce and they have to disguise themselves in two bizarre situations before the actual gender-bending opportunity comes along. First they dress up to join a gypsy band and then – yes, I'm afraid so – they black up to join a band called Big Fletchit, a name with unfortunate echoes of Stepin Fetchit. (Wilder misremembered the mountain and Bavarian bands.)

They join the girls' group through the same financial need – though a tough guy in the street actually says that our wimpish heroes look like a couple of girls – and the band are called primly "Cyclamen": pretty tame compared with Sweet Sue and her Society Syncopators, and the Germans have nothing to match Sweet Sue's acid wisecrack about all her girls being "virtuosos".

But the night-train journey is here: to Munich, not Florida, and is actually made slightly more complex by Hans changing back into his male garb to have breakfast in the restaurant car, and to flirt with the ensemble's dark-haired lead singer, Gaby, played by Inge Egger. She is a very sobersided and pretty dull figure compared with Marilyn – almost like a straight female romantic lead from an Abbott and Costello movie. She has no drinking problem and, in fact, coolly sees through their disguise relatively quickly, with almost sisterly bemusement.

There's a sexy blonde in the German band, though, and the camera rather lingers on her – did that plant a seed in Wilder's mind? Once in Munich, the bandstand and nightclub sets look very familiar.

The gag about an older, unattractive guy finding them sexy is in *Fanfaren der Liebe*, too, only there is no Osgood Fielding III figure; rather, the smitten male is the band's manager, Herr Hallinger (Oskar Sim), for whom the *SLIH* equivalent is Beinstock, Sweet Sue's harassed and only faintly lecherous sidekick. Weirdly, Hallinger falls for Hans, the straight man, whose lean, drawn face reminded me a little of George VI. The more obvious and, as Wilder clearly saw it, the more successful choice would be for the lovestruck dope to moon around the ugly comic turn. *Fanfaren der Liebe* has the two men perpetually coming out in their men's clothes, posing as the girls' supposed brothers, though Wilder evidently didn't care for this Shakespearean confusion and farce.

For *Some Like it Hot* fans, watching all this is like going into a parallel universe. It's a cultural séance: like going back in time and seeing it the way Wilder did, or like having Wilder's ghost sitting next to you. As you notice the differences and similarities, you can see how his mind must have worked, you can hear him thinking in real time: "Yes, not bad … but why not change that … let's switch that around and keep that … That would work better if we …"

Fanfaren der Liebe has a few specific Hollywood references. When Gaby tells her friend that she is meeting a man, she jokes that it's "Bing Crosby". A phoney Cary Grant evidently worked better for Wilder. At one stage, Hans is shown reading a copy of *Life* magazine with a picture of Rita Hayworth on the front.

But it has to be said: without the Chicago gangster angle, the story flags once the band have reached the Munich hotel. Just as I was thinking this, while watching the film, one of the bandmembers asks wonderingly about the two weirdly butch new girls. "Who are they?" she says. "Are they gangsters' molls?" Eureka! There, right there, you can see how and where Billy Wilder got his crucial idea.

Fanfaren der Liebe is a musical comedy with gaiety and fun, perfectly decent but destined to forever be overshadowed by the greater achievement of Wilder. But what a tremendous experience it is, an unmissable lesson in creativity and film history.

BRÜNO, THE GAY NEWS TRIAL AND ME

8/7/09

★ ★ ★ ★ ☆

Once again, events in the film world have supplied me with another not-especially Proustian rush back into the past. Sacha Baron Cohen's very funny new film *Brüno* has an aggressively gay hero who uncovers various dark strands of homophobia in modern America. If anything typifies the way in which things really have changed in British public life over the past thirty years, it is surely our attitude to homosexuality, and now even the Conservative leader is offering a *mea culpa* on the issue of Section 28. David Cameron said: "We got it wrong. It was an emotional issue. I hope you can forgive us." I can imagine Brüno rasping that sentence in his heavy mock-Viennese accent.

Weirdly, the film, with its in-your-face gay gags, brought back memories of the first thing I ever had published in a newspaper. It was in the summer of 1977, and it was a letter to, erm, *The Daily Mail*. Perhaps I should qualify this somewhat. It was a letter to the *Junior Mail* letters section that appeared in that paper on Saturdays, intended for letters from kids. And my letter was about Mary Whitehouse and her private prosecution of *Gay News* and the subsequent blasphemy trial. *Gay News* was fined £1,000 and the editor, Denis Lemon, received a fine of £500 and a nine-month suspended prison sentence, subsequently overturned on appeal. It was a key moment in the 1970s that doesn't get remembered much: the nasty, unfunny, depressing, vindictive and bloody awful 1970s.

I left the cinema after *Brüno*, took the underground to the British Library's newspaper archive in Colindale, and in a spirit of masochism ordered up the *Mail*'s microfilm roll for July 1977 and re-read my earnest letter about *Gay News* for the first time in thirty years. Here it is, in all its stately glory, under the headline: "I call this censorship".

After reading of the recent court case involving the publication by *Gay News*, the newspaper for homosexuals, of a poem describing a Roman centurion's love for the body of Christ, the only aspect of the whole affair which disgusted me was the fact that officious busybodies like Mary Whitehouse can still manage to invade the

freedom of the press in Britain in this way. As I see it, *Gay News* has every right to publish their poem, just as the British citizen has every right to agree or disagree with it. The poem's suppression smacks of Stalinesque censorship. Yours, Peter Bradshaw (aged 15)

I shall complete the agony by revealing that I received a postal order for £1, which I rushed out and radically spent on the Sex Pistols' single *God Save the Queen*, with the famous picture sleeve. The letter is of course fantastically callow; I'm not sure what "agreeing" or "not agreeing" with a poem exactly means, and, though I like to think that the *Mail's* subs added that explanatory line about *Gay News* being a "newspaper for homosexuals", I have a horrible feeling that I wrote it myself. Perhaps this is something else that would benefit from *Brüno* reading it aloud.

Maladroit it may have been, but I have to say that I was and in fact still am rather proud of having done this. In fact, it is one of the few things that I did as a teenager that doesn't cause me to cringe with horror. Speaking up for gay rights was not a particularly common occurrence in those days, even on the left, and certainly not in newspapers. *The Daily Mail* appeared to tolerate this sort of thing in the kids' section – I don't think my letter would have got into print had it been addressed to the grown-ups' pages. Web 2.0 didn't exist in those days; if it did, my letter might have been circulated and I could, I guess, have been bullied at school. As it was, my letter became chip paper like everything else and no one had the smallest clue that I had written it.

But oh God, how awful the *Gay News* trial was: one of the meanest, nastiest, pettiest things ever to have occurred in British public life, and one of the unfunniest things about that remarkably unfunny decade. Francis Wheen wrote that if the 1960s were a wild weekend, and the 1980s were a hectic day in the office, then the 1970s were a long Sunday afternoon and evening: filled with boredom and vague, nagging dread. The *Gay News* row epitomised the sheer loathsomeness of the time, a *Life on Mars* that was no Life at all. Graham Chapman was a friend and investor in *Gay News*, and the experience undoubtedly spurred him on to help create Monty Python's *Life of Brian* and generally stick it to the Christian right.

How glad I am to be living in the era of *Brüno*, and not the pinched era of Mrs Whitehouse and the *Gay News* trial. In pop cultural terms, we've never had it so good.

BRIDESMAIDS

23/6/11

★ ★ ★ ★ ☆

Through an act of karmic rebalancing, or cosmic reparation, the universe has made amends for *Hangover Part II. Bridesmaids* is a terrifically funny, smart and tender ensemble comedy starring its co-writer Kristen Wiig, and it pulls off the remarkable trick of being brutal and gentle at the same time. The full horror of being a bridesmaid is shown, but Wiig persuades you there is something genuinely loving and sisterly to be found at the end of this incredible ordeal.

A good deal has now been written about *Bridesmaids* being at the vanguard of a new feminist revolution in Hollywood comedy – a sorpack to go with the fratpack – and how, before this, women were marginalised or treated as second-class turns in Hollywood, a theory that holds up if you discount the colossal commercial success of the *Sex and the City* movies. It's certainly true the comedy of Rogen, Ferrell, Carell et al has been very laddish.

So there is something in *Bridesmaids* that is particularly interesting: how it offers a male, or male-seeming dimension that is not featured in all the other sugary girly-romcommy treatments of engagements, bridal showers, wedding ceremonies, etc: the world of status-envy and career-disappointment. It is the women's relationship with each other, and not with men, that is central. So what is dramatised in these characters is not the traditional single-girl qualities of vivacity or demureness, comically flavoured with man-pleasing sexiness or anxious self-doubt, but the bridesmaids' competitive sense of themselves as successful or otherwise: at home, in business and in the wider world. And what's important to social success is not romance, exactly, but marriage.

Wiig plays thirtysomething Annie, who in early middle age has woken up to find herself a failure. Her bakery business, in which she invested all her money, has gone broke; she has to walk past the boarded-up premises on the way to a terrible job in a jewellery store in which she cannot help but warn couples buying engagement

rings that love won't last. There is a magnificent scene in which Annie finds herself in an argument with a teenage girl who wants to buy a necklace reading "Friends for ever". She herself is single, in a demeaning "fuck buddy" relationship with Ted, played by *Mad Men*'s Jon Hamm. The only real thing in her life is her single friend Lillian (Maya Rudolph) who tells her she is getting married, and that Annie is to be maid of honour.

Annie must whoop and hug with delight, but Wiig shows that, in her heart, she is horrified at Lillian's disloyalty at leaving her behind in the dismal pit of spinsterhood. She instantly takes a dislike to one of the other bridesmaids, Helen (Rose Byrne) a wealthy, Martha Stewart superwoman who presumes to organise everything and to believe herself a better friend to the bride-to-be than Annie. Poor Annie has nothing in common with the motley crew of bridesmaids, and the traditions of being a bridesmaid are soon revealed to her not as a festival of love, but a theatre of cruelty, dominated by envy, unhappiness and fear.

Wiig hilariously dramatises Annie's desire to make the bridesmaids' parties and functions operate down at her own unmoneyed level – through an ambiguous need to rebuke smarmy Helen for her wealth and snobbery, or possibly just to wreck the whole thing. Just before the women visit an impossibly *chi-chi* boutique to have their expensive bridesmaids' dresses fitted, Annie insists on taking them to a dodgy Brazilian restaurant, where they pick up a dose of food poisoning, with horrendous results.

Annie is perpetually finding herself at posh engagement parties and social functions where she is financially out of her league. Mocking and laughing at it all – the sort of joke she crucially used to share with Lillian – is now quite unacceptable and inappropriate, and Wiig shows how desperately lonely and resentful Annie is becoming. There is a nice running gag in which Annie will find herself standing next to men, total strangers, and the people to whom she is introduced, steeped in the ideology of coupledom, keep assuming that she is "with" this embarrassed, random man.

To be a bridesmaid is to be a failure: that seems to be the awful truth. Something about someone else's impending marriage makes the bridesmaids' existences seem second best, and even the married bridesmaids – those who have attained the great prize – instantly

become disenchanted with their life choices. A gentle, almost childlike bridesmaid confesses her discontent with never having sex. A bridesmaid mom confesses her horror at sharing the house with three lively teenage sons ("There's semen everywhere. One blanket actually cracked") and at her husband's banal, insatiable conjugal needs: ("I just want to watch the *Daily Show* once, without him entering me"). Annie's own sense of failure, amplified and accelerated by the intolerable humiliation of being a bridesmaid, threatens to poison everything, including a promising new relationship with a nice cop, played by Irish actor Chris O'Dowd.

Obviously, *Bridesmaids* does resemble the *Hangover* template a little: one Bridesmaid, Megan (Melissa McCarthy) is in the Zach Galifianakis role. It's not exactly groundbreaking, but what's striking is how fresh and unusual the comedy looks. Offhand, the only recent point of comparison I can reach for is Jonathan Demme's 2008 movie *Rachel Getting Married*. As for Wiig herself ... well, some obvious wordplay suggests itself on the subject of how she has always been the supporting player but never the lead. Well, this movie has made her a star. It is her special day.

TED

2/8/12

★ ★ ★ ★ ☆

Britain's current Olympic mood – generous, wholesome and healthily upbeat – is very wrong for this film. Seth MacFarlane, the creator of TV's *Family Guy*, has co-written and directed a stoner fantasy comedy which is cynical and lethargic, sour and dour; it is misanthropic, crass, facetious, offensive, immature and very funny. *Ted* is about a grown man's relationship with a non-imaginary imaginary animal; it is quite without the sympathetic, redemptive notes of films such as *Harvey* or *E.T.* or the *Toy Stories*, movies to which it would not dare or bother to compare itself. However, compared to *The Beaver* starring Mel Gibson, the tale of a menopausal executive who speaks to a hand puppet, *Ted* is a watercolour exercise in whimsical charm.

Stolid, easygoing Mark Wahlberg stars as John Bennett, who as a lonely and unhappy child growing up in 1980s Massachusetts made a poignant Christmas wish on a falling star. He yearned for his teddy bear, named Teddy, to come to life … and so it did. We see the process of Teddy becoming a national sensation with TV appearances on Johnny Carson, but before you know it, they are both grown up, and Teddy has become curtly abbreviated to Ted (voiced by MacFarlane). He's a has-been, an ex-celebrity, depressed and foul-mouthed, addicted to casual and demeaning sex, smoking weed with his feckless buddy John on the couch at nine in the morning, or in the park, and complaining that he feels like one of the cast members of *Diff'rent Strokes* – "You know, the live ones." As for John, his adulthood has been catastrophically impaired by loyalty to his friend, the way the mental age of famous people is frozen at the age at which they became famous. He is working for a boring car-hire company, but is living with a beautiful, ambitious and very tolerant career woman, Lori (Mila Kunis), who is sick of sharing her man with a talking toy bear. Soon it will be time for John to make a big life choice. Either Ted goes – or she does.

It might be a stretch to claim that *Ted* is a satirical commentary on the infantilised state of Western male culture, because it is not so much a satire as a cheerfully and unironically supportive celebration. *Ted* could, with some script tweaks, be read as some sort of M. Night Shyamalan-type mystery, or a wish-fulfilment tale of males somehow finding a way to let their id cathartically speak out, loud and proud – though here again we are straying into Gibson/*Beaver* territory.

Actually, it is probably simply another example of the nostalgia to which screen comics are prone: the nostalgia for the student or ex-student days of messing around, talking about stupid TV shows and pop culture and having fun – the playful atmosphere from which their deadly serious vocation of comedy originally sprang. It is the same mood as that in *Old School*, or *Knocked Up*, or *The 40-Year-Old Virgin*: a man-boy world of guys who accept the future necessity of working for a living and want to escape it. A toy bear toils not, neither does it spin, and so exercises an awful fascination.

In *Ted*, MacFarlane includes a derogatory reference to Adam Sandler's appalling comedy *Jack and Jill*: and of course how could any reference to that film be anything other than derogatory? Yet there are Sandlerisms here. The poster showing John and Ted at the urinals is very like that for Sandler's foster-father comedy *Big Daddy* (1999), and in fact the knowing, goof-off mood is reminiscent of Judd Apatow's interesting film *Funny People*, about the emotionally paralysed life of a madly successful Hollywood comedian.

This unfolds in a series of vignettes without all that much in the way of an important narrative arc, and I admit Mila Kunis's role is a pretty thankless one. But in its shamelessly incorrect way, it is very funny. I enjoyed Ted and John's bizarre exchange on the subject of white-trash names, their final falling out, and the subsequent brutal and extended fight in a hotel room. This film may well be dismissed by some with the phrase "comedy is very subjective", a phrase traditionally used by pundits to mean: "This is absolutely and objectively unfunny but I am far too wearily mature to argue about it." In my experience, comedy is subjective, but no more so than anything else. *Ted* has nothing much to offer in terms of subtlety and sensitivity, but there are plenty of laughs.

THIS IS 40

14/2/13

★ ★ ★ ★ ☆

How interesting to compare the title of Judd Apatow's midlife comedy *This is 40* with his first feature – *The 40-Year-Old Virgin*, which famously starred Steve Carell as the tragically inexperienced nerd. The whole idea of not having done it by the age of forty looked like an outrageous and bizarre fantasy. Yet maybe we were misreading it. This new film shows how Apatow's debut could actually have been a through-the-menopausal-looking-glass parable. In *This is 40*, not having sex at this age is a brutally real experience, a depressing kind of reconstituted virginity for married types who increasingly find themselves too exhausted for sex, and too guilty and loyal for the extramarital sex of their daydreams.

It certainly looks like personal work. Forty-five-year-old writer-director Apatow has cast forty-four-year-old Paul Rudd as a harassed and likeable middle-aged guy in showbusiness called Pete, still boyish and open and funny despite the advancing years. He has cast his own wife, Leslie Mann, in the role of Pete's wife, Debbie, and his own daughters Maude and Iris Apatow as Pete's young children Sadie and Charlotte. The ingredients are in place for a very enjoyable, smart, fluent comedy with wittily managed moments of sadness and bittersweet regret.

This stressed couple resent how parenthood has made them snappy with each other and are currently swallowing their anxiety and dismay at the approaching big chill and the big four-oh. Pete and Debbie are in fact the same characters, a few years on, from Apatow's 2007 comedy *Knocked Up* (the children are the same, too, grown up a bit). Debbie is the controlled and self-possessed sister of the glamorous Katherine Heigl, who was improbably made pregnant by a slacker played by Seth Rogen. Rogen and Heigl do not appear in this film, which is odd, but makes it easier to take as a standalone item. From the first scene it hits the ground running; buzzing with the same neurotic, self-conscious energy that is eroding the happiness of its lead characters.

Atypically, Pete and Debbie are first shown having sex: wild and passionate sex in the shower, and yet the marital bliss this appears to show is soon shattered. The fortieth birthday of each hangs over them like a much-feared diagnosis, and Debbie is horrified by the surprise present that Pete turns out to have given her. He is facing up to the big number, but she has decided, for personal and professional reasons, to admit only to thirty-eight.

Leslie Mann shows how Debbie's borderline-OCD tendencies have been accelerated by the imminent horror. She is making her husband eat properly, insisting on healthy salads and cracking down on the cupcakes he loves, despite the fact that he doesn't appear to be putting on weight. Apatow adds to the dysfunction-portrait by making Debbie a secret smoker, puffing furtively out of an open window: she uses washing-up gloves and various breath- and air-freshening devices, an array of secret equipment like a bulimic or self-harmer. Meanwhile, Pete has increasingly withdrawn from family life by retiring to the lavatory for long periods to play online games on his iPad: he and his daughters are addicted to their computer devices. Pete is in denial about the financial crisis of his indie record company, which is bringing out new releases from old rockers, and Debbie about the similarly dire figures figures for her clothing boutique. She is also upset about a fibroid that her gynaecologist says is as big as the boulder in *Raiders of the Lost Ark*.

Apatow brings in two tremendous minor characters to add to everyone's dismay: Pete's feckless and sponging dad Larry (Albert Brooks) and Debbie's absent and blank-faced father Oliver (John Lithgow), both of whom now, disconcertingly, have second marriages and young families. Brooks and Lithgow give superb performances.

With this movie, Judd Apatow shows again that he is interested in a certain kind of male melancholy which can only be evoked by summoning up the music of his youth. In his 2009 comedy *Funny People*, it was James Taylor, playing *Carolina in My Mind* at a cynical corporate gig; here, gloriously, it is Graham Parker & The Rumour, the British post-punks on whom Pete has very rashly bet the farm. This is an exquisitely chosen band for Pete to like and a knowingly quixotic act of cultural retrophilia on Apatow's part: they are a group whose madeleine effect will work on a worryingly small number of people. Only a massively successful Hollywood figure like Judd

Apatow could give this band such an appearance; retrieving them is his rich man's caprice, which he has fictionally transformed into something financially catastrophic.

Of course, beneath the cynicism and worry, there is a reliable bedrock of sentimentality, and rather like Nancy Meyers, Judd Apatow takes his characters' material prosperity rather lightly. But this is terrifically assured work from Judd Apatow. And most importantly, funny.

PAIN & GAIN

29/8/13

There's something inspired about putting Michael Bay in charge of a brazen action-comedy about gym-pumped knuckleheads who screw up their own criminal masterplan most royally. Bay is Hollywood's biggest alpha-bull; this time he gallops through the china shop to entertaining effect. *Pain & Gain* is too long, and sometimes behaves as if it doesn't get the point of its own comedy, but there's plenty of zing. The story itself reads like something Florida thriller-writer Carl Hiaasen might have dreamed up; actually this is a true-crime case, based on an article by *Miami New Times* journalist Pete Collins. It's a tale from the roaring 1990s, and is shot in an archly 1990s pulp-fiction style. Mark Wahlberg is Daniel Lugo, a preening Florida bodybuilder, personal trainer and former conman obsessed with motivational fitness and realising the American dream by getting rich quick. Anthony Mackie is his buddy Adrian Doorbal, and Dwayne Johnson puts in an unexpectedly funny turn as Paul Doyle, the born-again Christian ex-con who joins the other two in a crazy scheme to kidnap a client and force him to sign over his assets. Bay shows how the three stupid amigos are always wired on an explosive cocktail of steroids, cocaine and inspirational "personal growth" rhetoric. It's all just chaotic enough to be true. The movie needed some more detachment – and brevity – but Wahlberg shows once again he has the comedy chops.

ENOUGH SAID

17/10/13

★ ★ ★ ★ ☆

As Etta James might say: at last. A romantic comedy that is romantic and funny and not simply an insult to the intelligence of all carbon-based life forms. Nicole Holofcener's *Enough Said* is a step up for this director, in whose previous work I have sometimes heard a few false notes — inaudible, I should however confess, to many others. She has created a thoroughly likeable and genuinely funny film and its stars, Julia Louis-Dreyfus and the late James Gandolfini, are a revelation, singly and together. Like their director, they unassumingly but decidedly took it to the next level on this movie. The fact that Gandolfini still had so much to offer as an actor is desperately sad.

Enough Said is about what love means in middle age and what it means to decide that some other divorced person is The One, or rather The New One, when the rational side of you knows that this person must surely be culpable, at least in part, for the death of their previous relationship. They must have awful habits that sunk the first marriage — habits that will only become clear once you have made a commitment to them. And by the same token, you too must have relationship-killing tendencies. Is the triumph of hope over experience a viable thing to wish for, the second time around?

Louis-Dreyfus plays a physical therapist called Eva, while Gandolfini is Albert. They meet at a swanky party and there is a connection: both are divorced and facing the same kind of loneliness; each lives with a grown-up daughter who is about to leave home for college. But the comic frisson that sparks the film into life is something that predates this scenario — it's the initial hallucination or optical illusion: when Elaine Benes met Tony Soprano!

Holofcener is clearly aware of the baggage these actors bring to the movie, and even playfully pre-empts and undermines our expectations by making Albert an archivist in an audio-visual library of TV classics. He supervises a viewing area where people watch TV gems on video with headphones. Albert can recite what was on TV

on any given day in the 1970s but says, tongue in cheek, that he is not interested in contemporary TV.

In fact, *Enough Said*'s great second-act plot development has a Seinfeldian ingenuity, and the comic discomfort surrounding a vocal tic of Albert's is something Jerry Seinfeld or Larry David might have been proud to have written. In her scene pointing out this appalling tic at a dinner party, Louis-Dreyfus is very funny, with all of Elaine's satirically wide-eyed astonishment and incredulity and theatrically suppressed laughter, but with a new undertow of sadness.

As for Gandolfini, he only becomes Sopranoesque, with that menacing deadness of eye, at a dark stage towards the end, and then not for long. The rest of the time he is quite different, and *Enough Said* brings home how much other directors have been in thrall to his small-screen mobster creation. Even Gandolfini's performance in Andrew Dominik's *Killing Them Softly* opposite Brad Pitt, though a great piece of work, was an obvious variation on the Soprano theme. But here he seems reserved, droll, self-deprecating, a thoughtful and even cerebral figure. That trademark Gandolfini mannerism, the laborious nasal wheezing, is almost entirely absent, though Holofcener cleverly alludes to this by having Eva ask him about it in bed. Albert just shrugs and says he broke his nose a couple of times.

Albert and Eva's relationship has to be negotiated within a tricky network of loyalties. Eva knows people like Sarah (Toni Collette) and Marianne (Catherine Keener), who for various reasons are flawed as confidantes. She has her daughter, Ellen (Tracey Fairaway) – but she is about to leave home and is looking forward to emotional independence, and is moreover baffled and irritated at Eva's new quasi-maternal friendship with her best friend, Chloe (Tavi Gevinson). This is not really a supportive female chorus: it is just something making Eva's life more complicated than it already is.

After Nora Ephron, it hasn't been clear who will take over the grown-up rom-com mantle: Nancy Meyers has looked far too escapist, with lovelorn fantasies that seem to exist only for the smugly wealthy. With *Enough Said*, it looks like Holofcener is a contender. This film is a smart and winning story about what is involved in the painful re-illusionment of middle-aged love.

THE WOLF OF WALL STREET

16/1/14

★ ★ ★ ★ ☆

If you can imagine the honey-gravel of Ray Liotta's voice in *Goodfellas* saying: "As far back as I can remember, I always wanted to be a stockbroker" you'll get some idea of Martin Scorsese's new movie *The Wolf of Wall Street*. It's a raucous, crazily energised, if occasionally slightly shallow epic on a familiar subject, conducted in the classic voiceover-nostalgia style with sugar-rush jukebox slams on the soundtrack. I've watched it twice in quick succession now, and though it skirts the edge of cliché, the sheer sustained blitz of bad taste is spectacular. This movie sprints frantically, in the direction of nowhere in particular, like our appalling hero after his first ecstatic toke of crack cocaine. It is based on the memoirs of crooked broker Jordan Belfort who during the 1980s and 1990s enjoyed unlimited amounts of sports cars, drugs and prostitutes, paid for by millions of dupes and dopes buying his fraudulently inflated stocks. Finally, like Henry Hill before him, Belfort has to swallow hard and confront the possibility of betraying his partners to minimise the inevitable jail term.

Leonardo DiCaprio – credited as producer, alongside Scorsese – plays Belfort and his character gets to the end of this long movie having learned nothing, conceded nothing and even physically changed in no obvious way. The vulpine salesman's broad smile is still more or less in place. The comparison with Hill is actually inexact: what Jordan wants to be specifically is rich, and shifting stocks on Wall Street is the way to do it. While Hill luxuriated in the minutiae and details of gangsterdom, and Sam Rothstein gave some feel for what the gambling world was about in Scorsese's *Casino* (1995), Belfort will often stop in the middle of explaining a financial scam, and say that we don't want to hear about anything as boringly technical as this – surely what we want is the naked girls and the wild times, and that's what we get.

It's entertainingly outrageous, and there's a shaggy-dog comic effect in seeing the same nightmare debauch over and over, although

I don't think the coke'n'strippers war stories exactly constitute that critique of capitalism that some pundits have claimed for this film. Perhaps it's not obvious what Belfort has to tell us about Wall Street's decadence that hasn't already been said by Oliver Stone's Gordon Gekko or indeed Tom Wolfe's Sherman McCoy. But what gives the film its unwholesome black-comic fizz, and a measure of originality, is that Belfort never displays any remorse; there is no narrative comeuppance, no rebuke from anyone whose moral authority he recognises. The sulphurous whiff is conjured by his very impenitence. And if we suspect that in 2014 the financial world agrees with former Barclays CEO Bob Diamond that its "period of remorse needs to be over"— well, maybe Belfort is the broker for our times. And he never saw any need for any period of remorse in the first place.

It zooms along, and DiCaprio always looks the part – there's even a touch of Cagney sometimes. Belfort starts getting rich through selling unregulated penny stocks over the phone in a "chop shop": a bunch of guys cold-calling the public from landlines installed in a converted garage, as in Ben Younger's 2000 film *Boiler Room*.

Belfort impulsively hires his neighbour Donnie Azoff, played by Jonah Hill, a nerdy overweight guy with a weird cosmetic dental plate and Donnie becomes his beta-male wingman in the unending conquest of money and prostitutes. Belfort turns his operation into a glitzy firm and holds colossal trading-floor parties with dancing girls like a low-rent Charles Foster Kane. But when the Securities and Exchange Commission and the FBI start taking an interest, he needs to hide the cash through Swiss and British contacts, enabling a cameo from Jean Dujardin as the corrupt banker Jean Jacques Saurel and a glorious appearance from Joanna Lumley as Belfort's "Aunt Emma" with whom he has a wonderfully surreal romantic clinch. Although not a natural comedy player, DiCaprio has a great comic moment when a cheesy infomercial he's shooting is horribly interrupted by the forces of the law.

The best scene comes when the Bureau's dogged, straight-arrow agent Patrick Denham, played by Kyle Chandler, requests a meeting with Belfort aboard his yacht. They have some fascinating exploratory banter with much coded joshing about what a shame it

is that Agent Denham makes so little money. What is going on here? It's a great moment: DiCaprio raises his game and the whole film achieves a new level of tension and complexity.

The Wolf of Wall Street does not quite have the subtlety and richness of Scorsese's very best work, but what an incredibly exhilarating film: a deafening and sustained howl of depravity.

THE GRAND BUDAPEST HOTEL

6/3/14

★ ★ ★ ★ ☆

This delirious operetta-farce is an eerily detailed and very funny work from the savant virtuoso of American indie cinema, Wes Anderson. It is set in the fading grandeur of a preposterous luxury hotel in an equally preposterous pre-war central European country, the fictional Zubrowka. This kind of milieu – the hotel spa or sanatorium occupied by mysterious invalids, chancers or impoverished White Russians – was loved by Thomas Mann and Vladimir Nabokov, but the closing credits reveal that the director has been specifically inspired by Stefan Zweig, author of *Beware of Pity* and *The Post Office Girl*. In fact, the movie's moustachioed star Ralph Fiennes does rather resemble Zweig.

Stefan Zweig, never entirely happy with movie adaptations of his work, might however have been baffled by this personal homage, just as Roald Dahl might have been by Wes Anderson's *Fantastic Mr Fox*. The way that Anderson supersaturates every square inch of his film's intricate fabric, every sofa covering, every snow-capped peak, every word of every sans-serif lettered notice, with loving comedy is something that the author might not have understood or cared for. But Anderson's brilliantly crafted forms are something other and something better than pastiche.

Ralph Fiennes is on glorious form as Monsieur Gustave, the legendary concierge of the Grand Budapest Hotel in the early 1930s: a gigantic edifice in the mountains. It's a cross between Nicolae Ceausescu's presidential palace in Bucharest and the Overlook Hotel in Kubrick's *The Shining*. In fact, the huge and staggeringly realised interiors of the Grand Budapest really have given Kubrick's place a run for its money. It is a superb cathedral of eccentricity, with a gorgeous dining hall the size of a football field, a gasp-inducing canyon of a lobby area, with corridors and rooms encircling an exquisitely ornate galleried central space which is to be the location of an extraordinary gunfight. The hotel looks like something a very

lonely, clever thirteen-year-old boy might have designed while never leaving his bedroom.

Gustave is energetic and exacting, taking a passionate pride in the high standards of his establishment and ruling the staff with a rod of iron. Like them, he is kitted out in a Ruritanian purple livery which matches the hotel's decor. Gustave affects an air of genial worldliness and deferential intimacy with the hotel's grander clientele, and despite the quasi-military correctness of his bearing in dealing with his subordinates, Gustave can also lapse into high-camp familiarity with the guests. Fiennes is absolutely brilliant in all this. I can imagine Christoph Waltz or Dirk Bogarde in the role, but neither would have been as good.

For reasons best known to himself, Gustave decides to mentor the hotel's vulnerable lobby boy, orphan immigrant Zero Moustafa, played by seventeen-year-old Tony Revolori. It is to Zero that Gustave reveals the engine that drives his hotel's wellbeing: his ready, enthusiastic appetite for servicing the intimate needs of thousands of aristocratic old ladies who come back every year. (In choosing to call his lobby boy "Zero", Anderson may have been subconsciously influenced by Zero Mostel, a great pleaser of little old ladies in *The Producers*.)

Gustave's greatest amour is the ancient and cantankerous Madame D, played by Tilda Swinton with wrinkly prosthetics and strange pale-blue contacts to show her near astigmatic blindness. The infatuated Madame D infuriates her sinister son Dmitri (Adrien Brody) by leaving Gustave, in her will, a priceless Renaissance portrait belonging to her family. Gustave is thus to face the family's fanatical attempts to disinherit this counter jumper, involving her butler, Serge (Mathieu Amalric) and Zero's courageous fiancee, Agatha (Saoirse Ronan), who works in the local Viennese-style patisserie. Gustave calls on the assistance of a secret professional society, a bit like Jeeves in *The Code of the Woosters*. There are numerous cameos for all Anderson's repertory players, and many more.

As ever, Anderson's world is created like the most magnificent full-scale doll's house; his incredible locations, interiors and old-fashioned matte-painting backdrops sometimes give the film a look of a magic-lantern display or an illustrated plate from a book. He and the cinematographer Robert D. Yeoman contrive the characteristic

rectilinear camera movements and tableaux photographed head-on. The film has been compared to Hitchcock and Lubitsch; I kept thinking of Peter Greenaway. It makes the audience feel like giants bending down to admire a superbly detailed little universe: I can't think of any film-maker who brings such overwhelming control to his films. Alexandre Desplat's score keeps the picture moving at an exhilarating canter, and the script, co-written by Anderson and his longtime collaborator Hugo Guinness is an intelligent treat. Watching this is like taking the waters in Zubrowka. A deeply pleasurable immersion.

WHAT WE DO IN THE SHADOWS

20/11/14

★ ★ ★ ★ ★

So many comedies are adoringly billed as "dark", forgetting the ancient showbusiness maxim, "dark is easy; funny is hard". Fortunately, this mockumentary from New Zealand succeeds in being both: in fact, it's the best comedy of the year. *What We Do in the Shadows* is directed by its stars Jemaine *"Flight of the Conchords"* Clement and Taika Waititi, who in 2005 was Oscar-nominated for his short film *Two Cars, One Night*. A group of vampires share a house in Wellington, squabbling about the washing up and facing off with a rival gang of werewolves, *à la Twilight*. The rigour with which their hideous and crepuscular world is imagined, combined with the continuous flow of top-quality gags, makes this a treat from first to last. After a while, I was embarrassed at myself for giggling so much. Our heroes are undead gentlemen from central Europe who have escaped problems and heartache in the old country to live in New Zealand. They bite a faintly annoying guy, who duly turns into a vampire and wants to hang out with them, and he brings along his best mate, a really nice non-vampire human bloke called Stu: all the vampires get a bromance crush, holding back from biting him and he is the Bella Swan of this story. But this film reminded me of something else: it is the comedy version of Abel Ferrara's 1995 *The Addiction*. I can't say fairer than that.

A GIRL WALKS HOME ALONE AT NIGHT

21/5/15

★ ★ ★ ★ ☆

Vampire fans, Jarmusch fans and, most importantly of all, cat fans will find something to enjoy in this droll monochrome comedy of the Iranian undead, which comes with music from the Iranian band Kiosk, who have a definite Tom Waits-y groan. It comes from first-time feature director Ana Lily Amirpour, a British-born Iranian who grew up in the US and has imbibed the regulation amount of American movies, classic Americana and consumer culture, including but not restricted to ads for Coke and blue jeans. In the hipsterised vampire genre of Jim Jarmusch and Abel Ferrara, Amirpour has found her own funny, smart expression for teenage-bedroom loneliness, romantic isolation and a kind of perpetual emotional exile. This has nothing to do with *Twilight*, but it is personal, and I suspect almost autobiographical, in ways that aren't too far from Stephenie Meyer. This film is just occasionally a bit too cool for school – but mostly just cool enough, which is very cool.

A lonely, thoughtful young woman in the traditional black veil, played by Sheila Vand, roams the night-time streets of a district in Iran, or a US-Iranian community, called Bad City: it could be on the outskirts of Tehran or Detroit. There is a power plant and an array of nodding oil derricks, but the whole place is weirdly deserted, just as in Jarmusch: the most crowded place is a bizarre plague-pit-type trench full of dead, but undecomposed bodies, past which people walk unconcernedly. It also has something of Robert Rodriguez's *Sin City*.

Her veil is a type of clothing that makes her look, weirdly, as if she is floating. She encounters a brutal, heavily tattooed bully (Dominic Rains) who takes her back to his apartment, thinking she is a prostitute. But the woman, cool and entirely unintimidated, reveals her teeth – and the fact that she is the predator here.

The woman's path is to cross with Arash (Arash Marandi), a moody boy who affects a James Dean style and who has improbably made enough money from gardening jobs to afford a sensational

1950s automobile. His emotional life is invested in his cat, and he is estranged from his father Hossein (Marshall Manesh), a rather ailing and self-pitying figure, addicted to heroin and prostitutes, both of which are supplied by the bully mentioned above.

But fate reverses Arash's fortunes, both financial and romantic, and he finds himself in the woman's bedroom with posters that appear to be classic shots of Madonna and Michael Jackson – but, oddly, not quite. Arash wants to make her a present of earrings and she allows him to pierce her ears with a safety pin sterilised with a flame from his Zippo lighter – a romantic switching of the vampire-vampiree physical relations.

A Girl Walks Home Alone at Night makes an interesting pairing with Desiree Akhavan's *Appropriate Behaviour*, a movie in a different vein but with comparable comic reflexes, about the experience of being a young Iranian-American woman in the States, who is subject to pressure both from secular US society and from her expatriate parents who are wealthy, worldly, but with old-fashioned expectations. Like Akhavan's heroine Shirin, Amirpour's woman has a certain elegant self-possession and a faintly glum calm. One is a heterosexual vampire, the other is a mortal bisexual.

It also reminds me a good deal of *Persepolis* (2007), Marjane Satrapi's inspired autobiographical animated movie based on her own graphic novel – about a girl exiled from Iran in Europe. There is just the same feeling of disjuncture, the sense of freedom that is also unmoored and listless. The veil itself, the tall moving triangle of black, makes you look like a cartoon, a squiggle of black on the landscape. It is not unlike the traditional movie vampire cloak, concealing a world of pain. I found myself thinking, too, of Jafar Panahi's *The Circle* (2000), about the way the cloak covers not just women but a whole male world of suppression and hypocrisy.

Amirpour's vampire is not tormented by the agony of living for ever. She knows what she wants and is not unduly troubled by the existential crisis of immortality; neither is she the heroic underdog of *Let the Right One In* (2008). This vampire victimises and bullies a small child for his skateboard, terrifyingly hissing in his ear: "To the end of your life, I'll watch you …" It's a film with bite.

TONI ERDMANN

2/2/17

★ ★ ★ ★ ☆

Against all odds, the world cinema limelight was comprehensively stolen last year by a sixty-nine-year-old Austrian character actor in an epic situationist romp, who dressed up in a wig, phoney teeth and sometimes dark glasses that made him look like Bingo from the Banana Splits. Towards Christmas, critics who would generally rather hang themselves than be seen praising a comedy were rushing to do exactly this in the case of Maren Ade's fascinating film about a fraught father-daughter relationship, *Toni Erdmann*, making it their favourite. Was this because it was a comedy that was long, in German and at Cannes? Not exactly. I suspect it is more because it is not really a comedy, despite some big laughs – of which more in a moment.

"How ill white hairs become a fool and jester" is the Shakespeare line that occurred to me watching *Toni Erdmann* for the second time, for its UK release. This subversive film suggests that maybe dark hair ill becomes a solemn young person, and, though it is embarrassing and inappropriate for old people to clown around, it is just as jarringly wrong for younger people to affect insufferable seriousness. Yet the film also suggests that comedy and laughs are themselves not necessarily a wonderful, life-affirming thing. They can – certainly in a family context – be a power mechanism, the means of wheedling, needling and passive-aggressive demands for emotional submission.

Peter Simonischek gives a superb performance as Winfried Conradi, an ageing, retired German schoolteacher whose friends, relatives and former colleagues have had to get used to his extraordinary fondness for japes and pranks and joke-shop false teeth. Without the wacky disguises, he has a strong, rather handsome face, but somehow you can see how that face is apt for exaggeration and inflation into a gargoyle; Winfried is a recognisable Jekyll to his alter ego, a hoax dress-up Hyde he calls Toni Erdmann.

At the very beginning, we see him masterminding a retirement concert for a former colleague, in which both he and the pupils are resplendent in Halloween-type horror corpse cosmetics, a giggling

reminder to the retiree that this is just the prelude to death. Winfried has a difficult relationship with his elegant daughter Ines (Sandra Hüller). She is away from the country quite a lot, working as a management consultant in Romania and China, and her return for a family birthday makes their relationship even more frosty.

Put quite simply: Ines doesn't find her dad funny any more. And this long delayed realisation is part of what triggers a mysterious crisis in Winfried, who also senses something unhappy and unfulfilled in her. When Ines returns to Bucharest for business meetings, she is astonished and a little scared to find that her dad has followed her there, like a stalker. He shows up at stylish bars and hotel lobbies, posing as his bizarre businessman alter ego "Toni Erdmann", in a bizarre attempt to … what? Bully her? Make her laugh? Make her cry?

The embarrassment is total: she hurts his feelings by rejecting him, an outcome he was plainly trying to provoke. But his crazy, boundary-crossing silliness unlocks something in her. It cracks her carapace of professional steel, and she winds up singing Whitney Houston in public and hosting a cocktail party in the nude. Hüller's performance is entirely sympathetic: vulnerable, human, in need of love.

It is a movie that has some of the bittersweet comedy of something like Jack Lemmon's *Kotch* (1971) or Alexander Payne's *About Schmidt* (2002), crossed with the confrontational freakery of Lars von Trier's *The Idiots* (1998). Of course, it is a questionable cliché for films to imply that women without children who happen to be doing rather well at their job must be emotionally sterile and unfulfilled. *Toni Erdmann* arguably comes a little close to this. But it subverts the cliché by showing the dysfunctional father making this observation. Would Toni/Winfried have dared undermine his child's professional standing if that child was a son?

Toni Erdmann is a long film. Writer-director Maren Ade has enough material here for an award-winning Netflix series, and sometimes it looks as if she just couldn't bear to lose any of the uproarious scenes and situations that she had devised. But it never loses your attention. The ending almost made me think of Lear and Cordelia. Only it's Cordelia who has to do the carrying.

The films that made me cry

Sad films are very like sexy films, but unlike horror films or comedies, in that the intense physiological reaction they provoke can't be honestly and immediately expressed. Sad moments will cause you to convert a quivering lip and a brimming eye into a cough, just as sexy moments will make you squirm and covertly recross your legs – but in a comedy or scary movie you can laugh or yelp as openly as you want.

Other people are sometimes ashamed of crying, or almost-crying, in sad films because it's often not a classy tragedy they're being moved by, or even an obvious classic tear-jerker they can be ironic about. They are intensely aware they're not crying in some screen version of *Electra* or *Hamlet*, but in some obviously manipulative and crass new film, and the tears might even be triggered just by the syrupy music. Sometimes it might simply remind you of something sad in your own life – arbitrarily, randomly. And there is something difficult about a sad moment that comes at the very end of a film, so you haven't had a chance to clear up the tearful mucussy mess before the house lights come up, and might even, most worryingly of all, snifflingly relapse on your way out. You are in real danger of catching a fellow sufferer's glance and doing a helpless sad smile or shrug as your eyes brim. How mortifying.

Tearing up is a primary response, almost a primitive response, and for critics the risk is that it is witnessed before it has gone through the refinement process of the computer-keyboard, which will result in it being denied completely or melodramatically or ironically upgraded to out-and-out open sobbing.

Having said all this, I have sometimes absolutely cried in a film, and I talk about this in the pieces that follow about *Toy Story 2* and Julian Schnabel's *The Diving Bell and the Butterfly*. There is a self-awareness, sometimes, in crying at films. Often you are not crying at the film but at a memory it has triggered, or the memory of a feeling, or something as inchoate as feeling sad at the sound of an A minor chord. I myself often feel unaccountably like crying at the old British war film *The Cruel Sea*, when British sailors die in the icy depths and from the bridge Jack Hawkins sees them and says helplessly: "There are men in the water just there!" and later says to Donald Sinden in anguish: "It's the war, number one, the whole bloody war!"

All this of course is different to crying at a film on your own, in your own home, in front of the TV or the tablet or the computer screen, and perhaps with a glass of wine to hand the size of a flower vase. In these circumstances, you can be as tearful as you like in front of *An Affair to Remember*, with Cary Grant and Deborah Kerr.

TOY STORY 2

21/1/10

★ ★ ★ ★ ★

This week, *Toy Story 2* is coming back out in cinemas in 3D as a curtain-raiser to the forthcoming release of *Toy Story 3*.

This is the time to return to the endlessly fascinating subject of crying in cinemas, because *TS2* contains what for me is the most lethally tear-jerking moment in any film: it is Randy Newman's song "When She Loved Me", performed by the cowgirl toy Jessie, remembering how her owner forgot about her as she grew into her girly-teenage years.

Go ahead. Watch it now. I dare you.

If you can stay dry-eyed, then you have a heart of stone.

Recently, I wrote about the experience of taking my five-year-old son Dominic to see *Up*, to find how my perception of the movie was altered in a child's presence.

Watching "When She Loved Me" from *Toy Story 2* again now, as a father of a young child, was even more devastating. It gave me what I can only describe as an intense personal epiphany, a sense that I was understanding the terrible truth about that song for the first time. When I first saw it in 2000, I had no children. Re-reading that review I see that I thought that "*Toy Story 2* conjures a brilliant dilemma out of nowhere, making the toys' dependent relationship with children a disturbing analogy to children's fearful relationship with adults. It enacts the child's deepest fear of abandonment, weakness and vulnerability." Well, that's what I thought at the time: that Jessie's song was about the child afraid of being abandoned by the adult.

Now, as a parent, the truth has hit me full in the face. I got it the wrong way around. Jessie's song is about the adult's fear of being abandoned by the child. Your kids will play happily with you while they are babies and toddlers, but they grow up. They don't want to play and be cuddled. They will change and outgrow you. Of course, your relationship with your children has to change; as they become adults it becomes more rewarding. But never again will it have that

complete innocent playfulness, and a part of you will wind up, like cowgirl Jessie, left under the child's bed, forgotten.

Is that too much of a "dark" reading of this moment? I don't know. But I have a weird feeling that I will have to revisit almost every film I have ever seen as a pre-parent, to see how it has changed.

THE SON'S ROOM

25/12/09

★ ★ ★ ★ ★

This beautiful film induces an ecstasy of sadness: it would be an insult to call it a "weepie", and yet weeping is almost the only intelligent response. Nanni Moretti is a director who has become associated with quirky, cerebral comedy and satiric commentary, and so this moving family drama was almost miraculous in its simplicity and emotional power. It won the Cannes Palme d'Or in 2001.

Moretti himself plays Giovanni, the paterfamilias of an educated, well-to-do household in the Italian town of Ancona on the Adriatic coast. He is a psychoanalyst and his beautiful, elegant wife Paola, played by Laura Morante, is a publisher of art books; they have two teenage children – Andrea (Giuseppe Sanfelice) and Irene (Jasmine Trinca). They are very happy, and yet Giovanni is beginning to have the tiniest twinges of doubt about the efficacy of his therapeutic practice. One day, he is forced through semi-sincere professional concern to make a house call to a demanding patient, which means he has to cancel a planned hiking expedition with Andrea; his son goes diving instead, and dies in an accident.

This terrible event's effect on the family is shown by Moretti in what seems like real time. The intelligence and compassion of his actors is remarkable, and for Moretti to have directed them so capably, from his own script, while acting with them himself in the most difficult and intimate scenes, was a remarkable coup.

Perhaps the most satisfying part of the film is its ingenious and wholly unexpected final act: all the more welcome when good endings are so rare in any sort of film. Spoilers will be avoided here – but suffice it to say that some months after Andrea's death the family receives a letter, whose author is to provide a plot twist which resolves the drama and brings closure to the film's characters and audience. It is heartbreaking, sweet and funny all at once. There are few films that one can, without irony, call noble. This is one.

E.T. THE EXTRA TERRESTRIAL

29/3/02

★ ★ ★ ★ ★

The digitally remastered re-release of Steven Spielberg's sublime classic after twenty years is a devastating rebuke to anyone who has presumed to patronise this great film-maker. It is depressing to think of the bogus sophistication and phoney, counter-revolutionary posturing which over the past decade made it acceptable to take this film lightly. I have in the past found myself affecting to deride its alleged juvenilisation of American cinema, and even its supposed manipulative tendencies – for all the world as if the clarity and miraculous power of Spielberg's emotional language was something anyone could do. I just wish I had put my hand in the fire, Cranmer-like, rather than write any of this.

Because *E. T. The Extra Terrestrial* – the story of the little boy from a broken home who befriends an extra-terrestrial creature stranded on Earth – really is a masterpiece. Watching it again is like getting a masterclass in American popular culture. Without *E. T.* there would be no *Toy Stories*, yet the *Toy Stories* with their hi-tech sheen can't match the easy swing of Spielberg's live-action storytelling. Without *E. T.* there would be no *X-Files*, but Spielberg's passionate idealism and faith in the power of love make the cramped, paranoid *X-Files* look ridiculous. Without *E. T.* there would be no *Harry Potter*, but *E. T.* doesn't have Harry's glow of self-congratulation. In the strange and beautiful love story of *E. T.* lies the genesis of Douglas Coupland's vision of Generation X: people in the West growing up in a secular, affectless society, yearning to feel rapture, and looking for love in the ruins of faith.

The strange, ugly little creature itself, with its great cow eyes, hydrocephalic head and Sistine Chapel fingers is orphaned by the departure of his spaceship, visiting earth on some kind of botanic expedition, and he is left stumbling around in the undergrowth. But a happy chance leads him to young Elliot (Henry Thomas) who, unknown to his mother or any grown-ups, takes him in, feeds him, witnesses E.T.'s healing gift, and finally in an ecstatic mind-melding

process, experiences a merging of consciousness with E.T. and a strange and divine state of grace.

Spielberg's "new" scenes reveal much earlier on what E.T. looks like (no need for suspense now) and he retrieves from the cutting-room floor some wacky moments in the bathroom. Henry Thomas gives a performance of remarkable and unadorned sincerity, though it is overshadowed in a way that the director could not have predicted, or indeed approved of, by the tiny moppet Drew Barrymore as his younger sister. Everything and everyone in this movie has become so iconic it's difficult to remember how singular Spielberg's films were then for having no stars – the movie was the star. But this certainly made Barrymore into a star, and was maybe her finest moment, the kind of knowing yet unpretentious child acting which was easily equal or superior to, say, Tatum O'Neal in *Paper Moon* or indeed Haley Joel Osment in the weirdly similarly-entitled *A.I. Artificial Intelligence*. Uncannily adult, yet adorably innocent, it is a marvellous comic turn which never upstages anyone else.

So Elliot and E.T. become best friends, united in their loneliness and vulnerability, and composer John Williams shows his inspiration by unveiling his classic soundtrack theme first in muted, minor variations, a musical foreshadowing of its eventual glorious triumph when the famous phrases blossom in a major key. E.T. learns to communicate from a spelling toy and from watching TV, and ingeniously modifies various household implements into a device for signalling to his "mother-ship": a seance-like activity of automatic writing. He even gets drunk on Coors beer from the fridge, and Elliot channels the sozzled creature's anarchic chaos in his classroom, defiantly freeing the bunch of frogs from their horrible dissective fate: a tough, prototypical stand on animal rights, which Elliot will duplicate when it comes to freeing E.T. himself.

It is in the final act, when the pale and wizened E.T. is dying, that Spielberg produces some stunning cinematic coups. At the precise instant when E.T.'s existence can no longer plausibly be withheld from the adult world, the door is opened to reveal a spaceman – in full NASA rig. It is an unforgettable image. The sinister "Keys" has been tracking E.T.'s presence here and preparing to enclose him in some clinical prison-bubble, yet the "spaceman" moment makes it look like the heartless and ignorant authorities are the real aliens.

Then there is Elliot's final speech to E.T., an inspired moment in Melissa Mathison's script. You simply don't have a pulse if you don't feel your spine tingling and scalp prickling at these lines: "I don't know how to feel; I can't feel anything any more. I love you, E.T."

Spielberg and Mathison's Christian imagery: the sacrifice, the ascension, the glowing heart – all this looks more emphatic than in 1982, but also somehow accidental, and doesn't seem preachy in the C.S. Lewis manner. This is a brilliant film about the alienated and powerless experience of being a child, especially a child forced to absorb the scalding ironies of divorce; it works as a brilliant metaphor for this pain as well being a superb sci-fi adventure. It is a visionary romance – and there have never been many of those.

THE DIVING BELL AND THE BUTTERFLY

8/2/08

★ ★ ★ ★ ☆

There have been plenty of times when I have choked up at a sad film (Nanni Moretti's *The Son's Room*, "When She Loved Me" from *Toy Story 2*) but this is the first time I have twitched off my glasses and openly and unapologetically cried in the cinema auditorium. Having watched it for a second time, I concede this might have been triggered a little too obviously by the melancholy piano score, by the elaborate profusion of old photographs that litter the screen, showing a little boy whose vulnerability is in poignant contrast both to his worldly adulthood and to his later, catastrophic illness, and most emphatically by the unbearable spectacle of an old man in grief: Max von Sydow, playing an ancient father crying for his son.

Nothing in director Julian Schnabel's career so far has anticipated the sweetness, sadness, maturity and restraint of this lovely movie. It is a very moving and deeply satisfying version of the bestselling 1997 memoir by Jean Dominique Bauby, the forty-three-year-old Parisian fashion magazine editor who, at the very height of wealth, health and success was paralysed by a stroke and suffered from "locked-in syndrome". He could hear and see perfectly, but could not move or speak. The thing he could do was blink his left eyelid and, with ferocious effort, learned to blink in a special alphabet-code and by this means "dictate" his extraordinary memoir. Bauby was submerged in a diving bell of physical immobility: that precious, fluttering eyelid was a butterfly of freedom and hope.

Armed with Ronald Harwood's robust screenplay, Schnabel has applied his visual sense to create a distinctive look and feel for his movie, part magic lantern, part hallucinatory fuzz, a watery depth from which float up memories and reveries, fantastical constructions and visions. It is only in the past and in fantasy that Bauby can escape his condition. These images drift past his field of vision, and sequences of almost narcotic melancholy or indeterminacy will suddenly snap shut as we are forced back into clinical reality. Schnabel moves with seamless assurance from Bauby's agonised, bedridden

point-of-view to the third-person camera positions showing us the ruined invalid, images whose objectivity is conditioned by Bauby's fiercely unsentimental sense of self.

He is played by Mathieu Amalric: an actor with one of the most beguiling screen faces: cherubic, ironic, sensual. When a flashback shows him in his pomp, breezing into a fashion shoot, dishevelled and unshaven as only a very celebrated or handsome man can afford to be, he radiates well-being. His story is a terrible demonstration of the fragility of our bodies and our lives. Another flashback shows a "dirty weekend" he tried to have in Lourdes — the location is beyond irony — with his mistress Inès (Agathe de la Fontaine); something in the place's religiosity and piety kills their relationship. A grizzled old trinket vendor and a priest to whom Bauby is later unwillingly brought are significantly played by the same actor: Jean-Pierre Cassel.

Like an infant prince (and his condition is horribly infantilising) Bauby is surrounded by adoring women. His beautiful speech-therapist Henriette is played by Marie-Josée Croze, who has a look of Naomi Watts. Henriette is exasperated and angry with Bauby, as well as being in awe of him — and a little in love with him. Bauby's estranged partner Céline (Emmanuelle Seigner) visits him *en famille* and, to entertain and cheer him up, his children sing a heartrending little song about a kangaroo escaping a zoo by jumping over the wall: a song that artlessly addresses his condition. (This is another Kleenex moment.) Agonisingly, Céline is forced to stay in the room when Inès calls and wishes to talk on the speakerphone; she is forced to "translate" the intimacies Bauby can express to her only through his eyelid.

The emotional centre of the film comes in another memory: when the still-healthy Bauby comes to the apartment of his invalid father Papinou: wonderfully played by Von Sydow. Grumpily, the old man submits to the indignity of being shaved by his son; irascibly, Bauby submits to the emotional discomfiture of being told by Papinou that he is very proud of him. It is a scene whose tacit emotion uncoils in their later, fractured conversations over the telephone: Papinou is of course too frail to visit him in hospital. It is only in their enforced inarticulacy and distance that some intimacy

is possible; the shattering blow of his illness has precipitated a miraculous expression of love.

Amalric is a tremendous screen actor; it may be that his forthcoming elevation to Bond villain in the new 007 film will bring him to a wider audience; I hope it does not caricature his style. This is a wonderful performance. As for Schnabel, it is an exhilarating breakthrough, and for screenwriter Ronald Harwood the movie is another triumph of responsive, creative intelligence.

BOYHOOD

10/7/14

★ ★ ★ ★ ★

Like the fabled Jesuit, Richard Linklater has taken the boy and given us the man. In so doing, he's created a film that I love more than I can say. And there is hardly a better, or nobler thing a film can do than inspire love.

This beautiful, mysterious movie is a time-lapse study of Mason, growing up from around the age of five to eighteen, from primary school to his first day in college. It is an intimate epic: over twelve years, Linklater worked with the young actor Ellar Coltrane, shooting scenes every year with him and other cast members, who grow visibly and heart-stoppingly older around him. The director's daughter, Lorelei Linklater, plays Mason's older sister, Samantha; Patricia Arquette is superb as their divorced single mom, hard-working and aspirational, but worryingly condemned to hook up with drunks and give the kids abusive stepdads. Ethan Hawke – his lean, chiselled face softening as the years go by – plays the kids' feckless and unreliable but charming father, who shows up every few weeks in his cool car. And Mason's own face changes from its young, moony openness to a closed, grown-up handsomeness. It is the face he will learn to present to the world.

In some ways, the movie invites us to see Mason from an estranged-dad's-eye-view, alert to sudden little changes and leaps in height. As an unestranged dad myself, I scrutinised Coltrane at the beginning of each scene, fascinated and weirdly anxious to see if and how he'd grown. But the point is that all parents are estranged, continually and suddenly waking up to how their children are growing, progressively assuming the separateness and privacy of adulthood. Part of this film's triumph is how it depicts the enigma of what Mason is thinking and feeling.

Boyhood is so ambitious and passionate that I can't imagine anyone cranking out another conventional "coming-of-age" picture. That genre now looks to be obsolete. Which is not to say this film is utterly novel: audiences must remember Michael Apted's *7-Up* TV

documentary project. Michael Winterbottom did something similar with his long-gestating 2012 movie *Everyday*, interestingly another absent-father tale, this one of a family left behind when the dad goes to prison. And Linklater got Hawke and Julie Delpy to grow up and grow old in his *Before* movie series. There are other approximate examples: Robert Guédiguian, Steven Soderbergh and Mike Myers have used recycled "flashback" scenes of actors' younger selves from other films. Perhaps the nearest comparison for Ellar Coltrane and Mason is Daniel Radcliffe and Harry Potter – a connection to which Linklater subtly alludes.

But none of these cases really do justice to the substance and completeness of this one thrilling film. The long-term commitment required is such that conventional assessments of "performance" are almost beside the point.

The film director sculpts in time, Tarkovsky said, and Linklater, with no guarantee about how his raw material would turn out, has sculpted this monumental study of a boy. Or maybe it is that he and time collaborated in the sculpting, or that time actually sculpted Linklater and Coltrane. It is a kind of *Bildungsroman* for modern American cinema, conducted at a superbly intelligent, low-key level. All the familiar rites of passage are here, but presented evenly, without the clichéd narrative beats – partly a function of the project's necessary open-endedness. Mason rarely, if ever, gets upset, although he comes near to tears in a debate with his dad about that flashy car while riding in his father's boring and dismaying new mini-van. The elderly parents of his dad's second wife turn out to be conservative Christians, who give this liberal kid a Bible and shotgun for his birthday. In another film, this would be the occasion for hammy arguments and a soupy resolution. Here, Mason accepts the gifts with reticent, diplomatic good-nature. Exactly what would probably happen in real life.

Boyhood is in touch with a simple, urgent truth: life is terrifyingly short. While our childhood in progress seems like an aeon, to our parents it flashes past in a dreamlike instant. Then to us, afterwards, it changes from an assumed sturdy narrative into a swirling constellation of remembered and half-remembered moments, which drift in and out of reach. It is with something like awe you grasp the obvious fact that Linklater's time-lapse technique could be easily applied

to every other character in the film. Children and adults are not separate species.

Perhaps Linklater and Ellar Coltrane will come back for sequels: *Manhood*, *Middle Age* and so on. Part of me longs to see Mason again, and part thinks there is an exquisitely perfect humility in how the film gently leaves him with his new friends in college. Either way, it is one of the great films of the decade.

STILL ALICE

6/3/15

★ ★ ★ ★ ☆

This inexpressibly painful and sad film from Wash Westmorland and Richard Glatzer is about a woman who declines steeply into early-onset Alzheimer's just after her fiftieth birthday, and somehow becomes a ghost haunting her own life.

It features a queenly, poignant and much-garlanded lead performance from Julianne Moore as linguistics professor Alice Howland. She begins the movie at the triumphant height of her career, enjoying a happy life with her husband John (Alec Baldwin), prosperous empty-nesters in a sumptuous New York home. They have three lovely grown-up children: Tom (Hunter Parrish), Anna (Kate Bosworth) and Lydia (Kristen Stewart). The only problem in Alice's life appears to be her strained relationship with Lydia, who has rejected college to be a struggling actor in Los Angeles.

With a terrible, almost Nabokovian irony, Alice's dementia begins with her inability to remember the word "lexicon" while giving a lecture, although Westmoreland and Glatzer show how the condition has a kind of prehistorical moment at her birthday dinner the night before, when Alice overhears her son-in-law talk about "sisters" arguing and for some reason thinks he must be talking about her relationship with her own sister, who died in a car crash when they were teenagers. As her disease advances, Alice is lost in thought about this dead sister. The terrible diagnosis arrives, and I defy any audience in the world not to strain frantically to complete the memory test that a doctor gives Alice in one heartwrenching scene. There are, moreover, terrible genetic implications to her condition.

Still Alice is perhaps a relatively straightforward film on this subject, compared with, say, Sarah Polley's *Away From Her* (2006) in which Julie Christie's Alzheimer patient forms a relationship with another man in a care home, or Richard Eyre's *Iris* (2001) in which Iris Murdoch, played by Judi Dench, descends into dementia in a kind of flashback parallel with the story of her younger self. There is admittedly something of the TV movie of the week in *Still*

Alice, a little like *Do You Remember Love*, from 1985, starring Joanne Woodward.

Alice's wealth admittedly makes palliative care an awful lot easier than for others less well off: the comfortable family set up, and Baldwin's presence as the husband sometimes makes this film look weirdly like a very dark version of Nancy Meyers's comfort-food relationship comedy *It's Complicated*. Yet Moore's heartfelt and self-possessed performance, as taut as a violin string, makes this a commanding film. It also boasts one truly sensational scene in which scared and bewildered Alice comes across a video message to herself: this is a flash of macabre ingenuity, as suspenseful as any thriller.

The crisis is all there in the title. Is she "still Alice"? Despite all the agony, the fear and the indignity of Alzheimer's, is there some unbreachable core of identity that will remain? Or is Alice's self utterly eroded, reduced to a set of symptoms?

It is an open question. Westmoreland and Glatzer give us a scene when Alice's disease is at a reasonably advanced stage, and show John getting the chance for a big career step-up that would mean moving from New York to Minnesota, though New York is a place which Alice loved – or loves. John assumes, without admitting or realising it, that she is not still Alice, that he can take her anywhere, give her the best care and continue with his own professional life. The question of whether she is, in fact, still Alice is to lead to a family crisis without anyone couching it in precisely these terms.

This film moreover has one thing that other movies about dementia do not: some very sharp, shrewd insights about how computer technology allows dementia sufferers to manage their symptoms – or conceal them. Or is it that technology use is itself a symptom? Alice is as addicted to her smartphone as anyone else. But she is increasingly dependent on its personal-organiser functions, and she Googles things on her phone that she should be able to remember without help. Are the earlier stages of her disease a parable for what we are all experiencing: a new kind of Googleheimer's? This is an affecting and thoroughly worthwhile film on a very contemporary topic – with some Larkinian reflections on what will and won't survive of us.

The films that made me worry: 9/11, the War on Terror, Obama and the awful aftermath

It was now a generation ago, but it still seems like yesterday. Babies born on that date are now old enough to vote, get married and join the armed services – and some of them indeed have — to fight in precisely those wars that 9/11 triggered. The fall of the World Trade Center towers was a horrible inversion of the hope and euphoria that followed the fall of the Berlin Wall a decade before: an atomic hatebomb of provocation, staggering in its situationist audacity and ruthlessness, a cataclysm of hate and disillusion. People my generation grew to careworn middle age in the shadow of 9/11, an inelegant image, I admit, but one inspired by the paradox of Sean Penn's short film in the 2002 collection *11' 09" 01*, in which Ernest Borgnine plays a sad widower oppressed by living in the shadow of the WTC towers – a shadow about to be lifted. And interestingly that portmanteau movie, produced so soon after the event, is still unique in attempting to understand 9/11 as a global event.

I remember that day walking out of a screening and getting a text from my partner, asking if I had heard the news, and then walking into a pub in Soho in Central London to find everyone staring dumbly up at the TV in the corner, like people mesmerised in an episode of *The Twilight Zone*. Back at the screening theatre, I heard later, the projectionist was putting up those images on the screen lately vacated by the utterly irrelevant piece of movie product I had been listlessly assessing – showing it for those journalists and employees still milling about there. And the question of how or whether the movies responded to this event – itself so obviously cinematic in its

inspiration – was one that had nagged me from the very beginning of my starting to write about film. Was cinema engaged in reflecting the crisis or urgently finding a new, contemporary escapism that could absorb and neutralise this unthinkable trauma?

It was an event that gave impetus to the polemical documentary form pioneered in the new century by Michael Moore, who was denigrated by those consensus-minded journalists who had glumly gone along with the War on Terror, and then had to concede that much of what Moore had to say was absolutely correct, especially when "Weapons of Mass Destruction" became almost a shorthand for official lying. (I felt especially old and weary on finding that I was one of the few people who remembered the fiction of Saddam's "supergun" in the first Gulf War of 1991.) And there was also the queasy and depressing "truther" documentary form, a forerunner of the populist Right's "fake news" hysteria, films about how it was all a put-up job, a scam, a hoax – the kind of thinking that has come to its full flower in the age of social media. There was a third documentary form, the foreign correspondent film which transmitted awful and yet fascinating images from the ruins of Basra and Baghdad. Paul Greengrass's *United 93*, one of the best (and simplest) of the 9/11 genre, found its expression in brutal documentary realism. And after about six years, a new and grisly genre was born: the hand-wringing liberal Hollywood drama which somehow had to square its intense need for patriotic submission with the impulse to resist.

9/11 and its blowback really was not reflected in the movies as it was to be in social media, which had still to be invented, and specifically the rise of YouTube, which allowed people to see for the first time the gruesome "money shot" impact footage of the planes hitting the towers which were transmitted live but which the networks tacitly decided not to show on mainstream TV ever again, preferring a long-distance shot of the second plane disappearing behind the tower as it collided. I saw the full, horrible images for the first time in a feature film – of all things, Denys Arcand's 2003 film *The Barbarian Invasions*, which used a clip. No Hollywood film would have dreamt of using it.

Now there are new crises and scandals that occupy all of our waking thoughts: Trump, Brexit, the rise of nationalism and a poisonous revival of alt-fascism and old-fashioned anti-Semitism, to

go alongside the drearily ever-present Islamophobia and misogyny. People remember hearing the news of Donald Trump's victory with the same kind of skull-dislocating disbelief. Yet the psychic horror of 9/11 has receded into the past now. Some days it feels as if it didn't happen, or it has been reconfigured as a semi-mythical event, like the Kennedy assassination, and that this passing has happened without our having understood it, or weighed it, or having come to terms with it – certainly without cinema having encompassed it. But nothing could be less like nostalgia than my memories of 9/11 and the films it inspired.

11' 09" 01

27/12/02

★ ★ ★ ☆ ☆

The film world and certainly Hollywood have been so reticent about any direct creative response to 9/11 that this collection of short films, whatever its faults, deserves attention. It's a bold attempt to define the terrorist attack as a global event, and a global tragedy, rather than simply in terms of American victimhood. It has yet to find a US distributor.

Producer Alain Brigand has assembled a mandarinate of world cinema to present its imaginative findings: Samira Makhmalbaf, Shohei Imamura, Mira Nair, Idrissa Ouedraogo, Youssef Chahine, Sean Penn, and others. They were invited to compose films with no constraint other than they should be exactly eleven minutes, nine seconds and one frame long, to correspond with the date: 11/09/01. (That non-American format might be something else that irritates US opinion.) Frankly, I find it a trying conceit – it smacks of a certain precious fetishisation of history, an arthouse miniaturisation of great events. However, the exact length of the films is not something anyone could possibly notice without being told in advance.

Samira Makhmalbaf's short has an Afghan teacher trying to enforce a minute's silence on her class, out of respect to the 9/11 victims; she asks if any of them know about what's happened; they only know about local people killed preparing shelters from the imminent American bombing. Mira Nair's piece is about a New York Muslim suspected of being a terrorist who actually turns out to be a heroic rescue worker. From Israel – arguably the epicentre of this debate – Amos Gitai has a preening TV news journalist enraged that her report about a Palestinian bombing in Tel Aviv will not get on the air because of late breaking news in New York. "Who gives a shit about New York?" she screeches. The Bosnian Danis Tanovic shows the widows of Srebenica having their daily demonstration upstaged. Ernest Borgnine plays a sad widower in Penn's film, oppressed by the darkness of his apartment in the shadow of the WTC: a shadow soon to be lifted.

Many are striking fictions. Makhmalbaf's classroom-set short reminded me that the only sustained screen reaction to 9/11 I'd seen before now was the notorious special episode of TV's *The West Wing*, in which the main characters – with much ersatz disagreement and debate among themselves – lectured a bunch of high-school students, and by implication the TV audience, about what to think.

But the most notable contribution is from Ken Loach, who notes that on Tuesday 11 September 1973 the Allende government of Chile was deposed in favour of Pinochet's brutal junta, supported by the US Secretary of State, Henry Kissinger. At first blush, this movie looks very much like a straight tit-for-tat. Its bottom line can only be: the great bully America had it coming. Is there in fact any "context" of this sort which is not, at bottom, a justification of the attack? This is certainly the most overtly anti-American of the movies here.

Yet Loach's link with Chile has been vindicated by events. Astonishingly, Henry Kissinger was chosen by the Bush administration to head an investigation into the 9/11 intelligence failure, a distinction he accepted and then declined, enigmatically citing "potential conflicts of interest" which he refused to specify. This grotesquely shabby episode makes Loach's movie look not merely admissible but brilliantly prescient.

Some of the pieces really don't work. Youssef Chahine's film, showing the movie director at a press conference grandly declining to comment, then communing with the spirit of a US marine killed in Beirut, is absurdly conceited and portentous. Idrissa Ouedraogo's *Just William*-style invention of a group of boys trying to capture a man they think is Bin Laden is pretty twee. And Alejandro Gonzalez Inarritu's shock-tactic glimpses of people jumping from the towers is crudely exploitative.

The most unexpected is from Imamura. A traumatised Japanese soldier in World War II thinks he is a snake. There is talk of Hiroshima. Ah-ha, we think; here is the regulation anti-American slant: Uncle Sam and his weapons of mass destruction. Yet Imamura links the fanaticism of the Japanese military (the inventors of kamikaze after all) with the modern prosecutors of "holy war". It is the only movie that appears to criticise Islamic extremism, rather than American power. There is something refreshing about a piece which goes against the grain.

THE HAMBURG CELL

25/8/04

★ ★ ★ ★ ★

Some thrillers grip. This one had me in an SAS chokehold. If there is a more important, more urgent story to be told than this, I can't think of it: the story of the 9/11 hijackers.

Until now, no film-maker has tried, perhaps due to a fear that they would be accused of romanticising or mythologising the participants. But British director Antonia Bird and screenwriters Ronan Bennett and Alice Pearman break the taboo with a devastatingly low-key, fictionalised drama-documentary. It recreates the unbearably tense five-year genesis of 9/11, beginning with a handful of expatriate Muslim students in Germany in 1997, drifting into Islamic fundamentalism. It ends as the killers board the planes.

This is a world of secret cells, whispered conversations, coded internet chatter, and locations ranging from Hamburg to Washington, Times Square to the Finsbury Park mosque. It is like something by Frederick Forsyth, but in *The Day of the Jackal*, we could at least relax in the knowledge that General de Gaulle doesn't get killed in the end. Here the opposite is true, and that simple fact is scalp-pricklingly horrifying.

Karim Saleh and an actor who styles himself simply "Kamel" play Ziad Jarrah and Mohamed Atta: the terrorists due to crash planes respectively into the White House and the World Trade Centre. Saleh is superb as the agnostic rich-kid Jarrah who, excitable, defensive and mixed-up, gets converted to extreme Islam. Kamel is outstanding as the chillingly committed Atta, at home in a fanatical, pitiless world where the Holocaust is airily dismissed: maybe a Zionist hoax, maybe not, who cares?

Euphoric at the prospect of restoring the honour of Islam by slaughtering Jews and Americans, he is pathetically timid and nervously submissive to his parents.

This Channel 4-funded feature is due to come out only on TV in the UK. It deserves a cinema release.

FAHRENHEIT 9/11

9/7/04

★ ★ ★ ★ ☆

The backlash to Michael Moore's thoroughly entertaining new film has had one of the longest and most elaborate gestation periods that I can remember. Ever since he became a big player with his anti-gun documentary *Bowling for Columbine*, and his bestsellers *Stupid White Men* and *Dude, Where's My Country*, there has been a strand of liberal opinion which holds that liking Michael Moore is uncool and infra dig, like squawking about the perfidy of Starbucks. Even before it hit the screens, his new polemic *Fahrenheit 9/11* has had pundits queuing up to offer knowing and avuncular putdowns.

However, it is incendiary, excitable, often mawkishly emotional but simply gripping: a cheerfully partisan assault on the Bush administration. Moore argues that, embarrassed by its failure to bring Osama bin Laden to justice and at its own family links with the extremely wealthy Saudi Bin Ladens, the Bush administration launched a diversionary war on Saddam. This film astonished everyone, including me, by winning the Golden Palm at Cannes, and Michael Moore's dizzying, counter-jumping success has made populist dissent the stuff not merely of websites or print journalism but big Hollywood box office. It is an exhilarating and even refreshing spectacle at a time when our pro-war liberals are evidently too worldly or sophisticated or amnesiac to be angry about the grotesque falsehood of WMD.

Undoubtedly, *Fahrenheit 9/11* has evasions and omissions that are exasperating. That tagline about "the film they didn't want you to see" is very annoying. (Who are "they"? Republican bogeymen? Hollywood moneymen? Please.) And his attempt to portray Bush as a fratboy slacker misfires. When Dubya's loafing around the golf course, he's actually rather likeable. But Moore's style does not seem to me to be more tendentious than any other sort of campaigning journalism.

Clips and graphics are stitched together with a droll, deadpan voiceover and often a declamatory musical score, though Moore's

ursine baseball-capped form does not itself shamble into view until well into the film. He cheekily begins with footage of the major players – Bush, Dick Cheney, Condoleezza Rice and Paul Wolfowitz – smirking and preening themselves as they prepare to go on TV. (Kevin Rafferty and James Ridgeway's 1992 documentary *Feed*, about the New Hampshire primaries, did the same thing with Clinton.) Wolfowitz has a habit of licking his comb before running it through his hair, which never fails to get a deafening "eeuuwwww" from the audience.

Here they are, is the implication, the whole ghastly gang who fixed the 2000 election, which began when Bush's cousin John Ellis, a Fox News executive, was instrumental in "calling it" for Bush/Cheney on election night and cowed the other TV networks into joining in. For the horrific day of 9/11 itself, Moore has two showman flourishes. The sound of explosions, crashing masonry and screaming come from an entirely black screen: a nightmare recalled with eyes tight shut. Then he shows the President's rabbit-in-headlights expression while at a children's literacy event, getting told about the second plane hitting the towers. A clock appears in the corner of the screen, as the minutes tick by and the president keeps reading *My Pet Goat*, not knowing what to do without his advisers to tell him. Now, this isn't new material. We all know where George W. Bush was at that historic moment. Yet only Moore has had the tactless sadism and mischievous flair to show, almost in real time, exactly how hapless he was. Unfair? Irresponsible? Oh dear, yes – and brilliant film-making.

The Afghanistan war comes and goes without the capture of Osama bin Laden; terrorism licenses the big war on diplomatically safe and target-rich Iraq, in whose reconstruction the big companies have a vested interest, and Moore's scattergun rhetoric takes in the homeland security issue, its politically profitable culture of fear, and the US military's recruiting grounds of blue-collar America, getting poor blacks and whites to fight Mr Bush's war as the body count ratchets upwards. Moore centres a big emotional moment on a bereaved military mom mourning her son outside the White House. This explains his reluctance to emphasise the issue of torture: though he has new and horrible footage of soldiers gloating over their captives – not just within the walls of Abu Ghraib but out in open country.

His big omission is Tony Blair and the UK. There's a pastiche of the old TV show Bonanza, with Bush and Blair mocked up to look like cowboys, and he shows how Bush's announcement that he will "smoke out" Osama is subconsciously plagiarised from old Westerns. But in a section about his "coalition of the willing" for the Iraq invasion there is no mention of the UK, nor of the other substantial European military powers that joined in, just facetious and condescending mockery of the tiny countries – which can only be because of Moore's insistence on America's international isolation and arrogance. It's a strange and self-defeating error.

On so much else, though, Moore incontestably scores points. We've become very used to cool, fence-sitting documentaries without a voiceover or riskily overt editorial content: the kind of film-making that prides itself on guiding the bull elegantly through the china-shop leaving the crockery undamaged. Michael Moore's inflammatory polemic is very different. It's certainly emotional and manipulative, brilliant and brazen. It won't get John Kerry into the White House on its own. But it lands a kidney punch on the complacency of the political classes.

UNITED 93

2/6/06

★ ★ ★ ★ ★

What other subject is there? What other event is there? Nothing is so important, so inextinguishably mind-boggling as the terrorist kamikaze flights of 9/11. Al-Qaida gave the world a situationist spectacle that dwarfed anything from the conventional workshops of politics and culture. Since then, Hollywood has indirectly registered tremors from Ground Zero, but here is the first feature film to tackle the terrible day head on, and Paul Greengrass has delivered a blazingly powerful and gripping recreation of the fourth abortive hijacking. It is conceived in a docu-style similar to *Bloody Sunday*, his movie about the 1972 civil rights march in Northern Ireland. He does not use stars or recognisable faces, and many of the characters in the air traffic control scenes are played by the actual participants themselves.

This is an Anti-*Titanic* for the multiplexes – a real-life disaster movie with no Leo and Kate and no survivors: only terrorists whose emotional lives are relentlessly blank, and heroes with no backstory. Greengrass reconstructs the story of the hijacked plane that failed to reach its target (the Capitol dome in Washington DC) almost certainly owing to a desperate uprising by the passengers themselves, who were aware of the WTC crashes from mobile phone-calls home, and who finally stormed the cabin, where terrorists were flying the plane. With unbearable, claustrophobic severity, Greengrass keeps most of his final act inside the aircraft itself.

The director is able to exploit the remarkable fact that the sequence of events, from the first plane crashing into the World Trade Centre at quarter to nine, to the fourth plane ditching into a field in Shanksville, Pennsylvania, at three minutes past ten, fits with horrible irony inside conventional feature-film length, and he is able to unfold the story in real time. It is at this point that a critic might wish to say: caution, spoilers ahead. But we all know, or think we know, how the story of *United 93* comes out, and this is what makes the film such a gut-wrenching example of ordeal cinema. When the

lights go down, your heart-rate will inexorably start to climb. After about half an hour I was having difficulty breathing. I wasn't the only one. The whole row I was in sounded like an outing of emphysema patients.

Every last tiny detail is drenched with unbearable tension, especially at the very beginning. Every gesture, every look, every innocent greeting, every puzzled exchange of glances over the air-traffic scopes, every panicky call between the civil air authority and the military – it is all amplified, deafeningly, in pure meaning. And the first scenes in which the United 93 passengers enter the plane for their dull, routine early-morning flight are almost unwatchable. These passengers are quite unlike the cross-section of America much mocked in *Airplane!* – with the singing nun and the cute kid – neither are they vividly drawn individuals with ingeniously imagined present or future interconnections, like the cast of TV's *Lost*. They are just affluent professionals from pretty much the same caste, with no great interest in each other, and nothing in common except their fate. And all these people are ghosts, all of them dead men and dead women walking. When they are politely asked to pay attention to the "safety" procedures, ordinary pre-9/11 reality all but snaps in two under the weight of historical irony.

But what does happen at the end of the story? In his memorial address, President Bush implied that the passengers committed an act of tragic self-immolation, rather than see the Capitol destroyed. Is that what happened? Greengrass evidently disagrees. In his vision, the passengers have a quixotic idea of using one passenger, a trained pilot, to wrest control and bring the plane down safely to the ground – a Hollywood ending, perhaps. But there is something very un-Hollywood in Greengrass's refusal to confirm that without the passengers' action they would have hit the Capitol. On the contrary, his script shows the terrorists making a miscalculation of their own.

United 93 is growing, in popular legend, into the tragic and redemptive part of the 9/11 story: America's act of Sobibór defiance. It is a myth-making which is growing in parallel with jabbering conspiracy theories that the plane was shot down by US air-force jets and the whole passenger-action story is a cover-up. On that latter point, Greengrass's movie shows us that it is easy to be wise after the event; it is a reminder of how unthinkable 9/11 was, of how

all too likely it was that the civil and military authorities would not have mobilised in time, and that any action would indeed have to come from the passengers themselves. The film is at any rate fiercely critical of Bush and Cheney, who are shown being quite unreachable by the authorities, desperate for leadership and guidance.

United 93 does not offer the political or analytical dimension of Antonia Bird and Ronan Bennett's 9/11 docu-drama *Hamburg Cell*; there is no analysis or explanation. The movie just lives inside that stunned, astonished ninety minutes of horror between one epoch and the next – and there is, to my mind, an overwhelming dramatic justification for simply attempting to face, directly, the terrible moment itself. The film might, I suspect, have to be viewed through an obtuse fog of punditry from those who feel that it is insufficiently anti-Bush. It shouldn't matter. Paul Greengrass and his cinematographer Barry Ackroyd have created an intestinally powerful and magnificent memorial to the passengers of that doomed flight. It is the film of the year. I needed to lie down in a darkened room afterwards. So will you.

WORLD TRADE CENTER

29/9/06

★ ☆ ☆ ☆ ☆

There are some films so awful, of such insidious dishonesty and mediocrity, that their existence is a kind of scandal. Roberto Benigni's sentimental Holocaust movie *Life is Beautiful* was one such, and now here is another. Oliver Stone's grotesquely boring and badly acted TV-movie-style *World Trade Center* spectacularly fails to do justice either to the global, geo-political nightmare of 9/11 or even to its ostensible subject: the courage of New Yorkers who risked their lives to help others that day.

It should not be possible to make a dull film on this subject, and yet Oliver Stone has managed it: a big, wilfully dumb, reactionary clunker of a movie that succeeds in cancelling the drama and avoiding all the history and the ideas. It is a fictionalised version of a true-life story. Two Port Authority cops, Jim McLoughlin (Nicolas Cage) and Will Jimeno (Michael Peña) were part of a rescue team buried in the rubble, and were themselves rescued against incredible odds by Dave Karnes, an accountant and US Marine Corps reservist. Karnes, enraged by the terrorist attack and feeling a Christian-patriot calling to help, drove to New York from his Connecticut home, pulled on his uniform, made his way into the Ground Zero danger zone and clambered up the terrifyingly precarious mountain of masonry, on a personal mission to find survivors.

Stone never puts a foot right. He uses lumberingly misjudged state-funeral camerawork and elegiac music actually before, and during, the horrific attack itself, smothering its dramatic impact in a hundredweight of scented cotton wool. And he insists on performances of utter fakeness from everyone. Once his heroes are trapped in that hellish tomb, Stone has nothing to say about them as real human beings with complex emotions, preferring stoical grit. All we are left with is two hours of boredom. One of their trapped comrades, overwhelmed with despair, appears to kill himself with his revolver. Or does he? Evidently, showing one of the 9/11 hero-saints committing suicide is unthinkable for Stone, so he fudges the

issue by having this man fire bafflingly into the air and then sort of expire afterwards. "He's gone," says one brother officer. Uh, yeah. I guess he has.

We intercut between this Stygian nightmare of dullness and the fraught drama of the lip-quivering womenfolk, and these people are like nothing on earth. Maria Bello, playing one of the doe-eyed spouses, has blue contact lenses that reduce her pupils to the size of needlepoints and make her look like a Stepford Wife. Maggie Gyllenhaal plays the other devoted life-partner and, like Bello, she gives a massively supercilious performance. The most outrageously Marie Antoinette-ish is Donna Murphy, who plays one of their drawn, lachrymose friends, like the star of an infomercial for something tasteful and discreet. These sleek Hollywood showponies are about as far from real human beings as Earth is from Alpha Centauri: they look like L'Oreal models in peril, twittering and wittering as the guys pull up outside in their squad cars and station wagons. Compare them, or anyone else from this film, with Paul Greengrass's *United 93*, that magnificently real tribute to American courage, and the sheer phoney-baloneyness of everything is just embarrassing.

The worst is yet to come. Stone has apparently instructed Michael Shannon, playing the Marine Corps hero Karnes, to walk around like a stone-eyed serial killer on anti-depressants. "Think Hannibal Lecter!" he must have yelled at him through his megaphone. "Think Jeffrey Dahmer!" When the nightmare is over, Karnes gets out his cellphone to inform his loved ones of his desire to re-enlist, and has what is effectively the movie's last word: "They're gonna need some good men out there – to revenge this." Out "there"? Where exactly? Over the closing credits, we get the answer in white titles on a black background. Karnes served two tours in Iraq.

Well, it's true: he did, although in real life he appears to have been stationed in the Philippines first, which doesn't have quite the same ring to it. In making and banging the drum for this boneheaded link between 9/11 and Iraq, Oliver Stone has voluntarily chopped about 100 points off his own IQ.

Not even the most egregious neocon nincompoop still believes that 9/11 had anything to do with Saddam – so what is the erstwhile beady-eyed king of the conspiracy theories doing here? Being ironic? Obviously not. Could it be that like many a tough-guy

liberal of a certain age, Stone is trying to out-macho his conservative tormentors? Maybe. My own theory is that Oliver Stone's auto-lobotomy is an act of sentimental primitivism, a misjudged tribute to the innocent patriotic beliefs of a fondly imagined yeoman class of blue-collar Americans.

What a shaming spectacle. In this paper, Natasha Walter recently had a brilliant, sceptical essay, wondering if the big-hitting novelists of the English-speaking world had really done enough to imagine the terrorists' worldview. It's a good question – and one that could be asked of cinema. There have been some bold and honourable movies. Antonia Bird's *The Hamburg Cell* was a thrilling investigation of this subject. Paul Greengrass's *United 93* was a head-on dramatic act of courage.

And Michael Moore's *Fahrenheit 9/11*, though deplored by many liberals who felt that complaisant fence-sitting was the more responsible approach, was a terrific polemic, and every day that goes past makes Moore look better, and his detractors more obtuse. But I fear all these movies are going to be temporarily bullied into the margins by this great big, malign village idiot of a film, which sets the bar very low, and which fatuously endorses the biggest political untruth of modern times. Just thinking about it gives me a headache.

IRAQ IN FRAGMENTS

19/1/07

★★★★☆

James Longley's outstanding documentary-portrait of ordinary lives in post-invasion Iraq has a structure and procedure that imitate its underlying political point: Iraq is fragmented. Broadly speaking, there are three fragments, and this is a reality with which the political classes here and in the US are becoming acquainted. In the centre: the Sunnis, from which group Saddam and his followers sprang. In the south: the Shias, depicted by Longley as the centre of a retributive new militancy. In the north: the Kurds, who welcomed the American and British military action as the antidote to their oppression – and still do so. Boldly, Longley's film gives the Kurds the final voice, and the overall effect is far from boilerplate anti-Americanism.

In a series of stunningly filmed sequences, Longley and his camera seek out the real lives outside the frame of conventional TV news, and he succeeds in creating both compelling journalism and superb images. In Baghdad, he finds a heartbreakingly lonely eleven-year-old orphan, apprenticed to a tough garage owner who has taken him in. This man appears at first to be affectionate to the boy in his rough and ready way, and the child's hesitant voiceover pays a kind of cowed tribute to how kind he is; and yet soon the man is cuffing him and shouting at him, and in the course of the film, the boy's feelings become something altogether different. In Baghdad, in the cafes and street corners, the cynical talk is of how things were actually better under Saddam – although these sentiments may have been disproportionately amplified.

In the south, the Shias are electrified by the historic opportunity that has opened up for them, and vigorously prosecute their new Islamic revolution; we see them loudly declaiming the great Satan Uncle Sam and brutally arresting people on suspicion of selling alcohol, a suspicion that does not appear to have much relation to due process of law. These people appear drunk with righteousness, and again, the dark talk is of a rampant new Saddam-ism. Then there is a gentle, pious Kurdish man who sadly reflects that his people's

religious identity has left them out of step with the fierce new flame of anger burning elsewhere in the country.

It is a superbly-made film, pessimistic but not simplistic. Longley's footage of Baghdad streetlife is outstanding: he seems to capture stunning images everywhere he looks, just by pointing the camera, a dozen scorching pictures every minute, rendered hyper-real on high-definition video. It looks like an imaginary landscape from some impossibly violent and traumatised futureworld, from which the director reports back with something other than the TV newsman's redundant rhetoric of sensation or forced compassion.

But in the end, my mind kept going back again and again to that small boy in Baghdad, who is at first trusting and accepting, and then coldly angry about what life has given him. With discretion and subtlety, Longley has created a narrative for the child without it seeming artificial or absurd. This alienated, orphaned figure becomes a metonym for Iraq, a tragically divided nation.

LIONS FOR LAMBS

9/11/07

★ ☆ ☆ ☆ ☆

Pure fence-sitting liberal agony is all that's on offer here, in a muddled and pompous film about America's War on Terror, which seeks to counter neo-con belligerence with a mixture of injured sensitivity and a shrill, pre-emptive patriotism of its own. In fact, it gives liberalism such a bad name that on leaving the cinema, I felt like going out and getting a nude study of Norman Podhoretz tattooed on my inner thigh. How incredible that something as shallow and badly acted as this could be presented as a serious, even Oscar-worthy picture from Hollywood's finest.

Like many other films on this subject, it is in the ensemble-mosaic genre (*Rendition*, *A Mighty Heart*, *Syriana*), tensely intercutting between various scenes in various parts of the world, but here on a relatively unambitious scale, and with no characters from the Islamic world. Robert Redford directs, and plays a Californian political science professor, giving a gentle dressing-down to a student, Todd (Andrew Garfield), who has let his grades and his idealism slide.

Meanwhile, another earnestly talky, school-debate scene is unfolding in Washington DC. Tom Cruise plays the ambitious Republican senator Jasper Irving, who has deigned to give an interview to liberal TV journalist Janine Roth (Meryl Streep); he bullishly defends the WoT, yet graciously admits to "mistakes", and seductively offers Janine a top-secret exclusive on the government's latest plan to wrest back the initiative. And on the frozen and windswept field of battle in Afghanistan, we see two US special forces soldiers, Ernest (Michael Peña) and Arian (Derek Luke) encounter a desperate situation – and we learn how their fates are bound up with those of the other characters.

Until seeing this, I thought that the most condescending and toe-curling liberal response to 9/11 was the notorious special edition of TV's *The West Wing*, in which the characters self-importantly addressed a visiting group of schoolchildren on all the attendant issues – and effectively talked down to the audience in the same

way. But *Lions for Lambs* is far worse: dull, inert, schoolteacherly, desperately self-conscious in its exposition of the issues – and with hogwhimperingly bad performances. Golden-haired Robert Redford, seventy-one years young, looks like some kind of animatronic model made out of wood, and whingey, snuffly Meryl Streep is supremely annoying. Tom Cruise, however, does deliver something like the right combination of sinister ideological commitment and flesh-pressing charm.

What is so infuriating is that Meryl Streep is playing a journalist – a journalist who apparently believes that the only respectable response to the Bush administration is impotent misery and career suicide. How indescribably pathetic of her. There were a dozen ways she could have got a critical story on the air, even on her cautious and conservative TV station. But this, perhaps, might mean Janine being exposed to criticism herself. The ending in Afghanistan has its own strange and unintentional gutlessness. The movie's title, incidentally, is taken from the apocryphal remark about World War I soldiers being incomparably finer than their incompetent commanding officers. According to Matthew Michael Carnahan's script, the phrase is "Lions led by lambs". The phrase is "lions led by donkeys", surely? Donkeys are very much in charge here.

REDACTED

14/3/08

★ ★ ★ ★ ☆

Of all the films being made about America's involvement in Iraq, evidently none is more loathed in the US than *Redacted*. This "fictional documentary" by Brian De Palma, about an outrage committed by US troops on Iraqi civilians, is powerful, provocative, shocking and even slightly crazy in ways that may not be entirely intentional. By the end of its ninety minutes, the china shop of taste and judgment is pretty well smashed to pieces by this great big bull of a film. I've seen it twice now – at the Venice film festival last year and at a screening in London – and both times I could feel huge numbers of people, hawks and doves alike, being gripped, baffled and appalled by its sheer semi-controlled offensiveness. This comes to full, horrible flower in the final sequence of still photo-images of butchery accompanied by an ominous and deafening orchestral score.

Redacted starts off looking like a familiar anti-war film, comparable to movies by, say, Michael Moore or Nick Broomfield, whose *Battle for Haditha* tackled a similar theme. But also, with its freewheeling handheld camerawork and shouty improv acting, it looks very similar to the no-budget "underground/political" movies of De Palma's youth: *Greetings* (1968) and *Hi Mom!* (1970).

There is something else going on there, too. Perhaps without quite realising it, De Palma is applying his extensively developed idiom of slash, splatter and gore. After a while, *Redacted* starts to feel like a sort of politicised exploitation-horror picture. I am still not entirely sure if it is just the director's default position for representing violence, or if the wayward genius in him senses that, in the era of Abu Ghraib, this is the truest way of representing the essentially grotesque nature of the military adventure in Iraq.

It is a media-collage, made up of many elements and fragments. There is a video diary being made by one soldier who hopes to get into film school, also an earnest professional documentary made by imaginary French film-makers, complete with French subtitles; there

258

is CCTV footage, fictional Arab TV, blogs, and gruesome footage of soldiers being killed and uploaded to al-Qaida-style websites. How and by whom this material has been assembled and cut together is, however, a mystery.

The narrative concerns a demoralised unit of troops stationed in Samarra manning a checkpoint; they are at risk of death every day from what the British call roadside bombs, and the Americans IEDs, or Improvised Explosive Devices. When the men's popular sergeant is killed by one of these, two of the unit's most notorious Neanderthals set out on a revenge mission against the civilian population: to rape a fourteen-year-old girl whom they have seen passing through their checkpoint every day.

Broomfield's *Battle for Haditha* also focused on abuses committed by the US military, but his movie was far more lenient. The violence there happens in the fog of war, and the troops were, as individuals, arguably not entirely culpable. De Palma doesn't see it that way. His troops are just vicious criminals given free rein – people who in the civilian world would be locked up.

De Palma's vision, or at any rate his emphasis, could be seen as simplistic, irresponsible. But haven't we all seen the Abu Ghraib photographs, showing soldiers clowning around with prisoners they have brutalised or killed? The De Palma approach – however crass or questionably motivated – might be in fact the correct one, and a liberal-humanist need for complexity or subtlety might be obtuse.

"Redacted" is a technical euphemism, like "rendition"; it means "censored" – that is, it refers to the deletions made to an official document, before it can be released to the public. But this movie is not really about exposure, and not conceived in opposition to censorship. It arrives at a time when everyone knows what is going on in Iraq, and in any case, De Palma's motives are not precisely political. He has just deployed his flashy, technically astute, visceral, yet weirdly amoral film-making sensibility and has found in Iraq a sickeningly responsive subject matter.

The result is often unforgettably shocking and bizarre, especially when De Palma insists on producing a succession of reportage-style images of civilians horribly butchered in the course of the war. An inter-title announces that these images are real. Or is this claim just another fiction?

The eyes of the people involved are blanked out, in a way that appears to allude to an earlier visual conceit of blanking out passages in army reports, but the final image of a young woman is not modified in this way; her eyes stare directly at us, and for a moment she does look very like the teenage girl featured in the (fictional) story. For an awful few seconds, the effect really is scary – scary in a way that the most effective psychological thrillers or horrors are scary.

De Palma may win no new fans with *Redacted*. But he has intuited something about the nausea, fear and hopelessness of the Iraq war in its long endgame.

THE HURT LOCKER

28/8/09

★ ★ ★ ★ ★

The war in Iraq, the war in Afghanistan and the "War on Terror" (to use the increasingly forgotten Rumsfeldian formulation) never really got their John Wayne/Green Berets moment in Hollywood: a big movie whose unembarrassed purpose is to endorse the military action. Most of the serious responses have been liberal-patriot fence-straddlers, multistranded stories urgently set in Washington, the Middle East, south Asia and elsewhere, tying themselves in knots in an attempt to acknowledge a dovey point of view while covertly leaning to the hawk's – pictures such as Stephen Gaghan's *Syriana*, which showed torture in terms of CIA man George Clooney being tortured by an Arab, Robert Redford's mealy-mouthed *Lions for Lambs*, Gavin Hood's issue-fudging *Rendition*, and Peter Berg's *The Kingdom*, with its feeble moral equivalence between jihadist zealots and the US army.

How weird and ironic, then, that the nearest thing we have to Wayne is also the best and most insightful anti-war film about Iraq: Kathryn Bigelow's blazingly powerful action movie *The Hurt Locker*, whose unpretentious clarity makes for a refreshing change. Bigelow is, in dramatic terms, on the side of the soldiers. She has a single location – Baghdad – and wants to find out what is going on inside the US combatants' hearts and minds. Debating the purpose and origins of the conflict is not the point. Yet, for my money, Bigelow says more about the agony and tragedy of war than all those earnest, well-meaning movies that sound as if they've been co-scripted by Josh and Toby from *The West Wing*.

The Hurt Locker is about the long, painful endgame in Iraq, the asymmetric nightmare in which the military cannot engage the enemy in any meaningful sense. Their purpose is a long, long series of patrols in which they are heavily armoured moving targets, in continuous danger from what the British call roadside bombs, a phrase now being superseded by the American term IEDs: Improvised Explosive

Devices – bombs hidden in rubble, and detonated as booby-traps or remotely, by phone.

Jeremy Renner stars as Staff Sergeant William James, head of a three-man bomb-tech unit or disposal squad. His immediate subordinate is Sgt Sanborn, played by Anthony Mackie, an African-American nettled by James's redneck recklessness – and the third man is Specialist Eldridge, played by Brian Geraghty, a young soldier visibly unravelling.

Sgt James is starting to unsettle his team with suicidal displays of bravado. Instead of sending in the remote controlled "auto-bot" with its fixed camera to investigate possible bombs, James is increasingly and impatiently striding in to the Kill Zone himself – as Iraqi civilians look on impassively, some with video cameras, getting ready, as the soldiers say, for their YouTube moment. Sometimes James does not even wear the heavy body armour that would minimise injury if the worst happened. He is earning a reputation as a "wild man" among the top brass, who are not rushing to rebuke him.

Is James becoming unhinged, driven over the edge by the intolerable life-threatening danger that tests the sanity of every soldier? Or is it something politically incorrect to say out loud: that the danger of war is deeply exciting and James wants to mainline it directly into the vein?

Either way, Sanborn and Eldridge, his stunned No. 2 and No. 3, are in a profound dilemma. They can sympathise with his death wish, certainly – it is an understandable response, perhaps in some Helleresque sense the only sane response, giving the finger to this losing game of Russian roulette. Bigelow adroitly shows how Sanborn and Eldridge resent and yet sympathise with their gung-ho commanding officer. They are scared by him, and yet they are excited and even inspired by him. In his crazy way, he has leadership qualities. And yet they also know that he could get them all killed. And so Sanborn and Eldridge, with military dispassion, have to weigh up a strategic option: killing James and making it look like an accident or enemy action.

In some ways, Bigelow's film repudiates the conventions of narrative: it could be seen as simply a series of unbearably tense vignettes, in which a soldier, his face dripping with fear and sweat, is hunched surgeon-like over a suspect device in the epicentre of

an area that has been cleared in the shape of the coming blast. In one bizarre but intestine-wrenching scene, James and his men come across some loose-cannon Brits, led by Ralph Fiennes, who affect T.E. Lawrence-style headgear that almost earns them some fatal friendly fire. The encounter, inevitably, winds up in a Wild West shoot-out that has a surreally drawn-out, hallucinatory quality.

That title basically means Shell Shock 2.0. It refers to the physical trauma of being in close proximity, time after time, to the deafening blast of an explosion, controlled or otherwise. That obscene noise and, perhaps just as awful, the tense prelude of compressed silence, encloses you in a tight prison of pain: the "hurt locker". Bigelow's film does a very good job of putting you inside it as well.

9/11 – HOW DID HOLLYWOOD HANDLE
THE TRAGEDY?

8/9/11

At the Venice film festival last week, George Clooney unveiled his new backstairs political drama, *The Ides of March*, about a Democratic presidential candidate getting bogged down in compromise, backstabbing and the dark political arts. Clooney said that he could conceivably have completed the film before now, but President Obama had been doing too well, and therefore the time wasn't right.

Perhaps Clooney was being serious and perhaps he wasn't. But the remark typifies the dwindling of the memory of 9/11 in Hollywood cinema. The Obama presidency, ushered in by the catastrophe of the Bush reign, is now perceived to be in trouble, and this enables a prominent Hollywood liberal to make the kind of savvy, ahistorically pessimistic political movie that could have been produced at any time in the last forty years – not too far away from Robert Redford in *The Candidate* (1972). The convulsions and aftershocks of the World Trade Centre attacks seem to be a very distant memory, and the consequent extraordinary military adventures, now in their endgame, are invisibly absorbed as a fact of life.

Perhaps the whole point of 9/11 was that it could never be represented on the cinema screen. The diabolic, situationist genius of the kamikaze attacks was that they were themselves a kind of counter-cinema, a spectacle very possibly inspired by the art-form, but rendering obsolete any comparable fictions it had to offer. The 9/11 attacks smashed Hollywood's monopoly on myth-making and image production, and inspiring as they did only horror and revenge, aimed a devastating blow at imagination, and maybe for a while enfeebled the reputation of cinema and all the arts. (Hal Foster, in his LRB essay on the 9/11 museum, has some interesting thoughts on the damage to constructive thinkability at Ground Zero).

For years after the attacks, a kind of willed blindness set in. Due to an unacknowledged understanding among broadcasters, only the most distant shots of the plane's impacts were shown on TV screens. It wasn't until I saw Denys Arcand's coolly anti-American

satire, *The Barbarian Invasions* (2003), which used a close-up clip of the second plane hitting the towers that I even realised that far more explicit material existed, broadcast live at the time, but rarely if ever repeated. It wasn't until YouTube was launched two years afterwards that people could see these blackly horrifying images.

There's a weird footnote to this. Johan Grimonprez's *Double Take* (2009) is a surreal mashup, imagining the older Alfred Hitchcock visiting his younger self in 1962, cleverly splicing together clips of Hitchcock clowning around for his TV show: the whole thing is a tissue of fictions, half-memories, dreams. One black-and-white sequence is about a B-25 bomber getting lost in heavy fog in July 1945 and crashing into the seventy-ninth floor of the Empire State Building. When I saw this, I assumed it was a spoof, some kind of retro-futurist fantasy, in questionable taste, on the theme of 9/11. But no. This actually happened.

It seems like a bad dream. There must be a new generation of teens and twentysomethings, the people now fighting in the wars in Afghanistan and Iraq, for whom the 9/11 attacks are a distant, nightmarish fable. Perhaps there is also a new generation of jihadis who assume that the 9/11 attacks were a response, and not a prelude to the Afghan and Iraq wars?

How could cinema respond to 9/11? It seemed for a while as if Hollywood considered silence the only patriotically supportive response: this was thoughtful and reasonable on one level, and yet also indicative of being unwilling to acknowledge or mythologise the attacks.

In the absence of this, *11' 09" 01* was a decently conceived portmanteau film from the French producer Alain Brigand, composed of short pieces on the theme of 11 September, each lasting eleven minutes, nine seconds and one frame, made by an international array of directors, including Samira Makhmalbaf, Sean Penn and Idrissa Ouedraogo.

For all its flaws, this was a film with a globalist view – it grasped the essential fact that 9/11 was not merely an American tragedy. When I saw this, I think I assumed that it would be the foundation stone for a new kind of multinational, questioning, experimental cinema tackling the 9/11 epoch. But this was really not forthcoming. There were no more startling collaborations of this sort.

The history of 9/11 in the cinema in the last decade is a history of evasion in one sense, and in another sense, a history of indirect intuition, the idea that cinema could feel and transmit the anxieties of 9/11 in situations which did not appear to be explicitly about the attacks. Is this a tribute to cinema's capacity for subtlety and complexity? Or a failure of will?

For example: James Marsh's wonderful 2008 documentary *Man on Wire*, about Philippe Petit's daring wire-walk across the WTC towers in 1974, is often said to be "about" 9/11 in a redemptive, transformative, healing sense. And so it is. But is it not also a turning away, an aversion of our collective gaze, shielding our eyes from reality and looking instead backwards at something uplifting and happy from the past? Perhaps. Did cinema simply fail after 9/11? Even after ten years, I'm still not sure.

This is not to say that Hollywood did not finally make up its mind to try tackling the events head-on. Oliver Stone's *World Trade Center* and Paul Greengrass's *United 93* both appeared in 2006 – one a true-life drama about the rescue mission in New York and the other about the passengers' famous uprising on one of the hijacked flights.

As a critic, I have to say, I am always dismayed to see these films bracketed together as if they are comparable. They are not. Greengrass's film is a bold and brilliant drama which attempts to think the unthinkable and put us inside one of the planes. Stone's movie is sentimental, mawkish and dewy-eyed, whose excruciatingly self-conscious patriotism results in a funereal and treacly slowness of pace which misrepresents the meaning of 11 September. Later, Stone would make *W* (2008), a similarly lenient and supportive film about George W. Bush, a biopic which managed to miss out the events of 11 September altogether. In my view, no single film-maker suffered more of a reputation loss after 9/11 as Oliver Stone.

The challenge was to put us inside the terrorists' minds. Greengrass did it to some degree, in simply showing us their strategy in action, but Antonia Bird's stunning *The Hamburg Cell* about the conspiracy itself, made for TV but shown at film festivals, is one of the most masterly 9/11 movies.

One of the most depressing symptoms of 9/11 was the appearance of a kind of film which I have written about many times before: the liberal fence-sitter. Agonised, conscience-stricken films about

the War on Terror appeared, often with an ensemble-mosaic cast, and multinational locations, wishing to express a slowly awakening sense that everyone has been duped by the Bush presidency, but still unwilling to risk being disloyal in any way. Robert Redford's *Lions for Lambs* (2007), Gavin Hood's *Rendition* (2007), Michael Winterbottom's *A Mighty Heart* (2007) and Stephen Gaghan's *Syriana* (2005) were all like this — this last movie offering the bizarre and politically obtuse spectacle of a CIA man being tortured by an Arab. These movies tied themselves in knots.

When Kathryn Bigelow's *The Hurt Locker* (2008) about the suicidal task of bomb disposal came out, I praised its power and its simple clarity. John Pilger attacked the movie, and attacked me for praising it on the grounds that it is just another propagandist piece of militarist violence porn. I disagree, and I think that the "liberal fence-sitter" genre deserves John Pilger's scorn much more.

Documentarists fared far better, and 9/11 triggered a revival in the genre. Michael Moore's *Fahrenheit 9/11* (2004) got it broadly right about the mendacity of the Anglo-American wars, at a time when mainstream media kept nervously silent, and tried to patronise his film. In some ways, this was Moore's finest hour, and the new documentary wave showed that cinema was willing to confront the most important things happening on our doorstep, and others' doorsteps around the world. Due praise has to be given, also, to Errol Morris's horrifying *Standard Operating Procedure* (2008), which told the brutal truth about torture at Abu Ghraib prison.

When I try to locate or define the 9/11 factor in the movies, it is frustratingly elusive. But there are three films which are now very interesting test-cases.

Samira Makhmalbaf's *At Five in the Afternoon* (2003), set in Afghanistan after the invasion, is in many ways a perplexing movie, a movie which I still find mysterious. It dramatises a deeply ambiguous attitude to the Taliban and theocratic power in Afghanistan. After the post-9/11 US attack, the Taliban are in retreat. Women's rights are being asserted once again, and Nogreh, a young Afghani woman, dreams of becoming president of the nation. But at a certain stage in the movie, these dreams and ambitions are abandoned, when her father forces her to come with him in the search for her brother. The attack from America and its allies is the greater evil, and whatever

advantage it appears to have in terms of feminist liberation just seems to weigh very little in the balance. Makhmalbaf's film is often described as if this final repudiation of Western gender liberation does not occur: but it does. The film embodies a painful scepticism. Women in the Muslim world may indeed wish to challenge the status quo, but if this liberation is to be imposed from without, as a Western-liberal pretext for aggression, if it is a "freedom" which comes from the barrel of an American gun, and involves an attack on their menfolk, then Muslim women of Afghanistan might well find it a "freedom" fraught with compromise and dishonesty and humiliation. *At Five in the Afternoon* is a complex and difficult film, a film which does not take obvious sides, and a film drenched in the debate about whether and how freedom can be promoted in the Muslim world after 9/11 by the counter-insurgent West.

Michael Haneke's *Hidden* (2005) is a brilliant 9/11 film. Perhaps this director's fascination with visiting a terrible revenge on the placid and conceited Western middle classes found its greatest expression in a surveillance nightmare that was not specifically about 9/11, but nonetheless spoke brilliantly about the new anxieties and nightmares that 9/11 conjured up. Daniel Auteuil is a famous TV presenter in Paris, fronting an arts review programme, who finds that someone is spying on him with a hidden video camera, and sending him the tapes. He suspects that it is an Algerian, who as a boy was fostered with his family but then cruelly sent away, and whose countrymen were brutally beaten and killed by police during "*la nuit noire*" in 1961, a notorious night of violence in which a demonstration was brutally suppressed. Clearly, *Hidden* is about the confrontation of the West and the Muslim world, and about a terrorist asymmetrical warfare: sending these anonymous surveillance tapes is a way of hitting back at those who are rich, protected and prosperous. But the essence of 9/11 is about more than this: it is about watching TV. Some of the most uncomfortable and scary parts of *Hidden* come when Auteuil simply has to watch the tapes on his TV screen: horrified, transfixed. The act of watching TV puts him one down: as a TV presenter, he is used to the high status of appearing on screen. On 11 September 2001, America and the world had no choice but to watch the disaster on live TV, watch the towers burn and then collapse – just helplessly sit there and watch.

The third film is one which I think can only grow in reputation; it is Chris Morris's *Four Lions* (2010). Here is a film which is a brutal and fearless black comedy – about 7/7 and the subsequent bungled UK plots, as much as 9/11 – which treats the Islamist suicide bombers of Britain not as terrifying warriors but a movement of berks and prats. Morris is a film-maker who is trying to do something which most directors in these ten years have not done: that is, attempt to get inside the mind of the suicide bombers. He found a black-comic, satirical register for this, but it is convincing nonetheless. And the absurdity and farce in *Four Lions* hints at something almost unsayable: that the 9/11 plotters got very, very lucky with a bizarre plan which they probably did not expect to work.

Here are ways in which 9/11 entered, perhaps briefly, the movie bloodstream. As to whether this catastrophic event will engender some further developments in cinema, inspire new dramas of confrontation or even catharsis, it is still too early to say.

The films that made me scared

The Queen once told me what her favourite horror film is. I was at an event at Windsor Castle, at which the high point was Sir Kenneth Branagh jovially presenting Her Majesty with her own honorary BAFTA. Before that she mingled with the guests, all of us stupefied with the kind of suppressed nervy hysteria that she must be used to in everyone she meets. I was in a small clutch of three or four people surrounding her at one stage and a cheerful American movie executive broke protocol by actually asking her a question, without waiting to be addressed:

"Hey, Your Majesty – what's your favourite scary movie?"

A tiny stunned silence descended on the rest of us Brits as we wondered if some Beefeater would drop from the ceiling and take him (and us, his mute anti-protocol accomplices) off to the Tower. Instead, the Queen's thoughtful gaze turned to me and said, in that unmistakable voice:

"What's that horror film … beginning with a G?"

Everyone turned to look at me. Time slowed down, and sort of melted, like something in a dream, or a Dali watch. The Queen was asking me what horror film begins with a G. My mind went a blank. I had to say something, anything. Eventually I mumbled:

"Ma'am, is it … *The Grinch*?"

"Yes, that's it! *The Grinch*!"

So there you have it. *The Grinch* is the Queen's favourite scary film, and in many ways it is pretty scary.

Like the nasty taste of alcohol, the scariness of horror films is something that children and young teenagers teach themselves to like until it becomes a manageable addiction for their adult life.

And of course, horror films can indeed be intensely and paradoxically pleasurable. They are the lifeblood of the film world; the promise of bonechilling terror – but safer than rollercoasters – is a reliable entertainment format that goes back to the fairground tent with its elephant man or bearded lady or similarly exploited or fake freak of nature. Horror is a mainstay of the film economy, it is relatively inexpensive to produce, offers an attractive entry-point to the first-time film-maker, and for the industry is the most reliable return on investment. To announce yourself a fan of scary movies, or conversely not especially a fan, are positions which you have to think carefully before committing yourself to. My experience of horror fans is that they are one of the most passionate and articulate blocs of opinion in the world of film criticism, and I wouldn't claim membership of the club lightly.

I am occasionally baffled by the fan-value system applied to scary movies. People coming out of successful thrillers will animatedly tell each other how excited they were, and people coming out of successful comedies will uproariously recount the funniest bits. But people coming out of a horror film will pretty much do the same thing – say how "great" or "funny" it was. They don't come out deadly pale, mumbling about how scared they were – the way they would if they had been mugged or survived a car accident. Movie scared is different from real world scared. It is a whoosh of exhilaration in which fear is a constituent element, to be carefully measured, like nicotine in a cigarette. Bad horror films will rely abjectly on the arbitrary pointless shock, accompanied by a digital musical stab on the soundtrack – the notorious "jump scare".

What was the first horror film I ever saw? Oddly, not *The Exorcist*, William Friedkin's 1970s masterpiece – which is what most people of my generation would say. For me, it was the two *Omen* films, *The Omen* and *Damien – Omen 2*. I can still remember my spasm of real horror and shock at the "dismemberment" scene in both: the moment when David Warner is decapitated by a sheet of glass in *The Omen* and the man who is sliced in two in a plummeting lift (a scene clearly intended to replicate the gruesome thrill of the first film's glass moment). But the reason I was mildly obsessed with the *Omen* was that Jonathan Scott-Taylor, the actor who played the eerily self-possessed teenage Satan figure – Damien – was in my

class at school in the 1970s: The Haberdashers' Aske's Boys' School in Boreham Wood, Hertfordshire, also attended by the comedian and author David Baddiel and in fact my fellow critic Mark Kermode.

Scott-Taylor had got the role, it was said, because director Don Taylor was impressed by his performance in a BBC drama production of Terence Rattigan's *The Winslow Boy*, in which he had to dress in military cadet uniform – also a requirement for Damien. He was a real live movie star. And he was sitting at the desk behind me. I was utterly in awe of him.

Jonathan had a cultured, rather breathy "acting voice" which was quite different from his normal accent, a stage-school refinement which he would demonstrate in English classes when we had to read aloud from *Macbeth*. However artificial it may have seemed, the strength, confidence and technique of his voice put the rest of us to shame. And anyway: he had been on TV! In movies! In the school holidays he would shoot films. He lived in an unimaginable realm of superhuman coolness. I had seen a red-carpet paparazzi shot of him in a film magazine. He also – and this was the real fascination – received creepy fan letters, addressed to him at the school, from weirdo delusional Satanists from all over the world who evidently confused him with the real thing.

But after school, a strange thing happened. After a few more screen credits, Jonathan quit the business. Googling him turns up no clear answers as to where he is now: there are rumours that he is a truck driver in Australia. He has vanished more thoroughly than any actor I know about. And that disappearing act makes his scariness in *Damien Omen 2* even more unsettling.

Here are some of my reviews of scary movies, and I have included scary films which are not strictly speaking generic: like Takashi Miike's *Audition*, Mick Jackson's made-for-TV *Threads* and Jordan Peele's *Get Out*.

AUDITION

16/3/01

★ ★ ★ ★ ★

"Japan is finished," says one world-weary movie executive to another in *Audition*. They're slumped over a whisky in a faceless hotel bar, and his mood of dejection and fear is the prologue to terrible events, just as *Audition* itself, in its violent madness, could be the harbinger of a compelling new pessimism: an Asian tiger at bay.

The trajectory of this film is extraordinary. *Audition* begins as the melancholy tale of a middle-aged Japanese widower in an ailing video production company who is persuaded by his teenage son to remarry. From there it morphs into a quirky, almost Reineresque romantic comedy as he uses subterfuge to find love in the autumn of his days. But then, in the final stage of its development, a horrific black butterfly emerges from the chrysalis.

The movie becomes the kinkiest, creepiest, most pungently sexual horror film in recent memory: as macabre as a jewel-inlaid dagger or antique instrument of torture. In its final act, it is a film to make the skin on the backs of your hands prickle with disquiet. Director Takashi Miike has devised a modern-day Jacobean revenge nightmare, which manages to make its delirium seem an integral and plausible extension of the ordinariness and sadness that prefigure it.

Ryo Ishibashi plays Aoyama, a world-weary player in the Japanese film business, who lives alone with his son − the death of his wife seven years before having provided a poignant prelude. Despite the doe-eyed, reproachful attentions of his secretary, Aoyama shows little interest in stepping once more aboard the carousel of romance, and starts lapsing into the habits of an old man.

But having been urged to renew his acquaintance with love by his son, Aoyama tries an ingenious scheme devised by his friend and fellow movie professional Yoshikawa (Jun Kunimura). They will hold open auditions for a film that they are trying to get off the ground, but with a secret agenda; by auditioning for a non-existent subordinate role, they will attract a certain type of applicant: essentially submissive and free from the diva-ish tendencies that

273

would distinguish someone after a leading role. Aoyama can then casually approach the one he likes best for a date.

Of course, the casting-couch try-out is hardly a novelty, and the audition scene here is shot like every audition scene in every film you've ever seen: with a jokey collage of clips of all the desperately unsuitable hopefuls. But what makes the audition here interesting is the elaborate, almost glacial formality with which Aoyama and Yoshikawa devise a plan which pleasingly matches the power relations between director and actress with those between husband and wife. Earnestly, and with no sense that what they are doing is in any sense disreputable, Miike's director and producer have scripted what they hope is a happy beginning and a happy ending to Aoyama's second marriage.

But it isn't long before Yoshikawa senses something wrong with the tall, willowy beauty with whom Aoyama falls head over heels in love. She is an ex-dancer, Asami Yamasaki, played by the former Benetton model Eihi Shiina. Her elegance and mysterious air of unlocatable sadness awaken in Aoyama his long-dormant sense of gallantry, and protectiveness – and something else too. What his doomed hero experiences is not *eros*, but *thanatos* – Freud's "death instinct". He is unbearably moved, and obscurely excited by her tale of having had to give up dance because of an injury to her hips and ecstatically tells her in the fateful audition that her stoic acceptance of this was like accepting death itself.

All of this is an unsettling augury – and Asami is a terrifying avenger, making manifest the pain and death that Aoyama senses in the audition process and visiting it on Aoyama himself, not merely as a punishment for the male sexual triumphalism inherent in Japanese society, but a gratification of his dark masochism of the spirit.

And it really is pretty scary stuff. In the final scene of Asami's hideous triumph over her suitor – made even more unspeakable by its semi-hallucinatory quality – Miike takes his stomach-turningly dark playfulness, and the teasing mendacity of his narrative, and marries it to the gruesomeness of a Clive Barker or the Stephen King of *Misery*.

Takashi Miike has planted an intricate torture garden of a film, lovingly maintained and manicured, with trickling water features and

green spaces of pleasingly geometric design. But somewhere within it is the screech of pain and the cry of pleasure: a lurid nightmare in which the power relations between women and men are acted out in the most barbarously extreme way. Not a horror film exactly, nor thriller, nor even arthouse drama – more a cinema of cruelty whose flourishes are opaque, enigmatic and deeply unsettling.

PARANORMAL ACTIVITY

25/11/09

★ ★ ★ ★ ★

It has been some time since I physically jumped at a scary movie. Horror has become a predictable genre and these days, maggoty skulls can leap out of wardrobes all they want, and we merely yawn. But in this film, all it took was one bedroom door to move twelve inches, unaided – just that, nothing else – and I felt like leaping into the arms of the person next to me. And there were moments when I thought I would not just need to change my trousers, but have them professionally incinerated by a biohazard disposal team.

This ingenious and often genuinely frightening film is a digital mocu-real nightmare, based on the idea of "found" video footage, comparable to *The Blair Witch Project* and *Cloverfield*, lower in budget and humbler in scale than both – but arguably scarier than either.

Moreover, it elegantly solves a problem that always threatened to sink both of those films, particularly *Cloverfield*: how is it that the camera-person so often manages to keep the scary thing more or less in shot? Wouldn't they just drop the camera and run?

Newcomers Katie Featherston and Micah Sloat give subtly authentic performances as Katie and her rugged boyfriend Micah, living together in a pleasant apartment – the film's single location. As the movie begins, we see what Micah sees: his girlfriend driving up to their apartment in a cool convertible – the first and last time we will see the normal world outside their home. To her bemusement, Micah is filming her, and not with any old camcorder; he has bought a big professional-quality digital movie camera, complete with the fixed spotlight which in restricted light creates a harsh light-halo in the middle of the frame – the halo that in *Blair Witch*, back in 1999, picked out the dense foliage with disorientating clarity and also the glistening mucus and tears on Heather's gibbering face.

This isn't just a boy-gadget thing. Micah tells Katie that he intends to film their daily lives as much as possible, and more

importantly, he is going to set up the camera in a corner of their bedroom, with high-quality recording equipment, in an attempt to get evidence of the nightly paranormal activity that Katie has begun to suspect. Like film of a badger's sett in some natural-history programme, we watch night-time footage of the sleeping couple with the timecode ticking over in the bottom right-hand corner. And then ... very creepy things happen, subtly at first, and then not so subtly.

Most disquietingly, we watch Katie one night get up, turn, and standby the bed, facing the sleeping Micah – asleep. Then the timecode speeds up, showing that she has eerily remained in that position for about an hour: sleepwalking or rather sleep-standing. The "fast-forward" effect accelerates the thousands of barely-perceptible movements we make when standing still, and so Katie's form wobbles and jerks. It creates something uncanny, a kind of spiritual shivering or trembling, imprinted on the video.

Having allowed us to watch these bedroom scenes directly, the film superimposes a second layer of anxiety by having Micah and Katie watch them later on the laptop screen, flinching and gasping just as we have done. As their lives unravel in this nightmare, we learn that Katie experienced visions as a child, and that whatever is happening has nothing to do with the house and everything to do with her personally.

Frightened and angry, Micah resents that she told him nothing of this before they moved in together, and despite her pleas for him to stop, he redoubles his determination to confront the ghostly invader on camera: filming is his way of staying in control of the situation and perhaps even his way of punishing Katie. Of course, filming does not put Micah in control: rather the reverse.

A matter-of-fact psychic expert, played with downbeat conviction by Mark Fredrichs, like a doctor making a housecall, calms their nerves for a while. But when this same man is called back in the film's final sequence, and backs nervously out of the apartment, horrified at what he can sense in the air – and that he personally is in danger – the effect is brilliantly upsetting, like a sort of nausea.

Writer-director Oren Peli has hit on such a simple idea, and such a low-cost way of making it work. How has it never been done

before? Well, part of Peli's skill is making it look easy, and he has elicited tremendously believable and relaxed performances from Featherstone and Sloat. Perhaps *Paranormal Activity* can be read as a parable of marriage, and the impossibility of knowing another person – the ghost of their past will always return in the most intimate of relationships. Or perhaps it's simply about … well, a literal ghost. I can only say: be very uneasy.

KILL LIST

1/9/11

★ ★ ★ ★ ☆

The title, and the fact that this was popularly acclaimed at London's recent FrightFest event, will tip you off about what kind of film it is. Or will it? Even now, I'm unsure how or whether to describe it generically. It's partly an occult chiller with shades of *Wicker Man* and *Blair Witch* – and be warned right now: there are some ultra-violent and infra-retch scenes that have had people making for the exits. I wondered if director Ben Wheatley considered putting a death metal version of *Maxwell's Silver Hammer* over the closing credits.

Yet *Kill List* is also something else entirely. It often looks like a film by Lynne Ramsay or even Lucrecia Martel, composed in a dreamily unhurried arthouse-realist style that is concerned to capture texture, mood and moment. The long expository scene looks like the beginning of a downbeat, miserablist film whose only object is to tell the story of a married man attempting to recover from depression through rebuilding friendship and re-entering the world of work. And in some sense this could be what *Kill List* is. But the drifting scenes of ordinariness are especially disquieting, both while they are happening and in retrospect, after the nightmarish situation has begun to reveal itself, and after the brutal explosion of violence.

Perhaps inspired by Thomas Clay's *The Great Ecstasy of Robert Carmichael*, Wheatley has set out to supersaturate ostensible normality with a flavour of evil. In many scenes he succeeds impressively. It's not entirely clear if *Kill List* is more than the sum of its startlingly disparate parts, or if the ending lives up to the promise of something strange and new, but its confidence is beyond doubt.

Neil Maskell and Michael Smiley give very good performances in the lead roles of Jay and Gal, two men who are best mates and professional colleagues, though their friendship is fraught, to say the least. Gal is a Northern Irish guy who is humorous, laid-back and relatively calm; Londoner Jay is moody, anxious, resentful and depressed. After a year of unemployment, Jay is going spare in a boxy detached house in the middle of the suburban sprawl, which

279

he shares with his Swedish-born wife, Shel (MyAnna Buring), and their young son. The action begins mysteriously to accelerate when Gal shows up with his new girlfriend, Fiona (Emma Fryer), for a dinner party at Jay and Shel's house, a dinner party that shows every sign of becoming a tense and embarrassing disaster. Wheatley and his co-writer Anna Jump sketch this out with a Mike Leighish shrewdness and wit. The dialogue is partly credited to the cast, so some lines are presumably improvised: this could have been true of the brilliantly toe-curling moment when Jay complains to Shel about spoiling their dinner table display by putting out a measuring jug of gravy, "like a chemistry experiment".

As well as conjuring bourgeois social tension, Wheatley discloses that Jay's unemployment is self-imposed. A previous job they did together a year before had gone very wrong. But Gal wants Jay to get a grip, to get back on the horse. They have had a new and lucrative offer of work from a shadowy client: work for which they are highly qualified.

This new job is to lead them into situations of extreme fear and revulsion, but also into extreme banality and boredom. Wheatley's trick is to suggest the banality is never quite extinguished by the fear; the fear leaches into the dullness and the normality. Somehow, Jay's visit to the GP is one of the film's most unsettling scenes. Jay and Gal have to do a lot of travelling around the country on behalf of their employer and stay in featureless chain hotels with soul-sappingly dull interiors. The conversations they have there are appropriately tedious, yet always hint at the horror of what they are doing. Gal asks Jay if the soap in the bathroom is in a sealed packet and is relieved to find that it is: "I hate dirty soap." Later, when driving back after a difficult engagement, he sharply asks Jay if he knows the sign of a good painter and decorator: clean overalls. A competent professional does not make a mess. The Wheatley double act is very different from a Tarantino double act or a Pinter double act. Jay and Gal are closer in spirit to Gervais and Merchant.

The moodscape of *Kill List* is inspired, the climax less so, and the more like a conventional scary movie it becomes, and the more clearly it reminds you of other scary movies, the less effective it is. But Wheatley is so distinctive a film-maker, and Michael Smiley and Neil Maskell gently create a convincing friendship: two men,

pathetically dependent on each other's company, yet often scrapping like ten-year-olds. There is a superb moment when it all kicks off in Jay's kitchen and one man actually grabs a mug from the twee little mug tree and smashes it over his friend's head. They're all friends again in a little while, yet a bizarre and inexplicable miasma of evil continues to wash over them. As far as British horror goes right now, *Kill List* is pretty much top of the range.

THE CABIN IN THE WOODS

12/4/12

★ ★ ★ ☆ ☆

In Keenen Ivory Wayans's *Scary Movie*, from 2000, a fleeing character is famously offered two directional options by the masked figure: safety or death. The joke is that there is no choice. No matter how cynical and wised-up everyone is about the horror film and all its various tropes, the genre triumphantly survives, to a great extent by playfully absorbing that cynicism and feeding it back to the fanbase. Drew Goddard plays on this postmodern connoisseurship in this meta-chiller, *The Cabin in the Woods*, co-written with Joss Whedon. The poster shows the cabin in question floating in the air, tricksily twisting in sections like a Rubik's cube.

It's an affectionately satirical nightmare that asks why horror is so potent: what awful human need is being fed by seeing attractive young people in states of semi-undress who are suddenly, brutally slaughtered, almost as if they are being punished for being young and sexy? Why does the genre adhere so closely to the belief that young people in jeopardy have to be picked off singly, leaving that one character who had initially appeared to be so vulnerable and unworldly, but in whom the situation has uncovered extraordinary reserves of heroism and grit? Could there be some anthropological answer to the ritualist behaviour in horror?

The Cabin in the Woods begins by unveiling two sets of characters: one middle-aged and oppressed by the workaday cares of life, the other young and carefree. Richard Jenkins plays Sitterson, a balding, bespectacled guy who resignedly shoots the breeze with his buddy Hadley, played by Bradley Whitford. Then we cut to a suburban home, and a teenage girl's bedroom – both disclosed via a soaring crane shot. This is Dana, played by Kristen Connolly, and genre buffs will smirk at the outrageous way we get to see Dana sauntering around in her underwear, packing for a restorative weekend away with her attractive friends at a cabin in the woods.

Dana is getting over a borderline-inappropriate relationship with her college professor. Her raunchy blonde friend Jules (Anna Hutchison) and Jules's macho jock boyfriend Curt (Chris Hemsworth) are trying to set her up with a cute guy they're bringing along, Holden (Jesse Williams). And just to complete the party, there is Marty (Fran Kranz), a dope-smoking free-thinker, forever railing against the establishment. The five of them turn up to the very creepy cabin after the regulation encounter with the dodgy local. Again, the film is archly aware of how predictable this character is, and overtly tips us a wink by repeatedly showing us the motorbike attached to the back of the camper van the five are travelling in. Could it be that this bike will feature heavily in a final getaway scene?

It isn't long before horrible things happen. But wait. Who were these older guys Sitterson and Hadley? Goddard and Whedon have allowed us to imagine that, being from the older generation, Sitterson is perhaps the harassed dad of one of the teen characters. But it's clear the connection is more disturbing than that.

The Cabin in the Woods is all about the reality conspiracy; mentioning the film's specific influences runs the risk of spoilers. The quintet's sadistic, formulaic victimisation is part of a larger picture, one that semi-seriously reproves its own audience for the cynicism and cruelty they have brought to the spectacle. The action climaxes in a sensational, surreal scene in which pretty much all the horrible things imaginable meet in a grand encounter not only with each other, but with those whose job it is to keep them under control – a sequence perhaps inspired by the "elevator" scene in *The Shining*.

It's a smart twist to an enjoyable movie, but there's not a whole lot more to it than that. The final explanation is so perfunctory it could have been devised on the back of a napkin by M. Night Shyamalan – though of course this absurdity, acknowledged with stoner fatalism, is part of the comedy.

I am still susceptible to the unironised, undeconstructed haunted-house film, and actually found myself substantially creeped out by the 2010 scary movie from Uruguay, *The Silent House*, now remade with Elizabeth Olsen. And the *Final Destination* series, in which a vengeful death angel finds ever more bizarre and black-comic

methods of killing off a series of young people, can still deliver a frisson here and there. *The Cabin in the Woods* is a shrewd, ingenious look at the programmatic elements of the genre, a satire that is also a lenient celebration, and it could wind up being a set text in any MA course in horror. But however smart and sophisticated this film is, it may disappoint those who, in their hearts, would still like to be genuinely scared.

THREADS

20/10/14

★ ★ ★ ★ ★

I have never regarded myself as a hardcore horror fan, although no cinephile can possibly deny the genre's habitual brilliance and flair. Polanski's *Rosemary's Baby* and Friedkin's *The Exorcist* are masterpieces – and there is a real case to be made, incidentally, for the first *Saw*, by James Wan, now enjoying its tenth anniversary. I have been unnerved, thrilled, sometimes shocked and often thoroughly creeped out, by horror films. But hand on heart I don't think I have ever been scared, really properly scared by horror: and this is despite being a fantastic scaredy-cat in real life. I often describe myself as a lover (of my own safety), not a fighter.

What disconcerts me sometimes is what's expected of the genre. People coming out of a great comedy will be laughing. People coming out of a great action movie will be whooping and fist-pumping. But people coming out of a great horror movie don't look horrified – they're laughing and whooping and fist-pumping. Which of course is fine.

The only film I have been really and truly scared and indeed horrified by – in an intense and sustained way – is Mick Jackson's post-nuclear apocalypse movie *Threads*, scripted by Barry Hines and originally made for BBC TV. It was made and broadcast in 1984, although the film's realistic content easily trumped whatever speculative Orwellian resonance was there to be noticed that year. That period was not as tense as the missile crisis of 1962, but after the Soviet invasion of Afghanistan, the diplomatic tensions between the great superpowers could hardly be worse and the ability of artists and film-makers to think the unthinkable had evolved. The government's "Protect and Survive" leaflets – themselves a blood-chilling promise of Armageddon – had entered the general consciousness: the phrase was satirically transformed by CND into "Protest and Survive". I attended a CND-sponsored screening of Peter Watkins's *The War Game* in 1981, when it was still banned from the airwaves, and that magnificent film was upsetting enough, particularly its voiceover

from nice, friendly, familiar Michael Aspel. But the intense discussion afterwards calmed us all – allowed us to channel and manage our fear.

It wasn't until I saw *Threads* that I found that something on screen could make me break out in a cold, shivering sweat and keep me in that condition for twenty minutes, followed by weeks of depression and anxiety.

It's about a couple in Sheffield living their normal lives, looking forward to being parents. They try to ignore the preamble to nuclear war by concentrating on decorating their flat. There's a nuclear strike in the north of England and over weeks, months and years the focus is opened up with a kind of satanic grandeur into the general catastrophe: we see how society degenerates into violent nothingness.

Everyone who has seen *Threads* knows where the real payload of horror comes, and those squeamish about spoilers or thermonuclear birth defects can look away now. The baby is born in the post-nuclear hell. Beyond pain, beyond love, the mother looks into the dirty bundle and she sees …

She sees …

Well, I still don't know exactly what. I was watching the film with my girlfriend and her sister in the manky basement of a pretty unsafe house off the Cowley Road in Oxford – a setting which seemed worryingly close to the film. At this moment, my girlfriend's sister gave a cry or a gasp which I will never forget, and walked out of the room. I looked at her, as a way of not looking at the screen, and then I looked down at the carpet. I was genuinely scared to look up. *Threads* had flooded my body with the diabolic opposite of adrenaline. We all went to bed in utter silence. I have still never experienced anything like it in years of film-going, telly-watching, book-munching, culture-consuming activity.

I was really, really scared. Much later, I remember watching Lucy Walker's admirable anti-nuclear documentary *Countdown to Zero* and almost trying to suppress the memory of *Threads*, to suppress the horror and despair so that I could concentrate.

It is a remarkable film, occasionally revived in film festivals. Jackson went on to direct the comparable *A Very British Coup* on TV, and then more mainstream fare like *The Bodyguard*. Barry Hines had of course famously adapted his own novels *A Kestrel for a Knave* and *Looks and Smiles* for Ken Loach – mighty achievements. But I think *Threads* is the dark masterpiece for both.

THE BABADOOK

23/10/14

★ ★ ★ ★ ☆

Jennifer Kent's clever, nasty, clammily claustrophobic chiller about a mother and child brought back a strange episode in my own parenting career. I was reading aloud to my son from a book that I didn't know anything about, and neither did he. As the pages turned, the prose got weirdly darker, more disconcerting and more age-inappropriate. My son had reposed an unhesitating, childlike trust in the story, and I – the supposed adult – had reposed precisely the same childlike trust in a book about which I knew nothing. If I stammered, or faltered, he would sense that something was wrong, and that the book was actually far more interesting that he had suspected. Eventually, I asked if he wouldn't rather play *Plants vs Zombies* on my iPad instead.

For the life of me, I can't remember what that book was, but the episode was strange. In this movie, a stressed single mother, Amelia (Essie Davis), is going to read aloud to her boy, Samuel (played by a troublingly brilliant newcomer Noah Wiseman). She is a widow: her husband was killed in a car crash taking her to hospital to have the baby who has now grown into this precocious, disturbed, difficult child. From nowhere, Samuel has discovered an odd book in his bedroom – called *The Babadook*, an odd title, perhaps baby-talk for baby's book, or mama's book? It's a creepy pop-up volume about a creature called the Babadook: a top-hatted, expressionist-looking shadow who comes into your house, and scares you. Far too late, Amelia realises that this isn't a nice book, and in reading it aloud, they are going to make it come true.

The Babadook is partly a psychological thriller in the style of Roman Polanski's *Repulsion* or *The Tenant*, a Freudian study of Amelia and Samuel's joint dysfunction and joint breakdown. In one sense, the book triggers their collapse, and is a symbol of Amelia's depression. With its top hat and cloak, the Babadook looks like the magician's outfit that Samuel likes to wear – he shows great talent for magic, and his fanatical need to impress and unnerve his mother with his tricks is becoming disturbing: already he is in constant trouble at school.

Kent shows that as Samuel gets older, he starts to intuit ever more clearly his father's absence and his own quasi-conjugal relationship with his mother. He is always clambering over her and heedlessly touching her in ways he doesn't understand. When desperately lonely Amelia is masturbating in bed one night, her moaning inevitably wakes Samuel and the resulting scene is almost unwatchable. In a sense, it is Samuel who is the invader, the vessel of agonised memories and warped needs, and the two have jointly projected this ordeal into the Babadook: a creature of their own making. But, of course, it is also a supernatural phenomenon that cannot be explained away.

The Babadook is superbly acted. Davis really does look like a sensitive, loving person at the end of her tether, whose emotions have been turned upside down by lack of sleep, and pale, gaunt, goggle-eyed Noah Wiseman convincingly combines being frightened and frightening. He looks weirdly like the young Amish boy played by Lukas Haas in Peter Weir's 1980s thriller *Witness*: he is permanently, secretly aghast at what he is experiencing. There are times when the pair almost fuse into one traumatised entity. Amelia can hardly assert her authority to get Samuel to take sedatives: "I am the parent and you are the child, so take the pill!" In another scene, Samuel sleepwalks over to Amelia and tells her to "wake up". "But you're the one who's asleep," Amelia replies, wonderingly.

Kent exerts a masterly control over this tense situation and the sound design is terrifically good: creating a haunted, insidiously whispery intimacy that never relies on sudden volume hikes for the scares. And the movie cleverly riffs on the surrogate parenting being provided, almost primitively, by children's books or fairy tales or stories. Even the sweetest of them – especially the sweetest of them – look threatening and bizarre, and there is something strange about inviting these sinister creatures into your homes and into your children's heads for the purposes of distraction and escapism. Books demand participatory complicity in a way that TV doesn't, and like vampires, the monsters and giants of children's stories cannot enter without being invited over the threshold. *The Babadook* leaves behind it a satisfyingly toxic residue of fear.

IT FOLLOWS

26/2/15

★ ★ ★ ★ ★

A friend confessed to me recently that this was the only film to have given him, in adult life, a proper wake-up-sweating nightmare. I don't think I have ever had a nightmare quite as scary as this film – a modern classic of fear to be compared to something by a young Carpenter or De Palma.

It Follows is from the American director David Robert Mitchell, whose 2010 debut movie, *The Myth of the American Sleepover*, was a gentle, unthreatening drama about teens and platonic crushes. That was Dr Jekyll to the snarling Mr Hyde of this new one. It genuinely is disturbing.

What Mitchell has given us is a contemporary reworking of ideas from M.R. James; in particular, his 1911 ghost story *Casting the Runes*. Jay (Maika Monroe) is a high-school student who has just started to date a nice enough guy called Hugh (Jake Weary); the rest of the time she hangs out with her sister Kelly (Lili Sepe), Yara (Olivia Luccardi) and a shy childhood friend called Paul (Keir Gilchrist) who has long had a hopeless crush on her. Jay's normal sex life takes its normal course, but then she finds out, too late, that she has been inducted without her knowledge into a supernatural death cult. The sex act means that she will be followed, at a zombie's walking-pace, by a demon that only she can see, and which will kill her. The only way she can get rid of her pursuer before this happens is to have consenting sex with someone else, and so pass the curse on to them. Her agonies of horror and indecision are compounded by the presence of Paul, piningly ready to protect the person he loves.

I love the title: a clear, deadpan, pitiless description, rather like the insect horror *They Nest* (2000). They did, and it does. The action of *It Follows*, with its viral spread of horror and shame, could be read as an abstinence parable or a herpes nightmare or a metaphorical account of Aids. But the point is that the *It Follows* demon is a satirical inversion of this literal case. Counter-acting the harmful or fatal effects of a sexually transmitted disease means stopping

what you're doing, not persisting. But it also means tracking down previous partners to warn them. So in this case you become the follower, and you have to be discreet about it – invisible, in fact, like the nightmarish figures in Mitchell's movie.

It Follows taps into something else about sex and intimacy. I found myself thinking about Simon Rich's short story "The Haunting of 26 Bleecker Street", in which a careworn priest tells a lovelorn young man that the ghost of his ex-girlfriend can only be exorcised if he has sex with someone else. Maybe the truth is that sex can often create a malaise of anxiety, a loss of self that can only be alleviated or reversed by another sexual contact. And so it follows and goes on, and humanity is kept alive with a chain-letter of fear, fending off death with desperate replication. (Although death is always present – one character broodingly reads Dostoevsky on her cute shell-shaped Kindle.) And the horrible, unspoken question in *It Follows* is … who first explained the rules at the very beginning?

The movie reminded me of Abel Ferrara's vampire nightmare *The Addiction* (1995), as well as John Carpenter's *Halloween* (1978), which is an obvious inspiration, with its clamorous synth score. There's also a touch of *Reefer Madness* (1936), the self-satirising propagandist film about the spread of drugs among young people. Everything takes place in a bland, suburban world of broad avenues and handsome detached houses, but without any sentimental or Spielbergian glow; it is seen in a perennial dusk. They live in Detroit, where the ruins cast their own sinister spell.

Larry Clark is another indirect influence. Mitchell captures something of the same listless, affectless world of young people hanging out, and he has a way of eroticising and fetishising the details. Older people are present only at the margin. There is a moment when Jay, at the height of her fear, just gazes down at some strands of grass that she has placed over her skin, and there is a something dumbstruck in the way Mitchell's camera captures this simple image: it looks weird, alien, almost evil, like everything else around her. Mitchell brings off some sensational set pieces of fear and suspense. I can't remember when I was last so royally freaked out in the cinema.

GET OUT

19/2/18

★ ★ ★ ★ ★

The nomination of Jordan Peele's *Get Out* for best picture, a category that sadly often only rewards middlebrow-prestigious classiness, shouldn't blind us to the fact that it is a brilliant scary movie: a horror suspense-thriller with hilarious moments. This is a cracking genre entertainment in the style of Ira Levin, and its piercingly relevant political satire – the basis on which it has been admitted to the 2018 Oscar club – needn't deflect the impact of its sheer enjoyability. There are some great films on this year's best picture list, but *Get Out* is the most purely subversive and raucously entertaining. It's a film to make you wonder how or why John Carpenter's *Halloween* never got a nomination.

A nasty ambiguity dangles silently from the title. *Get Out* ... you're not welcome here? Or *Get Out* ... while you still can? Is it about the exclusion of black Americans from white privilege? Or is it about an insidious welcome, a spurious inclusion, a learned pantomime of liberal friendliness, whose purpose is to disarm and defang grievance and relegitimise white class supremacy for the twenty-first century? Of course, it's both. And Peele avails himself of the satirist's prerogative: to be provocative, bold and even unfair; to stab at those well-meaning people whose anti-racism consists partly in a conviction that race prejudice is a thing of the past.

British actor Daniel Kaluuya plays Chris (resonantly surnamed Washington), a young black American making a name for himself as a photographer. For a few months, he's been dating a beautiful white girl, Rose, played by Allison Williams, who suggests they go together on a weekend trip to her palatial family home in the country to meet her super-progressive and relaxed parents. They are Dean and Missy, superbly played by Bradley Whitford and Catherine Keener: he's a retired doctor and she's a psychiatrist and hypnotherapist. With excruciating earnestness, Dean shows Chris the artworks he got from Bali and tells him he would have voted for Obama a third time if he could. When all their country-club friends show up for a big family

gathering that same weekend, one of the crusty old guests asks Chris if he plays golf and solemnly says how much he admires Tiger Woods.

But there's something very weird going on. Rose's parents have black servants who display unnervingly polite smiles (quietly brilliant performances from Betty Gabriel and Marcus Henderson) and make the house look like some sort of plantation. Over dinner, Rose's kid brother Jeremy (Caleb Landry Jones) makes boorish comments about Chris's physical endowments as a black man. Then Missy, ostensibly to cure Chris's smoking, begins to put him in a mild state of hypnosis. Meanwhile, back at home, Chris's best friend, Rod, is deeply suspicious about what his buddy is getting into: a great performance from comic LilRel Howery.

Get Out is a movie that challenges a single, important idea: progress. Surely we have made real progress since the days of, say, *Guess Who's Coming to Dinner*, the classic 1967 film with Sidney Poitier and Spencer Tracy? And when Barack Obama got elected in 2008, and then re-elected in 2012, surely the right-thinking people across the globe could be content that something important had happened, and real progress had been achieved? Well, *Get Out* has a surprise in store for Chris, and the 2016 presidential election had an awful surprise in store for everyone else: the gruesome twist ending of post-Obama America, that nonexistent third term that Dean piously invoked.

Get Out is a movie to put alongside Paul Beatty's novel *The Sellout* or Kevin Willmott's film *CSA*. It's also one of the vanishingly rare movies with interracial leads, and a mainstream feature film bold enough, tactless enough, irresponsible enough to invoke race outside the solemn confines of documentary. But a documentary is also what it reminded me of: Ava DuVernay's *13th* was a film that sought to open people's eyes to the fact that the persistence of racism after the American civil war isn't simply a kind of cloudy emotional or cultural residue, but part of the Jim Crow settlement. It was part of what induced the South to accept defeat.

You could say *Get Out* runs on a rocket fuel of defeatism and pessimism, but perhaps no more so than Jonathan Swift and his blisteringly satirical *A Modest Proposal* (in which he urges, with heavy irony, the Irish to improve their economic prospects by selling their children for food). The point is that *Get Out* takes that pessimism and converts it into defiance – and laughs.

SUSPIRIA

13/6/18

★ ★ ★ ★ ★

Is there a more purely bizarre film than Dario Argento's fantasy horror cult classic *Suspiria* from 1977, avowedly inspired by Thomas De Quincey's essay "*Suspiria De Profundis*", or "Sighs From The Depths"?

It is about a ballet school in Germany which is a front for an occult witch conspiracy, feasting on the innocent blood of its lithe young dance students. This could itself be a ballet, or perhaps an opera; it's so stylised and weird and mad, with grinding notes of campery and black comedy. The crazy, clamorous, scary electronic music by the Italian band Goblin is a calculated affront, a provocation: crashing, screeching, clattering its way into your eardrums from the opening credits. It is almost unbearable. Luciano Tovoli's Technicolor cinematography and Guiseppe Bassan's amazing production design create these fierce, retina-searing splashes of colour, as if from some disco lighting rig in hell. There are great meaty blocks of red, the kind of Technicolor red you don't see in the movies any more – stop sign red, poster-paint red. And then there's the intricate quasi-Art Deco interiors, with some window designs that look as if they are the work of a collaboration between William Morris and Dennis Wheatley.

Jessica Harper plays Suzy Bannion, a naive young American who shows up at the outrageously absurd "Tanz" Academy in Freiburg and is instantly disconcerted by the hostility and indifference she encounters at the airport: there is a rather extraordinary scene in which she simply walks nervously from the arrivals lounge to the exit and the whole interior seems buffeted by the high stormy winds outside, as if the storm seems supernaturally to have entered the building. On Suzy's arrival at the school, she sees a disturbed young woman running away from it, apparently in fear of her life. Unable to gain entrance to the building, Suzy must persuade her sullen taxi driver to take her back into the city, and on this journey, she actually

sees this woman running through the forest, starkly lit by – well what? There is no explanation for the light.

On returning the next day, Suzy is welcomed by dance instructress Miss Tanner (played by veteran Alida Valli with her death's-head grin) and the mysterious principal Madame Blanc, a swan-song role for Hollywood legend Joan Bennett. Really strange and horrible things are going on, and Suzy suspects that she herself is being groomed in some unspeakable way to be the school's next sacrificial victim.

Suspiria is often described as not making literal sense, or only the sense of dream-logic, though that isn't entirely true. However preposterous, it does more or less hang together – the only really odd departure is when Suzy somehow makes the acquaintance of an academic in the town, played by Udo Kier, who explains to her the origins of the dance academy and of witchcraft itself. There are very disorientating overhead shots, making Freiburg look almost like some North American city or university campus.

It is a melodrama, above everything else, a film whose violence is intended to be taken simultaneously deadly seriously and yet at the same time as a sly and queasy joke. Who could witness the blind accompanist with his treacherous dog, or the hulking servant with false teeth due to gingivitis, or the pert-faced evil child who wanders about everywhere with the malign hag who works in the kitchen – without laughing? But it is presented straight. It is more of a masque than a movie: a succession of scorching colours, grisly tableaux, death scenes, violent denouements. When Suzy finally gets away, she laughs, as if dismissing all the revolting things that have just happened as bad dreams, or preposterous ideas, and vanishes from the screen as the credits roll. What on earth was that about?

The films that made me swoon: love stories and sexiness

In this section, I have collected reviews of films about love and films about sex. Maybe that's a naive association: sex is about power as often as it's about love. What I haven't done is mixed these in with date movies – a genre whose narratives do not necessarily include dating or heterosexual romance. Kingsley Amis once wrote that the art of seduction was to bring up the subject of sex all the time but not explicitly, and without appearing to do so deliberately. It is also true of date movies: men will be making a rookie mistake if they take the object of their affections to a sexually explicit film. It's overplaying the hand. The saddest and most gruesomely unwatchable example of this in fiction is Scorsese's *Taxi Driver*, when – at the height of that era's porn chic – Travis Bickle actually takes Betsy to a porn film, thus revealing his abject desperation to have sex. Not unreasonably, she is grossed out. He has blown whatever chance he might have had with her. I have, incidentally, a theory about *Taxi Driver*. Travis Bickle is a virgin.

Going too far in the other direction, in my days of student singledom, I once took a woman to see Peter Greenaway's complex movie puzzle *The Draughtsman's Contract*. This was in the 1980s, when Peter Greenaway films were *de rigueur* among *The Guardian* and *Time Out* reading classes. It was, I still think, a pretty shrewd date movie choice on my part. Not desperate, or at least not in that sexual way. Cerebral. Intriguing. Slightly mysterious and cool. In taking this woman to see *The Draughtsman's Contract*, I had a chance. But no. With brutal efficiency, *The Draughtsman's Contract* hustled me over the border into The Friend Zone where I took up residence

in manacles and an orange jumpsuit, and was forced to watch as my exit visa was burned in front of me.

Interestingly, when I started going out with my girlfriend Caroline, now my wife, date movies and the cinema didn't actually play too important a role. But once our relationship was up and running we were always, always, going to see films at the now vanished Arts Cinema in Cambridge's Market Passage and then walking to the Cambridge Arms at the bottom of King's Street, where our conversation was utterly dominated by the film we had just seen. But we weren't discussing it. We were playing *Screen Test* – a game we had modified from the BBC TV children's quiz show in the 1970s, chaired by the legendary Michael Rodd. We just asked each other quiz questions based on factual points in the film, back and forth, back and forth, almost indefinitely. What was the name of Gabriel Byrne's character? (The name of characters in films is still something that routinely escapes me.) What was the colour of Tom Cruise's trousers? How many times did Tom Berenger touch his moustache in the precredit sequence? It sounds impossibly nerdy and it is – and yet I still recommend it as a very enjoyable post-film game. And there is something very innocent about it: I associate *Screen Test* with love.

In one of the pieces collected here, I write about the fastidiousness and learned dismissal that creeps into any discussion of explicit sex on screen. But perhaps even this issue has been superseded by the way sex has become coloured in the new era of #TimesUp and #MeToo, that almost revolutionary 2017 moment in the sexual politics of film production when it was revealed that leading producer Harvey Weinstein was a serial sex abuser and that his activities were not a one-off: plenty of powerful men shared his tastes and plenty more enabled it, covered up for it, turned a blind eye to it. That naivete is to some extent shared by critics and – I admit it – shared by me. Critics can be as innocent as children about what the actual industry is like. I have enthused about Quentin Tarantino as a film-maker, and still do. (In the same spirit I have praised Polanski and Allen.) But those recent accounts of how Quentin Tarantino behaved with Uma Thurman while making *Kill Bill* – not sex abuse as such, but bullying her into an unsafe car stunt, actually spitting in her face for verisimilitude – they are poisonous. Part of

the nauseous, dangerous and unregulated chemical by-product that's been churned out as part of getting cinema's Chanel No. 5 into the shops and under our delicate critical noses. But for what it's worth, I don't agree that it has any bearing on whether we admire "auteurs", any more than reports of how doctors or paediatricians engaged in sex abuse mean that we no longer have any respect for the idea of a "doctor" or a "paediatrician".

OF FREAKS AND MEN

14/4/00

★★★★☆

In a week of films intent on telling you what you know already, Alexei Balabanov's proto-Freudian bad dream *Of Freaks and Men* stands out as a compelling experience, sinuously original and deeply refreshing – although refreshing is perhaps not the exact word for this uniquely unsettling movie. Balabanov's brutal study of modern Russian gangsterism, *Brother*, is already on release here, and now this director's later picture marks him out as a distinctive and very remarkable talent.

Shot in a glittering, wintry monochrome, which attains a heavy sepia tint, *Of Freaks and Men* is set in turn-of-the-century St Petersburg. It imagines the bourgeois origins of Russia's fledgling porn industry: specifically that catering for images of flagellation and sado-masochism – catching this industry on the cusp of its movement from still photography to rudimentary moving pictures. The film's periodic silent-movie captions and its daguerreotype-hue are in homage to both media.

For this flourishing new porn culture, Balabanov invents a milieu of secrecy, exoticism and aberrant strangeness. The result is a disturbing, erotically creepy, funny and touching film whose images will live in your memory.

It concerns a doctor and his beautiful, blind wife who have adopted a pair of Siamese twins joined at the hip – Tolya and Kolya. The twins' singing ability in adolescence is exploited by their adoptive parents on the stage and they inspire an obsessive following with musical audiences, becoming the toast of polite society.

Nearby, a widowed engineer lives with his daughter Lisa in slightly less genteel circumstances, and the two households become connected by a below-stairs taste in pornography. Elaborate studies of naked women being spanked and thrashed with birch twigs are being turned out with fanatical artistic care by the glacial, deadpan Johann (Sergei Makovetsky) and his sinister, grinning sidekick Victor

Ivanovich (Victor Sukhorukhov), as a sideline to their respectable portraiture business.

Johann and Victor insinuate themselves into both houses: and their influence coincides with the descent of one of the twins into alcoholism, and the other's erotic obsession with Lisa. Victor, too, conceives an interest in Ekaterina, the doctor's wife, and the scene in which he tweaks up her skirts to examine her genitalia – while she appears to stare glassily, ambiguously ahead – is an extraordinary moment.

There is something very gamey and very kinky in the way Balabanov represents the consumers of Johann's wares as being women, and this conceit has its own element of pornographic whimsy. Balabanov's juxtaposition of pornography with the trim, prim world of stage performance and bourgeois musical taste – in the form of Tolya and Kolya's sensational career on the stage – endows this secret theatre of sexuality with a vulnerability and a terrible pathos.

The weird rapture of the beatings, which are first photographed, and then filmed, are overlaid with a sadness and an absurdity as Balabanov reveals the emotional relationship that exists between Johann and the old woman – "nanny" – who is wheeled out on camera to administer the punishment.

Balabanov's St Petersburg is shown as having something in common with Arthur Schnitzler's Vienna, in which heavily-furnished front parlours, upright pianos, mob-capped maids and antimacassars are the primal scenes for unacknowledged yearnings and sexual awakenings, both real and imagined. In *Of Freaks and Men*, Balabanov parodically invents a kind of prehistory of pornography, or a prehistory of sexual modernity: a deadpan world of suppression, displacement and exclusion in which nameless desires have an intensity for being hidden, but also a mortal and overwhelming sadness.

Of Freaks and Men is close to early David Lynch in its grotesqueness and Balabanov's images are faintly reminiscent of the photographs of Diane Arbus, with a suggestion of Joel-Peter Witkin, though they have always the solvent of tenderness. And, as in Balabanov's early movie *Happy Days* (released here last year), the bowler-hatted Johann and Victor have Beckettian severity and absurdity.

The extended sequence in which Johann is silently conducted by riverboat to Lisa's house, where he intends to propose marriage, icily impassive at the prow with his bunch of flowers, is riveting. It is a tremendous performance from Makovetsky, whose inscrutable mien gives him Buster Keaton's eerie self-possession. Balabanov's regular player Sukhorukhov is similarly watchable as Johann's subordinate, displaying low cunning and bad teeth. This is a film of pungent and distinctive flavour, maybe not to all tastes; but, for its originality and style, it must be seen.

IN PRAISE OF LOVE

23/11/01

★ ★ ★ ☆ ☆

Like Napoleon returning from Russia with the snow on his boots, Jean-Luc Godard has here retreated from the whimsy, the fatuity, the obscurity and the eccentricity of his recent work, to film-making which is closer to intelligibility and accessibility, and closer to film-making which shows real people for whom real issues are really at stake. Perhaps most pertinently, he has returned to Paris for the first time in thirty-five years, which in the first half of this movie is photographed by Christophe Pollock in the most classically beautiful black and white. It is as if those streetscapes themselves have gone some way to returning Godard to the wellspring of his youthful inspiration. In *Praise of Love* is speckled with all the stylistic tics and naive rhetorical mannerisms which have progressively alienated and exasperated even his most sympathetic audiences. But his latest film – a meditation on history, politics and love – unarguably has substance and a seriousness in its address to the viewer.

The director's protagonist, played by Bruno Putzulu, is Edgar, a handsome boyish figure, evidently of considerable personal means furnished for him by a wealthy artistic family. Edgar is brooding on the genesis of an artistic project, a project about love, but is unsure whether it should be a novel, a play, a film or an opera. Edgar's hesitancy certainly demonstrates a wonderfully elegant disregard for the practicalities which harass every other mortal artist in any of these media: a very Godardian note of semi-intentional comedy. But any dilettante-ish note is dispelled by his intense interest in one of the young women he has "auditioned" for this project, who then commits suicide.

The poignancy with which Godard invests this discovery is coloured by the memory of having met her three years earlier, along with her grandparents, Resistance fighters who were with de Gaulle in London. Edgar, typically high-minded, wishes to consult with them for a cantata he is writing about Simone Weil. But some boorish and arrogant US producers are there too, attempting to

railroad them in signing over rights for what is assumed to be a crassly illiterate Hollywood movie. It is in this second half, the platform for vintage anti-Americanism, Godard switches from his luminous monochrome to a colour-saturated video, a mischievous *épat*.

This film often has the air of a celluloid commonplace book, a forum for Godard's fragments and doodlings about love and history – fascinating in many ways, and pregnant with meaning, but often frustrating. Edgar's reading in the classics has given him a taste for the epigram. "Most people have the courage to live their lives," he ponders, "but not to imagine them." A brilliant *aperçu*, but one we have to pay for with yards of maundering and meandering. Both Godard and Edgar are in search of the meaning of adulthood, that intensely realised period of selfhood between the homogeneity of childhood and age: it is a time in which the individual's relationship with the constituent and determinant factors of history are most fully realised. Director and protagonist find their pivotal shift towards these political determinants in a happily chosen line from Georges Bataille: "The antithesis of the loved one is the state: whose sovereignty takes precedence."

This oppressive "state" finds, for Godard, its apotheosis in the US, which he excoriates as a place without history – a place which wishes to appropriate other's history: typical Yankee intellectual imperialism. This is bolstered with some very unconvincing bluster about Sarajevo, Kosovo and Vietnam. Since 11 September, of course, the debate about "anti-Americanism" – respectable dissentient viewpoint? or pure racism and chippiness? – has attained a new currency. But Godard's blundering, dated naivety is not exonerated by any of this: he behaves as if France had no history of imperialism.

For all this, his observations about American cultural imperialism are not without wit. His characters find themselves, at one point, standing in front of a movie poster for Bresson's *Pickpocket*, next to one for *The Matrix*. Later, Edgar reads aloud from Bresson's *Notes on the Cinematographer*, a passage about the primacy of stillness and silence, and some children come to the door, in historical dress, petitioning for state funds to dub *The Matrix* into Breton!

Well, it is a very sophisticated, arch mode of drollery. Perhaps more striking is that great shift from celluloid monochrome to video colour. It could be a droll comment on the nature of modernity, but

the shift is for going *back* in time. Perhaps, Godard is humorously implying, black-and-white photography is the most fiercely modern invention for representing reality: after all, no one had thought before that of painting in black and white. At all events, it is a *coup* of a sort and *In Praise of Love*, like a cinematic poem, is a difficult work, sometimes baffling and redundant, but often challenging and affecting.

FAR FROM HEAVEN

7/3/03

★ ★ ★ ★ ★

This extraordinary film, written and directed by Todd Haynes in homage to the "women's drama" Hollywood pictures of Ross Hunter and Douglas Sirk, is a cinematic event – an event where I came to mock and stayed to pray. At the premiere at last year's Venice film festival, we were all giggling in the first five minutes at what looked like a bafflingly elaborate "Hi-honey-I'm-home" 1950s skit, like something by David Zucker and Jim Abrahams. But quickly, through total immersion in this impeccably acted, brilliantly designed and unflinchingly serious drama, the giggling disappeared in my own case, and was replaced by nothing less than passionate endorsement of its every detail, every nuance, every narrative contour. We all came out stunned by what we'd just seen, instantly and correctly hailed as a *capo lavoro*, a masterpiece.

I've seen it enough times now to watch dozens of other people go through this same change of mind, and maybe you do need to experience and savour its knife-edge of absurdity, and your own initial incredulity, to appreciate the movie's Wildean connoisseurship of the seriousness in small things. It beats me how some look down on this film as just one big, camp joke. *Far from Heaven* is much more than camp or pastiche. It is an incredible cinematic séance or even a secular High Mass, at which the real presence of the past is quite unexpectedly summoned up and made to live, spectrally, all about you.

The setting is the autumn of 1957 in the affluent small town of Hartford, Connecticut. Cathy Whitaker, played by Julianne Moore, is a beautiful but sobersided mother of two, married to Frank (Dennis Quaid), a ruggedly handsome, go-ahead executive at the Magnatech TV company, who has, we are given to understand, seen active service in World War II as a US naval officer. It is a blissfully happy family scene into which drama and tragedy have yet to intrude.

Everything about *Far from Heaven* playfully yet reverently alludes to the 1950s as a movie genre. The rich and digitally enhanced autumn

leaves feature as tableaux, and as a discreet and tasteful design for the opening and closing credits. Elmer Bernstein's score imitates the lush foliage with its extravagantly emotional strings, later arranged with much emphasis on brooding keyboard and woodwind, dotting and crossing the drama's every "i" and "t". Mark Friedberg's production design is outstanding, surpassing his period work on *Pollock* and *The Ice Storm*. Sandy Powell's costumes are superb, especially for Moore herself who is allowed noticeably fuller skirts as the queen bee of her daiquiri-sipping ladies' circle, and some truly show-stopping elbow-length gloves for a party scene.

But writer-director Haynes is able to make explicit an issue which could not be tackled by the Sirk movies at the time, and is still partly implicit in a modern and distinctively gay critical sensibility which treasures them now – homosexuality. Frank's terrible secret is that he has encounters with anonymous men met in alleys or in Edward Hopper-type darkened cinemas. Astonished by this discovery, and Frank's self-loathing and drunken cruelty to her, Cathy finds solace in a friendship with her black gardener, Raymond: a cultured widower with a business degree whose appearance at a local art show scandalises the local bigots. It is a performance to which Dennis Haysbert brings a Poitier-esque dignity and poise.

So racism is the second theme. In this world, the black "help" silently take coats and serve drinks at cocktail parties, while boorish suburbanites unburden themselves of their reactionary opinions. But when Cathy earnestly assures Raymond of her support for "negroes" and the NAACP, Raymond is all charm and gentle tact at Cathy's maladroit token of solidarity, as if to calm the horrified frisson now running through the cinema audience itself.

Introducing race and sex into a genre in which they have always been understood to be excluded – showing what's underneath social and cinematic convention – creates a giddy heightened perception, like a drug. But there is something fundamentally serious about what is presented in this movie. Frank's tortured estrangement from his marriage, his coming to terms with himself, and Raymond and Cathy's doomed relationship are stories about human decency and human courage.

Irony or postmodernity are not permitted to undermine them. Cathy suggests to Frank they take a holiday in Miami as a break from

the psychiatric treatment he is undergoing for his homosexuality, and he grimaces at her unthinkingly bubbly remark that everything there is pink. "Maybe we'd better not go, then," he smiles, and his heroic attempt at self-deprecatory humour is nothing like an arch wink tipped at the audience. It's a gentle, tender moment between man and wife. Later, Frank bursts into tears in front of his shocked children: his little boy is solemn and silent; his daughter bursts into tears too in uncomprehending sympathy and fear. It is a stunningly real moment of family dysfunction.

When Raymond and Cathy confront the real feelings they have for each other, the effect is just as visceral. Raymond admires the way she can see beyond the surface of things; Cathy asks if he believes that to be truly possible, and Raymond says that he does. They mean the colour of their skin, of course. But here Haynes is also showing his own hand, showing how his story goes beyond the surface of things, goes beyond artifice and pastiche. It is a sensational affirmation of how he has availed himself of these things as craftsman and artist, and yet transcended them. He has used them as a ladder which he has been able to kick away at the last, to produce a brilliant essay in history and genre: a radical dive into the past.

Far from Heaven is such a remarkable achievement – made possible by superb performances from Moore, Quaid and Haysbert – and probably uniquely so. It's difficult to see how it could be developed any further, unless a modern Japanese director wishes to duplicate its effect with reference to Ozu movies like *Late Autumn*. Todd Haynes has directed a miraculous picture which has dispatched the tired debate about postmodernism; he has given us a vivid human story and a compelling love-letter to cinema itself.

THE GOOD OLD NAUGHTY DAYS

26/3/04

★ ★ ★ ★ ★

What a week this is for super-league turbocharged shockers. This is one of the most extraordinary, bizarre and hilarious films to be shown here for years: a fascinating chapter in the secret history of cinema, of the *belle époque* and of sexual politics. It is a sixty-seven-minute feature, originally entitled *Polissons et Galipettes* ("naughtinesses and tumbles") and anthologises a dozen or so sex films, furtively made in France between 1905 and 1925, well before the Chatterley ban and the Beatles' first LP. They were filmed with actors and male and female prostitutes, often covertly using the stages and costumes of legitimate productions, and originally designed to be shown in brothels and stag parties – certainly not cinemas.

If you think these films are going to be like coy Edwardian postcards, or that screen sex was invented in the 1970s, think again. This is in-your-face hardcore porn with surprisingly high production values, complete with flabby tummies, mottled thighs and armpit hair, and given a tinkling piano soundtrack which goes into trilling glissando runs for the money shots.

One gentleman, in a film called *Massages*, looks worryingly like John Malkovich, but it can only have been the glass of absinthe I took into the auditorium which made me think I'd glimpsed the young Lynda Bellingham. The raunchy action itself, with a century's hindsight, looks like an anthropological documentary about highly-sexed thespian tribes. You half expect David Attenborough to crouch up to the camera and whisper: "And here you can see a male bearing the distinctive false moustache, his penis semi-erect, attempting to deflower a schoolgirl in her mid-thirties while a female dressed as a Carmelite nun pleasures herself with a Jack Russell terrier." It should be shown in a double bill with Salvador Dali's *Un Chien Andalou*.

The Good Old Naughty Days has the rare distinction of getting the Restricted-18 certificate from the British Board of Film

Classification. Evidently too volcanically rude for an ordinary 18 certificate, this can only be shown in cinemas with a designated "club membership". You can make films with realistic rape and violence and get a humble 18, but grown-ups having consenting sex is R-18. Go figure.

9 SONGS

11/3/05

★ ★ ★ ☆ ☆

Film writers often get asked what they think about full-on explicit sex in the movies. My response is like Gandhi's apocryphal reply to the same question about Western civilisation: "That sounds like an interesting plan." We behave as if sex is everywhere in popular culture, but despite the ketchupy smothering of everything with a supposed sexiness, despite the speed dating, porn chic, reality TV bedrooms, desperate housewives etc etc, actual representations of ordinary, common-or-garden sex are still very uncommon. So this robust and unpretentious sex film from that extraordinarily prolific director Michael Winterbottom is outside the euphemistic mainstream.

I am relieved to report that the hardcore sex action is completely gratuitous – which, in real life, is the very best sort. It's certainly less pretentious and more cheerful than movies like, say, Patrice Chéreau's *Intimacy*, films which tend to surround the deed with worthy, maundering dialogue about love and sex, as if this additional material was being entered into exculpatory evidence for some putative Chatterley trial.

9 Songs is shot on low-budget digital video and it's really about nothing more, and nothing less, than two pretty young people with nice bodies having sex. Vanilla sex with a condom, that is, enlivened with a little light bedpost shackling and headscarves pressed into service as blindfolds.

Lisa (Margot Stilley) is an American student in London for the summer; Matt (Kieran O'Brien) is a research geologist whose work takes him out to the Antarctic to analyse the ice strata. He narrates the action in hindsight, gazing out over that freezing white mass, a continent unvisited by humans until the twentieth century. It's a landscape that reflects both his devastation at the end of the relationship and his passionate memory of Lisa's body, not so much a new-found-land like Donne's America, but an icy enigma, a sexy-scary blank.

They meet at a Black Rebel Motorcycle Club concert at the Brixton Academy in London and go back to his place for sex, setting a pattern of lovemaking and going out to gigs that repeats nine times through the film: guitar band, sex, guitar band, sex, guitar band, sex, and so on. We don't discover much about Lisa and Matt. They don't discover much about each other.

Poor, muddled Matt is quite unable to talk about his feelings for her, and the nearest he gets is sweetly running into the freezing cold sea on a pebbly British beach to prove his love. Their conversation has the uncertain, improvised aimlessness of real life, and their relationship is not developed and complicated in any traditionally scripted sense. In so much as there is a narrative arc, it traces their passionate infatuation, which becomes darker and more alienated as it shades into more ambiguous sex action. Then one of them has to say goodbye. It's not simply a case of two sweaty anonymous people shagging in a hotel room *à la Last Tango in Paris* or *9 Weeks*. Matt and Lisa go outside in daylight. Occasionally.

So this is no great love affair; there are no big scenes of tears and laughter; breaking up and making up. Leo and Kate on the prow of the *Titanic* it ain't. Its very casualness, its unfinishedness and downbeat messiness give the affair the feeling of real life, which by a further paradox makes it more engaging than something more obviously dramatic. And under the grunting and grinding and slurping and spunking, Winterbottom often places a sad piano soundtrack by Michael Nyman, leading to an uncomfortable reminder that sex, youth and rapture are very, very fleeting. (Come to think of it, this film's a bit fleeting at its cutely-judged sixty-nine minutes.) All this, and the spectacle of raunchy sex, makes *9 Songs* an entertaining if melancholy experience.

Traditionally, objectors to this sort of thing airily claim that it is "boring". This is the acceptable unshockable-sophisticate alternative to condemnation on moral grounds. *9 Songs* will undoubtedly have a chorus of pundits ostentatiously stifling their yawns in print. To which I can only say – boring? Gosh, really? Is that why all those male journalists in the audience were gulping and surreptitiously recrossing their legs? Because they thought it was boring?

Perhaps. Others, conversely, might affect to see in the sex infinitesimally subtle narrative stages, and also an intentional commentary

on the action in the lyrics of each of the nine songs by Franz Ferdinand, Primal Scream, the Dandy Warhols etc. It may be true. But I thought it was absorbing precisely because of the absence of artfully positioned ironies and narrative touches: it's just about going out for a good time, and then staying in for an even better time.

As for the sex itself, it has two basic stages. The sex is absolutely fantastic for Lisa and Matt and then, well, it's not so fantastic any more. Why try to complicate things? As to whether or not it is pornographic, the stakes are not quite so high with that question these days: it is pornographic in the sense that the sex act is shown on screen, complete with money shot. But it does not have the self-conscious porn sheen that arthouse directors like Lukas Moodysson and Tsai Ming-Liang are investigating: it doesn't have the porn tropes of transgression and exhibitionism. The people are too ordinary and the sex is too straightforward.

9 Songs is more like a very modest version of Richard Linklater's *Before Sunrise* with Ethan Hawke and Julie Delpy, only instead of penetrating conversation there's penetrative sex. Linklater's bittersweet sequel to that film reunited the lovers and gave them more brainy and flirtatious banter, only deepened with maturity. I like to think that if Winterbottom made his own sequel, *9 More Songs*, Lisa and Matt would just get down to sixty-nine more minutes of uncomplicated, if faintly tetchy humping, complete with grey hair and love-handles, breaking off nine times to listen to Radio 2.

LAST TANGO IN PARIS

13/7/07

★ ★ ★ ★ ☆

As far as erotic-obsession dramas go, we live in a dull margarine age, an era of low-cal olive spread. So it's bracing to revisit that great shocker of yesteryear, Bernardo Bertolucci's *Last Tango in Paris* from 1972. Nobody makes sex films like this any more, with the exception of France's Catherine Breillat, who actually has a minor acting role here.

The fantastically earnest story is about Paul (Marlon Brando), a damaged, grieving widower who meets up with freewheeling hippie-chick Jeanne (a heartbreakingly vulnerable-looking Maria Schneider) to cauterise his spiritual agony with regular anonymous sex in a Paris apartment. These sessions skiff out to the wilder shores of despair and degradation, and include the legendary butter-assisted sodomy; Brando later returns the compliment by allowing Schneider to do the same thing to him with two fingers, *sans* Kerrygold, an act rendered even more piquant by his later revelation that he has "a prostate like an Idaho potato".

What a bizarre film it is, capable of delivering some shocks, certainly, but possessing not power exactly, but a fascinating, unevolved clumsiness. Brando confronts the audience like a bull behind the china shop counter, and his extraordinary, old-fashioned charisma is what keeps you watching. That face is hyperreal in its leonine handsomeness. And you don't see it clearly at first. Like Don Corleone receiving petitioners in his inner sanctum or Colonel Kurtz in his cave, this is one of Brando's crepuscular roles, a brooding creature of the shadows, from which the first recognisable thing is the nasal-strangulation of the voice. Later he morphs into Cagney, a premonition of his final top-of-the-world moment in Maria's apartment, and he unleashes a hilarious hammy English accent, whose cadences give him Olivier's camp self-possession.

The sex is mostly fully clothed, although Maria gets entirely naked for a bathing scene, displaying some old-school luxuriant pubic hair; and Brando gets his great, flabby forty-something bum out

for the final scene in the tango bar when he "moons" an outraged proprietress who is attempting to throw him out. Thankfully, this is the nearest thing to nudity he has. The sodomy scene, incidentally, gives us a candid "pelvic thrusting" shot of the sort that Kirby Dick, in his excellent 2006 documentary about movie censorship, *This Film is Not Yet Rated*, tells us that the Motion Picture Association of America now considers absolutely beyond the pale, clothed or not.

Despite the legend that has grown up around the film, it is not simply about claustrophobic shagging in the one flat. Occasionally, they leave their Alex Comfort zone, and this is where the movie picks up dramatic speed. Schneider comes from a well-to-do family; her father was an army officer in Algeria in the 1950s. She has a callow, irritating film-maker boyfriend (Jean-Pierre Léaud) – whose callow irritatingness unfortunately seeps into the movie's texture a bit. He intends to make a drama-documentary about their lives together, perpetually showing up with a camera-crew in tow.

Paul turns out to have run a low-price hotel with his late wife, who committed suicide, for reasons that remain unclear, after an affair with one of the guests. Artfully, Bertolucci allows us to suspect that Paul may have actually murdered his wife, at which point the movie assumes the air of an impossibly explicit Hitchcock thriller, perhaps with a screenplay by Patrick Hamilton. Brando has a tremendous scene with Massimo Girotti, who plays Marcel, his wife's lover, with whom she appeared to have enjoyed gently uxorious evenings in matching dressing gowns. Paul thoughtfully tries on one of the dressing gowns, and the two rival males sit on Marcel's bed, in these same gowns: an unexpectedly sweet, sad scene. The most extraordinary moment comes when Paul's dead wife is shown bizarrely lying in state in one of the hotel rooms while he rants and raves over her corpse. An almost Buñuelian nightmare. With lines like "put your fingers up the ass of death until you feel the womb of fear", this movie is easily mocked. It probably deserves it. But in its raw, artless, innocently self-important way it packs a punch. You'll know when you've been tango'd.

THE LAST TOXIC TANGO

4/12/16

My female friends and colleagues, online and off, have been bleakly unimpressed this weekend by a recent display of bland and worldly impenitence from Bernardo Bertolucci about how he created the "butter" scene in the 1972 film *Last Tango in Paris*, starring Marlon Brando and Maria Schneider. But they are still more unimpressed about the resulting liberal horror, as if this was a bizarre and scandalous one-off, and not simply yet another detail in the colossal architecture of male power in the movies and everywhere else.

Hollywood's *Captain America* star Chris Evans tweeted: "This is beyond disgusting. I feel rage." Jessica Chastain tweeted: "To all the people that love this film – you're watching a nineteen-year-old get raped by a forty-eight-year-old man. The director planned her attack. I feel sick."

I felt this nausea because like everyone else, in my naivety, I had assumed that Bertolucci had discussed and rehearsed this scene with Brando and Schneider on equal terms, in advance of shooting. This was the shocking moment when Brando's character Paul brutally penetrates Schneider's character Jeanne using a stick of butter.

But in recently-surfaced video of an onstage event in 2013, Bertolucci announced that he did not tell Maria Schneider what was going to happen before the take; he and Brando had secretly planned it without her knowledge because the director wanted her humiliation to be real. Two powerful men, aged thirty-two and forty-eight, had arranged for her to be assaulted. For Maria Schneider herself, it was something more akin to actual physical assault: "I felt humiliated and to be honest, I felt a little raped." Bertolucci's Wikipedia page is now getting hammered to this effect.

I myself last wrote about the film in 2007, when *Last Tango in Paris* was re-released in the UK. I had always believed that the scene was only fifty percent of the film's meaning – and that the point was that Paul wanted Jeanne to do the same thing back to him: to be painfully penetrated with her fingers, and that his humiliation resided further

314

in being old – that remark about his prostate. In the fictional world of the movie there is a kind of consent, albeit of a loaded kind.

Well, we now know that there was no consent in real life. Whatever balancing moments existed in the story, Bertolucci certainly never discussed anything with Schneider without telling Brando. It was all the other way around. The power lay with the famous director and famous actor. As Chastain says, we are left with disgust.

Hollywood history is full of these iceberg-tips of abuse peeping out. Everyone knows about the big cases: the conviction and exile of Roman Polanski, the (denied and unproven) accusation of Woody Allen. But there is also a vast unacknowledged history of normalised abuse – virtually every female star and many male stars have endured a casting-couch assault, although the MO has of course been offscreen. In his effrontery, Bertolucci put his abuse in front of the camera and like so many men of that era, maintains a tacit claim of permissive liberation and declines to see what was wrong.

Amy Berg's documentary, *An Open Secret*, has disclosed the range of child abuse in the film industry. Corey Haim and Todd Bridges have revealed they were assaulted as children, a toxic and hateful pattern of power and manipulation which is part of that same continuum of abuse which reaches to the adult world.

To speak out takes courage. In 1937, a dancer named Patricia Douglas accused studio executive David Ross of rape at a party given by MGM chief Louis B. Mayer. Instead of staying silent, she filed a complaint in the LA County district attorney's office. And a brutal campaign to discredit her was then created by studio fixer Eddie Mannix. Witnesses were bribed to change their stories. The male establishment of the law, politics and the press ganged up and Douglas's career was crushed although her courage in taking on the system has since made her a heroine.

More recently, Thandie Newton has described her own outrage at this abuse happening as part of the panoply of Hollywood power – just as it did with Schneider. A certain male director was sneeringly boasting to her about having seen a lewd audition videotape another director had made Newton do when she was a struggling young actor.

In 2016, as in 1972, and 1937, there are plenty of disgusting men in the movie industry who don't see what the problem is. Now they are being forced to confront the poison they have created.

SEX EDUCATION FILMS – THEY DON'T MAKE THEM LIKE THEY USED TO

11/2/09

There can't be many new DVD releases of short film anthologies which are unstintingly riveting all the way through. But here's one. For the past couple of days, I have been glued to the BFI's incredible collection *The Joy of Sex Education*, which is a compendium of sex education films from 1917 to 1973. They have a weird similarity to old-fashioned stag films, not merely because of explicit content, but because they are designed to be watched in a semi-clandestine world: created not for cinemas or TV but for a private clientele in church halls and classrooms and family planning clinics.

Some of these films are genuinely horrifying. The brutally entitled *Don't be Like Brenda* (1973) is an eight-minute lecture to young women, telling them not to be sexually promiscuous like the film's hapless heroine – although heaven knows, the promiscuity hinted at here is tragically modest. Poor Brenda goes all the way with a boy who does not marry her. The film is stunningly without any useful educational content on contraception and makes it entirely clear that the woman, not the man, is to blame. The film even makes her poor unwanted child suffer from a heart defect, so that no one wants to adopt the poor little thing – just to hammer the point home. Katy McGahan's excellent programme note on this film (in the DVD's accompanying booklet) doesn't mention it, but the caddish male in the film is played by Richard Morant: many of the film's target audience would have seen him, two years previously, playing the evil Flashman in the BBC's teatime adaptation of *Tom Brown's Schooldays*.

The New York-set movie *Her Name was Ellie; His Name was Lyle* (1967) is a film about syphilis, starring John Pleshette as Bruce, a troubled teen who can't bring himself to confess to his parents or his steady girlfriend that he has caught syphilis from casual sex with a waitress called Ellie (who was infected by a swinging sexual predator called Lyle, whose scabby hands are glimpsed in the film's final frames). When Bruce finally attends a health clinic, the doctor wants to track down his sexual contacts and demands "names". This struck

me as having a weirdly McCarthyite ring. But perhaps it is precisely the other way round: these tough, unsentimental inquisitions, a secret part of many an American male's personal history in the services and after the war, may well have influenced the style of Joe McCarthy's committee. Could it be that *Her Name was Ellie; His Name was Lyle* is a film which offers a sensational insight into American political history?

Jez Stewart's programme note suggests that the movie's gritty look makes it look like Cassavetes – yes, and it also has a little something of Woody Allen. John Pleshette's scrawny teenage boy, who is actually really good at basketball, reminds me of Woody Allen's repeated protestations that despite his wimpy-looking frame, he was a real sportsman in his youth. Remarkably, Bruce's steady girl Laura is played by Amy Taubin, who was to become the legendary film critic for the *Village Voice*, and who is still a prominent and much respected attender of the Cannes film festival.

The People at no. 19 (1949) by J.B. Holmes is a seventeen-minute black-and-white British film from the government's postwar Central Office of Information (COI) about a young married couple, still living cheek-by-jowl with the bride's parents. The young wife Joan (Tilsa Page) comes back from the doctor's with what everyone hopes is wonderful news of a pregnancy – instead she has to tell her husband Ken (Desmond Carrington) that she has syphilis, caught while Ken was overseas during the war, from a male acquaintance of a woman friend who was no better than she ought to be, and came to an unspecified "bad end". The passing resemblance to Noël Coward movies such as *Brief Encounter* or *This Happy Breed* make the word "syphilis" genuinely shocking and there is some stage business with a bread knife that made me think of early Hitchcock. Here, as in other films, it is the woman who is stigmatised as the bearer of syphilis – perhaps as a way of scaring men into using condoms, although there is no explicit information about these.

The undoubted masterpiece of this double-DVD set is Martin Cole's twenty-three-minute *Growing Up* from 1971. Now, this begins with some pretty ripe statements about the differences between the sexes, with some blather about how the softer female sex stays home nesting and the questing males are "usually more inventive and creative". But the film boldly shows film of real people – not

coy line drawings – in a concerted attempt to show the realities of where (gasp!) babies come from. Remarkably, it even shows film of real people – a man and then a young woman – masturbating. This clear, frank and in fact rather dignified film got Cole tonnes of hate mail, encouraged by the tabloid press.

As with many of these films, you start watching with a knowing, ironic chuckle. Ho, ho, ho, you think, as a *fraightfully refained* female announcer talks about "gels' bodies changing", while we see healthy gels playing hockey. Hee, hee, hee, you giggle, while another film shows stock footage of Cliff Richard-style youth clubs and coffee bars in an agonisingly earnest attempt to get its message across to young people.

But then something strange happens. The laughter dies away and you find yourself watching, rapt at the sheer novelty of what is happening: films which are, according to their lights, trying to talk as frankly as they can about sex. We think that in 2009 we live in a super-sexy media age, with everything densely saturated with sex: mobile phones are sexy, reality TV shows are sexy, everything is sexy. But weirdly, I think, the sexiness has always to be semi-veiled to be commercially alluring, and media and culture are actually as prim as a Victorian governess about the nasty plumbing and circuitry of sex. These silly, schoolteacher-y films from the 1950s and 1960s are much freer and more honest about sex than the regular run of post-watershed TV.

My only worry is: where are the modern sex education films? The latest one here is from 1973. Do we make them any more? Or are we all overwhelmed with irony and self-consciousness the way previous generations were overwhelmed with embarrassment and shame? I don't know. But I think I might have to keep hold of Martin Cole's controversial *Growing Up* to show my own son when the time comes. Which will be sooner than I think.

BLUE IS THE WARMEST COLOUR

21/11/13

★ ★ ★ ★ ★

Big success in the film business often means opening a can of worms along with the champagne. The Palme d'Or at this year's Cannes film festival went to the epic and erotic love story *Blue Is the Warmest Colour*. But the jury and its president, Steven Spielberg, insisted the prize should be accepted not only by the director, Franco-Tunisian film-maker Abdellatif Kechiche, but also by his two young stars, Léa Seydoux and Adèle Exarchopoulos.

Julie Maroh, who wrote the original graphic novel, dismissed Kechiche's adaptation as a straight person's fantasy of gay love. As for Kechiche, his feelings about that last-minute requirement to share the Palme with his two actors can only be guessed at – and the same goes for their feelings about his feelings. Seydoux and Exarchopoulos have since said he was oppressive, intrusive, and even tyrannical in the demands he made, especially in the extended explicit sex scene, which took fully ten days to shoot.

Led by this internal dissent, the film's critical tide may be slowing, if not turning. But I think that the impact of the movie increases with a second viewing, and my own objections about the lovers' ferocious "confrontation" scene have been answered. It no longer looks melodramatic, but rather the icy and violent culmination of a hitherto invisible disconnect between the two women. This drama was never supposed to celebrate the equality of their romantic good faith. Its original French title is perhaps a better guide: *La Vie d'Adèle Chapitres 1 et 2*. Adèle, played by Exarchopoulos, is the sympathetic centre of the story, a schoolgirl at the beginning and a teacher by the end: the two chapters of innocence and experience.

What a passionate film it is. At the outset, Exarchopoulos's Adèle is a shy, smart high-schooler who finds that she is lonely and tentative in her social life. A good-looking boy who likes her is rewarded with a brief relationship, but he is merely John the Baptist to the imminent Christ: Emma, played by Seydoux, a twentysomething art student. The romantic spark between them is a lightning bolt.

319

As for the much-discussed sex scene, I predicted earlier this year that some sophisticates would claim to find it "boring". The second charge, that it is exploitative or inauthentic, is also naive. It is no more authentic or inauthentic than any sex scene, or washing-up scene, or checking-in-at-the-airport scene. It is fictional. The sequence certainly strikes me as uncompromising and less exploitative than any smug softcore romcom or mainstream thriller in which women's implied sexual availability is casually served up as part of the entertainment, although I will concede one tiny moment of misjudgment: when Emma is painting a nude of Adèle (unfortunately like Leo and Kate in *Titanic*) and the camera travels up her naked body.

When the love affair starts, Emma has blue hair; as it proceeds, the blue colour grows out. As Kechiche shows, that is a bad sign. Their love is cooling. Emma is always the senior, dominant partner: better educated, more worldly and higher up the social scale. Kechiche sketches this out by having Emma bring Adèle around for dinner with her mum and stepdad. There is no secret about their relationship, and they stylishly have oysters. When Emma meets Adèle's conservative folks, however, the food is humbler – spag bol – and Emma has to pretend to have a boyfriend. And when Emma's art career takes off, Kechiche shows how she is starting inexorably to outgrow Adèle, and yet it is Adèle who develops a kind of emotional maturity that Emma, the increasingly smug careerist, can't match.

The movie's final sequence is heart-stoppingly ambiguous. Yet the point is surely that there is no guarantee that either Adèle or Emma will ever find anything as good ever again. The notion that they can each go on to find a better or richer experience is illusory. This isn't young love or first love, it is love: as cataclysmic and destructive and sensual and unforgettable as the real thing must always be. To paraphrase Woody Allen, if it doesn't make the rest of your life look like a massive letdown then you're not doing it right. Here is Emma and Adèle's moment, the definitive blaze.

JEUNE & JOLIE

28/11/13

★ ★ ★ ☆ ☆

François Ozon's fervent and well-acted drama about a seventeen-year-old girl exploring her sexuality by becoming a high-class call girl is very watchable ... and entirely ridiculous. It has a stylish gloss and sexy glow, no doubt about it. Only French cinema could get away with it.

Yet once the credits roll, its essential absurdity and obtuseness become apparent: it's a solemn *belle de jour* tale with a touch of David Hamilton softcore, existing outside the grim reality of vulnerable women being abused and trafficked.

Abdellatif Kechiche's *Blue Is the Warmest Colour* was attacked as a movie for middle-aged men; that charge could be made far more powerfully against *Jeune & Jolie*.

Yet it has to be said that Marine Vacth is excellent as Isabelle, the schoolgirl with a secret life as a €500 prostitute, and Géraldine Pailhas and Frédéric Pierrot give gentle and warm performances as her mum and stepdad.

Isabelle experiences her sexual awakening on holiday after a so-so encounter with a German boy, and her kid brother Victor (Fantin Ravat) is saucer-eyed at Isabelle's seemingly exciting private life – I suspect Ozon himself is present, in the young Victor. The film's intense seriousness can only be appreciated by not taking it too seriously.

STRANGER BY THE LAKE

20/2/14

★ ★ ★ ★ ☆

Alain Guiraudie's *L'Inconnu Du Lac*, or *Stranger by the Lake*, is a stunning, confrontationally explicit psychological drama set at a French lakeside cruising spot for gay men. He creates an atmosphere of absolutely frank homoeroticism, utterly without inhibition or taboo. I was reminded of Alan Hollinghurst's *The Swimming Pool Library* or Thom Gunn's poem *The Discovery of the Pacific*. But when a single, terrible event takes place, the mood swings to that of classic Hollywood suspense, like John M. Stahl's *Leave Her to Heaven* (1945) or George Stevens's *A Place in the Sun* (1951), movies in which a beautiful lake becomes the epicentre of danger.

Christophe Paou plays Michel, a handsome, well-built man who comes to the lake and is instantly enamoured of Franck, played by Pierre Deladonchamps, who has already struck up a tender, platonic friendship with Henri (Patrick d'Assumçao), a fat, lonely and unhappy guy who sits by himself, away from the others.

This nexus of relationships is placed under intense scrutiny when the police are called in to investigate a certain terrible event. An inspector finds himself perplexed and frustrated by the cruising credo: guys who are into voyeurism should make good witnesses, but those who don't ask each other's names or phone numbers, guys who cultivate a willed forgetfulness about yesterday's experience so as to prepare the way for the next contact – they are creating a cloud of unknowing, highly injurious to a police investigation. Guiraudie's sheer frankness about sex is refreshing: far away from any prurient Joe-Eszterhas-type erotic danger. It is an almost pastoral scene, which makes the single violent act, and the reaction to it, so disturbing.

THE CANYONS

8/5/14

★ ★ ★ ☆ ☆

Paul Schrader's *The Canyons* has had a bad rap. This is the erotic thriller he shot with $250,000 (£150,000) raised through Kickstarter – making every cent count. It features a sulphurous script by Bret Easton Ellis, and stars the extravagantly unreliable and difficult Lindsay Lohan, with whom Schrader has now fallen out. Or perhaps it is rather that Lohan never regarded herself as having fallen in with him. The film is a pulp provocation with an eerily rancid atmosphere; it has been widely winced at by reviewers who wanted more of substance from this director. Casting porn-star James Deen in the leading role – the Patrick Bateman role, in point of fact – is perhaps a satirical in-joke at everyone's expense. The same might go for Lohan. She is pampered LA princess Tara, who has a troubled relationship with creepy rich kid Christian, in which role Deen certainly does an awful lot of porn-actor smirking and pouting, although I've seen non-porn actors do a worse job. (Michael Powell cast softcore pin-up Pamela Green in his 1960 shocker *Peeping Tom*, though admittedly not for the lead.)

When Christian suspects that Tara is having an affair with the actor in the low-budget movie he is supposedly "producing" (with his father's money), he embarks on a sinister campaign of psychological intimidation and manipulation. The film begins and ends with eloquent still shots of abandoned movie theatres; this has been interpreted as Schrader's wintry and disillusioned farewell to cinema. Yet perhaps it is an acid comment on the ruination that was always there, below the surface. There is a brilliant moment when Tara, over lunch with Christian's assistant Gina (Amanda Brooks), asks if she really, in her heart, likes the movies anyway. In LA, this is the final despair, the mortal sin. *The Canyons* deserves a look.

THE DUKE OF BURGUNDY

19/2/14

★ ★ ★ ★ ☆

Recently we've seen a film about BDSM driven by dead-eyed commercial imperative. Peter Strickland's new film, *The Duke of Burgundy*, is different: it is a labour of love, whereas *Fifty Shades of Grey* was a labour of money.

The Duke is an extravagantly artificial creation, all about fetish, kink and the sussuration of an insect's wings. The opening credits announce that it features "perfume by Je Suis Gizella". Attempts to Google this product exposed my failure to get the joke. Or maybe Strickland discovered a stockpile of obscure scent that ceased production in 1972. A nice touch, though – as if early silent movies had credited the music they played on-set to get actors in the mood.

This is the story of a love affair based on sadomasochistic role-play, with the choreography of sub and dom and the traditional paradox about who is really in charge. It is a passion based on a secret theatre of humiliation and pain. But what happens when one of the parties falls out of love and wants to end the affair, and the real humiliation and real pain come into play?

The movie inhales the lost aroma of Ingmar Bergman's *Persona* and Joseph Losey movies such as *The Servant* and *Accident*, and also looks like an agile homage to the arthouse eroticism of Walerian Borowczyk at his most preposterous. The presence here of Monica Swinn, once the star of 1970s exploitation pictures by Jess Franco, indicates another debt. A close-up shot of stockings being pulled on, with a rapt observer in the background, may even have been influenced by the famous poster for *The Graduate*.

Strickland's opening title-design is well-observed pastiche, but the rest of the film is something other than that. If Quentin Tarantino and Robert Rodriguez had set out to spoof early 1970s Euro-softcore, it might have come complete with faux-scratches on the print and digitally faked soundtrack crackles. Strickland is not sending anything up: he is doing it for real.

The Duke of Burgundy was shot in Hungary, where the locations and exotic exteriors stand for a place as abstract as the site of a Grimm fairytale. His stars are Danish and Italian: Sidse Babett Knudsen (from TV's *Borgen*) and Chiara D'Anna (whose previous credit is from Strickland's previous film, *Berberian Sound Studio*). The dialogue is in English, and their line-readings are sometimes a bit eccentric – was dubbing involved? – but intriguingly so.

Evelyn (D'Anna) calls on Cynthia (Knudsen) every day to clean her house and wash her underwear, enduring Cynthia's icy haughtiness; Evelyn demurely accepts punishments in the bathroom if her work is not up to scratch – encounters that are continued in the bedroom. In the same submissive spirit, rather like an assistant or grad student, she will accompany Cynthia to a strange lecture series on lepidopterology, which is Cynthia's passion. Strickland introduces a new and even weirder dimension to this situation by bringing in another character, a carpenter (played by Fatma Mohamed) who specialises in bespoke items to intensify transgressive sexual pleasure. But Strickland shows us backstage discontent leaking into the theatrical display: Evelyn wants to be treated ever more ruthlessly – like Proust's Baron de Charlus – and is beginning to suspect that Cynthia's heart is not really in it any more.

There are no men in this world, which partly accounts for the intensity of the atmosphere, and Strickland takes us on a freaky, Angela Carter-ish fantasy trip, in which genitalia becomes the heart of a lush but disturbing forest bristling with butterflies. It is all done with a poise and high seriousness that still contains a squeak of humour, at an insect-type frequency.

And *The Duke* is very funny, though I had the slight sense that the sheer artistry means that both the erotic charge and the comedy are sometimes fractionally less potent than they might be. It is quite different from Steven Shainberg's *Secretary*, in which transgressive sex was all the more potent because it involved characters who looked like people from the real world – although Cynthia and Evelyn are unreal in a more rewarding way than the daytime soapers Christian Grey and Ana Steele.

What Strickland is offering is arguably more refined: a lucid dream of sexual adventure. The title refers to a type of butterfly much loved by Cynthia. To paraphrase Muhammad Ali, this film floats like one, but stings as well.

EDEN

23/7/15

★ ★ ★ ★ ★

Getting loved up is a rare pleasure and purpose in the cinema, and it's what Mia Hansen-Løve's *Eden* is all about. Her hero Paul is a Paris club DJ who likes music combining euphoria and melancholia; this wonderful, mysterious film has both, though Paul often remains cool and impassive, even at the height of his ephemeral success. His emotions are displaced outwards into the music. From the early 1990s to the late noughties, he maintains an eerily fresh Dorian Gray look. While being carried home, apparently out of it, an elderly neighbour snaps something about "*la jeunesse*" – "the kids" – and Paul recovers sufficiently to mumble that he is thirty-four. (This is also the director's age.)

With elegant sidelong glances at Eric Rohmer and François Truffaut, Eden swims with the plotless aimlessness of being in your twenties, and shows how Paul's youth and ambitions pass in a dream: unfocused, unarticulated and unrealised, concealed by the illusory eternal present of clubbing, with its compelling hedonism and heartbreaking economics. Hansen-Løve coolly refuses the traditional plot emphases of ambition, hubris and redemption, keeping the narrative arc subtly contained within her movie's ambient sound. A movie about clubbing is difficult to pull off – though I have happy memories of Justin Kerrigan's *Human Traffic* (1999) – and Hansen-Løve manages it with tremendous style, bringing in small English-speaking roles for Greta Gerwig and Brady Corbet, and a running gag about those French music legends Daft Punk being repeatedly refused entry to clubs. This is a worthy successor to Hansen-Løve's previous films *Goodbye First Love* (2011) and *Father of My Children* (2009): it is absorbing and very moving.

Félix de Givry's Paul is a serious young man who gets into the early-1990s underground club scene while a student, notionally working on a literary thesis: De Givry has something of Jean-Pierre Léaud's priestly severity, in his shirt and V-necked sweater. Conceiving an overwhelming passion for garage, he forms a DJ partnership with his friend Stan (Hugo Conzelmann), drolly calling themselves Cheers,

and his friends include graphic artist Cyril (Roman Kolinka), fellow clubber Arnaud (Vincent Macaigne), American girlfriend Julia (Gerwig), and other girlfriends Louise (Pauline Etienne) and Yasmin (Golshifteh Farahani). Soon, Paul gets a radio slot, regular club nights and residencies, staging ambitious events in Paris and New York. The collective life of Paul and his *équipe* migrates from scene to scene, from episode to episode, with laidback insouciant sexiness, even when nothing overtly sexy is happening – or even when nothing of any sort at all is happening. There is even a New Wave cinephile touch in having the group argue about whether or not the awfulness of Paul Verhoeven's *Showgirls* is deliberate.

But where you might expect a narrative gradient towards wealth, cynicism and grey hair, Hansen-Løve keeps Paul looking weirdly the same, yet also shows that he isn't getting any more materially successful, as if trapped in a student eternity. A cash inheritance from his father floated this precarious adventure in the first place, but he is living at home with his widowed mother, who is having to bankroll everything. This is Arsinée Khanjian, and in this French-speaking role, Khanjian is refreshingly without the mannerism of some of her other performances. The spectacle of a packed club – and the cult of the DJ presiding over it all – creates the impression of overwhelming success. But the guestlist could be outweighing paying customers, and cocaine is a gigantic invisible expense. Other people are getting rich in the club scene during this fifteen-year period, and Paul is helping them, without seeing how he is starting to drown in the rising waters of others' prosperity.

In the first act, Paul is visited by a kind of augury: a cartoon bird that flies psychedelically over a dark woodland, an enigmatic indication of ... what? It could be nothing other than his own whimsy or spaciness. But the memory of that bird is strangely affecting by the end: a sign that his dedication to music was a secular state of grace, especially as it is not accompanied by greed or vanity: only naivety. It was also an emblem of youth: so evanescent, taken so casually, so lightly. Paul's character is avowedly based on the director's brother, but Hansen-Løve has a superbly light touch; her film does not force on us its autobiography, or its historical or personal insights. *Eden* is haunting, delicate: it's a vividly sensual movie about pleasure, which gives pleasure too.

The films that made me freak: shocking movies

Violence in films is something that no one will admit to liking, exactly – not in the way they love action movies or Westerns or thrillers which are theoretically violent, films in which people get punched, kicked, shot and set on fire all the time.

What we talk about when we talk about violence in the movies is probably the arthouse trope of "ultraviolence", to quote that film which is probably the great ancestor of the shockingly violent genre: *A Clockwork Orange*. It is a type of violence which is much closer to the upsetting reality of violence as it could be experienced in real life, different from the *thwap* of Bruce Lee's foot as it connects with some hapless goon's chest, generically different also from the gory outrages of horror which are importantly presented as a departure from the real world. And yet they are also different from the banality and drear of real-world violence. Ultraviolence is exoticised, sexualised, hyperdramatised, packaged and weaponised with an important aim in view: to shock. Audiences and film-makers are fascinated by violent movies, because of a longing for films to do something which many just don't – to have an effect on us. To do something to us. To pierce our rhino carapace of sophistication. Actually to make us feel something, even if it's something horrible.

That sounds jaded. And many accuse critics of overpraising and overthinking violent movies because they themselves have become jaded, through watching so many forgettable production line films whose only aim has been to lull the viewer into a consumerist stupor. But the best violent films are those which admit that violence actually exists – and is not being genre-bowdlerised – and which offer a commentary on violence beyond the obvious and easily

discounted truism that violence is bad. I myself remember the cold thrill I felt and still feel when I watch the ominous opening titles of Kubrick's *A Clockwork Orange*, or the eerie opening sequence of Michael Haneke's *Funny Games* in which a *gemütlich* middle class Austrian family is listening to Handel on the car sound system, which is then blitzingly replaced on the soundtrack by death metal ("Bonehead", by Naked City) — a satanically intense premonition of the way in which this family is about to be terrorised to death.

And I will never forget the first ever screening of Gaspar Noé's shocker *Irréversible* at the Cannes Film Festival, a film so shocking that the official gala premiere was actually scheduled for half past midnight, due to the sheer radioactivity of controversy it was bound to provoke — with ambulance crews waiting outside for those who fainted. They were needed. All of us were standing around outside the theatre afterwards in the dazed manner of people who have been evacuated from a burning building in the middle of the night. I didn't faint, but I was upset and discombobulated in a way that, I would now concede, was precisely what the director had in mind. I'm still not sure what I think about this film but it shook me up. It upended the apple cart of complacency: it created a situation which simply could not smoothly be converted into a bland review. Although I did have the presence of mind to quote to my friend, *Sight and Sound* editor Nick James, what Katherine Mansfield is supposed to have said on first reading James Joyce's *Ulysses*: "This is obviously the way of the future. Thank God I am dying of tuberculosis."

IRRÉVERSIBLE

31/1/03

★ ☆ ☆ ☆ ☆

If Gaspar Noé had never made another film after his 1998 feature debut, *Seul Contre Tous* (*I Stand Alone*), I would still have thought of him as some kind of genius. The extraordinary power of that movie – its rage, its horrible violence, its bleak despair – was married up to astonishing gestures of compassion, gentleness and even wit. It is a film with things to say about poverty and masculinity and France itself. But all these latter qualities have been excised from Noé's latest work, the ultra-violent, ultra-notorious rape-revenge nightmare *Irréversible*. What we are left with is an empty, shallow shocker whose vacuity is calamitously exposed in its final act.

But credit must go where it's due. This really is a shocker in a one-team Premiership of its own. So often, you hear films casually described as shocking, but *Irréversible* really does shock like a physical hammer blow. When I saw it in France for the first time last year, it was bizarre to come back here and find everyone wittering anxiously about the then controversial *Baise-Moi*. I felt like a battle-scarred Vietnam war veteran hunched in a bar, sullenly listening to pampered civilians talking about what a hard day they'd had in the office.

Extreme cinema does not get more extreme than *Irréversible*. It's extremer cinema, extremest cinema, or maybe extremist cinema. It's not so much hardcore as black-hole-core. The story is about Alex (Monica Bellucci), a beautiful woman who goes out partying *à trois* with her boyfriend Marcus (Vincent Cassel) and ex-boyfriend Pierre (Albert Dupontel). The two men banter cordially, but uneasily. But Alex quarrels with Marcus at the end of the evening, walks home alone and is raped in an underpass; Marcus and Pierre go looking for the rapist – a gay pimp nicknamed Le Tenia – and track him down at a gay S&M club called the Rectum, where Pierre winds up beating the wrong man to death with a fire extinguisher.

Only the story is told in reverse. First comes the revenge, then the rape – in ironic contrast to the terrifying irreversibility of fate – and

the camerawork continuously swirls and seesaws about to complete the nausea and confusion. The back-to-front storytelling and perpetual semi-darkness means that it is never clear whether Pierre has in fact killed the wrong man, or if it matters.

It is difficult to describe quite how horrifying this brutal scene is: someone is smashed in the head twenty-two times with a fire extinguisher, without the camera ever cutting or panning away. And then there is the rape scene itself, which is even more horrendous, lasting for nine deeply unwatchable minutes, each of which seems like an aeon.

Irréversible can be understood as an expression of the *neo-réac* movement in France. Like the novels of Michel Houellebecq, Noé's movies are a snarl of unaccommodated rage against modern life, against progress, against hypocrisy, against political correctness, against everything and nothing. *Seul Contre Tous* was a brilliant and radical commentary on the dark heart of a France in which Jean-Marie Le Pen continues to flourish. But *Irréversible* is at once more ambiguous and simplistic. Noé's movie is not the smallest bit interested in the woman's experience, but in male rage, and Noé the film-maker has a distinct macho swagger in the shocks he dishes out. "Who's the boss here?" he seems to be saying. "Who's the director?" Marcus and Pierre are told by some local guys that the police can do nothing, that revenge is a "human right" and that only they can track down the culprit: a lynch-law world in which rough non-justice is handed out by sweaty, shaven-headed young men. No prizes for guessing what political movement this is a breeding ground for.

But any access to contemporary reality that *Irréversible* appears to give is undermined by its strange naivety and curiously loaded assumptions – things that only occur to you once the nuclear blast of horror has worn off. Alex walks alone into an underpass because she is told by a stranger that it is "safer" than trying to hail a cab on the street. Well, if anyone ever believed that, they certainly won't after watching this movie, in which Noé sends Bellucci sashaying down into an obviously horrible tunnel dressed and made up as if for a *Marie-Claire* cover shoot. Her assailant, moreover, is homosexual – on the opposite team from Marcus and Pierre, the tragically righteous avengers – and hangs out at a grotesque gay club called the Rectum. Is this the ultimate joke in Noé's back-to-front story-telling? Narrative

sodomy? The reverse structure is a crude way of defamiliarising a very basic plot and has none of the formal invention and daring of, say, Tarantino's experiments in cause and effect.

Where *Irréversible* collapses though, really collapses, is in its third and final act. First the revenge, then the rape, then the pre-rape normality. Noé has cranked up our expectations very high: how can he top the horror? How can he raise his game in portraying the ordinary, complex life of this couple? What intelligence, what devastating insight can he bring to bear that will match all that has gone before? The awful truth is: nothing. It's a banal, cutesy bedroom scene, shot with softcore insistence on never showing either party's genitals. Alex reveals she is pregnant, and the end sequence revealing her to have a bit of a bump even hints that this whole thing might simply have been a dream or fantasy. What a failure of nerve! The British Board of Film Classification did the right thing in passing *Irréversible* uncut: snipping ten seconds here or there would have been absurd. But part of my job as a humble critic is to suggest what I think you need to see at the cinema. I think you need this like a fire-extinguisher-shaped hole in the head.

ELEPHANT

30/1/04

★ ★ ★ ★ ★

Gus Van Sant has the camera pointing upwards as his latest movie begins. We gaze at the sky as it allows clouds to drift fluffily through it, and appears entirely empty of portents. A hazy, uneventful summer's day seems in prospect, rather than a horrific Columbine-style high-school shooting that this movie summons up like a nightmare remembered with pitiless clarity.

With this stunningly effective film, Van Sant returns to his indie roots, blending them with a European sensibility; it's almost inconceivable for any commercial Hollywood career. He has turned his back on the white-bread world of *Finding Forrester* and *Good Will Hunting* and struck out for more difficult terrain: finding it first in *Gerry*, last year's striking but eccentric Beckettian story of two slackers lost in the desert, and now *Elephant*. Two boys, acting without any compunction, remorse, rage, bitterness or obvious emotion of any kind, shoot up their high school with assault weapons they have ordered over the internet.

Nothing about this movie is dramatic in the slightest: the cinematic locution employed by Van Sant is disconcertingly un-violent. There is no tension, no exclamatory score, no acceleration of editing, even the gunshots themselves are not as piercingly loud as we are accustomed to in movie thrillers; we are not even invited to feel the difference between the tragic nightmare unleashed by the killings and the innocent world that existed until that point. The time frame and sense of place is constructed so that we cannot even be sure when and where the shootings have begun.

Everything is dreamy, spacey, almost weightless. Van Sant and his cinematographer Harris Savides drift along corridors, into classrooms and offices, out into sports fields and into kitchens and bedrooms, hooking up with various characters, revisiting the same events from different angles, and all as if floating through clear cold water. It is as if nothing is happening in the here and now, but recalled through some medium that imposes a somnambulist slowness on everything:

the look and sound of dead men walking. Nowhere is there the full-scale panic shown on, say, the shocking CCTV footage Michael Moore gave us in *Bowling for Columbine*.

It is fully one hour before we hear the first safety catch disengaged and pump action rattled, and that after watching a nerdy, unhappy girl for some minutes as she helps the school librarian re-shelve some books. She turns round, puzzled but incurious at the noise, as impassive as livestock. And even this is not followed by mayhem, but a cut to another character in another part of the school.

We know what's coming; we've known it all along. But the result is not tension, but a sickly, gnawing sense that the horror has somehow spread backwards in time; normality is invested with an unearthly tingle of fear. With its deep focus and crystal clarity, the movie has a hyperreal ordinariness, with a still-photography aesthetic. The details are made to feel like those objects salvaged from the *Titanic*, like ashtrays and teacups, straightforward items in themselves, now invested with the occult fascination of doom.

The camera even floats through the girls' locker-room, that emotionally fraught area which has been a staple of high-school movies from *Porky's* to *Carrie*, and even matter-of-factly glimpses figures in the showers, but it is drained of any emotion, weirdly bloodless, like an undead autopsy.

As for the assailants, one is shown being teased and bullied (the classic motive); he's a gun enthusiast who plays Beethoven piano studies and even quotes Macbeth as he coolly presides over the bloodbath: "So foul and fair a day I have not seen." Maybe he's supposed to radiate Kubrickian menace, but always what is disturbing is his blankness and sheer lack of affect. Even a homoerotic moment in the shower looks listless. "The most important thing, man, is – have fun out there!" he says before they set off. It's like the analysis sequence at the beginning of Todd Solondz's *Happiness*, in which Dylan Baker's psychotherapist describes his recurring dream of quite calmly killing everyone in a park with an assault rifle and awaking feeling contented and happy.

But unlike Solondz, Van Sant is evoking a real event. A frisson of anger ran through America's media classes last year at the news that this won the Palme d'Or at Cannes, and the irritation mounted some months later when D.B.C. Pierre took the Booker prize in

Britain for his Columbine-inspired novel *Vernon God Little*. Salon. com jeered: "Furriners go nuts for gun-totin' Yanks!" The idea of Europeans converting, or sponsoring the conversion of one of its most painful tragedies into highbrow fare on film or in print was intolerable. Van Sant's movie certainly declines to signal emotion or indemnify itself against charges of exploitation in the usual way; instead, there is dead-slow camerawork which, like Gerry, recalls Béla Tarr, and the title alludes to Alan Clarke's 1989 TV film about Northern Ireland, and the unmentionable, ubiquitous violence that is the "elephant in the living room".

But how depressing to hear this film sneered at for its "art house" approach. After Columbine, America was in trauma and *Elephant*, with its dazed and disoriented feel, explores that clinical sense of shock. Before 9/11, Columbine and the Oklahoma City bombing were the most important issues in American life, and all the more difficult and irresolvable because they were not the work of Arab terrorists or "furriners" but Americans. What the Columbine killings mean for homeland security continues to be a haunting question for a country in love with guns. Van Sant's *Elephant* is a compelling response, as well as one of the best and most disturbing films of the year.

WOLF CREEK

16/9/05

★ ★ ★ ★ ☆

Wolf Creek is a swaggeringly nasty, self-assured piece of ordeal horror set in the Australian outback. With nods to *Duel* and *The Texas Chainsaw Massacre*, first-time writer-director Greg McLean shows the neo-goreheads from the US and UK how it ought to be done. Liz (Cassandra Magrath), Kristy (Kestie Morassi) and Ben (Nathan Phillips) are backpackers driving across country to Wolf Creek, the site of a prehistoric meteorite strike: an eerily vast crater in which uncanny things, far scarier than anything at Hanging Rock, are said to happen. In that colossal and implacable landscape, they find their car won't start. And they are vastly relieved when an amiable old Bushman called Mick (John Jarratt) shows up out of nowhere and offers to tow them to his remote shack, while he fixes their car and lets them sleep the night.

McLean's film shows its high IQ by letting nothing scary happen for around half an hour; there is something absorbingly real and even romantic in the way a shy attraction develops between Liz and Ben. The stomach-turning events that follow are leavened with moments of grisly comedy. There is a brilliant joke about Crocodile Dundee's catchphrase: "You call that a knife?" Spielberg himself might have admired the buttock-clenching suspense in which someone hears a faint bang outside his stationary vehicle and gets out to find a bullet hole in the thermos flask he had placed on the car roof just a moment before, the liquid glugging out of it. Then a distant clang and an approaching whine of a second bullet will have you ducking and yelping in alarm. This is the best Australian movie since *Lantana*, and deserves an audience outside the horror fanbase.

HIDDEN

27/1/06

★ ★ ★ ★ ★

A stiletto-stab of fear is what Michael Haneke's icily-brilliant new film delivers – not scary-movie pseudo-fear, but real fear: intimately horrible, scalp-prickling fear. It is a stalker-nightmare with a shiver of the uncanny and a double-meaning in the title: hidden cameras and hidden guilt. A famous Parisian TV presenter receives menacing, mysterious "surveillance videos" at his home, showing scenes from his private life. How on earth has the stalker filmed these? There is no dramatic musical score, none of the traditional shocks or excitements, just an IV-drip-drip-drip of disquiet leading finally to a convulsion of horror.

Hidden is partly a parable for France's repressed memory of *la nuit noire*, the night of 17 October 1961, when hundreds of Algerian demonstrators in Paris were beaten and killed by the police. As such, it is a cousin to events just eleven years later, dramatised by Steven Spielberg in *Munich* but utterly without Spielberg's need to find resolution and common ground. *Hidden* is incomparably darker and harder. It is about the prosperous West's fear and hatred of the Muslim world and those angry pauperised masses once under our colonial control, and over whose heads a new imperium is being negotiated in the Middle East and beyond. Haneke is often described as the "conscience" of European cinema: but he is more a Cassandra, announcing a coming catastrophe and fervently imagining its provocation, acting out the cataclysm's tinder-spark. Haneke's vision is as cold and unforgiving as the surface of Pluto.

The bad dream into which Haneke's characters are plunged is scrutinised with forensic clarity and dispassion. The opening scene is one continuous shot of the apartment exterior where celebrity intellectual Georges (Daniel Auteuil) lives with his publisher wife Anne (Juliette Binoche) and their twelve-year-old son, while the opening credits are silently written out from the top left-hand corner until they fill the screen – a classic opening. Then we discover that this is one of the creepy tapes that Georges is being sent, with the

cold sheen of high-definition video indistinguishable from the rest of the film that we are watching. Television star Georges is horrified to be observed on a basis quite other than his accustomed, glamorous visibility. More than that, he suspects he knows his tormentor: an Algerian called Majid to whom he did something unspeakable when they were both six years old. The grown-up Majid is now part of the Arab-Muslim underclass whose only chance of being on TV is on a surveillance screen. So this is turning the tables. But is Majid sending these videos? Or is there another explanation?

The performances by Auteuil and Binoche as Georges and Anne are superb. When the videos threaten his family and his livelihood, Georges seems chiefly paralysed by the need to carry on as if nothing has disturbed his gilded public life of success. Anne is enraged by his failure to trust her. His mother – an outstanding performance from Annie Girardot – is exasperated also by his dishonesty and evasion, but simply shrugs, having known it for a lifetime. Binoche is utterly convincing as the woman who finds that, in extremis, she doesn't know who her husband is.

Some familiar Haneke tropes are here. The director instigates an interracial shouting match in the street, and the audience feels nerve-janglingly uncomfortable for having already made its emotional investment in the white characters. There is video itself, that ubiquitously available medium which allows us to examine every aspect of our lives in greater detail than ever before. Almost every one of Haneke's shots is held as steady and implacable as a security camera. If there is a Recording Angel up there, noting our moral behaviour, then he is using celestial CCTV.

Most troublingly of all, Haneke shows us vital scenes from the point of view of this blank, affectless video-avenger; he invites us to share his destructive gaze. It is a casual critical truism when talking about voyeurism in the movies – discussing, say, Michael Powell's *Peeping Tom* – to say that it implicates the viewer. Until now, I have always felt like replying: speak for yourself, mate. Yet this really does implicate you. You feel like you too are participating in this terrible, remorseless destruction.

Hidden is Michael Haneke's masterpiece: a compelling politico-psychological essay about the denial and guilt mixed into the foundations of Western prosperity, composed and filmed with remarkable technique. It is one of the great films of this decade.

ANTICHRIST

24/7/09

★ ★ ☆ ☆ ☆

Splat! Lars von Trier's latest celluloid custard pie has landed squarely in the faces of audiences and the opinion-forming classes everywhere, its contents and trajectory calculated with rocket-scientist precision. Some recipients are spluttering with rage; others are solemnly licking the yucky filling off their cheeks, deciding how many Michelin stars to bestow.

What genre does *Antichrist* belong in? Scary movie? Extreme horror? Psychological drama? None of the above. It is a practical joke, an exquisitely malicious hoax, a superbly engineered wind-up – disguised as a film. Borat and Brüno have got nothing on Lars von Trier.

Well, the director has secured the bragging rights for his wildly controversial and explicitly violent spectacle, no question about it. This is what the commentariat are talking about, and the great man appears to have landed a thermo-nuclear *épat*. He is like the Riddler, cackling over his latest escapade, in front of a cinema auditorium full of Commissioner Gordons, but with no Batman to help us. I myself could only watch the film's impossibly grisly final twenty minutes through my fingers, and readily concede the brutally effective shock-factor, added to one or two subtler plus-points. In a way, Von Trier's uncompromising facetiousness and giggling insincerity allow you to sit back and appreciate his technique, of which there is a good deal.

The notional story is about a wealthy, handsome couple, played by Willem Dafoe and Charlotte Gainsbourg. The first sequence shows the pair making passionate love in the shower, filmed in glossy black and white like a perfume ad, to the accompaniment of a yearning soundtrack by Handel. There's a hardcore penetration shot in among the prettiness, just to keep it real. While the couple are having sex, their tiny infant son crawls out of the window of the seventh-floor apartment and falls to his death. This double-pronged assault on your emotions, at once deadpan and deeply crass, is followed by Dafoe (a professional therapist) taking Gainsbourg to a secluded woodland

cabin to embark on a radical, drug-free grieving process. But their solitude in this disturbing forest tips Gainsbourg into a psychotic state, and she becomes obsessed with evil. Here is where those squeamish about spoilers or violence had better leave the room, go to Netflix and order up a copy of *Ladies in Lavender* starring Judi Dench. After an orgy of sadistic violence against her partner, Gainsbourg takes a very large pair of rusty scissors and decides that she can and will do without her clitoris.

Now, this may be an excellent metaphor for the elimination of pleasure in the cinema, but it is not, as it happens, the film's punchline. This comes much later on, a deliberate arthouse pratfall which makes it utterly clear that Von Trier is just messing. Just before the credits, the director flashes up a dedication – to Andrei Tarkovsky, of all the hilariously inappropriate people. Hee, hee! Is he kidding? What do you think?

Before the absurdity sets in permanently and Von Trier's vivisected shaggy-dog story whimpers its painful last, *Antichrist* does have some freaky moments. There is a creepy, subliminal glimpse of a screaming woman's face, although my friend Mark Kermode points out that *The Exorcist* did this first. There is a disquieting fantasy sequence in which Gainsbourg is seen in long-shot, walking slowly over a bridge in a dream.

The bizarre, hallucinatory moment when Dafoe is addressed by a talking fox has been much mocked, and yet I thought it was witty, risky stuff and there's a nice line about nature being Satan's theatre. But of course none of this is enough for Von Trier, who has to twist the grossout dial clockwise for his final act. In the end, *Antichrist* is a smirking contraption of a film, a cheeky, nasty, clever device for making us upset about the dead kid, making us scared at the creepy happenings, making us freaked out at the violence, and finally making us convulsed with liberal outrage about violence, misogyny, censorship etc, debates which this cine-prank has been cynically engineered to provoke.

Von Trier himself has stated that *Antichrist* has arisen from his battles with "depression", a claim that I have never quite been able to treat with the cowed and brow-furrowing respect shown by others: Lars von Trier is never exactly on oath with any of his public pronouncements. But he may well be suffering from depression.

Plenty of men in the creative industries are, particularly those accustomed to high levels of attention and acclaim. And according to the traumatised actors Von Trier's worked with, his behaviour on set has always been troubled: something like a combination of David Brent and Jim Jones. My alternative theory, however, is that this talented mischief-maker was bored and dispirited by the lukewarm response to his previous, lower-key movies and decided to bodyslam his way back into the limelight. And this he certainly has done. Gainsbourg got the acting prize at Cannes for this film, but it's Von Trier who gives the most uproarious performance — the true heir to Phineas T. Barnum and Malcolm McLaren. If you want a bracing evening of pointless controversy in the cinema, then buy tickets. Whatever the price, it'll be a snip.

THE KILLER INSIDE ME

3/6/10

★ ★ ★ ☆ ☆

Casey Affleck grins like a death's head with the flesh reattached in this *noir* thriller from British director Michael Winterbottom, which is sickeningly violent but undoubtedly well made. It has been widely condemned for the scenes in which women are brutally assaulted and for many, this film will be just hardcore misogynist hate-porn with a fancy wrapper, and those who admire it, or tolerate it, are merely the women-haters' useful idiots. My own view is that this is a seriously intentioned movie, which addresses and confronts the question of male hate and male violence in the form of a nightmare. Of this, more in a moment.

The Killer Inside Me is adapted from the pulp thriller by Jim Thompson, and Affleck plays the chillingly sociopathic Lou Ford, who happens to be the deputy sheriff in a small Texas town in the 1950s. It's a place where, as Lou puts it in one of his drawling voiceovers, everyone thinks they know you, just because they have grown up with you.

Lou is a well-spoken young man, and a high-functioning career professional, fluent in the mannerisms of old-school Texas politesse, never neglecting to touch his Stetson as he passes a lady on the street. He is engaged to a local girl, Amy Stanton, played by Kate Hudson, but is carrying on an obsessive affair with a prostitute, played by Jessica Alba, and surrenders to the ecstatic love of violence this affair has unlocked within him. Lou has a sadistic taste for rough sex, evidently implanted by a troubled family background – a taste that is the prelude to a horrific, explicit succession of assaults. Lou rationalises these as the means by which he can pursue his plots and grudges, but clearly it is an addiction beyond his control or understanding.

Winterbottom conjures up the era and locale of 1950s Texas, and creates a film observantly derived from Hitchcock's *Psycho* and Capote's *In Cold Blood*, and perhaps the Coens' *Blood Simple* and *No Country for Old Men*, with touches of Edward Hopper's *Nighthawks*.

Winterbottom ratchets up the fear and the intimate unease with shrewdly chosen classic country numbers in the Hank Williams vein on the soundtrack – especially in the scene in which Lou goes on an aeroplane trip to Fort Worth. These are keening melodies of male self-pity that promise a terrible denouement.

Be warned: this really is a very violent movie, the like of which I haven't experienced since Gaspar Noé's legendary 2002 film *Irréversible*, and for me, extreme violence is difficult and oppressive. Winterbottom consciously turns the provocation dial up to eleven, to twelve, to thirteen and beyond by making the victim actually appear to be grateful and submissive. As if to turn the screw again and again, the film devises a scenario in which violence is meted out against a victim who is in some sense a consenting partner, and whose submissive love survives even after the full horror is disclosed. My view is that Winterbottom has consciously taken to extremes a situation that other types of drama would evasively sentimentalise. The film put me in mind of Nancy's notorious song from the musical *Oliver!* "As long as he needs me..." sings Nancy – that is to say, as long as I am sure that Bill Sikes needs me, and loves me, then it is all right for him to beat me up. This song concluded every episode of the BBC TV reality show designed to cast *Oliver*, without any indication of what it was actually implying.

There can be no doubt that Lou is loathsome, or that the still uncorrupted forces of law and order are visibly committed to his apprehension, but this is, I think, not exactly the point of Winterbottom's film. *The Killer Inside Me* is a particular distillation of male hate, as practised by repulsive and inadequate individuals who have been encouraged to see themselves as essentially decent by virtue of the trappings of authority in which they have wrapped themselves. And Winterbottom is tearing off the mask; like Michael Haneke, he is confronting the audience with the reality of sexual violence and abusive power relations between the sexes that cinema so often glamourises. *Here*, the movie is saying, *here* is the denied reality behind every seamy cop show, every sexed-up horror flick, every picturesque Jack the Ripper tourist attraction, every swooning film studies seminar on the *Psycho* shower scene. Here. This is what we are actually talking about.

I have seen films that really are insidiously misogynistic in a way *The Killer Inside Me* is not, films that make light of the denigration of women, and I should also say that this film does crucially show the consequences of violence, a responsibility shirked by what I call the "arthouse rape" genre, in which dreamy, languid movies are finally topped off with a flourish of sexual violence, just before the credits, without a smidgen of curiosity about what happens to the victim afterwards.

Lou's chilling MO is summed up by his visit to a troubled young guy in a police cell, a young man who has guessed Lou's awful secret and wheedlingly asks if the victim "had it coming". Lou replies: "Nobody has it coming. That's why nobody can see it coming." It is a *haiku* of despair to be compared and contrasted with Gene Hackman's gunfighter in Clint Eastwood's *Unforgiven* being told that he'd just assaulted an "innocent" man – Hackman snarls: "Innocent? Innocent of what?" Lou Ford is a poison cloud of violence infecting everything around him: this is a film with a carbon-core of horror and pessimism at its heart.

ENTER THE VOID

23/9/10

★ ★ ★ ★ ★

It has been eight years now since Gaspar Noé released his notorious rape-revenge film *Irréversible*, an ultra-violent, ultra-extreme movie that effortlessly exceeded in shock value anything, by anyone, at any time. I myself, having admired his previous feature, *Seul Contre Tous*, reacted fiercely against it as a piece of macho provocation. Re-reading my review now, I find none of its points wrong exactly, but I have to concede the possibility that I was just freaked out in precisely the way Noé intended. Having staggered out of the auditorium, my eyeballs still vibrating from the director's trademark sado-stroboscopic white light display, I may well have succumbed to a convulsion of disapproval.

Enter the Void is, in its way, just as provocative, just as extreme, just as mad, just as much of an outrageous ordeal: it arrives here slightly re-edited from the version first shown at Cannes. But despite its querulous melodrama and crazed Freudian pedantries, it has a human purpose the previous film lacked, and its sheer deranged brilliance is magnificent. This is a grandiose hallucinatory journey into, and out of, hell: drugged, neon-lit and with a fully realised nightmare-porn aesthetic that has to be seen to be believed. Love him or loathe him – and I've done both in my time – Gaspar Noé is one of the very few directors who is actually trying to do something new with the medium, battling at the boundaries of the possible. It has obvious debts, but *Enter the Void* is utterly original film-making, and Noé is a virtuoso of camera movement.

We get the classic Noé tropes: throbbing ambient soundscape, murky lighting design bursting into unwatchable vortices of dazzling, flickering light, explicit sex and violence, colossal sans-serif lettering for the title- and end-credits. This film, however, has a new motif: what we see is purely the point of view of its leading figure; we watch everything through his eyes. He is a small-time drug-dealer called Oscar (Nathaniel Brown). *Irréversible* had a horrific club called the Rectum; this one has a bar in Tokyo called the Void, where Oscar

is shot by cops. His spirit hovers over the city, an unquiet ghost unable or unwilling to leave, watching over his sister Linda (Paz de la Huerta), a pole-dancer now utterly alone in the world.

This brother and sister have a strange and tragic story, which might in other circumstances have interested authors like Ruth Rendell or P.D. James: orphaned as kids, they were fostered separately, and on becoming eighteen, the older child Oscar apparently enters into some modest trust-fund inheritance which enables him to travel to Tokyo – a long-lost childhood longing for exotic travel – and later makes enough through drugs to bring his adored sister over, and live with her in an atmosphere of incestuous yearning.

He revisits in horrified anguish, primal scenes from his childhood, including the death of his parents in a car wreck, which has seeded in Oscar this obsessive closeness to his sister and a sexualised longing for his lost mother, which finds expression in an affair with an older woman in Tokyo. Through some bizarre karmic influence, Oscar's spirit now sets out to part Linda from her current boyfriend, sinister tough guy Mario (Masato Tanno) and to get her together with his friend Alex (Cyril Roy), an amiable, dishevelled artist and the nearest thing this film has to a normal, sympathetic human being.

Oscar's dead-man floating-eye view gives us a ringside seat at scenes of unending horror, violence, squalor and pain. Yet there is a kind of barking-mad spiritual dimension in Noé's film. *Enter the Void* is about life after death. Specifically, it's about the life after death that troubles all of us atheists and rationalists most of all: the life after death that we all believe in – other people's lives in this busy and unhappy world carrying on heedlessly after we are dead.

The POV-style changes as the film progresses. When Oscar is still alive, we see strictly what he sees, and the view is periodically impeded by his blinks – as the initial scenes continued, I found my own blink-rate coming into synch with Oscar's, and so this became invisible. His thinking mind is represented by a whispered, paranoid soliloquy. After his death, this falls silent and he sees the past partly impeded by the back of his own head.

Then, this disappears as his spirit floats everywhere and anywhere: death as the ultimate out-of-body experience. It's like a psychedelic innerspace version of Kubrick's *2001*, and the film even finally presumes to offer a version of the star-child rebirth. Like Kubrick,

incidentally, Noé has a fondness for trad classical – he brings *Air on a G String* on to the soundtrack. As for the overhead visions of violence and claustrophobic horror, they are clearly influenced by the climactic sequence of Scorsese's *Taxi Driver.*

Noé's most startling achievement in *Enter the Void* is his vision of Tokyo: he reimagines it as a branching, crystalline network of neon laid out starkly against the night sky. The city is never seen in daytime. It is not real, but has merged with an illusory vision of the neon-model created by an artist friend of Victor's, and it is also an architecturalised version of those spiralling, kaleidoscopic snake-shapes that Oscar sees while tripping.

Some may find *Enter the Void* detestable and objectionable, though if they affect to find it "boring" I will not believe them. For all its hysterical excess, this beautiful, delirious, shocking film is the one offering us that lightning bolt of terror or inspiration that we hope for at the cinema.

WE NEED TO TALK ABOUT KEVIN

20/10/11

★ ★ ★ ★ ★

What happens when bad children happen to good parents? Does it mean they are not, in fact, as good as they had imagined themselves to be? With these questions, British director Lynne Ramsay has created a nihilist tale of guilt and horror. Working with co-writer Rory Kinnear, she has adapted Lionel Shriver's prizewinning 2003 novel – whose much-spoofed title is now part of the language – about a woman whose teenage son Kevin has committed a Columbine-style massacre.

This adaptation raises a subject which has eluded other films on the same subject, such as Gus Van Sant's *Elephant* or indeed Michael Moore's documentary *Bowling for Columbine*: the subject of the aftermath. Kevin cannot be tried as an adult. So who, in the end, will wind up getting the blame for a teenage boy's psychopathic rampage? Why, the mother of course, like the Blessed Virgin absorbing reflected adoration of the crucified Christ.

Tilda Swinton plays Eva, a former free spirit and city-dweller who has found herself having to move to the suburbs because of her husband Franklin (John C. Reilly) and his breezy insistence that the city is no place to bring up children. They have two: obnoxious smartmouth Kevin (Ezra Miller) and sweet younger sister Celia (Ashley Gerasimovich). Her success as a travel writer originally meant they could afford a handsome family home, but we join the story as Eva, her life in ruins, is living on her own in a scuzzy bungalow, a pill-popping drinker. Kevin's grotesque crime means her car and porch are always vandalised and she cannot leave the house without being screamed at or assaulted. She must spend the rest of her life trying, vainly, to make up for a crime for which she is not responsible and which she does not understand. She is simultaneously at the centre of this event and at its margins.

So Eva takes stock of her life and tries to find out if there was one key, terrible misjudgment or failing of hers as a mother, which set her son off on the road to murder. Swinton portrays Eva as a ghost,

haunting her past and haunted by it. She is gaunt, hollow-eyed, stunned: her eyes are almost blind, as if she can see only memories. And perhaps it is not that she created Kevin, but that Kevin created her. Eva's only identity is now that of someone who gave birth to horror. When Kevin's parents break off arguing one night to tell him, patronisingly, that he might not understand the "context" to their quarrel, he sneers: "I am the context."

From the first, it is clear that this is the worst case of post-natal depression in history, and perhaps the violent dénouement is its ultimate symptom. From the first, Eva doesn't like her baby and her baby doesn't like her. She can't stop him crying and, in the extremes of desperation and sleeplessness, coos at him satirically: "Mommy was happy before Kevin came along." Ramsay's film amplifies a central, emotionally incorrect theme: motherhood itself is a ritual in which the adult consents to gradual parasitic destruction. Maybe it's movies like this and *Rosemary's Baby* that are voicing forbidden fears, or even truths, about being a parent.

As Kevin grows to infanthood, he resents his baby sister and is diabolically intent on upsetting and disconcerting the once confident, successful Eva. He appears deliberately slow to speak and, particularly, to potty train. On this point he succeeds in goading Eva beyond endurance and then, with satanic cunning, securing her guilty submission by covering up Eva's violent overreaction. Finally he becomes a teenager and Ezra Miller is a compellingly sensual nemesis, coolly set on the anti-Oedipal plan of befriending his dad and destroying his mom.

Plenty of kids act up. Did Eva go wrong? Was it with bedtime stories about Robin Hood that encouraged his interest in archery? Or in dangerously teasing Kevin about being obviously impressed with the big photo of her in the bookstore window? Or did he just generally inhale her miasma of resentment, her own physiological disenchantment with motherhood itself?

And what does an independent-minded, career woman do when she is landed with a nasty little boy, precisely the kind of smug competitive male she has spent her whole life trying to subdue and surpass? What *American Psycho* was to consumerism, *We Need to Talk About Kevin* is to both sexism and feminism, a brilliantly extreme parable, operatically pessimistic. In the end, the audience is left with

the same unanswerable question: what made Kevin do it? Nature or nurture? A mother supplies both. Kevin is flesh of her flesh and perhaps an inability to judge him is her awful biological destiny. It is tremendously acted by Tilda Swinton (a performance to put aside her protective mother in David Siegel and Scott McGehee's 2001 thriller *The Deep End*) and by Ezra Miller, with inspired images from cinematographer Seamus McGarvey.

My only worry is that some hapless cinemas might schedule this as one of their special "parent–child" screenings. Bad idea.

MICHAEL

1/3/12

★ ★ ★ ★ ★

Brilliant and macabre, this debut feature from Austrian film-maker Markus Schleinzer shows the ordinary life of a man called Michael, played by Michael Fuith. As well as being a conscientious middle-manager in an insurance office, Michael is a paedophile, keeping a ten-year-old boy locked in a reinforced cellar beneath his bungalow. The film is not merely a chilling insight into the day-to-day banality of evil, but also an unbearably suspenseful and tense drama. I can't think of any other movie recently in which I have wanted so much to yell instructions at the screen – especially in the final five minutes, as we approach, in Graham Greene's words, the worst horror of all.

Schleinzer is a former actor, and a prolific casting director with over sixty features to his credit, a judge of faces who has worked with Ulrich Seidl, Jessica Hausner and, most importantly, Michael Haneke. He has clearly learned a good deal from the master's icy clarity and control. Haneke was reported to have shown an interest in directing Schleinzer's screenplay; I wonder how different this might have looked with Haneke in charge. The adult tormentor of a child in Haneke's *Funny Games* reveals himself to be armed with a cosmic rewind button – not the case here.

Michael himself is a very boring Pooter-Satan. He is a balding, bespectacled man who appears to be in a permanent, mildly bad mood and possibly clinically depressed. He is grumpy with his prisoner, a boy called Wolfgang (David Rauchenberger), allowing him up out of the cellar after a hard day in the office, fixing him supper, doing the washing-up with him and then permitting some TV before bedtime. We see him disappear for certain special visits to Wolfgang's bedroom cell, after which he washes himself in the bathroom and marks off the event in a desk diary.

Occasionally, Michael will take Wolfgang for excruciating days out to the countryside, walking with him as if with an invisible handcuff, in a prisoner-in-transit formation. Heartbreakingly, little Wolfgang looks around at another dad out walking with his son,

but such is the miasma of horror in which the film exists, it seems possible that this is just another paedophile with his victim. Michael and Wolfgang's home life is a surreal nightmare: when Wolfgang gets a high temperature, Michael succumbs to a tense, speculative daydream that is indistinguishable from real life. Later, he watches a crude porn film on TV, and it is quite unclear whether the next scene is a dream or waking reality. There are no firm clues about why Michael is like this, although there are some agonisingly clear hints as to how and where he found his victim. At the end, we hear of some innocuous things about Michael's own childhood and about his being "impatient", but nothing to explain things. He and Wolfgang are completing a jigsaw together, and the boy complains that some pieces are missing. Michael explains curtly that it doesn't matter. You can still see what the picture is.

When I first saw *Michael* last year, I wondered whether this film really told us anything new, for all its brilliance, and for all that it offered us the conventional enticements of plot twists and turns. Arguably, *Michael* can't compare in horror to the real-life Kampusch and Fritzl cases that have inspired it. But, for me, a second viewing allowed the implications to emerge.

Michael is a scabrous, satirical comment on the Stockholm syndrome inherent in all parent-child relationships. What is disturbing about this story is not simply the sexual abuse, which is kept off-camera, but the way Michael and Wolfgang fall so easily into a grotesque routine that looks like family life: this is the theatre of normality that takes place up on the ground floor. (Here, the movie is comparable to Haneke's *The Seventh Continent*, another truly horrible vision of violence, secrecy and family dysfunction.) Unlike the paedophiles in Todd Solondz's *Happiness* (1998) and Nicole Kassell's *The Woodsman* (2004), or even the child-killer in Fritz Lang's *M* (1931), Michael is supremely undramatic and dull. He is subdued at work, and testy, unpleasant and cold at home. What has made him like this? What else but the normal, dreary cares and worries of being responsible for a child – the terrible imprisonment of being a single parent?

And the film offers something else: a vision of male relationships themselves. In the brief timespan covered by the movie, Wolfgang begins to grow up, just a little; just perceptibly, he is approaching manhood, horrifyingly shaped and guided by Michael. In one

of the film's most mysterious scenes, Wolfgang gives Michael a Christmas card on which he has drawn, not a horribly ironic or parodic daddy-son picture, but two figures of equal height. Has he imagined his grown-up future alongside his captor? Michael is more furious and scared by this than anything else: imagining the future, and by that token understanding the present, is something of which Michael is incapable. The performances from Fuith and Rauchenberger are superb, and Schleinzer's direction and Gerald Kerkletz's cinematography have the touch and sheen of cold steel.

COMPLIANCE

21/3/13

★ ★ ★ ★ ☆

This chilling film, written and directed by Craig Zobel, is set in a fast food joint and based closely on the true story of a serial phone-prankster sociopath in the US who, for a decade, got away with a bizarre repeated hoax. His daring escalated and in 2004, he brought off his masterstroke of pure, insidious evil. The con trick was an almost satanic demonstration of the weakness and suggestibility of human nature, more devastating than anything in the well-known Stanford and Milgram experiments, because real lives were wrecked.

The event could have been turned into a documentary – and arguably, a documentary could have provided more of an overview of the trickster's criminal career in total – but Zobel's feature film brings out the creepy, banal horror of this culminating event, and the awful contemporary insights. It's a movie with as much to say about alienated corporate society and fast food consumerism as Morgan Spurlock's *SuperSize Me* (2004) or Richard Linklater's *Fast Food Nation* (2006).

Ann Dowd plays Sandra, the bustling, middle-aged manager of a fast food restaurant with the horrendous name of ChickWich. (Dowd was recently seen as the mother of Channing Tatum's disgraced investment banker in Steven Soderbergh's *Side Effects*.) Significantly, Sandra is having a really bad day: due to a screw-up by her listless and resentful underlings, almost $1,500 worth of bacon has been ruined, and Sandra is now conscious of doing an extra good job to please her bosses. One of the young people in her charge is twentysomething Becky, played by Dreama Walker, who spends a lot of time talking about her boyfriends, and Sandra, in a guileless but misjudged moment of girly self-revelation, talks about the fact that she herself is engaged to be married, and that her man sure can satisfy her. Once she is gone, Becky does a lot of eye-rolling and wincing at this unsought intimacy; Zobel shows how this has established a tension between the two women.

It is at this stage that Sandra takes a call from a cool, authoritative man who identifies himself as Officer Daniels, a policeman. Instantly, Sandra becomes compliant and keen to help. Officer Daniels says that

one of her employees has stolen money from a customer. A young blonde woman is the prime suspect; Sandra identifies Becky and then eagerly agrees to Officer Daniels's curt request to keep her effectively imprisoned in the back office until the squad car arrives. Then this mysterious voice gives orders, and as the terrible situation plays out, we get periodic glimpses of the deadly, uncaring fast food world out front.

At first, the voice is as implacable and mysterious as the truck driver in Steven Spielberg's *Duel*. Later in the film, we find out a little more about his *modus operandi* and well-worked phone manner: he switches with ease between jokey and brusque. Through some hideous instinct for human weakness, Officer Daniels has hit on a way of manipulating and exploiting total strangers. Is this the modern workplace as Abu Ghraib? Perhaps. The film does not belabour these larger implications, nor does it indulge in casting Sandra as a sitcom David Brent figure, although there are hints of an awful complacency.

What *Compliance* shows is how very important it is that "Officer Daniels" targets a fast food chain. Here is where the real degradation can flourish. Calling an office wouldn't work. The hoaxer needs a backstage area, a scuzzy secret place away from the (supposedly) ultra-clean zone where the public are fed. But calling a private restaurant wouldn't work either. The point is that a chain is always conscious of a menacing corporate authority somewhere above them: branch managers, regional managers, people who might only reveal themselves on the phone. Obedience and badly suppressed fear are the order of the day, especially on the unthinkable subject of hurting a customer. The staff take orders; the customers have limited food options. Relinquishing your free will and simply going with the flow is part of the process for all concerned. A fast food joint is a place to lower your guard as well as your standards. So when some brazen authority figure on the phone knocks everyone for a loop with some new situation, just submitting is all too easy. And yet at any time, in any period, when people supposedly in authority tell us what to do – we do it.

It is sometimes all but impossible to watch, especially when Sandra's fiance, Van, enters the picture, played by Bill Camp, an actor resembling George Kennedy. Here is where the whiff of sulphur emerges from the story. It is a cold, hard, shrewd film: satire with a drop of cyanide.

ONLY GOD FORGIVES

1/8/13

★ ★ ★ ★ ★

Like a thwacked *piñata*, critical opinion for something provocative at a film festival can swing off in any direction. But it was, for me, surprising to find that one of the very best movies at Cannes this year had such a shrill and hostile reception. Nicolas Winding Refn's brilliant, macabre and ultraviolent anti-revenge movie *Only God Forgives* – his most interesting work since the *Pusher* trilogy in the Mads Mikkelsen era – was deafeningly denounced at its first screening. Some booed from their seats, cupping their hands around their mouths so that the sound carried that vital few yards further. Then came the nervy, brushfire social-media consensus – a new feature of criticism at festivals – as insecure pundits checked their Twitter feeds and committed themselves to derision, evidently taking Refn's supposed failure to be the "story", and in any case believing that something has to be seen to take a pasting if the praise-economy is not to go bankrupt. And all the while, middleweight products and franchise mediocrities are cordially waved through.

I can only say that Refn's movie is entirely gripping, put together with lethal, formal brilliance, with bizarre set pieces of sentimentality and nauseous black comedy. It has its own miasma of anxiety and evil, taking place in a universe of fear, a place of deep-sea unreality in which you need to breathe through special gills – and through which the action swims at about ninety percent of normal speed through to its chilling conclusion. It is a kind of hallucinated tragi-exploitation shocker, an enriched uranium cake of pulp with a neon sheen.

The subject is expatriate American gangsters in a nightmarishly imagined Bangkok, self-exiled by traumatic family memories. Ryan Gosling plays Julian, a laconic tough guy who speaks hardly more than a paragraph's worth of dialogue throughout the whole film. He runs a drug business under the cover of a Muay Thai boxing

club, co-managed with his brother, Billy (Tom Burke), a violent and hate-filled misogynist whose grisly fate is to involve Julian in a strange metaphysical duel with Chang (Vithaya Pansringarm), an enigmatic, samurai sword-wielding cop. The situation is made even more eerie and grotesque with the arrival of Julian's exasperated mother, Crystal (Kristin Scott Thomas), demanding acts of retributive violence. She is a widowed mob matriarch who knows very well what Julian can do: she is at once grateful and resentful and contemptuous, for reasons that emerge towards the end of the film, and which will make sense of Julian's behaviour. He seems paralysed by something that can't exactly be called conscience. With her icy-blue eyes ablaze — Julian's eyes are the same — Crystal taunts and denounces him, like some mix of Gertrude and Lady Macbeth.

It is Chang who glides through the film with mysterious precision and ambiguity, calm and ruthless in his capacity for aggression, and for enforcing his own kind of natural justice on his own turf. Is he an avenger who punishes people — for seeking revenge? He could be a Zen master whose lifelong vocation is payback against payback, and whose students graduate with the loss of a limb. He could be a kind of black hole, drawing violent people in, nullifying them, cauterising them. Or perhaps he is just a Machiavellian figure with an instinctive gift for attracting and manipulating violence itself.

Either way, Chang utterly upends what we might expect of a violent movie, and certainly what we might expect of a violent movie starring sexy Ryan Gosling. The winners and losers in straight physical combat are not obvious. And for all the director's mischievous public pronouncements about being a "pornographer", the violence here, though sometimes almost unwatchable, is effectively questioned far more than in many another straight action film.

Refn's direction, Larry Smith's cinematography and Beth Mickle's production design are all superb. The disturbing tracking shots down infernal corridors brought to mind Travis Bickle's final descent in Scorsese's *Taxi Driver*. The queasily-presented Bangkok, in which daylight looks like just another kind of neon, is a little like that in Thomas Clay's *Soi Cowboy* (2008) or the Tokyo of Gaspar Noé's *Enter the Void* (2009), but a closer comparison might well be with a Thai

director, Wisit Sasanatieng, and his deadpan genre comedy *Tears of the Black Tiger* (2000), which had the same trope: the desolate singing of songs about lost love. Chang is a karaoke enthusiast, taking to the stage with his microphone, to sing impassively of heartache while his fellow officers sit around, their caps placed on tables, as respectful and alert as if at a debriefing. It's a fascinating film, and it deserves to be seen.

HOUNDS OF LOVE

27/7/17

★ ★ ★ ★ ☆

There could hardly be a tougher watch around than this brutal and brilliant independent film from Australia, based on the real-life case of serial killer couple David and Catherine Birnie in 1980s Perth and what became known as the "Moorhouse murders".

Writer–director Ben Young makes his fiercely commanding feature debut with a nightmarish fictional variation on the story. A respectable-looking man and woman cruise around in their car, asking teenage girls out walking on their own if they would like a lift. The results are horrifying, and the very unwatchability of this picture, its ability to make you put your face in your hands, is ironic, considering how superbly and even beautifully photographed it is, in a flat, hard light. It is superbly acted by Emma Booth as Evelyn, a damaged and pathetic woman in an abusive relationship with psychotic John – a role in which the veteran comic actor Stephen Curry is blood-chillingly plausible. Ashleigh Cummings is excellent as Vicki, a teenage victim who fights back by trying to exploit the tensions between them.

This is a truly stomach-turning film, an ordeal horror, the specific like of which I haven't seen for a while (maybe not since Greg McLean's *Wolf Creek* in 2005) and of course it is a very tough sell. But there is no doubt how accomplished Young's work is. I couldn't help noticing that the film included a classic trick edit, which is perhaps a homage to *The Silence of the Lambs*. Not for the faint hearted.

WETHERBY

27/6/18

★ ★ ★ ★ ★

It is over thirty years old, but David Hare's drama *Wetherby* shocks and perplexes and excites me even more than ever: a meditation on love, obsession, the buried poison capsule of the past and the terrible, unknowable mystery of other people's lives. It could be Hare's masterpiece, perhaps the best of his work in the movies – but maybe overlooked now because audiences effaced it from the cultural memory at the time, having recoiled from the horror of the film's central image, the tormented student John, played by a young Tim McInnerny, committing suicide in front of Jean, the lonely schoolteacher played by Vanessa Redgrave.

I remember seeing it for the first time at the Phoenix Cinema in Oxford in the 1980s and reading a shrewd programme note that Hare had composed for the occasion in which he proposed a maxim: Film Is Fast. Precisely. Film allows magical flights in time and space, and Hare's superb and disturbingly dreamlike crosscutting between past and present has the occult quality of Buñuel's *Belle De Jour*. I feel that this is the kind of intelligent, audacious moviemaking that the British should have been getting from their cinema in the 1980s and 1990s – to match the sustained industries of theatre and TV – but somehow never did. *Wetherby* is something which reaches back to the smallscreen work of Dennis Potter and forward to the lacerating cinema of Michael Haneke in the succeeding decades.

When the intense and troubled young postgrad student John Morgan, played by McInnerny, calls round to see Jean one evening at her cottage in Wetherby in Yorkshire – and blows his brains out in front of her – the explicit horror is like a blow which shatters into pieces the movie's sense of narrative and rational cause-and-effect. The preceding night Morgan had mysteriously showed up at a dinner party hosted by Jean for her friends Stanley (Ian Holm), Marcia (Judi Dench), Verity (Marjorie Yates) and Roger (Tom Wilkinson). Weirdly, John is discovered hanging around by Jean's front door and simply tags along with a couple of them as they are ushered in by the

hostess. These people assume he is a friend of Jean; Jean assumes he is a friend of theirs, and English embarrassment and reticence means that no-one asks. But John is to ingratiate himself in the course of this dinner party by fixing a hole in the roof.

But why did this man invade her home and life in the first place? He was in flight from being sent down from university in the South, in official trouble for stalking a beautiful fellow student, Karen (Susanna Hamilton). John had simply run away, far away on a train, and a sixth sense for Jean's loneliness and inner agony had brought him to her. Later Karen herself will come to see Jean, and Jean is to experience for herself this young woman's fascinatingly blank beauty, exerting a gravitational pull of desire, perhaps similar to that which Jean didn't realise she was exerting on John, and which Jean is now imposing on the gloomy copper investigating the case: Langdon (Stuart Wilson). John Morgan himself is described by Langdon as having a "central disfiguring blankness". Marcia herself had complained that a young woman at her place of work has this blankness as well. Is this what troubles middle-aged people about the young? Their pert and insolent refusal to offer up their existences and consciousness to an older generation for inspection?

Strangely, Karen insists on staying with Jean as a kind of houseguest, invading her life almost as John had done; Jean takes her along to the play which is being produced at the school where she teaches and at the party afterwards, a parent gets into conversation with her and then an odd and sexually charged argument in which he is seen trying to grab her arm. What was it all about? Karen refuses to say — perhaps because the sexual politics of the time has taught women to say nothing about an attempted molestation because the ensuing inquest will always make it worse for the complainant.

A further, recessive level of flashback reveals Jean's own troubled youth in the 1950s (she is now played, unforgettably, by Redgrave's daughter Joely Richardson). Young Jean was engaged to a young man who had just joined the RAF, preparing to fight in Malaya. And what happened to this man? The very fact that Jean is alone now permits us to expect, or suspect, the worst. But the truth is horrible, a kind of cosmic parallel to John's violent demise: he was murdered in a brawl in a Malayan gambling club, and this is made eerie by the fact that we know this but Jean almost certainly doesn't. The grisly

truth was surely withheld from her. In fact, the unknowability of the past is a motif. After Morgan's suicide, we see the police officers carefully reconstructing what they understand to be the event from what Jean has told them. The reason of course is that they suspect foul play, and can't be sure that Jean is telling the truth. We know of course that she is. But their sense of suspicion and shock leaks back into that remembered event.

Wetherby is a slightly less political work than I remember from the first viewing, although Nixon is a repeated topic of conversation and there is a very memorable dinner party conversation about Mrs Thatcher in which Stanley suggests a psychological reason for the Prime Minister's behaviour: "Revenge — that's what it is. For crimes behind the privet hedge. We've done nothing to her!" (Oddly, there is a "revenge" theory for Thatcherism — that her entire career was driven by a need to avenge the humiliation visited by local Labour politicians on her father, Alderman Alfred Roberts, during her girlhood, forcing him from his aldermanic seat by procedural trickery. It may be that Hare had this vaguely in mind.)

In the end, *Wetherby* refuses to make conventional sense. John simply turns up in Jean's life — randomly, yet not at all randomly — in a private anguish which somehow allows him to intuit her own long dormant agony, and his suicide in front of her is a bizarre and catastrophic gesture of twisted intimacy. And perhaps he has also somehow absorbed the knowledge about her fiancé's violent death in the past and is driven to demonstrate it in front of her. What daring there is in this film, a drama which takes in the jumble sales and market squares of provincial England and also whisks us back to a wartime situation which reminds you of nothing so much as *Casablanca*. A film of cold, stark, English ferocity.

The films that made me think about the real world: documentaries

The real world is what most fictional cinema is supposedly based on, in different forms, and yet cinema rewrites and reshapes this supposedly accessible reality in all sorts of different ways, rendering it quite unlike what we actually experience day to day, and often implanting in our heads the idea that our own individual lives are imperfect or unreal in some way. (In movies, you don't need to say "goodbye" at the end of a phone conversation, or pay the driver at the end of a cab ride, or spend ages testing the temperature of a shower before getting into it – unlike Janet Leigh and her miraculously temperature-controlled "*Psycho*" shower – and it's an enduring perspective trick in Hollywood that makes the moon look romantically huge in the night sky. For years growing up, I thought that the moon looked pathetically tiny when viewed from miserable Britain, but was properly big in America.)

So in some ways it's a relief to watch documentary cinema, a cinema which is concerned to engage with this world outside the cinema, not to fictionalise or to transform but to represent reality. Of course what is being shown on screen is, inevitably, shaped and manipulated as well. At about the time I started at *The Guardian*, documentary cinema was experiencing a huge resurgence, due really to one person: Michael Moore. His *Fahrenheit 9/11*, about the WTC attack and the subsequent War on Terror was infuriating and divisive for some, but he still has the distinction of being the first, or one of the first people from what we now call the MSM or Mainstream Media, to challenge the consensus as Britain and the British press

were endorsing the invasion of Iraq. There was excited talk about a single film changing the course of history. It didn't happen. George W. Bush Jr stayed in power and got his second term.

But documentary enjoyed a boom that continued until the next decade, especially in what *Variety* magazine called the "What's Up?" Doc – the issue film, the movie that was a call for action. Whereas many documentaries disdained the narrative voiceover as too signposted and coercive, the Moore-type doc gloried in its voice, its twangy, funny, standup comic style voice that presided over the graphics and the set pieces and the scenes where the film-maker gets thrown out of the corporate building, deep inside which there is a CEO who has refused to grant an interview. Other types of personal and revelatory documentary also gripped me, although there was a growing but unresolved debate about when and if these films should be allowed to use "reconstructions" of what is supposed to have happened. Some of our most exciting new British directors, like Clio Barnard and Carol Morley, have started their careers in documentary or in docu-realist essay film-making, and their creative trajectories have been thrilling to watch. In the selection here, I include Ken Fero's urgent and passionate film *Injustice*, about UK deaths in police custody, which is still one of the most remarkable documentaries I have ever seen. There is also Werner Herzog's extraordinary *Grizzly Man*, a staggering account of a man relationship with the animal world, and Andrew Jarecki's *Capturing The Friedmans*, an example of how the story can emerge, unexpectedly, from the filming process when quite a different endpoint had once been envisaged. Documentary has been a vital form in the last twenty years.

INJUSTICE: THE MOVIE

28/9/01

★ ★ ★ ★ ☆

Ken Fero and Tariq Mehmood's documentary – downbeat in manner, polemical in effect – tells a harrowing story. This is the testimony of the families of those people, almost entirely black men from south and east London, who died in police custody in the 1990s. As the film continues, a repeat-pattern *modus operandi* emerges. A twitchy, uncertain police presence on the street; a mysterious death in custody, then the closing of ranks. This has found its logical extension in sabre-rattling threats of legal action by the Police Federation, avowedly on the basis that individual policemen are mentioned, though this is always in the context of rehearsing the details of official inquiries and inquests.

Fero's film highlights the irony that, despite the ostentatious soul-searching that followed the Stephen Lawrence case, the violent deaths of black people while in official custody have been passed over in nervous silence. *Injustice* places itself deliberately outside this reticent media consensus. It is not clear whether Fero and Mehmood approached police authorities to be interviewed on camera, or if these requests were refused or ignored. At any rate, tight-lipped silence has unarguably been the police strategy the rest of the time, and Fero's film is about giving a voice to the relatives left behind, and their fight for answers, a fight in which they show enormous dignity. Last week, the Ritzy in Brixton, south London, pulled the film on "legal advice" – a piece of self-censorship which will make loyal Ritzy supporters groan. Let's hope the other venues across the UK and Ireland slated to show the film have more self-confidence. As a record of human courage, *Injustice* deserves to be seen.

THE STEPHEN LAWRENCE CASE AND
ANOTHER *INJUSTICE*

5/1/12

The news about the Lawrence verdict and sentencing took me back to the mid-1990s – the case has been hanging for such a shameful length of time – when we journalists stood around gaping at Paul Dacre's sensational "Murderers" headline in *The Daily Mail*, and discussing what it all meant. (The paper challenged the five suspects to sue: did that mean sue for criminal libel? For which legal aid was available? Well, they didn't sue.)

My next thought was to pick up the phone and call the film-maker Ken Fero, who, with Tariq Mehmood, directed one of the most sensational documentaries I think I've ever reviewed: the 2001 film *Injustice: the Movie*. This was about the extraordinary, continuing phenomenon of black and Asian people dying mysteriously in police custody without any prosecution being brought. The film-makers suggested that 1,000 people had died in this way between 1969 and 1999, and focused on cases such as those of Joy Gardner, David Oluwale and Shiji Lapite. Despite the soul-searching that followed the Stephen Lawrence case, the situation highlighted in *Injustice* went all but unnoticed: a colossal elephant in the room. The film itself had to be pulled from cinemas after legal threats from the Police Federation, but the directors have continued to put on *samizdat*-style screenings ever since, and Fero is now preparing to upload the film in its entirety to the Vimeo site.

I asked Fero what he thought of the Lawrence verdict and he drily called it "too little too late", while paying tribute to the persistence of Stephen's parents, Neville and Doreen Lawrence: "It's terrible it takes a family to do the state's job."

And what of the *Injustice* situation? Well, one indirect outcome was the replacement in 2004 of the PCA, or Police Complaints Authority, by the Independent Police Complaints Commission, a body with sharper teeth. Its existence was welcomed by the families mentioned in Fero and Mehmood's film, but it was nevertheless criticised in the wake of the Duggan affair, which was a trigger

for the summer riots. And the fact remains that deaths in police custody somehow do not show up on the radar as crimes.

Since 2001, I have been half expecting Fero and Mehmood to get the credit they deserve as documentary-makers and have their names mentioned in the same breath as Adam Curtis and Vanessa Engle. But, frustratingly, it hasn't come out like that and Fero tells me he has faced an uphill battle getting the follow-up to *Injustice* made. It was due to come out in 2011, for the ten-year anniversary. Things have been delayed. Depressingly, Fero and Mehmood have received no encouragement or funding from TV or production companies. (Although, with another dry laugh, Fero concedes that projecting his film onto the wall of the Channel 4 building probably meant that this particular company would be unlikely to stump up.) Instead, they have paid for everything out of their own pockets – which makes it an agonisingly long process. "If we thought about the economics of this, we'd just give up," says Fero.

However, *Injustice 2* is nonetheless due to emerge later this year. It promises to be a must-see documentary. Meanwhile, the first film is due to go up on Vimeo soon, and we can watch it there.

CAPTURING THE FRIEDMANS

9/4/04

★★★★☆

Andrew Jarecki's compelling and horrifying documentary reminded me of the moment in *Portnoy's Complaint* when young Alex Portnoy imagines his father confessing to sexual misdemeanours: "Come, someone, anyone, find me out and condemn me – I did the most terrible thing you can think of. Please catch me, incarcerate me, before God forbid I get away with it completely!"

Poor Mr Portnoy was only suspected of having an affair. Arnold Friedman, the mute and hangdog protagonist of this movie, is accused of something far, far worse. But his tragic self-reproach, and refusal to defend himself, is very similar. As his wife Elaine coldly puts it: "He had a need to confess. And a need to go to jail."

The film is a study of transgression and lifelong denial that is so disturbingly intimate it's all but unwatchable. The most incredible thing, among so many incredible things, is that Jarecki only set out to direct a modest movie about the son, David Friedman, a middle-aged man who makes a living as a New York children's-party clown, capering about Manhattan apartments in baggy trousers.

But the director came to discover that his subject's father Arnold and brother Jesse had been co-defendants in one of America's most sensational child-abuse cases, and that the family had a vast archive of home movie Super-8 reels and videotapes showing their life disintegrating during the trial. The tears, the screaming, the stunned silences – a family breakdown, live on camera. For a documentary-maker, that must have been like going potholing in Cumbria and stumbling on Tutankhamen's tomb.

Arnold Friedman was a well-liked teacher in a comfortable Jewish American household, married with three boisterous sons, who gave computer lessons for local kids in his home in Long Island, with his boy Jesse as an assistant. In the mid-1980s, the postal service intercepted a child-porn magazine sent to his address; a search of his house uncovered a huge stash of this material, together with what appeared to be a lewd computer graphic.

From there, zealous cops interviewed all Friedman's pupils. Their tough, leading questions induced a Salem atmosphere of hysteria in this close-knit community, and Arnold and Jesse found themselves charged with sexual assault of children with no proof other than the circumstantial evidence of the porn and the highly disputable testimony of the children themselves, some of it induced through hypnosis and "recovered memory" techniques.

But did Arnold and Jesse do it? Did they do some of it? It certainly looks as though a not-guilty plea and a trial might have got them off on "reasonable doubt". But poor Arnold, stunned by shame and probably given bad advice by his slimy lawyer, just slumped and pleaded guilty – to his wife's rage – claiming it would save Jesse. Jesse, however, wound up getting charged and he pleaded guilty, too, to lessen his own sentence.

The boys are screechingly, jabberingly insistent to this day on the innocence of father and son, despite this tactical guilty plea. But was their insistence on this doomed strategy and subsequent obsession with their tragic innocence a giant denial mechanism to save them thinking about their father's paedophilia? Whatever the murky truth, this is a movie about being in denial, about the biggest, smelliest elephant in the living room that they can't talk about.

When Elaine was shown the porn, she went into a state of hysterical blindness: "I didn't see it. My eyes were in the right direction, but I saw nothing." Later she says primly: "He would look on these pictures and meditate." My guess is he would meditate several times a day.

The most extraordinary thing is the way they distract themselves by clowning around in front of their home-movie camera, a habit inculcated in them by their father in happier times. Even on the night of Jesse's imprisonment, they're fooling around, doing wacky dances, acting out Monty Python sketches for the video. It's as if they're making their own reality-TV documentary to prove to themselves how fundamentally wholesome they really are.

Jarecki has compared these tapes to *The Osbournes*, and weirdly, as in that programme, one family member refused to take part in this documentary: Seth, who seems to have done at least some of the original home-camerawork.

The act of filming is a part of the dysfunction, as they compulsively record the rows, the violent confrontations (largely showing the

sons' rage at the mother's failure to support Arnold) and the repeated displays of redemptive comic hijinks.

Interestingly, Jarecki leaves this subject unexamined. There are no questions about when they got the camera, whose was it, who got to do most of the filming, did they review their tapes during the trial, etc. Maybe it's because this material is Jarecki's treasure-trove, and if filming is a neurotic, obsessive-compulsive activity, Jarecki is effectively complicit in it.

Capturing the Friedmans does not take sides; it does not present itself as a case for the defence. It shows that Friedman was a lifelong child-porn addict with paedophile tendencies, while also indicating that the assault convictions were as unsafe as they could possibly be. But neither does it indulge in any insidious relativist stuff about the objective truth not actually existing at all. It's just that within families, witnesses to the truth are so compromised, and have such a vested interest in looking the other way, that the truth is all but impossible to get at.

The movie lifts the lid on this seething cauldron of unspoken, unspeakable shame, takes a good long peep within and then drops the lid again with a clang. It shows how the happiest families can live with their own secrets for years; the Friedman family nursed their own festering, ghastly shame and the shock of its revelation led to disproportionate catastrophe. The effects were devastating. And now the effects on us, the audience, are pretty devastating, too.

GRIZZLY MAN

3/2/06

★ ★ ★ ★ ☆

Tragicomedy is an overworked word. Yet nothing else will do. Werner Herzog, that connoisseur of extreme figures in far-off places, has made an inspired documentary about the gonzo naturalist Timothy Treadwell, who in 2003 ended up as lunch for the bears he lived with in the remote Alaskan wilderness.

It is poignant, it is beautiful, and it is absolutely hilarious. Herzog didn't even have much work to do, what's more, because Treadwell – gifted, untrained film-maker that he was – had done almost everything himself, leaving behind hundreds of hours of videotape that he had shot at extreme and indeed fatal risk to himself. They contain sublime, dramatic shots of the bears and footage of his own mad and posturing rants to camera, wearing combats and a bandana – part surfer-dude, part drama-queen. And there's always a bear or two lumbering cheerfully up behind Treadwell, with a look in their eye that says: "Mmmmmm....tasty!" You know what's coming, and that suffuses every moment of Treadwell's artless presence on film with a thrill of horror and disbelief.

Timothy Treadwell was a mixed-up kid from Long Island in the US who wanted to be an actor. He auditioned for *Cheers*, but the shock and disappointment of coming second to Woody Harrelson sent him over the edge into drink and drug crises. He came out the other side clean and sober, but with a new passion: the grizzly bears of Alaska. Every summer, he went camping out there with his video camera and his attitude problem, regularly breaking the US park rangers' rule not to come within 100 yards of a bear. Timothy got up close and personal, giving them cute names like "Mr Chocolate" and "Sgt Brown", patting them on the nose, and becoming obsessed with gaining the bears' respect for his courage in doing so. His opening rant to camera is a comic classic, influenced, I very much suspect, by Dennis Hopper in *Apocalypse Now*: "I am a kind warrior! I will not die at their claws and paws! I will be a master!"

Bizarrely, his macho extreme-sports persona often alternates with something screamingly camp. Treadwell yoo-hoos wildly like Robin Williams at the bears who lope up to him: "Oh hi! Hiya! Oh he's a big bear! He's a surly bear!" And Treadwell is often very funny – a reality TV natural who never got his own show. There are too many choice moments to describe here, but among the classics is his sudden zooming-in on an immobile bumble bee on a flower, which he tearfully describes: "Isn't this so sad? A bumble-bee expired while it was doing the pollen thing. It's beautiful … it's sad … it's tragic … it's … WAIT! The bee just MOVED! Is it … is it just SLEEPING?" Later, Treadwell films a full-on macho-bear fight between Micky and Sgt Brown over a female called Saturn, whom Treadwell describes as the "Michelle Pfeiffer of bears".

His mission was to teach the world about these animals, and this he certainly did, according to his lights, touring schools and giving illustrated talks to kids without accepting a fee. But he also angrily claimed, in some of his looniest soliloquies, that he was "protecting" the bears from poachers or even the federal authorities. The awful truth was that he did not add anything to our knowledge of bears, and that any supposed danger these animals were in, living as they did in a protected national park, existed only in Treadwell's over-heated, self-dramatising imagination.

Treadwell's over-the-top persona is in contrast to the cool, deadpan drone of Herzog himself, who pays tribute to his intuitive skills as a film-maker, but repudiates Treadwell's Disneyfied view of nature, seeing in it only colossal coldness and indifference. Herzog appears on camera just once, listening through headphones to Treadwell's final screams – and those of his luckless girlfriend – as they are both eaten. It is only audio, as Treadwell was attacked before he could remove the lens-cap; in a masterstroke of restraint, Herzog does not let us hear this sound, and sorrowfully advises Treadwell's former girlfriend, Jewel, to burn the tape. I wonder if she has.

Was Timothy Treadwell an inspired radical operating outside the academic naturalist establishment – or a pain in the neck with personal issues? A little of both, of course. He was certainly a brilliant performer and director who, by crossing the taboo line (by as it were impaling himself on the taboo line's barbed wire) vividly demonstrated the alien-ness of nature, and therefore its strange

and terrible beauty, more than anything I've ever seen by David Attenborough. It is a superb documentary, because Treadwell has not been coerced or set up; he was enough of an amateur to be relaxed and unselfconscious, yet enough of a professional to generate all this outstanding footage, and quite rightly Herzog declines to patronise or make fun of him. If we didn't already know Timothy Treadwell's awful fate, it would be enough to say: a star is born.

THE PERVERT'S GUIDE TO THE CINEMA

6/10/06

★ ★ ★ ★ ☆

Looking like no one so much as Ricky Tomlinson's crazed Slovenian twin brother, that unruly thinker and critic Slavoj Zizek gives us a highly entertaining and often brilliant tour of modern cinema, with clips from Hitchcock, Lynch, Tarkovsky and Chaplin. The cinema, he says, is a "pervert's" medium because it tells us not what to desire, but how to desire; it fetishises an endlessly reordered and artificialised reality in order to induce rapture and fascination.

Taking his cue from *The Matrix*, and the famous two pills which allow the swallower either to remain in an illusory reality or irreversibly to enter the domain that lies behind this illusion, Zizek says he wants a third pill: that which will open our eyes to the assumptions on which this choice itself rests. What if cinema – with all its contrivances and conventions – is a realer reality than the mundane daylit world outside the movie theatre? What if its thrilling images offer us a glimpse of our inner natures which is more penetrating and more moving than anything available in our ordinary lives? And what if this is because of its infinitesimally subtle wrongness, its inauthenticity?

Like a ghost, Zizek haunts the famous locations and mock-up sets of classic movies in order to harangue us, like some intellectual Ancient Mariner. He fires off fluent reveries in his mangled, dentally challenged English like a virtuoso. Tremendously exhilarating stuff.

THE ARBOR

21/10/10

★ ★ ★ ★ ☆

Verbatim theatre is a new form of contemporary political drama, in which the proceedings of some hearing or trial are reconstituted word-for-word on stage, acted out by performers. Now artist and film-maker Clio Barnard has experimentally and rather brilliantly applied this technique to the big screen, ventriloquising the past with a new kind of "verbatim cinema". She has journeyed back thirty years with a movie about the late Andrea Dunbar – dramatist and author of *Rita, Sue and Bob Too* – who, physically weakened by alcoholism, died in 1990 of a brain haemorrhage aged twenty-nine.

Dunbar came from that part of Bradford's tough Buttershaw estate known as "the Arbor". Barnard has interviewed Dunbar's family, friends and grown-up children and then got actors to lip-synch to the resulting audio soundtrack, talking about their memories. Passages of Dunbar's autobiographical plays are acted out in the open spaces of the very estates where she grew up, surrounded by the (presumably real) residents looking on. The effect is eerie and compelling: it merges the texture of fact and fiction. Her technique produces a hyperreal intensification of the pain in Dunbar's work and in her life, and the tragic story of how this pain was replicated, almost genetically, in the life of her daughter Lorraine, who suffered parental neglect as a child and domestic violence and racism in adult life, taking refuge in drugs in almost the same way that Andrea took refuge in alcohol. The story of Lorraine's own child is almost unbearably sad, and the experience of this child's temporary foster-parents – who were fatefully persuaded to release the child back into Lorraine's care – is very moving.

Dunbar's story, and her success as a teenage playwright in Max Stafford-Clark's Royal Court, challenges a lot of what we assume about gritty realist theatre or literature from the tough north. In many cases, it is produced by men whose gender privileges are reinforced by university, and who have acquired the means and connections to forge a stable career in writing. However grim their

375

plays or novels, there is a kind of unacknowledged, extra-textual optimism: the author, at least, has got out, has made it. Dunbar hadn't got out; she did not have the aspirational infrastructure of upward mobility. In the end, she was left with precisely those problems she depicted. Barnard has created a modernist, compassionate biopic: a tribute to her memory and her embattled community.

KEN LOACH SAVES THE CHILDREN

1/9/11

★ ★ ★ ★ ★

This month, BFI Southbank in London marks Ken Loach's seventy-fifth birthday, and his fifty years in the business, with a colossal new retrospective. The centre-piece is perhaps the unveiling of his "lost" 1969 TV documentary, partly bankrolled by the Save the Children charity. It is an exhilarating experience. Perhaps Loach scholars will come to see it as an early, brutalist masterpiece, uncompromisingly angry and disdainful.

Never in the history of documentary film-making was the feeding hand bitten so spectacularly, so gloriously. To say that the Save the Children charity come badly out of the film, which they themselves had bankrolled, was the understatement of 1969, or any year. After a ferocious legal row, Save the Children actually demanded Loach's film be banned. Loach and his producer Tony Garnett finally negotiated a compromise: the unfinished film would be stored in the BFI National Archive until such time as the charity gave its permission for it to be screened. This it has now done, forty-two years after the event, and it will be shown in its raw state, with no titles or credits, and without a title – although I think "Save the Children" would be good.

Oh, to have been a fly on the wall when the executives of Save the Children first viewed Ken Loach's film! They would presumably have been given to understand that the first half of the film would be about the charity's holiday home for deprived children in Essex, and the second about its school for homeless boys in Nairobi, Kenya. As far as it goes, that is an accurate description. So far, so good ...

Famously, Loach's *Cathy Come Home* inspired the foundation of the Crisis charity. The high-ups at Save the Children probably thought that they and Loach were pretty much on the same page. They probably suspected that Loach would give a tough account of the social and political forces which created poverty, but then give a reasonably supportive picture of what little a charitable body could do under these circumstances.

How very wrong. Loach utterly derides the work of Save the Children, in both Britain and Africa, as a mere sticking plaster or temporary measure. One voiceover – unidentified in the film's still raw state – remarks: "Until these questions are addressed politically, then these fire-brigade rescue jobs cannot possibly solve it!" But it is not just this. The good faith and attitude of the charity are utterly dismissed. The Save the Children officers in Essex are shown to be grotesquely condescending and snobbish. One drawling woman is heard on the subject of the children's "animal instinct" and "cunning," in playing off the charity workers against each other to get privileges and treats. In Kenya, the homeless boys are put into an English public-school system, reading *Tom Brown's Schooldays*, but forbidden to speak Swahili or wear national dress.

In Africa, as in Britain, Save the Children is dismissed as a salve for the conscience of the prosperous West, pacifying the poor at home and, abroad, part of the dishonest "aid" mentality. Save the Children emerges from this film as the useful idiot of further oppression, an important part of the new technique of enslaving Kenya as an economic client state.

Loach's film is, magnificently, a world away from "responsible" documentary film-making. There is no cautious balancing view, no lenient acknowledgement of the fact that the poor, chuckle-headed Save the Children types are just doing their best. (However, in political terms, there is a balancing quote, of a sort. One woman is heard dismissing political action of the sort Loach espouses, on the grounds that it will just make the lower classes welfare-dependent.)

Inappropriate, I know, but I actually laughed out loud at the sheer, in-your-face provocation of this film. It is black and white, in every sense. My own theory – which I have to admit I have not put to the director himself – was that at some stage Ken Loach must have known that his film was going to be banned, and this liberated him to say whatever the hell he liked.

What is so radical, even slightly surreal about this documentary is that the Kenya half has little or nothing about the Save the Children charity. Loach just dwells, with superb tactlessness, on the poverty and racism that was still a feature there. He haunts the avenues and cafes and swimming pools of the city, listening to the chatter – a sort of *À Propos De Nairobi*. One white person is heard to say: "The

people here are frightfully interesting, even the people who live here ..." – and these people, the woman says, are happier in their picturesque state of poverty.

This film does look very ancient now, and it is perhaps as a social document of a bygone world that the charity has now decided to tolerate it. But what of its charity work now? Does Loach think that it has become more acceptable? And how about the unsaved children of 2011, the rioters and looters with whose perfidy Britain's magistrates are still dealing? What does Ken Loach think about them?

I would love to see Ken Loach make *Save the Children 2: Just When You Thought it Was Safe to Give Money to Charity.*

DREAMS OF A LIFE

15/12/11

★ ★ ★ ★ ☆

All the lonely people … where do they all come from? Documentary film-maker Carol Morley has focused on where one of them ended up, a modern-day Eleanor Rigby. It's a story both horrifying and heartbreaking. Reporting on this movie's premiere at the London Film festival earlier this year, I wrote that it lingered persistently in my mind, and it lingers still, like a melody of desperate sadness. Apart from having a gripping story to tell, this is a film with real questions to ask about sexual politics and the welfare state.

One grim day in 2006, acting on account of rent arrears, Haringey council officials broke down the door of a bedsit in a housing complex above Wood Green Shopping City in north London. This was occupied by a single thirtysomething woman, Joyce Vincent, whose corpse these officials then discovered, slumped on the sofa in the light of the TV set, which had remained on. She had lain there dead for almost three years: so long that it was impossible to determine a cause of death.

Vincent had had a record of hospital admissions, so it was possible this had been a medical crisis. She had spent time in a women's refuge, so murder or suicide, although unlikely, could not be entirely ruled out. Carbon monoxide poisoning from some inadequately maintained boiler is perhaps another marginal possibility, but the grim and extraordinary fact is that Joyce Vincent's corpse had been there simply too long for the facts to be clearly established. She was not a drug addict or an alcoholic, but an attractive and sociable, if somewhat secretive person, with a wide circle of acquaintances. Agonisingly, her corpse was surrounded by Christmas presents, which she had just wrapped. How could she have been so isolated? How could her death have gone unnoticed? Morley tracks down and interviews her friends, colleagues and ex-boyfriends, and stages dramatised reconstructions with actor Zawe Ashton in the Vincent role. She seeks to excavate, as if in some imaginative act of contemporary psycho-archaeology, the kind of person Vincent was, and the kind of society that let her down.

Everybody knows how Bridget Jones feared ending up alone, and being discovered dead after three weeks half-eaten by Alsatians. The terrible case of Joyce Vincent has turned that joke very, very sour. Bridget Jones was not sure of her romantic or her professional prospects: hers was the farce that actually preceded the tragedy of Vincent. Morley pieces together the story of a vibrant, attractive, intelligent and ambitious young woman, estranged from her family, taking office jobs and nursing hopes of becoming a professional singer. She entranced many of the men she met, but seemed unable to maintain a relationship. Was she always holding out for a better offer? Was she finally too proud to admit she was lonely and ask for help from those people she had left behind in search of a glamorous future in showbusiness? Maybe so. After all, laughing at the pathetic wannabes on *Pop Idol* was a national sport.

Again, you return to the simple facts: Didn't anybody notice? How about the smell? Well, perhaps the neighbouring population was too transient to register a complaint. Or perhaps, for various reasons, no one had any great interest in drawing official attention to themselves, or perhaps they just shrugged and put up with it, assuming that complaint was pointless. It was a non-community where no one cared, apparently, where uncaringness hung in the air. And Joyce's flat is, as it happens, near those districts of Tottenham and Wood Green hit hard by this summer's riots.

It's certainly a grim comment on the caring state. And could it be that even the most prosperous of us are welfare addicts, assuming in our hearts that the state will provide? Well, the case of Joyce Vincent is proof that the state will not provide, and it also proves that we can't be complacent about the "big society" rushing in to provide either.

Dreams of a Life is not without flaws: Joyce's sisters declined to be interviewed, and the absence of testimony from them is arguably a problem, as is the absence of a clear description from Morley of how she approached them and in what terms she was rebuffed. It's not easy to tell if, despite refusing to be interviewed on camera, they gave Morley off-the-record guidance. Perhaps they did.

However, this is still a searing prose-poem on celluloid about loneliness: the kind of loneliness that can only happen in the big city. It is a terrible vision of London as a kind of emotional wasteland, a world of single people in single flats, living quiet, unhappy lives:

like Schrödinger's cat, they could as well be alive or dead. A morbid thought is bound to creep into the mind of anyone watching this film: how many more Joyce Vincents are out there, alone, unloved and unremembered?

Dreams of a Life is a painful film, a Christmas film with no feelgood message, but one which I think would in fact have interested Charles Dickens. Watching it is an almost claustrophobic experience, but a very powerful and moving one.

THIS IS NOT A FILM

29/3/12

★ ★ ★ ★ ★

"One does not imprison Voltaire," General de Gaulle is reported to have said, in response to a suggestion that Jean-Paul Sartre could be silenced with a jail sentence. If only the Iranian government showed that kind of class. In December 2010, the film-makers and pro-democracy activists Jafar Panahi and Mohammad Rasoulof were sentenced to six years in prison for alleged crimes against national security. Grotesquely, Jafar Panahi – the director of *The White Balloon*, *Crimson Gold* and *Offside* – was also subject to a twenty-year ban on film-making, and forbidden moreover to give interviews or leave the country in that period. With this crass, quasi-Soviet attempt to crush his creativity and humanity, the government disgraced itself in a unique fashion. Hollywood big-hitters have signed petitions, but in the current climate, pressure from the US could just be counterproductive.

Meanwhile, Panahi and Rasoulof have become cinema's prisoners of conscience, and while pursuing his appeal, and confined to his apartment under effective house arrest, Panahi managed to make this gripping, zero-budget film about a day in his life, shot entirely within his flat, partly on a simple DV camera and on his iPhone. He then had it smuggled it out of the country on a USB stick, reportedly hidden in a cake – and it was shown at the 2011 Cannes film festival. (Rasoulof had a feature film at Cannes, too, the devastatingly sombre *Goodbye*, made under conditions almost as constricted as Panahi's.)

This is Not a Film is a compelling personal document, a quietly passionate statement of artistic intent, and an uncompromising testament to his belief in cinema. The government is trying to cut off the oxygen to his livelihood and life. But this film-maker is hitting back.

Panahi's title hints at the Magrittean absurdity of what he has to do to get round the law. Technically, it is the work of its cameraman Mojtaba Mirtahmasb, and Panahi is not being "interviewed" but rather speaking lines, like an actor, on the subject of film-making.

The result is a heartbreaking, agonising study of loneliness. Panahi just hangs around the flat, eating, watching the news, surfing the net on his Mac and iPhone, taking depressing and inconclusive calls from his lawyer. He tries and fails to look after a neighbour's querulous pet dog, which he has to return to its owner because it is upsetting his pet iguana, Igi. His wry sense of humour is impressive, and his elegant dignity is profoundly moving.

The neighbours are all preparing for New Year's Eve parties, and Panahi speaks about his family members making various festive outings. (They do not appear on camera.) But there are no outings for Panahi. He stays put and what he mostly does is talk – he talks to Mirtahmasb about his work, with a fluency and intensity born of a sense that everything is now at stake.

Impulsively, Panahi acts out an unproduced screenplay, on the theme of incarceration, marking approximate set outlines with tape on the floor, but then almost breaks down with anguish and frustration. This is not what cinema is – and here the title changes from surreal joke to tragic truth. Using DVD clips from his films *Crimson Gold* and *The Circle*, Panahi shows us that the best, most serendipitous moments were improvised, taking their cue from the real world. (This has to be the most heartwrenching "director's commentary" imaginable.) Panahi did not know what his actors were going to do, but he shaped and guided their instincts, both on location and in the editing suite. You can't script this: you need freedom. And freedom is precisely what Panahi doesn't have.

Finally, he is shown befriending a college student who is making some extra money with a job collecting the garbage from the apartments in Panahi's building. Panahi grabs his camera and follows him, desperate for someone to talk to, excitedly interviewing this somewhat baffled young man about his life. He follows him to the apartment complex gates, beyond which the parties and fireworks are in full swing. He can go no further. You can feel the prison door clang shut in his face. This film is a *samizdat* cine-poem in defence of cinema and freedom: the only response is contempt for those government bullies and bureaucrats ranged against Jafar Panahi.

NOSTALGIA FOR THE LIGHT

12/7/12

★ ★ ★ ★ ★

It isn't simply that Patricio Guzmán's Chilean documentary *Nostalgia for the Light* is moving: it has a tragic grandeur that really is very remarkable. It is deeply intelligent, intensely and painfully political, and yet attempts, and succeeds, somehow to transcend politics and perhaps even history itself. The film found its starting point in the title of a 1987 book by the French scientist Michel Cassé: *Nostalgia for the Light: Mountains and Wonders of Astrophysics*. It reflects on how a golden age for Chilean astronomy was due to begin in the vast lunar landscape of the Atacama desert whose high altitude and dry climate made it the ideal site for a huge new observatory in 1977 and promised to open up the country as a scientific Mecca.

But in the same era Chile was destined to be a closed society, and Atacama became known as the site for the Chacabuco Mine prisons: the concentration camps instituted by General Pinochet for political opponents. Later, bodies were buried in secret mass graves in the desert. Some were uncovered – the resulting TV pictures have echoes of Cambodia, the former Yugoslavia and wartime Germany – but not all. Now, in 2012, the grim and bitter business of searching goes on. The wives and sisters of the disappeared, now old women, continue their daunting task in the colossal desert, and will do so until death overtakes them. Guzmán interviews one, Violeta Barrios, and it is a stunning and heart-rending piece of cinema.

The astronomy itself continues: the study in which many of the film's interviewees hope to find a distraction or redemption. There is something Kubrickian in the way Guzmán evokes the desert's massive alienness, and the images border on the hallucinatory. It is as if Atacama is the distant planet, being watched by another astronomer on the moon. One interviewee says Chile needs an observatory that can look at its own landscape, find the missing bodies, uncover and root out all its unresolved agony. One young astronomer, whose parents were taken away during the Pinochet years, says:"Astronomy

has helped me give another dimension to the pain and loss." Her candour and courage are deeply moving. For Guzmán, the science of astronomy is not simply an ingenious metaphor for political issues, or a way of anaesthetising the pain by claiming that it is all tiny, relative to the reaches of space. Astronomy is a mental discipline, a way of thinking, feeling and clarifying, and a way of insisting on humanity in the face of barbarism. This is one of the films of the year.

STORIES WE TELL

27/6/13

★ ★ ★ ★ ★

This tender, painful, intimate film is the work of Canadian actor and director Sarah Polley. It is a portrait of her troubled parents, a complex labour of love – part of what is fascinating and even thrilling about this movie is that Polley may not be aware of what it reveals about her personally. This is the second time I have watched it since last year's premiere at Venice, savouring its humour, its heartbreak and its unintentional disclosures, revealing the director's vulnerability and her formidable composure.

Polley has been an object of fascination for me since I saw her charismatic, icily assured performance in Doug Liman's 1999 thriller *Go!*, and assured everyone that she was going to be bigger than that year's other up-and-comer Angelina Jolie; I still think I may have been right. She continued to be an on-screen presence in the succeeding decade, but turned to directing, notably giving us *Away from Her* (2006), an excellent drama about dementia, starring Julie Christie. After that, Polley lost me – with a mawkish, stilted drama about infidelity called *Take This Waltz* (2011), featuring a bizarre, sentimentally conceived sex scene.

Yet Polley has come storming back with this semi-dramatised documentary, which has a blazingly emotional story to tell. Apart from anything else, I think it makes some sense of the untransformed personal content of *Take This Waltz*.

Stories We Tell is a love-letter to her mother and father: the film's stars are retired British actor Michael Polley and the once-famous Canadian performer and TV personality Diane Polley, who died of cancer when Sarah was eleven years old.

It is a work of some audacity, even effrontery, mixing pastiche Super 8 footage and faux home movies in with her genuine archive material, avowedly because the film is about the unreliability of memory and the consequent importance of democratising personal histories, allowing everyone to tell their stories and give their view. Yet there are no real discrepancies of fact or even interpretation

in what she is telling us. In some ways, the "different stories" line could be Polley's way of rationalising or even suppressing unresolved feelings. The film, with all its images, fragments and layers, is Polley's semi-controlled emotional explosion.

Her mother was a sexy free spirit who enchanted everyone she met, and an actor and singer of vibrant talent. She became pregnant with Sarah in her early forties; after initially deciding on an abortion, she changed her mind on the way to the clinic. Her eventual death was devastating, but the eleven-year-old Sarah developed a deep and intense bond with lonely widower Michael. Then people started to ask why Sarah didn't look like her dad, and whispered about how Diane appeared to have conceived her while she was away from home, performing in a play in distant Toronto, and having all sorts of racy relationships with men friends, including a very special bond with the dreamily romantic film producer Harry Gulkin.

Polley interviews her siblings and her mother's surviving friends, and these testimonies are often moving and hilarious. But her conversations with Gulkin disclose something more tense. At the time of filming, Gulkin wanted to publish a memoir of Diane. This dismayed Sarah, and evidently at her urging, Michael wrote his own deeply felt reminiscences, and reads passages aloud; we see him doing this in the recording studio, with Sarah directing him, guiding him, asking for retakes. Yet Harry does not get to perform his memoir. This could be to redress the emotional balance in Michael's favour. But Sarah Polley is clearly in a kind of duel with Harry Gulkin, a duel of the nicest possible sort, but a duel nonetheless. And it's a duel that she, as the writer and director of this film, is allowed to win. As far as this story is concerned, she has established her own creative parenthood.

Stories We Tell is a challenging work, with that startling use of reconstructions, which are arguably self-conscious and in questionable taste. But it is compellingly vivid and heartfelt, with a real story to tell. Her gentle and tactful treatment of Michael is moving and the same goes, more subtly, for her approach to the enigmatic Diane. The questions remain. Did Diane find happiness? What was going through her mind when she decided against abortion and to have Sarah after all? What love, whose love, could she have been affirming at that moment of truth? We shall never be certain. Polley's cine-tribute is a gripping and absorbing meditation on the unknowability of other lives.

THE ACT OF KILLING

27/6/13

★★★★★

Indonesia's military coup in 1965 ushered in the rule of General Suharto, after a purge during which about half a million people were slaughtered as alleged "communists" by paramilitaries and mobsters. The memory of this mass murder is reawakened by film-maker Joshua Oppenheimer in a remarkable and at times unwatchably explicit film. It could be a Marat/Sade for our times. Just as Peter Weiss's play imagined the imprisoned Marquis de Sade leading the asylum inmates in a dramatisation of Jean-Paul Marat's assassination, so Oppenheimer has found some of the grinningly unrepentant killers in present-day Indonesia, now grey-haired grandpas, and persuaded them to act out their most atrocious crimes of torture and mayhem in the styles of their favourite movie genres: gangster flicks, Westerns, war movies, musicals. They are only too happy and excited to do it. Oppenheimer gives them more than enough rope to hang themselves.

The murderous bully who stars in this film is Anwar Congo, a racketeer who with his crew ran local cinemas: hence his interest in the movies. He and his associates killed hundreds; now they dress up in various bizarre costumes and helpfully take us through everything they did. Merely re-enacting these violent events is visibly too much for some of the participants playing the victims, who, before our eyes, begin to see what this violence actually meant. Despite or even because of the extravagant absurdity of this nauseous pantomime, the reality of what went on begins to dawn on the perpetrators. It is a gut-churning film: and a radical dive into history, grabbing the past in a way a conventional documentary would not.

CITIZENFOUR

16/10/14

★ ★ ★ ★ ★

This documentary is about that very remarkable man, the former NSA intelligence analyst and whistleblower Edward Snowden, shown here speaking out personally for the first time about all the staggering things governments are doing to our privacy.

Fundamentally, privacy is being abolished — not eroded, not diminished, not encroached upon, but abolished. And being constructed in its place is a colossal digital new Stasi, driven by a creepy intoxication with what is now technically possible, combined with politicians' age-old infatuation with bullying, snooping and creating mountains of bureaucratic prestige for themselves at the expense of the snooped-upon taxpayer.

Yet in spite of the evidence put in the public domain about this — due to Snowden's considerable courage — there has been a bafflingly tepid response from the libertarian right, who have let themselves be bamboozled by the "terrorism" argument. There's also been a worrying placidity from some progressive opinion-formers who appear to assume that social media means we have surrendered our right to privacy. But we haven't.

Laura Poitras's film shows the first extensive interviews with Edward Snowden, conducted in his hotel room in Hong Kong when he first revealed his information to reporter Glenn Greenwald: Snowden contacted him under the handle Citizenfour. Greenwald wrote about it for *Salon*, in his book *No Place to Hide* and for this newspaper. Snowden risked his neck, revealing that despite official statements to the contrary, the US and the UK were widely using their ability to eavesdrop upon every phone call, every email, every internet search, every keystroke. The pre-emptive mining of data has gone beyond suspicion of terrorist activity. As Snowden says: "We are building the biggest weapon for oppression in the history of mankind," and a martial law for intercepting telecommunication is being created by stealth. This is despite the bland denials of every official up to and including President Obama, whose supercilious

claim to have been investigating the issue before the Snowden revelations has been brutally exposed by this film.

Snowden himself seems notably calm and reasonable. Where Julian Assange is mercurial, Snowden is geeky and imperturbable, with a laid-back voice that sounds like that of Seth Rogen. Pressure that would have caused anyone else to crack seems to have have no real effect on Snowden, and he appears unemotional even as he reveals how he had to leave his partner, Lindsay Mills, in the dark. (She is now living with him in Russia, where he is in exile, a country whose own record on civil liberties provide a scalding irony.)

There are moments of white-knuckle paranoia. The interview is interrupted by a continuous alarm bell, Snowden calls down to reception, who tell him it's a routine fire drill. Snowden is satisfied by the explanation, but disconnects the phone in case it is bugged. When he types key passwords into his laptop he covers his head and arms in a bizarre shroud, like an old-fashioned photographer, so he can't be filmed. This is what he calls his "magic mantle of power". It looks absurd, but it isn't precisely melodramatic, and Snowden seems as if he both knows what he is doing and appreciates the absurdity of it all.

Meanwhile, governmental forces are ranged against him – and against ordinary citizens making a stand against snooping. Poitras shows us a scene from a US court case in which AT&T phone customers took action against having their affairs pried into. A sycophantic, bow-tied lawyer for the government tries to suggest that a court is not the proper place to discuss the matter. When a plain-speaking judge rebuked this weasel, I felt like cheering.

So what else can be done? There is a funny moment when *Citizenfour* shows how German chancellor Angela Merkel is far from amused at having her mobile phone conversations listened to by the NSA. It was an exquisite moment of diplomatic *froideur* and possibly did more to make Obama take this seriously than anything else.

Now activists are warning of "linkability". In US cities, subway commuters are being asked to put their transit pass accounts on their actual credit cards. One card fits all, and also gives officialdom access to a whole lot more of your information. British cities are being encouraged to do the same thing with "contactless" cards. Maybe we all need to think again. *Citizenfour* is a gripping record of how our rulers are addicted to gaining more and more power and control over us – if we let them.

AMY

2/7/15

★ ★ ★ ★ ★

When Asif Kapadia's documentary about Amy Winehouse aired at Cannes earlier this year, I was gripped: it is like a seance or a lucid dream. She is brought compellingly, thrillingly back to life. We see all of her loneliness, her anger, her need to give and receive love, her musicianship and creativity, her addictions and her fragility in the face of celebrity.

Like Kapadia's study of Ayrton Senna, it is a docu-collage, here entirely composed of extant TV footage and private home video. It is one of those very rare movies whose star is on screen, in close-up or near close-up, nearly all of the time. She is as commanding as a young Barbra Streisand, sensual, *jolie-laide*, enigmatic, with her exotic and yet somehow refined makeup. A Cleopatra with an asp perennially at the ready.

I wrote about this in May and was then tweeted and DM-ed by Amy's father, Mitch Winehouse, who suggested that the director had failed to represent his own actions fairly, had failed to include people he considered important, and quoted selectively from him, wrongly suggesting that he had a casual and perhaps dangerous attitude to the whole idea of rehab.

Well, a director has to shape his or her material, make judgments, select and omit. Revisiting the film, however, I think that what it suggests about how Amy's fate was shaped by those around her, and about her father personally, is not as clear-cut as Mitch thinks. The question of his own blame is perhaps more potent because of how much he remains in credit, and because of all that she owed him – specifically, as a musical influence: the jazz-lover who inspired her career.

Kapadia's film certainly implies that Mitch was a part of an Amy Winehouse coterie that effectively tried to make any conceivable rehab fit into her lucrative touring and recording schedule. Yet it does not exactly exempt Amy herself. She emerges as driven and

difficult, with a need for adoring courtiers. Kapadia introduces a string of male colleagues described as "friends", and leaves it to us to decide which ones were more than that.

Ultimately, the most culpable figure is surely Amy's husband Blake, who appears to have introduced her to hard drugs and a co-dependent, toxic relationship in which he could never quite get over his own insignificance. Mitch's shortcomings have a poignant, well-meaning quality that makes him more memorable than Blake – especially when he finally appears to be trying to launch a reality TV career on the back of his daughter's fame. Mitch's melancholy presence is part of what makes the film so moving.

It is an intimate and passionate tribute, tracing the awful trajectory of her celebrity destiny – the takeoff from the cliff edge – and responding to the mystery of Winehouse's voice. Her switch from the sound of streetwise north London in everyday speech to a rich, textured, Sarah Vaughan-type singing voice is stunning, like some benign version of The Exorcist. Jonathan Ross is shown congratulating her on being "common" and his identifying the elephant in the room is to the point, although the film doesn't press the point of how that voice just surged up.

Her face radiates wit and life. The moment in which she visibly twitches with boredom and irritation while an interviewer asks her about Dido is superb, as is her tragically disconnected response to the news of a major award. She couldn't enjoy it properly, she confessed, because she was not on drugs.

Perhaps inevitably, it is the song *Rehab* that is the kernel of the film's power, a personal and musical moment of destiny. Cinema and showbusiness are obsessed with the comeback and the second chance, and maybe if she had lived, Amy would have recorded *Redemp*. At any rate, *Rehab* was the result of almost diabolic inspiration and self-mythology, which triggered the supernova of fame. The idea of refusing rehab was a challenge to the hypocrisy and brutality of a celeb-industry that slavers spitefully over famous people being punished for their gilded lives by being unhappy.

But the nuance of the song was lost, and it simply looked like Amy Winehouse's USP: not going into rehab, devoted to excess.

Her addictive personality and vulnerabilities reacted badly to the attention, and the Klieg light of super-celebrity was blinding.

Like *Titanic*, we know the ending, and yet it doesn't make it any less harrowing. There is a genuinely tragic depth to this film. It shows with pitiless clarity how Amy Winehouse was approaching a fate that everyone could see and no one could do anything about.

A SYRIAN LOVE STORY

17/9/15

★★★★★

Sean McAllister's documentary about a family of Syrian refugees
in Europe would be compelling at any time. Now it is unmissable.
This is about love, but it could as well be called *A Syrian Rage Story*
or *A Syrian Despair Story*. It is the tragic portrait of a disintegrating
marriage; the story of two people whose love has been hammered
by fate, history and each other.

These are not refugees as we are encouraged to understand them
by the nightly news: nameless poor people to whom the prosperous
West can respond with pity or guilt. These refugees don't want to be
passive recipients of compassion, but active participants in their own
destiny. Above all, they are angry. Their anger floods the screen.

McAllister begins his story in 2009, when Syria was being
marketed to Westerners as a glamorous, cosmopolitan new tourist
destination with ancient culture and monuments as important as
anything in Greece and Turkey. And so McAllister begins his movie
with a brutal twist of irony, a subliminal flash-forward to a later
reality in which our certainties about the Arab spring have been
overtaken by the existence of Islamic State. In the capital Damascus,
McAllister meets Amer Douad, a Palestinian activist from the coastal
town of Tartus who has a heart-rending story to tell. While in prison,
Amer fell in love with a fellow inmate, Ragdha Hassan, a beautiful
left wing Syrian activist against the Assad regime. Now they have
three children: Shadi, Kaka and Bob, but she is back in prison and
Amer must raise them on his own. McAllister is present with his
camera as day by day, week by week, Amer and the children lavish
their love on the idea of an absent wife and mother. When Ragdha
is finally freed, their joy is overwhelming.

But then McAllister is briefly imprisoned by the regime; his
friendship makes Amer and Ragdha's position in Syria untenable.
They move, first to the Palestinian enclave of Yarmouk camp, outside
Damascus, then to Lebanon, and finally to Paris, having been granted
refugee status by the French government. But their marriage is

coming apart and McAllister records its breakdown from 2009 to the present.

Raghda is suffering from post-traumatic stress at her brutal jail treatment; she is pierced with guilt at having effectively deserted her comrades' struggle against Assad, and at becoming an irrelevance herself, washed up on a far shore away from a battle she considers crucial to her identity. Ragdha becomes filled with resentment and depression, and McAllister's camera captures the way her face, once alight with beauty and fun, becomes clouded and pained. Amer's face, too, becomes older: hunted, almost furtive, a man with secrets. The film allows us to consider the awful thought that the couple were happiest apart, when they had only the tragically exalted idea of each other. Love depended on prison. Now he accuses her of being impossible to live with, of being arrogant and simply nettled at her own loss of status. Amer's love curdles into machismo as he demands Ragdha attend to the duties of motherhood. There are walkouts from the family home, suicide attempts and accusations of infidelity.

Incredibly, McAllister was there for a great deal of this. The scenes look real enough. It takes its toll on the children, although their son Kaka emerges as exceptionally perceptive and smart. As a little boy in Syria, he is asked by McAllister about the Assad tyranny: "Does it make you want to leave? Live somewhere else?" He replies: "No, fight." His views as a teenager in Paris are very different. As for Amer, he begins by speaking to McAllister about Ragdha like this: "She is a strong woman; I am a very weak man."

Perhaps he has foretold their destiny. But the heartwrenching thing is that her strength and his weakness – as he perceives it – might not have been a problem, had they been able to stay in Syria. Who can tell? It could have been the agony of Syria that destroyed their relationship, or it might have fallen apart in any case. McAllister and his camera might have accelerated the breakdown, though it is just as likely he provided valuable therapy. Even at the end, Amer and Ragdha clearly have feelings for each other. This is love among the ruins.

TAXI TEHRAN

29/10/15

★ ★ ★ ★ ☆

Jafar Panahi is the Iranian film-maker and democracy campaigner facing official harassment with unique wit, grace and humanity – all apparent in his new movie *Taxi Tehran*, whose quietly defiant good humour and charm will grow on you, as they grew on me when I first saw it in Berlin earlier this year. It is engaging and disarming: a freewheeling semi-improv piece of guerrilla film-making, cleverly staged and choreographed, with the discursive, digressive qualities of an essay film.

In 2010, following his protests against President Ahmadinejad's democratic legitimacy, Panahi was sentenced to six years' house arrest on the spurious charge of crimes against the state, together with a twenty-year ban on film-making and leaving the country. Yet he has continued to work, shooting films covertly on smartphones and camcorders, smuggling them out of the country as digital files, technically avoiding the ban by having his direction credited to other people, or – as with this one – no credits at all.

Once these complex and subtle films appear abroad, Panahi leaves it to Iranian officialdom to react or not as it wishes, and as far as can be judged, the authorities do not want to appear any more foolish and ham-fisted than they do now. At any rate, the appearance of each of Panahi's films is now almost a kind of procedural miracle, not seen since Yilmaz Güney directed the 1982 Palme d'Or-winner *Yol* from prison.

Panahi appears as himself: reduced to driving a cab. The great film director is now a humble taxi driver picking people up on the streets of Tehran, dropping them off, amiably allowing customers to share a ride, sheepishly admitting he doesn't know where anything is, and never asking for money. If Uber had a special app for hailing free rides from cineastes … well, that would be him. He's a fictional variant of himself, shooting a zany ridealong selfie on his dashboard-mounted videocam. Or maybe he's Iran's equivalent of Larry David, shruggingly accepting his own woes and his own tense celebrity and spinning it all into his creative work.

He has a bizarre mix of clientele. A couple of women get in with some live goldfish in a bowl, leading to predictable disaster when Jafar hits the brakes too hard and winds up having to replenish the bowl with water he would normally use for the radiator. He takes a gravely injured, blood-spattered man and his keening wife to hospital. There is an aggressive young guy who starts arguing with a fellow passenger about whether hanging thieves is a good deterrent.

Panahi allows that argument to echo with a conversation he has later with a friend who has been attacked in his shop, apparently for standing up for a man and woman caught stealing money. In this way, the questions of crime and punishment are coolly, indirectly raised.

Panahi has to pick his niece up from school. She is mortified that her supposedly prestigious film-director uncle only has this nasty little car. She is studying film, and the precocious tyke starts talking about what's "distributable" and tells him how she has been told to avoid "sordid realism". Panahi smiles enigmatically: he knows how much sordid realism to avoid. Another young guy studying film asks him about existing works and Panahi says: "Those films are already made; those books are already written. You have to look elsewhere ..."

Perhaps an unemployed director is like a taxi driver, cruising the streets, looking to pick up ideas, but benignly: an anti-Travis Bickle, and perhaps being under house-arrest feels like being a driver unable to leave his cab. Certainly, shooting a film inside a car is discreet, and good for evading bans. Abbas Kiarostami has also used the car as a symbol of imprisonment, aimlessness and loneliness in films such as *Ten* (2002) and *Taste of Cherry* (1997).

Taxi Tehran comes to two separate crunches. Panahi picks up a friend who is a lawyer, disbarred and prevented, like Panahi, from practising her trade. They discuss the case of Ghoncheh Ghavami, the Iranian woman jailed for trying to attend a men's volleyball match. Panahi maintains a smilingly fatalistic attitude to it all. Later, Panahi's feisty niece starts making a short film for her school project; she accidentally films a boy taking money that isn't his and dramatically intervenes in the situation. Panahi is maybe playfully showing the authorities that film-making is a force for good.

Taxi Tehran is the work of a unique director – and survivor.

HOMO SAPIENS

21/11/16

★ ★ ★ ★ ★

If the spirit of Stanley Kubrick lives in any current film-maker, it is surely the Austrian director Nikolaus Geyrhalter, whose 2008 documentary *Our Daily Bread* was a chilling study of mechanised food production and animal slaughter. Now he has created a visually extraordinary film composed simply of long, static shots of abandoned human constructions: theatres, hospitals, swimming pools, malls, railway stations, entire apartment complexes. He has found images from all over the world, including Fukushima and Nagasaki in Japan.

This simple, eerie succession of images is as gripping as any of the sci-fi thrillers or post-apocalyptic dramas that would normally use scenes like these as establishing shots. At first, I almost expected to see a group of armed YAs blunder into the wrecked streetscape of mossy, overgrown buildings.

Geyrhalter goes beyond ruin porn to a sustained meditation on the post-human state; his film is perhaps inspired by Claude Lévi-Strauss's remark: "The world began without man, and it will complete itself without him."

Homo sapiens is conspicuous by its absence – there are no human beings visible – or rather by the stunningly fragile, impermanent and weirdly irrelevant constructs which, without their human use, look like mysterious, surreal sculptures or giant machinery left here by aliens. Each image is a Stonehenge of strangeness, especially Geyrhalter's showstopper: the rollercoaster which is now partly immersed in the sea. There is also an incredible interior, apparently a cave, filled with wrecked cars.

Sometimes you can only work out what it is you are looking at by trying to find signage. One shot, taken from a high vantage point, perhaps an encircling galleried walkway, shows a floor filled with fixed seating surrounded by bulbous, hulking booths. A tiny sign to the left of the image says "Duty free shopping"; it is an airport departure lounge. "There's nothing emptier than an empty swimming pool," said Raymond Chandler, and there is one here,

which I identified on seeing the weird overhead tube, realising it was a flume. There was a vast hall with dangling metal objects like baskets that baffled me entirely.

One shot showed railway lines with weeds growing over them. Another showed the process at a more advanced stage: straight ley-lines of dense green vegetation receding to the horizon. Geyrhalter favours these straight, rectilinear shots, a composition which emphasises the distance and alienation, almost like a surveyor's picture.

The sound is doubly strange. Without humanity's noise pollution of cars, planes, machinery and amplified music, the quiet is stunning, although not peaceful. There is the blank chirp of birdsong. Some pigeons flap about occasionally – the only visible life form. Mostly there is dripping. It seems very often to be raining. Holes are letting the rain into these places, most strikingly in an office space where computer mainframes are being stored (which, incidentally, is what the "cloud" is) and now, of course, ruined. The erosion process has begun, and stalagmites are in the making.

Homo Sapiens has a kind of fictional dimension: Geyrhalter has put together images that together show what the humanless future could look like. (Perhaps there were bathetic moments in filming when a hapless bloke in a hard hat and hi-vis jacket blundered into shot and the director had to shout "cut".) It is a little like the speculative, eco-futurist work *The World Without Us* by Alan Weisman, who is thanked in the closing credits. For its sheer visual exaltation, this is the most extraordinary documentary I have seen in years.

The films that made me reflect on childhood, mine and other people's

Rightly or wrongly, when I think about films for children, and films about childhood, mine and other people's, I think about animation. Of course there are great animators whose work is not intended for children, like Walerian Borowczyk or Jan Švankmajer and now Wes Anderson. But animation was the first way I experienced onscreen entertainment – in the form of cartoons: vivid, fierce, brilliant cartoons which delivered comedy, characterisation and storytelling thrills straight into my prepubescent veins. Cartoons meant the sensationally exciting and funny *Bugs Bunny* during the day and *Tom and Jerry* just before the early evening news on Saturday nights, an intensely traditional but forgotten British activity, like getting milk delivered in glass bottles. And we got our cartoons in black and white on our ancient TV. So animations in colour, and on the cinema big screen, properly blew my tiny mind.

What was the first film I ever saw in the cinema? Like deciding on your earliest memory, this is actually a tricky thing to retrieve, but I am as sure as I can be that it was Walt Disney's *The Jungle Book* in the Odeon in Watford High Street (unlike most cinemas of my childhood, that one is actually still there). I would have been about six or seven years old, sitting there with my mum and my sister, Sarah, saucer-eyed, open-mouthed, mechanically and frantically filling my face with sweets (though not popcorn, actually), like an engine driver shovelling coal as if this was part of the process that powered the ongoing cinema process.

My first memory of being scared and transported in the cinema was in fact the sight of the constrictor snake Kaa's mesmeric and creepy eyes in extreme close up as he begins to subject Mowgli to his wicked mental powers. It wasn't simply that this face was overpoweringly scary: I remembered thinking that Kaa's eyes were somehow the largest single intelligible objects that I had ever seen in my life. Those sharp, clear, blocks of colour were a U-certificate acid trip. And that extraordinary ending, when Mowgli sees the Indian girl and forsakes his animal pals, a remarkable premonition of sexual maturity. It left me unsettled for months afterwards.

The first film my son Dominic ever saw, with me, was *Ratatouille* – an excellent film, though I don't think it can really have had the same overwhelming impact. Today, the moving image is more commonplace, and the cinematic experience is more ubiquitous and various.

The cinema screen itself was profoundly mysterious to me: that vast shimmering wall of images. I knew in my heart that it was a plain wall onto which the pictures were projected. But I was fascinated – especially by the apron-space that was placed around the screen, a *cordon sanitaire* that separated it from the front row of seats. I remember thinking as a child that if I placed my hand onto a screen while the film was in process, my hand would move through that picture plane and into the action itself. And this was before I knew *Alice Through the Looking Glass*. I thought of my hand immersed in those pools and its rainbow flooding my field of vision, the colour bleeding into my hands.

SHREK

29/6/01

★ ★ ★ ★ ★

There was a time when swearing was a big no-no in films from the squeaky-clean DreamWorks stable. But then we had "cunt" in *American Beauty*, and now, in *Shrek*, their glucose-enriched computer animation comedy for all the family, we have "fuckwad". That is: the evil Lord Farquaad, who banishes all fairy tale characters from his kingdom, and the purpose of whose odd name can only be to contain that single entendre. It's hardly a pointer to the rest of the movie's tone; in fact it's a measure of *Shrek's* uproarious wholesomeness that it almost gets away with the sheer effrontery of that gag without anyone noticing.

Shrek itself is the name of a big, green, cantankerous ogre voiced by Mike Myers in a slightly scaled-down version of his "Fat Bastard" Scottish accent. And that name has a Germanic, Grimm brothers feel: *schreck*, horror; or perhaps the kiddie phrase *Schreckbild*, or bogey man. Either way, he's a horrible, giant, oafish creature who stomps crossly about in a kind of medieval jerkin, terrifying the local villagers and doing gross things like removing a great conical plug of wax from his ear to serve as a candle.

But Shrek's grumpy solitude is invaded when the autocratic Farquaad decrees that all fairytale creatures – dwarves, blind mice, mendacious wooden boys with growing noses, the lot – should be herded into a holding camp that happens to be Shrek's back garden. Farquaad offers to remove them if Shrek helps him with his love life. The ogre must journey forth and bring back the beauteous Princess Fiona – whose Waspy name is in evident contradistinction to Shrek's central European handle – for Farquaad to marry. In addition to this burden, Shrek has to endure the companionship of a feisty talking donkey, brilliantly voiced by Eddie Murphy in a very similar role to the character he played in the Disney cartoon, *Mulan*. Fiona's ineffably blonde and patrician tones are courtesy of Cameron Diaz, and the villainous Farquaad is John Lithgow, whose vocal characterisation is somewhere between Kelsey Grammer and Alan Rickman.

All these people get unprecedented star billing on the posters and opening credits. It's a very long way from, say, George Sanders as Shere Khan in Disney's *The Jungle Book*, whose contribution was acknowledged in vanishingly small type at the end – a convention which has held firm until now. Does cranking up the star factor in this way mean an increase in status and prestige for the animation genre?

Possibly. At any rate, Andrew Adamson and Vicky Jenson's film contains some breath-taking state-of-the-art computer animation, with every blade of grass in the meadow and every donkey hair lovingly distinguished. This film is more lively, more sparky, and indeed more animated than Disney's ponderous *Dinosaur* – and the better craftsmanship here consequently does more comic and dramatic work.

But the comparison with the *Toy Story* movies can't be avoided, and here *Shrek* inevitably suffers. Perhaps that is unfair: hardly any film measures up. *The Toy Stories* were dazzlingly daring, playfully self-referential, and had genuinely moving moments. *Shrek* cannot match them. In fact, its animation, like its storyline, is developed in a much more conservative direction. *Toy Story* foregrounded the fact that its animated protagonists were toys – doubly unreal, their clothes, skin tone and facial expressions were vividly unnatural. They were found behind cellophane, or as simulacra of themselves in computer games, or in a bizarre landscape of Brobdingnagian domestic items: huge chairs and tables, and carpets in which each nylon whorl was visible. The animation made sport with the sheer fantastical unreality of it all.

But Shrek, Donkey, Fiona and Farquaad inhabit not a zany, fractured unreality, more a kind of unitary hyper-real universe that could be approximated far more easily in ordinary live action movies. The great rolling fields that Shrek crosses reminded me of the road to Oz, or even the grasslands of TV's *Teletubbies*. And the actual faces of human beings – Farquaad, Fiona, the villagers and courtiers – were disappointingly ordinary looking and unexpressive, almost like claymation figures.

Set against that, though, is the pzazz of the story and a very nice script from Ted Elliott, Terry Rossio, Joe Stillman and Roger Schulman. Not a minute goes by without a happy invention or

a laugh line of some kind. My favourite was Farquaad torturing information out of a gingerbread man that he has chained to a table after breaking off its legs. "You can't catch me, I'm the gingerbread man," he sneers cruelly. And there is a terrific romantic sequence where Shrek and Fiona stroll through a meadow, having inflated a toad and a snake as balloons, to the sound of "My Beloved Monster" by the Eels. Shrek may not have the class of Buzz Lightyear, but he's a lovable great lunk, and you could do a lot worse this summer than see this.

SPIRITED AWAY

12/9/03

★ ★ ★ ★ ★

Magical is a word used casually about films like this, films about
fantasy and childhood. Yet this one really does deserve it: an enchanted
and enchanting feature from the Japanese animator Hayao Miyazaki
which left me feeling lighter than air. It is a beautifully drawn and
wonderfully composed work of art – really, no other description will
do – which takes us on a rocket-fuelled flight of fancy, with tenderly
and shrewdly conceived characters on board.

Before this movie, I was agnostic about Miyazaki and his world-
renowned Ghibli studio; I couldn't join in the mass hollering of
superlatives that greeted the release of his *Princess Mononoke* last
year. That was striking and distinctive, but I found the kaleidoscope
of visual images oddly depthless and psychologically uninvolving
and the Japanimated moppet faces an acquired taste. Even now, my
euphoria after seeing *Spirited Away* is soured a smidgen by reading
comments by some of its more supercilious cheerleaders, who affect
to adore it at the expense of "America" and "Disney": thus fatuously
denigrating a great animation tradition to which Miyazaki is patently,
and honourably indebted.

There are actually many Western influences and resemblances:
Homer's *Odyssey*, Lewis Carroll, L. Frank Baum and maybe even
The Secret Garden by Frances Hodgson Burnett. But it's undoubtedly
in a class and genre of its own: its alien, exotic qualities, all the more
intense for a non-Japanese audience, are part of how extraordinarily
pleasurable it is to watch.

Miyazaki begins with a very real picture of family life: a mother
and father in the front of their gleaming Audi saloon – daddy
gloats over his vehicle's four-wheel drive – are heading for a new
home in the provinces. In the back, hunched and scowling, is little
ten-year-old Chihiro, utterly miserable about leaving behind all
her friends. An only child, whose hurt feelings are treated fairly
brusquely by these well-to-do professional parents, Chihiro is
scared by the feelings of loneliness that are creeping up on her.

Forlornly, she clutches a dying bunch of flowers she has apparently been given as a farewell gift by her old friends, and is overwhelmed with grief and despair. "My first bouquet – and it's spoiled," she moans, discomfiting her parents with this precocious sense of her future, adult prerogatives.

Chihiro's family gets lost in a strange, secluded woodland. They park the car, and walk through a tunnel carved in a red sandstone edifice to emerge in what the father airily announces must be a deserted theme park. Chihiro watches in horror as they then tuck in to a buffet mysteriously laid out for them and turn into a couple of fat, slobbering pigs; Chihiro finds herself a wanted human fugitive in a divine bathhouse-cum-recreation-zone: "a place where eight million gods come to rest their bones". The crone priestess and proprietress of this psychedelic R'n'R area is Yubabu, whose employees must all sycophantically greet their god-customers: magnificent creatures of all shapes and sizes. She is obliged, according to her own rules, to tolerate Chihiro as long as she is prepared to do useful work. So she is made to scrub out a huge tub, preparing for the arrival of a noisome slime-monster, a Jabba the Hut lookalike. In all this, Chihiro is helped by her only friend, a slightly older boy called Haku; it is he who must teach her how to survive and restore her parents to human form.

There is just so much going on in this story that it's impossible to sum up. But it had me utterly involved from the very start, and that's down to the mind-bogglingly superb animation that, for me, had a human and psychologically acute element to add to the expected dimension of hallucinatory fantasy. It's this that makes the claim of "masterpiece" so plausible – that, and the wit, playfulness and charm that Miyazaki mixes into the proceedings.

Spirited Away is the result of organic, non-GM animation: everything is hand-drawn before being digitalised. Yet it has a dazzling quality that I have come to associate solely with the new generation of animators and FX stylists, a fleetness and lightness in the way it switches from the close-up on a deft little sight gag or a sweet character observation, sweeping out for a breath-taking panorama of an extraterrestrial landscape imagined with passionate detail and specificity. I can't think of a film that is so readily able to astonish and wears that ability so lightly and insouciantly.

Spirited Away couldn't be more different from, say, *Shrek* – another masterpiece that Ghibli enthusiasts patronise at their peril – and yet the out-of-this-world visual inventions of *Spirited Away* have the same gasp-inducing quality, but achieved without its hi-tech sheen and glitz. The scenes of Yubabu's palace complex seen at dusk across water, at sunrise through the mist, or in moonlight or sunlight made me purr with pleasure. And the compositions of Miyazaki's scenes in a bright flower garden are sublime in their forthright, untarnished innocence.

This remarkable film – finally released here two years after it was made – first entranced European audiences at the Berlin film festival. It is available in two versions: the Japanese original with subtitles, or, if you really want, dubbed with American voices. To those who prefer a dubbed version, I can only say that like screwtop wine, it might turn out to be all right. But why compromise the pleasure of this film with an error of taste as silly as that? *Spirited Away* is fast and funny; it's weird and wonderful. Mostly wonderful.

PERSEPOLIS

25/4/08

★ ★ ★ ★ ☆

Here is an adaptation so inspired, so simple and so frictionless in its transformation of the source material that it's almost a miracle. When I tell people it's a lo-fi animation, largely in black and white, about Iran, they put their heads in their hands and make a low groaning sound. But I've seen those same people bounce happily out of the cinema after seeing it as if they had had some sort of caffeine injection.

Superbly elegant and simple, it is based on the comic-book series by the Franco-Iranian artist Marjane Satrapi, a coming-of-age story that I can only describe as an auto-graphic-novel-ography. Satrapi has co-written and co-directed the movie version, and what a treat: funny and moving with a bracingly authentic feel, reproducing the graphic work with broad, bold strokes and a depth-of-field effect achieved with a recessive series of two-dimensional planes, like the ocean waves at the back of a panto set. Muted colour tones are introduced for sequences happening in the present, and deploying the cartoonist's classic skill, Satrapi creates witty and sympathetic facial expressions with hardly more than a squiggle. This is one of those rare things in the cinema: a movie with an urgent new story to tell and an urgent new way of telling it.

It is the story of Marjane as a little girl growing up in pre-revolutionary Iran in the 1970s. Her hero is Bruce Lee, and she is always scampering under the grown-ups' legs at parties, baffling one and all by striking ferocious martial arts poses. She is the indulged and adored daughter of well-to-do secular leftists who campaign ceaselessly against the Shah, and find family members harassed and imprisoned. When the revolution arrives, Marjane's parents and their cigarette-smoking, alcohol-drinking, idea-discussing and life-enjoying friends at first welcome it. The fanatical theocrats make them nervous, but they are confident that all this is just a phase on the road to progressive enlightenment. But they find that the Islamic state is here to stay. And there is one group it hates most of all: women.

Marjane herself, particularly as a little girl, is a superb character, smart, vulnerable, with a cheerful, non-PC love of Western trash culture. She has something of Lisa Simpson and a little more of *Peanuts'* Lucy van Pelt, but with a seriousness and a single-mindedness that is all her own. She is close to her mother, closer still to her wise and worldly grandmother, whose wit and shrewdness she imbibes. Hers is a funny and deeply involving story but its sharp stabs against the women-hatred of the Iranian governing classes are enough to trigger rage.

The streets are patrolled by a swaggering cadre of morality police. One barks at Marjane's hard-working and modest mother, as she is getting her daughter into the car: "Fix your scarf, sister!" – that is, pull it even more tightly and meekly around your head. When her mother mildly protests, he screams in her face: "I fuck whores like you and throw them in the trash." It is a shocking moment, and has every sign of being based on the exact truth. The movie's most agonising moment comes when Marjane confesses to her grandmother a shaming episode of collaboration with the oppressor. Fearing that she would be pulled up by these morality street cops for wearing lipstick and makeup, she pre-emptively diverts them by claiming that a man was ogling her – an entirely innocent bystander who was then dragged off for questioning. This shaming, absurd, petty episode makes the Iranian state look like a Soviet tyranny.

As she grows into her teens and twenties, Marjane is sent abroad for a chaotic education in Europe, where she experiences the finest condescension and misogyny that the West has to offer: in fact, something of the exploitation inherent in sexual-liberalism that the mullahs warned her about, while not scrupling themselves to enforce a far harsher subjection. In spite of herself, Marjane finds a gravitational pull to a homeland that rejects free-thinking women: a complicated, bittersweet sense of exile which Satrapi has cultivated in her graphic novels and in this richly seductive and entertaining movie.

Persepolis gives us the sheer pleasure of narrative, rarely found in modern cinema or indeed fiction: a gripping story of what it is like to grow from a lonely imaginative child into an adult, and to find this internal tumult matched by geo-political upheaval.

My only disappointment with the UK release is that it is being shown here in the English-dubbed version. Chiara Mastroianni voices Marjane and Catherine Deneuve the mother, speaking in heavily accented English. But Danielle Darrieux's original voice performance as the grandmother has been replaced by Gena Rowlands – perfectly good, though this version in general loses some of the flavour of the French original. My only other tiny worry is that the presence of an American producer – veteran Spielberg associate Kathleen Kennedy – might get the movie suspected in some quarters of anti-Iranian propaganda. But Persepolis is too complex for that, too entertaining, and too robustly alive.

TOY STORY 3

15/7/10

★ ★ ★ ★ ☆

Nothing deserves its U certificate less than this: *Toy Story 3* is a brutally adult movie with brutally adult themes: the origin of evil in childhood pain, the death of childhood and, well, just death. There are scary villains and intensely, unbearably sad moments. Earlier this year, I wrote here, online, about how having a child of my own opened my eyes to the true and terrible meaning of the *Toy Story* movies, and particularly cowgirl Jessie's heartrending song "When She Loved Me" in *Toy Story 2*, describing how her mistress gradually fell out of love with her as she became a teenager.

Before I became a parent, I had vaguely thought that song was a parable for the child's fear of abandonment. Watching it recently again as a dad, I experienced something between an epiphany and a nervous breakdown. Like the theologian crazed by his theory of the New Testament in Borges's short story "Three Versions of Judas", I was gibberingly convinced that I, and I alone, understood the real meaning of the *Toy Stories*; John Lasseter had spoken directly to me. We, the adults, are the toys. One day, our children will get bored playing with us. They won't want to be cuddled by us; they won't want to confide in us; they will go away and leave us. It will never be the same again. The toys in *Toy Story 3* are sent away to a daycare centre where they are victimised and mistreated – just like the infantilised inmates of an old people's home.

TS3 undoubtedly takes its cue from *TS2*'s gloomy visions of mortality and obsolescence, and amplifies them in ways that, though not as brilliant and novel as the second movie, are tremendously inventive and, yes, powerfully sad. The melancholy that was largely compressed into "When She Loved Me" is now diffused throughout the film, but it is still superb, and the opening sequence is as thrilling, funny and visually gorgeous as anything in the Pixar canon.

We join the story as Andy, seventeen, is about to go up to college. Sentimentally loyal to his boyhood self, he intends to take Woody (voiced by Tom Hanks) with him as a mascot and store the rest,

including Buzz (Tim Allen) in the attic – but a mixup means they all get taken to a daycare centre. At first delighted by the prospect of playing with real kids once more, the gang find the roost is ruled by an evil bully: the insidiously cute Lotso-Huggin' Bear, voiced by Ned Beatty, who turns the centre into a jail like the one in *Cool Hand Luke*. He has a horror-movie-style sidekick in the form of Big Baby, a chilling, dead-eyed enforcer.

The humour, the drama, everything in the film seems targeted more at the parents than the children: certainly those cheeky hints at the metrosexual proclivities of Barbie's true love, Ken, with his scarf and blow-dried hair. That said, it's an effortlessly superior family movie. We grown-ups, however, may have to gulp back our tears and somehow keep it together in front of the kids: just like the toys who revert to blank grins when their owners come back into the bedroom.

THE ILLUSIONIST

19/8/10

★ ★ ★ ★ ★

This movie by the French film-maker Sylvain Chomet is an act of homage and an act of cinematic love: a classically conceived, hand-drawn animation based on an unproduced script by Jacques Tati, written in 1956: a manuscript evidently guarded for more than fifty years by his family, and particularly his daughter Sophie, until Chomet begged for permission to adapt it, with a new British setting. The result is utterly distinctive and beguiling, with its own language and grammar of innocence: gentle, affectionate, whimsical, but deeply felt and with an arrowhead of emotional pain. I think it will be admired and loved as much as Hayao Miyazaki's *Spirited Away* was ten years ago.

The Illusionist is a semi-silent movie, with rudimentary, mumbled fragments of dialogue, about an old-fashioned variety-turn conjuror at the end of the 1950s, specialising in rabbits and hats, paper flowers and coins. He presents each creaky trick with a deadpan fastidious flourish and a raised forefinger, like a distracted *sommelier* in an empty restaurant.

Lack of work forces him to leave France for England, from where he heads north and acquires a companion, a girl from rural Scotland, who shares tatty theatrical digs with him as a daughter-figure – or is it that he is her "uncle"? – heartbreakingly dazzled by the dusty, faded showbiz glamour that everyone else finds so *passé*, or perhaps actually believing in the illusions themselves. It is in Edinburgh, where the movie winds up, that the illusionist becomes disillusioned, but brings off an authentic act of human magic.

Simply being an animation, and an old-style animation, is a great effect. *The Illusionist* is like a seance that brings to life scenes from the 1950s with eerie directness, in a way that glitzy digital animation or live-action period location work could somehow never do. Something in the unassuming simplicity of the composition allows the viewer to engage directly with the world being conjured up. This is, after all, a film for which the 1950s is the present-day. The

visions of the old King's Cross railway station in London, or the old boat-train, or Edinburgh with its lonely seaside-cry of seagulls, are all weirdly like a remembered dream of a fictional childhood. Everything is paradoxically, vividly present.

And animation allows the Illusionist to be Tati himself, a decision which seems audacious, while being arguably at the same time inevitable. That unmistakable figure, all elbows, chin, nose and great unwieldy backside, suggests someone between middle-aged and old, and yet also like a gawky, maladroit teenager or hopeless boy. He looks heavy-set and yet agile and eccentrically graceful, as if persistently rising on tiptoe: the Tati-Illusionist has something of Hugh Dalton's description of Charles de Gaulle: "A head like a pineapple and hips like a woman."

Leaving his native France, an innocent abroad, he gets work coming on after one of the new super-cool pop groups, Billy Boy and the Britoons (do I sense a Gallic disdain for Anglo-Saxon youth culture in that name?). Chomet shows how excruciatingly obsolete our hero has become, waiting politely in the wings as Billy Boy and the band do encore after preening encore for screaming teens who are clearly going to loathe his quaint act. (Lulu is also on the bill, incidentally, but sadly we never see her on screen.)

Later, we glimpse a headline outside a newsagent to the effect that Billy Boy and the Britoons have been involved in a "scandal" and Chomet elegantly leaves it to us to wonder … a Mick Jagger scandal? A John Gielgud scandal? Billy Boy is still in work, though not a massive star.

The Illusionist gets an awful gig at some sub-Glyndebourne summer party, where a very drunk man in a kilt books him to play his pub in the Scottish Highlands, and it is here that the starstruck girl tags along, running away from home to join him in Edinburgh. The scenario is swathed in innocence. The girl's family are evidently relaxed or fatalistic enough not to pursue her, and there is no question of the Illusionist's intentions being anything other than honourable: he is tender and protective, buying new dresses for his *protégée*, and without either man or girl fully realising it, she begins, shyly, to blossom.

Piercingly well-observed details are everywhere: the tiling around a hissing old gas fire, the test card playing on the TVs in the shop

window, a woman's crucifix matching the cross on her Bible in the train compartment. Whole interior scenes will play solely to the sound of shoes and boots squeaking and creaking across floorboards. In case we thought the movie was too sugary, we see a gang of short-trousered boys booting an unconscious tramp. Yet when Chomet's animated "camera" takes off for a swirling, overhead shot of a lovingly realised Edinburgh, the effect is dashing, breath-taking, even weirdly moving.

Admittedly, one has to adjust to the gentle, undemanding pace of this movie, which does not force its insights and meanings but allows them to meander into view, a pace which suddenly jolts into a higher gear when Chomet and Tati show us how the Illusionist loses his faith in his vocation. There is something shocking in the way he deliberately, angrily sabotages a trick with short and long pencils, thus upsetting and bewildering a little boy. But the real magic, the magic he has created, is happening behind his back, and under our noses. *The Illusionist* is an intricate jewel.

FROZEN

5/12/13

★ ★ ★ ★ ☆

This movie is no guilty pleasure, but an entirely innocent one. *Frozen* is an animated fairytale musical in the classic Disney manner, a new twist on Hans Christian Andersen's "The Snow Queen".

It's a slap-up Christmas treat, a wide-eyed charmer of a film with terrific musical numbers from Kristen Anderson-Lopez and Robert Lopez (who worked on *The Book of Mormon* and *Avenue Q*); there are lovable characters and a robust, satisfying story with a big heart and a neat twist. Elsa, voiced by Idina Menzel, is the princess of an ancient kingdom, endowed with the magical power to create ice and snow. Having to conceal this dangerous talent causes her great loneliness; she is finally exiled on suspicion of witchcraft, but her devoted sister Anna, voiced by Kristen Bell, goes on an epic search to find her – and perhaps to find love. The spectacle is great and the song lyrics are a joy ("Are you holding back your fondness/ Due to his unnatural blondness?") Elsa's gaunt, strained appearance at her coronation scene put me pleasantly in mind of Cate Blanchett in *Elizabeth*, and her supernatural powers are the most impressive since Frozone in *The Incredibles*. Cheesy critical metaphors are hard to avoid: with such warmth within its icy landscape, this is a celluloid baked alaska. It is glorious family entertainment.

WHEN MARNIE WAS THERE

9/6/16

★ ★ ★ ★ ☆

This lovely animation from 2014 was Studio Ghibli's last film before its self-imposed hiatus following the retirement of founder Hayao Miyazaki. It is another example of Ghibli's Anglophilia: a prominent and under-analysed part of its identity. Like other Ghibli films such as *Howl's Moving Castle* and *Arrietty*, the movie is taken from a classic English children's book, this time Joan Robinson's Norfolk fantasy adventure from 1967. Clearly the studio responds to a certain kind of heartfelt, un-ironic writing for children. The film shifts the setting to a Japanese coastal town, where a lonely and troubled foster child, Anna, has been sent to stay with relatives. She grows fascinated with an apparently deserted mansion, where she befriends a mysterious Western blonde girl of her own age called Marnie – very rich, but every bit as unhappy as Anna. Is Marnie a ghost? A hallucination? A projection of Anna's own longings? The gentle, unforced charm of the animation feels like the very best of book illustration come to miraculous life, but with a strong, almost Hitchcockian streak of excitement and danger.

The films that made me ponder my suitability for Lycra

If you were to ask me to choose the single most extraordinary scene in any film I've watched in the last few years, I well might pause and brood about all those great movies by the masters of world cinema, all those films I have savoured in darkened rooms all over London's West End. Paul Thomas Anderson's *Inherent Vice* ... Andrey Zvyagintsev's *Leviathan* ... Kathryn Bigelow's *The Hurt Locker* ... Roy Andersson's *A Pigeon Sat on a Branch Reflecting on Existence* ... Martin Scorsese's *The Wolf of Wall Street*. Great films. But what is the scene that I will, in an idle moment – when I am supposed to be working – call up on YouTube and watch on my laptop again and again while munching Doritos?

It is the now legendary Quicksilver scene in the Pentagon from *X-Men: Days of Future Past*. Quicksilver (played by Evan Peters) is a mutant in the X-Men, with the ability to move at great speeds, and, to very briefly recap, he has turned up at the Pentagon with Professor Xavier (played by James McAvoy) and also Wolverine (played by Hugh Jackman) on a mission to rescue another of the X-Men from prison, the one who has gone over to the dark side – Magneto (Michael Fassbender). They are cornered in a kitchen; guards open fire on them – and Quicksilver springs into action.

We watch time slow waaaay down, while impish, Puckish Quicksilver dashes naughtily about the room, plucking the bullets out of the air as they drift towards him and his friends; casually, he musses the hair of security guards and cheekily tastes their coffee as it spills in slo-mo out of a cup. He repositions their fists against their faces and their gunbarrels up in the air so that there will be bizarre mayhem when he slows down and their normal time recommences.

But the stroke of pure genius is that this breath-takingly exciting action sequence is accompanied by Jim Croce's sad guitar ballad "Time in a Bottle", a track from 1973, all about the fact that life goes by so fast and there's nothing you can do about it.

There is something absolutely compelling about the juxtaposition of that poignant song and the thrilling scene that's happening over it. Fight scenes in films are often praised for being "balletic" – mostly by critics who've never seen a ballet or indeed a fight in their lives – but this is beyond balletic. It is operatic, dynamic, melancholic and of course cinematic. Its emotional and dramatic effects don't really make sense, but they are superb.

It could only happen in a superhero film! Superhero movies are the new superpower in world cinema. It's an unusual month or even week in the film business where a massive superhero film hasn't been trailed with a media campaign and a special appearance by its director and stars at the fan convention Comic-Con, in an attempt to get the fans on board – the all-important guardians of the flame, whose disapproval can turn the web and connoisseur opinion against the film.

But the critical fraternity is scratchy about superheroes. We moan. We whinge. We declare ourselves to be sick of the sight of them, and denounce them as childish and dumbed down. We look at the list of superhero films slated for the coming year and wonder if there isn't some way we can take the rest of our working lives off.

I say "we" – but I mean "they". Because I don't worry about superhero films. I positively look forward to them. They are surreal and extravagant gestures of colour in a dull world; they are detonations of Pop Art fun.

Superhero films are the new Western. Westerns were once produced *en masse* by Hollywood – and it was part of Hollywood's genius to persuade America and the world to accept as a kind of universal reality something which was certainly important but was a minority experience: the pioneers, the homesteaders and ranchers of the Old West. Audiences understood or thought they understood what a "cowboy" was, and didn't trouble with the problem of what this cowboy could be doing when there seemed to be no actual cows for him to busy himself with from the beginning to the closing credits. From the end of the war until the 1970s, Westerns were a

lingua franca in cinemas , but the 1960s space race put an end to this. Science fiction was the new pop genre and astronauts became the new cowboys and aliens the new Apaches. Westerns, sci-fi – and now superheroes.

And what's wrong with that? People complain that they are all the same. But aren't there unifying elements in romcoms? In thrillers? In weepies? In *noirs*? What's the problem with superhero films? Critics who simply look down their noses at superhero films are cutting themselves off from a great driving force. Superheroes are the Olympics, the Wagner, the circus, and the Premier League of the cinema.

THE INCREDIBLES

19/11/04

★ ★ ★ ★ ★

There can't be many films of which you can truly say: what you've got on the label is what you've got in the can. This new animation from the mighty Pixar stable – the people who brought us *Finding Nemo* and the *Toy Stories* – really is pretty incredible, even for a studio before whose films I have regularly had to scoop my lower jaw up from the cinema floor with both hands.

The Incredibles is brought to us by former Simpsons director Brad Bird, whose feature debut was the terrific animated version of Ted Hughes's *The Iron Man*; it's an all-conqueringly funny and blastingly energised family comedy that made me feel like one of its tiny pixillated civilians that get flung through walls, plunged into indigo-blue oceans or catapulted into the sky like a vanishing dot. And in its insouciant way, it has audacious things to say about the difference between meritocracy and mediocrity.

Plenty of ideas go into the mix. There's something of *X-Men*, *The Fantastic Four*, *Spy Kids* and also the quirky retro-feel of TV shows like *Get Smart* and the 1960s *Batman*. But as ever with Pixar, influences are subsumed into something new, something supercharged with insolent originality and modernity.

It's set initially in the superhero's postwar heyday: the world of the late 1940s when a lantern-jawed titan with a red jersey called Mr Incredible (voiced by Craig T. Nelson) steps in to assist embattled citizens and foil robberies. In this, he is helped by his fiancée, Elastigirl (Holly Hunter), whose superpower is to stretch infinitely in every direction. Just after their wedding, and at the very height of their success, disaster strikes. A would-be suicide takes Mr Incredible to court for saving his life, and the survivors of a train he saved from crashing also file suit for various whiplash injuries. Soon an army of snippy little lawyers achieve what no supervillain could: they debar the caped heroes from plying their trade, and the government has to relocate Mr and Mrs Incredible to another city and forces them to stay in their mild-mannered identity like normal people.

So a decade and a half later, in a late 1960s world of low-slung automobiles and affordable suburban housing, we find poor Mr Incredible incognito in civvy street, his waistline advancing and hairline retreating. He has a job in an insurance company, a terrible perversion of his true vocation. The dazzling couple has to be Mr and Mrs Ordinary in a new age of dullness, despite now having kids with secret superpowers too. Their son, cheekily named Dashiell, or Dash, has super-speed running abilities. But his mom tells him not to beat the other kids on the track, lest he draw attention to himself. "Everyone's special, Dash," she says to him piously. "Which is another way of saying nobody is," grumbles Dash. No surprise then, that when a mystery benefactor offers Mr Incredible a chance to work as a real superhero again, he jumps tall buildings at the chance. But who is the shadowy sponsor of Mr Incredible's return to greatness – could he be the most dangerous enemy of all?

The animation is, as ever, gasp-inducing with dazzling effects of light and detail that we have almost, but not quite, got blasé about. As with the *Toy Stories*, it is somehow the streetscapes that are the best things. The sheen and texture of cars, Tarmac, glass, brickwork, are all intensified by the dizzying horizontal and vertical perspectives: tall buildings and straight roads along which we zoom at the speed of thought.

The Incredibles is pitched more directly at kids than, say, DreamWorks' *Shrek*, which offered a bigger portion of smart, adult-orientated dialogue. That's not to say there aren't some very snappy things in the screenplay. I laughed inordinately at the idea that a second-rate supervillain can always be tempted into the classic mistake of "monologuing": talking continuously about the inner sense of hurt and resentment which propelled him into villain-hood, and so giving the hero a chance to catch his breath and counter-attack. "You sly dog," sneers one supervillain with the neurotic name of Syndrome, "you almost got me monologuing."

And there is one fantastically funny character: Edna Mode – tellingly voiced by Bird himself – the visionary designer of superhero couture to whom Mr Incredible applies to have his super-clobber upgraded. She is a tiny bespectacled lady, a cross between Anna Wintour and Helen Gurley Brown, who lives in an absurdly grand fastness, a veritable fortress of solitude, with an Olympic-classic design. Edna

is always looking for the next thing in superhero-costume: "I never look back darling! It distracts from the now!" It is for this reason that she detests capes in superhero-design and starts monologuing very amusingly about how dangerous they are: sucking superheroes into jet engines and ripping them to shreds when they get stuck in something on takeoff.

All I can say is: for those of you looking for the classic holiday movie, call off the search. These Incredibles claim to be an authentic family of superheroes. I believe them.

THE DARK KNIGHT

25/7/08

★ ★ ★ ★ ☆

A sound like a batgloved fist smacking into a cupped palm is what this film delivers: only deafeningly amplified and clarified with crisp, digital precision. It is the sound of all other recent super-hero movies getting their asses well and truly kicked. *The Dark Knight* is strange, dark, grandiose and mad; it is overlong and overhyped but hugely entertaining. In a simple, physical sense it really is huge, with cityscape sequences filmed on Imax technology, that demand to be seen on the vast Imax screen. Watching the first dizzying, vertiginous overhead shot of the glittering skyscrapers and minuscule streets, I literally forgot to breathe for a second or two, and found myself teetering forward on my seat — timidly, I had chosen one high up at the very back of the auditorium — as if about to topple into the illusory void.

The Dark Knight is the continuation of British director Christopher Nolan's reinvention of the Batman story and it takes the story up to his primal confrontation with the Joker, the villain who among the wrongdoer-gallery ranged against Batman is first among equals: here leading an unspeakable cabal of wiseguys. The caped crusader himself (although this camp designation is now not used) is again played by Christian Bale, clanking around in a kind of titanium-lite exoskeleton and making use of a heavy-duty Batmobile so macho and military-looking it makes a Humvee look like the kind of Prius driven by Gok Wan. Otherwise, he bops around town on a brutal motorbike with wheels the size of rubber boulders, cape fluttering in the slipstream.

The Joker is played, tremendously, by the late Heath Ledger. His great grin, though enhanced by rouge, has evidently been caused by two horrid slash-scars to the corners of his mouth, and his whiteface makeup is always cracking and peeling off, perhaps due to the dried remnants of tears, making him look like some self-hating Pagliaccio of crime, sweating backstage after the latest awful spectacular. Ledger has a weird collection of tics and twitches,

kinks and quirks; his tongue darts, lizard-like, around his mouth, a little like Frankie Howerd, or perhaps Graham Kerr, the galloping gourmet of 1970s TV.

Batman is still a reasonably novel figure in Gotham city as the action begins. They still refer to this dubious vigilante with a retro-sounding definite article: he is "the Batman". And there is a new, conventional crime fighter in town: the handsome, dashing district attorney Harvey Dent, played by Aaron Eckhart, a man who believes that the rule of law has to be upheld by a democratically accountable person, not some shadowy figure of the night. To the chagrin of Batman and his far-from-mild-mannered alter ego, billionaire Bruce Wayne, Harvey is dating the love of Batman's life: legal eagle Rachel Dawes, played by Maggie Gyllenhaal. Gary Oldman plays Lt Gordon, before his historic promotion to "Commissioner" status. Michael Caine and Morgan Freeman provide droll performances as Wayne's ancillary staff, his butler Alfred and his Q-like costume designer, Lucius Fox.

There are some really exhilarating set-pieces, especially the one that kickstarts the proceedings: Nolan starts off with a high-tension, high-anxiety bank raid, carried out by a dodgy crew all in Joker masks, all whispering among themselves about the crazy guy in clown makeup who hired them to do the job. Why isn't he there personally? Wait – is he there personally?

With some big masculine face-offs, and a high-speed convoy scene, Nolan appears to have imbibed the influence of Michael Mann, and a sequence in Hong Kong has a touch of the *Infernal Affairs* movies. Various debates about Jack Bauer/*24*-type torture methods appear to show modern Hollywood discovering, if not a conscience exactly, then a certain self-consciousness. But the film is better at pure action – particularly one awe-inspiring chase scene Nolan later contrives between Batman on his bike and the Joker at the wheel of an enormous truck. The conclusion to this sequence had the audience in a semi-standing crouch of disbelief.

Perhaps the most bizarre moment comes when the Joker has evidently abducted some unfortunate from the local psychiatric hospital to "impersonate" Batman's lost love: this man does appear to resemble Maggie Gyllenhaal: a joke of considerable malice, sophistication and lack of taste.

Nolan has made an enormously profitable smash with the Batman franchise, but at the risk of sounding priggish, I can't help thinking it may be a bit of a career blind-alley for the talented director who gave us brilliant and disquieting movies like *Following* (1998) and *Memento* (2000), whose inventions still linger in the mind. *The Dark Knight*'s massive box-office success has surely given Nolan the means to write his own cheque, and in addition something sweeter still — clout. I hope that he will use it to cultivate movies that are smaller and more manoeuvrable than that great armoured Batmobile.

WATCHMEN

6/3/09

★ ★ ★ ☆ ☆

Zack Snyder's movie version of the DC Comics graphic novel *Watchmen* is a fantastically deranged epic; it might be making a bid for flawed-masterpiece status, except that it is probably more flaw than masterpiece. There are dull moments and moments of inspiration, moments of sublime CGI trickery and, repeatedly, moments when you suspect that a much-loved pop-rock standard is being bashed out on the soundtrack to make sure your interest levels don't flatline. It is a radioactive mosaic of bizarre touches and surreal tweaks: pop culture and newsreel history are audaciously morphed into a counter-factual landscape against which is played out the strange story of paranoid and vulnerable human beings who were once superheroes, but no more. Owing to public disillusion with unaccountable vigilantes, they have been forced to abandon their vocation — a postmodern twist also explored by the Pixar-Disney classic *The Incredibles*.

It is 1985, but not as you know it. Richard Nixon is still in charge, having passed a law allowing himself more than two terms; he is in any case wildly popular owing to the huge US victory in Vietnam. This is because the Americans had on their side awesome superhero Dr Manhattan (Billy Crudup), a flaming-blue colossus with Blakean musculature and godlike powers to bend nature to his will. He is one of the Watchmen, the now disbanded crew of superheroes, including Ozymandias (Matthew Goode), Silk Specter 2 (Malin Akerman), Nite Owl 2 (Patrick Wilson), Rorschach (Jackie Earle Haley) and The Comedian (Jeffrey Dean Morgan). The Watchmen are in fact the second-generation descendants of a prewar super crew called The Minutemen, with the original Silk Specter (Carla Gugino) and the original Nite Owl (Stephen McHattie).

The Watchmen are hardly straightforward good guys. They include someone truly despicable: the Comedian is a rapist, murderer and fascist stooge — a hitman for Tricky Dicky. He is shown as being the second gunman on the grassy knoll who assassinated Kennedy

in 1963: this sequence is stunningly convincing. But disgusting as he is, the Comedian's depravities are to be surpassed by the mad hubris lurking within the disbanded Watchmen's ranks, the hubris that might destroy humanity itself.

There is something exhilarating in the sheer madness of *Watchmen*: a wacky world turned upside down – famous people from history are always getting dream-like cameos. Costumed combatants flit across the screen in the company of Nixon, Henry Kissinger and Pat Buchanan: the Watchmen's existence pokes some sharp satire at the besuited, capeless warriors of conservative America. The synapse-frazzling ambition of *Watchmen* is impressive as it lurches from hyperreal Earth to photoreal Mars; it is dizzy, crazy and quite sexy – when it's not being self-indulgent and pointless. If it doesn't quite hang together or add up, or stick faithfully to the comic-book original, these offences aren't major. What a spectacle.

KICKASS

★ ★ ★ ★ ★

Like an explosion in a bad taste factory, Matthew Vaughn's teen-superhero black comedy *Kick-Ass* is a thoroughly outrageous, jaw-droppingly violent and very funny riff on the quasi-porn world of comic books – except that there is absolutely no "quasi-" about it. Vaughn and screenwriter Jane Goldman have adapted a comic-book series by Mark Millar and John Romita Jr by crushing the essence of *Kill Bill*, *Spider-Man* and *Ghostbusters* to create something fantastically anarchic and gloriously irresponsible: a surrealist fantasy of adolescent wish-fulfilment and fear, sploshed on to the screen in poster-paint colours.

In its monumentally mad and addled way, *Kick-Ass* might even be saying something about the ethics of civilians "having a go" at criminals, about teenagers getting bullied and about our brave new world of homemade internet celebrity. And between them, Vaughn and Goldman show a genius for incorrectness and pure provocation: an entire edition or perhaps an entire series of Radio 4's *Moral Maze* might have to be devoted to the extraordinary action sequence in which a prepubescent superheroine called Hit Girl, in mask and purple wig, boldly denounces a dozen bad guys with the c-word before letting them have it with the gleaming "Benchmade model-42 butterfly knife" she has just got from her adoring father for her eleventh birthday. And all this to a cranked-up version of the Banana Splits theme tune on the soundtrack. What I experienced was not so much a moral panic, as a full-scale gibbering fit in the stalls.

At the centre of the story is a New York high-school kid and comic-book obsessive called Dave Lizewski, played by the British up-and-comer Aaron Johnson, who has just portrayed the young John Lennon in *Nowhere Boy*. Dave is obsessed with the great conundrum of our time: why has no one yet actually tried to be a superhero, for real? (In the counter-history of *Watchmen*, cops became masked vigilantes to whack villains who evaded the law; some wacky

aspirants tried it in the comic series and 1999 film *Mystery Men*.) So Dave orders an incredibly uncool green-and-yellow ski suit and mask from the internet, and paces around the New York streets, under his new name, Kick-Ass. Inevitably, he is half-killed by the very first baddies he attempts to confront and, in the back of the ambulance, begs the bemused paramedics to hide his shameful costume, leading to rumours in school that his body was found naked, and that he is therefore gay. Weirdly, this new metrosexual image gives poor Dave status in school with the super-hot Katie (Lyndsy Fonseca) who likes the idea of a gay best friend. His self-esteem improbably climbing, Kick-Ass takes to the streets once again, where he finds himself protected by real superheroes: the eleven-year-old Hit Girl (Chloe Moretz) and her doting father Big Daddy (Nicolas Cage), a masked avenger in the style of Christopher Nolan's Batman. They are fighting the good fight against a creepy crimelord Frank D'Amico (Mark Strong) whose own nerdy son also longs to be a superhero. This is Chris, played by Christopher Mintz-Plasse as a variation of his legendary McLovin character from *Superbad*.

The unlikely triumph of *Kick-Ass* is that, for a microsecond, it presents a plausible scenario in which an amateur superhero might somehow actually succeed, and like *Galaxy Quest* with its collision of phoney and real space aliens, *Kick-Ass* fantasises about a meeting of wannabe and real superheroes. Bruce Wayne's superpower was money: Dave Lizewski's is unembarrassability. His nerve-endings are a little shot from his initial beating, but he is cushioned more by a sublime lack of irony. When he walks around in the silly outfit and suicidally takes on another crew of villains, it isn't long before a stunned crowd of onlookers are videoing the punch-up – and Kick-Ass survives just long enough for the bad guys to be hobbled by the thought of their imminent appearance on YouTube, battling a crazy guy in a superhero outfit. It could incriminate them, but more importantly it will make them look stupid. So they back down. Kick-Ass, with an unconscious talent for divining the zeitgeist, has made the powers of the internet work for him: YouTube makes him a star, and his MySpace page builds his career. Peter Parker may have been bitten by a radioactive spider, but Dave has been bitten by the web celebrity bug. In the old days, Clark Kent and Peter Parker took work on newspapers, because that was how they found out where

the action was. That was old media. Kick-Ass uses the online world to self-publish his superheroism.

In parallel with the bizarre and chaotic adventures of Kick-Ass, Big Daddy is mentoring and generally home-schooling Hit Girl in the ways of crime-fighting. The education she gets does look horribly like abuse, especially when she smilingly submits to being shot by her father, as a way of getting used to a bullet-proof vest, and also as part of the wholesome toughening-up process. (There is a very similar scene in Matteo Garrone's Neapolitan mob drama *Gomorrah*.) The sheer bad taste is what gives the comedy its super-power.

Perhaps I shouldn't have enjoyed it as much as I did: but with more energy and satire and craziness in its lycra-gloved little finger than other films have everywhere else, *Kick-Ass* is all pleasure and no guilt.

IRON MAN 3

22/4/13

★★★★☆

To use a recondite term in professional film criticism: whoo-hoo! *Iron Man 3* is descending on cinemas with an almighty crash, assuming the dramatic-yet-camp landing pose that Tony Stark in his exo-body-chassis favours on arrival: right knee down, right fist in the smashed asphalt, left elbow back, head up. This is luxury superhero entertainment and the director and co-writer is Shane Black, who gave us the excellent *Kiss Kiss Bang Bang* in 2005. I bow down to Mr Black as the Aaron Sorkin of action comedy; he gets the biggest laugh of the year with a joke about Croydon, with some additional Anglophile kisses blown to *Downton Abbey*, and what I suspect is a disguised homage to Mike Myers's immortal creation Austin Powers.

Robert Downey Jr is back, smashing walls and cracking wise as the billionaire industrialist Tony Stark, now out of the closet as Iron Man, living the dream in his future-tech clifftop pad and co-habiting with the beautiful Pepper Potts — Gwyneth Paltrow's excellent, relaxed performance making me wish she spent more time on film sets and less with her nutritional website. As so often in modern superhero tales, Stark's confrontation with wickedness triangulates into a question of two separate evildoers. Guy Pearce plays suave science entrepreneur Aldrich Killian — brilliant, yet unstable and unprincipled in the traditional manner – whose obsession with Stark may arise from a traumatic rejection in his youth, rather like Syndrome in *The Incredibles*.

And then, showing that Black playfully relishes the Hollywood convention of casting Brit thesps as the bad guys, there is the terrifying middle-eastern terrorist, Mandarin, played with relish by Ben Kingsley. Mandarin is taking to the airwaves to gloat over his various explosions, which appear to happen without bombs. Oddly, Mandarin prefers old-school TV for these publicity appearances and has no Twitter account. Meanwhile, Stark has to juggle a tense relationship with his old buddy James Rhodes (Don Cheadle) and beautiful ex-girlfriend Maya (Rebecca Hall).

Iron Man 3 is smart, funny and spectacular – I particularly liked Stark's brutally unsentimental reaction to the news that a kid who is helping him is missing his errant dad. Stark now probably succeeds Chaplin as Downey's key creation as an actor, loosing off funny lines with virtuoso skill, throwing away gags and delaying punchlines: Alec Baldwin does something similar, but in a more reflective style. This may not be to everyone's taste and some odd repeated jokes about Christmas indicate that a different release date may have been planned. But it is quality Friday night entertainment: the innocent pleasure of the week.

THE AMAZING SPIDER-MAN 2

17/4/14

★ ★ ★ ☆ ☆

Here is the second new Spider-Man film – or the fifth, if you are tactless enough to remember the once colossal Sam Raimi-directed trilogy that finished in 2007, quickly to become the boringly obsolete boot to this reboot – a sobering lesson in consumer capitalism and franchise movie-making.

This latest Spidey, written by Alex Kurtzman, Roberto Orci and Jeff Pinkner and directed by Marc Webb, is high-energy entertainment; Andrew Garfield's Peter Parker has rangy charm and there is a genuine romantic spark between him and Emma Stone, as sharp as ever playing Gwen Stacy. Webb at one stage conjures a beautiful seasons-passing montage of Peter Parker's unhappy loneliness that reminded me of the relationship comedy *(500) Days of Summer*, which made his name. But despite sensational new backstory developments, the sense of template deja vu here is unavoidable, and as in Raimi's *SM3*, the dramatic investment is thinly spread across a portfolio of characters, each of whom individually has quite a small supporting role.

As well as the Gwen situation, there is Parker's tense, class-divide-straddling bromance with high-school contemporary Harry Osborn, played by Dane DeHaan (from the Beat-era drama *Kill Your Darlings* and Josh Trank's *Chronicle*). He is destined to clash with Spider-Man as the Green Goblin. The other antagonist, Electro, is played by Jamie Foxx – a lonely and unappreciated electrical engineer, Max Dillon, is fatefully electrocuted into supervillainy. There are also tiny walk-ons for Paul Giamatti as Russian bad guy Alexei Sytsevich, or The Rhino, and Felicity Jones as Felicia, Harry Osborn's new assistant. Everyone brings their professional A-game and the hollow-eyed DeHaan is a fiercer and more plausible Harry than James Franco ever was. His wan, faintly poignant listlessness brings to mind Gilbert Adair's description of Michael Jackson: "The face of an adolescent masturbator, dishevelled, drained and ashy-white." However, Foxx is wasted in the role of Electro. It is strange to

see this star, so magnificent in *Django Unchained*, playing such a so-so part (he was better as the mousy nerd in Michael Mann's *Collateral*). Still, Foxx and Garfield get a rousingly zappy spectacular in which Spider-Man confronts Electro in a strange digital simulacrum of New York's Times Square.

In this very masculine world, there still seems to be no question of a female villain, and despite being notionally on different sides of the moral barrier, all these variously unhappy, insecure and dadless males – Spider-Man, Harry, Electro – are pretty much on the same team. It is the women who are alien, and Gwen provides the real clash of opposition. It is her that Parker feels he must stay away from, because he once made a promise to Gwen's dad to protect her by staying out of her life, and it is Gwen who at first angrily breaks up with Peter.

Their scenes together are easily the best moments in the film. From the first, Gwen is more serious than Peter, and simply smarter. His bedroom is littered with slightly callow cultural stuff – posters for *Blow-Up* and *Dogtown and Z Boys*, and a copy of (inevitably) *Infinite Jest*. We don't see Gwen's room, but she is the one with the academic attainment, having been offered the possibility of studying medicine at Somerville College, Oxford, an event that is to trigger a further crisis in their already tempestuous relationship. When Peter and Gwen avoid some bad guys in the Oscorp building (Harry's corporate HQ) and duck into a broom cupboard, Peter drolly whispers that this is a clichéd peril location, and Gwen acidly replies: "Well, I'm sorry I didn't take us to the Bahamas of hiding places!" It's a really nice moment, and the line feels improvised and relaxed, as if Garfield and Stone really were just making it up, like real people.

Garfield is a likeable Peter Parker and his face has a cartoony, almost Muppety look, with its shock of hair sticking up; his simply drawn mouth and puppyish eyes showing us his excitement and inner turmoil, and the unibrow periodically becoming a circumflex of sadness. He is a very young-looking thirty years old, a convincing high school graduate and contemporary of Gwen's (Emma Stone is twenty-five) although as before, the onward march of time means that this lucrative Spider-Man franchise might soon need to be re-cast and re-launched just as we were getting used to it. (The grizzled

Robert Downey Jr, on the other hand, could carry on playing Iron Man for years.)

Gwen isn't given much space to develop, but Emma Stone's sharp, witty presence – and her chemistry with Garfield – is such that the role manages to be more than what was in the script. It exceeds the sum of its screentime minutes. *The Amazing Spider-Man 2* almost succeeds in being something interesting and unusual for a superhero movie: a love story.

X-MEN: DAYS OF FUTURE PAST

22/5/14

★ ★ ★ ☆ ☆

With a whoosh, the X-Men go forward to the past, or possibly sideways to an alternative present. This headspinning and chaotic time-travel adventure is a funky, surreal experiment in counter-factuals and variant myths. It channels *Watchmen*, *The Terminator*, *The Matrix*, *Life on Mars* and *Independence Day*. At its best, it's delirious, crazy fun with splashes of passion and romance; at its worst, it gets muddled (the way time-travel films will always tend to) and becalmed in its own fanboy portentousness.

We begin in a dark future. The war between the non-mutants and the mutants has resulted in devastation all over the world. No one, it seems, is the true winner. Some holdout mutants appear to be battling a rearguard guerrilla action against terrifying new soldier-robots called Sentinels. They are physically at a disadvantage but have the ability to escape through portals in the space-time continuum – they can scoot back in time to warn themselves when and where a Sentinel attack is on the way.

It is upon this grim scene that Professor Xavier (Patrick Stewart), Magneto (Ian McKellen) and Wolverine (Hugh Jackman) make an almost Shakespearian entrance, like an exiled king and his retinue. Xavier is excited by the potential of time-travel to rescue their destinies. The new plan is that Wolverine will go back many decades to 1973, but there will be no ironic retro kidding around. This is when Raven (Jennifer Lawrence), or now rather Mystique, made her fateful attempt to assassinate anti-mutant scientist Dr Trask (Peter Dinklage) at the Paris peace conference. The way things turned out, she was captured and through some hideous scientific means her metamorphic properties were decanted to create the Sentinels. If only Mystique can be stopped, then none of this will happen.

What Wolverine must do is go back in time – or rather, his mind must go back, in a sort of *Inception*-style inner universe, while he twitches on a bed covered with wires – to persuade Magneto and Xavier's younger selves to join him in this exotic quest. The problem

is that he will be a stranger to the younger generation, who are played by James McAvoy and Michael Fassbender. The further complicating factors are that Xavier is at this stage able to walk, with medication that however strips his mental powers, and the metal-controlling Magneto is incarcerated in an ultra-secure unit below the Pentagon, in Loki-cum-Lecter seclusion, suspected of having been behind the Kennedy assassination, with its well-known swerving bullet. Wolverine and Xavier have to spring Magneto, and this opens old wounds. It reawakens their angry debate about how mutants should comport themselves, and their feelings for the beautiful Mystique herself.

Perhaps inevitably, it is in the film's opening act where almost all the fun is to be had. Wolverine firstly recruits Beast (Nicholas Hoult) and Quicksilver (Evan Peters) to help him bust into the Pentagon. Quicksilver's infinitely fast moves effectively trump every other power and superpower; it is a slight bafflement, in fact, that Quicksilver himself does not rule the world, or at least appear in much more of the film. There is a glorious "bullet-time" scene during a shoot-out in which Quicksilver ambles around, catching the bullets as they float towards the cowering, freeze-framed Magneto and Xavier – and all to Jim Croce's yearning song "If I Could Save Time in a Bottle".

Fassbender's Magneto is curt, cool, duplicitous – an elegant foil to Xavier and his angry self-pity. Set against them is Lawrence's Mystique, who is always required to disport herself in her blue body-hugging quasi-nudity. (As Spinal Tap's Nigel Tufnel might have commented: "What's wrong with being sexy?") As for Jackman's Wolverine, he is as robust and unassuming as ever, though I feel he is always in danger of being upstaged by the other, more cerebral and self-aware characters.

The action flashes eagerly around – to Vietnam, Paris, to that post-apocalyptic wasteland from which Wolverine makes his blast to the past. And, of course, there's Washington DC, where the mutants are to encounter the president, Richard Nixon (Mark Camacho), in a truly spectacular setting. Finally, the X-Men extricate themselves from incoherence – more or less – with the help of a newspaper front page that explains to the audience how exactly a reasonably happy ending has supposedly been achieved. It was a dizzying but enjoyable ride.

AVENGERS: AGE OF ULTRON

22/4/15

★ ★ ★ ★ ☆

Recently, there has been a shrill cultural panic at the thought of all the superhero movies due to be released in the next few years: *Ant-Man, Captain America: Civil War, Doctor Strange, Guardians of the Galaxy 2, The Spectacular Spider-Man, Thor: Ragnarok, Avengers: Infinity War Part 1, Black Panther, Captain Marvel, Avengers: Infinity War Part 2, Batman vs Superman: Dawn of Justice* … the list goes on. But what's the problem? For me, it's no more of an issue than all the romcoms and horror the business is readying at the far end of the chute, and this exotic new strain of supers could well be stimulating the industry. And there's certainly no problem if they're as exuberant, funny, silly and crazily exhilarating as this new Avengers movie from writer-director Joss Whedon, which is a pure aspartame rush.

Once again, the Avengers have assembled under the mercurial and possibly duplicitous leadership of Tony Stark, otherwise Iron Man, played with the usual single-breath delivery of throwaway wisecracks by Robert Downey Jr. It's a role which now threatens or promises to define his whole career. Previously, I have described the assembled Avengers as the Traveling Wilburys of superheroism. Now they are more like a G7 summit of world-saving and crime-fighting with every constituent member becoming a veritable Angela Merkel of demurely offbeat virility.

Mark Ruffalo is excellent as the troubled and introspective Dr Bruce Banner, for whom Hulk transition is not in and of itself a problem. The issue now is the way in which he must be coaxed into remorphing into human form and Black Widow, nicely played by Scarlett Johansson, is becoming the Hulk whisperer. The intuitive tenderness with which she deals with Banner/Hulk is turning into a sweet love affair: it seems to involve a great deal of delicately erotic hand-holding: her tiny hand in his galumphing green mitt; yet Dr Banner is holding back from returning her love, unwilling to burden her with his terrible rage potential. Chris Hemsworth is Thor, continuously resident on Earth for the time being and without

claims from Asgard to distract him. (My one quarrel with the film is that Tom Hiddleston's Loki doesn't show up.) Chris Evans's Captain America is a stolid reminder of wartime values and Jeremy Renner is Hawkeye, whose bow and arrow make him the quaintest and yet most romantic warrior of the group.

But now they find themselves up against a couple of new enemies: Pietro Maximoff, or Quicksilver, played by Aaron Taylor-Johnson, and his twin sister Wanda Maximoff, or Scarlet Witch, played by Elizabeth Olsen. They are blessed variously with super speed and mind control (as one character puts it, "he's fast; she's weird") and Scarlet Witch almost immediately uses her head-messing capabilities to show a secretly aghast Stark how he might betray and even destroy his fellow Avengers.

But more importantly, Stark begins to experiment (without his comrades' knowledge) with an artificial intelligence programme that could impose absolute power on Earth, supposedly to repel all enemies: this insubstantial mega-brain, like a floating blue jellyfish, instantly goes rogue, becoming a terrifyingly dangerous new enemy named Ultron, appropriating a new exoskeleton, and becoming a bizarro version of his effective creator: Stark. Ultron uses the blandly Chamberlain-esque phrase "peace in our time" to describe its planned totalitarian rule, the Pax Ultronica, and the irony will hardly be lost on the World War II veteran Captain America. The Avengers realise that they are actually fighting against a hideously parodic version of their own ally: Stark, his worst and perhaps even strongest self.

It's all operatically mad, and the city-destroying final confrontation is becoming a bit familiar, but Whedon carries it off with such joy and even a kind of evangelism. His script is a thing of wonder, jam-packed with great lines: I loved Stark's wearied remark: "I've had a long day ... Eugene O'Neill long ..." And the unresolved romantic and sexual tension between Black Widow and Hulk creates a weird driving force to the narrative: even the absurdity is somehow recirculated into the film's internal economy as comedy and irony and the cast-of-thousands effect never seems to split the focus: Andy Serkis plays metal trader Ulysses Klaw and Julie Delpy has a blink-and-you'll-miss-it cameo as Black Widow's sinister former controller. It's a superhero cavalcade of energy and fun.

The films that made me take my protein pills and put my helmet on

On screen, science fiction sometimes gets patronised as a matter of spaceships, Bacofoil suits and monsters, or reduced critically to a genre which forty years ago split catastrophically into the fun (and therefore bad) tradition of *Star Wars* and the dark (and therefore good) tradition of *2001* and *Silent Running*. It's a genre which challenges the parochialism of most genres and indeed, the parochialism of the way we live our lives. Because – wait – *are* there sentient beings on other planets? Or did humanity just win the universe's golden ticket as being the highest, or only form of life on the most habitable planet anywhere? And does the question rewrite the rules about how we think about our sublunary existence down here, under the ionosphere? Isn't that an important and relevant topic for movies to be attempting? Why is it sillier than movies about people kissing other people or chasing other people in cars? Science fiction is a genre which, among its many functions, states and re-states the Arthur C. Clarke question about man either being alone in the universe or there being someone or something else – and both possibilities being equally terrifying. Perhaps more than any genre, sci-fi is embedded in history and historical change. The space race of the 1950s and 1960s gave a live-ammo immediacy to the inventions of sci-fi. Humanity really was going into space. First a circumnavigation of Earth, then a landing on the Moon. And then? Well, the narrative logic optimistically implied in that sequence of events made arriving at Mars and other planets entirely plausible. Since the 1970s, the moon missions have become a thing of the past,

leaving that kind of narrative more in the fictional realm, orphaned by the times, but perhaps thereby made more exotic and strange: the idea of other worlds in the movies is like discovering a ruined monument. And like superhero movies, the sci-fi genre takes on the challenge once limited to the Western: the question of the mythic, the epic, the existential.

2001: A SPACE ODYSSEY

27/11/14

★ ★ ★ ★ ★

Kubrick's *2001: A Space Odyssey* is now re-released in cinemas, and after Christopher Nolan's flawed and heartfelt voyage in *Interstellar*, it is salutary to revisit the film which invented so many of its tropes and ideas. Maybe only rocket science and deep space could absorb Kubrick's famous coldness and control and tendency to visionary gigantism. It has become customary to place *2001* in a challenging or dark or dystopian sci-fi tradition as opposed to the all-conqueringly sucrose *Star Wars*. Actually, *2001* doesn't exactly fit that first camp either: something in its mandarin blankness and balletic vastness, and refusal to trade in the emollient dramatic forms of human interest and human sympathy. Kubrick leaves usual considerations behind with his readiness to imagine a post-human future. For all its sentimentality, Steven Spielberg's film *A.I. Artificial Intelligence* (a project once nursed by Kubrick) is nearer in spirit to *2001* than *Interstellar*. And at one remove, Steven Soderbergh's intelligent, respectful remake of Tarkovsky's *Solaris* in 2002 has some trace elements. This chance to see *2001* on the big screen shouldn't be missed.

SUNSHINE

6/4/07

★ ★ ★ ★ ☆

Set the controls for the heart of the sun, ordered Pink Floyd in 1968, and this beautiful-looking new space adventure written by Alex Garland and directed by Danny Boyle does exactly this. It's a film with some stunning sequences and gobsmacking NASA-graphic visuals which are destined to be shown on giant Imax screens around the country.

It has at its centre a single, compelling idea. In the near future, our sun will begin to die, but to save humanity an elite manned space mission will embark on an anti-Conradian journey into the heart of light, with a payload of nuclear material on board "equal in mass to Manhattan island". The crew will fly up to the sun, close enough to fire their terrifying bomb into its ailing heart – and re-ignite the precious flame. Then they do a swift U-turn while the detonation timer mechanism counts down, get the heck out of there and arrive back on a rebrightened earth a decade or so later. This environmental nightmare, and the extraordinary advances in space travel and nuclear fission necessary to counter it, are supposed to exist in AD 2057, just fifty years from now.

Garland and Boyle's story reaches out, or reaches back, to the lost 1970s tradition of darkness, scepticism and subversion in science fiction, a period that combined the technological optimism of the Sputnik/Apollo era with the succeeding decade's political discontent. *Sunshine* alludes, empathically and even unsubtly, to Kubrick's *2001* and Carpenter's *Dark Star* with their weightlessly calm personnel procedures, vertiginous perspective planes of hyperdrive and enigmatically mutinous computers. We also feel the austere mysticism of Tarkovsky's *Solaris* – a movie that shows what space travel would be like if they'd managed it in the reign of Henry II – and the paranoid contaminations of Ridley Scott's *Alien*. The crew eat lunch and have important meetings around the same kind of tabletop, which is lit from below, like a photographer's lightbox, giving them all the same fierce pallor. But *Sunshine* also channels

queasy modern anxieties from our modern age: a world of climate change, weapons of mass destruction and even suicide bombers.

The crew's leading scientist is the twentysomething prodigy Capa (Cillian Murphy) who is in charge of detonating the weapon; the captain is Kaneda (Hiroyuki Sanada) and the technician who cultivates the ship's huge indoor field of oxygen-producing plants is Corazon, played by Michelle Yeoh. Their craft's official name is *Icarus II. Icarus I* was the first mission, led by Capt Pinbacker (Mark Strong) which went out some years ago and disappeared with crew and mega-bomb unaccounted for. Perhaps they all became demoralised by the frankly rather tactlessly chosen name. Inevitably, and in the time-honoured way, the crew of *Icarus II* start hearing a distress signal: it is from their mysterious predecessors. Are they still alive? Why was their mission abandoned? What are they now planning on doing with their bomb? Did proximity to the all-consuming, retina-scorching sun – the great implacable god that pre-exists and pre-empts all our puny religious folktales – push them psychologically and spiritually over the edge? "They had an epiphany," muses one of Capa's colleagues. And actually that would be a better name for their spacecraft: *Epiphany I* and *Epiphany II*.

Sunshine takes its intelligent and honourable place in the history of grown-up science fiction on the screen and on the page: a genre that seeks to break free of parochialism and think about where and why and what we are without the language of religion. When Kubrick's *2001* came out, audiences genuinely did believe that space travel and encounters with other worlds, and therefore an enhanced understanding of our own world, were plausible twenty-first-century achievements. It is shaming to think how we have abandoned this idealism with hardly more than an incurious shrug. Interest in other existences gets laughed off as absurd or cranky, and yet the implied assumption that we are alone, or at any rate uniquely relevant in the universe, is surely its own kind of Ptolemaic irrationalism.

This is not quite, as it happens, what *Sunshine* is about, though like *Solaris*, it can be read as a parable or metaphor: an inward journey. Yet that, too, is a kind of evasion. The point is that space really does exist, out there, whether or not humanity has the will or the technology to venture beyond its global backyard and encounter it.

I have to confess that there were times when *Sunshine* looked like a clever, but essentially cool anthology of mannerisms and ideas from other movies, and I wasn't sure about the great dramatic encounter in its final act, which did not, for my money, emerge satisfactorily from the personalities established at the very start. But I loved *Sunshine* for its radical proposal that humans can and will do something about a catastrophe, and that our weapons could be used up in the service of preservation. Converting the nuclear sword into a ploughshare is not, however, as easy as that: and the movie also suggests a terrible and unalterable act of hubris in trying to augment the sun's fissile energy with a big bang of our own – or an unconscious, ambiguous kind of thanatos. Rather than endure a slow fadeout as the sun runs down, we will gamble on blowing it and everything else in the universe to kingdom come in one supremely risky act of helio-deicide. Superbly photographed by Alwin Kuchler and designed by Mark Tildesley, *Sunshine* is a thrilling and sensual spectacle.

GRAVITY

★ ★ ★ ★ ★

Alfonso Cuarón's incredibly exciting, visually amazing film is about two astronauts floating in space. The title refers to the one big thing almost entirely absent from the film: it's like *The Seventh Seal* being called *Levity* or *Last Tango in Paris Chastity*. With gorgeous, tilting planet Earth far below in its shimmering blue aura, a bulkily suited spaceman and spacewoman veer, swoop and swerve in woozy slo-mo as they go about their business tethered to the station, like foetuses still attached to their umbilical cords. The movie's final sequence hints at some massive cosmic rebirth; a sense that these people are the first or last human beings in the universe, like something by Kubrick.

Sandra Bullock plays a scientific engineer, Dr Ryan Stone, who after six months' specialist NASA training has been allowed into space to attach a high-tech new scanning device to the Hubble telescope. She is under the watchful supervision of Matt Kowalski, a genial and grizzled space veteran played by George Clooney. The voice of Houston mission control is played by Ed Harris, in playful homage to Ron Howard's 1995 space-disaster classic *Apollo 13*. Only this time it is him telling them about the problem. Soon, a terrifying situation unfolds.

Director and co-writer Cuarón brilliantly manages to create both awe at his glorious space vistas, and knuckle-gobbling tension at what's happening in the foreground. It's like a bank heist in Reims cathedral – in space. You could find yourself asthmatically gasping with rapture and excitement at the same time. After it was over, I was ten minutes into my tube ride home before I remembered to exhale.

Since its release, various specialist observers have unsportingly emerged to say that the science involved in *Gravity* is fanciful and wrong. No matter. What makes *Gravity* so gripping, and so novel, is that it behaves as if what everyone is doing is happening in a world of commonplace fact: like a movie about two drivers on a runaway

train or hot-air balloon. A movie set in space tends to trigger an assumption: that it is set in the future (although not the case with *Star Wars*). If it is not like *Apollo 13*, about the bygone era of space exploration carried out by guys in quaint crewcuts, then it is going to be set in some madeup futurist world about space exploration in aluminium-foil costumes and spacecraft doors opening and closing with zhhh-zhhh sounds – a world that may or may not involve extraterrestrial creatures, but which importantly and patently doesn't exist; a movie whose effects depend, at least partly, on the assumption that what is being shown is not true.

Gravity isn't like that. It's not sci-fi, more a contemporary space thriller. It's happening in the here and now. That is why it is so absorbing, although you may have to abolish your own scepticism-gravity – suspending disbelief at the idea that Stone's training would have allowed her to be reasonably familiar with the control panels of Russian and Chinese spacecraft with their Cyrillic and Chinese letterings. Of course, these aspects may have been cunningly devised by Cuarón so that his movie can blast off in Russian and Chinese territories.

The movie draws, broadly, on the style, if not the substance, of that dystopian tradition stretching from Kubrick's *2001* (1968): it is comparable to *Alien* (1979) or *Dark Star* (1974) or *Silent Running* (1972), in that it adopts something of their downbeat, quasi-realist behaviour, applied to something notionally real; it has some of their flashes of humour and horror and tension, but it is without cynicism or satire, without monsters or talking computers. Incidentally, the deeply scary question of what happens if you accidentally become detached from your spacecraft and float irreversibly off into space brought back memories of Brian de Palma's little-liked *Mission to Mars* (2000). But importantly, it's supposed to be real.

Clooney effectively concedes star status to Bullock and Stone's face, as she finally reveals the personal anguish she's brought up to space inside her, becomes gaunt and waxy and agonised: a very real 3D image of pure human pain. When she cries in zero-gravity, with real tears floating away from the face, it is a heartstopping spectacle. Kowalski's gallantry and Stone's yearning are compelling and unexpectedly romantic.

Is *Gravity* very deep or very shallow? Neither. It is a brilliant and inspired movie-cyclorama, requiring neither gravity nor gravitas. This is a glorious imaginary creation that engulfs you utterly, helped by superlative visual effects design from Tim Webber, cinematography by Emmanuel Lubezki and production design by Andy Nicholson. As you sit in the cinema auditorium, you too will feel the entertainment G-forces puckering and rippling your face.

THE FORCE AWAKENS

16/12/15

★ ★ ★ ★ ★

It's here — the real Episode Four! From the first few minutes, or even the first few frames, J.J. Abrams's exciting, spectacular and seductively innocent *Star Wars: The Force Awakens* shows itself a movie in the spirit of the original trilogy, which ended with *Return of the Jedi* in 1983. (This one takes up the story thirty years later.)

Technically, of course, that was reconfigured as Episode Six, but *The Force Awakens* makes you forget about the redundancy and pedantry of the prequel-trilogy that came fifteen years later. It restores the comedy that *Phantom Menace* abandoned. *The Force Awakens* is in touch with the force of action-adventure and fun. My only tiny reservation, which I will get out of the way now, is with a tiny new droid who has a bit of a Scrappy-Doo vibe about him.

The Force Awakens re-awoke my love of the first movie and turned my inner fanboy into my outer fanboy. There are very few films which leave me facially exhausted after grinning for 135 minutes, but this is one. And when Han Solo and Chewie come on, I had a feeling in the cinema I haven't had since I was sixteen: not knowing whether to burst into tears or into applause.

J.J. Abrams and veteran co-writer Lawrence Kasdan have created a film which is both a narrative progression from the earlier three films and a shrewdly affectionate next-gen reboot of the original 1977 *Star Wars* — rather in the style of his tremendous re-imagining of the Kirk/Spock *Star Trek*. Familiar personae, situations and weapons will appear like covers or remixes, and meshed in with new storylines. This notice will be a safe space, incidentally, with a trigger warning only for basic plot points and material already in the public domain.

The original movies were always based on the most extraordinary nexus of personal and family dysfunction: a motor of guilt, shame and conflict. Luke was driven by an increasingly complex Freudian animus against Darth Vader; Han Solo referred to the Millennium Falcon as "she"; male audiences were encouraged both to identify with Luke and to lech over Princess Leia in her outrageous gold

slave bikini – and then, with exquisite narrative sadism, we were told they were brother and sister. All this agony is reborn in *The Force Awakens*: new contortions of fear and black-comic absurdity amidst the romance and excitement.

Luke has been famously absent from the poster for this film, which led me to fear at first that over the past thirty years, like Atticus Finch in Harper Lee's *Go Set A Watchman*, he had gone over to the dark side. Suffice it to say that Luke, played by a now grizzled Mark Hamill, is a potent but unwontedly enigmatic presence.

Princess Leia is now a General and still the warrior queen of the resistance – a tougher and more grandmotherly figure. The dark force is resurgent in the form of the First Order, intent on re-establishing a more candidly fascist control, with quasi-Nuremberg rallies. Ranged against them are new fighters for good. There is Rey, a resourceful survivor on the remote planet of Jakku, who feels destiny within her: she is played by newcomer Daisy Ridley with the brittle determination of a young Keira Knightley. British actor John Boyega plays Finn, a former storm trooper who seeks redemption through betraying his evil masters.

This brings me to the terrific performance from Adam Driver as Kylo Ren, the new Dark Lord with a terrible secret. He is gorgeously cruel, spiteful and capricious – and unlike the Vader of old, he is given to petulant temper tantrums, with his lightsaber drawn, when uniformed subordinates have the unwelcome task of telling him of some new, temporary victory for the Resistance. Driver's almost unreadably droll facial expression is very suited to Kylo Ren's fastidious and amused contempt for his enemies' weakness and compassion. There is a brilliant moment when he uses the telekinetic power of the Force against a laser shot.

The lightsaber contests themselves are of course more athletic than in the 1970s and 1980s but also somehow more humanly interesting: Rey herself needs no condescending advice from men either on unarmed combat or flying the Millennium Falcon.

J.J. Abrams has an instinctive sympathy for the classic *Star Wars* landscapes and lays them out with élan: the switch from galaxies to shadowy forests and of course vast rippling deserts. In almost her first appearance, Rey is seen tobogganing down a huge dune on a sled made of rope. For me it's a reminder that though the first Star Wars

was avowedly inspired by Kurosawa's *The Hidden Fortress*, I think it originally derived its look from David Lean's *Lawrence of Arabia* or even the dreamscapes of Dalí.

But of course this film is part of an entertainment world so huge it need refer only to itself. *The Force Awakens* does not, in the way of other franchises, feel the need to be "dark" – having of course repudiated the dark side. It basically powers along on a great surging riptide of idealism and optimism, that family-movie ethic which some have derided for killing off the dystopian tradition of sci-fi. In fact, *Star Wars* has now gone beyond the sci-fi genre to its own kind of intergalactic quasi-Arthurian romance: that and a return to the world of Saturday morning pictures. *The Force Awakens* is ridiculous and melodramatic and sentimental of course, but exciting and brimming with energy and its own kind of generosity. What a Christmas present.

PRIMER

19/8/05

★ ★ ★ ★ ☆

Your mind might not exactly be blown, but it should get substantially interfered with by this low-fi sci-fi nightmare from newcomer Shane Carruth about two scientists who come up with the world's most important invention in their garage. In its occultist intensity, *Primer* is obviously influenced by Darren Aronofsky's *Pi* and the downbeat menace of Francis Ford Coppola's *The Conversation*.

That doesn't do justice to its prickly originality, however; it sometimes resembles a rabbitless *Donnie Darko* for grown-ups, and the film's paranoid grain is similar in texture to Michael Mann's *The Insider*. In its weird idealism, though, it actually reminded me a little of *The Man in the White Suit*, with Alec Guinness as the sprightly boffin who invents self-cleaning cloth. As in that movie, Carruth believes in portraying scientists not as clichéd geeks or sinister corporate lackeys, but authentic, if flawed, heroes of original thought who achieve astounding things without institutional help.

Primer was head-scratchingly baffling for an awful lot of the time, especially towards the end. Yet it had me completely gripped like nothing else around. This is a type of movie-making that assumes its audience are intelligent adults – and it breaks lots of other Hollywood rules, too! The dialogue is indirect, obscure, technical stuff. The characters do not overcome emotional obstacles; the two male leads are both married men, yet there is no romantic crisis and the invention's success does not test their friendship in the conventional manner. They even get involved with an extraordinary showdown involving a gun and a woman – yet the narrative style is so indirect, so gnomic, that this event occurs in a dramatic zero-gravity.

As for the science itself, it is evidently bizarre and absurd, though precisely how bizarre and absurd I am not qualified to judge. Writer-director Shane Carruth began his working life as an engineer, though his script might yet find its way into the Bad Science column of this newspaper's "Life" supplement. But for all its weirdness and indeed barking madness, *Primer* is a glorious rebuke to a dumbed-down

movie world in which scientific and technological investigation means looking something up on Google.

Carruth and David Sullivan play Aaron and Abe, two guys who have day jobs as engineers, and in fact wear suits and ties in various stages of dishevelment throughout the film. They are developing funky projects on their own time, which they are hoping to punt out to VCs – venture capitalists. One of these is a new refrigeration system that gets things cold without itself being cold. But Aaron and Abe become distracted by the strange way in which certain inert gases, in a homespun metal box, appear to increase the mass of an enclosed object under certain conditions. Five years' worth of mould grows in five minutes. A watch left in there runs backwards. That's right. They have invented a time machine.

It is a giant achievement for this film that you don't laugh out loud. You whisper: "Wow." And this deadpan effect is achieved by very plausible stunned behaviour on the part of the two inventors, who don't turn cartwheels or immediately scramble for winning lottery numbers, but look as if the universe might just split in two, right where they have found the hairline crack. They are too scared to say out loud what they have done.

The insuperable difficulty of time-travel stories comes when you travel back to before your time-travel machine was invented. It is a self-cancelling impossibility which *Primer* sidesteps – kind of – by having its two time-travellers make cautious six-hour hops ahead, before scuttling back to the present. They climb into a great big humming box hidden in a self-storage warehouse from which they are able to make forays into the future, cautiously learn about successful stock prices for companies with trade volumes large enough to camouflage their own bets, before coming back to ground-level. Then they spend that repeat time holed up in a hotel room, where there is no danger of meeting their parallel future-doubles, out foraging for inside information. "Are you hungry?" one asks languidly. "I haven't eaten since later this afternoon."

Does it make them rich? Does it make them happy? Does it, like the treasure of the Sierra Madre, turn them against each other? No, no, and not exactly. There is no obvious moral: Abe and Aaron are tensely in denial about their discovery, which they treat as matter of factly as card-counting at blackjack – the only viable alternative

to going gibberingly insane. They fantasise a little about riches and about punching their boss on the nose, before the storyline takes a weird detour into a subplot about someone threatening a woman they know with a gun at a party. In fine *Groundhog Day* style, they revisit the event again and again, to perfect their technique for disarming the attacker and so impressing the woman's father – an important venture capitalist who can make them both billionaires. The paranoia kicks in when one suspects the other of already spilling the secret to this shadowy Mr Big.

Primer really does spread a radioactive creepiness around its subject, simply by treating it as an everyday conspiracy thriller, and this radioactivity pours relentlessly from the screen. Like its characters, this film is very, very ambitious and rather mad. Yet how much more interesting than the usual low-IQ product elsewhere. It's an exhilarating, disturbing and funny experience.

SOLARIS

28/2/03

★ ★ ★ ★ ☆

With audacity and style, Steven Soderbergh has revisited one of Russian cinema's landmarks, and done so very successfully. He has said that this isn't a remake of Andrei Tarkovsky's 1972 sci-fi classic, but rather a new screen version of the 1961 novel by Stanislaw Lem. Actually, every frame shows that he has been emphatically and intelligently influenced by Tarkovsky, and, just a little, by the Hollywood movie to which Tarkovsky's film was supposed to be a riposte: Kubrick's *2001*.

George Clooney plays Chris Kelvin, the psychologist sent by a US space agency of the future to investigate a troubled mission to the planet Solaris. Something in the planet's make-up means it is functioning like a brain, creating psycho-virtual replicant images of visitors' dead loved ones. Kelvin's beautiful, mysterious wife Rheya (Natascha McElhone) has died some years previously, and Solaris presents him with what he fears and longs for most of all.

Soderbergh has maintained Tarkovsky's strangely, stubbornly undramatic pace, somewhere between languid and somnambulist, and like Tarkovsky he preserves the singular effect of taking us straight from the Earth locations to the spaceship interiors without the traditional, exciting business of blast-off, pulling G-forces, dials and readouts, etc. But, miraculously, he tells the story in a perfectly efficient ninety-nine minutes, whereas Tarkovsky took 165.

It is almost like a commercial miniaturisation, or a *Cliff's Notes* guide to a daunting set text. Clooney himself gives a perfectly acceptable performance, wobbling only when he wakes up to find his late wife asleep beside him. "Goddamn!" he has to gasp while jumping to the other side of the room, a tricky task for any actor. McElhone herself is perfect casting, with just the right unearthly beauty and poise. It's a very impressive achievement, reawakening my heretical doubts as to whether the Russian original needed to be every bit as opaque and lugubrious and slow. The Soderbergh version has nothing to apologise for. It measures up.

SOLARIS

18/2/05

★ ★ ★ ★ ★

Three years after Steven Soderbergh's honourable, high-minded attempt to remake *Solaris*, the 1972 original is now presented as part of an Andrei Tarkovsky season at the National Film Theatre in London. Watching it again shows how that remake, though decently conceived, still did not approach the beauty, the mystery and grandeur of Tarkovsky's movie. What I had earlier remembered as the heresy of objecting to its pace now looks like a wrong-headed attempt to apply Soderbergh to Tarkovsky. They are different people with different views.

Chris Kelvin (Donatas Banionis) is a spaceman whose mission is to visit the planet Solaris, whose alien constitution allows it to function like a brain, and creates psycho-virtual replicants of visitors' loved ones – and Kelvin's wife appears in front of him.

This film takes a vertical leap away from the unchallenging clichés of modern Hollywood sci-fi, and it is very different from Kubrick's own pioneering masterpiece, *2001: A Space Odyssey*, to which it was considered a riposte, though its black-and-white "TV report" scenes at the beginning might have something of the *Strangelove* War Room.

The film asks us to see our own planet as an alien planet, and to look again at the unconquerable alienness of other people, at the enigma of absence and presence, death and life. But these mysteries lend beauty, rather than disenchantment to the view.

ALIEN: THE DIRECTOR'S CUT

31/10/03

★ ★ ★ ★ ★

Here is the original and magnificent best. They really don't make them like this any more. In this newly extended and digitally remastered form, Ridley Scott's 1979 movie emerges not just as the sci-fi shocker we all remember – or think we remember – but a late and unheralded classic of 1970s Hollywood, an offshoot of the *Easy-Riders-Raging-Bulls* era of great film-making.

It is a genuinely frightening movie which makes splatterfests like *The Texas Chainsaw Massacre* look juvenile. With style and intelligence, Scott absorbs the influences of Kubrick and Spielberg, together with movies like *Westworld* and *The Stepford Wives*, but makes a movie quite distinct from any of these. He puts together a white-knuckle intergalactic ride of tension and fear, which is also an essay on the hell of other people, the vulnerability of our bodies, and the idea of space as a limitless new extension of human paranoia. *Alien* also functions as a nightmare-parody of the Apollo 11 moon-landing, which had happened just ten years previously, with all its earnest optimism about human endeavour. And perhaps most stunningly of all, this new version of the movie reveals how it works as a conspiracy satire about state-corporate complicity in manufacturing biological weapons of mass destruction.

Sigourney Weaver stars in the movie which was to make her name and a very great deal of her fortune. She is Ripley, a crewmember of a mining space-ship trudging back home, which is forced to make a detour on receiving a mysterious SOS signal from a deserted planet. Her colleagues include the engineer Parker, played by Yaphet Kotto – and for me nobody's face calls up the 1970s like Kotto's. His associate is the petulant and resentful Brett, played by Harry Dean Stanton. Tom Skerritt plays crew-member Dallas; John Hurt is Kane, an eager volunteer for the job of exploring the planet's surface and Ian Holm is superb as the scientific officer Ash with a sinister secret. Except Ash, these unfortunate souls venture out on their exploratory mission and bring back the horrific unwanted guest.

Weaver's face is the most disturbingly young-looking from this class of 1979 – an ungallant observation perhaps. She is girlish, serious, unlined, almost puffy. But what is so gripping is the way she ages in the course of this film, changing, by the time we reach its harrowing finale, into the toughly self-reliant and sexy take-charge woman who defined her subsequent roles. Her career evolves before our very eyes.

As for the men, John Hurt has an essentially straightforward character; but his reputation as the dark Caligula-force of the 1970s probably meant that he was the obvious candidate to ingest the horrible alien. Interestingly, the famous heart-stopping moment where the alien-embryo jumps out of the egg and grabs Hurt's face happens much more fleetingly than I remembered. Scott cuts away from it quickly, leaving the negative-image, as it were, impressed on our retina, and then concentrates on the insidious and drawn-out horror of Hurt lying on the operating table back in the spacecraft, with the creature clinging to his naked face, pumping its spore down his mouth. The second famous scene, where the gestated child-alien bursts out of Hurt's stomach, is interestingly the only one which doesn't quite hold up. A ripple of indulgent laughter ran round the screening room when we realised it was imminent, and everyone spotted Hurt's packed-up-looking T-shirt.

But there's nothing laughable about the creature itself, a thoroughly insidious and hateful little beast. Scott and editors Terry Rawlings and Peter Weatherley have cut the film so cleverly that we never have a clear notion of what the alien's body actually looks like until the very last shots. Without CGI, Scott kept his alien mostly hidden in the shadows, and it's all the scarier for it. But it's also something to do with our sheer physical recoil. I just didn't want to look at it, and – just as when as I saw it in 1979 – I had to master the overwhelming need to climb behind my seat and hide, gibbering with fear. The very idea of the alien starting the size of a toad, going to hide in the shadows and then emerging the size of a bus with multiple rows of razor-teeth, is skin-crawlingly obscene.

A lot has happened since those days, including knighthoods for Ridley Scott and Ian Holm. Everything about the look and feel of *Alien* is redolent of a different kind of film-making. It's not that the space-technology seems creaky or dated. On the contrary, the

vast alien-architecture of the deserted planet and the newly restored scenes of the victims' bodies' "nest" look like they could have been designed and built yesterday. It's actually that the film looks realer and nastier and more uncomfortable than anything that gets made now: particularly the shrill and ill-tempered arguments between the crewmembers. There is none of our modern screenwriting need to provide story arcs, lenient human touches and love interest. Everything is about mood, fear, violence and horror – and Sigourney Weaver left alone to combat evil without feeling the need to do so in romantic consort with a man. After twenty-five years, *Alien* looks better than ever.

INTERSTELLAR

5/11/14

★ ★ ★ ☆ ☆

Most film-makers think small or medium. Not Christopher Nolan, for whom even big or bigger won't cut it. His new picture is his biggest: biggest event, biggest spectacle, biggest pastiche, biggest disappointment. It's a colossal science-fiction adventure avowedly in the high visionary-futurist style of Kubrick's *2001*, but sugared up with touches of M. Night Shyamalan. Nolan takes on the idealism and yearning from *2001*, but leaves behind the subversion, the disquiet and Kubrick's real interest in imagining a post-human future. What interests Nolan more is looping back to a sentimentally reinforced present.

Interstellar is a muscular, ambitious film with bang-per-buck visuals that broadly make up for the moderate acting and toenail-extracting dialogue. Nolan's stars are Matthew McConaughey, Anne Hathaway and Michael Caine, who have not exactly been encouraged to leave their performance comfort zones, or divert from their usual acting orbit trajectories. McConaughey can be entirely insufferable, though there is one real emotional coup in *Interstellar* that has been slightly overlooked in the Enronising hype the movie has triggered so far.

A global food crisis has turned America into a coast-to-coast dustbowl of unproductive emergency farmland. McConaughey plays Cooper, a retired NASA pilot who, like every other adult, has had to turn to the soil: he is a widower living with two tricky kids, Tom (Timothée Chalamet) and Murph (Mackenzie Foy), and his grumpy father-in-law Donald (John Lithgow).

Cooper is furious at the world's dreary earthbound dullness, and that his kids' school teaches that the Apollo moon missions were a hoax designed to bankrupt the Soviets. He is rightly disgusted at this nonsense: I would have liked to have heard a more explicit speech attacking it, and incidentally making it clear that space exploration was not what did for the Soviet economy. Weird Shyamalanesque signs lead Cooper to a top-secret research station where his old NASA

boss Dr Brand (Caine) tells his stunned ex-employee that Earth is finished, but that a recently discovered "wormhole" in the space-time continuum looks likely to lead us to other habitable planets for resettlement – and that Cooper surely has the Chuck-Yeagerish Right Stuff to lead an expeditionary space-team right away, without training or preparation. His crew will include Brand's daughter, the comely and borderline-preposterous Amelia (Hathaway), along with Doyle (Wes Bentley) and Romilly (David Gyasi).

They get the regulation white suits, Nixon-era tech, long-sleep hibernation routines, flickery video messages from home and standard-issue talking robot called Tars, who is quirky but obedient basically Hal2D2. Wormholes are presented in this film as different from, say, wizards or unicorns: they are supposed to be scientifically real. Kind of. Nolan has been inspired by the work on this subject by the theoretical physicist Kip Thorne from Caltech, who is not just scientific consultant but executive producer, a credit that may be intended as an extra-textual guarantee of authenticity. But, inevitably, these wormholes do the traditional narrative work of a warp drive or time machines. When McConaughey thinks of something mathematically brilliant to do with gravitational pull and fuel consumption, he writes it on his little spaceship whiteboard and Hathaway says frowningly: "Yeah. That'll work!" It's all you can do not to smile at our two rocket scientists.

Nolan contrives a great scene: Cooper comes out of the hole to find that time has slipped forward decades while he's been away hours and twenty years' worth of backed-up video messages reveal that his little kids have turned, in the blink of an eye, into two middle-aged adults, played by Casey Affleck and Jessica Chastain: angry and embittered in their own ways by their abandonment. With some psychological acuity, Nolan shows that grown-up Tom is permanently trapped in psychological defeat. But all the rest is mannerism and starburst portentousness, underscored by Hans Zimmer's score that toys playfully with Straussian themes but relies on heavy, wheezingly religiose, organ-type chords.

The appearance of *Interstellar* is a moment to reflect that Kubrickian sci-fi, like Loachian social-realism of the same 1960s period, was once rooted in the real world: social-realist films could change the law, and sci-fi reflected and even inspired a world in

which the moon really was about to be conquered, and everyone assumed that manned space exploration would continue onwards at the same rate. Today, this is a lost futurism. What remains is style, and Nolan has got plenty of that. He gives us more of his signature universe-manipulations, in which the ground or sea will turn up ninety degrees, like a surreal cliff-face: huge, dreamlike and wrong. It's exhilarating. But *Interstellar*'s deep space turns out to be shallower than we expected.

HARD TO BE A GOD

6/8/15

★ ★ ★ ★ ★

The past is another planet – they do things differently there. This monochrome dream-epic of medieval cruelty and squalor is a non-sci-fi sci-fi; a monumental, and monumentally mad film that the Russian film-maker Alexei German began working on around fifteen years ago. It was completed by his son, Alexei German Jr, after the director's death in 2013. If ever a movie deserved the title *folie de grandeur* it is this, placed before audiences on a take it or leave it basis: maniacally vehement and strange, a slo-mo kaleidoscope of chaos and also a relentless prose poem of fear, featuring three hours' worth of non-sequitur dialogue, where each line is an imagist stab with nothing to do what has just been said.

What on earth does it mean? I have my own theory, of which more in a moment. *Hard to Be a God* is based on the 1964 novel by Arkady and Boris Strugatsky, whose later work *Roadside Picnic* was filmed by Andrei Tarkovsky in 1979 as *Stalker*. It is set in what appears to be a horrendous central European village of the middle ages, as imagined by Hieronymus Bosch, where grotesquely ugly and wretched peasants are condemned to clamber over each other for all eternity, smeared in mud and blood: a world beset with tyranny and factional wars between groups called "Blacks" and "Greys". In the midst of this, what looks like an imperious baronial chieftain called Don Rumata, played by Leonid Yarmolnik, walks with relative impunity: this sovereignty is based on his claim to be descended from a god.

And in a way it is true. Because this current location is an alien planet, eerily and exactly similar to our own, and Rumata is a secret observer or interloper from Earth. How he arrived there is a mystery. There are no scenes of him hiding a spaceship with branches or secretly reporting back to base with some incongruously non-medieval bleeping transmitter. He has gone native so thoroughly, and become so indistinguishable from the inhabitants, that his belief in his origins could be a delusion. But for a medieval earthling

to have conceived such a futurist idea would be a sign of almost extraterrestrial genius – of the sort I'm now inclined to attribute to Alexei German. At any rate, our world and the other world are basically the same: it reminded me of Tarkovsky's *Solaris* in this respect, and also his *Andrei Rublev*. (Another comparison is *Monty Python and the Holy Grail*, in which King Arthur was identified by the peasants, because "he hasn't got shit all over him".)

It really is authentically and awe-inspiringly insane, an unspooling nightmare of dismay, with long takes opening up a seamless surreal panorama. German appears to have overdubbed the dialogue (a little like Alexandr Sokurov) so that wherever they are spoken, lines sound like they are being intoned from within – which makes it all even more like a bad dream. There is a great deal of that Kafkaesque anxiety and wounded humour of the kind that German brought to the satires of the Stalin era from earlier in his career.

Each shot is a vision of pandemonium: a depthless chiaroscuro composition in which dogs, chickens, owls and hedgehogs appear on virtually equal terms with the bewildered humans, who themselves are semi-bestial. The camera ranges lightly over this panorama of bedlam, and characters both important and unimportant will occasionally peer stunned into the camera lens, like passersby in some documentary.

The most startling lines are those in which people complain about the lack of a Renaissance: "Where's the art? Where's the Renaissance?" moans one. In my view, this is the key. Just as in Narnia it is always winter and never Christmas, so in *Hard to Be a God* it is always the middle ages and never the Renaissance. Cultural and human advances never arrive in this alternative Earth, and what we are seeing is not the middle ages but the present day.

This is an ahistorical hell of arrested development, and also the film's satirical core: whatever unimaginable advances have been necessary for interplanetary travel, they have brought us back to this dark-age swamp – and then been forgotten. We laugh at medieval maps that say "Here Be Dragons", but we steadfastly refuse to consider the question of what, if anything, or who, if anyone, lies beyond our own planet, our own earthly existence; a willed blankness as fierce as the dragon-fearing forebears. *Hard to Be a God* creates its own uncanny world: it is beautiful, brilliant and bizarre.

SILENT RUNNING

27/9/18

★ ★ ★ ★ ★

This beautiful and mysterious film is about a wilderness adrift in a wilderness. After some unspecified apocalyptic catastrophe, the authorities have attempted to evacuate the planet's biodiversity by enclosing a representative breeding selection of its flora and some fauna within a giodesic dome and blasting it into space. It is a bristling mini-forest of trees, plants and little animals, artificially maintained on board a ship patriotically named *Valley Forge* as it floats surreally among the stars, while the human curators await possible orders for later replantation on Earth or maybe some other planet.

Crewmember Freeman Lowell, unforgettably played by Bruce Dern, is in charge of tending this mini-Nature, like a mixture of Adam, God, Thoreau and St Francis, often wearing a monastic habit. But he must co-exist with secular colleagues who deal with more banal supplies and equipment, boorish guys who mock Lowell's cantankerous solemnity and blazing-eyed sense of mission, and who drive their golf-cart-type transport buggies carelessly over his flowerbeds and vegetable patches.

Eventually, the crew of *Valley Forge* receive some fateful news. It is the longed-for message that they are allowed to return to Earth, but without their precious eco-cargo. Circumstances dictate that this is now a luxury that Earth cannot afford: Lowell's Eden now has to be blown up. Lowell decides that he must disobey.

What does the title mean? Joan Baez sings two songs which explain, or withhold, the meaning. The first is heard while Lowell earnestly tends to the Creation and ponders the conservation mission statement by his bed. She sings:

Earth between my toes and a flower in my hair
that's what I was wearing when we lay, among the ferns.
Earth between my toes and a flower I will wear when he returns.

Wind upon his face and my fingers in his hair
that's what he was wearing when we lay, beneath the sky.
Wind upon his face and my love he will wear when swallows fly.

Tears of sorrow running deep
running silent in my sleep
running silent in my sleep.

The second is "Rejoice In The Sun" – which plays out over the film's final images:

Fields of children running wild in the sun
Like a forest is your child, growing wild in the sun
Doomed in his innocence in the sun

Gather your children to your side in the sun
Tell them all they love will die
Tell them why in the sun

Tell them it's not too late
Cultivate, one by one,
Tell them to harvest and rejoice in the sun

The natural world's beauty is something we sensuously submit to, but with a tragic sense of its fragility and our own fragility, our impermanence, our own selves which have to be sacrificed to this larger natural world and its central "sun" which goes on even as we die off The "tears of sorrow" are "running silent" in our sleep as we tacitly acknowledge this. The second song speaks of children "running wild" in the sun, but they too are mortal.

We are used to sci-fi movies having a classic "rebellion" scene in which machines or computers creepily reveal that they have minds of their own and won't do what we tell them. In Kubrick's *2001*, Hal won't open the Pod bay doors. In John Carpenter's *Dark Star*, Bomb #20 refuses to abort the countdown. In Duncan Jones's *Moon*, the creepy artificial helpmeet may be duplicitous.

But in *Silent Running*, the human is the rebel. He is the one refusing to open the Pod bay doors. He is the rogue element, not

the machinery. But he can only save his little natural world by killing all three of his comrades: it is, as he comes to see, an unnatural act. This act of murder is the apple-bite in his Eden. And he comes to see that his paradise can only be maintained without the poison of Man: his giodesic Dome is to drift out into space without him, but with a little drone tending to it, with a sweetly innocent little watering can. Can it be that one day, lifeforms will grow and evolve from this new Noah's ark, in a state of artifically contrived innocence? It is a fittingly eerie image for this rich and strange story.

The films that made me consider Tilda Swinton's maxim: "There is no such thing as an old film."

In 2017, I went to an event featuring Tilda Swinton at the Lumière Film Festival in Lyon, at which this unique actor and cinephile was on characteristically elegant and gnomic form. She took to the stage and announced: "There is no such thing as an old film."

As paradox and provocation, it was unimprovable. Of course there is such a thing as an old film ... isn't there? But wait. It is an established beef from critics that people don't talk about old books and old paintings, but talk about "old" films the way they might about an obsolete washing machine. And how old is old? It is only with an effort of will that I realise films released when I started writing about films for a living – *American Beauty*, *The Sixth Sense*, *Fight Club* – are now what most people might consider old films. But that isn't what Swinton meant. With a kind of naive but knowing simplicity, she was asking us to treat films as if they existed in an eternal present, which is what in other contexts art is considered to do in any case. News that stays news. And with cinema still being a relatively young and unevolved art, it is less of a stretch to imagine a movie from the 1950s arriving at the same time as one released yesterday. In some ways, the Swinton maxim flies in the face of everything I have ever been taught: that works of art are embedded in their historical context and to denude them on that, even as a kind of aesthetic thought experiment, is a kind of philistinism. But there is also something liberating and even exciting about it: a remystification of the process of consuming movies.

So here are some of my reviews and essays — some long, some short — on what I shall call "classic" films, although of course having

470

covered almost two decades of new releases, I realise that the distinction between new and old, or new and classic is blurred. There are pieces on two of my very favourite films, which both happen to be in black and white: Scorsese's *Raging Bull* (1980) and Hamer's *Kind Hearts And Coronets* (1949). Thinking about them always makes me think about my mum and dad: they are both now dead, and I think about them both every day. My dad, "A.D." or Albert Desmond Bradshaw was from Belfast and came over to London in the 1950s to be a photographer, and that was where he met my mum, who was working as a secretary. Before they had children, they lived in Highgate, North London and were a rather hip and moviegoing couple-about-town before my sister Sarah and I came along and they moved to a little cottage in Letchmore Heath, near Watford. If I had to cast dad in a film, I think I might use an actor like Adrian Dunbar or maybe John Lynch, although neither of those two men would be exactly right for the way my dad looked as we were growing up — how tall and beanpole-thin (before age and illness made him put on weight), with a perennial expression of droll disapproval and even mockery, which we loved as little kids, but found infuriating when we were stroppy teenagers.

Because dad was always, always taking the mickey. And he had a strange habit of getting the names of famous actors wrong in conversation, and to this day I'm not sure if it was a conscious or unconscious windup. Charlton Heston he always called "Charles Heston" and George Sanders was "George Saunders" (I can never see the name of that famous author now without thinking of dad.) And if you tried correcting him, that would put you mysteriously in the wrong: you would be absurdly pedantic or high-and-mighty, presuming to correct your poor old dad. Actually, come to think of it, maybe an actor like Conleth Hill would be good casting for dad — right for his subversive sense of humour.

It was of course my parents, and particularly my dad, who got me into watching films in the first place. I'll never forget being about ten or eleven and, with Sarah sitting next me at the dinner table, asking my parents about a film which I had seen on the weekend TV listings — something called *Psycho*. (It sounded like something I would buy at the shops, like Rolo, or Toffo, or possibly Omo.) My mum raised her eyebrows, clearly thinking that such things were not appropriate for the dinner table. But dad gleefully launched into a

description of what the first bit of the film was all about – up to and including Anthony Perkins's spying on the naked Janet Leigh in the shower, and even asking me and Sarah if we understood why he should want to be spying on her. (Talking about *Psycho* was the nearest he came to talking about sex apart from an earlier, excruciating birds-and-bees talk which appeared to have no connection or relevance to what he was telling us now.) My memory is that we both nodded, dumbly, although sitting there in suburban Hertfordshire we didn't understand anything about it. A "motel"? Like the motel in *Crossroads* on TV? For all we understood of what dad was telling us about a world of nightmarish sexual obsession and misogynist violence he could have been describing a tea-making ceremony indulged in by some undiscovered creatures on Pluto. The discussion ended there. I had no idea of what the later, legendary "shower" scene was actually going to be like until I watched the film as a student.

And it was my dad who told me to watch *Kind Hearts and Coronets*, the Ealing classic starring Dennis Price and Alec Guinness – it seemed to be on TV all the time in the 1970s. My dad adored it, especially because he was a photographer, and loved the scene in which young Henry D'Ascoyne artlessly greets Louis Mazzini outside the country pub, where he is pretending to take pictures, and exchanges hobbyist camera chat with Henry as a way of getting into his confidences. ("Excuse me. Isn't that a Thornton Pickard? – Yes. Are you a photographer? – Dabble in it. Got a *Sanger Shepherd*!")

To my frustration and shame, I realise that I don't know what cameras my dad used; he quit the business when I was in my teens and sold his equipment. Before setting up in photography on his own, he was assistant to the noted photographer Maurice Broomfield, who recorded the world of postwar industrial Britain and was the father of the documentary film-maker Nick Broomfield. When dad heard that I was reviewing a film by Broomfield, he would insist on whimsically referring to this director by the childhood nickname that Maurice used for him: "Nick-nicks". Dad actually took a lot of photographs for *The Financial Times* in the 1950s, but they are pretty well untraceable, because uncredited, or credited only to Maurice – but I still own a great cache of wonderful photographs that dad took of postwar streetlife in France.

How thrilled dad would always be as we watched *Kind Hearts and Coronets* together on TV – particularly the scene in the darkroom,

which Louis plans as the site of Henry's murder. We had a darkroom in our house: next to my bedroom, as mysterious and wonderful (and inaccessible) as Aladdin's Cave, full of strange chemicals and occult technical devices. Much later on, when I recorded the audio commentary for the DVD edition of *Kind Hearts and Coronets*, with Terence Davies and Matthew Guinness (son of Alec) I was almost speechless with unexpressed emotion. We recorded it four years after dad died of cancer. It was the nearest I could come to a séance, recalling my dad's spirit.

What my dad would have thought of Scorsese's *Raging Bull*, I don't know. I can be reasonably sure he never saw it. After I saw this film for the first time, as a teenager, I got my dad to pick me up and give me a lift home from the cinema (the Screen on the Hill in Belsize Park, North London, now renamed the Everyman). I asked him what he thought of Jake LaMotta. "Just a brawler," said my dad dismissively, who followed boxing a little bit, and went to see matches all the time as a teenager in Belfast, when as a smoker he would contribute to the electric-blue haze that engulfed the ring. He and his mates would roar with laughter at the referee's traditional dismissal of any fighter's whingeing claim to have been rule-breakingly injured, say with a headbutt: "Box on," the ref would say, laconically – a phrase he himself would use in his strong Belfast accent if my sister or I would claim to have been injured in one of our many squabbles. Box on.

Dad loved the cinema, but never went, or hardly ever. It was a habit that belonged to his youth, before the children came along. He watched movies on TV avidly, and with the VHS revolution in the 1980s he would get the big clunky videocassette boxes or record films off the TV and nerdishly write the films' titles in big thick marker pen on the adhesive rectangular strip that you could detach from the backing strip and stick along the video's spine. As a boy in Belfast though, he and his brothers went all the time – at a time when the city had forty movie theatres, and he went (I think) to the Curzon on the Ormeau Road, which was later to be bombed to smithereens in The Troubles. He was especially obsessed with the psychological drama *Gaslight*, directed by George Cukor. He would always be working on his goofy impersonation of Charles Boyer sinisterly purring his wife's name: "Paula....!" – only with a Belfast accent. "Paula!" he would mysteriously boom sometimes at the dinner table and mum would

laugh while Sarah and I were baffled. He loved Carol Reed's 1947 thriller *Odd Man Out* – effectively set in the Belfast of his own youth.

The strange thing is – dad was a kind of film-maker. Like so many other dads, he loved home movies, and had a beautiful Bolex Super 8 cine camera. But it wasn't just that: he scorned people who just shot raw silent footage and showed it like that. He had an 8mm film editor and the Bolex technology allowed him to create a sound strip. He filmed me and my sister playing badminton at the caravan park when we went on holiday. He filmed us in our caravan having breakfast. He filmed us on the beach having our packed lunch. Later, he put on music, sound effects from the LP borrowed from the public library (the "waves breaking" effect, superimposed on a shot of the surf, always seemed eerily as if it was actually recorded at the time) and also created voiceover commentary in a heart-rendingly slow and careful enunciation that made him sound like a Belfast Jacques Cousteau. Incredibly, he even had a go at recording speech, simultaneously taping me speaking with our vintage cassette recorder, and doing a clapperboard style "clap" in front of the camera with his hands before I was allowed to speak. "Thanks, Pete!" he would say afterwards, with an air of judicious reserve. As an actor, I think I did not entirely satisfy the director. The one and only time that he and mum took my sister and me to the cinema was in 1975, to see Sidney Lumet's *Murder on the Orient Express*, the Agatha Christie murder mystery starring Albert Finney as Hercule Poirot; it was showing at the old Watford Empire near the Vicarage Road football ground (I later saw *Jaws*, *The Long Good Friday* and *Blade Runner* at this now vanished place, though without him). Dad looked around at the scuzzy auditorium and professed to be astonished at how clean and fresh everything looked. He said that the cinemas of his own boyhood were like boxing halls, every surface furred with fag-ash and the screen images always flavoured with cigarette-smoke. I think I asked him afterwards what he thought of the film. "Oh pretty good hokum!" he grinned – which was his habitual term of approval for anything, a word I heard for the first time from him.

How did I get on to the subject of my dad? I don't really know. That fallacious and sentimental concept of old films. Ones which live in the heart, and stay young.

474

RASHÔMON

17/6/10

★★★★★

Spy magazine in the 1990s had a witty essay on how, in American journalism, it only took a couple of slightly conflicting accounts of the same event for someone to trot out the word "*Rashômon*". Here is an opportunity to revisit Akira Kurosawa's 1950 film, and to appreciate how the cliché does not do justice to a uniquely disturbing drama.

Rashômon is about a court proceeding, recalled in flashback, relating to a mysterious crime. A bandit, Tajômaru (Toshirô Mifune) is on trial for murdering a samurai (Mayasuki Mori) and raping his wife (Machiko Kyô) in the remote forest. Each of these three figures addresses the court, the dead man via a medium – an amazingly, electrifyingly strange conceit, carried off with absolute conviction. A fourth witness (Takashi Shimura) offers his own version, again different. But it is not just a matter of the witnesses being slippery: crucially, the bandit, the samurai and the samurai's wife each claim to have committed the murderous act themselves, the samurai by suicide. Truth, history, memory and the past … are these just fictions?

One character is told that lying is natural for all of us, and it is in the discrepancies that the essence of our humanity resides. Kurosawa invests the unknowability of the event with horror, suggesting that the three of them somehow chanced upon, or created, a black hole in human thought and communication, whose confusion and violence can never be clearly explained or remembered, as in the Marabar caves in *A Passage to India* with their endless echoing "Bo-oum". Unmissable.

WENT THE DAY WELL?

8/7/10

★ ★ ★ ★ ★

Alberto Cavalcanti's 1942 film, presented as part of a new BFI retrospective, is a wartime conspiracy thriller, a black-comic nightmare and a surrealist masterpiece in which stoutly English-seeming army types reveal themselves to be Nazis, like the reflected figures turning their backs on us in René Magritte's mirror.

The movie's influence shows up in *Dad's Army*, in *Village of the Damned*, and maybe even, with a twist, in Tarantino's *Inglourious Basterds*. In the sleepy English village of Bramley End, dozens of soldiers turn up, needing a billet. They are a fifth-columnist troop of Nazi agents, a revelation made more glitteringly disturbing by the fact that Cavalcanti never reveals how this infiltration has been achieved. The film shows the Germans being capable of violence and beastliness towards civilians – even daringly putting a slant on the World War I rumour about bayoneting babies, a rumour still at that time current, but revealing to us now, in 2010, an eerie innocence of what the Nazis were actually capable of doing.

There's also, incidentally, a pretty good slap at the defeatist French. Propaganda this may have been, but how extraordinary, in 1942 – with the war far from won – playfully to imply that the home-front manners of British decency could easily be an insidious veneer. Thora Hird's performance as the stout-hearted land girl seeing off the Nazis is a joy, as is the infant Harry Fowler, playing the *Just-William*-ish lad who has a role to play in defending these islands. "You know what 'morale' is, don't you?" he is asked. "Yes," he pipes up tactlessly, "it's what the wops ain't got!" The dialogue about exotic animal recipes, when the besieged inhabitants of Paris in 1870 allegedly ate the occupants of the city zoo, is pure surrealist oxygen.

FIVE EASY PIECES

12/8/10

★ ★ ★ ★ ★

The narrative trajectory of Bob Rafelson's newly restored 1970 tragicomedy is from New America to Old Europe. Jack Nicholson plays the poignantly-named Robert Eroica Dupea, an angry, insubordinate smartmouth precariously employed as an oil-rigger out west, and trapped in a toxic relationship with Rayette (Karen Black), a diner waitress and would-be country singer. It is only when we learn that his father is dying, and Robert must travel back to the family home in Washington state for a last goodbye, that we learn that Robert is in retreat from his poisoned vocation: once a brilliantly promising classical pianist, he has angrily given up music, having failed to reach the standards set by his father and by himself. So Robert and poor, uncomprehending Rayette are guests in his ramshackle family home chock-full of decaying and defeated musical talent, like something from Dickens or Chekhov. His pianist sister Partita, played by Lois Smith, is sabotaging her own career with a bad habit of humming along to her own performance in the recording studio, like Glenn Gould. Robert attempts to seduce his brother's girlfriend Catherine (Susan Anspach) by playing her an easy piece by Chopin, and angrily declares he played it better, more valuably and with more integrity when he was eight years old.

The dark comedy of these later scenes is the more potent for being unexpected: Anspach was to play Woody Allen's discontented wife in *Play It Again, Sam* two years later, and Rafelson and Allen are somehow breathing the same comic atmosphere. Yet to see the younger, vulnerable Nicholson crying in his encounter with his silent father is powerful and moving: a glimpse of the human face behind the "devil" mask that would grow in Nicholson's later career. Individual scenes and moments have the improvised feel of things chosen at random from life, a serendipitous, invisibly crafted fragment mosaic. Each constituent part is a gem: the bowling-alley scene, the hitchhiker sequence, the moment in which Robert gleefully jumps

up on a flatbed truck in a freeway traffic jam, and starts playing the upright piano strapped on top of it, while the truck chaotically accelerates off in the wrong direction – an apparently impetuous piece of craziness which actually demonstrates his heaviness and self-hate. This superbly composed film comes as close to perfection as it gets.

PEEPING TOM

18/11/10

★ ★ ★ ★ ★

The grisly release history of Michael Powell's *Peeping Tom* would be enough on its own to guarantee its cult status. In 1960, hostile reviewers and panicky distributors famously sank this film and *Peeping Tom* became hardly more than a rumour, a forbidden text. Successive audiences have been fascinated and appalled that it features the director himself and his then nine-year-old son Columba, in cameo, playing the killer's father filming his child's very real-looking reaction to sadistic "fear" experiments. Arguably, all this has caused the sensational *Peeping Tom* to be overvalued in relation to the rest of Powell's films – and yes, maybe it does sag a little, after its lethally macabre and brilliant opening scenes. But if anything deserves the "dark masterpiece" tag, this does: a brilliant satirical insight into the neurotic, pornographic element in the act of filming, more relevant than ever in the age of reality TV and CCTV. Carl Boehm plays Mark, a focus-puller at a movie studio, part-time porn photographer and compulsive amateur film-maker, who has amassed a huge snuff-porn collection of black-and-white footage showing him murdering prostitutes – with a still more horrendous refinement, not revealed until the very end. *Peeping Tom* has a resemblance to Powell's *The Red Shoes*: it features a dancer played by Moira Shearer and a tortured, Germanic-sounding anti-hero. (How, I wonder, would Anton Walbrook have played the Mark role?) There's hardly anything more extraordinary in British cinema than Mark's Ballardian passion in the seedy photo studio, seeing his new model has an ugly deformity: "They said you needn't photograph my face," she sneers with poignantly empty bravado. "I vant to … I vant to!" he gasps. An intimately disturbing experience.

THE LAST PICTURE SHOW

14/4/11

★★★★★

Peter Bogdanovich's masterpiece from 1971, co-written with the original novel's author Larry McMurtry, is set in a small, dusty, windblown town in Texas at the time of the Korean war, with shades of John Updike's *Tarbox* and *Peyton Place*. (The last picture in question, which is to say the final feature to be shown in the town's dying movie theatre, is Howard Hawks's *Red River*.) Timothy Bottoms and a heartbreakingly young-looking Jeff Bridges play Sonny and Duane, two boys destined to fall out over their interest in the stunningly beautiful, exquisitely manipulative Jacy, played by Cybill Shepherd. This movie is baked hard in the high summer heat of eroticism and sexual tension. Sonny's affair with a melancholy older woman Ruth (Cloris Leachman) is compelling. It begins with the awkward teen agreeing to drive her to the clinic for an illness that is never specified and appears later to vanish, perhaps cured by this glorious adventure. The nude swimming-party scene is inspired: shy Jacy strips off on the diving board, stumbles in, and smilingly shows to a handsome naked boy that the watch her boyfriend has given her has stopped. Bodganovich deserves a special laurel for that quietly superb sequence. The cast, including Ellen Burstyn, Eileen Brennan and Ben Johnson, take their leave in quaint "curtain-call" style final credits that, for some reason, made me want to sob. The soundtrack from Hank Williams and others is a joy. Unmissable.

DON'T LOOK NOW AND NIC ROEG'S RED COAT

18/1/11

★ ★ ★ ★ ★

It is red: red as a wound, or some mutant traffic signal without an amber or a green – the red plastic mac worn by a dead little girl. In director Nicolas Roeg's 1973 movie classic of the English supernatural, *Don't Look Now*, based on the short story by Daphne du Maurier, this mac is what she is wearing when she drowns in the pond of her parents' English country home. Her art historian father, John, later takes his grieving wife Laura away for a healing trip to Venice (of all the ironic waterlogged places), having accepted a commission to restore a church building.

There, two strange, elderly ladies persuade his wife that their daughter, Christine, is speaking to them from beyond the grave, and John sees the red plastic mac flickering by the dark canals, as its tiny wearer rushes and scampers by the water's edge. It is a revelation that comes at the same time as the miraculous revival of their sex life. Their daughter has come back, haunting the dark alleys and echoing waterways of Venice, with a message. Is it a message of forgiveness, of love – or a terrible warning?

All too late, John then discovers a second garment, a bizarre red coat, apparently woollen, like Paddington Bear's duffel coat, being worn by a wizened female-dwarf serial killer who has been terrorising Venice with a string of murders. She claims her final victim, slashing him with a kitchen knife, having first shaken her head enigmatically at him, and us – no, she is saying, you have misunderstood. The red coat symbolises the tonal ambiguity, or superimposition of the erotic and the uncanny. Pathos and grief become fear and horror, overlaid with an insistent sensual charge. The figure in the red coat is both agonisingly vulnerable and menacing, and only in the final moments do we understand that combination.

The death of John and Laura's daughter is the climax of one of the most disturbing sequences in British cinema. After a leisurely weekend lunch, we see uncollected crockery, cutlery and a wisp of cigarette smoke from an ashtray. The little girl is outside, messing

481

around, playing with a toy soldier, a sort of Action Man with a recorded voice; but for some reason, the recorded voice is not a macho male warrior's but a woman's. Her brother is riding his bicycle. Christine is also playing with a ball, white with a red pattern in the style of Escher, which makes the ball's shape appear to undulate as it rolls along – another touch that subliminally discombobulates the viewer.

Then there is that red mac. Why on earth is this girl wearing a rainproof mac on a fine, warm summer afternoon? Evidently, she is very attached to it, though a waterproof garment is the most ironically wrong thing to be wearing. Roeg once told me that he had extensively rehearsed this scene with the girl's father present, but with her wearing a swimming costume. When the time came, however, to shoot the scene for real, and the child was fully clothed in the famous mac, the parent simply couldn't stop himself rushing forward and trying to grab his daughter out of the water. Wearing clothes was what made this moment so painful, so transgressive.

And how exactly does she drown? Common sense would suggest face down, grabbing for the lost ball, attempting to swim, scrabbling, desperately floundering. But no. In a later image we see Christine sinking face up, like Millais's portrait of Ophelia, her face receding like a memory in the depths. Shakespeare's Ophelia is committing a sort of semi-intentional suicide, while Christine's death is a terrible accident, and yet the staging here implies something willed – a grotesque, parodic christening ceremony which is a sinister symbol or prophecy of another death still to come.

Christine's mother and father are played by Donald Sutherland and Julie Christie, and their relationship is the most authentic portrait of a marriage that I think I have ever seen in any film. Watching the movie it is easy to believe that the actors are in fact married, and Roeg's portrait of Venice, with its intelligent, non-tourist locations, is a real vision of a real, working city. And, of course, it is in Venice that John and Laura have sex for the first time since their daughter's death, perhaps the best, tenderest, if not precisely the most real sex scene in cinema history. Famously, Roeg constructs a sequence in which their love-making is interspersed with their getting dressed again and preparing to go out to dinner. Generally, sex scenes in the movies are between couples who are having sex for the first time.

This shows a couple having sex for the nth time – having married sex in fact. And it is the disappearance and reappearance of clothing that is so startling: first naked and then clothed and then naked and then clothed, Laura and John demonstrate the routine of married sex, and tacitly make a claim for the intimacy and excitement that triumphantly survives the accomplishment of the sex act itself. Roeg even shows the man post-coitally zipping himself up: that unglamorous, faintly absurd post-sex moment.

Don't Look Now is drenched with sex and displaced sexual longing, given a dark eroticism by the shadow of death. Roeg and his screenwriters Allan Scott and Chris Bryant made important changes to the original short story: the sex scene was entirely their invention, and it was originally John's wife Laura who wore a red coat, not Christine or the dwarf serial killer. When John sees a vision of Laura in his own future funeral procession in Venice, after she has left for England, it is this red coat that stands out.

Sex and fear are embedded deeply within the film's DNA in ways that even the movie's biggest fans perhaps might not quite grasp. For Daphne du Maurier, "Venetian" was her private word for lesbian, and she herself had a lifelong struggle to come to terms with her own homosexuality, never far from the surface. Furthermore, "going to Venice" was her private code for having a lesbian sexual adventure. Crucially, Du Maurier herself, long before this story was written, went to Venice to get over the death of someone dear to her – her lover Gertrude Lawrence – and it may have been on this visit (although she made a number of literal visits to Venice) that she herself mistook a dwarf for a child. Denial and fear and excitement are transformed, in this story, into a tale of supernatural longing and horror.

The movie shimmers with Du Maurier's ghost, and the ghosts of other stories and other connections: she in fact wrote another story set in Venice, entitled *Ganymede*, about a gay man addicted to his rapture at boys, a story obviously influenced by Thomas Mann's *Death In Venice*, and Roeg's film has perhaps inhaled some of the unwholesome, narcotic atmosphere of Luchino Visconti's movie version, in which a child is obsessively tracked, in the shadow of death.

In *Don't Look Now*, Roeg is careful to exclude, as much as possible, the colour red from his screen, so that Christine's red mac becomes

even more starkly visible. In fact, there is one important moment where he permits another red garment to be visible: and that is the cardinal's red hat. It is the cardinal who oversees John's restoration work on the church, an apparently kindly, worldly, enigmatic man who senses some unnamable catastrophe is approaching but can do nothing but pray. The church, like the police, are ambiguous figures of authority, at best watchfully neutral in the calamity that John is facing.

The colour red has its own history in Venice. In the sixteenth century, Jews were forced to wear red as a distinguishing mark, a law changed to yellow when it became clear that it made them too much like cardinals. John's agonised glimpses of Christine's red coat has another literary echo: in Proust's *Remembrance of Things Past*, the narrator has a famous journey to Venice, and it is in Venice that he sees, in the distance, the distinctive cloak of an aristocratic fraternity, and with a stab of pain it instantly reminds him of the elegant gown worn by his lost love, Albertine – a red gown.

Director Roeg, his writers Scott and Bryant and, perhaps most importantly, his costume designer, Marit Allen – who went on to work on Stanley Kubrick's *Eyes Wide Shut* and Ang Lee's *Brokeback Mountain* – created a shape-shifting garment in that sinister red item. In its two guises, the child's mac and the serial killer's coat, it exemplifies Joyce's two faces of tragedy, pity and terror, the one showing us the effects of our unhappy condition, the other showing its source. The child has died, but the horror of the situation isn't that we are left grievingly alive but that we must join her, and sooner than we think. The red coat conceals someone terrible, a non-child, an anti-cherub of mortality, grinningly shaking her head as she slashes our throat. The awful truth about what's in store for all of us is stripped naked at last.

I KNOW WHERE I'M GOING!

24/8/11

★ ★ ★ ★ ★

I've just returned from the Isle of Mull in Scotland. It was a holiday which quickly assumed the character of a secular pilgrimage to the key locations in the 1945 Michael Powell/Emeric Pressburger classic *I Know Where I'm Going!*, a sublime and utterly distinctive romantic comedy, set towards the end of World War II.

It stars Wendy Hiller as the headstrong, self-possessed and rather conceited young Englishwoman, Joan Webster, who travels to the Hebrides to marry a wealthy industrialist on the remote island of Kiloran. The title of course reflects her confidence and hubris. I was incidentally struck by Emeric Pressburger's description of his creative process, quoted in his biography, *Emeric Pressburger: The Life and Death of a Screenwriter*, written by his grandson Kevin Macdonald: "I never sit down to write the real script until I know where I'm going and I've worked out the rhythm and so on beforehand."

Foul weather strands her on the neighbouring island of Mull the night before their wedding – the first time in her life anything or anyone has ever interfered with her plans. Yet, little by little, she finds herself beguiled by the island and the islanders – in particular Torquil MacNeil, a young naval officer who also happens to be the rightful Laird of Kiloran, a title he wears modestly but proudly. He is played with delicacy and forthright charm by Roger Livesey.

Before I left, the film writer and documentary maker Mark Cousins – who has a passionate love of both this movie and Mull itself – lent me his Ordnance Survey maps which marked the key spots, including the Carsaig pier from which Joan wistfully looks out towards a distant Kiloran (this island is a fictional spot on the site of the genuine Colonsay). It also marks the telephone box which is sited, absurdly, on a steep hill near a rushing waterfall rendering all phone conversations all but inaudible. Pretty overexcited, I tweeted a picture of myself in this legendary spot.

Mull is beautiful, and its richness and calm, together with the extraordinary majesty of its landscape, are well represented in Powell

and Pressburger's film. It would be perverse not to recognise its gentleness and overwhelming charm, but somehow watching it on DVD in the restful context of Mull had an interesting effect on my reading of the film: it brought out its darker, more subversive, more peppery side.

It really is quite odd that Joan repeatedly calls her father "darling", and chooses to reveal to him that she is getting married to Sir Robert Bellinger, a man roughly her father's age, not at their home, but at a somewhat racy, noisy nightclub. It's the sort of place where attractive young women might well meet their sugar daddy boyfriends. Her father is understandably bemused to be told that she is leaving Manchester for Scotland that very night on a sleeper, a rare luxury which Sir Robert's connections have secured for her.

As she is settling in to her compartment there is a moment which I used the freeze frame to savour. The camera pans along the carriage from the outside and we glimpse the young couple next door to Joan. You see them for no more than a moment. Their intimacy is fascinating. They could of course be a bored married couple, but they look loved up to me. It is a brilliant, subliminal flash of erotic adventure.

Of course it is clear that these faintly unwholesome overtones of older-man infatuations and the Electra complex are supposed to be part of the shallow townie world which Joan will, undeniably, abandon in favour of real values in Mull. But there are dark notes here as well.

On the first night of being marooned on the island, both Torquil and Joan find themselves having to stay in a house in Carsaig, owned by a childhood friend of Torquil – Catriona, played by Pamela Brown. With a certain type of Scottish patrician breeziness, together with almost sensually wild unconvention, Catriona welcomes them. Torquil casually reveals that she is a childhood friend, that her husband is away in the Middle East and that her children are at boarding school. Obviously, there is a spark between Torquil and Catriona. Were they childhood sweethearts? Adult lovers? Catriona instantly appreciates the growing, illicit bond between Torquil and Joan, but something in it does not entirely please her. That arched eyebrowed look of shrewd scepticism and scorn has a glint of something unhappy, jealous or even dangerous in it. When Joan conceives her

crazily dangerous plan of sailing across to Kiloran in stormy weather, Catriona looks almost contemptuous, even cruel. She savours Joan's desperation to get away, to avoid the truth about her feelings for Torquil, and to imprison herself in a boring but wealthy marriage.

Watching *I Know Where I'm Going!* in Mull, I realised who it was that Pamela Brown's Catriona resembles: Kathleen Byron's Sister Ruth in *Black Narcissus*. Ruth is obsessed with what she imagines to be Sister Clodagh's love for Mr Dean; on a much gentler, saner level, Catriona has the same approach to Joan and Torquil. The difference is of course that Catriona is not deluded, she is fundamentally lucid and she is someone who wishes them both well. She is Dr Jekyll to Sister Ruth's Mr Hyde. But there is something similar: a tiny flash of jealousy and frustration. She provides a tang and savour of sex in the movie. It isn't too far-fetched to wonder if she is still in love with Torquil, and even if she entertained hopes of what might happen when he was here on leave, with her husband and children away. In which case there is something selfless and noble in her taking it upon herself to make it clear to Torquil (the silly chump) that Joan is trying to leave Mull because she loves him. Another type of film might have experimented with developing Torquil and Catriona's complex backstory – and even made Catriona the villain of the piece.

It's such a great movie: if you're watching it again on DVD, don't forget to freeze-frame that sleeper-compartment scene.

THE MEANING OF *KIND HEARTS AND CORONETS*

24/8/11

★ ★ ★ ★ ★

The Ealing genre reached utter perfection with this superb black comedy of manners, made in 1949, directed by Robert Hamer and adapted by Hamer with accomplished farceur John Dighton from the 1907 novel *Israel Rank*, by Roy Horniman. Dennis Price gave a performance which he was, sadly, never again to equal as Louis Mazzini, the suburban draper's assistant who becomes the most elegant serial killer in history. Finding himself by a quirk of fate distantly in line to a dukedom, and infuriated by this aristocratic family's cruel treatment of his mother, he sets out to murder everyone ahead of him in line to the ermine. All the members of this complacent family are famously played by Alec Guinness in various guises, and this multi-performance is superbly detailed and differentiated: not a pantomime dressing-up turn, but an inspired tour de force, as if eight different excellent actors from the same family had somehow been brought to the screen.

Joan Greenwood is in her element as the honey-voiced siren Sibella, with whom Louis is briefly entranced, and Valerie Hobson is utterly convincing as the morally pure Edith D'Ascoyne, whom Louis is to marry. (In 1963, Hobson was poignantly to find a similar "loyal wife" role in real life, standing by her husband, disgraced politician John Profumo.) This was Robert Hamer's masterpiece, and though his troubled life and career were sadly brief, it surely entitles him to be mentioned in the same breath as, say, Max Ophüls, and to be considered one of the great British directors.

The source novel, *Israel Rank*, is by the Edwardian actor-manager and author Roy Horniman – a work which attained a kind of cult fascination by virtue of being, until very recently, obscure and almost impossible to find. *The Daily Telegraph* journalist Simon Heffer, with enormous energy and resourcefulness, tracked down a copy and wrote about the book's importance, and it is Mr Heffer who has the distinction of having single-handedly retrieved this novel from oblivion. It is witty, tremendously written and a real page-turner, and

is now republished as a print-on-demand item from Faber Finds, with an introductory essay online by Heffer.

There is a very specific reason why *Israel Rank* has been shrouded in reticence and unspoken embarrassment. In the movie, Dennis Price's social-climbing serial killer was supposed to be half-Italian: in the book he is a Jew, whose first name speaks for itself and whose second name hints punningly at social hierarchy but also, unquestionably, at a bad smell.

The adaptation's change – which of course arguably offends Italians – could be read as a tacit admission that one of our greatest films is taken from a dubious source, and that there is something questionable about the idea of a Jew (actually his father is Jewish, his mother a Christian) insinuating himself into the intimate friendship of the English nobility, and then murdering them, his cunningly concealed ambition feeding parasitically off the dead bodies of these aristocrats. The most deliriously inspired homicide – which is not used in the movie – is Israel's murder of a baby boy by wiping the infant's face with a handkerchief impregnated with the spores of scarlet fever. That comes really very close to the ancient blood libel.

So is *Israel Rank* the most obviously antisemitic novel of modern times? Simon Heffer argues forcefully that it in fact satirises anti-Semitism, daringly conjuring up the antisemite's most paranoid fantasies, though in doing so "skirts dangerous territory, and possibly even wades into it". This I think is true, and I think Horniman is also, specifically, satirising English attitudes to the career of Benjamin Disraeli: his wicked antihero at one stage relaxes with a copy of Disraeli's novel *Vivian Gray*. In its dreary suburban setting, it is also a premonition of the work of Patrick Hamilton.

No lover of the film will want to remain in ignorance of this book; reading it, while imagining Dennis Price's musical voice in your head, is like having access to a delicious deleted scene. But it also has the unfortunate effect of smudging what I can only describe as the film's innocence, if a film about an unrepentant serial killer can be described in this way. The original is, arguably, chancy and provocative in a way that the film isn't. Offensiveness has a certain worrying potency.

Set against this is the fact that the changes made by Hamer and dramatist John Dighton immeasurably improve the book. The

murders onscreen have a cantering gaiety and narrative momentum which Horniman lacks. The book has an unwieldy third love-interest for the protagonist, a woman whose abject love for him creates the plot twist which saves Rank from the gallows. But Hamer and Dighton stick to just two women in Louis's life – Sibella and Edith – creating a simpler dilemma which is far more satisfying. Finally, Hamer and Dighton come up with a completely original final act, devising an irony by which Louis is arrested for the one murder he never commits: this is a masterpiece of suspense, much better than *Israel Rank's* final anticlimactic and implausible sloppiness.

Most importantly, removing the "Jewish" part of the book makes it a universal story. *Kind Hearts and Coronets* is a brilliant satirical parable for career ambition: anyone who has ever yearned enviously for a certain job or position – and tormented himself with those people ahead of them in the pecking order – will recognise and perhaps secretly admire Louis for his criminal daring. *Israel Rank* was a minor classic for its time; *Kind Hearts and Coronets* is still a major classic now.

I want to close with something about the film's most interesting single moment. It is the close-up on the icy face of Sibella – the flighty coquette who cruelly rejected poor Louis's heartfelt marriage proposal – when Louis reveals to her that he has been offered a job in the Chalfont private bank.

It's not a big close-up: the framing that cinematographer Douglas Slocombe contrives is just the head and shoulders. But that image of the minxy and duplicitous Sibella is startling nonetheless. It is a very human and banal reaction shot: very unlike the images of womanhood in the rest of the film. Her face shows a cold, hard surprise and dislike at what she has discovered, realising how she has very seriously miscalculated something relating to her own future and been fatefully bested in what she now realises has been an erotic duel between her and her would-be lover Louis.

For Louis himself, this tiny but exquisite moment is perhaps his greatest moment of triumph – greater than actually becoming the tenth Duke Of Chalfont. The film has already shown us how his aristocratic mother had been rejected by the Chalfont family for getting married to an Italian opera-singer (Louis's father). Now

Louis has vowed to avenge his mother and his own humiliatingly poor upbringing by murdering all the members of this family until he can place the coronet on his own head. But the spirit of revenge has extended to Sibella herself, the pretty, but capricious girl with whom he has been hopelessly in love since schooldays, and whose father took him in as a lodger out of pity after Louis's mother died. Louis impulsively proposed marriage and Sibella contemptuously rejected him because he was poor – preferring the boorish but well-off Lionel. And now Louis has just casually told her he has got a job in the Chalfont banking firm: that it is he, not the oafish Lionel, who is going to be seriously rich.

After his pathetic marriage proposal was rejected, Louis grimly determined to murder all these people – and their children if need be – in order to become Duke. However bizarre and exotic and absurd this situation is, this moment is very relevant to sexual politics in the twenty-first century: virtually a parable of sex, power, money and status.

In his naivety, Louis had believed in his proposal. Conceited though he might have been – and quietly spiteful as he later reveals himself to be – Louis believed that his love had a chance. He had thought that, on a level playing field, he could win Sibella's heart: with a compliment, a present (we see him offering a box of chocolates), a joke, a dance, a kiss, a gallant proposal of marriage. But of course we can see it isn't the case, and would probably have failed even with someone more generous than Sibella. So Louis goes away and gets on with the business of murdering people.

He discovers something that all men discover – all men, at any rate, who have been rejected. He discovers that he must remove himself from the arena of love, get out of the dating game, and just invest in his own prestige, rise up in society. Because it is only with that heightened prestige that he has something to offer. And like many men, he might also discover that this heightened prestige is in fact more important to him than the rejection that originally inspired it: more important than love. After all, Louis is almost casually insolent about saying that his news is nowhere near as interesting as Sibella's: poor Sibella had begun the scene by dancing around the room celebrating the fact that a date for her now shabby-seeming wedding had been set.

In a later voiceover, Louis congratulates himself on his "revenge" on Lionel and quotes the old maxim about revenge being a dish best enjoyed cold. Well, Lionel had been pretty beastly to him. But of course his revenge is not on Lionel. It is on Sibella. There is an unlovely batsqueak of misogyny in Louis at this moment, for all his silken elegance. He has illicit sex with his defeated enemy: that is what makes his triumph delicious. And that is what Sibella's close-up tells us: she realises things have gone wrong for her. But that close-up tells us something else. In the final scene of the film, she is going to get a revenge of her own. Even colder than this one.

MARTIN SCORSESE'S *RAGING BULL*

24/10/11

★ ★ ★ ★ ★

When I first saw it in 1980, I was nineteen years old; it was at the Screen on the Hill cinema in North London, now renamed the Everyman Belsize Park. When it was all over, I felt exhausted, but also possessed of a strange need to scream, or laugh, or run all the way home, or pick up parked cars and flip them over. The film was Martin Scorsese's *Raging Bull* or, to give it the title that appeared on screen, *RagingBull*; it was run together, like *GoodFellas*.

It starred Robert De Niro, electrifyingly and horribly charismatic in the role of 1940s middleweight boxing champ Jake La Motta. In the ring, he was a graceless brawler, outside it a repugnant bully and wife-beater who was in thrall to the mob. The film actually suppresses many of the nastier aspects of La Motta's life and essentially takes him at his own lenient estimation of himself, emphasising what was allegedly his initial, pig-headed resistance to gangsters' parasitic involvement in his career. The effect is to combine stunning scenes of brutality and self-destruction with a lethal, even outrageous sentimentalism and self-pity. It's all captured in dreamlike, pin-sharp monochrome cinematography, stark images reproduced like a Weegee crime scene. The result is operatic and mad and compelling.

The fight sequences themselves, with the camera swirling and swooping around the ring, and the soundtrack sometimes gulping out into silence and sometimes moaning with weird half-heard animal noises, are unforgettable: an inspired reportage recreation in the manner of a *Life* magazine shoot, which also looks like expressionist newsreel footage of a bad dream. The punch-ups that break out in the crowd at that first fight ... the screaming woman trampled underfoot, glimpsed and then instantly forgotten about ... it still scares me.

I can't think of any other film which so persuasively shows a character getting older. Young La Motta in the ring and old La Motta on the skids, pensively going through his monologue routine in the dressing room before his night-club act: they are the same person,

yet different, and of course this was partly because of the weight De Niro famously piled on for the part.

The young fighter is tense, moody, seeming to vibrate like a plucked guitar string: he erupts with anger, which then morphs either into sullen resentment or giggling mockery, as if it is his victims who are behaving absurdly. I remember the first time I saw this film, being utterly fascinated by Jake, self-consciously seated at night clubs or restaurants, accepting the proffered handshakes of fans or gangsters negligently, with a wince of polite impatience or discomfiture. Guiltily, I thought: imagine being that cool!

Old La Motta is quite different. With an audacious absence of Method acting, he drones his way through Brando's *On the Waterfront* speech, thoughtfully puffing his cigar. Actually, De Niro does a much stronger impression, when young Jake confesses to his brother his darkest anguish: "No matter how big I get … I ain't never gonna fight Joe Louis." That nasal, glandular whine: for a moment, it is pure Brando.

Joe Pesci is superb as Jake's pugnacious, exasperated brother and manager Joey. Frantic with worry and impatience at first; later he appears older, balder, with a thin moustache, utterly unable to respond to Jake's boorish attempts to effect a tearful reconciliation in the street. Unlike Charley in *On the Waterfront*, Joey is the brother who really is, for his sins, looking out for Jake. He gets him a championship shot. But first, of course, Jake must – in the time-honoured fashion – take a dive. At the height of his prestige, he has to be matched with a patsy on whom bookies' odds are sky-high. The mobsters bet big on the no-hoper and Jake has to lose. In return, the wiseguys will arrange for a title fight.

This grotesque ordeal for Jake is, in its way, at the very centre of the film's meaning. It isn't simply about the money: it is a dysfunctional, abusive ritual in which he has to be emotionally mutilated like a gelding by his sneering mob sponsors. Like all contenders, he has to be humiliated, shown who's really in charge. He must bow the knee to East Coast boss Tommy Como, played by Nicholas Colasanto, who in his creepy avuncular way paws and slobbers over Jake's wife Vikki, played by Cathy Moriarty, in his hotel suite before the fight. After Tommy has gone, Jake screams abuse at Joey and Vikki, whom at the height of his paranoia he will suspect of having an affair.

Moriarty is tremendous; like Jake's first wife she is utterly bemused and disgusted and scared by his behaviour, and simmers with self-reproach at having put up with it for as long as she has. Yet Vikki's first date with Jake at the crazy golf course is an extraordinarily romantic sequence: the clear sunlit sky of this atypical outdoor scene shows up like a sugary-wet expanse of pale grey across the screen. It is so weirdly innocent, even while it crackles with sexual tension, even when Jake casually acknowledges the existence of his wife who he says must be "out shopping" when he takes Vikki back to the apartment. Jake had first met Vikki while she was hanging out at the swimming pool. I can still remember my nineteen-year-old self's awe at how Jake provokes a gorgeous, reluctant smile from the incandescently beautiful Moriarty. Throughout university, I was obsessed with this film, and watched it about once a month.

Cut to thirty years later, and I am at this year's Cannes. As a juror on the *Un Certain Regard* section, I have the headspinning honour of being at an official dinner seated near De Niro. My fellow juror Geoff Gilmore, artistic director of the Tribeca film festival, cheerfully advises me to go up and introduce myself, and so I do. Jittery and numb, I walk towards the great man's unmistakable profile – he is talking to someone very important. Am I going to pass out? Well, I get his attention and stammer some sycophantic nonsense.

Did I tell him about when I first saw *Raging Bull*? I think I might have explained that the Screen on the Hill is now called the Everyman Belsize Park, but that the name change happened only recently. I can't remember. De Niro smilingly shook my hand: briefly, negligently with a wince of polite impatience or discomfiture. Deja-vu made my awestruck expression even more bovine.

CASABLANCA

9/2/12

★ ★ ★ ★ ★

Seventy years on, this great romantic *noir* is still grippingly powerful: a movie made at a time when it was far from clear the Nazis were going to lose. Humphrey Bogart is the tough, cynical American with a broken heart, brooding over chess problems in the private room of his bar in the Vichy-controlled Moroccan capital. Ingrid Bergman is his former lover Ilsa making a fateful reappearance; Paul Henreid is her husband, the Czech resistance leader Victor Laszlo to whom Rick gallantly concedes first place in Ilsa's heart. It is filled with great lines, although my own favourite actually isn't much quoted. An agonised Bogart says: "I bet they're asleep in New York; I bet they're asleep all over America." Traditionally glossed as his wakeup call for isolationist Americans, it also speaks of his own agonised wakefulness and weariness. J. Hoberman's new book *An Army of Phantoms*, about cinema and the Cold War, notes that just five years after this, *Casablanca*'s screenwriters Howard Koch and Julius and Philip Epstein became one of the first wave of victims of the HUAC Red Scare, fired from the studio by Jack Warner.

THE BAD AND THE BEAUTIFUL

19/4/12

★ ★ ★ ★ ★

Re-released sixty years on, Vincente Minnelli's Hollywood black comedy stars Kirk Douglas as Jonathan Shields, the mercurially brilliant but widely hated producer: no one in 1952 used words like "bipolar". He is remembered in flashback, like a lower-rent Charlie Kane. Three former colleagues are approached by Walter Pidgeon's world-weary studio boss, begging them to work with Shields again: director Fred Amiel (Barry Sullivan), screenwriter James Lee Bartlow (Dick Powell) and star Georgia Lorrison (Lana Turner). Each icily refuses, and we see why: three intimate personal betrayals, of increasing horror, which nonetheless furthered the victims' careers in the long run. Shields's relationship with Georgia is fascinatingly ambiguous: Georgia's actor father once gave young Shields a deflowering introduction to manhood and the business. Now, by building up Georgia, he seeks – revenge? Redemption? Hollywood here looks diabolically seductive.

JAWS

14/6/12

★ ★ ★ ★ ★

Here it comes, looming back out of the water: a restored print of Steven Spielberg's serial-killer masterpiece from 1975; a film that apart from everything else, invented the "forensic-autopsy-running-commentary" scene, delivered by a scientist trying not to puke. It was adapted from Peter Benchley's filthier bestseller: a killer shark with the cunning of a U-boat commander is eating swimmers, and threatening to destroy the precarious prosperity of a US beach resort over the 4 July weekend. As a picture of pre-bicentennial angst, *Jaws* stands alongside Robert Altman's *Nashville*. Richard Dreyfuss, Roy Scheider and Robert Shaw are the three glorious hombres of 1970s Hollywood tracking down the shark, whose presence is signalled by John Williams's orchestral theme, the creepiest since Herrmann's *Psycho*. All have something to prove: Dreyfuss is oceanographer Hooper, a superbly natural, utterly real performance, who has to show he's man enough to take down the big fish. Scheider's police chief has to redeem himself after participating in that contemporary political phenomenon, a cover-up: he withheld information about the shark to protect tourism. And Shaw's grizzled seadog Quint is haunted by a chilling wartime memory. Don't listen to the cynics who claim the shark looks iffy now. This is a suspense classic that leaves teeth-marks.

PSYCHO

23/7/12

★ ★ ★ ★ ★

"I declare!"
"I don't! That's how I get to keep it!"

Hitchcock's macabre pulp masterpiece from 1960 begins with the most dangerous piece of tax evasion in movie history. Sweaty, leery, cowboy-hatted businessman Tom Cassidy has come into the office of a Phoenix realtor, George Lowery, to close a house purchase in cash: an ostentatious wedding present for his eighteen-year-old daughter, due to get hitched the next day.

He boasts to the secretary, Marion Crane, that the $40,000 he's waving under her nose has been amassed without reference to the tax authorities. He even brags that he never carries more than he can afford to lose. In a shrewd instant, Marion reaches a conclusion Hitchcock cleverly never spells out. If she steals his money, he can take the hit and won't call the cops because that would alert the IRS. She's right. As things turn out, Cassidy only engages a private detective, the stolid Arbogast. But her fantasies of Cassidy's rage-filled threats about getting his money back are weirdly prescient: "If any of it's missing, I'll replace it with her fine soft flesh!" What a very psycho image.

Lost and disorientated on the rainy highway, runaway Marion winds up in a remote motel – not so different from the hotels where she enjoyed furtive lunch hours of passion with her lover. It is run by a strange taxidermy enthusiast, Norman Bates, played by a saturnine Anthony Perkins.

Hitchcock's low-budget, black-and-white shocker looks like a bad dream of crystalline clarity and detail, ushered in with crazed operatic intensity by Bernard Herrmann's superb score. There are moments in which it appears to decelerate to a floating slo-mo: Arbogast (Martin Balsam) climbing the stairs; Marion's sister Lila (Vera Miles) approaching Norman's house, her eyes stark and terrified. And then Hitchcock will stamp hard on the accelerator

pedal, most famously for the shower scene in which Marion (Janet Leigh) will meet her destiny. For all its jagged cuts and shrieking violin stabs, it somehow seems as substantial as an entire second act, as if half an hour's dramatic incident has been compressed into one dense and horrible mass. (It took Hitchcock seven days to film, out of a thirty-day shooting schedule.)

Psycho is the sort of brilliant, nimble, cheap movie you'd expect from a young hotshot at the beginning of his career. But Hitchcock was sixty-one, known for classy and elegant films with high production values, and he was reaching what many saw as the end of an illustrious career. Yet *Psycho* gave Hitchcock a quantum leap to further greatness.

The story took its inspiration, partly, from the true-life horror of Ed Gein, the notorious 1950s serial killer who made bizarre trophies from his victims' skin, their fine soft flesh. He, in turn, was said to have been a reader of pulp magazines such as *Unknown Worlds* and *Marvel Tales*, which featured the work of Robert Bloch, who later wrote the novel, *Psycho*, on which the movie was based.

My favourite part of the film is something only an Englishman could have devised. Marion is driving out of town with the stolen cash, having told her boss she was taking the money to the bank and then going home to bed with a headache. While waiting at a red light, she actually sees her boss with Cassidy: their eyes meet, and she can't help herself giving him a little polite smile of greeting. But he returns it with a puzzled frown, and she looks away, mortified, stricken with embarrassment. It would be out of the question to shout some absurd excuse from the driver's-side window. The moment is superbly played by Janet Leigh: this is an unbearably tense and horribly real scene – different, in many ways, to the remaining rococo fantasy of strangeness and fear.

The film's inspiration, for me, resides in the twin worlds of motel cabin and house. The rooms themselves are stark, bright, featureless, anonymous and modern: models of the twentieth-century American service economy. But the mouldering house on the hill behind comes from the nineteenth century, a dark suppressed history, a world of Edgar Allan Poe. The house is gloomy, cluttered, infested with a secret personality. As the door opens, you can almost smell the damp and furniture polish. On her brief, horrified tour, Lila finds

a little toy rabbit (does Norman still take it to bed with him?) and Beethoven's *Eroica* still on the turntable.

As Marion undresses in cabin number one, Norman is the creepiest-ever boy next door, spying on her through a peephole. Earlier that evening, he'd invited her to supper: "I don't set a fancy table, my kitchen's awful homey!" Perkins turns the second syllable of "homey" into a weird, bashful, gulping little laugh, with a vulnerable, boyish grin. Has he rehearsed this unctuous line in his head? Did he use it on the other two missing women? Later, we will see his second grin, his mother's grin: sinister and predatory and defiant, bared at the audience directly. And with pure outrageous chutzpah, Hitchcock superimposes the skull's death's-head subliminally on his grin, and then dissolves to the radiator grille of Marion's recovered car. Was there ever a directorial flourish like it?

I sometimes wonder what happened the day after the theft, the wedding day of Tom Cassidy's daughter. The ceremony probably took place in a church like the one from which we see Sheriff Al Chambers emerging after a Sunday service. Was Cassidy (so tremendously played by B-movie stalwart Frank Albertson) beaming and proprietorial and still unaware of his loss? Was he still complacently planning to announce the gift of a house at the reception? Or did he already know something was up? He and Lowery might have gone to the bank after they saw Marion on the street the day before. He might now be scowling and frowning on the wedding day he was unwilling to cancel, curtly shaking his head when his wife and daughter asked if anything was wrong. And the eighteen-year-old herself: is her sublime innocence the key to the whole thing? Lonely, frustrated Marion, who yearned for marriage and respectable love ... perhaps something within her snapped with rage at the thought of this smug little rich girl and her unearned day of happiness. Part of the film's genius is that this first psycho moment happens silently, invisibly, inside Marion's head.

THE SHINING

1/11/12

★ ★ ★ ★ ★

The re-release of Stanley Kubrick's *The Shining* (1980) is another chance to savour, first of all, those magnificent interior sets. Instead of the cramped darkness and panicky quick editing of the standard-issue scary movie, Kubrick gives us the eerie, colossal, brilliantly-lit spaces of the Overlook Hotel (created in Elstree Studios, Hertfordshire), shot with amplitude and calm. It looks like an abandoned city, or the state rooms of the *Titanic*, miraculously undamaged at the bottom of the ocean. There's pure inspiration simply in the scene in which young Danny (Danny Lloyd) rides his tricycle around the endless corridors, the wheels thundering on the wooden floor, then suddenly quiet over the carpets. And this is before he sees the strange little girls. Jack Nicholson and Shelley Duvall play Danny's parents, Jack and Wendy, who have the live-in job of caretaking a gigantic resort hotel while it is closed for the winter. But the place is drenched in the memory of a violent past, and the horror and trauma rise inexorably to the surface. The unhurried pace, extended dialogue scenes and those sudden, sinister inter-titles ("One Month Later", "4 p.m.") contribute to the insidious unease. Nicholson's performance as the abusive father who is tipped over the edge is a thrillingly scabrous, black-comic turn, and the final shot of his face in daylight is a masterstroke. *The Shining* doesn't look like a genre film. It looks like a Kubrick film, bearing the same relationship to horror as *Eyes Wide Shut* does to eroticism. The elevator-of-blood sequence, which seems to "happen" only in premonitions, visions and dreams, was a logistical marvel. Deeply scary and strange.

LAWRENCE OF ARABIA

22/11/12

★ ★ ★ ★ ★

They don't make them like this any more, though John Huston's *The Man Who Would Be King* (1975) and Anthony Minghella's *The English Patient* (1996) came close. Peter O'Toole made an unforgettable debut in this magnificent epic from 1962 by David Lean, now re-released in its whoppingly complete 224-minute version. O'Toole is T. E. Lawrence, the brilliant and mercurial Arabist and aesthete who as a serving officer in World War I found himself leading an Arab revolt against the Turks in the British interest, but failed to create the national self-determination he promised his followers. An American reporter is on hand to print the legend and to impress his readers with Britain's abiding capacity for martial glory, far from the futility of the Western Front and the disaster of Gallipoli. Edward Said wrote that Lawrence invented the Arab's "primitive simplicity" though there is nothing simple here about O'Toole's Lawrence, as he discovers in himself a taste for sensual ruthlessness and is wracked with self-hate after being captured and beaten by the Turks: this movie hints obliquely at sexual assault. The blackface casting of Alec Guinness looks ill-judged now, especially compared with Omar Sharif's spirited, ingenuous performance, but what red-blooded passion this film has and what formal brilliance. The cut from Lawrence's blown-out match to the burning desert sun is itself a masterpiece: a tiny imagist cine-poem. This is a movie with the excitement of a cavalry charge.

BABETTE'S FEAST

13/12/12

★ ★ ★ ★ ☆

The complacent and nauseating word "foodie" is often used in connection with Gabriel Axel's 1987 film, now re-released in cinemas. But if you're salivating over the food, you're missing the point. The film is based on a short story by Danish author Karen Blixen, whose memoir of *Out of Africa* was famously adapted for the cinema in 1985. In nineteenth-century Denmark, spinster sisters Filippa (Bodil Kjer) and Martine (Birgitte Federspiel) are honouring the memory of their late father, a stern preacher, by doing good works and hosting prayer groups, having long since rejected the pleasures of love, marriage and children. Into these old women's lives comes a mysterious Frenchwoman, Babette (Stéphane Audran), an acquaintance of a former dejected suitor, a refugee from the French civil war.

Babette agrees to work as their cook and housekeeper; and, on coming into a huge amount of money, offers to cook for them and the cantankerous old villagers a sumptuous French banquet. It is as if the portions of everyday sensuality they have refused all their lives are now to be totalled up and paid to them all at once in this remarkable feast, just when they must bid farewell to the world, with all its pleasures and vanities. Twenty-five years on, the story is still charming and beguiling.

POINT BLANK

28/3/13

★ ★ ★ ★ ☆

In 1967, John Boorman caused a sensation with his adaptation of Donald Westlake's crime thriller *The Hunter*, a movie that took Hollywood's marching-band certainties and added the cool Euro jazz of Godard and Antonioni. (I wonder about a possible further resemblance to Sidney Furie's conspiracy-espionage thriller *The Ipcress File*, which emerged two years previously.) *Point Blank* has not dated very much at all: an angular, spiky, startling picture that shifts a knight's move away from the thriller form.

Lee Marvin is Walker, the robber shot and left for dead by his criminal associates in the eerily deserted precincts of Alcatraz prison, where they had been planning to steal mob cash being secretly transported there by helicopter. After his miraculous and in fact superhuman recovery and escape, Walker plans to get back at the guy who ran off with his loot and his wife; this man is now part of the shadowy "Organisation" – a very 1960s setup – and Walker becomes involved with his wife's beautiful, troubled sister, Chris (Angie Dickinson). It is a movie about memory: a gunshot is always liable to trigger the memory of previous violence, the trauma lurks nearby, at point-blank range, part of a skein of remembered bloodshed extending backwards as the revenge plot pushes forwards. An intriguing, disorientating 1960s artefact.

JOURNEY TO ITALY

9/5/13

★★★★★

Roberto Rossellini's mysterious, gripping and moving *Viaggio in Italia* (1954) – now restored and re-released – is a cine-ancestor to Antonioni's *L'Avventura* and Roeg's *Don't Look Now*. George Sanders and Ingrid Bergman are Alexander and Katherine Joyce, a well-to-do English couple who have come to southern Italy to sell some property and do a little sightseeing, but something in their enforced leisure, the disturbing beauty of the landscape and vertiginous sense of history accelerates a crisis in their troubled marriage. The movie is often characterised as a study in *ennui* and curdled *dolce far niente*, a sunbaked torpor and languor that incubates marital despair. But actually, Alexander and Katherine's senses have been peeled; they are more alive than ever, intensely aware of each other and themselves, and although irritated, they are perversely intrigued by one other. It is a kind of delayed anti-honeymoon of dark revelation, made more poignant by the incessant Neapolitan love songs Rossellini creates in the background. Katherine's revelation of a previous tendresse for a young poet associated with the locale – together with the couple's surname – may faintly recall Joyce's short story "The Dead". The final sequence in Pompeii, as the stunned couple witness the exhumation of two people at the moment of death, is electrifying and moving. There is real greatness in this movie.

THE MEANING OF *BLACK NARCISSUS*

10/7/13

The title is a two-word surrealist poem on its own; it speaks of something transgressive and perverse. It could mean the Greek mythical character, Narcissus, gazing adoringly at his own image that he has somehow turned black, racially or in some other way, or perhaps it means his reflection in the dark pool. Or perhaps it is the flower itself, the narcissus whose petals have turned black through some secret horticulture. As a young man, after all, Michael Powell worked for and idolised the great silent movie director Rex Ingram who made a film called *Black Orchids*.

Of course, it actually turns out to be the name of a gentlemen's cologne, a perfume worn by an exquisite young Indian nobleman which he has bought from the Army and Navy Stores – of all places. Surrounded by the dense flora, the magnificent landscape and the sensual tastes and smells of India, this man exults in an absurdly-named scent imported from a London department store. In taking this ephemeral and inauthentic detail, and enigmatically giving it star-billing status in the title, the movie (like the original novel) crucially gives us India through the lens of England before anything has happened at all.

In many ways, the 1947 film *Black Narcissus*, the story of a prewar nunnery in India, is Powell and Pressburger's most conventional movie, with a big Hollywood studio star and a Hitchcockian finale full of vertigo and high anxiety. It is an adaptation – which marks it out from their mostly self-generated projects. However sensational, it arguably doesn't have that distinctive eccentricity and waywardness. Emeric Pressburger's script sticks reasonably closely to the 1939 novel by the Anglo-Indian author Rumer Godden and I've heard it said that to love *Black Narcissus* more than their other films means that you are not a true believer in the Powell/Pressburger canon.

Maybe. But this is to overlook this film's eerie connection to the unacknowledged love-triangle in their earlier film, *I Know Where I'm Going!*. It is operatic and magnificent and mad; a fascinating parable of the colonial experience in India, which has to be read

in the context of England's imperial adventure in South Asia and Rumer Godden's own troubled life. And it showcases a lethally scary performance from the one of the most beautiful women in the history of cinema: Kathleen Byron, playing Sister Ruth, whose final, vengeful appearance never fails to frighten the hell out of me, in her final appearance in the sexy dress and the scarlet lipstick.

Black Narcissus is the story of an order of Anglo-Catholic sisters in Darjeeling who are made an offer they can't refuse by a local potentate: he will offer them a Palace high up on the Himalayas as the site for a new nunnery: there, they will be an expeditionary force for Christ. The strange, ornate building formerly housed his harem, but it is haunted by more than just sex. The sisters of St Faith themselves are not demure shrinking violets; on the contrary, they pride themselves on their open, practical engagement with the world outside the church – planning to open a school and medical clinic. Deborah Kerr plays the Sister Superior, Clodagh, cool, self-assured, but with a supercilious manner and what the kindly, shrewd Mother Superior fears is a kind of spiritual arrogance and immaturity. Sister Philippa, industrious and doughty, is to be in charge of the vegetable garden, and she is played by Flora Robson. Sensible Sister Briony is played by Judith Furse and sweet, childlike Sister Honey by Jenny Laird.

But the fifth nun is the explosive element in this group-dysfunctional mix, Kathleen Byron's Sister Ruth is shrill, spiteful, highly-strung, with an unformed, self-destructive sexiness; from the very first, she is competitive and envious with Sister Clodagh. Any time Kathleen Byron is on the screen, her pale, gaunt face attracts the eye like a magnesium flare. As the film proceeds, she is to be neurotic, then psychotic, and then daemonic. When the Mother Superior is giving Clodagh an initial run-down of who to pick for her team of nuns for this dangerous mission, Ruth is the candidate she pauses over. She is well aware of Ruth's difficult behaviour. Perhaps this is the challenge she needs. Or perhaps not. "She's a problem," concedes the Mother Superior. And how do you solve a problem like Ruth? Not by putting her under sexual stress in the remote Himalayan mountains, that's for sure.

Because the presence of two men is to unsettle all the women. The youthful nephew of the local chief, known as the Young

General and played by the Indian former child actor Sabu, has insisted on being taught in the nuns' school and he is developing a *tendresse* for the winsome young pupil there, Kanchi, played by Jean Simmons — a discarded concubine of the local British land agent, a boorish hard-drinking sensualist called Mr Dean, on whom the sisters have to rely for handyman skills and local knowledge. This handsome fellow, played by David Farrar, becomes friendly in spite of himself with Sister Clodagh, and Sister Ruth, in her madness and fanaticism, conceives an obsession for this man and his possible relationship with Clodagh.

Part of what's gripping in all this, quite aside from the superb performances of Kerr and Byron, is the remarkable similiarity of this anti-love triangle to a similar fraught emotional dynamic in the film Powell and Pressburger made three years before, *I Know Where I'm Going!*, set on the Scottish island of Mull. Wendy Hiller's young heroine — headstrong and a little self-important like Clodagh, is emotionally attracted to Torquil MacNeil, the Laird of Kiloran, played by Roger Livesey: cut from finer cloth than Mr Dean, to be sure, but like him a man embedded in the landscape and customs. Then there is the sharp-witted, sharp-faced Catriona, played by Pamela Brown, who has some emotional history with Torquil, shrewd and watchful and not entirely pleased by their burgeoning love-affair. She is eerily like Sister Ruth in many ways.

It is no surprise to learn that Michael Powell had had affairs with both Deborah Kerr and Kathleen Byron (and indeed Pamela Brown) and was in all probability in love with both women while he was making this film, perhaps especially Kathleen Byron, who shared some of Sister Ruth's mercurial personality. In his autobiography, Powell writes: "I have always had a special respect for Kathleen ever since she pulled a gun on me. It was a revolver, a big one, US army issue, and it was loaded. A naked woman and a loaded gun are persuasive objects." Powell never explains further, but I have never read that passage without imagining Byron, not naked but in her nun's habit.

It isn't just sex. It's something in the earth, and in the air, in the giant implacable mountain that they must look at each day — and the Palace itself. One of the intriguing things about the film is that we know that an order of religious brothers had also been

offered this same building the previous year and had retreated for unexplained reasons, perhaps suffering similar tensions through the gender looking glass. I like to imagine a secret Powell/Pressburger prequel to *Black Narcissus* called something like *The Brothers' Trial*, perhaps in black and white, with Anthony Quayle and Dirk Bogarde facing off like Kerr and Byron.

Many narratives about the colonial experience in India emphasise the stifling heat, but that is not the case here. The nuns feel an intense cold, a lucid, clarifying cold which heightens the senses. As Sister Clodagh says: "You can see too far." It is almost as if the sisters had ingested some narcotic stimulant, or something like the red pill in *The Matrix* which had shown them the true nature of things. And what is so important in *Black Narcissus* is the recurrent theme of being drugged or poisoned. In this film, both the nuns and the locals fear it. When Sister Clodagh sends Sister Ruth a glass of milk, Ruth instantly suspects some kind of foul play and secretly pours the drink away. When a local sick baby dies, unfortunately just after being given some futile medicine at the nuns' clinic, the villagers suspect the white ladies have poisoned the child and Mr Dean has to drink the medicine in front of them to prove it isn't true. The strange resonance of these events can't be understood without knowing about Rumer Godden's own life. Five years after she wrote her novel, and three years before the movie came out, Rumer Godden herself had to leave her beloved India because a servant had tried to poison her with powdered glass. The trauma expelled her. *Black Narcissus* taps into this personal nightmare felt by both sides in their enforced intimacy with its potential for fear and resentment. *Black Narcissus*, released a few months after Indian independence, is partly a political metaphor for the British retreat, but its power resides specifically in finding this insidious poisoning trope, a hot-button issue since the days of the Indian Mutiny, when Hindu and Muslim soldiers feared that the paper cartridges they had to bite were contaminated with smears of beef and pork.

The look of *Black Narcissus* is thrilling. Long before the days of digital effects, Powell had found a way to suggest South Asia in Pinewood Studios. Now, to our modern eyes, it might not look real, but that's not the point. It is unreal, or hyperreal. Reality here is like a painting by Caspar David Friedrich. The brilliant and

exquisitely dreamlike world of the film, its deep-focus artificiality, is part of Powell/Pressburger repudiation of standard Brit realism. The Himalayan landscapes and locations are created with passionate care by Technicolor cinematographer Jack Cardiff and designer Alfred Junge in the studio and in a tropical garden in West Sussex: Leonardslee Gardens, once open to the public, but closed since 2010; now they are a gigantic secret garden⋆. Recently, in response to a begging letter from me, the new owners allowed me in, wandering all alone in this gigantic quasi-tropical landscape with its Himalayan plants and seven lakes, an extraordinary valley of foliage, creating the impression of a huge, humid Anglo-Saxon Asia in the middle of England. To walk through this garden, to imagine Powell himself sizing up the location, was for me almost like a séance.

Black Narcissus is satirically, subversively about the exotic, with all the condescension and incomprehension that the word implies. India and the Indians look exotic to the well-meaning Westerners, until they realise to their mounting anxiety that the strange majesty of all that they see cannot be contained within this term. Actually, in this movie the landscapes of Ireland, where Sister Clodagh spent her romantic young womanhood, look as daunting and wild in their own way. The Himalayas are forbidding and exciting and menacing and unexplainable. But they are not the terrain that is ultimately important: the real territory is the woman's body and womanhood itself. Michael Powell called *Black Narcissus* "the most erotic film I have ever made". I can only add that it is the most erotic film I have ever seen.

PATHS OF GLORY

1/5/14

★ ★ ★ ★ ★

It is arguably the best film about World War I, and still has a reasonable claim to being Stanley Kubrick's best film. *Paths of Glory* (1957) is now re-released for the 1914 anniversary: this brilliant tale of macabre futility and horror in the trenches was adapted by Kubrick, Calder Willingham and pulp master Jim Thompson from a 1935 novel by Herbert Cobb, in turn inspired by a real incident.

George Macready plays General Mireau, an officer who in 1916 orders a suicidally pointless attack on a German stronghold and after the inevitable fiasco orders three men to be chosen, by lot, to be shot for cowardice. (Mireau is a cousin to Sterling Heyden's Brigadier General Jack D. Ripper in *Dr Strangelove*: calculating percentages of acceptable loss is something that happens in both films.) The resulting execution scene is like a nauseous non-crucifixion — three thieves without Christ or three Christs without a thief.

Kirk Douglas plays Colonel Dax, the tough old soldier disgusted with his superiors' arrogant incompetence, who attempts to defend these innocent men. Kubrick's juxtaposition of battle scenes and this sickening petty tyranny behind the lines is masterly and there is a demonic flash of pure genius in making one condemned man, just before his execution, announce that he has not had "one single sexual thought" since the court martial. The final sequence, in which a German civilian woman sings to the troops, has a mysterious redemptive beauty. Kubrick combines compassion with something of those commanding officers' cool detachment and control. A real cinematic field marshal.

PULP FICTION

15/5/14

★ ★ ★ ★ ★

Twenty years on, Quentin Tarantino's *Pulp Fiction* has been re-released in cinemas, and it looks as mesmeric and mad as ever: callous, insolent, breath-taking. The icy wit, the connoisseur soundtrack, the violence (of which the N-bombs are a part), the extended dialogue riffing, the trance-like unreality, the inspired karmic balance of the heroin scene and the adrenalin scene, the narrative switchbacks that allow John Travolta to finish the film both alive and dead, the spectacle of him being made to dance badly, but also sort of brilliantly ... above all else, the sheer directionless excitement that only Tarantino can conjure. In 1994 it broke over my head like a thunderclap, and in 1990s Britain this touchstone of cool seemed to extend its dangerous influence everywhere: movies, fiction, journalism, media, fashion, restaurants, you name it. Everyone was trying to do irony and incorrectness, but without his brilliance it just looked smug. (The Americans get Tarantino; we get Guy Ritchie and Jeremy Clarkson.) Travolta and Samuel L. Jackson play Vincent and Jules, a couple of bantering hitmen working for Marsellus (Ving Rhames), who is highly protective of his wife, Mia (Uma Thurman), and about to conclude a payday from a fixed boxing match; Marsellus's fighter, Butch (Bruce Willis), is haunted by a childhood encounter with his late father's best friend (a jaw-dropping cameo from Christopher Walken). Everyone's destiny plays out with that of a couple of freaky stick-up artists, played by Amanda Plummer and Tim Roth. In 1994, all the talk was of former video-store clerk Tarantino's indifference to traditional culture. That patronised his sophisticated cinephilia, and in fact, twenty years on, the writerly influences of Edward Bunker, Elmore Leonard and Jim Thompson seem very prominent. Don DeLillo began the 1990s by warning that the US is the only country in the world with funny violence. Maybe *Pulp Fiction* was the kind of thing he had in mind. Unmissable.

THE DEER HUNTER

31/7/14

★ ★ ★ ★ ★

Michael Cimino's bold and brilliant Vietnam war epic *The Deer Hunter* is re-released; thirty-six years on, the film's combination of sulphurous anti-war imagery, disillusion and patriotic melancholy is even more striking. (I haven't watched this since it first came out in 1978; this time I literally gasped at how beautiful a twenty-nine-year-old Meryl Streep is in her pink bridesmaid's gown.)

Three Pennsylvania steelworkers, Mikey (Robert De Niro), Nick (Christopher Walken) and Steven (John Savage), obey Uncle Sam's call to fight in Vietnam, leaving behind wives and sweethearts, including shopworker Linda (Streep) who may be in love with more than one of them. Before they leave, they attend Steven's wedding: a ceremony in which, without realising it, they are saying goodbye to their old lives. These guys like nothing more than a laugh, a drink and hunting deer in the mountains. Here is where Mikey and Nick have a dimly conceived belief that the hunter's vocation is austere and manly and the deer's death noble and ennobling, unlike the gruesome chaos of war in south-east Asia, where they are captured and forced to take part in a hideous Russian roulette death cult.

Of course, this is just as much a fantasy as Francis Ford Coppola's Wagner-fuelled helicopter attack in *Apocalypse Now*, and *The Deer Hunter* has been criticised for this literal inaccuracy and showing Vietnam in terms of American victimhood. But for me, those macabre Russian roulette sequences stunningly proclaim war to be dehumanising and arbitrary. A simple, much-forgotten fact slaps you in the face after watching *The Deer Hunter*. Vietnam was different to Iraq and Afghanistan in one vital respect: the soldiers were drafted. They had no choice. The idea of sacrifice permeates everything, along with the cruelty and horror. This is Cimino's masterpiece.

CHARULATA

21/8/14

★ ★ ★ ★ ★

Satyajit Ray's film *Charulata* (1964), based on Rabindranath Tagore's story *The Broken Nest*, is fifty years old, but it's just so extraordinarily vivid and fresh. While watching this – in fact any of his films – the same question recurs: why aren't we talking about Ray more? Or, in fact, all the time? There is such miraculous clarity here, such great acting, staged with theatrical aplomb and shot with unshowy genius. It has the effortless fluency and gaiety of a Shakespearean comedy. The setting is Calcutta in British India: Charulata, played by the hypnotically beautiful Madhabi Mukherjee, is the bored, cultured wife of a newspaper editor and proprietor who prides himself on being a bold free-thinker. His charming young wastrel cousin, a would-be writer called Amal (Soumitra Chatterjee), comes to stay and Amal and Charulata take an interest in each other's literary aspirations – as well as in each other generally. The delicate pathos and subtle comedy of their romance is a joy, and there is wonderful audacity in the way Ray shows Charulata's life at the beginning – simply looking out of the window, studying the passersby with the engaged curiosity of a true artist. Ray's own artistry and poise emerges very strongly. This film is a tonic – a vitamin boost for the mind and heart.

M

4/9/14

M is for Murder, or *Mörder*, the chalked letter pressed on the shoulder of a notorious child-killer in Berlin by a member of an organised criminal underground – a secret sign to identify the psychopath and kill him. This is so that the police can call off their own city-wide manhunt, which is seriously inconveniencing the criminal classes. Fritz Lang's 1931 movie is back on re-release and Peter Lorre plays the porcine, pop-eyed serial killer Hans Beckert, speaking German with a rasping, querulous shout – rather different to the unmistakable nasal, lugubrious English of his later Hollywood career.

Otto Wernicke plays pudgy police inspector Lohmann, and Gustaf Gründgens is Schränker, the crime overlord who will finally sit in judgment on Beckert, presiding over something between a kangaroo court and a revolutionary tribunal. Lang depicts the paranoia and feverish atmosphere that gives birth to the dual investigation from the cops and the criminals. Lohmann has a determined, forensic technique, analysing the handwriting on Beckert's jeering letter to the press, and the woodgrain of the table the paper appears to have pressed on.

Meanwhile, a hidden army of crooks and thieves pass on their own tips, and a blind peddler crucially recognises the tune Beckert whistles. It is a cousin to the early Hitchcock of *The Lodger*, and I have always found something even something faintly Ealingesque about its cynicism and satire. What is fascinating is how Lang fetishises smoking: everyone has huge cigars, bulbous pipes and cigarettes in holders. It is as if smoke is the endless industrial byproduct of the city's folly, greed and shame.

AU REVOIR LES ENFANTS

28/1/15

★ ★ ★ ★ ★

Louis Malle's quasi-autobiographical masterpiece *Au Revoir Les Enfants* from 1987 is now re-released in cinemas in the same week as Holocaust Memorial Day. It remains breath-takingly good. There is a miraculous, unforced ease and naturalness in the acting and direction; it is classic movie storytelling in the service of important themes, including the farewell that we must bid to our childhood, and to our innocence – a farewell repeated all our lives in the act of memory. The scene is Nazi-occupied France in 1944 and the wealthy, urbane parents of twelve-year-old Julien (Gaspard Manesse) have sent him away to a Catholic boarding school in the country. Here he makes the acquaintance of a shy, clever new boy called Jean Bonnet (Raphaël Fejtö), about whose wellbeing the headmaster seems very solicitous. The boys' friendship may not be enough to protect Jean when a momentous secret is discovered. Malle shows how the French are conflicted about their collaborationist attitude. The German soldiers seem sympathetic: many are Catholic people from southern Germany and come to the schools' priests, politely asking for confession. When the boorish local civilian militia try to eject an elderly Jewish man from a restaurant, some German officers, lunching at the same establishment, gallantly if drunkenly intervene on the man's side. And among the French there is a genuine disgust with fascism and anti-Semitism, but fatally combined with shame, class division and a dark tendency towards denunciation and spite. As an evocation of childhood it is superb, comparable to Jean Vigo's *Zéro de Conduite* and François Truffaut's *The 400 Blows* – perhaps better. Every line, every scene, every shot, is composed with mastery. It has to be seen.

THE TALES OF HOFFMAN

26/2/15

★ ★ ★ ★ ★

"Made in England" is how Michael Powell and Emeric Pressburger finally stamped their unworldly, otherworldly *Tales of Hoffmann* from 1951, an adaptation of the Jacques Offenbach opera, which is now on re-release. It actually negated English and British cinema's reputation for stolid realism. This is a hothouse flower of pure orchidaceous strangeness, enclosed in the studio's artificial universe, fusing cinema, opera and ballet. It is sensual, macabre, dreamlike and enigmatic: like *Alice's Adventures in Wonderland*. In his autobiography, Powell recalls talking to a United Artists executive after the New York premiere, who said to him, wonderingly: "Micky, I wish it were possible to make films like that ... " A revealing choice of words. It was as if what this executive thought he had seen was some kind of miraculous film that he still did not believe was "possible" in any sense. Robert Rounseville is the famous poet Hoffmann, in love with a dancer, played by Moira Shearer. Hoffmann regales tavern drinkers with tales of his three former loves: Olympia, Giulietta and Antonia – an automaton, a courtesan and an invalid, three different manifestations of love's dangerous, seductive power. In each case Robert Helpmann plays the dark nemesis figure, with his extraordinary, skull-like face. You might compare this to the 1948 Powell and Pressburger film *The Red Shoes*, though in many ways it is even more hallucinatory.

CITIZEN KANE AND THE MEANING OF ROSEBUD

25/4/15

★ ★ ★ ★ ★

Spitting Image once made a joke about Orson Welles – that he lived his life in reverse. The idea, effectively, is that Welles started life as a fat actor who got his first break doing TV commercials for wine, moved on to bigger character roles as fat men, but used his fees to help finance indie films which he directed himself; their modest, growing success gave him the energy and self-esteem to lose weight. Then the major Hollywood studios gave him the chance to direct big-budget pictures, over which he gained more and more artistic control until in 1941 he made his culminating mature masterpiece: *Citizen Kane*, the story of the doomed press baron Charlie Kane – played by Welles himself, partly based on W.R. Hearst – and told in a dazzling series of fragments, shards, jigsaw pieces and reflected images.

Poor, poor Orson Welles: repeatedly talked about as a tragic disappointment, his achievements somehow held against him, as if he had culpably outlived his own genius. After all, he only created arguably the greatest Hollywood movie in history, only directed a string of brilliant films, only won the top prize at Cannes, only produced some of the most groundbreaking theatre on Broadway, only reinvented the mass medium of radio, and in his political speeches, only energised the progressive and anti-racist movement in postwar America. As the room service waiter in the five-star hotel said to George Best: "Where did it all go wrong?"

Perhaps it is the fault of *Citizen Kane* itself, that mysterious, almost Elizabethan fable of kingship, which so seductively posits the coexistence of greatness and failure. Martin Scorsese, in his brilliant commentary on the film, said that cinema normally generates empathy for its heroes, but the enigma of Kane frustrates this process. The audience wants to know and love Kane, but can't – so this need to love was displaced on to Welles himself, and accounted for his immense popularity and celebrity in the 1940s. It is the same with cinema: however immersive, however sensual, however stunningly effective at igniting almost childlike sympathy and love, cinema

withholds the inner life of its human characters, while exposing the externals: the faces, the bodies, the buildings, the streetscapes, the sunsets.

The story of Charles Foster Kane is a troubled one: the headstrong newspaper proprietor who makes a brilliant marriage to the niece of the US president and takes a principled democratic stand for the little guy against monopoly capitalism, but only to reinforce his own prerogatives, and only in an attempt to pre-empt the growth of trade unionism. And Kane's own political ambitions, like those of Charles Stewart Parnell in Ireland, are destroyed by sexual transgression: an affair with a singer who is to become his second wife. Kane's indiscretion generates precisely the kind of salacious, destructive news story that he had pioneered in his own newspapers.

Diminished by the Wall Street crash and personal catastrophe, Kane becomes a pro-appeasement isolationist, complacently unconcerned about European fascism, though in his youth cheerfully willing to indulge the idea of a short circulation-boosting war with Spain. He dies in the present day, in 1941 – *Citizen Kane* was released seven months before Pearl Harbor. Kane himself becomes a remote figure, enervated and paralysed by his mythic wealth, somewhere between Scott Fitzgerald's Jay Gatsby and Adam Verver, the unimaginably rich art collector in Henry James's *The Golden Bowl*.

But how about that tiny detail that Kane's would-be biographers believe is the key to everything? The murmured word on his deathbed: "Rosebud". It is a mystery which they fail to solve, but we do not – it relates to Kane's last moments of childhood innocence and happiness, playing in the snow before his bank-trustee appointed guardian, the Dickensian Mr Thatcher, comes to take him away to prepare for him his lonely new life as a twentieth-century American oligarch. Kane's business manager, Mr Bernstein, played by Everett Sloane, tells us never to underestimate the importance of tiny moments, and famously remarks that never a month goes by without him thinking of a fleeting glimpse he had once of a beautiful girl in a white dress and parasol. Never a week goes by without me thinking of that scene, without me trying to imagine that woman's beauty, and who might play her in a flashback scene (I suggest Mary Astor) and of the awful fact that Everett Sloane was to become obsessed with his own ugliness and addicted to cosmetic surgery.

For any journalist, *Citizen Kane* is a glorious, subversive, pessimistic film. We all know what newspaper journalists are supposed to be like in the movies: funny, smart, wisecracking, likeable heroes. Not in *Citizen Kane*, they're not. Journalists are nobodies. The person who counts is the owner. And Welles's Charlie Kane is not even a self-made man. He had his wealth handed to him. He was never the underdog. Haughty, impulsive, charming and charismatic: the twenty-five-year old Welles is so handsome, leonine, with an intelligent, perennially amused face, like a young Bob Hope.

I've lost count of the times I've watched the scene in which he first shows up with what we would now call his entourage at the offices of *The New York Daily Inquirer*, the little underperforming paper he seizes on as the cornerstone of his future career – rather in the way Rupert Murdoch started with *The Adelaide News*. He blows through that dusty office like a whirlwind. Kane derides the idea of his paper remaining closed twelve hours a day: later, he will buy an opera house for his wife to sing in and for his newspapers to promote. And so Kane, in fiction, invented the idea of rolling twenty-four hour news, and a vertically integrated infotainment empire. Welles himself had a newspaper column for many years after *Kane*, and I suspect he thought of himself as in some ways a newspaper proprietor with other people's money. He told Peter Bogdanovich in their celebrated interview series in 1969 that he never saw *Citizen Kane* again after watching a finished print in an empty Los Angeles cinema six months before it opened in 1941 – and never stayed to watch the film at the premiere. Perhaps the image of Kane's failure became increasingly painful.

One of the main characters is Jedediah Leland, played by Joseph Cotten with his handsome, sensitive face. Kane's college buddy, he has been kept around as a corporate courtier and is, in Leland's own words, a "stooge". He has given Kane an intense loyalty which never quite becomes friendship, and gets the job as the drama critic who must review the woeful professional debut of Kane's second wife, Susan, played by Dorothy Comingore. Leland is pathetic, with neither the cunning to suppress his opinion, nor the courage to express it plainly. He slumps drunk over his typewriter and in an ecstasy of self-hate and masochistic defiance and despair, Kane completes the review himself. Critics are always implicated in the system, says

Kane, and the system's owners are exposed by their attempts to show themselves independent.

Kane has his parallels with British newspaper bosses – in fact, I'm always surprised that the comparison isn't made more often. He is very like Lord Copper, owner of *The Beast* in Evelyn Waugh's novel *Scoop*, who appreciated the excitement of short, sharp foreign wars. "*The Beast* stands for strong mutually antagonistic governments everywhere," said Copper, and to a reporter who has just cabled that there is no war in Cuba, Kane replies: "You provide the prose-poems, I'll provide the war." Waugh also said that Lord Copper loved to give banquets, and "it would be an understatement to say that no one enjoyed them more than the host, for no one else enjoyed them at all." I think of that line every time I watch the magnificent scene in Kane showing the banquet given to celebrate the *Inquirer's* success – with dancing girls brought in, shouldering sparkly cardboard-cutout rifles, in honour of America's forthcoming war with Spain. Cotten's tense, tired face and sad smile hints at an awful truth: despite Kane's boyish glee and the apparent general raucous excitement, it might be a terrible strain and unspoken humiliation for these salaried employees to pretend to be enjoying themselves worshipping their boss. I wonder how many newspaper bosses have watched that scene and taken it as a how-to guide for triumphalism at work.

It also reminds me of a strange moment in my life: twenty years ago, I was invited to a colossal party at the Earth Gallery in London's Natural History Museum, hosted by Sir David English, legendary editor-in-chief of *The Daily Mail*. It was a lavish, but strangely tense occasion, a notionally generous send-off for an editor whom English had forced into retirement. After a speech full of clenched and insincere *bonhomie*, the editor-in-chief brusquely asked us all to raise our champagne glasses – he did so himself, his arm extended. It was an uncomfortable moment, and quite a few people had on their faces Cotten's strained smile from *Citizen Kane*.

Moments are what we are left with in *Citizen Kane*: a *pointilliste* constellation of gleaming moments from which we can never quite stand far enough back to see the bigger picture in its entirety. One of the most stomach-turning is the "picnic" that Kane offers to give Susan in a moment of drowsy *ennui*. Kane and Susan begin to argue in their private tent while music and dancing begin

outside, becoming more abandoned and maybe even orgiastic. Welles orchestrates these sounds contrapuntally with the couple's quarrel, they climax with a strange sound of screaming, as if Kane and Susan's own malaise had been projected to the party outside.

The scenes of Kane and Susan together in Xanadu are eerie: an Expressionist bad dream, all darkness and weird perspectives, the couple marooned in the gigantic, sinister house, Kane prowling up to Susan while she morosely fits together a jigsaw. Kane wanders to a bizarrely huge fireplace and for a second he looks tiny, and Xanadu looks like the giant's lair from *Jack and the Beanstalk*.

And yet Welles's scenes with Ruth Warrick, playing his first wife, Emily, are no less vibrant, no less meaningful, especially on their arrival home for breakfast as young marrieds, having partied all night – and contemplating going to bed, but not to sleep. It is subtle but still a sexy scene.

It circles back to Rosebud: the anti-riddle of the anti-Sphinx. Welles himself playfully claimed that the word was Hearst's own term for his wife's genitalia, and so naturally the mogul was annoyed. Another false trail. The murmuring of "Rosebud" is in one way the film's teasing offer of synecdoche: the part for the whole, the one jigsaw piece that is in fact the whole puzzle. But it isn't.

Rosebud is more probably Welles's intuition of the illusory flashback effect of memory that will affect all of us, particularly at the very end of our lives: the awful conviction that childhood memories are better, simpler, more real than adult memories – that childhood memories are the only things which are real. The remembered details of early existence – moments, sensations and images – have an arbitrary poetic authenticity which is a by-product of being detached from the prosaic context and perspective which encumbers adult minds, the rational understanding which would rob them of their mysterious force. We all have around two or three radioactive Rosebud fragments of childhood memory in our minds, which will return on our deathbeds to mock the insubstantial dream of our lives.

This brings me to my own "Rosebud" theory of the film, the moment that may or may not explain everything. It is in fact the moment that isn't there, a shocking, ghostly absence that Welles allows you to grasp only after the movie is over: the death of his first

wife and his son in an automobile accident. We only hear of it in the newsreel about Kane that begins the film – the brief roundup that we are invited to believe does not get to the heart of the man. But that is the last we hear of it. It happens two years into his second marriage. When does Kane hear this terrible news himself? How does he react to the death of his first wife and his adored little boy? We never know. Welles leaves it out – perhaps he is saying that Kane did not react, that he is too blank, too emotionally nullified, too spiritually deracinated to respond, having made his own complete and ruinous emotional investment in himself, the same egocentricity of self esteem culture and image management that has now been miniaturised and democratised in the age of social media. Kane has the plutocrat's obsession with trying to control those around him in the way that he controls his media empire, whose purpose in turn is to control the way people think. And this is the final unspoken moral of *Citizen Kane*: a terrible tragedy of ownership and egotism – a narcissistic drowning.

THE THIRD MAN

25/6/15

★ ★ ★ ★ ★

With every new viewing, the resurrection of Harry Lime looks to me less secular. This classic 1949 *noir* – written by Graham Greene and directed by Carol Reed and now on re-release – is a compelling parable of guilt. Joseph Cotten plays the down-on-his-luck pulp thriller writer Holly Martins, just arrived in postwar Vienna, a city carved up by the victorious Allies, and swarming with chancers and black-marketeers. He's been invited by his old pal Harry Lime to take up a job – or maybe simply be a loyal, tame witness to his bogus disappearance.

Lime has supposedly been killed in a car accident and his landlord says he's gone to heaven or hell, pointing in the wrong directions, down and up. But this is just a conspiracy of sinners: a scam cooked up by all the crooked associates who've profited by Lime's wicked trade in stolen penicillin. The net is closing in; Lime needed to disappear and is now in Philbyesque exile in Vienna's Russian sector. The British officer Major Calloway (Trevor Howard) needs Martins as bait to tempt his old friend out into the open. Martins feels tainted – but through having betrayed Judas Iscariot, rather than Jesus.

Welles's performance as Lime is superb: blustering, conceited, charming. Is Lime in hell? Purgatory? Could he repent his sins? Or be a mysterious instrument of grace whereby others might repent theirs? This is a unique classic.

LA GRANDE BOUFFE

2/7/15

★ ★ ★ ★ ☆

Of no film was it more rightly said: they don't make them like that any more. Marco Ferreri's *La Grande Bouffe*, from 1973 (or *Blow-Out*, to use its explosive English title) is on re-release. Jaded, authentically perverted, drenched in *ennui*, this absurdist nightmare is a *locus classicus* of 1970s chateau erotica. In all its seedy sophistication and degraded hedonism, it focuses not on desire but disgust. The nearest immediate comparison is possibly that episode of the Simpsons where Homer challenges trucker Red Barclay to a steak-eating contest which turns out to be fatal. There is also something here of Rabelais, De Sade and the surrealist Raymond Roussel, who believed in the subversive potential of eating the courses of a meal in the wrong order. Four middle-aged men gather for a weekend at a rambling Parisian townhouse – an airline pilot, a TV producer, a judge and a chef – and set out to treat themselves to what looks like an outrageous Roman feast, complete with fine wines and prostitutes. Actually what they want to do is eat themselves to death. Everything about this is grotesque and horrible, perhaps especially the elaborate *haute cuisine* of that period itself. Britain's Fanny Cradock used to serve up continental food on TV that looked very similar. It's a film of its time: crass and preposterous and a bit depressing but with a vinegary satirical tang, a parable for menopausal self-pity and babyish male conceit.

TOUCH OF EVIL

9/7/15

★ ★ ★ ★ ★

All liberals should memorise this film's superb line, spoken by, all of people, Charlton Heston: "A policeman's job is only easy in a police state!" Orson Welles's brilliant 1958 *noir* melodrama *Touch of Evil* is now on re-release. Adapted by Welles from Whit Masterson's pulp thriller *Badge of Evil*, it had streaks of teen degradation and reefer madness, and the most intense interracial relationship since *The Searchers*.

Like much of Welles's work, it was taken out of his hands by studio chiefs and re-edited without his approval, but has been restored as far as possible according to wishes he expressed in a long, anguished memo – especially in the removal of the credits that were superimposed on the famous opening tracking shot.

Welles gave one of his most Shakespearean performances as the ageing, corrupt police chief Captain Quinlan in a small US town right on the Mexico border. Charlton Heston plays Vargas, an idealistic Mexican cop who has just married Susan (Janet Leigh), a beautiful American blonde, to the titillated, censorious fascination of everyone around. Nettled by the uppity Vargas's intermarrying and meddling, the crooked Quinlan decides to use the local drug gang to attack Susan at a remote hotel, and frame her as a supposed drug addict. To associate with Quinlan is to be touched, smeared, molested by pure evil. But poor Quinlan long ago resigned himself to his own petty corruption.

MIKEY AND NICKY

15/6/18

★ ★ ★ ★ ★

Masculinity never got more toxic, or more desolate, than in *Mikey and Nicky*, an extraordinary *noir* drama from the great writer, comic and film-maker Elaine May, which is showing in London next week. Starring John Cassavetes and Peter Falk, each at the top of his acting game, it is a neglected 1976 gem from a neglected Hollywood genius. May was known for her comedy but here proves absolutely fluent in the language of mobster lowlife, with an edge of caustic, disillusioned humour, and strange yet shockingly real outbursts of violence in which cafe owners and bus drivers are suddenly roughed up.

Cassavetes is Nicky, a smalltimer who has stolen about a thousand dollars from the mob and now fears for his life. Hiding out in a flophouse, crazed with fear, sleeplessness, lack of food and the pain from a stomach ulcer, he calls his best friend from childhood, a connected guy called Mikey, played by Falk. Mikey shows up, wearily accustomed, it seems, to getting his buddy out of jams. He chivvies and begs and cajoles the querulous Nicky into getting shaved and dressed and coming with him to the airport where he can be spirited out of town. Nicky appears relieved yet somehow even more panicky. His moods turn on a dime, sometimes he is extravagantly grateful to his old friend, sometimes resentful and suspicious. Noting that Mikey keeps making payphone calls, Nicky keeps changing their plan – he cancels the airport idea suggesting the train instead; they head to a bar, a late-night cafe, an all-night movie theatre.

He is of course right to be suspicious, because Mikey has been tasked by the mob with bringing Nicky in so he can be killed. But a weird, ambiguous current of meaning opens up between the two men as they roam the city and their childhood haunts – an unspoken negotiation. Perhaps Mikey might change his mind and let his friend get away, if his friend will only give him the genuine friendship and respect he has always craved from him. As for Nicky, he can't be sure: openly accusing Mikey will cause him to lose the only ally and

friend he has. And all the time, the clock is ticking. Nicky's death is approaching. Maybe Mikey's as well.

Mikey and Nicky is a film about talking: the characters talk, talk, talk with theatrical vehemence and musicality. This is a stag-rutting choreography of the emotions, with a sour smell of lonely defeated men, a tang of being up all night with cigarettes and beer. May introduces women into the picture – the people who wait at home. Nicky's abused girlfriend Nellie has to tolerate loathsome behaviour when the guys show up at her place in the middle of night. (She is played by the writer Carol Grace, who was married to William Saroyan and Walter Matthau and was acquainted with Truman Capote and may have partly inspired his character Holly Golightly.)

Both men are in fact married. Mikey's wife Annie (Rose Arrick) is a respectable wife and mother who waits for him patiently in their house in an elite neighbourhood. Nicky's wife Jan (Joyce Van Patten) has left him and taken their baby to her mother's. These are the people who are used to picking up the pieces when their bleary, depressed menfolk show up drunk at the family home at dawn.

It is a vivid, almost sensually rancid slice of 1970s cinema, a movie in which you can almost taste the sweat in the air. There's that wailing, moaning ambient sound of car horns on the soundtrack that you only get in American pictures of that era. And it is an extraordinary succession of scenes and tableaux: the bars – including one where Nicky makes a racist remark and narrowly escapes with his life – the movie theatre foyers, the buses, the streets. And above all, the faces; faces that Gillray or Hogarth might have drawn; faces from a nightmare or an odyssey through hell.

DAUGHTERS OF THE DUST

31/5/17

★ ★ ★ ★ ★

The big screen is the best place to see this restored 1991 gem from African-American film-maker Julie Dash; it now has a cinema re-release, perhaps partly due to the fact that its imagery and style inspired Beyoncé's *Lemonade* video. It is a mysterious, fabular and sometimes dreamlike film with its own theatrical poise. At times it reminded me of Chekhov, or maybe a performance of Shakespeare's *Tempest*. (I wondered if this might not have been an influence on Kenneth Branagh's 1993 screen adaptation of *Much Ado About Nothing*.)

It is set in 1901 on the South Carolina island of St Helena, where descendants of slaves have lived away from the burgeoning twentieth century of the US and kept African culture alive. Nana Peazant (Cora Lee Day) is the village's proud matriarch and embodies an ageless spiritual connection with the past. "The ancestor and the womb are one and the same," she says. Though Nana has no desire to live anywhere else, younger generations are impatient to go to the mainland and distant cousins arrive with exciting news of this place where the future awaits them. Christianity is part of this future, the cause of tension with the islanders' religious practices; more tension is due to the fact that Eula (Alva Rogers) is pregnant after being raped on the mainland and her husband, Eli (Adisa Anderson), cannot come to terms with this, or the fact that the child may not be his.

Daughters of the Dust has a sensibility that could be compared to the post-colonial fiction of India and Africa. As for Dash, she is still at the height of her film-making powers. Perhaps Hollywood could make it possible for this remarkable director to make a new fiction feature, maybe a full-length remake of her short *Illusions*, about African-Americans in the 1940s US film industry.

OCTOBER

24/10/17

★★★★★

Coleridge said that seeing the fiery Edmund Kean act was "like reading Shakespeare by flashes of lightning". Watching Sergei Eisenstein's classic silent film *October* (1927) is like watching the Russian revolution the same way. It's surreally lit up by stark images that sear your retina; gone the next second, to be replaced by others just as mysterious and disorientating. *October* is not a historical document, more a remembered dream. I sometimes wish we could see it without music, with just a deafening thunderbolt on each of its 3,200 cuts. A violent electrical storm of strangeness.

The film was commissioned in Stalin's Soviet Russia for the tenth anniversary of the 1917 October revolution, as a suitably fervent propagandist celebration. Eisenstein was the obvious candidate to direct, having won an international reputation for his brilliant *Battleship Potemkin*. Like Orson Welles, he had first made his mark in experimental theatre (And, like Welles, he later got bogged down in a big Latin American location shoot that resulted in a lost film — for Welles: *It's All True*, for Eisenstein: *¡Que viva México!*).

October has fierce, declamatory intertitles with exclamation points, unforgettably intense close-ups on faces, staggering crowd scenes with swarming masses, savage and ambiguous satiric digressions and epic set pieces for which Eisenstein was pretty much given licence to do what he liked in Leningrad (as it then was). He was recreating or reimagining historical events so soon afterwards, and with so many of the original participants, that the film is almost a docu-hallucination of what happened.

The action follows the historical record, in its way. The February revolution sees the pulling down of the statue of Alexander III; there is tension and frustration between the workers, peasants and soldiers. April sees the incendiary arrival of Lenin from exile, demanding an end to the Provisional government. The July Days are shown, with their riots, the Bolsheviks' unwillingness to attack and the spectacular urban disorder. General Kornilov launches

a Tsarist counter-revolutionary assault, which is foiled after a reverse-time vision of the Tsar statue being de-toppled; the Provisional government's leader Kerensky is shown strutting pompously around, affecting his Napoleonic mannerisms; and finally there is the storming of the Winter Palace itself.

The film pioneered a number of things, quite apart from the montage – the audacious juxtaposition of images – for which Eisenstein became famous. Stalin himself interfered at an early stage, viewing an early rough assembly of material and demanding that scenes with Trotsky and even Lenin were removed. And so he became cinema's first overbearing producer, in a nauseous parallel with his censorship, tyranny and mass murder. Eisenstein was never terrorised by Stalin in the way other artists were, and was arguably as complicit as any *apparatchik*, but he was certainly later compelled to abandon his experimentalism for Stalin's favoured "socialist realism". He was further forced to make humiliating public apologies when Stalin declared he had got it wrong and he underwent constant fear.

October is of course very different from classic Hollywood film-making, as in, say, David Lean's *Doctor Zhivago* (based on the Boris Pasternak novel), in which a conventional love story anchors the political events. Eisenstein doesn't offer any characters for us to relate to. Lenin and Kerensky hardly count. My personal theory, moreover, is that the puffed-up, boastful figure of Kerensky is not only to be compared to Napoleon – apart from the lack of a moustache, he could be Marshal Stalin himself in his uniform and his stiff bearing.

The storming of the Winter Palace is a concept Eisenstein almost invented. It became the eternal trope for the revenge of the dispossessed: a simple, dual image. Power and wealth inside the luxurious palace; downtrodden poor outside. In reality, it was a chaotic and weirdly anticlimactic affair involving far fewer people. Eisenstein reimagined it for posterity as a sweeping battle scene, like the storming of the Bastille. He also added irresistible images, such as the Bolshevik jeering incredulously at the padded lavatory seat in the Empress's bedroom.

Perhaps more astonishing is an earlier sequence, in which the government orders the raising of a drawbridge to prevent the Bolshevik masses from entering the city; in the melee, a dead white horse, attached to a carriage, is caught at the point where

the bridge separates. It dangles high above the river: poignant, awe-inspiring and in some mysterious way sacrificial. It has a stranger-than-fiction reality. What a horribly undignified end for this noble beast. What on earth can it symbolise? In its pure unreadability it has a poetic power in excess of Eisenstein's much-discussed montage pairing of the conceited Kerensky with shots of an imaginary mechanical peacock.

Above all else, *October* is about violence. The whole movie is shot through with an atmosphere of delirium. For all that it is a loyal and ideological tribute to the revolution, it also looks like a bacchanal of violent insurrection, or a panoramic portrait shattered into thousands of shard-like images. This is partly due to the unfinished World War I: Russia was in conflict within and without, and its own civil war – that great unmentioned subject that comes between the events of this film and the circumstances of its release – hovers over it. *October* is an intuition of what Pushkin called the merciless senselessness of the *Pugachevshchina*, the eighteenth-century peasant revolt from which the ruling classes learned secretly to fear and hate the lower orders. Lenin himself said the "proletarian state" is a "system of organised violence". Eisenstein's film could be said in its own way to have systematised it.

Yet there is always something more unquantifiable going on. When the all-female 1st Petrograd Women's Battalion of Death is summoned to defend the Winter Palace, Eisenstein creates a very curious byway in which a soldier is shown in a sort of reverie triggered by a Rodin statue. That is partly to mock women's alleged incapacity for martial service, but it is also just to knock things for a visual loop. The same is true, I think, for the grand ladies with their parasols attacking the worker during the July Days. Of course that is to satirise the *bourgeoisie*, yet Eisenstein appears in that instant on the women's side, obscurely excited by the exotic flare-up of aggression.

October is a film which attaches itself to Russian history's dark combustion, almost as if political reality was metaphorically subordinate to Eisenstein's own radical formal upheaval as an artist. The events gave him the perfect pretext for explosive unruliness on a grand scale. His guiding spirit was not Lenin, but Bakunin. The film is pure anarchy.

IN THE MOOD FOR LOVE

20/9/18

★ ★ ★ ★ ★

It is one of the very few bits of film memorabilia that I own: a poster of Wong Kar-wai's 2000 film *In the Mood For Love* signed by the director, and by the two stars: Tony Leung and Maggie Cheung. They play Chow and Li-zhen, a married man and his married woman neighbour, a journalist and shipping office secretary, who in Hong Kong in the early 1960s embark on an ambiguous, intense but unconsummated relationship when they realise that their respective partners are having an affair. My signed poster could be worth quite a bit on eBay. But I'm not selling.

I have it framed, with its image of Chow passionately embracing Li-zhen from behind, kissing her neck, their hands clasped just below Li-zhen's throat. His face is almost entirely obscured. Her eyes are closed, lips parted. It is an image which appears nowhere in the film itself, and is in fact slightly misleading, given the heartbreaking restraint practised by both characters. Never in the whole movie do they so much as kiss.

And the English title that Wong chose for the film – was ever a title so wrong, with its air of light-heartedness and gaiety? But then the ironic wrongness is part of the film's charge of unhappiness.

When I first wrote about the film, I described its erotic register of despair and its romantic dimension of *ennui*. Now, watching it again almost twenty years later, those things come back stronger than ever, but since *In The Mood For Love* was first unveiled at the Cannes Film Festival, it has become something of a style touchstone, with people talking it about as if it were some kind of pop video. And there are many fashion-icon things about it – many languorous, swooning shots of the wand-like form of Maggie Cheung in various beautiful cheongsams, floating up and down staircases. But seeing the film again is a reminder of how purposefully un-gorgeous and un-sensual Wong made his movie: it is a world of tatty corridors, down-at-heel offices, dark streets, subdued restaurant booths. The

film is mostly shot in cramped close-up, from camera positions which sometimes look as if they are in hiding places. What is so striking about *In the Mood For Love* is its theatricality, its unreality, like a strange dream. Hong Kong itself (what little we are allowed to see of it) looks like an illusion, a stage-set. There isn't a conventional musical score, but suddenly there will be an intense musical stab, as if out of nowhere, like Nat King Cole singing "Perhaps, Perhaps, Perhaps" or the Chinese star Zhou Xuan singing "Full Bloom". That contributes to a sort of out-of-body experience that you can have while watching it.

Some of the dialogue, too, turns out to be role-play. Li-zhen practises how she will confront her husband with his infidelity, with Chow playing the stolidly unrepentant husband. Later, and far more agonisingly, they actually rehearse the conversation that they will need to have when the relationship – whatever it is – is over and Chow leaves for Singapore, where he has accepted a job, simply so that he can avoid the agony of this situation. (Trevor Howard, in *Brief Encounter*, goes off to a new job in South Africa in much the same spirit. Actually, the echo of Noël Coward – co-screenwriter of *Brief Encounter* and author of the original stage-play – feels even stronger now, especially as the cheating spouses are never seen, and Li-zhen and Chow are alone together like Elyot and Amanda on their respective balconies in *Private Lives*.)

There is a sensuality and a kind of self-lacerating eroticism in what Chow and Li-zhen are doing: but it is not simply love, or doomed love, or forbidden love or even a kind of ruined sibling love, which is how I saw it the first time around. It is their way of trying to enter into the minds of their spouses, their way of somehow breaching the unknowability of other people.

But that incredible final section: after some glimpses of the years that follow their quasi-affair, a sudden and profoundly mysterious shift takes us to Cambodia and the Angkor Wat; from the earlier claustrophobic world to an eerily and surreally vast arena. There we have the unbearably moving finale, which turns on an intimate and tiny moment of agony.

Even that isn't the greatest part of the film. For me it is Maggie Cheung's dazzling smile – actually, the only time she smiles in

the film – when she and Chow are having their first flirtatious conversation, which is ambiguously their exploratory way of recreating the beginning of their spouses' affair. She extends a finger and touches Chow on his belt, or perhaps it is his shirt, or jacket. It lasts no more than a moment, but it's as passionate as a caress, and even more charged because it does not lead to kissing. It is the spark that lives forever.

Index

2 Days in Paris 190–2
9 Songs 309–11
11'09"01 239, 242–3, 265
12 Years A Slave 54–6
2001: A Space Odyssey 444–5, 457–8, 462, 468

Abrams, J.J. 451–2
Accidental Husband, The 104
Act of Killing, The 389
Adamson, Andrew 404
Ade, Maren 221–2
Affleck, Ben 66–7
Affleck, Casey 342
Alien: The Director's Cut 459–61
Alien Versus Predator: Requiem 102–3
Allen, Woody 23, 159, 180, 191, 195, 315, 317, 320, 477
Amalric, Mathieu 232–3
Amazing Spider-Man 2, The 435–7
Amirpour, Ana Lily 219
Amy 392–4
Anderson, Paul Thomas 8, 48, 50
Anderson, Wes 215–17, 401
Andersson, Roy 193–5, 419
Aniston, Jennifer 127
Annie 171–2
Antichrist 339–41
Apatow, Judd 205, 206–8
Arbor, The 375–6
Arcand, Denys 240, 265

Argento, Dario 293
Arterton, Gemma 153–4
At Five in the Afternoon 267–8
Au Revoir Les Enfants 517
Audition 273–5
Australia 112–13
Auteuil, Daniel 337–8
Avengers: Age of Ultron 440–1
Axel, Gabriel 504

Babadook, The 287–8
Babel 88, 90
Babette's Feast 504
Bad and the Beautiful, The 497
Balabanov, Alexei 298–300
Barbarian Invasions, The 240, 265
Bardem, Javier 105
Barnard, Clio 375–6
Baron Cohen, Sacha 185–7, 199
Barrymore, Drew 229
Bauby, Jean-Dominique 231
Bay, Michael 66–7, 209
Beckinsale, Kate 66–7, 77
Being John Malkovich 179–81
Bergman, Ingmar 193, 324
Bertolucci, Bernardo 312–15
Best Exotic Marigold Hotel, The 147–8
Best of Me, The 169
Bigelow, Kathryn 261–3, 267, 419
Binoche, Juliette 337–8

Bird, Antonia 244, 250, 253, 266
Bird, Brad 422
Black Narcissus 507–11
Black, Shane 433
Blades of Glory 177, 188–9
Blair Witch Project, The 276, 279
Blanchett, Cate 89–90, 93–5,
 116–17, 417
Bling Ring, The 53
Bloom, Orlando 84
Blue is the Warmest Colour 319–20
Bogdanovich, Peter 480, 521
Boorman, John 505
*Borat: Cultural Learnings of America
 for Make Benefit Glorious Nation of
 Kazakhstan* 185–7
Borgnine, Ernest 239, 242
Boyhood 234–6
Boyle, Danny 445
Branagh, Kenneth 96–8, 270, 530
Brando, Marlon 312–15
Brawne, Fanny 26–8
Breslin, Abigail 121–3
Bridesmaids 201–3
Bright Star 26–8
Bruckheimer, Jerry 66, 68
*Brüno, The Gay News Trial and
 Me* 199–200
Byron, Kathleen 508–10

Cabin in the Woods, The 282–4
Caine, Michael 96–8, 152, 155, 462
Cameron, James 3
Campion, Jane 26–7
Canyons, The 323
Capturing the Friedmans 368–70
Carruth, Shane 454–5
Casablanca 496
Cassavetes, Nick 121–2
Cat in the Hat, The 74
Cavalcanti, Alberto 476
Ceylan, Nuri Bilge 46–7
Chahine, Youssef 242, 243
Charulata 515

Cheung, Maggie 534–6
Chomet, Sylvain 414–16
Christensen, Hayden 81–2
Cimino, Michael 514
Citizen Four 390–1
Citizen Kane 519–24
Clement, Jemaine 218
Clock, The 41–3
Clockwork Orange, A 328, 339
Clooney, George 261, 264,
 448–9, 457
Cloverfield 276
Cody, Diablo 21, 22
Coen brothers 10–11, 100, 105,
 152, 342
Cole, Martin 317–18
Coltrane, Ellar 234–6
Compliance 354–5
Coppola, Sofia 53
Crowe, Cameron 84
Cruise, Tom 256–7, 296
Cuarón, Alfonso 448–9
*Curious Case of Benjamin Button,
 The* 116–18
Curtis, Richard 78
Cusack, John 179–80

Dafoe, Willem 339–40
Damien – Omen 2 271, 272
Dark Knight, The 425–7
Dash, Julie 530
Daughters of the Dust 530
Davis, Essie 287–8
De Niro, Robert 140, 165,
 185, 493–5
De Palma, Brian 258–60, 289, 449
Deakins, Roger 10
Deer Hunter, The 514
Delpy, Julie 190–2, 235, 311
Depp, Johnny 160–1
Dern, Laura 18–19
Diana 162–4, 166
Diaz, Cameron 85–7, 121–2, 152,
 172, 179, 403

DiCaprio, Leonardo 157–9, 212–14
Disney 91–2, 130, 149, 401–4, 406, 417, 428
Diving Bell and the Butterfly, The 224, 231–3
Dogtooth 38–40
Don't be Like Brenda 316
Don't Look Now 481–4, 506
Douad, Amer 395–6
Double Take 265
Douglas, Michael 77, 101
Douglas, Patricia 315
Draughtsman's Contract, The 295–6
Dreams of a Life 380–2
Duke of Burgundy, The 324–5
Dunbar, Andrea 375–6
Dunst, Kirsten 84

Eat Pray Love 138–9
Eckhart, Aaron 100, 127, 155
Eden 326–7
Eisenstein, Sergei 531–3
Ejiofor, Chiwetel 54–5
Elephant 33–5, 348
Elizabeth: The Golden Age 93–5
Elizabeth II 270
Elizabethtown 84
Enough Said 210–11
Enter the Void 345–7
E.T. The Extra Terrestrial 228–30
Exorcist, The 271, 281, 285, 340
Extremely Loud & Incredibly Close 144–6

Fahrenheit 9/11 245–7, 253, 267, 363–4
Fame 124–6
Fanfaren der Liebe: The Original Some Like it Hot 196–8
Far from Heaven 304–6
Fero, Ken 365, 366–7
Ferrell, Will 154, 169, 178, 188–9, 201
Ferreri, Marco 526

Fiennes, Ralph 114, 215–16, 263
Fifty Shades of Grey 174–5
Filth and Wisdom 119–20
Fincher, David 116, 118
Firth, Colin 104, 152
Five Easy Pieces 477–8
Forbes, Bryan 75
Force Awakens, The 451–3
Force Majeure 61–2
Four Lions 269
Foxx, Jamie 172
Frozen 417
Funny Games 329
Fuqua, Antoine 155
Fussell, Paul 65

Gainsbourg, Charlotte 339–40
Gambit 152
Gandolfini, James 210–11
Garfield, Andrew 435–7
German, Alexei 465–6
Get Out 291–2
Geyrhalter, Nikolaus 399
Ghibli 406, 408, 418
Girl Walks Home Alone at Night, A 219–20
Glatzer, Richard 237–8
Glazer, Jonathan 58–9
Godard, Jean-Luc 301–3
Goddard, Drew 282
Good Luck Chuck 99
Good Old Naughty Days, The 307–8
Grace of Monaco 166–7
Grand Budapest Hotel, The 215–17
Grand Central 60
Gravity 448–50
Great Gatsby, The 157–9
Green, Debbie Tucker 63
Greenaway, Peter 295
Greengrass, Paul 240, 248–50, 252–3, 266
Griffiths, Eric 178
Grimonprez, Johan 265
Grinch, The 270

Grizzly Man 371–3
Growing Up 317–18
Grudge Match 164
Guinness, Alec 82, 454, 472, 473, 488, 503
Guiraudie, Alain 322
Gulkin, Harry 388
Guzmán, Patricio 385

Half Past Dead 72
Hamburg Cell, The 244, 250, 253, 266
Hamer, Robert 488–90
Hammer, Armie 160–1
Hampton, Christopher 73
Haneke, Michael 29–32, 35, 39–40, 62, 268, 329, 337–8, 343, 351–2, 360
Hansel & Gretel: Witch Hunters 153–4
Hansen-Løve, Mia 326–7
Hard to be a God 465–6
Hare, David 360
Hartnett, Josh 66–7
Hassan, Ragdha 395–6
Hausner, Jessica 35–7, 39
Hawke, Ethan 190, 234–5, 311
Haynes, Todd 304–6
Headless Woman, The 32–4, 40
Heder, Jon 188–9
Heffer, Simon 488–9
Heigl, Katherine 140–1, 206
Her Name was Ellie; His Name was Lyle 316–17
Herzog, Werner 371–3
Heston, Charlton 471, 527
Hidden 32, 62, 268, 337–8
Hilton, Paris 53
Hirohito, Emperor 15–17, 52
Hirschbiegel, Oliver 162
Hitchcock, Alfred 19, 167, 217, 265, 313, 342, 374, 499–500, 516
Hoffman, Michael 152
Hoffman, Philip Seymour 23–4, 49
Holiday, The 85–7

Holofcener, Nicole 210–11
Homo Sapiens 399–400
Hounds of Love 359
Hurt, John 57, 103, 459–60
Hurt Locker, The 261–3, 267, 419

I Know Where I'm Going 485–7
Ides of March, The 264
Illusionist, The 414–16
Imagining Argentina 73
In the Mood for Love 534–6
In Praise of Love 301–2
In The Fog 51–2
Iñárritu, Alejandro González 88, 90, 243
Incredible Hulk, The 107–8
Incredibles, The 422–4, 428
Injustice: The Movie 365, 366–7
Inland Empire 18–20
Interstellar 462–4
Iraq in Fragments 254–5
Iron Man 3 433–4
Irréversible 329, 330–2, 343, 345
It Follows 289–90

Jackman, Hugh 111–12, 176
Jackson, Mike 285–6
Jackson, Peter 3
Jarecki, Andrew 368–70
Jarmusch, Jim 57, 219
Jaws 498
Jenson, Vicky 404
Jeune & Jolie 321
Johansson, Scarlet 58–9
John Carter 149–50
Jolie, Angelina 69, 71, 387
Jonze, Spike 179
Journey to Italy 506
Joy of Sex Education, The collection 316–18
Juno 21–2

Kapadia, Asif 392–3
Kapur, Shekhar 94

Kar-wai, Wong 534
Kaufman, Charlie 23–5, 179
Keats, John 26–8
Kechiche, Abdellatif 319–20, 321
Ken Loach Saves the Children 377–9
Kent, Jennifer 287
Kerr, Deborah 508–10
Kickass 430–2
Kidman, Nicole 21, 75–7, 111–12,
 166–7
Kill List 279–81
Killer Inside Me, The 342–4
Kind Hearts and Coronets 471, 472–3,
 488–92
Knightley, Keira 170
Krause brothers 102
Kubrick, Stanley 329, 346–7, 399,
 444–5, 449, 457–9, 462, 468, 484,
 502, 512
Kurosawa, Akira 453, 475

La Grande Bouffe 526
Lang, Fritz 516
Lanthimos, Giorgos 38–40
Lara Croft: Tomb Raider 69–71
Lassie 79–80
Last Airbender, The 136–7
Last Picture Show, The 480
Last Tango in Paris 312–15
Law, Jude 85–7, 96, 96–8
Lawrence of Arabia 503
Lawrence, Stephen 365, 366–7
Lean, David 503
Leigh, Mike 12, 14, 32, 97
Lewis, Jerry 121
Linklater, Richard 190, 191, 234–6,
 311, 354
Lions for Lambs 256–7, 261, 267
Liotta, Ray 91, 92
Loach, Ken 243, 286, 377–9
Lohan, Lindsay 323
Lone Ranger, The 160–1
Lonergan, Kenneth 44
Longley, James 254–5

Louis-Dreyfus, Julia 210–11
Lourdes 35–7
Love Happens 127
Love in the Time of Cholera 105–6
Loznitsa, Sergei 51–2
Lucas, George 81–3
Luhrmann, Baz 111–12, 157–9
Lynch, David 18–20, 23, 59, 162,
 299, 374

M 516
MacArthur, General Douglas
 15–17
Macy, William H. 91
Madden, John 147
Madonna 119–20, 142–3
Maguire, Toby 157–9
Makhmalbaf, Samira 242, 243, 265,
 267–8
Malkovich, John 179–81
Malle, Louis 517
Man Who Wasn't There, The 9–11
Man on Wire 266
Marclay, Christian 41–3
Margaret 44–5
Marsden, James 169
Marsh, James 266
Marshall, Garry 140–1
Martel, Lucrecia 32–4, 40, 279
Master, The 48–50
May, Elaine 528
Maze Runner, The 168
McAllister, Sean 395–6
McConaughey, Matthew 462–3
McDormand, Frances 10
McGregor, Ewan 81–2
McKay, Adam 178
McLean, Greg 336
McQueen, Steve 54–6
Mehmood, Tariq 365, 366–7
Michael 351–3
Miike, Takashi 273–5
Mikey and Nicky 528–9
Minnelli, Vincente 497

Mitchell, David Robert 289–90
Miyazaki, Hayao 406, 408, 414, 418
Moore, Julianne 237–8, 304–6, 348
Moore, Michael 183, 240, 245–7,
 253, 258, 267, 334, 363–4
Moretti, Nanni 227
Morley, Carol 380–1
Morris, Chris 269
Mulligan, Carey 157–9
My Sister's Keeper 121–3
Myers, Mike 74, 235, 403, 433

Nair, Mira 242
Neeson, Liam 173
New Years' Eve 140–1
Newton, Thandie 109, 315
Nicholson, Jack 477–8, 502
Nighy, Bill 147–8
No Reservations 100–1
Noé, Gaspar 329, 330–2, 343,
 345–7, 357
Nolan, Christopher 425–7, 444,
 462–4
Northup, Solomon 54–5
Norton, Edward 107
Nostalgia for the Light 385

October 531–3
Of Freaks and Men 298–300
Ogata, Issei 16
Old Dogs 130–1
Olympus Has Fallen 155–6
Omen, The 271–2
Once Upon A Time in Anatolia
 46–7
Only God Forgives 356–8
Only Lovers Left Alive 57
Oppenheimer, Joshua 389
Östlund, Ruben 61
Other Guys, The 178
O'Toole, Peter 79, 503
Ouedraogo, Idrissa 242, 243, 266
Oz, Frank 75–6
Ozon, Francois 321

Page, Ellen 21–2
Pain & Gain 209
Pan 176
Panahi, Jafar 383–4, 397–8
Paquin, Anna 44–5, 103
Paranormal Activity 276–8
Parker, Trey 182–3
Paths of Glory 512
Pattison, Robert 128–9, 132
Pearl Harbour 66–8
Peele, Jordan 291
Peeping Tom 479
Peli, Oren 277–8
Penn, Sean 239, 242, 265, 266
People at No. 19 317
Persepolis 409–11
Pervert's Guide to the Cinema,
 The 374
Phantom Thread 8
Phoenix, Joaquin 48–9
Pinochet, Augusto 385–6
Pinter, Harold 96, 97
Pitt, Brad 55, 89, 116–17, 211
Point Blank 505
Poitras, Laura 390
Polley, Diane 387–8
Polley, Michael 387–8
Polley, Sarah 387–8
Powell, Michael 479, 485–6, 507,
 509–11, 518
Pressburger, Emeric 485–6, 507,
 509–11, 518
Primer 454–6
Psycho 471–2, 499–501
Pulp Fiction 513

Rafelson, Bob 477
Raging Bull 165, 471, 473, 493–5
Ramsay, Lynne 348
Rashômon 475
Rasoulof, Mohammad 383
Ray, Satyajit 515
Reader, The 113–15
Rebound, The 135

Redacted 258–60
Redford, Robert 256–7, 261, 264, 267
Reed, Carol 525
Refn, Nicolas Winding 356–7
Renner, Jeremy 153–4, 262
Ritchie, Guy 109–10
Roberts, Julia 138, 140–1
Rocknrolla 109–10
Roeg, Nicolas 481–4, 506
Rossellini, Roberto 506
Roth, Tim 167, 513

Sandler, Adam 205
Sarandon, Susan 84, 182–3
Say When 170
Schleinzer, Markus 351, 353
Schnabel, Julian 36, 231, 233
Schneider, Maria 312–15
Schrader, Paul 323
Scorsese, Martin 145, 212, 214, 295, 347, 419, 471, 473, 493–5, 519
Scott, Ridley 459–60
Scott-Taylor, Jonathan 271–2
Seagal, Steven 72
Second Coming 63
Shining, The 502
Shrek 403–5, 423
Shyamalan, M. Night 136–7, 205, 283, 462
Silent Running 467–9
Simpson, Wallis 142–3
Sleuth 96–8
Snowden, Edward 390–1
Snyder, Zack 428
Soderbergh, Steven 457
Sokurov, Aleksandr 15–17, 52, 466
Solaris (Soderbergh) 457
Solaris (Tarkovsky) 444–6, 457–8, 465
Son's Room, The 227
Spielberg, Steven 228–30, 319, 355, 411, 444, 459, 498
Spirited Away 406–8, 414

Stallone, Sylvester 165
Stanton, Andrew 149
Star Wars 3: Revenge of the Sith 81–3
Staunton, Imelda 12–14
Stepford Wives, The 75–7
Stewart, Kristen 128–9
Still Alice 237–8
Stone, Emma 435–7
Stone, Matt 182–3
Stone, Oliver 251–2, 266
Stories We Tell 387–8
Stranger by the Lake 322
Streep, Meryl 256–7, 514
Strickland, Peter 324–5
Sturridge, Charles 79
Sun, The 15–17, 52
Sunshine 445–7
Suspiria 293–4
Swinton, Tilda 57, 216, 348–50, 470
Synecdoche, New York 23–5
Syrian Love Story, A 395–6

Taken 3 173
Tales of Hoffman, The 518
Tarantino, Quentin 54, 280, 296, 324, 332, 513
Tarkovsky, Andrei 444, 445, 457, 458, 465
Taxi Driver 295, 357
Taxi Tehran 397–8
Taylor-Johnson, Sam 174–5
Team America: World Police 182–4
Ted 204–5
Third Man, The 525
This is 40 206–8
This is Not a Film 383–4
Thompson, Emma 73
Thornton, Billy Bob 9, 10
Threads 285–6
Thurman, Uma 104, 296, 513
Tom Cat 151
Toni Erdmann 221–2
Touch of Evil 527

Toy Story movies 149, 161, 205, 228, 404–5, 422–3
 Toy Story 2 224, 225–6, 231, 412
 Toy Story 3 412–13
Travolta, John 91, 130–1, 162, 513
Treadwell, Timothy 371–3
Twilight Saga: Eclipse 132–4
Twilight Saga: New Moon, The 128–9

Under The Skin 58–9
United 93 240, 248–50, 252–3, 266

Van Sant, Gus 333–5, 348
Vaughn, Matthew 430
Vera Drake 12–14, 32
Verbinski, Gore 160
Vincent, Joyce 380–2
Von Trier, Lars 339–41

W 266
Waititi, Taika 218
Watchmen 428–9
Watts, Naomi 162–3, 166
Wayans brothers 125
W.E. 142–3
We Need to Talk About Kevin 348–50
Weaver, Sigourney 459–61
Webb, Marc 435
Wedding Date, The 78
Weitz, Chris 128
Welles, Orson 519, 521, 523–5, 527, 531
Went The Day Well 476

West, Simon 70
Westmoreland, Wash 237–8
Wetherby 360–2
What We Do in the Shadows 218
Wheatley, Ben 6, 279
Whedon, Joss 282, 283, 440, 441
When Marnie was There 418
Whishaw, Ben 26–7
White Ribbon, The 29–31
Wiig, Kristen 201–3
Wild Hogs 91–2
Wilder, Billy 196–8
Wilkinson, Tom 147–8
Williams, Robin 130–1, 372
Winehouse, Amy 392–4
Winslet, Kate 85–7, 113, 115
Winterbottom, Michael 309–11, 342–3
Wiseman, Noah 287–8
Wolf Creek 336
Wolf of Wall Street, The 212–14, 419
World Trade Center 251–3, 266

X-Men: Days of Future Past 419–20, 438–9

You, The Living 193–5

Zeta-Jones, Catherine 77, 100–1, 135
Zizek, Slavoj 374
Zlotowski, Rebecca 60
Zobel, Craig 354